# THE AGE OF
# INSIGHT

RANDOM HOUSE

NEW YORK

# THE AGE OF
# INSIGHT

...

THE QUEST TO UNDERSTAND

THE UNCONSCIOUS IN

ART, MIND, AND BRAIN, FROM

VIENNA 1900 TO THE PRESENT

# ERIC R.
# KANDEL

3/ 97201

The publication of this book benefited from the interest and support of Columbia University's Mind, Brain and Behavior Initiative. This initiative reflects the University's commitment to linking science and technology with the arts and humanities, through a deeper understanding of neural science.

Published in the United States by Random House, an imprint of The Random House Publishing Group, a division of Random House, Inc., New York.

RANDOM HOUSE and colophon are registered trademarks of Random House, Inc.

Grateful acknowledgment is made to the following for permission to reprint previously published material:

ARTISTS RIGHTS SOCIETY (ARS): "The Dreaming Youth" by Oskar Kokoschka as translated by Carl Schorske in *Fin de Siècle Vienna* by Carl Schorske, © 2012 Fondation Oskar Kokoschka/Artists Rights Society (ARS), New York/ProLitteris, Zurich. Reproduction, including downloading of Kokoschka works, is prohibited by copyright laws and international conventions without the express written permission of Artists Rights Society (ARS), New York.

BLACKWELL PUBLISHING, LTD: Excerpts from *Autism: Explaining the Enigma* by Uta Frith, copyright © 1989, 2003 by Uta Frith. Reprinted by permission of Blackwell Publishing, Ltd.

ROWMAN & LITTLEFIELD PUBLISHING GROUP: Excerpts from *Desire and Delusion: Three Novellas* by Arthur Schnitzler, translated by Margaret Schaefer, English translation copyright © 2003 by Margaret Schaefer (Chicago, IL: Ivan R. Dee, Publishers, 2003). Reprinted by permission of Rowman & Littlefield Publishing Group.

THAMES & HUDSON LTD., LONDON: Excerpts from *Oskar Kokoschka: My Life* by Oskar Kokoschka, translated by David Britt, © 1974. Reprinted by kind permission of Thames & Hudson Ltd., London.

LIBRARY OF CONGRESS CATALOGING-IN-PUBLICATION DATA

Kandel, Eric R.
The age of insight: the quest to understand the unconscious in art, mind, and brain, from Vienna 1900 to the present / Eric R. Kandel.
p. cm.
ISBN 978-1-4000-6871-5
eISBN 978-1-5883-6930-7
1. Subconsciousness. 2. Perception. 3. Subconsciousness in art.
I. Title.
BF315.K296 2011  154.2—dc23  2011025274

www.atrandom.com

2 4 6 8 9 7 5 3 1

FIRST EDITION

*Book design by Barbara M. Bachman*

*Pour Denise—toujours*

## PART TWO

# A COGNITIVE PSYCHOLOGY OF VISUAL PERCEPTION AND EMOTIONAL RESPONSE TO ART

...

## PART THREE

# BIOLOGY OF THE BEHOLDER'S VISUAL RESPONSE TO ART

...

# CONTENTS

⌇

*Preface ... xiii*

PART FOUR

# BIOLOGY OF THE BEHOLDER'S EMOTIONAL RESPONSE TO ART

...

PART FIVE

# AN EVOLVING DIALOGUE BETWEEN VISUAL ART AND SCIENCE

...

⊂\∕⊃

WHEN AUGUSTE RODIN VISITED VIENNA IN JUNE 1902, BERTA
Zuckerkandl invited the great French sculptor, together with Gustav
Klimt, Austria's most accomplished painter, for a *Jause*, a typical Vien-
nese afternoon of coffee and cakes. Berta, herself a leading art critic
and the guiding intelligence of one of Vienna's most distinguished sa-
lons, recalled this memorable afternoon in her autobiography:

> Klimt and Rodin had seated themselves beside two remarkably
> beautiful young women—Rodin gazing enchantedly at them. . . .
> Alfred Grünfeld [the former court pianist to Emperor Wilhelm I
> of Germany, now living in Vienna] sat down at the piano in the
> big drawing room, whose double doors were opened wide. Klimt
> went up to him and asked: "Please play us some Schubert." And
> Grünfeld, his cigar in his mouth, played dreamy tunes that floated
> and hung in the air with the smoke of his cigar.
>
> Rodin leaned over to Klimt and said: "I have never before
> experienced such an atmosphere—your tragic and magnificent
> Beethoven fresco; your unforgettable, temple-like exhibition;
> and now this garden, these women, this music . . . and round it
> all this gay, childlike happiness. . . . What is the reason for it
> all?"
>
> And Klimt slowly nodded his beautiful head and answered
> only one word: *"Austria."*[1]

This idealized, romantic view of life in Austria, which Klimt shared
with Rodin and which bears only the most tenuous relation to reality, is
also etched in my imagination. I was forced to leave Vienna as a child,

but the intellectual life of turn-of-the-century Vienna is in my blood: my heart beats in three-quarter time.

*The Age of Insight* is a product of my subsequent fascination with the intellectual history of Vienna from 1890 to 1918, as well as my interest in Austrian modernist art, psychoanalysis, art history, and the brain science that is my life's work. In this book I examine the ongoing dialogue between art and science that had its origins in fin-de-siècle Vienna and document its three major phases.

The first phase began as an exchange of insights about unconscious mental processes between the modernist artists and members of the Vienna School of Medicine. The second phase continued as an interaction between art and a cognitive psychology of art, introduced by the Vienna School of Art History in the 1930s. The third phase, which began two decades ago, saw this cognitive psychology interact with biology to lay the foundation for an emotional neuroaesthetic: an understanding of our perceptual, emotional, and empathic responses to works of art.

This dialogue and the ongoing research in brain science and art continue to this day. They have given us an initial understanding of the processes at work in the brain of the beholder—the viewer—as he or she looks at a work of art.

THE CENTRAL CHALLENGE of science in the twenty-first century is to understand the human mind in biological terms. The possibility of meeting that challenge opened up in the late twentieth century, when cognitive psychology, the science of mind, merged with neuroscience, the science of the brain. The result was a new science of mind that has allowed us to address a range of questions about ourselves: How do we perceive, learn, and remember? What is the nature of emotion, empathy, thought, and consciousness? What are the limits of free will?

This new science of mind is important not only because it provides a deeper understanding of what makes us who we are, but also because it makes possible a meaningful series of dialogues between brain science and other areas of knowledge. Such dialogues could help us explore the mechanisms in the brain that make perception and creativity possible, whether in art, the sciences, the humanities, or everyday life. In a larger sense, this dialogue could help make science part of our common cultural experience.

I take up this central scientific challenge in *The Age of Insight* by focusing on how the new science of mind has begun to engage with art. To obtain a meaningful and coherent focus for this reemerging dialogue, I purposely limit my discussion to one particular form of art—portraiture—and to one particular cultural period—Modernism in Vienna at the beginning of the twentieth century. I do this not only to focus the discussion on a central set of issues but also because both this art form and this period are characterized by a series of pioneering attempts to link art and science.

PORTRAITURE IS A HIGHLY suitable art form for scientific exploration. We now have the beginnings of an intellectually satisfying understanding—in both cognitive psychological and biological terms—of how we respond perceptually, emotionally, and empathically to the facial expressions and bodily postures of others. Modernist portraiture in "Vienna 1900" is particularly suitable because the artists' concern with the truth lying beneath surface appearances was paralleled and influenced by similar, contemporaneous concerns with unconscious mental processes in scientific medicine, psychoanalysis, and literature. Thus, the portraits of the Viennese modernists, with their conscious and dramatic attempts to depict their subjects' inner feelings, represent an ideal example of how psychological and biological insights can enrich our relationship to art.

In that context, I examine the impact of contemporary scientific thought and of the wider intellectual environment of Vienna 1900 on three artists: Gustav Klimt, Oskar Kokoschka, and Egon Schiele. One of the characteristic features of Viennese life at that time was the continual, easy interaction of artists, writers, and thinkers with scientists. The interaction with medical and biological scientists, as well as with psychoanalysts, significantly influenced the portraiture of these three artists.

The Viennese modernists are appropriate for this analysis in other ways as well. To begin with, they can be explored in depth because there are so few of them—only three major artists—yet they are important in the history of art both collectively and individually. As a group, they sought to depict the unconscious, instinctual strivings of the people in their paintings and drawings, yet each artist developed a distinctive way of using facial expressions and hand and body gestures

to communicate his insights. In doing so, each artist made independent conceptual and technical contributions to modern art.

In the 1930s scholars at the Vienna School of Art History were instrumental in advancing the modernist agenda of Klimt, Kokoschka, and Schiele. They emphasized that the function of the modern artist was not to convey beauty, but to convey new truths. In addition, the Vienna School of Art History, influenced in part by Sigmund Freud's psychological work, began to develop a science-based psychology of art that was initially focused on the beholder.

Today, the new science of mind has matured to the point where it can join and invigorate a new dialogue between art and science, again focused on the beholder. To relate present-day brain science to the modernist painting of Vienna 1900, I outline in simple terms, for the general reader and for the student of art and intellectual history, our current understanding of the cognitive psychological and neurobiological basis of perception, memory, emotion, empathy, and creativity. I then examine how cognitive psychology and brain biology have joined together to explore how the viewer perceives and responds to art. My examples are taken from modernist art, particularly Austrian Expressionism, but the principles of the viewer's response to art are applicable to all periods of painting.

WHY WOULD WE WANT to encourage a dialogue between art and science, and between science and culture at large? Brain science and art represent two distinct perspectives on mind. Through science we know that all of our mental life arises from the activity of our brain; thus, by observing that activity we can begin to understand the processes that underlie our responses to works of art. How is information collected by the eyes turned into vision? How are thoughts turned into memories? What is the biological basis of behavior? Art, on the other hand, provides insight into the more fleeting, experiential qualities of mind, what a certain experience feels like. A brain scan may reveal the neural signs of depression, but a Beethoven symphony reveals what that depression feels like. Both perspectives are necessary if we are to fully grasp the nature of mind, yet they are rarely brought together.

The intellectual and artistic environment of Vienna 1900 marked an early exchange between the two perspectives and resulted in a tremendous boom in the development of thinking about the human mind.

What would the benefits of such an exchange be today, and who could gain from it? The gain for brain science is clear: one of the ultimate challenges of biology is to understand how the brain becomes consciously aware of perception, experience, and emotion. But it is equally conceivable that the exchange would be useful for the beholders of art, for art and intellectual historians, and for artists themselves.

Insights into the processes of visual perception and emotional response may well stimulate a new language about art, new art forms, and perhaps even new expressions of artistic creativity. Much as Leonardo da Vinci and other Renaissance artists used the revelations of human anatomy to help them depict the body more accurately and compellingly, so, too, many contemporary artists may create new forms of representation in response to revelations about how the brain works. Understanding the biology behind artistic insights, inspiration, and the beholder's response to art could be invaluable to artists seeking to heighten their creative powers. In the long run, brain science may also provide clues to the nature of creativity itself.

Science seeks to understand complex processes by reducing them to their essential actions and studying the interplay of those actions—and this reductionist approach extends to art as well. Indeed, my focus on one school of art, consisting of only three major representatives, is an example of this. Some people are concerned that a reductionist analysis will diminish our fascination with art, that it will trivialize art and deprive it of its special force, thereby reducing the beholder's share to an ordinary brain function. I argue to the contrary, that by encouraging a dialogue between science and art and by encouraging a focus on one mental process at a time, reductionism can expand our vision and give us new insights into the nature and creation of art. These new insights will enable us to perceive unexpected aspects of art that derive from the relationships between biological and psychological phenomena.

Reductionism and the biology of the brain in no way deny the richness and complexity of human perception or lessen our appreciation and enjoyment of the shape, color, and emotion of human faces and bodies. We now have a good scientific understanding of the heart as a muscular organ that propels blood throughout the body and the brain. As a result, we no longer view the heart as the seat of emotion; yet that new insight does not diminish our admiration of the heart or our appreciation of its importance to us. Similarly, science may explain as-

pects of art but it will not replace the inspiration that art evokes, the beholder's enjoyment of art, or the impulses and aims of creativity. On the contrary, an understanding of the biology of the brain will most likely contribute to a broader cultural framework for art history, aesthetics, and cognitive psychology.

Much of what we find interesting and compelling about a work of art cannot be explained by the current science of mind. Yet all visual art, from the ancient cave paintings of Lascaux to contemporary performance pieces, have important visual, emotional, and empathic components that we now understand on a new level. A greater understanding of those components will not only clarify the conceptual content of art, but also explain how the beholder brings memory and experience to bear on a work of art and, as a result, assimilates aspects of art into a broader body of knowledge.

While brain sciences and the humanities will continue to have their own distinctive concerns, my purpose in this book is to illustrate how we can begin to focus the perspective of the science of mind and the perspective of the humanities on certain common intellectual problems and continue in the decades ahead the dialogue that began in Vienna 1900 as a quest to connect art, mind, and brain. This possibility encouraged me to conclude *The Age of Insight* by considering historically the broader issues of how science and art have influenced each other in the past and how in the future these interdisciplinary influences could enrich our knowledge and enjoyment of science as well as art.

PART ONE

...

A

PSYCHOANALYTIC

PSYCHOLOGY

AND ART OF

UNCONSCIOUS

EMOTION

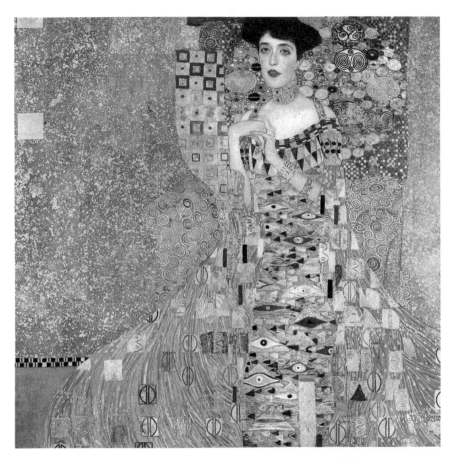

Figure 1-1. Gustav Klimt, *Adele Bloch-Bauer I* (1907).
Oil, silver, gold on canvas.

# AN INWARD TURN:
# VIENNA 1900

❧

IN 2006 RONALD LAUDER, A COLLECTOR OF AUSTRIAN EXPRES-
sionist art and the co-founder of the Neue Galerie, the expressionist
museum in New York City, spent the extraordinary sum of $135 mil-
lion to purchase a single painting: Gustav Klimt's captivating, gold-
encrusted portrait of Adele Bloch-Bauer, a Viennese socialite and
patroness of the arts. Lauder first saw Klimt's 1907 painting in the
Upper Belvedere Museum when he visited Vienna as a fourteen-year-old
and was smitten by the image. She seemed to epitomize turn-of-the-
century Vienna: its richness, its sensuality, and its capacity for innova-
tion. Over the years Lauder became convinced that Klimt's portrait of
Adele (Fig. 1-1) was one of the great depictions of the mystery of wom-
anhood.

As the elements of Adele's dress attest, Klimt was indeed a skilled
decorative painter in the nineteenth-century tradition of Art Nouveau.
But the painting has an additional, historical meaning: it is one of
Klimt's first paintings to depart from a traditional three-dimensional
space and move into a modern, flattened space that the artist decorated
luminously. The painting reveals Klimt as an innovator and major con-
tributor to the emergence of Austrian Modernism in art. The Klimt
historians Sophie Lillie and Georg Gaugusch describe *Adele Bloch-
Bauer I* in the following terms:

> [Klimt's] painting not only rendered Bloch-Bauer's irresistible
> beauty and sensuality; its intricate ornamentation and exotic
> motifs heralded the dawn of Modernity and a culture intent on

radically forging a new identity. With this painting, Klimt created a secular icon that would come to stand for the aspirations of a whole generation in fin-de-siècle Vienna. [1]

In this painting Klimt abandons the attempt of painters from the early Renaissance onward to re-create with ever-increasing realism the three-dimensional world on a two-dimensional canvas. Like other modern artists faced with the advent of photography, Klimt sought newer truths that could not be captured by the camera. He, and particularly his younger protégés Oskar Kokoschka and Egon Schiele, turned the artist's view inward—away from the three-dimensional outside world and toward the multidimensional inner self and the unconscious mind.

In addition to this break with the artistic past, the painting shows us how modern science, particularly modern biology, influenced Klimt's art, as it did much of the culture of "Vienna 1900," or Vienna during the period between 1890 and 1918. As the art historian Emily Braun has documented, Klimt read Darwin and became fascinated with the structure of the cell—the primary building block of all living things. Thus, the small iconographic images on Adele's dress are not simply decorative, like other images in the Art Nouveau period. Instead, they are symbols of male and female cells: rectangular sperm and ovoid eggs. These biologically inspired fertility symbols are designed to match the sitter's seductive face to her full-blown reproductive capabilities.

THE FACT THAT THE Adele Bloch-Bauer portrait was magnificent enough to fetch $135 million—the most ever paid for a single painting up to that time—is all the more extraordinary considering that at the beginning of Klimt's career his work, although highly competent, was unremarkable. He was a good but conventional painter, a decorator of theaters, museums, and other public buildings who followed the grand historicist, conventional style of his teacher, Hans Makart (Fig. 1-2). Like Makart, a talented colorist who was called the new Rubens by the Viennese patrons of art who idolized him, Klimt painted large portraits dealing with allegorical and mythological themes (Fig. 1-3).

It was not until 1886 that Klimt's work took a bold, original turn. That year, he and his colleague Franz Matsch were each asked to commemorate the auditorium of the Old Castle Theatre, which was about

Figure 1-2.
Hans Makart,
*Crown Princess
Stephanie of Belgium*
(1881).
Oil on canvas.

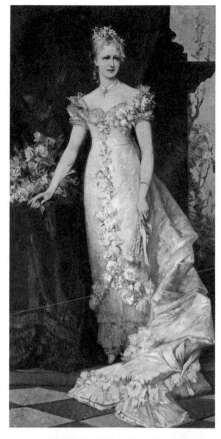

Figure 1-3.
Gustav Klimt, *Fable*
(1883).
Oil on canvas.

to be demolished and replaced by a modern structure. Matsch painted a view of the stage from the entrance, and Klimt portrayed the last performance at the old theater. But rather than painting a view of the stage or the actors on it, Klimt painted specific, recognizable members of the audience *as seen from the stage*. These members of the audience were not attending to the play but to their own inner thoughts. The real drama of Vienna, Klimt's painting implies, did not take place on the stage, it took place in the private theater of the audience's mind (Figs. 1-4, 1-5).

Soon after Klimt painted the Old Castle Theatre, a young neurologist, Sigmund Freud, began treating patients who suffered from hysteria with a combination of hypnosis and psychotherapy. As his patients turned inward, freely associated, and talked about their private lives and thoughts, Freud connected their hysterical symptoms to traumas in their past. The paradigm for this highly original mode of treatment derived from Josef Breuer's study of an intelligent young Viennese woman known as "Anna O." Breuer, a senior colleague of Freud, had found that Anna's "monotonous family life and the absence of adequate intellectual occupation . . . [had] led to a habit of daydreaming"—what Anna referred to as her "private theater."[2]

The remarkable insight that characterized Klimt's later work was contemporaneous with Freud's psychological studies and presaged the inward turn that would pervade all fields of inquiry in Vienna 1900. This period, which gave rise to Viennese Modernism, was characterized by the attempt to make a sharp break with the past and to explore new forms of expression in art, architecture, psychology, literature, and music. It spawned an ongoing pursuit to link these disciplines.

IN PIONEERING THE EMERGENCE of Modernism, Vienna 1900 briefly assumed the role of cultural capital of Europe, a role in some respects similar to that assumed by Constantinople in the Middle Ages and by Florence in the fifteenth century. Vienna had been the center of the Habsburg dynastic lands since 1450 and gained further prominence a century later, when it became the center of the Holy Roman Empire of the German-Speaking Nation. The empire comprised not only the German-speaking states, but also the state of Bohemia and the kingdom of Hungary-Croatia. Over the next three hundred years, these disparate lands remained a mosaic of nations that had no common unifying name or culture. It was held together solely by the continuous

Figure 1-4.
Gustav Klimt,
*The Auditorium of the
Old Castle Theatre*
(1888).
Oil on canvas.

Figure 1-5. Detail of
the Auditorium
showing Theodor
Billroth, the leading
surgeon in Europe;
Karl Lueger, who
would become mayor
of Vienna a decade
later; and the actress
Katharina Schratt, the
mistress of the
Emperor Franz Joseph.

rule of the Habsburg Holy Roman Emperors. In 1804 Francis II, the last of the Holy Roman Emperors, assumed the title Emperor of Austria as Francis I. In 1867 Hungary insisted on equal footing, and the Habsburg Empire became the Dual Monarchy, Austria-Hungary.

At the zenith of its power, in the eighteenth century, the Habsburg Empire was second only to the Russian Empire in the size of its European landholdings. Moreover, the Habsburg Empire had a long history of administrative stability. But a series of military losses in the latter half of the nineteenth century and civil unrest in the early twentieth century diminished the empire's political power, and the Habsburgs reluctantly turned away from geopolitical ambitions and toward a concern with the political and cultural aspirations of their people, especially the middle class.

In 1848 Austria's liberal middle class became energized and forced the country's absolute, almost feudal monarchy, dominated by the Emperor Franz Joseph, to evolve along more democratic lines. The ensuing reforms were based on a view of Austria as a progressive, constitutional monarchy modeled on those in England and France and characterized by a cultural and political partnership between the enlightened middle class and the aristocracy. This partnership was designed to reform the state, to support the secular cultural life of the nation, and to establish a free-market economy, all based on the modern belief that reason and science would replace faith and religion.

By the 1860s, most Austrians sensed that their nation was in transition. In negotiation with the emperor, the middle class had succeeded in transforming Vienna into one of the most beautiful cities in the world. As a Christmas present to the citizens of Vienna in 1857, Franz Joseph ordered the demolition of the old walls and fortifications surrounding the city to make room for the Ringstrasse, a grand boulevard that would encircle the city. On both sides of the Ringstrasse, magnificent public buildings—the Parliament, City Hall, the Opera House, the Old Castle Theatre, the Museum of Fine Arts, the Museum of Natural History, and the University of Vienna—were to be erected, together with palaces for the aristocracy and great apartment buildings for the more affluent middle class. At the same time, the Ringstrasse brought the surrounding suburbs—populated by shop owners, tradesmen, and laborers—into closer contact with the city.

The progressive views of the middle class and the emperor had a

particularly profound effect on the Jewish community. In 1848 Jewish religious services were legalized and the special taxes on Jews were abolished. Jews were also allowed for the first time to seek out professional and governmental careers. The Fundamental Laws of 1867 and the Interconfessional Settlement of 1868 gave the Jewish community civil and legal rights equaling those of other, mostly Catholic, Austrians. During this brief period in Austrian history, anti-Semitism became socially unacceptable. In addition to introducing freedom of religious practice, these laws also introduced state education and allowed civil marriages between Christians and Jews, which had previously been prohibited.

Finally, government restrictions on travel within the Habsburg Empire, which applied to everyone, were eased in 1848 and abolished in 1870. The vibrant cultural life and economic opportunities of Vienna attracted talented people, especially Jews, from all over the empire. As a result, the number of Jews in Vienna increased from 6.6 percent of the city's population in 1869 to 12 percent in 1890, making a tremendous impact on the emergence of Modernism. The abolition of restrictions on travel also increased the social and cultural mobility of scholars and scientists. Vienna benefitted from an influx of talented individuals from different religious, social, cultural, ethnic, and educational backgrounds. Together with the modernization of education, this influx led to the emergence of the University of Vienna as a great research university. The resulting transformation of science and technology created a vibrant, interactive intellectual atmosphere that contributed importantly to the later emergence of Modernism in Vienna.

BY 1900, VIENNA WAS home to nearly two million people, many of whom had been attracted to the city because of its emphasis on intellectual excellence and cultural achievement. A remarkable number of them were pioneers in a broad range of modernist movements. In philosophy, the Vienna Circle, a group around Moritz Schlick that later included Rudolf Carnap, Herbert Feigl, Philipp Frank, Kurt Gödel, and most important, Ludwig Wittgenstein, introduced an attempt to codify all knowledge into a single standard language of science. The Vienna School of Economics was founded by Carl Menger, Eugen Böhm Bawerk, and Ludwig von Mises. The great composer Gustav Mahler prepared the transition from Haydn, Mozart, Beethoven,

Schubert, and Brahms, the first Vienna school of music, to a new generation of composers led by Arnold Schönberg, Alban Berg, and Anton Webern, the second Vienna school of music.

The architects Otto Wagner, Joseph Maria Olbrich, and Adolf Loos reacted to the magisterial public buildings on the Ringstrasse—contemporary copies of Gothic, Renaissance, and Baroque styles—by creating a clean, functional style of architecture that paved the way for the German Bauhaus School of the 1920s. Wagner insisted that architecture be modern and original, and he understood the importance of transportation and city planning. This was evidenced by the design of more than thirty beautiful stations for the Vienna city railway system, as well as the design of viaducts, tunnels, and bridges. In all of these efforts, Wagner strove for a harmony between art and purpose. As a result, Vienna had one of the most advanced infrastructures of any major city in Europe. The Wiener Werkstätte, or Vienna Workshop—the arts and design institute led by Josef Hoffmann and Koloman Moser—advanced the beauty of everyday life with elegant designs of jewelry, furniture, and other objects. In literature, Arthur Schnitzler and Hugo von Hofmannsthal formed Young Vienna, a modern school of fiction, drama, and poetry. Most important, as we shall see, a chain of scientists stretching from Carl von Rokitansky to Freud established a new, dynamic view of the human psyche that revolutionized thinking about the human mind.

Creative activity in the arts, art history, and literature paralleled the advances in science and medicine, while the optimism of the medical, biological, and physical sciences filled the void created by a decline in spirituality. Indeed, Viennese life at the turn of the century provided opportunities in salons and coffeehouses for scientists, writers, and artists to come together in an atmosphere that was at once inspiring, optimistic, and politically engaged. The advances in biology, medicine, physics, chemistry, and the related fields of logic and economics brought with them the realization that science was no longer the narrow and restricted province of scientists but had become an integral part of Viennese culture. This attitude fostered interactions that brought the humanities and the sciences closer together and that serve to this day as a paradigm for how an open dialogue can be achieved.

Moreover, the liberal intellectual spirit of Vienna 1900 and the progressive attitudes of the university's science faculty helped to spur the

political and social liberation of women advocated in Schnitzler's writing and in the work of the three artists.

Freud's theorizing, Schnitzler's writings, and the paintings of Klimt, Schiele, and Kokoschka had a common insight into the nature of human instinctual life. During the period of 1890 to 1918, the insights of these five men into the irrationality of everyday life helped Vienna to become the center of modernist thought and culture. We still live in that culture today.

MODERNISM BEGAN IN the mid-nineteenth century as a response not only to the restrictions and hypocrisies of everyday life, but also as a reaction to the Enlightenment's emphasis on the rationality of human behavior. The Enlightenment, or Age of Reason, was characterized by the idea that all is well with the world because human action is governed by reason. It is through reason that we achieve enlightenment, because our mind can exert control over our emotions and feelings.

The immediate catalyst for the emergence of the Enlightenment in the eighteenth century was the scientific revolution of the sixteenth and seventeenth centuries, which included three momentous discoveries in astronomy: Johannes Kepler delineated the rules that govern the movement of the planets, Galileo Galilei placed the sun at the center of the universe, and Isaac Newton discovered the force of gravity, invented calculus (Gottfried Wilhelm Leibniz independently discovered it at the same time), and used it to describe the three laws of motion. In so doing, Newton joined physics and astronomy and illustrated that even the deepest truths in the universe could be revealed by the methods of science.

These contributions were celebrated in 1660 with the formation of the first scientific society in the world: the Royal Society of London for Improving Natural Knowledge, which elected Isaac Newton as its president in 1703. The founders of the Royal Society thought of God as a mathematician who had designed the universe to function according to logical and mathematical principles. The role of the scientist—the natural philosopher—was to employ the scientific method to discover the physical principles underlying the universe and thereby decipher the codebook that God had used in creating the cosmos.

Success in the realm of science led eighteenth-century thinkers to assume that other aspects of human action, including political behav-

ior, creativity, and art, could be improved by the application of reason, leading ultimately to an improved society and better conditions for all humankind. This confidence in reason and science affected all aspects of political and social life in Europe and soon spread to the North American colonies. There, the Enlightenment ideas that society can be improved through reason and that rational people have a natural right to the pursuit of happiness are thought to have contributed to the Jeffersonian democracy that we enjoy today in the United States.

THE MODERNIST REACTION to the Enlightenment came in the aftermath of the Industrial Revolution, whose brutalizing effects revealed that modern life had not become as mathematically perfect, or as certain, rational, or enlightened, as advances in the eighteenth century had led people to expect. Truth was not always beautiful, nor was it always readily recognized. It was frequently hidden from view. Moreover, the human mind was governed not only by reason but also by irrational emotion.

As astronomy and physics inspired the Enlightenment, so biology inspired Modernism. Darwin's 1859 book *On the Origin of Species* introduced the idea that human beings are not created uniquely by an all-powerful God but are biological creatures that evolved from simpler animal ancestors. In his later books, Darwin elaborated on these arguments and pointed out that the primary biological function of any organism is to reproduce itself. Since we evolved from simpler animals, we must have the same instinctual behavior that is evident in other animals. As a result, sex must also be central to human behavior.

This new view led to a reexamination in art of the biological nature of human existence, as evident in Édouard Manet's *Déjeuner sur l'Herbe* of 1863, perhaps the first truly modernist painting from both a thematic and stylistic point of view. Manet's painting, at once beautiful and shocking in its depiction, reveals a theme central to the modernist agenda: the complex relationship between the sexes and between fantasy and reality. The artist depicts two fully and conventionally dressed men seated on the grass in a wooded park, engaged in conversation over lunch, while a nude woman bather sits beside them. In the past, nude women were represented in paintings as goddesses or mythical figures. Here, Manet breaks with tradition and paints a real, living, contemporary Parisian woman in the nude—his favorite model, Victorine Meurent (Fig. 1-6).

Despite the attractiveness of Victorine's voluptuous body, the two men appear as indifferent to her as she is to them. While the men appear to be speaking with each other, the nude woman, sharing the men's denial of sexuality, attends only to the viewer. In addition to its astonishingly modern theme, the painting is also startlingly modern because of its style. Several decades before Cézanne began to collapse three dimensions into two, Manet here had already flattened the viewer's sense of perspective by providing little depth or perspective.

The art historian Ernst Gombrich elaborated on the later accomplishments of Viennese modernist art:

> Art is an institution to which we turn when we want to feel a shock of surprise. We feel this want because we sense that it is good for us once in a while to receive a healthy jolt. Otherwise we would so easily get stuck in a rut and could no longer adapt to the new demands that life is apt to make on us. The biological function of art, in other words, is that of a rehearsal, a training in mental gymnastics which increases our tolerance of the unexpected.[3]

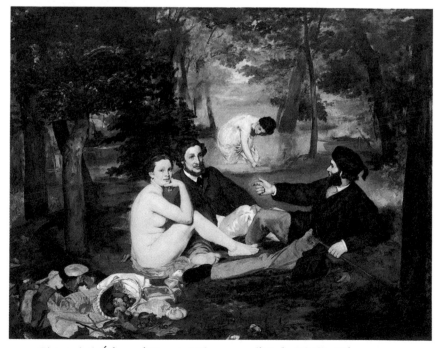

Figure 1-6. Édouard Manet, *Déjeuner sur l'Herbe* (1863). Oil on canvas.

In Vienna, Modernism had three main characteristics. The first was the new view of the human mind as being largely irrational by nature. In a radical break with the past, the Viennese modernists challenged the idea that society is based on the rational actions of rational human beings. Rather, they contended, unconscious conflicts are present in everyone in their everyday actions. By bringing these conflicts to the surface, the modernists confronted conventional attitudes and values with new ways of thought and feeling, and they questioned what constitutes reality, what lies below the surface appearances of people, objects, and events.

Consequently, at a time when people elsewhere wanted to obtain greater mastery of the external world, of the means of production and the dissemination of knowledge, modernists in Vienna focused inward and tried to understand the irrationality of human nature and how irrational behavior is reflected in the relationship of one person to another. They discovered that beneath their elegant, civilized veneer, people harbor not only unconscious erotic feelings, but also unconscious aggressive impulses that are directed against themselves as well as others. Freud later called these dark impulses the death instinct.

The discovery of our mind's largely irrational nature prompted what may be the most radical and influential of the three revolutions in human thought that, as Freud noted, determined how we view ourselves and our place in the universe. The first such revolution, the Copernican revolution of the sixteenth century, revealed that the earth is not the center of the universe, but rather a small satellite orbiting the sun. The second, the Darwinian revolution of the nineteenth century, revealed that we are not created divinely or uniquely but instead evolved from simpler animals by a process of natural selection. The third great revolution, the Freudian revolution of Vienna 1900, revealed that we do not consciously control our own actions but are instead driven by unconscious motives. This third revolution later led to the idea that human creativity—the creativity that led Copernicus and Darwin to their theories—stems from conscious access to underlying, unconscious forces.

Unlike the Copernican and Darwinian revolutions, the realization that our mental functioning is largely irrational was arrived at by several thinkers at the same time, including Friedrich Nietzsche in the middle of the nineteenth century. Freud, who was much influenced by

both Darwin and Nietzsche, is most frequently identified with the third revolution because he was its most profound and articulate exponent. It was, however, a discovery he did not make in isolation: his contemporaries Schnitzler, Klimt, Kokoschka, and Schiele also discovered and explored new aspects of our unconscious mental life. They understood women better than Freud, particularly the nature of women's sexuality and maternal instinct, and they saw more clearly than Freud the importance of an infant's bonding to its mother. They even realized the significance of the aggressive instinct earlier than Freud did.

Moreover, Freud was not the first person to reflect on the role of unconscious mental processes in our psychic life. Philosophers over the centuries had dealt with this idea. Plato discussed unconscious knowledge in the fourth century B.C., pointing out that much of our knowledge is inherent in the psyche in latent form. In the nineteenth century, Arthur Schopenhauer and Nietzsche, who called himself "the first psychologist," wrote about the unconscious and about unconscious drives, and artists through the ages had dealt with male and female sexuality. Hermann von Helmholtz, the great nineteenth-century physicist and physiologist, who also influenced Freud, advanced the idea that the unconscious plays a critical role in human visual perception.

What set Freud and the Viennese intellectuals apart was their success in developing and unifying these ideas, expressing them in strikingly modern, coherent, and dramatic language, and thereby educating the public about a new view of the human mind, especially women's minds. Just as Otto Wagner developed the clean lines that liberated modern architecture from earlier forms, so Freud, Schnitzler, Klimt, Kokoschka, and Schiele unified and extended their predecessors' ideas about unconscious instinctual striving and presented them in a compelling, modern light. They helped liberate both men's and women's emotional life and essentially set the stage for the sexual freedom we enjoy today in the West.

THE SECOND CHARACTERISTIC of Modernism in Vienna was self-examination. In their search for the rules that govern the nature of human individuality, Freud, Schnitzler, Klimt, Kokoschka, and Schiele were eager not only to examine others, but even more to examine themselves—and not just outward appearances, but the inner world

and idiosyncrasies of their private thoughts and feelings as well. Much as Freud studied his own dreams and taught psychoanalysts to study countertransference (the feelings and responses evoked in the therapist by a patient), so Schnitzler and the artists, especially Kokoschka and Schiele, boldly explored their own instinctual strivings. They went deep into their own psyche, using self-analysis as a vehicle for understanding and depicting the instinctual strivings of others as well as the feelings they experienced in response. This self-examination defined Vienna 1900.

THE THIRD CHARACTERISTIC of Modernism in Vienna was the attempt to integrate and unify knowledge, an attempt driven by science and inspired by Darwin's insistence that human beings must be understood biologically in the same way as other animals. Vienna 1900 opened new vistas in medicine, art, architecture, art criticism, design, philosophy, economics, and music. It opened a dialogue among biological sciences and psychology, literature, music, and art, and thereby initiated an integration of knowledge that we are still engaged in to this day. It also transformed science in Vienna, especially medicine. Under the leadership of Rokitansky, who was a follower of Darwin, the Vienna School of Medicine put medical practice on a more systematic scientific basis: it routinely combined the clinical examination of a living patient with the results of an autopsy after the patient's death, thus elucidating the disease process and arriving at an accurate diagnosis. This scientific approach to medicine contributed a metaphor for the modernist approach to reality: only by going below surface appearances can we find reality.

Eventually, Rokitansky's ideas spread out from the School of Medicine and became an integral part of the culture in which Viennese intellectuals and artists lived and worked. As a consequence, the Viennese concern with reality would stretch from medical clinics and consulting rooms to artists' studios and finally to neuroscience laboratories.

Although he had little direct contact with Rokitansky, Freud started his training in medicine at the University of Vienna in 1873, when Rokitansky was still at the peak of his influence. As a result, Freud's early thinking appears to have been molded in important ways by the Rokitanskian spirit of the age. This spirit continued to be promulgated after Rokitansky retired from the medical school: Ernst Wilhelm von Brücke

and Theodor Meynert, two of Freud's mentors, were appointed by Rokitansky, and Freud's colleague Josef Breuer studied directly with him.

Schnitzler, who also was a student at the School of Medicine in the last years of Rokitansky's leadership and who worked with Rokitansky's associate Emil Zuckerkandl, drew on unconscious mental processes in his literary writings. Schnitzler's analytical descriptions of his lively, almost insatiable, sexual appetite greatly influenced the thinking of the young Viennese men of his generation. Much like Freud, Schnitzler explored the unconscious psychology of both sexuality and aggression.

The same fascination with the unconscious is evident in the drawings and paintings of Klimt, Kokoschka, and Schiele. They, too, were influenced by Rokitansky as they broke with the artistic past and portrayed sexuality and aggression in new ways. Whereas Freud and Schnitzler were products of the medical school, Klimt studied biology informally with Zuckerkandl. Schiele was influenced by Rokitansky indirectly, through Klimt. Kokoschka taught himself to focus on going deep beneath the skin, and he did so in celebrated, penetrating portraits of his sitters' innermost thoughts and urges.

DESPITE THEIR COMMON fascination with unconscious instincts, which they viewed as the key to understanding human behavior, Freud, Schnitzler, and the modernist artists did not work in lockstep. The artists were undoubtedly influenced by Freud and Schnitzler, but each evolved independently in response to the influences in Vienna 1900.

Freud thought much more systematically than the other four. He articulated the Rokitanskian zeitgeist in simple, elegant language and applied it to mind by going deep below the surface of mental appearances to the psychological conflict below. More important, he used that vision to develop a coherent, nuanced, and rich "theory of mind," which he used to explain both normal and abnormal behavior. Freud's theory differed from Schnitzler's and the artists' view, and even from Nietzsche's, in treating mind as a domain of empirical science, not as a platform for philosophical speculation. Freud's theory of mind stands as the first attempt to develop what later would be called cognitive psychology—an attempt to account for the complexity of human

thought and feeling in terms of the mind's systematic internal representations of the outside world. Finally, based in part on his cognitive theory of mind, Freud devised a therapy designed to alleviate personal suffering.

Paul Robinson, a contemporary philosopher, emphasizes Freud's intellectual legacy in the language of the Rokitanskian generation:

> He is the major source of our modern inclination to look for meanings beneath the surface of behavior—to be always on the alert for the "real" (and presumably hidden) significance of our actions. He also inspires our belief that the mysteries of the present will become more transparent if we can trace them to their origins in the past, perhaps even in the very earliest past. . . . And, finally, he has created our heightened sensitivity to the erotic, above all to its presence in arenas . . . where previous generations had neglected to look for it.[4]

Freud emphasized that much of mental life is unconscious; it becomes conscious only as words and images. This is indeed what he, Schnitzler, Klimt, Kokoschka, and Schiele accomplished with their prose and their images. Beyond dealing with the same concerns in their common culture, each brought to his work a scientific curiosity about mind and emotion that was characteristic of Vienna 1900.

# EXPLORING THE TRUTHS HIDDEN
# BENEATH THE SURFACE:
# ORIGINS OF A SCIENTIFIC MEDICINE

HE VIENNA SCHOOL OF MEDICINE PLAYED A KEY ROLE IN THE attempt to unify knowledge that characterized Vienna 1900. Sigmund Freud and Arthur Schnitzler trained as physicians there, and the school influenced Klimt's thinking about art and science. In addition to this broader cultural accomplishment, the Vienna School established a standard of scientific medicine that still influences the practice of medicine.

If a patient walked into a physician's office almost anywhere in the world today and complained of shortness of breath, the physician would put on a stethoscope, place the disk on the person's chest, and listen to the sounds the lungs make as the person breathes. If the physician heard rales—abnormal sounds that result from fluid in the lungs—he or she might suspect that the patient was experiencing heart failure. The physician would confirm that impression by tapping on the person's chest and listening to the echoes, which would sound duller than normal. The physician would then use the stethoscope again, this time to listen for premature heartbeats, which are potential signs of an abnormal heart rhythm, and for murmurs, which might signal defects in the mitral or aortic valve of the heart. In this way a trained physician could diagnose a malfunctioning heart or lung with simple, readily available tools.

In placing a stethoscope on the outside of the body to plumb the depths within, the modern physician is following a scientific protocol that was perfected a century ago at the Vienna School of Medicine. The

whole thrust of this modern approach to medicine is to see below the symptoms on the surface to the disease processes that are active below the skin. How did this approach to medicine come about?

MODERN HISTORIANS TRACE the origins of systematic science to the seventeenth century, so it is not surprising that until the beginning of the eighteenth century, European medicine was largely prescientific. The key tools for understanding disease at that time were the patient's narrative and the physician's observations at the bedside. This was a time when science and the humanities did not represent two distinct cultures: the medical degree was valued not only for the curative powers it conferred but also for the high level of cultural scholarship it encouraged. Indeed, because the medical degree was the best pathway to study the natural world, some of the great thinkers of the French Enlightenment—Diderot, Voltaire, and Rousseau—studied medicine in order to expand their humanistic knowledge.

The emphasis on culture as well as science derived from the fact that as late as the eighteenth century, many physicians still practiced medicine much as prescribed by the Greek physician Hippocrates two thousand years earlier and as codified in about A.D. 170 by Galen, the influential Greek-born physician who worked in Rome. Galen dissected monkeys to understand the human body and in this manner gained some remarkable insights into biology, such as the idea that the nerves control the muscles. But Galen also entertained a number of incorrect ideas about human biology and disease. In particular, he argued, as did Hippocrates, that diseases are not caused by specific bodily malfunctions; rather, they are caused by an imbalance in the body's four humors: phlegm, blood, yellow bile, and black bile. Moreover, he believed that the four humors govern mental functions as well; thus, a dominance of black bile predisposes a person to depression.

Accordingly, physicians focused not on the site at which symptoms originated but on the body as a whole—specifically, on restoring equilibrium among the four humors by administering such treatments as bleeding or purging.[1] Despite repeated challenges to these ideas, based, for example, on the anatomical dissections of Andreas Vesalius in the 1540s and on experimental observations such as William Harvey's discovery of the circulatory system in 1616 and Giovanni Battista Morgagni's establishment of the discipline of pathology in 1750, some of

Galen's ideas continued to influence medical teaching and clinical practice until the beginning of the nineteenth century.

A major step toward a more systemic, science-based medicine took place in France in the aftermath of the French Revolution, when a variety of royal restrictions on medical practice and limitations on the performance of autopsies were lifted. French physicians, surgeons, and biological scientists responded by reorganizing medical education and medical practice, with clinical training in a hospital or clinic becoming obligatory.

The Paris School of Medicine was led at this time by Jean-Nicolas Corvisart des Marets, Napoleon's personal physician and a pioneer in the use of percussion, or tapping on the chest, to distinguish between pneumonia and heart failure, both of which cause congestion in the lungs. Three other physicians made historic contributions to the Paris School of Medicine in its early years: Marie-Francois-Xavier Bichat, René Laënnec, and Philippe Pinel. Bichat was one of the first pathologists in Europe to emphasize that an understanding of human anatomy is essential to the practice of medicine. He discovered that each organ in the body is made up of several different types of tissues, that is, ensembles of cells that carry out a common function. The specific tissues of an organ, Bichat argued, are the actual targets of disease. Laënnec invented the stethoscope and used it to characterize the various sounds of the heart and correlate them with anatomical findings at autopsy.

Pinel founded psychiatry as a discipline of medicine; he introduced humane, psychologically oriented principles to the care of mentally ill patients and attempted to form a personal, psychotherapeutic relationship with them. Pinel argued that mental illness is a medical illness and that it occurs when people with a hereditary predisposition to psychiatric disorders are exposed to excessive social or psychological stress. This view is very close to our current understanding of the etiology of most psychiatric disorders.

France's ability to chart new scientific domains was aided by a centralized system of education with high academic standards, as well as by the nation's advances in biology and medicine. The Paris School of Medicine set the standard for basic medical science and clinical practice and shaped European medicine from 1800 to 1850.

Surprisingly, given its brilliant beginning and the presence of creative giants in biological research like Claude Bernard and Louis Pasteur, clin-

ical medicine in France began to decline after the 1840s, perhaps due to the political conservatism of the July Monarchy under Louis Philippe and the Second Empire under Napoleon III. The centralized system of French education became rigid, leading to a decline in the creativity and quality of science. By 1850 French medicine, according to the historian Erwin Ackerknecht, had "its momentum spent" and "maneuvered itself into a dead end."[2]

The exhaustion of the pioneering spirit in French clinical practice and teaching was soon reflected in a massive shift of foreign medical students from Paris to Vienna and other German-speaking cities, where there was a pronounced movement toward the formation of new types of research-oriented universities and research institutes and the development of laboratory-based medicine. In stark contrast to their counterparts in Paris, all of the major hospitals in the German-speaking countries had been operating as part of a university since 1750. In Vienna, all clinical training was carried out as part of the university's academic mission and had to meet the university's standards of excellence. By 1850 the University of Vienna had become the largest and best known of the German-speaking universities, and its medical school was arguably the best in Europe, rivaled only by Berlin's.

THE FIRST STEPS toward a science-based medicine in Vienna were undertaken a century earlier, when the Empress Maria Theresa reorganized the University of Vienna. Both she and her son Joseph II placed a premium on high-quality medicine because they viewed medical education and medical care as essential to the welfare of the state.

Maria Theresa searched Europe for an outstanding physician to head the new effort in medicine and in 1745 recruited the great Dutch physician Gerard van Swieten. Van Swieten formed what is now known as the First Vienna School of Medicine, a school that began to transform Viennese medicine from the practice of therapeutic quackery based on humanist philosophy and the teachings of Hippocrates and Galen into a practice based on natural science.

In 1783 Emperor Joseph II commissioned the design of a comprehensive medical complex, and in 1784 van Swieten's successor, Joseph Andreas von Stifft, opened the Wiener Allgemeine Krankenhaus, the great Vienna General Hospital. The smaller hospitals around the city were closed, and all the medical facilities were centralized in this one

extensive complex, which consisted of the main hospital building, a maternity wing, a hospital for infants, an infirmary, and a mental hospital. The largest medical institution in Europe, the Viennese General Hospital aspired to be a center of modern, scientific medicine. The University of Vienna School of Medicine became what Rudolf Virchow of Berlin, the father of cellular pathology, called the "Mecca of Medicine."

In 1844 Stifft was succeeded as head of the Vienna School of Medicine by Carl von Rokitansky (Fig. 2-1), who introduced Modernism into biology and medicine. Inspired by Darwin's insistence that human beings be understood biologically in the same way as other animals, Rokitansky over the next thirty years put medical practice at the Vienna School of Medicine, reorganized as the Second Vienna School of Medicine, on a new, scientific basis, thereby achieving international prominence.

ROKITANSKY PUT MEDICINE on a more scientific footing by systematically correlating clinical observations and pathological findings. In Paris, each clinician was his own pathologist. As a result, physicians performed too few pathological analyses to develop expertise in diagnosing disease. Rokitansky separated clinical medicine and pathology into different departments and placed each in the hands of a fully

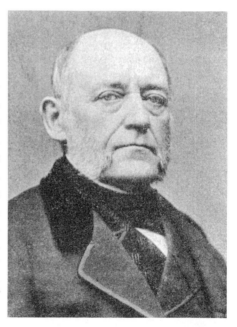

Figure 2-1. Carl von Rokitansky (1804–78). Rokitansky gave medicine a firm scientific basis by introducing correlations between symptoms and the diseases that cause them. He served four terms as dean of the Vienna School of Medicine and became the first freely elected rector of the University of Vienna in 1852. This photograph was taken around 1865, two years after Rokitansky was appointed medical adviser to the Federal Ministry of the Interior in Vienna.

trained, highly competent practitioner. Each patient was examined by a physician and, after death, by a pathologist, and the two practitioners correlated their findings.

This development had two roots. First, as noted, every patient who died in the Vienna General Hospital was autopsied under the supervision of a single, highly trained person, the head pathologist. In 1844 Rokitansky assumed this position. During a career spanning over thirty years, he and his associates carried out some sixty thousand autopsies,[3] from which he gained an enormous amount of knowledge about diseases of the organs and tissues. The second root was the presence at the Vienna General Hospital of a great clinician, Rokitansky's student and colleague Josef Skoda. Skoda's brilliance in clinical diagnostics paralleled Rokitansky's brilliance in pathological diagnosis. The two men routinely collaborated, and a deep sense of collegiality grew up between them, thus bridging the divide between their specialties.

With this rigorous, collaborative process, the Vienna School of Medicine was able to correlate, more effectively than before, insights about an illness gained at the bedside with insights gained in the autopsy room and to use those systematic correlations to develop a rational, objective method for understanding the disease and thus for arriving at an accurate diagnosis. The process gave rise to a new understanding of the clinical-pathological correlation that has characterized modern medicine ever since.

Rokitansky was an intellectual descendant of the great Italian pathologist Morgagni, who argued that, contrary to the teachings of Galen, clinical symptoms arise from disorders of individual organs: symptoms are the cries of suffering organs. To understand disease, one must first find where in the body the disease originates.[4] Morgagni also taught that postmortem examination could be used to test ideas developed from clinical inspection. His teachings gave rise to the radical new idea that a disorder should be named after its biological source—and when possible, for the specific organ that gave rise to it: for example, appendicitis, lung cancer, heart failure, or gastritis.

Rokitansky argued that before a physician can treat a patient, the physician must have an accurate diagnosis of the disease. An accurate diagnosis cannot be achieved merely by examining the patient and evaluating his or her signs and symptoms, because the same signs and

symptoms can be produced by different parts of the same organ or even by different illnesses. Nor can a patient's signs and symptoms be evaluated solely by conducting a pathological examination of the patient's body after death. Whenever possible, therefore, pathological examinations must be coordinated with clinical examinations.

Happily, Skoda readily adopted Rokitansky's scientific approach and used it in his examination of living patients. A specialist in diseases of the heart and lungs, he dramatically improved the practical use and theoretical bases of percussion and auscultation. Using Laënnec's stethoscope, Skoda made detailed studies of the sounds and murmurs he heard when listening to a patient's heart and then correlated those sounds with Rokitansky's findings of damage to the heart muscle and valves after the patient's death. In addition, to better understand the physical basis of the heart's sounds, Skoda carried out experiments on the cadaver. As a result, he was able for the first time to separate normal sounds caused by the opening and closing of the heart valves from heart murmurs caused by malfunctioning valves. In this way Skoda became not only a skilled listener to the heart's sounds, but also a remarkable interpreter of their anatomical and pathological significance, setting the standard for current medical practice.

Skoda applied a similarly rigorous approach to examination of the lungs. He used the stethoscope to listen to a patient's breathing and then combined the sounds he heard with the techniques of auscultation developed earlier in Vienna by Josef Leopold Auenbrugger, tapping on the chest and listening for abnormal sounds that might emanate from congested chest cavities. Skoda's improvements in diagnostic accuracy brought him international renown as the founder of modern physical diagnosis—the first well-rounded, scientifically based approach to the examination of the patient. "Thanks to Skoda, medical diagnosis . . . reached a degree of certainty which previously could not even have been imagined,"[5] writes Erna Lesky. To this day, most diseases that result from damage to the valves of the heart are first diagnosed at the bedside by listening carefully with a stethoscope and interpreting sounds using the criteria developed by Skoda.

In his collaboration with Skoda, Rokitansky reached the height of his fame. Beginning in 1849, he published his major work, the three-volume *Manual of Pathologic Anatomy,* the first textbook of pathology. The *Manual* dealt with the specific pathological anatomy of the various

organ systems. Moreover, Rokitansky used it as a platform for empha-
sizing his idea that in order to understand and ultimately cure a fully
developed disease, the physician must study the origin and natural
course of the disease.

IN RESPONSE TO THESE advances at the School of Medicine, great
numbers of foreign students poured into Vienna. American students in
particular were drawn to the medical school because of its growing
reputation for excellence and the availability of bodies to examine at
autopsy, in contrast to the poor quality of nineteenth-century instruc-
tion and practice in the United States. These student pilgrimages were
enhanced by the fact that the period of Rokitansky's leadership coin-
cided with the building of the Ringstrasse and with numerous other
changes that transformed Vienna into an exciting, modern metropolis
and one of the most beautiful cities in Europe.

The intellectual historians Allan Janik and Stephen Toulmin argue
that the United States owes its current preeminence in the medical sci-
ences in part to the thousands of medical students who traveled to Vi-
enna at a time when the standards of American medicine were low. In
fact several of the founders of academic medicine in the United
States—William Osler, William Halsted, and Harvey Cushing—
studied medicine in Vienna before assuming their leadership roles.

WHAT ROKITANSKY ACCOMPLISHED in his leadership of the Vienna
School of Medicine was not original in its components—clinical and
pathological studies—but brilliant in its organization, execution, and
widespread impact. He placed pathological anatomy at the scientific
center of academic medicine not only in Vienna but throughout the
Western world. In emphasizing that a biological understanding of dis-
ease must precede the treatment of patients, he and the faculty of the
University of Vienna were advocating ideas that have come to form the
underpinnings of modern scientific medicine: research and clinical
practice are inseparable and inspire each other, the patient is an experi-
ment of nature, the bedside is the doctor's laboratory, and the teaching
hospital of the university is nature's school. By comparing various
stages of a disease, Rokitansky and Skoda also provided the scientific
basis for the concept of the disease process, the idea that each disease

has a natural history and progresses through a series of steps from its onset to its termination.

As the person who synthesized in his vision and in his teaching the various biological strands that had originated in French and Italian medicine in the previous century, Rokitansky's influence on medicine was broad. Moreover, by systematically developing the clinical-pathological correlation, he was applying to medicine the insight of the Greek philosopher Anaxagoras (500 B.C.), a founder of atomic theory: "The phenomena are a visible expression of that which is hidden."[6] Rokitansky argued that to discover the truth, we must look below the surface appearance of things. This idea spread to neurology, psychiatry, psychoanalysis, and literature through Theodor Meynert and Richard von Krafft-Ebing and their influence on Josef Breuer, Sigmund Freud, and Arthur Schnitzler. Of particular interest in the context of the development of Viennese Modernism, Rokitansky's influence spread, through his fellow anatomist Emil Zuckerkandl, to Klimt and the Vienna expressionists.

Moreover, as president of the Imperial Academy of Science and expert adviser to the Ministry of Education, Rokitansky became Vienna's leading spokesman for science, arguing strongly for the legitimacy of research unfettered by political considerations. With his appointment to the Upper House of the Austrian Parliament by the Emperor Franz Joseph, Rokitansky became a public intellectual. He was a forceful spokesman and used his expanded visibility and influence to promote his ideas to the Viennese public. Long after his death, his vision continued to influence not only Viennese medicine but also Viennese culture, giving rise to Modernism's search for the deep-seated biological rules that govern human behavior.

# VIENNESE ARTISTS, WRITERS, AND SCIENTISTS MEET IN THE ZUCKERKANDL SALON

ᘓⱱᕲ

HOW DID CARL VON ROKITANSKY'S VISION SPREAD FROM THE Vienna School of Medicine to the Viennese modernist artists? In turn-of-the-century Vienna, artists, writers, physicians, scientists, and journalists moved in amazingly small, tight-knit, interconnected circles. Unlike the intellectual elites of New York, London, Paris, and Berlin, who, with rare exceptions such as London's Bloomsbury group, lived apart from one another and remained relatively segregated in their professional communities, Viennese intellectuals interacted with one another on a regular basis. As a result, many of them had friends in other disciplines.

Such interaction began in the gymnasium, the college-preparatory level. Because gymnasium students were taught both the humanities and the sciences at a high level, they developed broad cultural interests. Their education enabled them to bridge effortlessly the gaps between the sciences, the humanities, and the arts. This is manifest, as Käthe Springer has pointed out, in the enthusiasm with which the philosophers in the Vienna Circle spoke about the possibility of unifying first the sciences and then the arts and the sciences by means of a common grammar.[1]

In addition, Vienna had only one major university, located in a series of buildings within walking distance of each other and the general hospital. When people met and discussed ideas at the University of Vienna, they often continued their discussions in select coffeehouses, such as Café Griensteidl or Café Central.

Free and extensive interaction between Jews and non-Jews also

contributed to the burst of creativity in the late nineteenth century. In fact, interaction with their Christian colleagues greatly enhanced the creativity of Jewish scholars, scientists, and artists. As a result, the contributions of Jewish scholars to the culture of Vienna 1900 compare favorably with the substantial Jewish contributions to the Golden Age in Moorish Spain from the eighth to the twelfth centuries. The interaction of Christians and Jews even continued during the early part of the twentieth century, when Jews were once again being discriminated against in the civil service and in many aspects of social life.

The Viennese also met in dynamic, inviting salons. There, thinkers and artists could share ideas and values and could mingle with the business and professional elites, who were proud of their education, culture, and artistic interests. Salons were gatherings held on a regular basis in private homes, many of them hosted by Jewish women. These women developed their salons as cultural, rather than social or religious, institutions. A particularly important salon in Vienna for bringing together writers, artists, and scientists was that of Berta Zuckerkandl, a talented writer and influential art critic for the *Wiener Allgemeine Zeitung* and a co-founder of the Salzburg Music Festival. A student of biology and of Darwinian evolution, Berta was married to the anatomist Emil Zuckerkandl, an associate of Rokitansky's (Figs. 3-1 and 3-2).

Berta knew everyone who was anyone in Vienna. "On my divan Austria comes alive,"[2] she wrote. Freud was an acquaintance. The Waltz King, Johann Strauss the Younger, called her "the most marvelous and witty woman in Vienna."[3] Arthur Schnitzler was a friend and attended her salon often. It was there that he met the great theater director Max Reinhardt and the composer Gustav Mahler. In fact, it was at Berta's salon that Mahler met Alma Schindler, his future wife. Klimt was a frequent visitor, as were various biological and medical scientists, the psychiatric investigators Richard von Krafft-Ebing and Julius Wagner von Jauregg, and the surgeons Theodor Billroth and Otto Zuckerkandl (Emil's brother).

Berta Zuckerkandl's father was publisher of the *Neues Wiener Tagblatt*, the leading liberal newspaper in Vienna, and the leading adviser of Crown Prince Rudolf, the heir apparent to the Austro-Hungarian Empire who committed suicide in 1889. In 1901 Berta's father, who loved science, founded the first popular science magazine in Austria, *Das Wissen für Alle* (*Knowledge for All*). A stream of intellectuals and

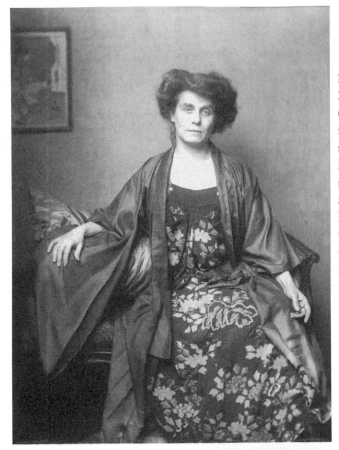

Figure 3-1. Berta Zuckerkandl (1864–1945). An influential salonnière who hosted artists, scientists, writers, and thinkers in her living room, Berta was an art critic, writer, and co-founder of the Salzburg Music Festival. This photograph was taken in 1908.

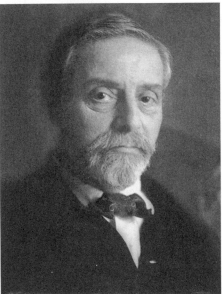

Figure 3-2. Emil Zuckerkandl (1849–1910). A fine scientist, Zuckerkandl was chair of anatomy at the Vienna School of Medicine and the inspiration for Gustav Klimt's interest in biology and medicine. This photograph was taken in 1909.

statesmen flowed through the Szeps's home. As a result, it was said of Berta that she inherited from her father not only intellectual curiosity and social poise, but also social contacts that few people could have acquired on their own at a young age. From the time of her marriage in 1880 until she fled Vienna for France in 1938, Berta led her salon.

This was truly a salon of Modernism, and Berta was its greatest proponent. She was one of the first collectors to purchase two of the "character head" sculptures made by Franz Xaver Messerschmidt, who was a century ahead of his time in using psychological exaggeration to reveal mental states. She strongly defended Klimt's art in her column "Art and Culture," and it was at her salon that a group of artists led by Klimt first discussed the idea of the Vienna Secession, a radical, modernist break with the more conservative Künstlerhaus, or Artists' House, the artistic establishment of the day. Berta's influence extended well beyond Vienna. Her sister, Sofie, married Paul Clemenceau, the brother of the French president Georges Clemenceau. Through Sofie, Berta became friends with Rodin and other Parisian artists.

Two factors accounted for Berta's influence. First, she was genuinely interested in people and expressed a wide-ranging intellectual curiosity about them. Second, she was an effective, well-connected critic of art and literature who did not hesitate to assist people whose talents she admired. She and her family actively promoted the sale of Klimt's paintings. Emil's brother Victor, an art collector, owned Klimt's *Pallas Athena* and many of his important landscapes. Moreover, by underwriting individual artists, Berta helped finance the construction of buildings for the Vienna Secession. Freed from the restrictions of the Künstlerhaus's exhibition hall, the group held its own annual exhibition, displaying not only the works of younger Austrian painters, but also the work of artists from other parts of Europe.[4]

The free exchange of scientific and artistic ideas was integral to the spirit of her salon. Berta herself was intrigued by and quite knowledgeable about biology. She was fascinated by her husband's work and that of his colleagues, and she was familiar with the work of Rokitansky and his circle at the Vienna School of Medicine, a circle to which her husband belonged. Most important in this regard, Emil was a brilliant, highly popular lecturer on anatomy. Both Berta and Emil Zuckerkandl tutored Klimt in biology and introduced him to the thinking of Darwin and Rokitansky.

EMIL ZUCKERKANDL WAS BORN in Raab, Hungary, in 1849 and studied at the University of Vienna. In 1873 Rokitansky recruited him as his assistant in pathological anatomy. In 1888 Zuckerkandl assumed the First Chair of Anatomy at the University of Vienna and remained there until his death in 1910. Zuckerkandl's interests in biology ranged widely. He made contributions to the anatomy of the nose, the skeleton of the face, the organs of hearing, and the brain. Several discoveries now carry his name, including the Zuckerkandl bodies (masses of tissue associated with the autonomic nervous system) and the Zuckerkandl gyrus (a thin sheet of cortex—gray matter—in the front of the brain).

Zuckerkandl invited Klimt to watch him dissect cadavers, and it was from these observations that Klimt gained the deep understanding of the human body that he would draw on repeatedly in his own work. Inspired by Zuckerkandl's insights, Klimt arranged for him to give a series of lectures on biology and anatomy to a group of artists, writers, and musicians. In these lectures Zuckerkandl introduced his audience to one of the great mysteries of life: how a single cell, the human egg, is fertilized and develops first into a fetus and then, through various stages, into an infant. In her autobiography Berta describes how, in one of those lectures, her husband demonstrated to his artistic audience a marvelous new world that far exceeded their "creative fantasies." He darkened the room and projected lantern slides of stained microscopic tissue samples, revealing the inner world of cells. Zuckerkandl told his audience that with "a drop of blood, a little bit of brain substance, you will be transported to a fairy-tale world."[5]

In addition to embryology, Zuckerkandl introduced Klimt to Darwinian evolution—and themes from both fields appear repeatedly in the background ornamentation of Klimt's paintings. In fact, his radical portrayals of the nude female figure are seen by the art historian Emily Braun as reflecting a naturalistic, post-Darwinian perspective: "After Darwin, the body in painting stands nakedly for itself: a biological species subject to the same procreative laws as every other organism."[6]

This perspective is evident in one of Klimt's most controversial works, *Hope I,* in which the artist painted the body of a naked woman in the final stages of pregnancy, highlighting her brilliant red pubic

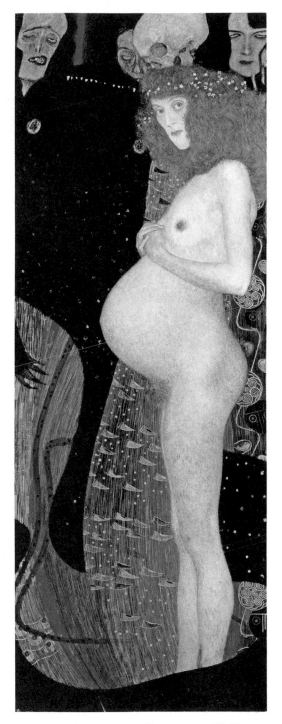

Figure 3-3. Gustav Klimt, *Hope I* (1903).
Oil on canvas.

hair (Fig. 3-3). Braun has noted that the dark-blue, primitive, sea-creature-like form winding behind the woman's swollen belly echoes a prevailing view at that time, namely, that the development of a human embryo follows the same path as human evolution. This view that "ontogeny recapitulates phylogeny," advanced by the German biologist Ernst Haeckel, is derived from the belief that human embryos possess gills and tails reminiscent of their primitive, fishlike ancestors but lose those features as they develop. Just as the avowed Darwinian Freud asks us to contemplate the conservation through evolution of the immensely powerful and primitive sexual drives, Klimt asks the beholder of *Hope I* to regard the process of human reproduction and development in a naturalistic, evolutionary light.

Similarly, Klimt incorporated biological symbols into his painting of Zeus coming to Danaë (Fig. 3-4). Here, the artist transforms the shower of golden raindrops and black rectangles, symbolizing Zeus's sperm, on the left side of the canvas into early embryonic forms, symbolizing conception, on the right side.

BERTA RECOGNIZED THE influence of contemporary science on Klimt's work. She wrote that the artist profiled "the endless ceasing and becoming," to which Braun adds the phrase "deep beneath the surface of things."[7] "Klimt's evolutionary narrative," Braun continues, "places him in the fluid post-Darwinian, pre-Freudian cultural matrix."[8] Berta describes in her autobiography how Klimt's interest in biology emerged from her husband's exciting lectures. The medical historian Tatjana Buklijas elaborates:

> Bertha argued that the colour scheme of Klimt and the ornamental repertoire of the *Wiener Werkstätte* both took from nature's treasure trove. Indeed, a closer look at Klimt's work in the years immediately after 1903 reveals an abundance of shapes . . . reminiscent of epithelium [cells] with black "nuclei" in whiteish "cytoplasm."[9]

It is precisely this aspect of Klimt's art that reveals biology's profound influence on him.

Klimt's use of biological symbols to convey the truth beneath the surface was paralleled in the work of Sigmund Freud, Arthur Schnitz-

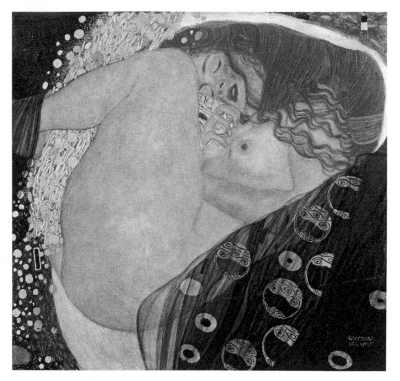

Figure 3-4. Gustav Klimt, *Danaë* (1907–8). Oil on canvas.

ler, Oskar Kokoschka, and Egon Schiele. Moreover, the work of all five of these modernists pays unconscious tribute to Berta Zuckerkandl and her salon, whose intellectually stimulating atmosphere encouraged the dialogue between scientists and artists and thus made Rokitansky's ideas part of the culture of Vienna 1900.

*Chapter 4*

# EXPLORING THE BRAIN BENEATH THE SKULL: ORIGINS OF A SCIENTIFIC PSYCHIATRY

ๆ\✓๖

THE MODERNIST VIEW OF THE HUMAN MIND EMPHASIZED THE role of unconscious instincts in determining behavior. The Vienna School of Medicine contributed to this view of mind in three ways. First, it advanced the principle that all mental processes have a biological basis in the brain (the biology of mind). Second, it advocated the idea that all mental illnesses are biological. Finally, one of its members, Sigmund Freud, discovered that much of human behavior is irrational and based on unconscious mental processes; he concluded that to understand the complexities of the unconscious mind in biological terms, it was first necessary to develop a coherent psychology of mind.

THE IDEA THAT *all* mental functions are derived from the brain originated with Hippocrates, but it was largely neglected until the late eighteenth century, when Franz Joseph Gall attempted to link psychology and brain science. Gall attended the University of Vienna School of Medicine from 1781 to 1785. Following his graduation, he set up a very successful medical practice in Vienna. His linking of psychology and brain biology led him to a second idea that is central to the biology of mind: the brain—and particularly its outer covering, the cerebral cortex—does not function as a single organ; therefore, different mental functions can be localized to different regions.

Gall took advantage of what was already known about the cerebral cortex. He was aware that it was bilaterally symmetrical and subdivided into four lobes, the frontal, temporal, parietal, and occipital (Fig.

14-3). However, he found that these four lobes were, by themselves, inadequate to account for the forty-odd distinct psychological functions that psychologists had characterized by 1790. As a result, he began to "finger heads of hundreds of musicians, actors, painters and also criminals, relating certain bony elevations or depressions under the scalp to the predominant talents or defects of their owners."[1] Based on his skull palpations, Gall subdivided the cortex into roughly forty regions, each of which served as an organ for a specific mental function. He assigned intellectual functions such as comparison, causality, and language to the front of the brain; emotional functions such as parental love, amativeness (romantic love), and combativeness to the back of the brain; and sentiments such as hope, veneration, and spirituality to the middle of the brain (Fig. 4-1).

While Gall's theory that all mental processes derive from the brain proved to be correct, his methods for localizing specific functions were deeply flawed because they were not based on what we would now consider valid evidence. Gall did not test his ideas empirically by performing autopsies on the brains of patients and correlating damage to specific regions with defects in mental attributes; he distrusted the diseased brain and did not think it could reveal anything about normal behavior. Instead, he developed the notion that as each mental function is used, the particular area of the brain responsible for that function becomes enlarged, much as muscles bulk up with use. Eventually, he believed, a given area may become so bulky that it pushes out against the skull and produces a bump on the head.

Figure 4-1. Joseph Gall developed a system called phrenology, which assigned specific mental functions to specific regions of the brain based on correlations between the subject's personality and external measurements of his or her skull.

Gall explored the skulls of people with particular psychological strengths or mental aberrations, very bright students, and people exhibiting psychopathic behavior, hyper-religiosity, or extreme erotic passions and convinced himself that characteristic bumps were associated with these traits. Based on his theory that excessive use leads to increased size, he assigned each trait to the region of the brain located below its corresponding bump. His findings led him to the further view that even the most abstract and complex of human behaviors, such as cautiousness, secretiveness, hope, sublimity, and parental love, are mediated by individual regions of the cerebral cortex. We now know these ideas to be completely fanciful, even though Gall's overall theory is correct.

A more convincing approach to the localization of mental function was taken up a generation later by the French neurologist Pierre-Paul Broca and the German neurologist Carl Wernicke. Broca and Wernicke each conducted postmortem examinations of the brains of people with speech defects and found that specific disorders of language are associated with damage to specific regions of the brain. Thus, language can indeed be localized. The understanding of language is located in the back of the cortex (in the left posterior superior temporal gyrus), the expression of language is located in the front of the cortex (in the left posterior frontal lobe), and the two sites are connected by a bundle of nerve fibers.

These and other discoveries strongly supported Gall's general idea that mental functions are localized to different regions of the brain; however, they did *not* indicate that complex mental functions such as language are localized to single regions of the brain. Instead, Broca and Wernicke's findings showed that such functions require a network of interconnected regions (Fig. 4-2). Their work gave rise to a flurry of discoveries, including the precise region of the cortex responsible for muscle movements.

These achievements were a severe setback to scientists who thought that the cerebral cortex functions as a unit and that its subregions are generally not specialized as to function. Proponents of this view argued, incorrectly, that it is not the location of brain damage that determines what mental functions are lost, but the size or extent of the damage.

Carl von Rokitansky also contributed to brain research. In 1842,

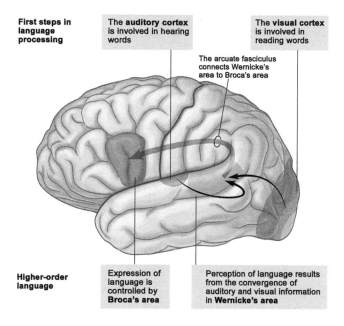

First steps in language processing

The **auditory cortex** is involved in hearing words

The **visual cortex** is involved in reading words

The arcuate fasciculus connects Wernicke's area to Broca's area

Higher-order language

Expression of language is controlled by **Broca's area**

Perception of language results from the convergence of auditory and visual information in **Wernicke's area**

Figure 4-2. Wernicke's model of complex behavior:
complex behaviors such as language involve several
interconnected areas of the brain.

when he was only thirty-eight years old, he discovered that stress and other instinctual responses derive from the brain—specifically, from a region called the hypothalamus, a small cone-shaped structure that lies deep in the brain. Rokitansky found that infections at the base of the brain that affect the hypothalamus interfere with normal functioning of the stomach and often lead to massive bleeding in the stomach. This work was later extended by the brain surgeon Harvey Cushing, who showed that damage to the hypothalamus produces stress that can cause what we now call "stress ulcers" in the stomach. Subsequent work by other scientists showed that the hypothalamus controls the pituitary gland and the autonomic nervous system and therefore plays a central role in mediating sexual, aggressive, and defensive behavior and in controlling hunger, thirst, and other homeostatic functions.

THE FIRST PSYCHIATRIST to go beneath the surface of the skull to study mental illnesses was Theodor Meynert. Meynert made three major contributions to the anatomy of the brain. First, he studied how the brain develops. From comparative studies of human and animal

brains, he learned that the human brain consists of regions that have been conserved through evolution; for example, the basal ganglia, which control reflex movements, and the cerebellum, which controls the memory of motor skills, are quite similar in all vertebrates. Moreover, following Charles Darwin's thinking, Meynert proposed that the evolutionarily older regions of the human brain develop first. This idea led him to argue that these primitive structures, located below the cerebral cortex, mediate unconscious, inborn, instinctual functions. Furthermore, Meynert proposed that instinctual functions are regulated by the cerebral cortex, which emerges later in both evolution and human development. Meynert thought of the cerebral cortex as the executive, or ego-functioning, part of the brain, mediating complex, consciously learned, and reflexive behavior.

Second, Meynert's comparative approach to brain anatomy led him to observe the correlation between the kangaroo's very large hind limbs, which the animal uses in jumping, and the extraordinarily large size of the kangaroo's motor (movement) pathway. Thus, he discovered a basic principle of sensory and motor representation within the brain: the size of the representation of a body part within the brain indicates the functional importance of that body part to the animal.

Third, Meynert discovered that the cerebral cortex has six distinct layers, each of which is made up of a different population of nerve cells. Moreover, he found that although the number of layers does not change from one region of the cortex to the next, the cell types do: different regions of the cortex have somewhat different populations of nerve cells.

These three contributions brought Meynert international renown, and with Rokitansky's strong support, he rose rapidly to become chairman of the Department of Psychiatry at the University of Vienna. As chairman, Meynert extended Rokitansky's thinking to the brain. He insisted that "psychiatry be given the character of a scientific discipline by determining its anatomical basis."[2] To this end, he made a major effort to trace various mental illnesses to specific abnormalities in specific regions of the brain. Meynert's search for the anatomical basis of mental illnesses is still being carried out today.

Besides placing psychiatric illnesses squarely in the brain, Meynert rejected the view generally held in Austrian and German medical schools that such illnesses are irreversible degenerative processes (de-

mentias). His findings led him to two new views of psychiatric illness: that disturbances in the development of the brain can be a predisposing factor for psychiatric illness, and, as Philippe Pinel had found, that certain psychoses are reversible.

This last idea led Meynert to a more optimistic view of the outcome of psychiatric illnesses. He introduced the term *amentia* to indicate that certain acute psychotic episodes caused by head trauma or toxins could be fully reversible. The isolation of a benign, curable psychosis (now called Meynert's amentia) opened up a new perspective on the study of mental disorders. It is probably no accident that four of the first people to introduce active, specific treatments into psychiatry—as opposed to the nonspecific, humane treatments instituted by Pinel—were students of Meynert: Josef Breuer and Freud, who successfully treated illnesses such as hysteria with psychoanalysis; Julius Wagner von Jauregg, who introduced fever treatment for syphilis; and Manfred Sakel, who introduced insulin coma for psychotic illnesses.

The next head of the Department of Psychiatry, Richard von Krafft-Ebing, took a different tack. Like Meynert, he carried out postmortem examinations of his patients' brains and was interested in linking psychiatry and neurology, but unlike Meynert, he was first and foremost a clinician. Moreover, Krafft-Ebing thought of psychiatry primarily as an observational and descriptive clinical science, not an analytic one. He therefore downplayed the importance of brain science in clinical psychiatry. In addition to being an outstanding descriptive psychiatrist and the author of two major texts on forensic (legal) psychiatry and clinical psychiatry, Krafft-Ebing was the first psychiatrist to focus on the function of sexual activity in everyday life, thereby making "the unspeakable speakable, certainly in medical circles and even beyond."[3]

In his classic text of 1886, *Psychopathia Sexualis, with Special Regard to Contrary Sexual Feeling,* Krafft-Ebing described a spectrum of sexual behavior and anticipated the importance of sexual instincts, two ideas that were later to emerge in psychoanalysis. Indeed, he outlined the importance of sexual instincts not only for normal and abnormal sexual functioning, but also for art, poetry, and other forms of creativity. He introduced concepts such as sadism, masochism, and pedophilia to describe specific types of sexual behavior, thus laying the foundation for modern sexual pathology.[4] Although first published in Latin—to reach a medical audience while at the same time discouraging adoles-

cents looking for sensational literature—the textbook nonetheless attracted a flock of readers, including, presumably, artists and scientists who were willing to put the Latin they had learned in gymnasium to use for the first time.

Krafft-Ebing stands as one of the founders of the modern, broad-based study of human sexual behavior in all of its manifestations. His work was insightful for its time, yet some of his ideas do not accord with today's views. Rather than seeing homosexuality and other sexual practices as variations from the bourgeois norm, Krafft-Ebing saw them as indicative of abnormality and illness. According to the Viennese medical historian Tatjana Buklijas, many homosexual people accepted this view and actively sought treatment.

Freud and Arthur Schnitzler were students of Meynert at the Vienna School of Medicine and were influenced by Krafft-Ebing. But they differed from Krafft-Ebing on this point. Although they did not always succeed, Freud and Schnitzler tried to avoid making moralistic judgments. They made it their life's work to embrace and explore variations in sexual practices, exposing what had always been hidden behind closed doors to the light of collective experience.

SIGMUND FREUD (Fig. 4-3) was born in 1856 to Jewish parents living in Freiberg, a small town in Moravia that is now part of the Czech Re-

Figure 4-3. Sigmund Freud (1856–1939). This portrait was taken in 1885, the year Freud spent in Paris studying with the French neurologist Jean-Martin Charcot.

public. In 1859 the family moved to Vienna, where Freud lived until June 1938, when he immigrated to England in response to Germany's annexation of Austria; he died there on September 23, 1939. Upon Freud's death, the British poet W. H. Auden commented that Freudian thought no longer represented the ideas of a single individual, but a "whole climate of opinion." Freud's thinking evolved throughout his long life, but it can be divided into two major phases. In the first phase, which began in 1874 and extended to about 1895, he was a student of neurology focused on describing mental life in basic neurobiological terms. In the second phase, extending from 1900 to 1939, he developed a new psychology of mind that was independent of the biology of the brain.

An outstanding student who was consistently at the top of his class in the Leopoldstädter Gymnasium, Freud entered the University of Vienna in 1873, just after the stock market crash of that year. The crash brought with it unemployment and a return of anti-Semitic bias and hostility. In his *Autobiographical Study* of 1924, Freud attributes his later sense of independence to the isolation he experienced at the university:

> When, in 1873, I first joined the University, I experienced some appreciable disappointments. Above all, I found that I was expected to feel myself inferior and an alien because I was a Jew. I refused absolutely to do the first of these things. I have never been able to see why I should feel ashamed of my descent or, as people were beginning to say, of my "race." I put up, without much regret, with my non-acceptance into the community; for it seemed to me that in spite of this exclusion an active fellow-worker could not fail to find some nook or cranny in the framework of humanity. These first impressions at the University, however, had one consequence which was afterwards to prove important; for at an early age I was made familiar with the fate of being in the Opposition and of being put under the ban of the "compact majority." The foundations were thus laid for a certain degree of independence of judgement.[5]

After first considering a career in law, Freud entered the School of Medicine at age seventeen.

Freud was in every sense a product of Vienna and its School of Medicine. When he entered medical school, Rokitansky was still the leader of the faculty. In fact, Rokitansky took the time to become familiar with Freud's early neuroanatomical research. In January and again in March 1877, Rokitansky attended Freud's presentation of papers on his work to the Austrian Academy of Science. On each occasion, with Rokitansky participating in the evaluation, the papers were deemed to be of high quality and accepted. When Rokitansky died, in 1878, it affected Freud as it did almost everyone at the medical school. He wrote to his friend Eduard Silberstein that "today we buried Rokitansky" and described accompanying the coffin to the cemetery. In 1905 Freud wrote an essay titled "Jokes and Their Relation to the Unconscious," in which he refers to "the great Rokitansky." In later years, Freud kept in his library a copy of Rokitansky's important 1862 lecture on "Freedom of Biological Research," an essay that emphasized the material basis of the medical sciences and the need to keep science free of political interference.

In Freud's obituary, Franz Alexander, a junior colleague and one of the leaders of the Psychoanalytic Institute in Berlin, refers to the education that Freud received at the Vienna School of Medicine and to its leader, Rokitansky, as having laid the foundation for Freud's later work. Fritz Wittels, a psychoanalyst who entered the University of Vienna Medical School in 1898 and later became an associate of Freud's, also saw Rokitansky as a critical part of Freud's "scientific cradle." Wittels writes:

> There is in psychoanalysis a certain danger of wild interpretation, leading away from observation to more or less ingenious ideology and back to romanticism. The tradition of Skoda and Rokitansky enabled Freud to avoid this pitfall.[6]

Strongly attracted to basic biology and greatly influenced by his extensive reading of Darwin, Freud intended to obtain a degree in comparative zoology as well as medicine. During his eight-year tenure in medical school, he was more a basic scientist than a medical student. His research training was shaped first by Ernst von Brücke, in whose basic science laboratory he worked for six years, and later by Meynert, under whom he worked at the Vienna General Hospital. Brücke, head

of the Department of Physiology at the medical school, instilled in Freud a lifelong identification with fundamental, positivist science.

Brücke and his contemporaries Hermann von Helmholtz, Emil du Bois Reymond, and Carl Ludwig changed the nature of physiology and medical science generally by launching a research program designed to replace vitalism with modern, reductionist, analytic biology. Vitalism taught that cells and organisms are controlled by a life force that does not comply with physical and chemical laws and therefore cannot be studied scientifically. In 1842 Emil du Bois Reymond summarized the group's view in the following terms: "Brücke and I pledged a solemn oath to put into power this truth: no other forces than the common physical-chemical ones are active within the organism."[7] Freud said of Brücke that he "carried more weight with me than anyone else in my whole life."[8]

Encouraged by Brücke to study the nervous system, Freud completed one study of the lamprey, a simple vertebrate animal, and another study of the crayfish, a simple invertebrate animal. He found that the cells of the invertebrate nervous system are not fundamentally different from those of the vertebrate nervous system. As a result of this work, Freud discovered—independently of Santiago Ramón y Cajal, but without realizing the significance of his observation—that the nerve cell, the neuron, is the fundamental building block and signaling unit of all nervous systems. In a lecture published in 1884 on "The Structure of the Elements of the Nervous System," Freud emphasized that what distinguishes the brain of vertebrates from the brain of invertebrates is not the nature of the nerve cells, but the number of nerve cells and how they interconnect. As the great student of the brain Oliver Sacks points out, Freud's early work bolsters Darwin's idea that evolution operates conservatively, using the same fundamental anatomical building blocks in a variety of progressively more complex arrangements.

THIS PROMISING BEGINNING set Freud on the road to a productive scientific career. However, a full-time research career would have required a private income, which he lacked. Brücke, who knew that Freud was engaged to marry Martha Bernays, advised him to leave the laboratory and go into the clinical practice of medicine. Freud took his advice and spent three years obtaining clinical experience, working

first with Meynert in psychiatry, but also in other departments of the hospital. In the course of his studies with Meynert, Freud considered becoming a neurologist and spent time in the wards of the Vienna General Hospital to improve his diagnostic skills. During this period, Freud made several contributions to research on the neuroanatomy of the medulla oblongata (the part of the nervous system that contains the centers for breathing and heart rhythms), and carried out several important clinical neurological studies on cerebral palsy and aphasias.

In 1891, in the course of his studies on aphasia, Freud encountered patients who were unable to recognize objects in the visual world, despite having a normal eye, retina, and optic nerve. He named this blindness *agnosia,* a defect in knowing, reasoning that their blindness was caused by a defect in the brain. He also undertook an unrelated set of pharmacological experiments with cocaine that ultimately led him to conclude that this substance might serve as a local anesthetic, a use to which it was put by eye surgeons. Meynert appreciated Freud's talents. As Freud wrote in his *Autobiographical Study:* "One day Meynert . . . proposed that I should definitely devote myself to the anatomy of the brain, and promised to hand over his lecturing work to me."[9]

There were many neurologists in Vienna, however, and only a limited number of patients. In searching for related areas of medicine in which he could make a significant intellectual contribution while earning a reasonable income, Freud became interested in neurotic illness, especially hysteria, which afflicted an abundance of patients in the Vienna of 1880. His interest in hysteria was kindled by Josef Breuer, one of Vienna's most accomplished internists, whom Freud had met and become friends with in Brücke's laboratory. The friendship grew after Freud married in 1886. In fact, Freud named his eldest daughter Mathilde after Breuer's wife.[10] In 1891 Freud also dedicated his first independent book, *On Aphasia,* to Breuer "in friendship and respect."

Breuer, who was also Jewish and fourteen years older than Freud, had entered the Vienna School of Medicine in 1859. There, he studied with Rokitansky and Skoda and was also greatly influenced by Brücke. After graduating, he was appointed a research assistant at the medical school. Breuer made his scientific name with two world-class discoveries: that the semicircular canals in the middle ear are the organs that control the body's balance and equilibrium, and that breathing is controlled reflexively, through the vagus nerve (the Hering-Breuer reflex).

But it was Breuer's third discovery, involving a patient known to history by the pseudonym "Anna O.," that most intrigued Freud and initiated the second phase of his career. Indeed, it was through Anna O. that Breuer and Freud started down the path that would lead them to make some of the most important contributions of the Vienna School of Medicine: the discovery, in a clinical context, that unconscious mental processes exist; that unconscious mental conflict can give rise to psychiatric symptoms; and that those symptoms can be alleviated when the memory of the underlying, unconscious cause is brought into the patient's conscious mind.

Psychoanalysis, which arose from the pioneering work with Breuer, was developed by Freud as a dynamic, introspective psychology, a precursor of modern cognitive psychology. But psychoanalysis suffered from a serious weakness: it was not empirical and was therefore not amenable to experimental testing. As a result, it is not surprising that components of Freud's theory of mind have been proven wrong and that the assumptions of a number of other components of psychoanalytic theory have not yet been tested.

Nevertheless, three of Freud's key ideas have held up well and are now central to modern neural science. The first idea is that most of our mental life, including most of our emotional life, is unconscious at any given moment; only a small component is conscious. The second major idea is that the instincts for aggressive and for sexual strivings, like the instincts to eat and to drink, are built into the human psyche, into our genome; moreover, these instinctual drives are evident early in life. The third idea is that normal mental life and mental illness form a continuum and that mental illnesses often represent exaggerated forms of normal mental processes.

As a result of these key ideas, the consensus is that Freud's theory of mind is a monumental contribution to modern thought. Despite the obvious weakness of not being empirical, it still stands, a century later, as perhaps the most influential and coherent view of mental activity that we have.

# EXPLORING MIND TOGETHER WITH THE BRAIN: THE DEVELOPMENT OF A BRAIN-BASED PSYCHOLOGY

⌒⌣⌒

*We cannot do without men with the courage to think*
*new things before they can prove them.*

—SIGMUND FREUD[1]

FREUD INITIALLY ATTEMPTED TO EXPLORE THE HUMAN MIND in biological terms: that is, to explore it in terms of the functioning of the brain. This early attempt began in collaboration with Josef Breuer and focused on Breuer's patient Anna O. Freud describes his early fascination with the case of Anna O. in his *Autobiographical Study* of 1924: "[Breuer] repeatedly read me pieces of the case history, and I had an impression that it accomplished more towards an understanding of neuroses than any previous observation."[2]

Anna O., whose real name was Bertha Pappenheim, was a highly intelligent twenty-one-year-old woman who later became a leader of the feminist movement in Germany. When she first presented herself to Breuer, in 1880, she was suffering from a severe cough, loss of sensation and motor paralysis of the left side of her body, difficulties in speech and hearing, and periodic loss of consciousness. Breuer conducted a thorough neurological examination, but the results of his tests were completely normal. He therefore diagnosed Pappenheim's illness as hysteria, a psychiatric condition in which the patient exhibits symptoms of neurological disease, such as paralysis of a limb or difficulty in talking, without any organic evidence of disease.

There was nothing novel in Breuer's ability to diagnose hysteria in

a patient in Vienna at that time. What was unusual—and of the deepest interest to the young neurologist Freud—was Breuer's method of therapy. Influenced by the French neurologist Jean-Martin Charcot's use of hypnosis, Breuer hypnotized Pappenheim but added a new twist: he encouraged her to talk about herself and her illness. This combined treatment, which Pappenheim later called the "talking cure," gradually dispelled her symptoms.

Together, Breuer and Pappenheim discovered that the roots of her hysterical symptoms—such as the paralysis of the left side of her body—lay in traumatic events in her past. Through the free association of events and feelings during hypnosis, Pappenheim described how, as she was nursing her father, who had recently died of a tubercular abscess in his lungs, he commonly lay with his head resting on her left side, the side that now was paralyzed. As Freud later recounted:

> In her waking state the girl could no more describe than other patients how her symptoms had arisen, and she could discover no link between them and any experiences of her life. In hypnosis she immediately discovered the missing connection. It turned out that all her symptoms went back to moving events which she had experienced while nursing her father; that is to say, her symptoms had a meaning and were residues or reminiscences of those emotional situations. It was found in most instances that there had been some thought or impulse which she had had to suppress while she was by her father's sick-bed, and that, in place of it, as a substitute for it, the symptom had afterwards appeared. But as a rule the symptom was not the precipitate of a single such "traumatic" scene, but the result of a summation of a number of similar situations. When the patient recalled a situation of this kind in a hallucinatory way under hypnosis and carried through to its conclusion, with a free expression of emotion, the mental act which she had originally suppressed, the symptom was abolished and did not return. By this procedure Breuer succeeded, after long and painful efforts, in relieving his patient of all her symptoms.[3]

Until Breuer focused his attention and his very considerable therapeutic skill on Bertha Pappenheim, patients with hysteria were often

treated as malingerers, people who pretended to be ill in order to gain attention or some other secondary benefit. Moreover, in describing the history of their symptoms to a physician, hysterical patients insisted that they did not have the vaguest idea how those symptoms had come about. Even Freud initially thought that any well-functioning person who had the incapacitating physical symptoms of a hysterical patient—paralysis, crying fits, outbursts of emotion—must surely have some idea of what events or insults had contributed to the emergence of those symptoms. But he concluded that:

> if we keep to our conclusion that a corresponding psychical process *must* be present, and if nevertheless we believe the patient when he denies it; if we bring together the many indications that the patient is behaving as though he *does* know about it; and if we enter into the history of the patient's life and find some occasion, some trauma, which would appropriately evoke precisely those expressions of feeling—then everything points to one solution: the patient is in a special state of mind in which all his impressions or his recollections of them are no longer held together by an associative chain, a state of mind in which it is possible for a recollection to express its affect by means of somatic phenomena without the group of the other mental processes, the ego, knowing about it or being able to intervene to prevent it. If we had called to mind the familiar psychological difference between sleep and waking, the strangeness of our hypothesis might have seemed less.[4]

Pappenheim's case also led Freud to the realization that Rokitansky's medical dictum—look below the surface of the body to find the truth—applies to mental life as well. But as the locus of investigation changed from the physical brain to mental events submerged in the patient's past, the physician's examination tools changed from reflex hammers and needles to words and memory. As we shall see, there was a remarkable similarity between Freud's ability to use language to probe the unconscious and the ability of the modernist painters to depict it.

BREUER'S SUCCESS WITH Pappenheim sparked Freud's interest in hysteria and hypnosis. Accordingly, he undertook a six-month fellow-

ship to Paris in the autumn of 1885, where he studied at the Salpêtrière Hospital with Charcot. Early in his career, Charcot had described several important neurological abnormalities, including amyotrophic lateral sclerosis and multiple sclerosis. By the time Freud arrived, Charcot was reaching the end of his career, and his interest had shifted from pure neurology to hysteria. More than anyone else, Charcot changed the medical opinion of hypnosis from a form of quackery to a method of investigation with diagnostic and therapeutic potential. A keen observer and excellent clinician, he gave weekly demonstrations of hypnosis in charismatic and dramatic public sessions; the demonstrations were photographed to provide scientific documentation of their validity.

Charcot found that, under hypnosis, a hysterical patient could be relieved of symptoms and a normal person could acquire symptoms indistinguishable from those of hysteria. Moreover, he gave both hysterical patients and normal volunteers posthypnotic suggestions to carry out certain tasks or to feel certain emotions. When brought out of their hypnotic state, they would all carry out the tasks and experience the emotions without any conscious awareness of why they were doing or feeling as they were. The revelation that people's actions can be determined by unconscious motives of which they are completely unaware strengthened Freud's early conviction, developed through discussions with Breuer, that "there could be powerful mental processes which nevertheless remained hidden from the consciousness of men."[5]

Freud learned that a person under hypnosis remembers and expresses painful emotions but upon awakening does not remember anything he or she had just expressed—as if the conscious components of personality had not taken part in the experience. He concluded that hysterical symptoms are manifestations of emotions so painful that the patient cannot confront or express them freely, whether in the form of emotional release (such as crying or laughing), motor action, or normal social interaction. Guided by Charcot's demonstrations and his own observations with Breuer, Freud discovered *repression*, a cornerstone of what would later become psychoanalytic theory. Repression is a defensive reaction, the mind's resistance to recognizing unacceptable emotions, wishes, and patterns of action. Freud's search for a way of overcoming repression ultimately led him to free association.

When Freud returned to Vienna after his fellowship in Paris, he asked Breuer to teach him the therapeutic approach he had used with Pappenheim. Freud opened his own practice at this time, relying heavily on Jewish and immigrant patients referred by Breuer, who also helped him financially by extending him loans. Freud repeated Breuer's approach on a number of patients with hysteria and observed that Breuer's findings were in every case confirmed. He now proposed that they should collaborate on a publication.

The two published an article in 1893 on the treatment of patients with symptoms of hysteria, and in 1895 they published a book, *Studies in Hysteria*. Freud wrote four of the five case histories and Breuer wrote the fifth (Anna O.) and the theoretical discussion.

But Freud and Breuer disagreed about the nature of the experiences that hysterical patients were struggling to remember. Freud concluded:

> I now learned . . . that it was not *any* [arbitrary] kind of emotional excitation that was in action behind the phenomena of the neurosis but habitually [specifically] one of a sexual nature, whether it was a current sexual conflict or the effect of earlier sexual experiences. . . . I now took a momentous step. I went beyond the domain of hysteria and began to investigate the sexual life of the so-called neurasthenics who used to visit me in numbers during my consultation hours. This experiment . . . [convinced] me . . . that in all of these patients grave abuses of the sexual function were present.[6]

This "seduction theory" of hysteria—which attributed the cause of a relatively common psychiatric condition to a single source, sexual seduction—seemed so radical and unlikely to Breuer, and to many others in the Viennese medical community, that it triggered an immediate break with Freud. It ultimately led to Breuer's "retirement from our common work," leaving Freud "the sole administrator of his legacy."[7] In 1896 Freud wrote in "Heredity and the Aetiology of the Neuroses": "What gives its distinctive character to my line of approach is that I elevate these sexual influences to the rank of specific causes."[8] In this view, the traumatic event that generates hysterical symptoms is invariably a physical act of sexual abuse, such as the seduction of the patient as a child by her father or a close relative. Freud's early thinking

was thus essentially environmental: he thought that hysterical behavior represents a person's response to the external sensory stimuli that accompanied the seduction.

Freud's environmental view is reflected in the 1895 essay "The Project for a Scientific Psychology," a bold but somewhat chaotic attempt to unify knowledge about the science of mind and the science of the brain. The essay stands in dramatic contrast to a parallel effort by William James, the American philosopher, psychologist, and student of the brain. James's two-volume *Principles of Psychology*, published in 1890, is a clear, beautifully written treatise, whereas Freud's essay is remarkably dense and difficult to understand. It clearly is an unfinished paper, lacking the clarity and stylistic polish that characterize his published works, and Freud did not publish it during his lifetime. The essay was discovered decades after his death and subsequently edited and published in 1950 by Ernst Kris, a noted art historian, psychoanalyst, and student of Freud's.

In the essay (originally titled "Psychology for Neurologists"), Freud tries unsuccessfully to develop a scientific psychology—ranging from neurons to complex psychic states—that is intended to be "an extension of the natural sciences."[9] In other words, he attempts to give psychology, the science of mind, a firm grounding in biology.

IN TRYING TO FORMULATE a scientific psychology, Freud and James were undertaking a challenge that was almost a century ahead of its time. Indeed, their goal of grounding the science of mind in biology is completely in accord with goals we are only now pursuing at the beginning of the twenty-first century. Yet, whereas James continued along this line, Freud abandoned his effort soon after he had begun it. Why did Freud undertake this highly ambitious effort? And once undertaken, why did he so readily abandon it? After reviewing some of Freud's key writings from this period, I have come to the conclusion that he believed he could develop a biological model of the human mind and its disorders because he had simplified his thinking about how the brain works.

Three factors allowed him to develop a simple, abstract biological model. First, he believed that an environmental stimulus, an external sensory event—the actual seduction—was the cause of hysteria. Although he later recognized the important role of internal stimuli, or

instinctual drives, he initially focused only on perception of external stimuli. Thus, he proposed that for the brain to carry out important mental processes, it needed only three interrelated systems: perception (sensory information from the outside world), memory (recall of that information from the unconscious), and consciousness (awareness of the memory).

Second, influenced by the great British neurologist John Hughlings Jackson, Freud began to think that brain events do not cause mental events, as Gall had proposed and as most brain scientists now believe, but rather that mental events and brain events work in parallel. As Freud explained in his earlier, beautifully written and well-argued book *On Aphasia*, published in 1891: "The relationship between the chain of physiological events in the nervous system and the mental processes is probably not one of cause and effect. . . . The psychic is a process parallel to the physiological."[10]

Third, Freud doubted that higher cognitive functions could be localized to specific regions and combinations of regions in the brain. That view was quite different from the one held by most of the influential academic anatomists and neurologists of his day—Pierre-Paul Broca, Carl Wernicke, Theodor Meynert, and Santiago Ramón y Cajal—and from the view we hold today. Freud strongly questioned the classic findings of Broca and Wernicke on the localization of language and, because of their concern with the precise neural circuitry of language, referred to them as "the diagram makers of aphasia."

Freud was impressed with the loose constructionist view of cerebral localization held by Sigmund Exner, a student and assistant of Ernst von Brücke's when Freud was studying with him. Exner carried out experiments in dogs which suggested that areas of the cerebral cortex are not sharply delineated from one another. These experiments led him to conclude that cortical areas overlap to some degree and thus to postulate the notion of *moderate localization*.

Part of Exner's argument was based on the study of people with aphasia. He noted that brain damage that leaves one speech area intact but destroys the surrounding areas nevertheless produces a language deficit. Rather than concluding that this sort of deficit might be caused by disruption of a pathway between the intact area and other areas of the brain involved in language, Freud interpreted the findings as indicating that language lacks precise anatomical localization. Indeed, he

thought that the distinct receptive and expressive language areas de-scribed by Broca and Wernicke constitute one large, continuous re-gion. Freud therefore advanced the idea of a global speech apparatus that consists of dynamic functional centers, which he called cortical fields, that are defined not by anatomical boundaries but by specific functional states of the brain.

This idea freed Freud to contemplate a functional model of mind without having to worry about where in the brain particular conscious and unconscious functions are located. He could simply base his model on a set of three abstract neural networks, each with different proper-ties mediating different functions: one for perception, one for memory, and one for consciousness. None of the three systems was localized to specific regions of the brain. Freud then used part of this model to il-lustrate how repression, a primary defense, might work (Fig. 5-1). It is interesting to note in this regard that James, who had made a parallel attempt to combine the science of mind and the science of the brain in his *Principles of Psychology*, emphasized the importance of the localiza-tion of mental functions, while alerting the reader that the theory was not universally accepted (Figs. 5-2, 5-3).

WHY DID FREUD ABANDON his biological model of mind? One rea-son is that it failed to accommodate his revised view of unconscious processes, a revision that resulted from his modification of Breuer's talking cure.

Soon after the publication of *Studies in Hysteria* in 1895, Freud elim-inated hypnosis as part of his treatment. He now relied completely on free association, the associations made by alert patients who described whatever came into their minds. While hypnosis had created a con-trolled distance between Freud and his patients, the "talking cure" made the relationship immediate and personal. This change increased transference, the process by which patients direct toward their therapist some of the unconscious emotions that characterize their key relation-ships, especially childhood relationships. Freud analyzed his patients' transference and discovered new dimensions of the unconscious defen-sive mechanisms that people use to deal with what is really bothering them.

In particular, Freud was impressed with how often fantasies of se-duction were projected onto him by his patients. He realized that sexual

**Freud's Neural Model of a Primary Defense:  Repression (modified)**

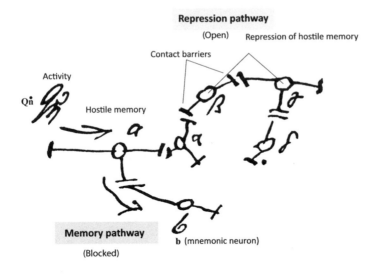

**Contemporary View of Freud's Neural Model of a Primary Defense:  Repression**

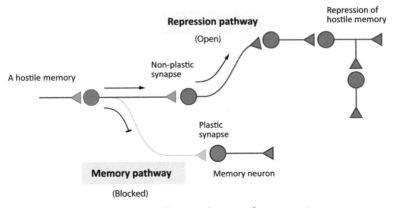

Fig. 5-1. Freud's neural circuit for repression
based on his neural model of mind.

abuse in childhood could not possibly be so widespread as to account for the large number of women who suffered from hysteria. He therefore concluded that his patients' reports were based not on real events but were "only phantasies which my patients had made up or which I myself had perhaps forced on them."[11] This led him to alter his seduction theory. He now saw the traumatic seduction experienced by the patient not as an actual physical act, but as an *imagined* physical experience with the patient's parent, a fantasy that he concluded was universal.

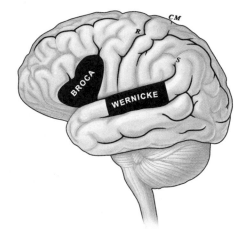

Figure 5-2. William James's
Schematic Profile of Left Hemisphere,
adapted from his *Principles of Psychology*.

This revision, formulated in 1897, was important for Freud's thinking in several ways. It reflected his growing belief, reinforced by his analysis of transference, that erotic wishes and desires are manifested in disguised form in many aspects of mental life. In addition, he now appreciated that the erotic life of the adult invariably has its origin in childhood. Finally, he became convinced that some unconscious mental activity—the dynamic unconscious—draws no distinction between reality and fantasy.

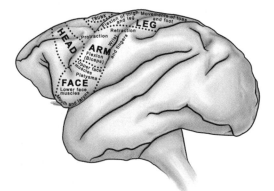

Figure 5-3. William James's sketch of
Left Hemisphere of Monkey's Brain,
adapted from his *Principles of Psychology*.

Freud concluded that his earlier, environmental model of mind was oversimplified. His new appreciation of internal, instinctual drives gave rise to his mature view of mind as a functional entity that can be affected by internal (unconscious) as well as external (environmental) stimuli.[12] As we shall see, this search for what goes on beneath the social exterior of human behavior was a driving force not only for Freud, but also for Arthur Schnitzler, Gustav Klimt, Oskar Kokoschka, and Egon Schiele, the other Viennese explorers of the unconscious mind.

A second, more important reason why Freud abandoned his biological model was his conviction that the effort to link three different levels of analysis—behavior, mind, and brain—was premature. Having carried out research at the frontiers of brain science, he was aware that too little was known about the inner workings of the brain for him to make a serious effort to cross, in one step, two huge divides in knowledge: that between clinical behavior and mind, and that between mind and the brain.

As a result, at the end of 1895, a few months after having completed it, Freud abandoned his biological model and completely disowned his manuscript of "The Project for a Scientific Psychology." Recognizing that his biological thinking in the essay was vastly oversimplified and inadequate, he wrote to his friend and confidant William Fliess, a nasal surgeon who had read several earlier versions, that he could no longer understand the state of mind in which he concocted the psychology: "It seems to have been a kind of aberration."[13]

ABANDONING THE BIOLOGICAL model was difficult for Freud because he did not seek to reject biology or to divorce his work from it. Rather, he saw the decision as a necessary and, he hoped, temporary separation that would allow time for both the psychology of mind and the biology of the brain to mature before any ultimate unification of the two was attempted—a radical idea at that time. He realized that before human behavior could be linked to brain science, a coherent, dynamic psychology of mind had to be developed. Implicit in this thinking was a three-tiered approach to linking behavior and the brain (Fig. 5-4). In this approach, observable clinical behavior is the lowest tier, psychoanalysis—the dynamic psychology of mind—is the linking tier, and the biology of the brain is the highest tier.

In developing this view, Freud was employing a strategy that had

**A conceptual view of Freud's idea of psychoanalysis
as an attempt to develop the beginning of a
cognitive psychology that could serve
as a transitional discipline between behavior and the brain**

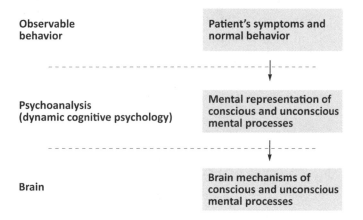

Figure 5-4. The Freud Three-Step Plan for the Biological Analysis of Mental Processes. The biological analysis of observable emotion requires, as a critical intermediate step, an analysis of how perception and emotion are represented in psychoanalytic-cognitive psychological terms. These same three steps have given rise to the new science of mind in the twenty-first century.

been applied repeatedly in science, one based on the belief that insights into causes are most likely to emerge if a subject has first been systematically observed and described. Newton's discovery of gravity, for example, emerged from Kepler's astronomical observations, and Darwin's ideas about evolution were based on the detailed classification of animals and plants by Linnaeus. Perhaps the most direct influence on Freud was the thinking of Hermann von Helmholtz. A close friend and colleague of Brücke's and one of the most remarkable scientists of the nineteenth century, Helmholtz helped bring physiology together with physics and chemistry. In his work on visual perception, Helmholtz came to see psychology as fundamental to an understanding of brain physiology.

Freud's separation of psychoanalytic psychology from brain science proved healthy for psychology for a long time. It permitted him to develop descriptions of mental processes that, although not based on experimental observation, also were not contingent on vague correlations

with neural mechanisms. The soundness of Freud's judgment is reinforced by the fact that in 1938, a radically different psychologist, the rigorously experimental behaviorist B. F. Skinner, argued along similar lines that separating the study of behavior from brain science was, for the moment, scientifically necessary.

Despite this self-enforced separation, Freud anticipated that brain science would ultimately revolutionize his conception of mind. "We must recollect that all of our provisional ideas in psychology will presumably one day be based on an organic substructure,"[14] he wrote. In his book *Beyond the Pleasure Principle*, written in 1920, he continued:

> The deficiencies in our description would probably vanish if we were already in a position to replace the psychological terms with physiological or chemical ones. . . . We may expect [physiology and chemistry] to give the most surprising information and we cannot guess what answers it will return in a few dozen years of questions we have to put to it. They may be of a kind that will blow away the whole of our artificial structure of hypotheses.[15]

TO DEVELOP A PSYCHOLOGY that could provide the basis for a new science of mind, Freud needed to overcome two challenges. First, he had to develop a theory of mind that was broader than that of the two great students of associative learning, Ivan Pavlov and Edward Thorndike. Associative learning was first delineated by Aristotle, who pointed out that we learn by associating ideas. John Locke and the British empiricists, the forerunners of modern psychology, elaborated on the idea. Pavlov and Thorndike went a step further, rejecting the unobservable psychological construct of thought in favor of an observable behavioral construct, the reflex action. To Thorndike and Pavlov, learning was not an association between ideas, but an association between a stimulus and behavior. This paradigm shift in thinking made the study of learning amenable to experimental analysis: responses could be measured objectively, and the rewards and punishments linking a response to a stimulus could be specified and even modified.

Although Freud made use of the association of ideas in his principle of *psychic determinism*—the principle that the associations in memory are linked causally to events in one's life—his theory of mind was

much broader than that of Pavlov and Thorndike. Freud appreciated that there are many things in the human psyche that extend beyond associations, beyond learning about reward and punishment. He wanted a psychology that included the mental representations—cognitive processes—that intervene between a stimulus and a response: perceptions, thoughts, fantasies, dreams, ambitions, conflicts, love, and hate.

Second, Freud did not want to limit himself to psychopathology. He aimed to establish a psychology of everyday life that could account for both normal mentation and psychopathology. His determination was based on the remarkable insight that unlike many neurological disorders, psychiatric disorders—and psychopathology in general—are extensions and distortions of normal mental processes.

Thus, more than half a century before Ulric Neisser coined the term, Freud had developed the first *cognitive psychology*, one that despite its scientific weakness proved to be a precursor of the later cognitive psychologies. Neisser defined cognitive psychology in almost Freudian terms:

> The term "cognition" refers to all processes by which a sensory stimulus is transformed, reduced, elaborated, stored, recovered and used. It is concerned with these processes even when they operate in the absence of relevant stimulation, as in images and hallucinations. . . . Given such sweeping definition it is apparent that cognition is involved in everything a human being might possibly do, that every psychological phenomenon is a cognitive phenomenon.[16]

Neisser and his contemporaries originally focused on the "faculty of knowing" and limited cognitive psychology to the transformation of knowledge—perceiving, thinking, reasoning, planning, and acting—without regard to emotion or unconscious processes. Current thinking in the field is much broader and includes all aspects of behavior: emotional, social, as well as knowledge-based, conscious as well as unconscious. In this sense, the aims of contemporary cognitive psychology are in line with the original aims of Freudian dynamic psychology. However, the cognitive psychology of Neisser and his contemporaries, unlike Freudian psychology, was designed to be empirical: the basic tenets could be isolated and their validity tested.

———

IN RETROSPECT, IT IS CLEAR why cognitive psychology has proven so important as a transition between behavior and brain biology. During the last two decades, a large number of empirical studies have started to test certain of Freud's ideas. They have found that certain cognitive psychological features that Freud began to focus on, such as erotic and aggressive instincts, are essential for survival and have been selected for and conserved by evolution. The elementary components of perceptual, emotional, empathic, and social processes are also conserved in evolution and are shared by simpler animals. These recent findings provide still further support for Darwin's argument that emotions and social behavior are conserved in animals and people.

Most immediately relevant to Vienna 1900, however, is the fact that Freud's three-tiered approach to linking behavior, mind, and brain was also adopted in the 1930s by his associate Ernst Kris, and later by Kris's collaborator Ernst Gombrich, who used it in their attempt to link art and science. In doing so, Kris and Gombrich developed the first cognitive psychology of art—an interdisciplinary psychology of perception and emotion—with the idea that it might ultimately pave the way for a biological approach to perception, emotion, and empathy. As Gombrich was to say prophetically: "Psychology is biology."[17]

# EXPLORING MIND APART
# FROM THE BRAIN: ORIGINS OF A
# DYNAMIC PSYCHOLOGY

T HE PROGRESSION OF FREUD'S THINKING FROM A BIOLOGICAL to a psychological exploration of mind began in the context of a personal trauma, the death of his father in 1896. Freud, who was forty years old at the time, later referred to a father's death as "the most important event, the most poignant loss, in a man's life."[1]

Curiously, Freud responded to this loss in two ways. He started to collect antiquities. This newfound passion was fueled by his early fascination with the past, with myths, and with archaeology, particularly Heinrich Schliemann's discovery in 1871 of Ilios, in what is now the coastal plain of Turkey, as the site of Homer's Troy. Freud recognized parallels between the work of a psychotherapist and that of an archaeologist and even used archeological metaphors to formulate psychoanalytic ideas. As he explained to one of his early patients, the Wolf Man (Sergei Pankejeff): "The psychoanalyst, like the archaeologist in his excavations, must uncover layer after layer of the patient's psyche, before coming to the deepest, most valuable treasures."[2]

The loss of his father also prompted Freud to take on a new patient whose nighttime dreams he would dutifully record and interpret, layer by layer, for the rest of his life. As he wrote in an 1897 letter to Fliess, "The chief patient I am busy with is myself."[3] He devoted thirty minutes at the end of each working day to an analysis of himself, and thus self-analysis became part of his lifelong attempt to mine what lies beneath the surface. The probing into his own psychology led Freud to a new focus: the significance of dreams.

———

DREAMS PERVADE THE HUMAN experience. Although they are a common occurrence, they have been a mystery throughout most of history. What are dreams? Why do we have them? What do they mean? Are dreams a means of divine communication, are they prophetic visions, are they reworked events from everyday life, or are they just noise in the machinery of the brain?

Freud addressed these questions in his self-analysis, which culminated in his most famous work, *The Interpretation of Dreams*. In this book Freud outlines his ideas about conscious and unconscious mental processes, all of which apply in full measure to dreams. Dreams, he argues, are disguised fulfillments of a person's unconscious, instinctual wishes. Often, these wishes are unacceptable to the person's waking mind and are therefore censored, manifesting themselves later in dreams.

For Freud, dreams are the prototypical mental experience; analysis of them provides a royal road to the unconscious and reveals potent clues to how the human mind works. Through his analysis of dreams, Freud inferred the interplay among three key components of the psyche: everyday events, instinctual drives, and defense mechanisms. That set of insights led him to develop a new model of mind based on psychological processes rather than brain anatomy.

Freud now came to believe that all forms of mental life—whether phobias, slips of the tongue, or jokes—follow the pattern of dream production. Moreover, conflict is central to all human psychological activity, as one part of the mind is commonly at odds with another. The dreams of normal people and the symptoms of Freud's patients were a direct, disguised consequence of this hidden struggle. Thus, *The Interpretation of Dreams* is to Freud's work as dreams themselves are to the unconscious mind. Although the book was finished in the last few weeks of 1899, the publisher gave it the publication date of 1900 to highlight Freud's belief that it represented the new psychology of the twentieth century.

FREUD INTRODUCES HIS radical theories about dreams in the initial sentences of the first chapter of *The Interpretation of Dreams*, and he

does so in the elegantly clear and persuasive style that was to characterize his future writing:

> In the following pages I shall demonstrate that there is a psychological technique which makes it possible to interpret dreams, and that on the application of this technique every dream will reveal itself as a psychological structure, full of significance, and one which may be assigned to a specific place in the psychic activities of the waking state. Further, I shall endeavour to elucidate the processes which underlie the strangeness and obscurity of dreams, and to deduce from these processes the nature of the psychic forces whose conflict or cooperation is responsible for our dreams.[4]

He goes on to review the concept of dreams in antiquity, beginning with Joseph's interpretation of dreams in the Old Testament book of Genesis. The ancients believed that dreams were related to the supernatural world and that they "brought inspirations from the gods and demons."[5] Freud argues that the common person's belief that dreams have meaning is closer to truth than the skepticism of most medical scientists. He proposed to put the analysis of dreams on a scientific footing by applying to it the technique of free association that he and Breuer had developed.

The first dream that Freud describes is one that he had, and that he analyzed, in July 1895 in Schloss Bellevue, a house on the Cobenzl just above Grinzing, a resort town where he was spending the summer. Freud's dream relates to his professional life and is about a young patient and family friend, Emma Eckstein. Freud refers to her as Irma and to the dream as "Irma's Injection." He describes the free associations he had on awakening, associations that led him to discover the dream's underlying wish fulfillment: namely, that a diagnostic mistake he had made should be attributed to a colleague, not to himself. The dream also showed him that one person can be substituted for another in a dream and that unacceptable feelings of guilt are expressed in displaced form.

The occasion of Freud's visit to Schloss Bellevue was a birthday party he had planned for his wife, Martha, who at the time was preg-

nant with Anna, their youngest daughter. Freud had invited several of his physician friends to the party, as well as some of his patients. One of these patients was Emma, who had lost some of her physical symptoms while being treated. Freud proposed that they discontinue Emma's treatment while on vacation. The young woman had recently undergone a routine operation on her nose, carried out by Freud's friend and supporter William Fliess. Fliess's friendship was particularly important to Freud at that time because it coincided with the deterioration of his relationship with Josef Breuer. Freud had recommended the operation to his patient even though he was not certain that it was absolutely necessary for her health.

Fliess operated on Emma in February 1895, and Freud assumed responsibility for the young woman's follow-up care. During the procedure, Fliess left a piece of a gauze pad in Emma's sinus cavity, resulting in infection. By March she had started to bleed and almost died. Emma was operated on by other physicians, who removed the gauze, but she continued to experience pain and to bleed from her nose. Rather than directing himself to the surgical maltreatment of Emma, Freud insisted to Fliess, and to some degree to Emma herself, that her symptoms were psychological, not medical. As Emma began to improve over the next few weeks, she still had gastric discomfort and problems walking. On the day of the dream, one of Freud's physician friends, Oskar Rie, had told him that Emma continued to have pain and had failed to respond to treatment.

In his dream, Freud sees himself in a large hall, greeting the many guests who had arrived for the party. One of the guests is Emma, whom Freud takes aside and assures, once again, that her remaining pain is psychosomatic and simply her own fault. She responds by saying, "If you only knew what pains I've got."[6] Concerned that he might have overlooked an actual physical ailment, Freud asks her to open her mouth and to stick out her tongue so that he can look down her throat. There he sees an extensive array of whitish-grayish scabs. He asks his physician friends to examine her also, to confirm his observation. One of them exclaims, "There is no doubt it's an infection."

At this point in the dream, Freud sees the chemical formula for trimethylamine—a substance believed to be the basis of sexuality— float before his eyes. Emma had actually received an injection recently, and Freud knew this. He thinks to himself that perhaps the syringe

with which Emma was injected was not sterile, and he reprimands the physician (presumably Fliess) for making the injection so carelessly.

Freud interprets the dream as a reflection of his guilt, which he handles by blaming everyone but himself—Fliess, Emma, the other doctors, and finally trimethylamine: "So many important subjects converged upon that one word. Trimethylamine was an allusion not only to the immensely powerful factor of sexuality, but also to a person [Fliess] whose agreement I recalled with satisfaction whenever I felt isolated in my opinions."[7] The dream also reflects Freud's anxiety that Martha's pregnancy, which was unexpected, was the result of a "thoughtless injection." But most important, he believes that the dream's overlying message was that sexuality is at the root of all neuroses—a point he had been eager to prove.

This dream analysis reads like a medical detective story. Freud attempts to decipher the psychic meaning of the figures, elements, and events of his dream with the same investigative zeal he applies to the symptoms of his neurotic patients. Charles Brenner, the great teacher of psychoanalysis, describes dreams in general in the following terms:

> The subjective experience which appears in consciousness during sleep and which, after waking, is referred to by the sleeper as a dream is only the end result of unconscious mental activity during sleep which, by its nature or its intensity, threatens to interfere with sleep itself. Instead of waking, the sleeper dreams. We call the conscious experience during sleep, which the sleeper may or may not recall after waking, the *manifest dream*. Its various elements are referred to as the *manifest dream content*. The unconscious thoughts and wishes which threaten to waken the sleeper we call the *latent dream content*. The unconscious mental operations by which the latent dream content is transformed into the manifest dream we call the *dream work*.[8]

Freud interprets the distortions in this pivotal dream by considering the dream's two main features: its manifest content, the literal story line of the dream (the party, Emma's presence, her medical condition, and so on), and its latent content, the dreamer's underlying wishes and desires. He argues that repression disguises the latent content of the dream and prevents raw, uncensored data from entering the manifest

content. He goes on to show how repression converts unacceptable latent thoughts into acceptable manifest content, ending with what he considers his most important insight into the psychological function of the dream: "When the work of interpretation has been completed, we perceive that a dream is the fulfillment of a wish."[9] Freud extends the idea of wish fulfillment further in the second edition of *The Interpretation of Dreams*, published nine years later, arguing that most dreams deal with sexual material and express erotic desires.

As if trying to solve the mystery of dreams were not enough, the book also contains Freud's initial ideas about the Oedipus complex, derived from the ancient Greek story of Oedipus Rex, who unknowingly killed his father and married his mother. Freud holds that during the first years of life, a male child harbors sexual wishes toward his mother, accompanied by wishes to eliminate his father, a rival for the mother's attention. Female children have the opposite wish. Freud also continues an earlier line of thought—namely, that to understand a person's present, one must turn inward and understand that person's earliest experiences in childhood, both real and imagined.

As even a cursory description makes clear, *The Interpretation of Dreams* is the seminal achievement of Freud's remarkable career. He himself was immensely proud of it. In a letter to Fliess dated June 12, 1900, he writes of revisiting Schloss Bellevue, where five years earlier he had had the dream he called Irma's Injection: "Do you suppose that some day a marble tablet will be placed on the house, inscribed with these words: In this house, on July 24, 1895, The Secret of Dreams was revealed to Dr. Sigmund Freud."[10] This sentiment remained with Freud for the rest of his life. In 1931 he wrote in a foreword to the English translation of the book: "It contains, even according to my present-day judgment, the most valuable of all the discoveries it has been my good fortune to make. Insight such as this falls to one's lot but once in a lifetime."[11]

FREUD'S THEORY OF MIND emerged from *The Interpretation of Dreams* as a coherent cognitive psychology based on the idea that all mental acts have a cause and an internal representation in the brain. The theory encompasses four key ideas.

First, mental processes operate primarily unconsciously; conscious thought and emotion are the exception rather than the rule. This hy-

pothesis is an extension of Freud's attempt to probe beneath the surface phenomena of mental life to the inner reality.

Second, no aspect of mental activity is simply noise in the machinery of the brain. Mental events do not occur by chance, but adhere to scientific laws. Specifically, mental events follow the principle of psychic determinism, which holds that the associations in a person's memory are linked causally to actual events in his or her life. Every psychic event is determined by an actual event that preceded it. Association of ideas governs unconscious as well as conscious mental life, but it does so along markedly different pathways in the brain.

Third, and critical to unlocking the secrets of the human unconscious, Freud argued that irrationality per se is not abnormal: it is the universal language of the deepest unconscious strata of the human mind. This idea led naturally to Freud's next conclusion.

Fourth, normal and abnormal mental function lie on a continuum. Every neurotic symptom, no matter how strange it may seem to the patient, is not strange to the unconscious mind, because it is related to earlier mental processes.

As Freud later pointed out, the first two of these ideas, which Brenner has referred to as "the two fundamental hypotheses of psychoanalysis,"[12] are not completely original. Freud's thinking about unconscious mental processes was influenced by his readings in philosophy, particularly the writings of Arthur Schopenhauer and Friedrich Nietzsche. Similarly, his contention that nothing in a person's psychic life occurs by chance stems from the Greek philosopher Aristotle, who first suggested that memory requires the association of ideas, a notion elaborated later by John Locke and the British empiricist philosophers and later still by the behaviorist psychologists Ivan Pavlov and Edward Thorndike.

For Freud, the association of ideas in the unconscious mind explained psychic determinism. Slips of the tongue, apparently unrelated thoughts, jokes, dreams, and images within dreams are all related to psychological events that precede them, and they all have a coherent and meaningful relationship to the rest of a person's psychic life. The core methodology of psychoanalytic treatment—free association—derives from this concept.[13]

What proved to be Freud's most original and influential idea is that mental activity adheres to scientific laws. Whereas philosophers from

Aristotle to Nietzsche had profound insights into the human mind, none of them thought of mind as being governed by scientific principles. And whereas the behaviorist psychologists who came after Freud did conduct empirical studies, they largely ignored the mental processes that intervened between a stimulus and the response to it.

OVER THE NEXT THREE decades, Freud shaped these ideas into a structural theory of mind. In his view, mind consists of three interact-

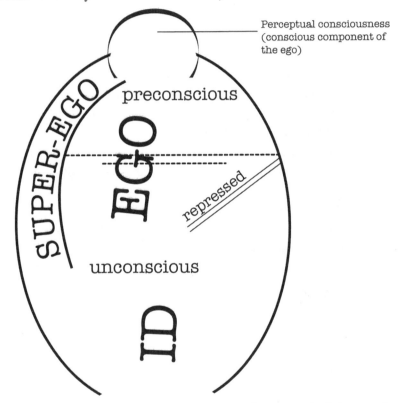

Figure 6-1. Freud's structural theory. Freud conceived of three main psychic structures—the ego, the id, and the superego. The ego has a conscious component (perceptual consciousness) that receives sensory input and is in direct contact with the outside world. It also has a preconscious component, which is an aspect of unconscious processing that has ready access to consciousness. The id is the generator of sexual and aggressive instincts. The superego is the largely unconscious carrier of moral values. The dotted lines indicate the divisions between those processes that are accessible to consciousness and those that are completely unconscious. (Adapted from *New Introductory Lectures on Psychoanalysis*, 1933.)

ing psychic agencies: the ego, the superego, and the id. Each of these agencies differs in cognitive style, goal, function, and direct access to consciousness. In 1933 he depicted the three agencies in the schematic shown in Fig. 6-1.

The *ego* (the "I," or autobiographical self) is the executive agency. Freud conceived of this component of mind as including a sense of self and the perception of the external world. The ego has both conscious and unconscious components. The conscious component is in direct contact with the external world through the sensory apparatus for sight, sound, touch, taste, and smell; it is concerned with perception, reasoning, the planning of action, and the experiencing of pleasure and pain. This *conflict-free* component of the ego operates logically and is guided by the *reality principle*. One of the unconscious components of the ego is concerned with psychological defenses (repression, denial, sublimation), the mechanisms whereby the ego inhibits, channels, and redirects the sexual and aggressive drives of the id. Freud proposed that some unconscious mental activity—the *dynamic unconscious*—is actively repressed yet indirectly affects conscious mental processes.

The *superego*, which influences and censors the ego, is the mental representation of moral values. Freud thought of this agency as being formed by the infant's identification with the moral value system of its parents and as being the source of feelings of guilt. The superego also represses instinctual drives that might threaten the ego and interfere with its capability for planning and logical thinking. The superego therefore serves to moderate the conflict between the ego and the id.

The *id* (the "it"), a term Freud borrowed from Nietzsche, is totally unconscious. It is not governed by logic or reality but by the hedonistic *pleasure principle* of seeking pleasure and avoiding pain. It represents the primitive mind of the infant and is the only mental structure present at birth. The id is the source of the instinctual urges that drive human behavior and that are governed by the pleasure principle. In his early formulation, Freud ascribed all of these instinctual urges to the sexual instinct. Later, he added a parallel aggressive instinct.

In Freud's view, neurotic illness results from the conflict between repressed sexual drives and the conscious components of mind. The dynamic unconscious is guided by the pleasure principle and *primary-process thinking*, which is unconstrained by logic or a sense of time and space, is comfortable with contradictions and does not tolerate delays

in gratification. This style of thought also characterizes an important component of the creative process. In contrast, conscious experience relies on *secondary-process thinking,* which is orderly, coherent, and capable of rational thought and delayed gratification. The superego is the unconscious moral agency, the embodiment of our aspirations.

In his later writings on structural theory, Freud revised the concept of the unconscious and used it in three ways. First, he used the term to refer to the dynamic, or repressed, unconscious. This is what the classical psychoanalytic literature continues to refer to as *the* "unconscious." It includes not only the id but also that part of the ego that contains unconscious impulses, defenses, and conflicts. In the dynamic unconscious, information about conflict and drive is prevented from reaching consciousness by powerful defensive mechanisms such as repression.

Second, Freud held that another part of the ego is also unconscious, but is not repressed; this is what we now call the *implicit unconscious.* The implicit unconscious, which we now realize is a much larger part of our unconscious mental life than Freud thought, is not concerned with instinctual drives or conflicts. Instead, it is concerned with habits and perceptual and motor skills, which involve procedural (implicit) memory. Even though it is not repressed, the implicit unconscious is never accessible to consciousness. The basis for Freud's thinking about the implicit unconscious was provided by the noted physiologist Hermann von Helmholtz, who proposed that a considerable amount of the brain's processing of perceptual information is carried out unconsciously.

Finally, Freud used the term *unconscious* in a broader sense—the *preconscious unconscious*—to describe almost all mental activities, most thoughts, and all memories that are unconscious but can readily enter consciousness. Freud held that a person is unaware of almost all of his or her mental processing yet can readily gain conscious access to it by an effort of attention. From this perspective, most mental life is unconscious much of the time; it becomes conscious only as sensory percepts—words, images, and emotions.

IF MOST OF OUR mental life is unconscious, as Freud held, what is the function of consciousness? Freud developed an idea that we shall consider later in the context of the work of the neurologist Antonio Damasio—namely, that consciousness is Darwinian: it allows us to

experience thought, emotion, and the states of pleasure and pain that are essential for the propagation of the species.

EVEN AS FREUD turned his attention to developing a new psychology that was not based on the brain, or even on empirical evidence, he nevertheless continued to see himself as a scientist. He writes—anticipating Arthur Schnitzler and the Viennese modernist artists—that biological approaches "lead nowhere in the study of hysteria, whereas a detailed description of mental processes such as we are accustomed to find in the works of imaginative writers enables me, with the use of a few psychological formulas, to obtain at least some kind of insight into the course of that affliction."[14] In charting this new course in psychoanalysis, Freud thought of his consulting room as a laboratory; the dreams, free associations, and behavior of his patients—including the behavior of that most important patient, himself—became his observational material. Although Freud did not succeed in testing his ideas about the unconscious empirically, he felt strongly, albeit erroneously, that in the absence of experimental validation, good scientific intuition is sufficient to assure scientifically meaningful results.

Despite the admittedly speculative quality of much of his theorizing, Freud did not see his science of mind as an exercise in philosophy. Throughout his life he insisted that his purpose was to create a scientific psychology, divorced from the burdens of philosophy, that could be a bridge to the biology of mind. He emphasized his scientific origins and purpose, and he retained the ideas of instinct and memory trace, derived from biology, as basic structural concepts of psychoanalysis. As we have seen, Freud's work often began with an idea derived from scientific research that he carried several steps further.

Throughout his career, Freud was greatly influenced by Darwin. That influence is evident in Freud's early neuroanatomical work, which revealed that characteristics of the nerve cells of invertebrate animals persist, later in evolution, in the cells of vertebrate animals. Darwin's influence is even more evident later in Freud's career. In *The Descent of Man, and Selection in Relation to Sex,* and again in *On the Origin of Species by Means of Natural Selection,* Darwin discusses the role of sexual selection in evolution. He argues that sex is central to human behavior because the primary biological function of any organism—be it plant or animal—is to reproduce itself. As a result, sexual attraction and

mate selection are critical in evolution. In natural selection, males compete with one another for females, and females choose some males rather than others. These ideas find expression in Freud's emphasis on the sexual instincts as the driving force of the unconscious and on the central role of sexuality in human behavior.

Freud also elaborated on Darwin's more general ideas on instinctual behavior. Darwin held that since people evolved from simpler animals, people must have the same instinctual behaviors evident in other animals—not only sex, but also eating and drinking. Conversely, in simpler animals, as in people, every instinctual behavior must be guided to some degree by a cognitive process. Freud saw in Darwin's concept of instinctual behavior a way of explaining much of innate human behavior. Finally, Freud's pleasure principle—the hedonistic seeking of pleasure and avoidance of pain—was outlined by Darwin in his last great book, *The Expression of the Emotions in Man and Animals,* published in 1872. In that book Darwin points out that emotions are part of a primitive, virtually universal approach-avoidance system designed to seek out pleasure and decrease exposure to pain. This system exists across cultures and is conserved through evolution. Thus Freud—often referred to as the Darwin of the Mind—extended Darwin's revolutionary ideas about natural selection, instincts, and emotions to his own ideas about the unconscious mind.

Krafft-Ebing's ideas also influenced Freud. In his first theoretical work on human sexuality, *Three Essays on the Theory of Sexuality,* published in 1905, Freud developed his idea that the libido, the sexual drive in its various manifestations, is the main instinct that drives unconscious mental life. Sexual desire, Freud argued, might take a number of different forms, much as Krafft-Ebing had pointed out, but beneath the surface lies the pleasure principle, the instinctual yearning for gratification that is present from birth. In describing the wide range of human erotic experiences and practices, Freud realized that this gratification is not only sexual or erotic, but can also be sublimated to include feelings of love, bonding, and attachment. In addition, Freud developed further Krafft-Ebing's idea that the sublimation of instinctual drives gives rise to art, music, science, culture, and the structure of civilization.

DESPITE HIS PROFOUND INSIGHTS, Freud remained remarkably ignorant about female sexuality, an ignorance that perhaps was an ex-

treme example of his tendency to test his ideas in the context of examining his patients. He often seemed unaware of the observer bias that he introduced into these explorations, even though he speaks freely about countertransference. Freud freely admitted in the *Three Essays* and in a paper on female sexuality in 1931 that he understood little about women's sexual life. Yet he nonetheless continued to express strong opinions about female sexuality up to the end of his life, as we shall see in his descriptions of his patient Dora (Chapter 7). Freud defined the libido as "invariably and necessarily of a masculine nature, whether it occurs in men or in women and irrespective of whether its object is a man or a woman."[15] He continued in this simplistic, patriarchal view of female development as second best and second-rate. Thus, toward the end of his life Freud wrote: "We call everything that is strong and active male, and everything that is weak and passive female."[16] The psychoanalyst Roy Schafer concludes that "Freud's generalizations concerning girls and women do injustice to both his psychoanalytic method and his clinical findings."[17]

Surprisingly, Freud did not focus on aggression as a separate instinctual drive until 1920. His thinking underwent a massive shift in the aftermath of the cruelty, aggression, and brutality that he witnessed in World War I. He realized that he could no longer maintain the view—which he had held on to tenaciously—that seeking pleasure and minimizing pain were the only psychological forces driving human existence. In learning about the killing at the front during the war, he began to realize that the human psyche has built into it at birth an aggressive drive—an independent, instinctual component of mind that is fully comparable in strength and significance to the sex drive.

At this point, Freud posited that human psychological functioning is driven by the interaction of two inborn instinctual drives of equal importance: the life instinct (Eros) and the death instinct (Thanatos). The life instinct includes the preservation of the species, sex, love, eating, and drinking, while the death instinct is reflected in aggression and despair. Until the end of the First World War, Freud did not think of the death instinct as a separate drive but as an offshoot of the erotic instinct. In contrast, Gustav Klimt linked aggression and sexuality in *Death and Life* (Fig. 8-29) and *Judith* (Fig. 8-27) more than a decade before Freud did.

———

TODAY, IT IS EASY to see how Freud's focus on the unconscious and on the constraints placed on instinctual drives by morality and culture emerged from Vienna 1900, and particularly from the Vienna School of Medicine. Even though Freud insisted that he had developed his ideas with an attempt at scientific rigor, detail, and self-criticism, similar ideas about instinct had in fact emerged earlier, in less nuanced form, and had become part of the common language of Vienna's intellectual community.

But Freud did not simply elaborate on ideas in common currency in Vienna 1900. Despite some mistakes in judgment, he possessed remarkable breadth of vision, depth of thinking, and commitment to science as a way of thought and a method of investigation. Moreover, his literary gifts alone would ensure him an enduring place in modern culture. The clarity and excitement of Freud's writing make his studies of human behavior and unconscious processes read like mystery novels whose secret is nothing less than the workings of the human psyche. The patients in his five major case studies—Dora, Little Hans, the Rat Man, Schreber, the Wolf Man—have become characters as indelible in the canon of modern literature as those of Dostoevsky.

The impact of Freud on modernist thought was immense, despite its shortcomings and the uncertainty of many of his conclusions. His overriding accomplishment was to take the concept of mind out of the realm of philosophy and make it a central concern of the emerging science of psychology. In so doing, he understood and emphasized that ultimately the principles that govern the psychoanalytic science of mind must go beyond clinical observations and become susceptible to the same experimental analysis that Rokitansky was applying to the science of the body and Ramón y Cajal was applying to the science of the brain.

## SEARCHING FOR INNER MEANING
## IN LITERATURE

᧰⍀⍰

IN THE SAME YEAR THAT SIGMUND FREUD PUBLISHED *THE INTER-pretation of Dreams,* Arthur Schnitzler added his contribution to a modern view of mind by introducing the interior monologue to Austrian literature. This literary device enabled him to reproduce in his fictional characters the natural patterns of a person's private thoughts and fantasies. Schnitzler dispensed with conventional narration and instead created his stories by giving the reader direct access to his characters' minds—to the free flow of their impulses, hopes, aspirations, ideas, impressions, and perceptions—in much the same way that Freud sought access to his patients' minds through the technique of free association. In endowing his characters with their own voices, Schnitzler allows readers to reach their own conclusions about the characters' motivations.

Schnitzler first used the interior monologue in *Lieutenant Gustl,* a novella published in 1900. Gustl is a young, aristocratic, self-centered, and not very bright officer in the Austro-Hungarian army who must confront the possibility that he will die the next morning in a duel that he has provoked through a thoughtless comment made to an elderly man, a baker, with whom he had a trivial quarrel after a concert. Gustl is frightened of the fate that may await him and is reexamining the meaningful relationships of his life. Since the military code to which he adheres forbids him to duel with civilians, Gustl contemplates suicide to avoid compromising his honor as an officer. Finally, to his immense relief, Gustl learns that the baker has suffered a fatal stroke. Schnitzler

offers no commentary throughout the novella—he is invisible—instead letting Gustl's thoughts carry the story.

The novella begins with Gustl before the quarrel, attending the concert, and shows how Schnitzler uses the internal monologue to depict the banality of Gustl's thought processes:

> How long is this thing going to last? Let me look at my watch . . . it's probably not good manners at a serious concert like this, but who's going to notice? If anyone does, he's not paying any more attention than I am, so I really don't need to be embarrassed. . . . It's only a quarter to ten? . . . It feels like I've been at this concert for a good three hours already. Well, I'm just not used to it. . . . What is this piece anyway? I've got to look at the program. . . . Oh yes, that's right: an oratorio! I thought it was a mass. Things like this really belong in church.[1]

Schnitzler also introduced new substantive dimensions to Austrian literature. He was the amoral voice of his generation, discussing sex with unprecedented openness, and he portrayed women with far greater sensitivity than other writers of his time. His characters reflect the decline of social values and the loss of meaning in life experienced by many Viennese with the approach of World War I. Young people live bored, directionless, unhappy lives that are full of deception, disappointment, and emptiness. There is a terrible gap between their aspirations and their achievements. His young men strive for love but fail to achieve it. They yearn for intimacy in marriage but cannot attain it. They turn to affairs in their desperate need for acceptance and pleasure, but even there they are disappointed.

SCHNITZLER UNDERSTOOD, INDEPENDENTLY of Freud, the pervasive importance of sex. From age seventeen until his death, he kept a diary in which he described his numerous sexual experiences—he began visiting prostitutes regularly when he was sixteen years old—and recounted every single orgasm he ever experienced. This autobiographical obsession was manifested in his characters, most of whom enjoyed a hyperactive and self-aware sexuality. Schnitzler wrote repeatedly about flirtations and affairs between a pleasure-seeking Vien-

nese man of the aristocracy or upper middle classes (such as himself) and his current mistress, who would soon be replaced by another.

In 1893 Schnitzler extended his self-analysis to *Anatol*, one of his first and best-known plays. In a sequence of seven scenes, Anatol, a young philanderer, is entangled in a variety of love affairs. Schnitzler's perverse double standard is exposed in the first scene, entitled "Ask No Questions and You Will Hear No Stories." Suspecting that his mistress has been unfaithful, Anatol hypnotizes her to find out the truth. Once she has been hypnotized, however, Anatol refuses to ask her the pressing question. He can remain secure in his conviction that any woman with whom he has an affair must be faithful to him only by keeping his ignorance intact. He thus maintains his self-deception, even as he is gnawed by doubt. Anatol's behavioral paradoxes reflect Schnitzler's own inconsistencies of character, embodying what Freud would call the "double code of morality."[2] Anatol, like Schnitzler, is wildly unfaithful in every relationship, yet he expects each of the women with whom he has an affair to be absolutely faithful. The impossibility of this narcissistic fantasy causes Schnitzler's male characters to leave their mistresses' or lovers' erotic lives generally unquestioned.

Schnitzler also introduced a political dimension to Austrian literature. His most important political work, *The Road into the Open* (or *The Road into Freedom*), was published in 1908 and deals with rising anti-Semitism in Vienna and the emerging Zionist movement. *The Road into the Open* depicts the social world of Jews in Vienna by focusing on a group of friends who participate in the salon of the Ehrenberg family. It is here that Schnitzler introduces a theme Freud would later recapitulate in *Moses and Monotheism:* anti-Semitism as a version of the Oedipus complex. In this case, the Oedipus complex takes the form of a son's dislike of his father's religion. The host of the salon, Oskar Ehrenberg, a wealthy industrial tycoon, is proud of his Jewish background, much to the annoyance of his social-climbing family, particularly his son, who wants to imitate the Roman Catholic aristocracy. The participants in the Ehrenberg salon are deeply troubled by the increasingly virulent outbursts of anti-Semitism in Vienna. They endlessly discuss their Jewish identity and whether they think of themselves primarily as Austrians or Jews. They listen and respond to emo-

tionally charged calls for loyalty to the newly emerging forces of Zionism and the possibility of living in Palestine.

A central theme of *The Road into the Open* is that there are many roads to freedom—liberalism, socialism, political anti-Semitism, Zionism—but each one is blocked by the others. As each participant in the Ehrenberg salon attempts to escape into freedom along a particular route, another participant prevents him from achieving that goal. In their quandary, the younger generation chooses art as an alternative to the politics that had disenchanted their elders. Schnitzler's implied message that art is the only viable road to freedom is perhaps a cynical comment on Viennese culture—after all, the sort of escape that became routine in fin-de-siècle Vienna was an escape from reality into the theater of one's own mind.

SCHNITZLER (Fig. 7-1) BEGAN HIS professional life as a physician, not a novelist. He was born in Vienna in 1862 to Jewish parents. His father, Johann Schnitzler, was a famous ear, nose, and throat specialist and a professor at the University of Vienna. Schnitzler entered the University of Vienna School of Medicine in 1879 and graduated in 1885. Although Rokitansky had just retired, his way of thought influenced Schnitzler, who studied with Emil Zuckerkandl, Rokitansky's associate. Schnitzler's years as a medical student overlapped Sigmund Freud's. Like Freud, he was influenced early on by the psychiatrists Theodor Meynert and Richard von Krafft-Ebing, and he later became fascinated with psychology, sharing Freud's interest in hysteria and neurasthenia. In 1903 Schnitzler, then forty-one years old, married Olga Gussmann, a twenty-one-year-old actress of Jewish origin with whom he had been having an affair for three years and with whom he had had a son a year before they married. The two had a second child, Lili, in 1910 and divorced in 1921. In 1927 Lili married a man twenty years her senior. The marriage proved unhappy and ended in 1928 with Lili's suicide. Her death was an enormous blow from which Schnitzler never recovered. He died three years later from a cerebral hemorrhage.

Dreams and hypnosis fascinated Schnitzler. He worked as an assistant to the noted French neurologist Jean-Martin Charcot, wrote his thesis on hypnosis, and used it in his medical practice to treat patients who had lost their voice, a condition known as aphonia. Schnitzler's first

Figure 7-1. Arthur Schnitzler (1862–1931). This portrait was taken in 1908, just after he completed his novel *The Road into the Open,* in which he explored the sociology and the individual psychology of the growing anti-Semitism in Austrian society.

paper on the topic, *On Functional Aphonia and Its Treatment through Hypnosis and Suggestion,* covers some of the same issues that Josef Breuer and Freud discussed. Freud valued Schnitzler's paper and cited it in his 1905 case study of Dora, a fixture in the literature of psychoanalysis.

After the death of his father, Schnitzler left medicine and devoted himself exclusively to literary pursuits. He became internationally famous for his mastery of short literary forms—one-act plays, short stories, and novellas—but he also wrote two full-length novels. Much as Freud became the leader of the psychoanalytic movement and Klimt the leader of the Austrian modernist artists, so Schnitzler became the center of the avant-garde literary movement Jung-Wien (Young Vienna). As a physician, Schnitzler, like Freud, was aware of the literary power of clinical case studies. He realized that in taking a patient's medical history, the physician is writing a narrative, one that depends both on the patient's story and on how the physician interprets it.

Case studies lend themselves to plays in particular, because the patient-physician relationship is readily transposed into a character-audience relationship. Indeed, for many years Schnitzler wrote primarily for the theater. He realized that the theater audience, like the psychiatrist, draws its conclusions directly and solely from human behavior. An astute student of human behavior, Schnitzler recognized from his own varied and remarkable sexual experiences, as well as from the experiences of people around him, that a person's joys and miseries are driven to a great degree by instinctual urges.

SCHNITZLER WAS INFLUENCED by Freud's work, especially by *The Interpretation of Dreams,* as is evident in his *Traumnovelle (Dream Novel),* written in 1925. The novella, which later was made into a film called *Eyes Wide Shut* by Stanley Kubrick, tracks the sudden unraveling and uncertain repair of a young couple's marriage—that of the Viennese physician Fridolin and his wife, Albertine—over the course of two nights. To blur the boundaries between their desires and the events of the day, Schnitzler explores the liminal spaces between dream, fantasy, and reality. The couple's initial estrangement is triggered when Fridolin and Albertine confess to each other the harmless flirtations each had engaged in with strangers at a masked ball they had both attended. Their confessions are followed by the recounting of dreams in which each had entertained thoughts of extramarital lust.

Fridolin is outraged by the knowledge that his wife has an erotic inner life, even after having admitted to one of his own. A late-night house call in the city provides him with the opportunity to take revenge on his wife for her fantasized emotional infidelity and to reclaim his sense of desirability. He embarks on a sexual misadventure—from the thwarted temptation of various women to a secret masked orgy—that takes on an increasingly dreamlike, surrealistic quality as the night progresses. When he eventually returns home, Albertine confesses to having had an erotic dream in which she had sex with the naval officer she met on the couple's last holiday. This time, Albertine's dream is laced with her festering resentment of Fridolin, which spurs him on to a final, jealousy-fueled quest. Thus, it is only through dreams that Albertine can free herself from her husband's insensitivity; dreams allow her to unleash her unconscious desires. But Fridolin can do more

than dream: he is able to realize his fantasies and to act out his dream in the external world.

Dreams play both a therapeutic and a destructive role in Schnitzler's work, exposing the characters' psychic life just as his interior monologues do. The effortless folding of erotic desire into the landscape of the dream shows that Schnitzler understood Freud's analysis of the workings of dreams—that dreams incorporate the residue of the day's events and combine it with instinctual urges that would be pleasant to satisfy but are repressed because they are socially unacceptable. For his part, Freud felt an intellectual kinship with Schnitzler's literary depictions of the "underestimated and much-maligned erotic,"[3] as Freud described it. Indeed, Freud's feeling of kinship seems to have verged on rivalry. In a remarkable letter dated May 14, 1922, the eve of Schnitzler's sixtieth birthday, Freud wrote to him:

> I shall make a confession to you which I will ask you to be good enough to keep to yourself. . . . I have plagued myself over the question how it comes about that in all these years I have never sought your company. . . . I think I have avoided you from a kind of awe of meeting my "double". . . . Your determinism and your skepticism . . . your deep grasp of the truths of the unconscious and of the biological nature of man . . . and the extent to which your thoughts are preoccupied with the polarity of love and death; all that moves me with an uncanny feeling of familiarity. . . . The impression has been borne in on me that you know through intuition—really from a delicate self-observation—everything that I have discovered in other people by laborious work. Indeed I believe that fundamentally you are an explorer of the depths.[4]

Of the two fellow explorers of the unconscious, Schnitzler would prove to be the better "depth psychologist" of women. While he realized that the libido is present in everyone, regardless of social class, Schnitzler illuminated with particular clarity the life of the working-class woman engaged in an affair with a narcissistic man of high social rank. In particular, he explored the character of *"das süsse Mädl,"* a term he introduced to describe the sweet, young, uncomplicated, un-

married woman who felt free to pursue her sexual curiosity. Emily Barney, an intellectual historian of Vienna 1900, describes Schnitzler's view of these young women and their affairs:

> The *süsse Mädl* was a pretty, lower-class girl. She was attractive to upper-class men as a lover for several reasons: there was less of a risk of disease than with prostitutes; her male relatives did not have the social standing to challenge the upper-class lover to a duel; and (in theory) the man could treat her frivolously, throwing a few gifts and luxuries her way, while the *süsse Mädl* would shower him with love and attention.[5]

IN 1925 SCHNITZLER published *Fräulein Else*, a remarkable novella that deals not with a lower-class *süsse Mädl*, but with a young woman from an upper-class family. Here, Schnitzler reveals a new level of skill as a psychologist of women. Margret Schaefer, a scholar and translator of Schnitzler's work, suggests that he wrote the novella *Fräulein Else* in response to Freud's insensitive portrayal of his patient Dora in a famous case study twenty years earlier.[6]

In *Fräulein Else*, Schnitzler introduces a more radical form of interior monologue that allows the reader to witness the shifting mental states of the nineteen-year-old Else as she confronts a seemingly untenable sexual situation. Else is a romantic, highly assimilated Jewish girl who is spending a holiday at an elegant spa with her aunt, her cousin Paul, and Paul's lady friend, Cissy. Else takes great pride in her Jewish heritage, a characteristic that Schnitzler uses to tap into a Viennese stereotype linking Judaism to heightened sexuality. During the holiday Else receives a telegram from her mother saying that her father is in danger of being sent to jail for debt. She asks if Else would save him by approaching an elderly acquaintance of the family, Herr Von Dorsday, for the money necessary for her father's bail. Despite her paralyzing apprehension, Else meets Dorsday in the courtyard and presents him with the problem. He responds lecherously, at first making a blatant sexual proposition and then tempering it to suit Else's incredulous response: he will give her the money on the condition that she stand completely naked before him, in private, for fifteen minutes. Else is horrified by the suggestion and repelled by Dorsday.

In the interior monologue that follows, Schnitzler captures Else's overwhelming and conflicting thoughts as she weighs her limited options. Like an actor on her own private stage, Else confronts both men who are responsible for her sudden entrapment:

No, I won't sell myself. Never. I'll never sell myself. I'll give myself away. Yes, if I find the right man, I'll give myself away. But I won't sell myself. I'll be a wanton, but not a whore. You miscalculated, Herr von Dorsday. And Papa did too. Yes, he miscalculated. He must have foreseen this. After all, he knows how people are. He knows Herr von Dorsday. He must have guessed that Herr von Dorsday wouldn't do it for nothing— otherwise he would have telegraphed or come here himself. But it's easier and more convenient this way, isn't it, Papa? When one has such a pretty daughter, why should one have to march off to prison? And Mama, stupid as always, just sits right down and writes the letter.[7]

Else's emotions vacillate wildly as she tries to understand her father's "passion for gambling," which has turned her into no more than a commodity to be traded and wagered with in the phallic economy. By defiantly rejecting the rules that guide her father's behavior, Else attempts to seize control of her own volition and body. But in the end, she submits to the dominant patriarchal order:

Papa receives us in a striped prison uniform. . . . He doesn't look angry, just sad.—Oh, he'll be thinking, Else, if you had gotten me the money that time—but he won't say anything. He won't have the heart to reproach me. He's so good-hearted; he's just irresponsible. . . . He didn't give enough thought to the letter either. Maybe it never even occurred to him that Dorsday would use the situation to demand such an indecency from me. He's a good friend of the family; he loaned Papa eight thousand gulden once before. How could he suspect the man would do a thing like that? Papa certainly tried everything else first. What must he have gone through to resort to having Mama write that letter? He must have run from one friend to the other. . . . And

they all abandoned him. All his so-called friends. And now Dorsday is his last hope, his only hope. And if the money doesn't come, he'll kill himself.[8]

But it is Else who kills herself, joining her dramatic contemporaries, Henrik Ibsen's Hedda Gabler and August Strindberg's Miss Julie. Upon receiving a second telegram from her mother, now requesting fifty thousand gulden, Else places an overdose of sedatives on the table next to her bed. She takes off her clothes, puts on her coat, and goes in search of Dorsday. Finding his room empty, she leaves a note about the inflated amount her father needs. Finally, she spots Dorsday in a small recital room filled with people. In attempting to catch his attention, she inadvertently lets her coat fall open, revealing her naked body to everyone in the room. The music stops. Else faints and is carried back to her room by Paul and Cissy. Dorsday is extremely upset and leaves, presumably to send the money to Else's father. Left alone in her room for a moment, Else takes the fatal overdose she had prepared earlier.

In Else, Schnitzler has created a profoundly sympathetic portrait of a young, inexperienced woman struggling with parental affection, betrayal, responsibility, and deep personal shame. Ultimately, she falls victim to the male-dominated order of the world, a world at odds with the romantic life she had imagined for herself.

W. E. Yates, a scholar of Austrian literature, points out that Schnitzler realized women had been deprived of the understanding they need, and he praises the writer as "a pioneer of equal rights" for women. Yates cites an article by Klara Blum, published shortly after Schnitzler's death, in which she writes:

Women's claim to equal rights in society, in work and in love was something that Schnitzler took completely for granted. But it is still not taken for granted generally; and for that reason we may regard Schnitzler not as the representative of times past but rather as a pioneer, the *patient pioneer of an idea*, whose struggle is still in the forefront of attention, still in the spotlight: a pioneer of the *idea of equality in the erotic sphere*.[9]

FREUD'S CASE STUDY of Dora contrasts dramatically with Schnitzler's sympathetic treatment of Else. Dora, whose real name was Ida

Bauer, was an eighteen-year-old girl who had been repeatedly accosted by an older, wealthy, and controlling man who was a friend of her family. Freud began treating her on October 14, 1900, and stopped treating her only eleven weeks later. He saw his patient again briefly, on April 1, 1902, but he did not publish the case study until three years later, and then only with considerable hesitation. In many ways, this case study is a continuation of *The Interpretation of Dreams*. It is certainly very different from the studies Freud published earlier with Josef Breuer.

Dora's father was an affluent manufacturer who took his daughter to Freud for treatment. The father himself had contracted syphilis before his marriage and had been treated for the disease by Freud. Dora's symptoms consisted of depression, avoidance of social contact (with some thoughts of suicide), fainting spells, difficulty breathing, and loss of voice. The case was particularly complex because members of the Bauer family were intertwined socially and sexually with their friends the K family. Dora's mother, a highly obsessive woman, spent much of her time cleaning house and apparently gave her husband little sexual satisfaction, a situation he remedied by having a passionate affair with Mrs. K. The implicit rejection of Mr. K by his wife encouraged him to turn his attention to Dora. Dora had begun to show some signs that Freud thought were indicative of hysteria, notably migraines and a nervous cough. The symptoms became more severe with time.

To account for her depressed state and her dislike of Mr. K, whom she had earlier liked and trusted, Dora described how he had made sexual advances toward her. When Dora was fourteen, Mr. K had suddenly embraced and kissed her passionately when he saw her one day in his office. Offended and disgusted by his advances, Dora slapped him. By the time she was an attractive sixteen-year-old, she began to openly declare her dislike of Mr. K and his repulsive approaches to her. He denied Dora's charges and went on the offensive, claiming that she was reading pornographic literature and only cared about sex. Dora's father dismissed his daughter's accusations as fantasy and took Mr. K's side. Dora attributed her father's refusal to take her complaints seriously to his affair with Mrs. K, which inhibited him from initiating an argument with Mr. K. In this sense, Dora felt she was being used as an accomplice in her father's affair.

As he took Dora into analysis, Freud recognized contradictions in

her father's story and decided to reserve judgment. This was perhaps the most sympathetic moment in Freud's relationship with the girl. As the relationship developed, it became characterized by mutual distrust and a surprising insensitivity on Freud's part. Rather than acknowledging that Mr. K had violated Dora's trust, Freud interpreted the girl's disgust at being kissed by him as a reversal of her true feeling.

Freud could not understand why Dora would not have been excited by the advances of a mature man. He insisted that Mr. K's romantic and erotic advances could not possibly account for her florid hysterical symptoms. The hysteria, Freud concluded, must have existed earlier. He attributed Dora's symptoms to strong, unconscious sexual feelings toward her father, toward Mr. K, and toward Mrs. K. Freud wrote: "[This] was surely the situation that would call up in a fourteen-year-old innocent girl a distinct feeling of sexual excitement."[10] Freud aligned himself with Dora's father and Mr. K. and interpreted her vehement rejection of Mr. K as a neurotic defense. He was incapable of understanding that an adolescent girl might be traumatized by the betrayal of a trusted family friend. By invalidating Dora's feelings and twisting her story, he only heightened the preexisting damage to his patient. Dora ultimately abandoned therapy.

Dora's is a sad case, a low point in Freud's career. It has often been viewed as an example of his inability to visualize erotic encounters from a woman's perspective. Freud acknowledged that the treatment was a failure, but he attributed it to his failure to identify the underlying cause: Dora's transference, her unconscious erotic interest in him. Freud's failure, of course, has a deeper, more problematic cause. He did not detail the nature of his own countertransference, his unconscious response to Dora's presence and her erotic interest. Despite his insistence on his openness to and acceptance by his patients, Freud had a tendency in some of his early cases to force his interpretation on his patients, as he does here on Dora.[11] As with Emma Eckstein in his dream "Irma's Injection," Freud did not empathize with Dora's suffering; instead, he blamed her for the attempted seduction.

As we have seen, Freud admitted repeatedly that he did not understand the sexual life of women. He blames Dora, the victim, and disassociates himself from her father. In contrast, Schnitzler places the blame for Else's fate firmly on her father, mother, and the other men in her world. Indeed, he displays a remarkable degree of candor and self-

scrutiny, considering that he was very much a roué and had large gambling debts of his own, as Schaefer notes.

WE ARE LEFT WITH a classic contradiction between the author's character and his work. It is easy to tear a page out of Schnitzler's diary and claim that he exploited women, or to point to Anatol's perverse attitudes toward women as the last word on Schnitzler's attitudes. It is easy because Schnitzler generally did behave selfishly rather than sympathetically toward women. But it is also clear from Schnitzler's work that he understood women on an emotional level. As a writer, he empathized with them, and his sensitive, intimate characterizations evoke an empathic response from the reader. In fact, Schnitzler's success as a philanderer may well have enhanced, and benefitted from, his understanding of women.

The wide, rich range of Schnitzler's female characters bore similarities to most feminine archetypes in fin-de-siècle Vienna. His women are radical, complex, and erotic. Their internalized voices form a chorus of repressed desire that has reverberated for over a century against the social constructs that sought to silence them. It is the sound of women struggling to maneuver and survive in a male-dominated world, a world inhabited by Schnitzler the man, but challenged by Schnitzler the writer.

# THE DEPICTION OF MODERN
# WOMEN'S SEXUALITY IN ART

∼

As SCHNITZLER WAS DELINEATING THE RICHNESS AND SUB-
tlety of women's inner lives and their struggle to achieve social and sex-
ual identities independent of men, Gustav Klimt was at the forefront of
a parallel development in Austrian art. Austrian modernist painting
grew from the belief that for an art to be truly modern, it not only had to
express modern feelings, it also had to depict honestly the unconscious
strivings that motivate men and women alike. In the hands of Klimt and
his protégés, Oskar Kokoschka and Egon Schiele, painting proved to be
analogous to creative writing and to psychoanalysis in its ability to delve
beneath Vienna's restrictive attitudes toward sex and aggression and re-
veal people's true inner state. As Kokoschka claimed, "Expressionism
was a contemporary and rival of Freud's development of psychoanaly-
sis."[1] He might as well have said, "We are all Freudians, we are all mod-
ernists; we all want to go deep below surface appearances."

Klimt was the acknowledged leader of the new modernist move-
ment in Viennese art. The first Austrian artist to delve below surface
appearances, he broke with the dramatic, historical style that charac-
terized Austrian painters of the first half of the nineteenth century and
became the key transitional figure between Impressionism and the ex-
plosive lines of Viennese Expressionism. Klimt combined Jugendstil
art, the Viennese version of the international Art Nouveau style of
ornamentation, with a modernist abstract form—a flatness of
depiction—that derived in part from the French Post-Impressionist
painters and Cézanne, and in part from Byzantine art.

But Klimt was more than just a stylistic pioneer; he was the first

Austrian modernist to confront mortality in his paintings and to depict graphically the taboo subjects of female sexuality and aggression. Unlike his Viennese predecessors, he felt no need to repress the sexuality of the nude models he saw before his eyes or to veil it in allegory or stylized symbols. In his delicate, sensitive drawings, Klimt focused on the pleasures of sex, while in his paintings he also depicted women's capability for aggression. Thus, Klimt is stylistically a decorative, Art Nouveau artist and thematically an expressionist, and he paved the way for the two great expressionist artists Kokoschka and Schiele.

In addition to ushering in the modernist era with his paintings and drawings, Klimt provided leadership for a group of dissident artists in Vienna. The Künstlerhaus, or Artists' House, established in 1861, had close ties with the influential Academy of Fine Arts, to which many of its members belonged. But in time the Künstlerhaus became more and more parochial in its taste and outlook. In 1897 a group of nineteen disenchanted artists seceded from the Künstlerhaus and formed the Vienna Secession. Klimt was elected the first president of this group. After building an exhibition hall of its own, the Vienna Secession was able to stage exhibitions by foreign artists such as Van Gogh as well as by emerging young artists. Indeed, Klimt provided critical support for the early work of both Kokoschka and Schiele.

KLIMT HAD NUMEROUS meaningful romantic affairs, and from these he learned a great deal about women. His profound understanding of their sexuality, combined with his extraordinary gifts as a draftsman, enabled him to depict more than the sensuousness of the naked female body: he captured the feeling, the very essence of femaleness. Klimt's drawings show the model self-aware and responsive to the artist in an entirely new way. As Albert Elsen has described it:

> Rather than posing for posterity on a modeling stand with various supports and props . . . but having to appear oblivious to any audience, she is now self-consciously in the private presence of a man who is deeply interested in her, not as a poesy, but as a woman.[2]

Through an endless stream of pencil, charcoal, and crayon drawings that reveal some of his boldest creativity, Klimt openly portrayed

the intense sexual pleasure a woman can achieve, whether from a partner—male or female—or from herself. He thus introduced into Western art new dimensions of women's sexual life (see his *Seated Woman in Armchair* [Fig. 8-1], drawn in 1913, and *Reclining Nude Facing Right* [Fig. 8-2], drawn in 1912–13). The women in these drawings,

Figure 8-1. Gustav Klimt, *Seated Woman in Armchair* (c. 1913). Pencil and white chalk.

like Freud's patients, are lost in their own fantasy world, a world that seems to alternate between reverie and reality. In his honest depiction of erotic life, Klimt was probably inspired by Auguste Rodin's contemporaneous drawings of nude women pleasuring themselves and by the emphasis on the erotic in Aubrey Beardsley's art and that of the Post-Symbolist artists. Klimt also learned from Rodin to work from direct observations of his models. Rodin had developed a technique of making contour drawings of models without taking his eyes off them as he drew; earlier artists would take their eyes off the models, essentially drawing them from memory.

By today's standards, Klimt's drawings of women may be seen as representing simply a male view of female sexuality. After all, the subjects of his drawings were models, and the poses they assumed may well have been suggested to them by him, or they may have assumed those poses themselves to please him. But even if Klimt captured only limited aspects of women's erotic lives, those aspects were new to most viewers of art. Moreover, they had largely eluded Freud, as well as other students of female sexuality in Vienna. Klimt's insight into the psyche of women was undoubtedly clearer than Freud's, a point emphasized by Ruth Westheimer, a scholar of human sexuality. In her book on painting and sculpture, *The Art of Arousal,* she describes a Schiele drawing based on a drawing by Klimt (Fig. 8-3):

Figure 8-2. Gustav Klimt, *Reclining Nude Facing Right* (1912–13). Pencil and red and blue pencil.

Whereas it would be easy to dismiss these works as porno-graphic for men—and debasing for women—these pictures can also be seen as expressing an increasing awareness of women's sexual self-sufficiency. That awareness led naturally, but all too slowly, to a greater independence of women in all spheres of life. Perhaps if Freud had seen these works he might not have sad-dled us with his myth that women require vaginal penetration to achieve orgasm. He might have also realized that clitoral stimu-lation is neither regressive nor immature but rather a healthy way for a woman to give herself pleasure—or to receive plea-sure from someone else.[3]

Unlike his paintings, most of Klimt's four thousand surviving draw-ings were intended for his private collection; many of them are un-signed. He created these images of women to please the artist in himself, not to invite the prurient interest of other male viewers. One important exception to this rule was the set of fifteen drawings that Klimt contrib-uted in 1906 to a new translation of the *Dialogues of the Hetaerae*, dis-cussions by a group of educated, thoughtful, and gifted courtesans on love, sex, and fidelity written in the second century A.D. by the Assyr-ian theologian Lucian of Samosata. The drawings that Klimt contrib-uted, and that therefore became available to the public, are very similar to the rest of his drawings, which he kept private, although many of

Figure 8-3. Egon Schiele, *Reclining Nude* (1918). Crayon on paper.

them have since entered the public sphere. The art historian Tobias G. Natter, who has written about the *Dialogues*, describes the drawings in the following terms:

> Klimt depicted women in onanistic raptures, illustrated the erotic potentials of self-contemplation, and took on the voluptuous theme of lesbianism. . . . With these works Klimt defined, or helped to create, a modern female type. . . . Such audacity would not be seen again in the realm of art in Europe or the United States until the 1920s.[4]

Although Klimt's depiction of women's erotic life was radical and innovative for Vienna 1900, it was not new in the history of art. Vivid, even exaggerated erotic depictions can be found in prehistoric art, and eroticism remained a major theme throughout history, particularly in Eastern and Indian art. Klimt was influenced by Japanese woodblock prints such as those by Utamaru in his two volumes from about 1803, *Picture Book: The Laughing Drinker,* which show that women can be sexually independent and give themselves sexual pleasure.

Eroticism is also evident in early Western art, notably the Grecian vases from Stamnos, the statuary and wall paintings of the Roman city of Pompeii, and the prints of Giulio Pippi (Giulio Romano). The great mannerist painters of the Venetian (Sensualist) School—Giorgione, Titian, Tintoretto, and Veronese—all celebrated the female nude, as did their mentor Raphael and their disciples Rubens, Goya, Poussin, Ingres, Courbet, Manet, and Rodin. Moreover, Giorgione and Titian depicted Venus, the Roman goddess of love, masturbating (Figs. 8-4 through 8-9).

In both Giorgione's *The Sleeping Venus* (1508–10) and Titian's *Venus of Urbino* (before 1538), the goddess's hand is placed over the pubis with her fingers curled, not extended. This positioning is so subtle and ambiguous that the paintings' eroticism can readily be—and indeed repeatedly has been—repressed by the beholder and interpreted as depicting female modesty rather than masturbation. In his chapter on "Censorship of the Senses" in *The Power of Images*, the art historian David Freedberg emphasizes that, with rare exceptions, even professional art historians have repressed their own sexual responses and not commented on this aspect of the paintings, focusing instead on icono-

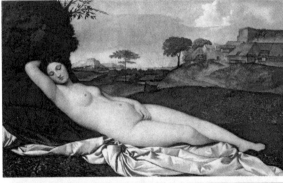

Figure 8-4. Giorgione da Castelfranco, *The Sleeping Venus* (1508–10). Oil on canvas.

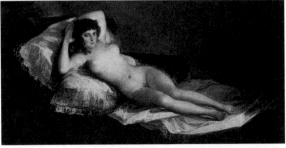

Figure 8-5. Titian, *Venus of Urbino* (before 1538). Oil on canvas.

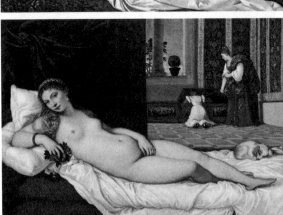

Figure 8-6. Francisco José de Goya y Lucientes, *The Naked Maja* (c. 1800). Oil on canvas. Image flipped.

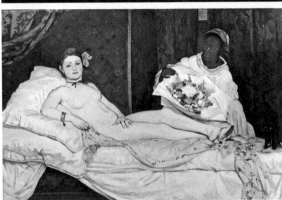

Figure 8-7. Édouard Manet, *Olympia* (1863). Oil on canvas.

Figure 8-8. Gustav Klimt, *Reclining Nude Facing Right* (1912–13). Pencil and red and blue pencil. Image flipped.

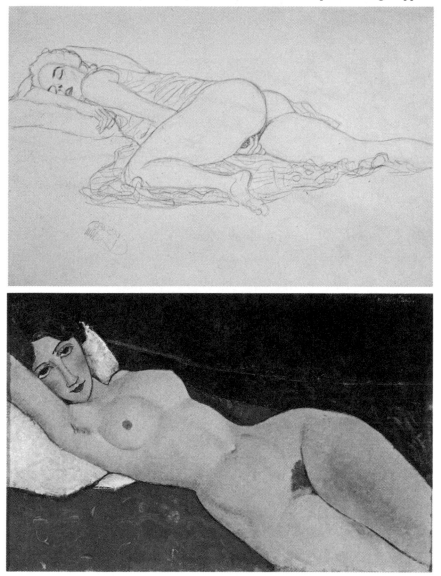

Figure 8-9. Amedeo Modigliani, *Female Nude on a White Cushion* (1917–18). Oil on canvas.

graphic readings, aesthetic evaluation of the form, color, and composition, and other interesting features. In contrast, it is next to impossible for the beholder to repress an awareness of or sexual response to Klimt's nudes pleasuring themselves.

What Klimt added to the great historical tradition of the nude in Western art—to Giorgione's and Titian's Venus, Goya's *The Naked Maja* (c. 1800), and Manet's *Olympia* (1863)—was a thoroughly modernist perspective. Even Manet's *Olympia,* which depicts a real, modern woman in place of the virginal Venus, lacks the unabashed sexuality of Klimt's drawings. Unlike many earlier Western artists, Klimt was not plagued by a sense of sin and therefore felt no need to disguise the sexuality of his models. The nudes in his drawings differ from their predecessors not only in being real, uncensored women rather than mythological figures, but also in being modern, feminist women. Klimt portrayed sexuality as a natural, frequently spontaneous part of life; this is evident in his drawings of women still fully clothed as they become aroused and begin to masturbate. Most earlier nudes look out from the canvas at the viewer, seeking permission for a shared and quiet eroticism, as if they could not be complete sexual beings without a male partner. Klimt's nudes, on the other hand, are either oblivious to or unconcerned with the male gaze (Fig. 8-8); they are absorbed in themselves and their fantasy life. In these drawings, the viewer does not actively engage with a figure that looks out at him, but rather passively observes a private act.

This dynamic implies not only sexual self-sufficiency on the part of the subject, but also voyeurism on the part of the viewer. Thus, these drawings expose not only the subject's inward sexual desires, but the viewer's as well. Even Modigliani, a later artist whose nudes are startling because "the female body is literally in your face,"[5] does not give us as deep an insight into either the female psyche or the male gaze as Klimt. In all of these paintings by other artists, we learn what makes the nude female body alluring and arousing, but we learn little about how women themselves might think about and experience sexuality.

KLIMT (Fig. 8-10) WAS BORN in Vienna in 1862, the son of the goldsmith and engraver Ernst Klimt. From his early years onward, he exhibited remarkable drawing skills; his wonderfully realistic sketches capture the details of a scene with almost photographic fidelity. He

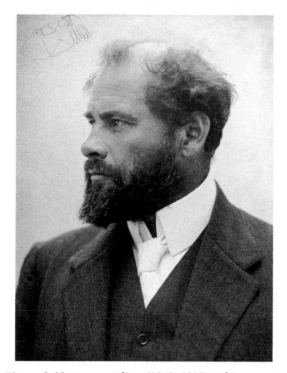

Figure 8-10. Gustav Klimt (1862–1918). This portrait
was taken circa 1908, the year he painted *The Kiss*.

skipped high school and at a young age entered the Viennese School
for Arts and Crafts as an architectural decorator. He finished his stud-
ies just as construction of the monumental buildings on Vienna's Ring-
strasse was entering its final phase. The great artist of the Ringstrasse
was Hans Makart, who specialized in grand historical and allegorical
paintings and official portraits. As a young man, Klimt painted adorn-
ments for provincial playhouses and other official buildings following
Makart's style. When Makart died in 1884, Klimt and his younger
brother Ernst were invited to work on the last two great buildings of
the Ringstrasse—the Museum of Fine Arts and the new Castle The-
atre. Klimt was commissioned to paint *The Auditorium of the Old Castle
Theatre* (see Chapter 1). This 1888 painting was the first indication that
he would break away from Makart, turn inward, and develop a highly
original style of his own.

In 1892 several events in Klimt's personal life converged. First, his
father died. Soon thereafter, his brother Ernst also died. Klimt as-
sumed responsibility for the care of Ernst's widow, Helene Flöge, and

her daughter. He then met and fell in love with Helene's younger sister Emilie, herself an artist. This succession of emotionally charged events is thought to have generated a creative crisis in the artist, one that carried him to a new, highly personal style of painting and iconography.

Not everyone appreciated the evolution of Klimt's new style. In 1894 he was commissioned by the State Ministry of Culture, Religion, and Education to paint three murals for the Assembly Hall of the University of Vienna to celebrate its three great faculties: medical, legal, and philosophical. Klimt was charged with portraying "the victory of light over darkness." He exhibited *Philosophy* in 1900, *Medicine* in 1901, and *Jurisprudence* in 1903 (Figs. 8-11, 8-12). In each case the murals, which were influenced by the Belgian symbolist painter Fernand Khnopff, were highly metaphorical and found to be unsatisfactory by a number of faculty members. The murals were alternately criticized for being too erotic, too symbolic, and too difficult to understand. Moreover, the bodies Klimt painted were considered ugly. The principal spokesperson for the dissatisfied professors was the philosopher Friedrich Jodl, who explained that they were protesting not against nude art, but against ugly art.

Franz Wickhoff, a professor at the Vienna School of Art History, and Berta Zuckerkandl vigorously defended Klimt against these critics. In a highly influential lecture before the Philosophical Society entitled "On Ugliness," Wickhoff argued that the modern period has its own sensibility and that those who see modern art as ugly cannot face modern truths. Alois Riegl, a founder of the School of Art History, joined him in arguing that in art, as in life, truth is not necessarily beautiful. Riegl noted that each period has its own value system, its own sensibility, which is embodied in and portrayed by contemporary artists. In this context, Wickhoff insisted, Klimt's work stands out "like a star in the evening sky."[6]

The murals were provocative not only in their content, but also in their composition. Artists since the Renaissance had created paintings that simulate a realistic, three-dimensional space, with the painting acting as a window through which the viewer can enter into the scene. Klimt took a different approach. In *Medicine*, for example, the figures are rendered in three dimensions, but their placement relative to one another is not three-dimensional. The figures are stacked one on top of

Figure 8-11.
Gustav Klimt, *Hygieia*
(1900–07),
detail from *Medicine*.
Oil on canvas.

Figure 8-12.
Gustav Klimt,
*Medicine* (1900–07).
Oil on canvas.
Destroyed by
fire in 1945.

another in a vacuous, horizonless space; as a result, the mural is more a visual stream of thought than a coherent, three-dimensional image. Rather than being a scene that the viewer can step into, the image feels more like a dream; in fact, it resembles Freud's description of the unconscious in dreams as "disconnected fragments of visual images." Thus, instead of presenting a realistic depiction of the external world, Klimt captures the fragmentary nature of the unconscious psyche in a way not previously depicted by other artists.

In response to the rejection of his university murals, Klimt turned his evolving insights to the *Beethoven Frieze,* and began in 1902 to work with gold leaf, a medium he would use frequently over the next few years. By the beginning of the twentieth century, the appreciation of Beethoven had reached new heights, in part because the composer Richard Wagner and the philosopher Friedrich Nietzsche had praised his work so highly. To recognize the role Vienna played in Beethoven's life, the Secessionist artists planned a *Gesamt Kunstwerk*—a combination of artistic efforts—architecture, sculpture, painting, and music—to honor the composer, as part of the opening of their new building: the Secessionist Museum. The composer Gustav Mahler conducted Beethoven's Ninth Symphony, the sculptor Max Klinger created a bust of Beethoven, and Klimt painted a frieze that ran along the top of the walls of the room surrounding the statue. The frieze was based on Richard Wagner's interpretation of Beethoven's Ninth Symphony: the human struggle and yearning for happiness and love, which reaches its highest fulfillment in the unification of the arts. The arts as viewed by Klimt leads to the Kingdom of the Ideal, be it a heaven on earth or in paradise, where alone one can find pure joy, pure love, which he depicts in the last two images of the frieze as the choir of heavenly angels and the embracing lovers.

The three murals and the subsequent Beethoven frieze that proved so shocking to members of the faculty exerted a strong influence on Kokoschka and Schiele. As Kathryn Simpson has pointed out: "The most truthful pictures were ones that showed their subjects naked, diseased, painfully exposed, angry, and deformed."[7] Once Klimt led the way in connecting art with truth, Kokoschka and Schiele produced work that boldly challenged the aesthetic focus on beauty and the association of beauty with truth.

———

KLIMT'S NEW STYLE also incorporated another modern idea—that of the beholder's share, the viewer's relation to art. The idea that the viewer's participation is critical to the completion of a work of art was first put forth in a coherent and systematic way at the beginning of the twentieth century by Alois Riegl, perhaps the most influential art historian of his time.

Riegl's focus on the beholder was part of a larger aim: to develop art history into a means of relating art to culture. To accomplish this, he introduced a formal method for analyzing works of art. Riegl argued that a work of art must not be viewed simply in terms of an abstract or ideal conception of beauty. Instead, it must be viewed in terms of the style that prevailed during the historical period in which the work was created. He referred to this as the *Kunstwollen,* the aesthetic impulse within a culture, and argued that it leads to the development of new forms of visual expression. Riegl and Wickhoff proposed a new set of values that held that each age must define its own aesthetics. Thus, in the broadest sense, Riegl and Wickhoff developed a new approach to art history, one that was designed to help the public understand the role of innovation in art.

Riegl and Wickhoff's view of aesthetics was not based on a hierarchy, with what is traditionally considered "beautiful" in classical art at the top and what is considered "ugly" at the bottom. Their view of ugliness in art differed radically from that of earlier art historians; in fact, it differed from the view of many of their peers, as we have seen in their defense of Klimt's murals. As Immanuel Kant had pointed out in 1790 in his *Critique of Judgment,* nature is different from art: what is ugly in nature we may find beautiful in art. Rodin perhaps stated it best when, speaking for artists, he said, "There is nothing ugly in art except that which is without character, that is to say that which offers no outer or inner truth."[8]

This argument addresses one of the paradoxes of art: artists through the ages have aroused the same emotions in their viewers, yet people never tire of art. Why do we not become sated? Why do we continue to seek out and respond to new forms of art? Riegl's answer is that artists in every age implicitly educate the public to look at art anew and to find

in it new dimensions of truth. What arouses a viewer's emotions in a work by a twentieth-century artist, he argues, is quite different from what arouses that viewer's emotions in a work by a seventeenth-, eighteenth-, or nineteenth-century artist—and it is certainly different from what aroused the emotions of people who lived in the seventeenth, eighteenth, and nineteenth centuries. Taste evolves, and it does so in part because artists shape it and the beholder responds to it.

Without necessarily being aware of it, Klimt and his followers, Kokoschka and Schiele, taught viewers new truths about the unconscious instinctual urges that lay beneath the surface of their lives. Klimt and the architect Otto Wagner, who described the modernist era as showing man "his true face,"[9] endorsed the cry to arms of the art critic Ludwig Hevesi at the end of the nineteenth century: "To the age its art, to art its freedom."[10]

In his emphasis on the historical context in which the art emerged and the importance of the beholder's participation for the completion of a painting, Riegl stripped art of its pretension to achieve a universal truth and placed it into its proper context as a material object that derives from a particular time and a particular place. His ideas influenced Ernst Kris, Ernst Gombrich, and later generations of art historians to develop a more objective and rigorous art history, much as Rokitansky's ideas influenced Freud, Schnitzler, and their generation of medical scientists to place clinical medicine on a more scientific basis.

Riegl expanded on his ideas in the classic book *The Group Portraiture of Holland,* which was published in 1902, just a few years after Klimt and his fellow modernists had launched the Secessionist movement in Austrian art. The book compares Italian art of the fifth through sixteenth centuries to Dutch art of the sixteenth and seventeenth centuries.

Much Italian art of the Byzantine, Gothic, and Renaissance periods was designed to depict the eternal truths of Christianity and to elicit idealized feelings of piety, faith, pity, pathos, fear, and passion from viewers. The Roman Catholic Church established and promulgated its views by means of a religious hierarchy, and that structure is reflected in group portraits of the time, including Masaccio's *The Trinity* (Fig. 8-13), painted around 1427. In this dramatic depiction of the crucifixion, painted on a wall of the church of Santa Maria Novella in Florence, the artist arranges figures in hierarchical order. Everyone knows his or

her rightful place in the world: the viewer is outside the picture frame, the donors are at the front edge of the canvas, the grieving Mary and Joseph are behind them on either side of the dying Christ on the cross, and God hovers over Christ. The hierarchy is further emphasized by the power of linear perspective, whereby a three-dimensional scene is projected on the two-dimensional surface of the wall. Even though Mary addresses us with her outwardly directed look and points with

Figure 8-13. Tommaso Masaccio, *The Trinity* (1427–28). Fresco.

her hand to the scene before us, the picture is a complete drama in its own right: the viewer's participation is not required to complete the story. This self-sufficiency is characteristic of many Byzantine, Gothic, and Renaissance paintings and demonstrates what Riegl calls "inner coherence."

Holland in the sixteenth and seventeenth centuries was a democratic society bound together by mutual respect and civic responsibility. Riegl argues that, with some exceptions, the hierarchical organization evident in Italian painting went against the aesthetic urge of the egalitarian Dutch artists, who emphasized in their actions and in their work an "attentiveness," or respectful openness, to one another. Dutch artists were the first to balance station in society with human equality. Thus, even though a hierarchy exists in Frans Hals's 1616 *A Banquet of the Officers of the St. George Militia Company* (Fig. 8-14), the painting emphasizes a shared sense of values in which even the servants participate.

In contrast to the inner coherence of Masaccio, the Dutch artists created what Riegl calls an "external coherence," in which the viewer's participation is critical for completing the narrative and the picture. Not only are the people in a painting on equal terms with one another, they actively engage, and are on equal terms with, the viewers outside the picture frame. In some early works, the artist achieved this equality mainly by eye contact; in later pictures, the viewer is invited into the narrative of the painting. Riegl's recognition of "the beholder's involvement" had an enormous impact on thinking about the viewer's

Figure 8-14. Frans Hals, *A Banquet of the Officers of the St. George Militia Company* (1616). Oil on canvas.

response to art, as we shall see. Gombrich later elaborated on this idea, referring to it as "the beholder's share."

Klimt's *Schubert at the Piano* (Fig. 8-15), painted in 1899, two years after the centennial of Franz Schubert's birth, should be viewed as a continuation of the group portraits of Holland, argues the art critic Wolfgang Kemp. Like the Dutch paintings, it is entirely committed to an "ethics of attention": the attention of Schubert to the music, the attention of the four listeners to Schubert, and the attention of one of the listeners (the woman at the left) to the viewer, thereby bringing the viewer into the picture and completing the circle.

Klimt, Kokoschka, and Schiele had two goals with respect to the viewer's role. First, they wanted to create art whose external coherence is based not on the viewer's social equality with the people in the painting, but on the viewer's emotional (empathic) equality with them. Whereas the Dutch painters invited the viewer into the physical space of the painting, the Viennese invited the viewer into the emotional space of the painting. By recruiting the viewer's empathy, the Viennese artists enabled the viewer to identify with and experience the instinctual striving of the person in the painting. The composition of the Viennese paintings was specifically designed to evoke an emotional

Figure 8-15. Gustav Klimt, *Schubert at the Piano* (1899).
Oil on canvas. Destroyed in World War II.

response; unlike the Dutch paintings, which often featured large groups of people in social situations, the Viennese paintings typically contained individuals or small groups of two or three people in private spaces, people with whom the viewer could identify and who confronted the viewer directly, without the formal barriers of composition, pedagogy, or decorum.

Second, since external empathic coherence is more selective and difficult to achieve than external social coherence, the Viennese artists saw themselves not as educating the public at large, but as educating a self-selected group who shared their values or could be readily acculturated to them. Klimt and his disciples tried to help viewers look at art and at themselves in a new, more emotionally introspective way that would acknowledge the psyche of the sitter and thus illuminate the unconscious anxieties and instinctual drives present in everyone. To convey unconscious emotion, the artists exaggerated and distorted the human form. In this way, they were trying to elicit from modern, secular viewers the same type of powerful emotion inspired in religious viewers by Gothic sculpture and mannerist art, but instead of focusing on more conscious emotions, such as agony, pity, and fear, as religious art had done, Austrian modernist art focused on unconscious ecstasy and aggression.

In turning the Vienna School of Art History from classicism to Modernism, Riegl, Wickhoff, and their students negotiated a new path between tradition and innovation and initiated a new philosophical interest in the changing views of beauty. Two of Riegl's younger associates at the Vienna School, Max Dvořák and Otto Benesch, saw Austrian Expressionism as exemplifying innovation and these changing views of beauty. Dvořák, who was Kris's mentor, began to champion Kokoschka, and Benesch supported Schiele.

KLIMT WAS DEEPLY offended by the reaction to his murals. He did not want his paintings to be owned and viewed by people with whom he disagreed on what art should convey, so he simply bought the paintings back. He again turned inward and increasingly incorporated the expressionistic themes he had begun to develop in the murals into his decorative, Art Nouveau paintings.

Like many other artists of his time, Klimt was aware of the increasing technological refinement and popularity of photography, including

the emergence of nude photography in Paris in 1850. His response to the realism of photography can be seen in his paintings, in which he moves from literal depiction to more symbolic representation (Figs. 8-16 through 8-23). Gombrich puts this well:

> The photographer was slowly taking over the functions that had once belonged to the painter. And so the search for alternative niches began. One such alternative lay in the decorative function of painting, the abandoning of naturalisms in favour of formal harmonies; the other in the new emphasis on the poetic imagination which could transcend mere illustration by evoking dream-like moods through haunting symbols. Not that the two were incompatible; they sometimes fused in the oeuvre of individual masters of the *fin de siècle*. One of them, of course, was Gustav Klimt whose controversial paintings dominated the art scene in Vienna . . . around 1900.[11]

The delicacy of Klimt's drawings and his insights into the inner life of the women he drew also stand in stark contrast to the photography of his time. Klimt's women create a sensual daydream, a world of their own inhabited only by themselves, self-sufficiently and unself-consciously, not performing for any camera. The artist often surrounds them with iconic, sexually symbolic ornamentation that enhances the daydream and widens even further the gulf between the deep psychological exploration of women in his drawings and the reality of photography (Figs. 8-1, 8-2, 8-17, 8-19, 8-21, 8-23).

KLIMT'S EVOLVING STYLE between 1898 and 1909 reflects his concern with going below the surface of appearances to focus on the sitter's emotional state. As a first step in going deep beneath the surface of consciousness, Klimt realized that he would have to overcome the limitations inherent in painting on canvas. Freud could use metaphors to explain how unconscious forces shape human behavior, and Schnitzler could use the interior monologue to reveal those forces acting on his characters, but to portray the depth of the human psyche on a flat, two-dimensional surface, Klimt needed new artistic strategies. In devising them, he turned for inspiration to a much earlier style of painting, Byzantine art.

Figure 8-17. Gustav Klimt, *Sitting Nude, Arms Crossed Behind Her Head* (1913). Pencil on paper.

Figure 8-16. Otto Schmidt, *Female Nude* (c. 1900). Photograph (detail).

Figure 8-20. Otto Schmidt, *Female Nude* (c. 1900). Photograph.

Figure 8-19. Gustav Klimt, *Frontal Female Nude with Covered Face* (1913). Pencil on paper.

Figure 8-18. Otto Schmidt, *Female Nude* (c. 1900). Photograph.

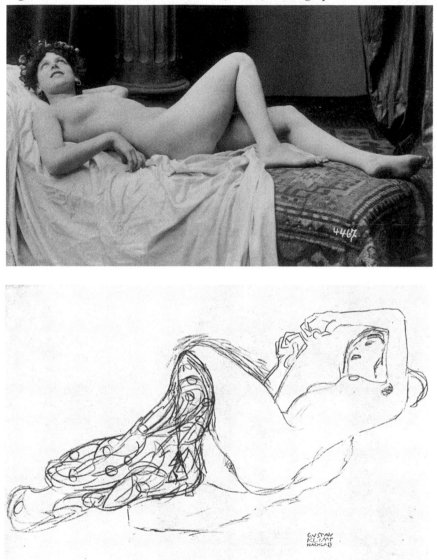

Figure 8-21. Gustav Klimt, *Reclining Female Nude with
Covered Lower Legs* (1914–15). Blue pencil on paper.

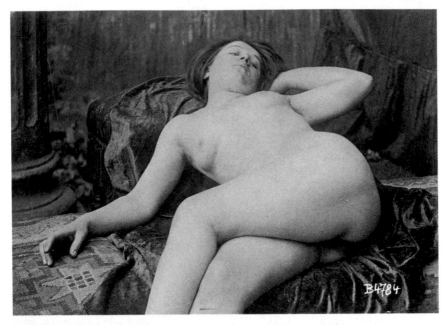

Figure 8-22. Otto Schmidt, *Female Nude* (c. 1900). Photograph.

Figure 8-23. Gustav Klimt, *Reclining Half-Nude* (1914). Pencil on paper.

As Gombrich has pointed out, the history of Western art is characterized by a systematic progression toward realism, the depiction of a believable, three-dimensional world on a flat, two-dimensional surface. Klimt abandoned three-dimensional reality for a modern version of the two-dimensional representation that characterizes Byzantine art. He combined in his paintings areas of three-dimensional figuration with large swaths of flat, gilded ornamentation, thus creating a stunning and pictorially jarring push-pull effect that further enhances the works' radiant, sensual aura. This emphasis on two-dimensionality, which had appeared in the paintings of Édouard Manet and Paul Cézanne, would be adopted and expanded by the cubists and other artists throughout the twentieth century.

The modernists' rationale for using only two dimensions was that art should not attempt to reproduce physical reality, because it simply cannot. Moreover, there is no single reality: art should strive for a higher, more symbolic truth, or simply present itself as an object. In his seminal 1960 essay on modernist painting, Clement Greenberg, an art critic and champion of abstract expressionist painting, wrote:

> The essence of Modernism lies . . . in the use of characteristic methods of a discipline to criticize the discipline itself. . . . Modernism used art to call attention to art. The limitations that constitute the medium of painting—the flat surface, the shape of the support, the properties of the pigment—were treated by the Old Masters as negative factors that could be acknowledged only implicitly or indirectly. Under Modernism these same limitations came to be regarded as positive factors, and were acknowledged openly. . . . Because flatness was the only condition painting shared with no other art, Modernist painting [of the 1940s and the 1950s] oriented itself to flatness as it did to nothing else.[12]

Klimt now saw flatness as truth. He had begun experimenting with flatness and gold ornamentation in 1898 in *Pallas Athena*, but in 1903 he took an important step further, traveling to Ravenna, Italy, to study Byzantine mosaics. These early examples of Christian art are characterized by flatness, which emphasizes the material nature of the mosaics on the wall, and by a gold background, which emphasizes spirituality, the higher reality that Klimt was seeking to portray. Ravenna had been

the capital of the vast Italian portion of the Byzantine Empire from the sixth to the eighth centuries and was one of the major cultural and artistic centers of medieval Europe. The city's mosaics are monumental in scope and richly ornamented with gold, vividly colored glass, and precious stones.

One such mosaic, in the Church of San Vitale, particularly fascinated Klimt: that of the Empress Theodora (c. A.D. 547), wife of the Emperor Justinian. The empress, considered to have been a very beautiful woman, is wearing a purple robe and a gleaming crown studded with sapphires, emeralds, and other precious stones (Fig. 8-24). Klimt realized that two-dimensionality imposed on her image an abstract timelessness and a rhythmical composition that differed from contemporary attempts to copy nature.

Under the influence of the Byzantine mosaics, Klimt began to combine flatness with a highly ornamented style of painting. He used a square-shaped canvas and gold and metallic colors, colors which he had first used in the Beethoven frieze and with which he was familiar from his father's goldsmith shop. To enhance the psychological meaning and depth of his portraits, Klimt decorated his canvases with iconic

Figure 8-24. *The Empress Theodora with Her Entourage* (c. 547). Apse mosaic.

sexual symbols. He had learned about the shape and form of sexual organelles from Emil Zuckerkandl while visiting his wife Berta's salon (see Chapter 3). Moreover, as the art historian Emily Braun has documented, Klimt was aware of Darwin and his theory of evolution, and he owned all four volumes of *Illustrierte Naturgeschichte der Thiere* (*Illustrated Natural History of the Animal Kingdom*, 1882–84), which contain pictures of sperm, eggs, and embryos viewed through a microscope. Stylized versions of those pictures appear in his paintings as decorative patterns on his sitters' garments. Klimt used this ornamentation to suggest the forms underlying all of human life.

These two stylistic changes—flatness and ornamentation—ushered in Klimt's Golden Phase, a relatively brief period that dates from his return to Vienna in 1903 until 1910. In *The Kiss* (1907–8), probably the most popular of his paintings, the combination of flatness and golden ornamentation reaches its apex (Fig. 8-25). The bodies of the lovers are almost completely covered by their clothing, and the clothing merges with the two-dimensional, decorative gold background. The painting's extraordinary stylization succeeds in conveying desire; indeed, the two bodies are brought together in such physical intimacy that they appear, at first glance, to be fused. In addition, the lovers' clothes, like the flowery base on which the woman kneels, are adorned with sexual icons. The erect rectangles, symbolizing sperm, on the man's cloak are matched by ovoid and floral symbols of female fertility on the woman's dress. The two defined fields of sexual symbols are juxtaposed and brought into a union of opposites by the vibrant cloth of gold that is their common, *flat* ground. On this ground, as the Klimt scholar Alessandra Comini has put it, the "eventual culmination of mutuality of desire is beautifully enacted in the ornate intercourse of circular and vertical forms."[13]

Although Klimt painted women throughout his long career, his most famous portraits, all of which depict idealized women, were done during this golden period (Fig. 8-26). The paintings themselves are otherworldly. In contrast to his drawings, the paintings do not probe the psyche of Klimt's sitters. Rather, their faces radiate a special mystery, a stereotypical glow, and emotional ambiguity.

The 1907 portrait of Adele Bloch-Bauer (Fig. 1-1), bought by Ronald Lauder in 2006, is perhaps Klimt's best-known portrait. In it the artist has placed a fairly realistic, three-dimensional image of his sitter

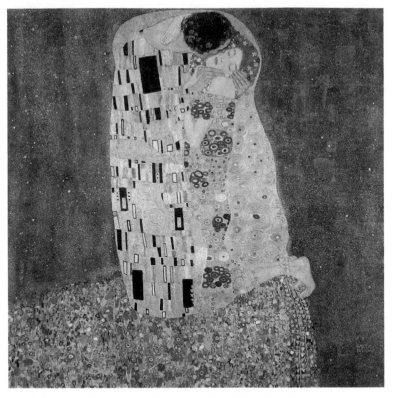

Figure 8-25. Gustav Klimt, *The Kiss* (1907–8). Oil on canvas.

into a flat, abstract background of gold ornamentation. Klimt had begun work on the painting in 1903, the year he went to Ravenna to study Byzantine mosaics, and the finished portrait shows the influence of the mosaic of the Empress Theodora. Like the empress, Adele is surrounded—indeed, almost constrained—by geometric forms (compare Figs. 8-24 and 1-1). Although it is not immediately obvious, she is sitting on a throne of sorts, an upholstered armchair richly decorated with spiral forms.

The portrait exemplifies an important element of Klimt's new style: the deliberate blurring of the boundaries between the various elements of the painting. The viewer is hard put to delineate Adele's gown, the chair, and the background. In fact, the boundaries metamorphose into one another, creating a pulsating sense of movement in the beholder's perception of space and form. By flattening the background and fusing it with Adele's gown, Klimt obliterates the traditional distinction, especially notable in portrait painting, between figure and ground, between

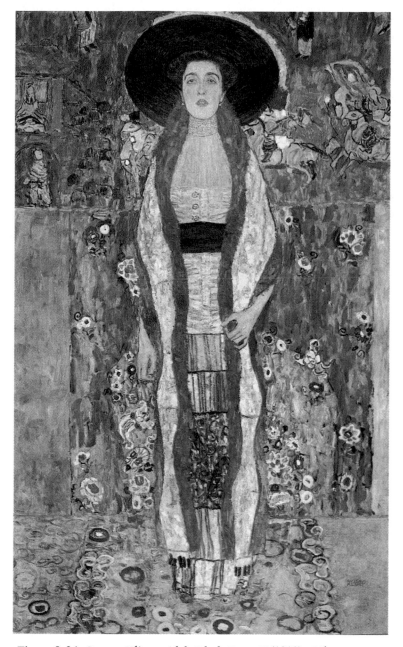

Figure 8-26. Gustav Klimt, *Adele Bloch-Bauer II* (1912). Oil on canvas.

the figure and the surface decoration. The central portion of her gown, the part closest to her body, is covered with rectangular and ovoid sexual symbols similar to those in other paintings, such as *The Kiss*. Her folded hands mirror the hands of the two lovers in *The Kiss*. Klimt's use of hands to symbolize emotion is a device elaborated on later by Kokoschka and especially Schiele.

The changing boundaries in the painting and the dense, symbolic ornamentation of the dress convey the idea that the stark, ordered geometry of the background is restrictive and socially imposed, whereas the symbols on Adele's dress reveal her instinctual drives. The Klimt historians Sophie Lillie and Georg Gaugusch comment on this conflict when they write that "Klimt's painting appears a compelling visual expression of Freud's theory" expressed several years earlier in *The Interpretation of Dreams:* namely, "that emotions buried in the subconscious rise to the surface in disguised form."[14]

Much like Rembrandt, who strove to reveal the soul of his sitters by isolating their hands and face in a field of amorphous shape, Klimt exposes only the hands and face of Adele Bloch-Bauer. Unlike the spiritual image of the Empress Theodora, however, the portrait of Adele shows her with full lips, flushed face, half-closed eyes, and a distinctly seductive, wistful smile. The ruby- and sapphire-studded diamond choker draws attention both to Adele's face and to her obvious wealth, as does the golden bracelet on her left wrist.

With his ability to produce almost photographic likenesses of his sitters and to place them with consummate decorative skill into highly ornamented golden gowns and backgrounds, Klimt soon found himself in great demand as a portrait painter, almost invariably of women. In contrast to Kokoschka and Schiele, who never tired of painting themselves, Klimt did not paint self-portraits: "I have never painted a self-portrait. I am less interested in myself as a subject for a painting than I am in other people, above all, women."[15]

AS HIS WORK EVOLVED from Art Nouveau to Modernism, Klimt focused on two themes that had come to dominate his thinking since the deaths of his father and brother and his marriage to Emilie and that came to characterize Expressionism: sexuality and death. Thus, simultaneously with Freud and Schnitzler, Klimt embarked on an explora-

tion of the unconscious instincts that drive human behavior. He became a painter of the unconscious, revealing the interior lives of women.

Klimt clearly was aware not only of the seductive, but also the destructive power of female eroticism. In several of his paintings he replaced demure, feminine types, all of whom look very much alike and are devoid of any deep psychological interest, with more overtly sensual creatures, women with a capacity for the same range of emotions as men: pain as well as pleasure, death as well as life. He began to explore, as did Edvard Munch and others before him, what he saw as the dangerous, irrational power of women, thereby illustrating that the consequences of sex are not always pleasurable. In the first of these paintings, his 1901 portrait of the biblical Judith (Fig. 8-27), Klimt revealed that the power of women can be downright frightening to men.

The Book of Judith tells the story of a Jewish heroine, a pious young widow whose courage, strength, and resourcefulness saved her people. In about 590 B.C., Babylonian-Assyrian forces led by Holofernes laid siege to the city of Bethulia. Before long, the siege began to exact a heavy toll on the residents, so Judith devised a plan to save them. She pretended to flee the city, together with her maidservant, and in the process encountered Holofernes, whom she captivated with her great beauty. The general ordered a feast in her honor with much wine, which she encouraged him to drink. After dinner, Judith retired with Holofernes to his tent, where she seduced him. Holofernes, drunk and sated, fell into a deep sleep. Judith drew his sword, which was hanging above his head, and decapitated him. She then took his head back to Bethulia. On seeing the head of the enemy general, the citizens routed the Babylonians.

In *Judith*, Klimt provides an extreme interpretation of the pious widow, depicting her as a symbol of the devastating power of the female erotic urge. Judith, barely clothed and fresh from the seduction and slaying of Holofernes, glows in her voluptuousness. Her hair is a dark sky between the golden branches of Assyrian trees, fertility symbols that represent her eroticism. This young, ecstatic, extravagantly made-up woman confronts the viewer through half-closed eyes in what appears to be a reverie of orgasmic rapture. While beckoning the viewer to enter into her ecstatic state, Judith reveals Holofernes' severed head, only a portion of which appears in the painting. The theme

Figure 8-27. Gustav Klimt, *Judith* (1901). Oil on canvas.

of decapitation is carried further by Judith's gold choker: rendered in the same gilded style as the background, it formally severs Judith's own head from her body. Although the title of the painting identifies the figure as Judith, this dangerous beauty, who resembles Adele Bloch-Bauer, is arrayed like an elegant lady of the contemporary Viennese upper class, the sort of woman whom Klimt painted and with whom he had affairs. Her jewelry is archaic in style but obviously of modern production, while her robe recalls the fine materials that were the hallmark of the Wiener Werkstätte's Arts and Crafts style.

It is fascinating to compare Klimt's treatment of Judith with Caravaggio's, painted in 1598 (Fig. 8-28). Like Klimt, Caravaggio did away with convention. He had no respect for classical views of ideal beauty and wanted to look at art in a new way. Also like Klimt, Caravaggio was accused of trying to shock the public. However, unlike Klimt's Judith, who shocks the viewer by reveling in her fatal seductive power, Caravaggio's Judith looks virginal and is repulsed by her deed and by her sexuality.

Klimt's Judith is a true femme fatale: she evokes in men both lust and fear, and she obtains pleasure from both. We understand why Holofernes fell for her—she is both beautiful and seductive. Moreover,

Figure 8-28. Michelangelo Merisi da Caravaggio, *Judith and Holofernes* (1599). Oil on canvas.

despite the beheading, there is no trace of blood or violence in the picture. Judith's murder of Holofernes is symbolic only. Thus, the painting discloses the psychological problem that Freud predicted would accompany the liberation of women's sexuality: namely, men's nightmares about sexual anxiety and the relationship between sex and aggression, life and death. Klimt recognized this problem before Freud ever wrote about castration anxiety.

The painting is of further interest because it expands our understanding of women's sexual desire. In his delicate drawings, Klimt most commonly shows the pleasurable aspects of sex, with women enjoying their sexuality with a partner or involved in self-indulgent private fantasies as they pleasure themselves. But in *Judith,* Klimt also reveals the destructive aspects of sexuality, thus enlarging our understanding of the range of sexual emotion that women are capable of experiencing, a range similar to that of men.

Klimt grapples with the themes of love and death in a number of contexts, perhaps most famously in his paintings of the life cycle. In his 1911 *Death and Life* (Fig. 8-29), a mass of humanity (the life force) is

Figure 8-29. Gustav Klimt, *Death and Life* (c. 1911). Oil on canvas.

grouped on the right, opposite the solitary figure of Death on the left. Klimt integrates death into life with separate color zones: Death wraps himself in the colors of night, while the human bodies expressing life and love display a rich diversity of colorful, gay ornaments. Love and death are shown in even starker terms in *Hope I*. Here, a nude expectant mother, whose iridescent red hair is echoed in her proudly displayed pubic hair, is filled with dreams of her child, while being shadowed, unawares, by the skull of Death (see Fig. 3-3).

It should come as no surprise, therefore, that following Klimt, Kokoschka and Schiele also explored sex, aggression, death, and the unconscious instincts underlying human behavior in highly original ways.

# THE DEPICTION OF THE PSYCHE IN ART

ALTHOUGH OSKAR KOKOSCHKA'S EARLY WORK WAS STRONGLY influenced by Gustav Klimt's visually rich and decorative style, he soon abandoned Klimt as a model. Jugendstil art (Art Nouveau) did not go deeply beneath the skin, Kokoschka argued: it "set out only to beautify the surface and made no appeal to the inner life."[1] He criticized Klimt's paintings for their presentation of the erotic drive through symbols and ornaments, saying that the artist depicted society ladies trifling with sexuality. Moreover, he considered Klimt's paintings of women to be unemotional.

Kokoschka brought a combination of psychoanalytic insight and expressionist style to bear on his portraits, which he painted with the belief that truth in art is based on seeing the inner reality. He described himself as a "psychological tin can opener":

> When I paint a portrait, I am not concerned with the externals of a person—the signs of his clerical or secular eminence or his social origins. . . . What used to shock people with my portraits was that I tried to intuit from the face and from its play of expressions, and from gestures, the truth about a particular person.[2]

In setting out to expose the psychological core of his sitters, Kokoschka emerged as the first Austrian expressionist painter.

Kokoschka later advertised himself as working in parallel with Sigmund Freud to uncover the unconscious psychic world of human be-

ings. Much as Freud excavated layer after layer of mind to reach a patient's true personality, Kokoschka saw himself as exploring both his own and his sitters' inner psychological processes. In his autobiography, published in 1971, Kokoschka writes in a boldly immodest fashion that expressionist painting, with which he strongly identified, "was a contemporary and rival of Freud's development of psychoanalysis and of Max Planck's discovery of quantum theory. It was a sign of the times, not an artistic fashion."[3]

LIKE KLIMT, KOKOSCHKA was fascinated by biology. In describing his youth, Kokoschka states: "The very first book given me by my father before I could even read, Jan Amos Comenius's *Orbis Pictus,* has never ceased to be useful to me. . . . It described both the phenomena of the animate and the inanimate realms and put man in his true place in the cosmos."[4] *Orbis Sensualium Pictus,* initially published in 1658 and updated as late as 1810, was the first children's encyclopedia. It was copiously illustrated and sought to provide a summary of all that was known about the world and its inhabitants. Kokoschka was drawn to the biological drawings, particularly the anatomical illustrations of the skeleton, the muscles, and the internal organs that lie below the skin (Fig. 9-1).

As an adult, Kokoschka was influenced by the medical use of X-rays. In 1895 the German physicist W. C. Roentgen had found that X-rays could pass through the surface of the body and make visible the underlying skeleton. This remarkable discovery was immediately disseminated by the Viennese press, and it caused a sensation. Claude

Figure 9-1.
Joannes Amos Comenius,
*Orbis Sensualium Pictus*
(1672). Drawing.

Cernuschi, the Kokoschka scholar, describes the reaction: "To see through opaque substances! To look inside a closed box! To see the bones of an arm, a leg, a body, through flesh and clothing! Such a discovery is, to say the least, quite contrary to everything we have been used to consider certainty."[5]

In addition, Kokoschka was very likely aware of Freud's work in psychoanalysis, if not through reading his books then certainly through close contact with intellectuals such as the noted Viennese architect Adolf Loos, who contributed to the social critic and dramatist Karl Kraus's newspaper *Die Fackel,* which often addressed Freud's views.

The anatomical drawings in the *Orbis Sensualium Pictus,* the medical use of the X-ray, and Freud's understanding of mind all contributed to Kokoschka's idea that to depict the inner life of his sitters, he had to look for truth beneath the surface. He used a sitter's facial expression, posture, and attitude to strip away the person's social façade and reveal his or her true emotional state. He would start work on a portrait by encouraging his sitter to move, talk, read, or become absorbed in his or her thoughts and therefore unaware of the artist's presence; in much the same way, a psychoanalyst would ask a patient to lie down on the couch, facing away from the therapist, in order to forget the therapist's presence and feel comfortable enough to begin to free-associate.

The Danish art critic Karin Michaelis (whose portrait Kokoschka drew in 1911) writes that Kokoschka "looked right through people like certain psychiatrists, one glance was enough and he found the most secret weaknesses, the sadness or vices of people."[6] Loos in fact described Kokoschka as having "X-ray eyes." As Cernuschi notes:

> Implicit in the practical modes of operation established by the New Vienna School are the very intellectual and interpretive assumptions that . . . the human body cannot be observed simply from its external layer, that the body is a spatial entity, a three-dimensional organism whose "truth" is revealed not by external appearance, but by its hidden infrastructure. . . . This same position . . . provided both the very methodological and intellectual backbone of Rokitansky's medical practice. . . . Indeed, it was very much with a medical kind of mind-set that Kokoschka could associate his own visual experiments with a philosophy of

truth, that Loos could associate those same experiments with the discovery and medical use of X-rays, and that art historians have somehow found metaphors of dissection an effective way to describe Kokoschka's visual experiments.[7]

KOKOSCHKA WAS BORN in 1886 in Pöchlarn, a small town on the Danube River about sixty miles west of Vienna. Like Klimt, he came from a family of goldsmiths, although his own father was first a traveling salesman for a jewelry firm and later a bookkeeper in Vienna. Also like Klimt, Kokoschka's background was in applied arts. From 1904 to 1908 he studied at the Austrian Museum of Art and Industry's School of Applied Arts, where he learned printmaking and book illustration in addition to drawing and painting.

In 1906, influenced by Klimt, Auguste Rodin, and Edvard Munch, as well as Paul Gauguin's Tahitian paintings, Kokoschka began to draw prepubescent nudes, both male and female. Here, his art reflects another idea that he shared with Freud: that instinctual strivings—including sexuality and aggression—are evident in children and adolescents, not just in adults. The subject of childhood sexuality had emerged in Vienna following the publication in 1905 of *Three Essays on the Theory of Sexuality*, in which Freud describes the physical maturity of adolescence as merely catching up with the rich sexuality of infancy. The public was not ready for adolescent sexuality as a topic of art, however, much less for Kokoschka's sexually charged depictions.

In drawing the emerging sexuality of his young models, Kokoschka captured both their natural openness and their shyness. For example, in his 1907 drawing *Standing Nude with Hand on Chin* (Fig. 9-3), the model's awkward pose suggests her discomfort at posing nude. Here, as well as in *Female Nude Sitting on the Floor with Hands behind her Head* (Fig. 9-2), we can see Kokoschka's fascination with how movement betrays a psychological trait or social awkwardness. Moreover, the boyish figure and angular outlines of the female body in these two drawings emphasize the sitter's youth. The girl in both drawings is most likely Lilith Lang, a fourteen-year-old fellow student at the School of Applied Arts. These early drawings, especially the *Reclining Female Nude* (Fig. 9-4), illustrate how Kokoschka revealed, through angular bodily contours, both the free, unconstrained

Figure 9-2. Oskar Kokoschka, *Female Nude Sitting on the Floor with Hands behind her Head* (1913). Pen and ink, watercolor, and pencil on wrapping paper.

gestures and the unconscious emotional urges of his young female models.

In 1907, while still a student, Kokoschka began to work for the Wiener Werkstätte, where he designed posters and picture postcards and decorated fans. While working there, he combined a daydream about his first adolescent love affair, written in the form of an expressionist

poem, with a series of eight color lithographs. The resulting book, *Die Träumenden Knaben* (*The Dreaming Youths*), published in 1908, is generally considered one of the great art books of the twentieth century.

Using sexually charged illustrations, Kokoschka documents the rich, erotic fantasy life of young adolescents that Freud inferred from his clinical studies of adult patients. The noted art critic Ernst Gombrich points out that during Kokoschka's early years, a great deal of attention was paid to the art of children and to their sense of originality and independence. These tendencies are evident in the slightly awkward depictions of *The Dreaming Youths*. Like the drawings of adolescent nudes, these decorative illustrations, completed when Kokoschka was only twenty-one years old, still show Klimt's strong influence. In

Figure 9-3. Oskar Kokoschka, *Standing Nude with Hand on Chin* (1907). Pencil, watercolor on paper.

Figure 9-4. Oskar Kokoschka, *Reclining Female Nude* (1909).
Watercolor, gouache, and pencil on heavy tan woven paper.

fact, the book not only begins with an elegantly designed dedication to
Klimt, it continues the tribute in the second image, which depicts a
grateful Kokoschka leaning on Klimt for support (Fig. 9-5).

In *The Dreaming Youths,* as in his earlier expressionist poetry and
his plays, Kokoschka deals not only with dreams but with infantile and
adolescent eroticism and with the fusion of eroticism and aggression—
all themes that Freud had introduced several years earlier in *The Inter-
pretation of Dreams*. It is unlikely that Kokoschka had read either *The
Interpretation of Dreams* or the *Three Essays on the Theory of Sexuality* by
this time, but he was quite likely to have been familiar with their ideas,
since they had become part of the culture at large. Certainly the litho-
graphs, with their dreams and adolescent sexuality, as well as their Oe-
dipal striving and competition with the father, may have been influenced
by Freud's writings.

The book was originally designed as part of a series of children's
fairy-tale books sponsored by the Wiener Werkstätte, and the bright
colors of its lithographs and their thick black outlines indeed give the
appearance of a book for children. But the book is not for children, nor
is it based on an existing fairy tale. Rather, it is an original, highly per-
sonal, poetic exploration of erotic maturation in the form of a love letter
to Lilith Lang, who was sixteen years old at the time. She had modeled

for him earlier, and they dated from 1907 to 1908. But by the time the book appeared, their relationship, which Kokoschka had hoped would lead to marriage, had ended—because, according to Kokoschka, of his excessive possessiveness.

The lithographs are highly original (Fig. 9-6). They are flat, ornamented, and stylized, resembling in feeling and tone a combination of Byzantine and primitive art, as well as Japanese wood-block prints and Art Nouveau. Although the lithographs are rich with flat, geometric forms, Kokoschka's lines are much more angular and nervous, more like caricature, than the sensuous calligraphy of Klimt. The images are not intended to be literal illustrations of the poem, but like the poem they depict the turmoil of an adolescent boy (presumably the artist)

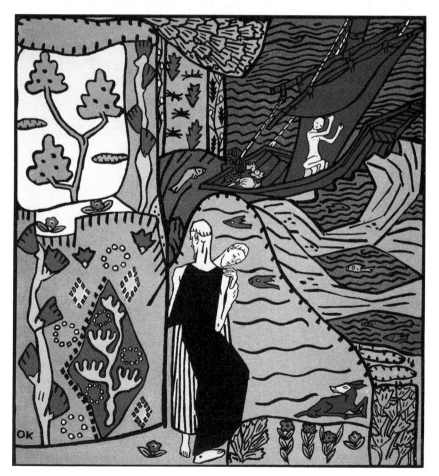

Figure 9-5. Oskar Kokoschka, illustration for
*Die Träumenden Knaben* (1908). Color lithograph.

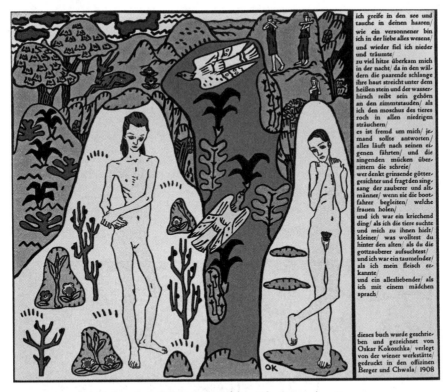

ich greife in den see und
tauche in deinen haaren/
wie ein versonnener bin
ich in der liebe alles wesens/
und wieder fiel ich nieder
und träumte/
zu viel hitze überkam mich
in der nacht/ da in den wäl-
dern die paarende schlange
ihre haut streicht unter dem
heißen stein und der wasser-
hirsch reibt sein gehörn
an den zimmtstauden/ als
ich den moschus des tieres
roch in allen niedrigen
sträuchern/
es ist fremd um mich/ je-
mand sollte antworten/
alles läuft nach seinen ei-
genen fährten/ und die
singenden mücken über-
zittern die schreie/
wer denkt grinsende götter-
gesichter und fragt den sing-
sang der zauberer und alt-
männer/ wenn sie die boot-
fahrer begleiten/ welche
frauen holen/
und ich war ein kriechend
ding/ als ich die tiere suchte
und mich zu ihnen hielt/
kleiner/ was wolltest du
hinter den alten/ als du die
gottzauberer aufsuchtest/
und ich war ein taumelnder/
als ich mein fleisch er-
kannte/
und ein allesliebender/ als
ich mit einem mädchen
sprach/

dieses buch wurde geschrie-
ben und gezeichnet von
Oskar Kokoschka/ verlegt
von der wiener werkstätte/
gedruckt in den offizinen
Berger und Chwala/ 1908

Figure 9-6. Oskar Kokoschka, *The Dreaming Boys*
(1908, published 1917). Color lithograph.

who is tormented by the awakening of sexual urges in his body as he searches for the girl of his dreams (Lilith).

The two adolescent lovers are for the most part depicted separately, embedded in bizarre landscapes, a Garden of Eden consisting of ponds containing goldfish and islands inhabited by deer, birds, snakes, and mountain stags. In this modern version of Adam and Eve, the lovers do not appear together until the last image, which shows them expelled from the garden (Fig. 9-6). Self-consciously aware of their nakedness, they stand separated, their love still not consummated. As they leave their paradise and their innocent youth behind them, they enter the adult world of erotic urges with considerable anxiety.

The images are powerful statements of much that was to come in expressionist art. In particular, the nude self-portrait in the last image is a harbinger of the explosion of nude self-portraits that Egon Schiele produced a few years later and that, as Emily Braun has pointed out, re-emerged as a major theme in the British figurative art of the 1950s

and 1960s, notably that of Francis Bacon and Sigmund Freud's grandson Lucian Freud.

The language in the poem is erotically drenched, expressionistic, and almost incomprehensible. The youthful poet in the story begins with a prologue and then describes seven consecutive dreams, each of which is announced by the same phrase: "And I fell down and dreamt." In the dreams the poet is transformed into a werewolf that invades the garden of his beloved:

you gentle ladies
what springs and stirs in your red cloaks
in your bodies the expectation
of swallowed members since
yesterday and always?

do you feel the excited
warmth of the trembling
mild air—I am the were-
wolf circling round—

when the evening bell dies away
I steal into your garden
into your pastures
I break into your peaceful corral

my unbridled body
my body exalted with pigment and blood
crawls into your arbors
swarms into your hamlets
crawls into your souls
festers in your bodies

out of the loneliest stillness
before you awaken my howling shrills forth
I devour you
men
ladies
you drowsily hearkening children

the ravening
loving werewolf within you

and I fell down and
dreamt of unavoidable change
. . . . . . . . . . . . . . . . . . . . . . .
not the events of
childhood move through me
and not those of manliness
but boyishness
a hesitant desire
the unfounded feeling of shame before what is growing
and the stripling state
the overflowing and solitude
I perceived myself and my body
and I fell down and dreamt love[8]

The lithographs were exhibited for the first time in the spring of 1908 at the Kunstschau Wien, the Viennese art exhibit organized by Klimt to celebrate the sixtieth year of the reign of the Emperor Franz Joseph. Even though he sensed that Kokoschka was developing in a direction quite different from his own, Klimt nonetheless strongly supported him and gave him his first opportunity to show his work in public. Klimt justified his decision by saying, "Kokoschka is the outstanding talent among the younger generation. We may be risking the physical destruction of the Kunstschau, but that can't be helped. We will have done our duty."[9] Indeed, Kokoschka's lithographs stood out so boldly that they earned him the title "King of the Beasts" and foreshadowed the breakthrough to Expressionism that he was to achieve in the next few years.

LOOS SAW *The Dreaming Youths* at the art show and strongly encouraged Kokoschka to change his decorative style and stop working with the Wiener Werkstätte. By the next summer, a year before he graduated from the School of Applied Arts, Kokoschka had freed himself from the Arts and Crafts style and from Klimt's influence as well. He was encouraged in this by Kraus and Loos, neither of whom had seen Klimt's remarkable drawings and both of whom considered his highly ornamented paintings to be superficial. The friendship between the

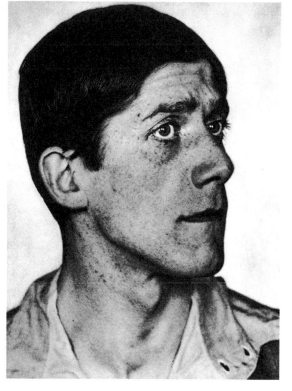

Figure 9-7. Oskar Kokoschka (1886–1980). This photograph was taken around 1920, after Kokoschka was appointed professor at the Dresden Academy of Fine Arts.

forty-eight-year-old Loos and the twenty-two-year-old Kokoschka was instrumental in transforming Kokoschka into a bold, original artist who was concerned not with beauty, but with truth (Fig. 9-7).

The stylistic break with Klimt was achieved, as Cernuschi points out, in Kokoschka's 1909 painted clay sculpture, *Self-Portrait as Warrior* (Fig. 9-8). This polychrome bust, with its mouth wide open in "an impassioned cry," as Kokoschka wrote in his autobiography, was influenced by a Polynesian mask that he had seen in the Museum of Natural History in Vienna. It was also quite likely to have been influenced by the remarkable character heads of Franz Xaver Messerschmidt, the Austrian Baroque sculptor whose depictions of extreme emotion were a precursor of Austrian Expressionism (Fig. 9-9).

In this bust, Kokoschka attempts to make his art both more truthful and more jarring by exposing the techniques he used to sculpt it: he exposes the physical methods he used to work the unfired clay surface, the technique he used to peel back the skin and to suggest the blood flowing just under the surface. Moreover, to emphasize his own individuality as an artist, he pressed his hands into the clay and used un-

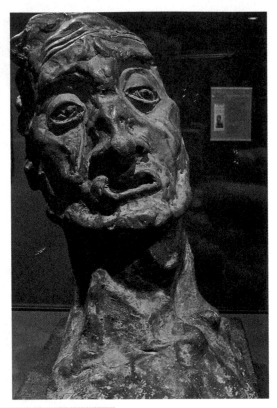

Figure 9-8.
Oskar Kokoschka,
*Self-Portrait as Warrior*
(1909). Unfired clay
painted with tempera.

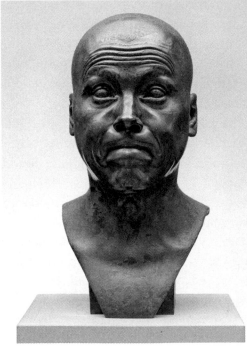

Figure 9-9. Franz Xaver
Messerschmidt,
*The Incapable Bassoonist*
(1771–77?). Tin cast.

natural colors—the red above the upper eyelids and the blue and yellow on the face and hair—to convey extremes of emotion beyond all social or painterly decorum. Here we see Kokoschka's first attempt to forsake the realistic use of color and texture in favor of their emotional qualities. By freeing color from its representational function, as Van Gogh had started to do, Kokoschka shifted his art's emphasis from pictorial accuracy to pure expression.

In the aftermath of the rejection of Klimt's murals, the Vienna School of Art History rejected the classical association of truth and beauty and began to think that the most truthful art, like that of Messerschmidt and Kokoschka, depicts subjects as they really are, even when angry or deformed. Max Dvořák, a disciple of Alois Riegl and Franz Wickhoff at the Vienna School of Art History, became a strong supporter of Kokoschka and later wrote a foreword to Kokoschka's 1921 collection "Themes and Variations." In his introduction, Dvořák writes that Kokoschka uses the physical to represent the spiritual.

BETWEEN 1909 AND 1910, Kokoschka painted a series of extraordinary, explosive portraits in which he transferred to the canvas the techniques he had used in his sculpture: multiple scratches, thumbprints, and unnatural colors. The portraits were a dramatic departure from contemporary taste, which had been formed by Klimt's beautifully decorated portraits of women. Kokoschka's bust, his portraits, and two expressionist plays he wrote around this time threw Viennese society into turmoil.

Kokoschka's portraits represent a quantum leap in the evolution of the Viennese Modernists' painterly technique. Much as Klimt broke with the past in abandoning centuries of illusionist art and introducing Byzantine flatness into modern art, so Kokoschka broke new ground by fusing mannerist exaggerations of form and color with both primitive art and aspects of caricature. Mannerist art emerged in about 1520, both as an outgrowth of and a reaction to the harmonious, rational, and beautiful depiction of the world in the High Italian Renaissance. Mannerist artists abandoned the idea that the beauty of nature can best be captured by careful observation and accurate depiction. They altered and exaggerated the details and imposed action on people, objects, or landscapes to create a more dramatic, aesthetically striking, and psychologically penetrating image.

As John Shearman, a scholar of this period, explains, Mannerism restructures nature according to its own view and sense of drama by exaggerating form and using color more dramatically. He attributes to Michelangelo, a giant of the High Renaissance and an early mannerist, the advice that "a figure has its highest grace and eloquence when it is seen in movement"[10] and that all motion of the body should be represented in such a way that the figure appears graceful, which it will do if it has a twisting, serpentine form.

Titian, considered by many art historians to be the most innovative portrait painter in European history, adopted these early mannerist ideas and applied them to a new method of painting: oil on canvas. Until the beginning of the sixteenth century, Renaissance art in Italy had focused on fresco and egg tempera paints on wood panel; these paints were water-based, smooth, and quick-drying. Oil paint is radically different: it dries slowly, allowing an artist to work and rework certain areas of a painting. Oils also allow the painter to use viscous and translucent coats of paint, which can be glazed over successive layers of dry paint, permitting the artist to continually revise a painting as well as create depth and texture. Thus, Titian could convey emotion by using translucent layers of paint superimposed on one another and strong brushstrokes to emphasize and distort the surface of the painting. As Holland Cotter has pointed out, Titian stopped signing his paintings because his "raw" use of paint, including his scratching of the painted surface, was so distinctive that his work needed no further identification.

Kokoschka notes in his autobiography[11] that he was inspired by Titian's use of light and color to create the illusion of movement and thereby to supplement color with perspective. He also writes about Titian's *Pietà*, in which the artist uses light to transform and re-create space, with the result that the beholder's eye is no longer directed by the signposts of contour and local color but can focus on the intensity of light: "As a result, my eyes were opened as they had been in childhood when the secret of light first dawned on me."[12]

El Greco, the Greek-born Spanish mannerist, had a similarly profound influence on Kokoschka. In fact, an exhibition of El Greco paintings in October 1908 at the Salon d'Automne in Paris had a major impact on the entire European artistic community. Reproductions of the artist's work circulated through Vienna, Klimt traveled to Spain

in 1909 to see El Greco's work in the original, and Kokoschka began incorporating El Greco's elongated faces and bodies into his own work.

Thus, a chain of influence extends from the Mannerism of Titian and El Greco to the early Expressionism of Messerschmidt and Van Gogh, to the Expressionism of Kokoschka. A decade later, Gombrich and Ernst Kris, both scholars in the Vienna School of Art History, drew attention to this lineage from Mannerism to Expressionism and saw Expressionism as a synthesis of the classical mannerist tradition in art, aspects of primitive art, and caricature. Arguably, this synthesis was first achieved in European portraiture by Messerschmidt's character heads and Kokoschka's *Self-Portrait as Warrior* and the portraits of 1909 to 1910.

THE BERLIN ART DEALER Paul Cassirer used the term "Expressionism" to distinguish the work of Edvard Munch from that of the impressionists. Munch's art emphasized the timeless, subjective expression of deeply rooted, universal emotions in a stressful, anxiety-ridden modern world, whereas the Impressionists focused on the fleeting outward appearance of persons and things in natural light. In its most general sense, Expressionism is characterized by the use of exaggerated imagery and unnatural, symbolic colors to heighten the viewer's subjective feeling when looking at art.

This critical transition from transient surface impressions to a more persistent, powerful, and emotional means of expression is described particularly well by Van Gogh. In a letter to his brother, Theo, the artist explains that in painting the portrait of a valued friend, capturing the friend's likeness was only the first stage. Having done that, Van Gogh set about changing the colors of the sitter and of the setting:

> I am now going to be an arbitrary colorist. I exaggerate the fairness of the hair, I get to orange tones, chromes and pale lemon yellow. Beyond the head . . . I paint infinity, a plain background of the richest intensest blue I can contrive, and by this simple combination the bright head illuminated against a rich blue background acquires a mysterious effect, like a star in the depths of an azure sky.[13]

Kokoschka used the short brushstroke developed by Van Gogh and the powerful expression of emotion developed by Munch, but he carried those extensions of mannerist technique further, introducing an artistic exaggeration of the face, hands, and body that had previously been restricted to caricature. Whereas Van Gogh used exaggeration primarily to enhance external characteristics and Munch used it primarily to convey external displays of terror, Kokoschka used exaggeration to reveal a new internal reality—the psychic conflicts of the sitter and the tortured self-inquiry of the artist. In doing so, he went beyond Klimt's Modernism and initiated a full-blown, explosive Austrian Expressionism.

Gombrich writes about expressionist art and Kokoschka's work in this period:

> What upset the public about Expressionist art was, perhaps, not so much the fact that nature had been distorted as that the result led away from beauty. That the caricaturist may show up the ugliness of man was granted—it was his job. But that men who claimed to be serious artists should forget that, if they must change the appearance of things, they should idealize them rather than make them ugly was strongly resented.[14]

Portraiture has historically had a dominant role in Western art because the face carries so much information. Before the advent of photography, individuals of affluent and influential families used portraits to convey to posterity what they looked like. Moreover, portraiture was successful because beholders could compare the portrait in front of them with their memory of the faces of other people of stature and accomplishment. Kokoschka was aware of this and set about to change some of the assumptions on which portraiture was based. He abandoned the long-standing tradition of presenting the sitter, whether royalty, aristocrat, or commoner, as a representative of all members of his or her class. Thus, while Klimt painted idealized women who seem designed to represent all women, from Adele Bloch-Bauer to Judith, Kokoschka's highly individualized "soul paintings" seek to reveal the inner life of a specific person. The art historian Hilton Kramer writes about Kokoschka's early portraits:

There is . . . a depth of empathy and a determination to remain undeceived by the masks of public demeanor that together have the effect of seeming to penetrate to the inner core of the psyche itself.[15]

Klimt painted women against a highly ornamented background to emphasize their permanence, whereas Kokoschka used a plain, dark background to bring out the psychological and individualistic features of the faces, eyes, and hands of the people he painted. Hilton Kramer, the art critic for *The New York Times* and *The New York Observer*, writes:

Kokoschka places each of his subjects in a pictorial space that is neither the space of nature nor that of some recognizable domestic interior. It is an infernal space, at once eerie and unearthly, haunted by demons and threatened by dementia. The light in this space, with its bizarre chiaroscuro and frightening tints, is fugitive and unabashedly intimate.[16]

As we have seen, Kokoschka rejected the decorative motifs that Klimt used to draw the viewer's attention away from the demanding techniques he used in painting his great portraits. Kokoschka's portraits look as if they were painted with a crude scalpel, which they essentially were. As with his clay bust, the portraits boldly display the methods he used to achieve his depictions of inner reality. An immensely gifted craftsman, he sometimes applied the paint so thinly that it barely covered the surface. In other areas he applied the paint thickly, using a palette knife to create a textured surface. Here, he would wipe off excess paint with a rag, with his fingers, or with a flat metal instrument; he would press the painted surface of the canvas, leaving depressions in the paint. This interplay of thin layers and impasto, often containing a large quantity of opaque white paint, contributes to the subtle orchestration of texture that characterizes his paintings.

Kokoschka used these techniques not to present a literal record of his sitter, but to capture the person's psychological traits, feelings, and mood. In the process, he unconsciously conveys his own unbridled, instinctual urges. At times the paint is recognizably aggressive; elsewhere it is calm and quiet. The application of the paint thus acts as a

narrative of Kokoschka's own unconscious as he constructed the image, a narrative that is often wholly independent of the person he painted.

To achieve his insights into personality, Kokoschka focused on four main ideas. First, painting portraits is a good way to learn about another person's psyche. Second, painting portraits of other people is also a journey of self-discovery, a process through which the artist uncovers his own nature. Kokoschka realized that the royal road to portraiture and to another person's psyche was through an understanding of his own psyche and, by extension, through self-portraits. Third, gestures, especially hand gestures, can communicate emotions. Fourth, the opposite poles of emotion—approach and avoidance—are invariably in-

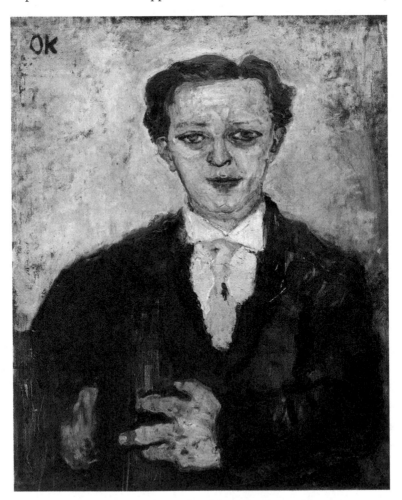

Figure 9-10. Oskar Kokoschka, *The Trance Player,*
*Portrait of Ernst Reinhold* (1909). Oil on canvas.

formed by sexuality or aggression; moreover, such instinctual strivings are evident in children as well as adults.

KOKOSCHKA'S FIRST PORTRAIT was of his friend Ernst Reinhold (whose real name was Reinhold Hirsch) (Fig. 9-10). His objective in painting Reinhold, and in subsequent portraits, was "to re-create in my own pictorial language the distillation of a living being."[17]

To depict Reinhold's unconscious striving, Kokoschka uses bold, loud, unnatural colors and applies the paint rapidly, working it into the canvas unevenly and rubbing it vigorously with his fingers and the handle of the brush. In parts of the portrait, he scrapes the paint on the canvas with a stick or his hand. Kokoschka places the redheaded actor dramatically in the center of the foreground and has him engage the viewer directly with his piercing blue eyes. The artist employs an abstract background here, as in his other portraits, not just in reaction to Klimt's ornamental background, but also as a way of focusing dramatically on the subject, particularly the subject's inner life. The art historian Rosa Berland writes that this background, plus the painting's rough texture and ghostly lighting, calls attention to the process of painting and thus functions as a visual metaphor for "the process of artistic creation."

Kokoschka later wrote about this painting:

> The portrait of Reinhold, a picture especially important to me, contains one detail that has been hitherto overlooked. In my haste, I painted only four fingers on the hand he lays across his chest. Did I forget to paint the fifth? In any case, I don't miss it. To me it was more important to cast light on my sitter's psyche than to enumerate details like five fingers, two ears, one nose.[18]

Kokoschka renamed this painting of Reinhold *The Trance Player,* because "I had many thoughts about him that I could not put into words."[19] One thought that Kokoschka clearly had not put into words was how an artist as observant as he was could possibly have left off a finger of his friend's hand. If we follow the period of great portraits that began with *The Trance Player,* it is clear that this was a slip in the Freudian sense—an omission with great unconscious meaning.

The actor's left hand represents Kokoschka's first attempt to com-

municate psychological ideas and feelings by distorting a part of the sitter's body. Distortions of the body and flesh later became his favored means of analyzing and representing a sitter's interior life. In *The Dreaming Youths,* Kokoschka is still working in a Klimtian decorative style, and his iconography is ornamental and symbolic. In *The Trance Player,* we see a great shift, from meaning residing in traditional, allegorical symbols to meaning residing more fully in the body. Klimt used the hands to symbolize meaning in *The Kiss* and *Adele Bloch-Bauer,* but Kokoschka goes further: the four fingers on Reinhold's left hand symbolize perhaps a sense of incompleteness in the man's personality. This iconography of hands, arms, and body was later developed more fully by Schiele.

In 1910 Kokoschka exhibited twenty-seven oil paintings, twenty-four of them portraits, and all of them painted without preparatory studies in one year's time! In the two years between 1909 and 1911, he painted over fifty portraits, mostly of men. In them, he reveals character dramatically, especially through the sitter's eyes, face, and hands. Sometimes, as in the 1910 portrait of *Rudolf Blümner,* he uses those parts of the body to convey deep anxiety—or sheer terror (Fig. 9-11). Kokoschka respected Blümner as a friend of modern art and wrote of him that he was "a tireless fighter in the cause of modern art . . . a sort of modern Don Quixote, hopelessly engaged in battle against the entrenched prejudice of his times, and this was reflected in my portrait of him."[20]

Most of the early portraits are half-length, usually stopping just below the hands. Kokoschka believed that hands could convey emotion, and he emphasized these "talking hands" in his portraits. Sometimes, as in the Blümner portrait, the hands are outlined or stained in red. Blümner's right hand is raised as if to make an important argument with his hand as well as his body; the energy of his movement is conveyed upward into his body by the ruffled right sleeve of his jacket. The red color suffuses Blümner's face, providing ominous spots of high color in an otherwise deftly executed pale complexion. His facial features are delineated in red, suggesting veins or arteries. The viewer's attention is drawn to Blümner's eyes, one of which is larger than the other. He does not look directly at the viewer but gazes distractedly elsewhere, as if obsessed with his inner self.

The paint in this portrait is thin and dry, with a rubbed or scraped quality, indicating that Kokoschka was willing to compromise obser-

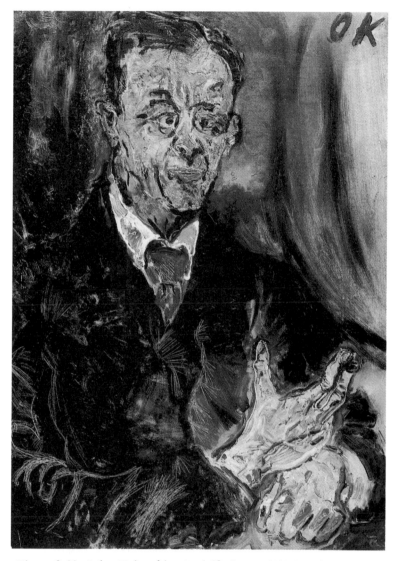

Figure 9-11. Oskar Kokoschka, *Rudolf Blümner* (1910). Oil on canvas.

vation of detail in order to capture his own excited state. Here, as in many of his other portraits, Kokoschka's brushstrokes and his scraping of paint on the canvas are so noticeable that the viewer's attention is drawn to the surface of the painting at the same time that he or she is attending to the person being depicted. This texture expresses not so much the unconscious feelings of the sitter, but the artist's reactions to the sitter, as well as the artist's anxiety about capturing his own feelings. The thinness and translucency of the paint convey an eerie sense

of immediacy and transparency. As Kokoschka himself claimed, he was attempting to obtain a pictorial version of an X ray revealing the sitter's skull.

Kokoschka's ability to see into a sitter's psyche is difficult to evaluate, particularly since both he and Loos repeatedly emphasized—indeed, hyped—his ability. With characteristic immodesty, Kokoschka writes in his autobiography: "I could have foretold the future life of any of my sitters at that time [of the sitting], observing, like a sociologist, how environmental conditions modify innate character just as soil and climate affect the growth of a potted plant."[21] Immodesty aside, however, Kokoschka did have an uncanny ability to see in his subjects not only the present, but also aspects of the future. We see this prescience in two remarkable portraits from this period, that of Auguste Forel and that of Ludwig Ritter von Janikowski.

Forel was, like Freud, an internationally known psychiatrist. He was also interested in comparative anatomy and behavior and had devised his own neuron doctrine independent of Freud and Santiago Ramón y Cajal. In the spring of 1910, Kokoschka painted a portrait of Forel (Fig. 9-12) that was commissioned by Loos, who at the time managed all of Kokoschka's portrait work. As in the other portraits of this period, Kokoschka rubbed and scraped the paint with his brush and his hand, conveying a sense of the direct presence of the sitter. But in this painting, Forel's right hand and right eye are atypical and look very different from his left hand and eye. He holds his right hand in a flexed position and supports it by placing the right thumb into the left sleeve of his jacket. The right eye has a staring quality quite different from the left, suggesting, as it did to Forel and his family, that the man had had a stroke on the left side of his brain.

Forel had the option of accepting or rejecting the finished picture. Once he saw the portrait, he rejected it. Kokoschka privately agreed that the painting depicted Forel as if he had suffered a stroke. Two years later, while bending over his microscope, Forel had a stroke that affected his right face and arm exactly as Kokoschka had painted them. Whether the painting reflects a purely accidental depiction by Kokoschka of Forel's impending stroke, or whether the artist's eye for detail and his sense of the physical and psychic attributes of his subject enabled him to spot a transient ischemic episode, the precursor signs of stroke, is not clear.

Another example of Kokoschka's prescience is his 1909 painting
*Ludwig Ritter von Janikowski* (Fig. 9-13). Janikowski, a literary scholar
and friend of Kraus, is depicted as descending into psychosis, which he
did shortly after the portrait was completed. Kokoschka portrays this
mental state by focusing on Janikowski's head and painting it as if it
were in motion, slipping out of the bottom of the picture. The bright,
almost surrealistic patches of color on his face and in the background
create a sense of terror, which people characteristically feel as they
begin to have a psychotic breakdown. Janikowski looks directly at the
viewer. We comprehend his enormous anxiety and feel sympathetic
toward him because he looks so terrified—his eyes are asymmetrical
and frightened, his ears are asymmetrical, he lacks a neck, and his coat

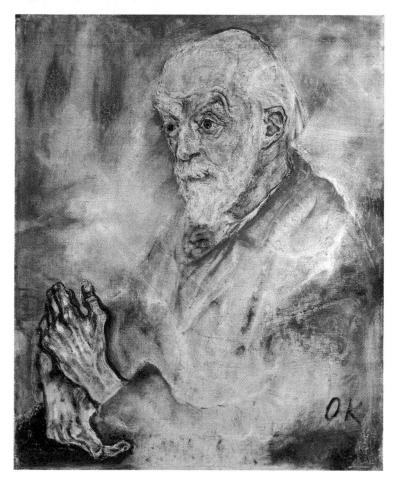

Figure 9-12. Oskar Kokoschka, *Portrait of
Auguste Henri Forel* (1910). Oil on canvas.

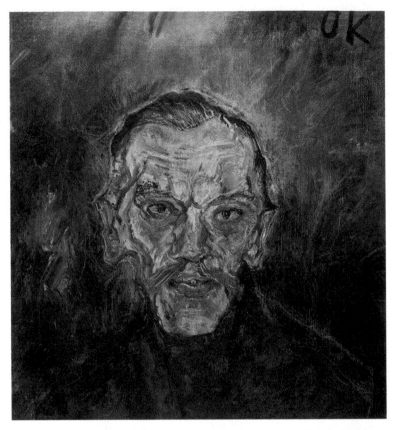

Figure 9-13. Oskar Kokoschka, *Ludwig Ritter von Janikowski* (1909).
Oil on canvas.

jacket merges with the background. To further suggest that Janikowski is at the edge of madness, Kokoschka uses the wooden end of the paintbrush to carve lines and create deep furrows and wrinkles on his face, eyes, mouth, and bright red ears, as well as on the background.

Hilton Kramer wrote of these early Kokoschka portraits:

> The style that Kokoschka perfected in the early portraits has sometimes been called "nerve painting" or "soul painting," terms which provide a salutary warning that the conventions of realistic depiction—never mind pictorial flattery—are not to be expected in these pictures. . . . There is, instead, a depth of empathy and a determination to remain undeceived by the masks of public demeanor that together have the effect of seeming to penetrate to the inner core of the psyche itself. . . . And when the

artist came to paint his own Self Portrait (*Hand on Chest*) in 1913, he did not exempt himself from this radical candor.[22]

Although Kokoschka was capable of vanity and self-promotion, these characteristics did not enter into his self-portraits. In keeping with Vienna 1900, he analyzed his personality in psychological terms that were more penetrating and merciless than those of his artistic predecessors when they were his age. Indeed, Kokoschka was more open and certainly more critical in his self-analysis than either Freud or Arthur Schnitzler. What emerges from the very beginning in Kokoschka's self-portraits is a deep probing of the self.

In the famous self-portrait poster designed in 1911 for the art magazine *Der Sturm* (*The Storm*), Kokoschka responds to the brutal assessment of the Viennese critics who branded him "chief savage" for his expressionist art and dramas. He presents himself as an outcast, a cross between a criminal (shaved head, powerful jutting jaw) and Christ, grimacing and pointing with his hand to a bleeding stigma in his right chest, as if to reprimand the Viennese for the wound they had inflicted on him (Fig. 9-14).

A different form of self-criticism is evident in the self-portraits painted during Kokoschka's tumultuous affair with Alma Mahler, the widow of Gustav Mahler and one of the most beautiful women in Vienna. In April 1912, three days after they met, some eleven months after the death of her husband, Kokoschka proposed to Alma in a passionate letter. Thus began a stormy relationship in which Kokoschka never felt secure. At age thirty-three, Alma was much more mature and experienced than the twenty-six-year-old Kokoschka. Although the affair lasted only two years, it dominated the artist's early life. When it ended, with Alma aborting their unborn child, Kokoschka destroying a death mask of Gustav Mahler, and Alma leaving him for the architect Walter Gropius, Kokoschka expressed his sorrow in a series of self-portraits and depictions of his allegorical reenactments of the relationship with a life-sized, three-dimensional doll in Alma's image.

During the affair, Kokoschka painted himself in a richly colored dressing gown that belonged to Alma, a gown he often used while painting. In one self-portrait, his eyes are open and questioning, and his large hands form the center of the picture. He is anxious, almost

terrified, an impression heightened by streaks of dark green in the background converging upon him (Fig. 9-15). In their several double portraits (for example, Fig. 9-16), Alma is typically calm while Kokoschka looks at once passive and agitated, as if he is about to suffer a mental collapse. In the most powerful of these, *The Wind's Fiancée*, Kokoschka and Alma lie in a boat, shipwrecked in mid-ocean, buffeted by the waves of their tempestuous relationship. She is sleeping calmly and he, as usual, is agitated, rigidly hovering near her (Fig. 9-17). In this painting, Kokoschka uses thick paint and dark colors and builds the surface of the painting layer by layer, giving it depth and conveying a sense of the emotional turmoil he was experiencing. The redder and more emotionally charged colors blend into his deadened skin tone, while the green, earthy colors enliven Alma.

Figure 9-14. Oskar Kokoschka, poster design
for the cover of *Der Sturm* magazine (1911).

Figure 9-15. Oskar Kokoschka, *Self-Portrait with Hand Near Mouth* (*Selbstbildnis, die Hand ans Gesicht gelegt*) (1918–19). Oil on canvas.

In the self-portrait of 1917 (Fig. 9-18), Kokoschka points to his left chest with his right hand. His face and eyes express a sadness reflecting not only the injury to his ego entailed by the loss of Alma Mahler three years earlier, from which he still had not fully recovered, but also a physical injury sustained in the war, a stab wound that pierced his left lung. The pain of this double loss is also reflected, as Berland points out, in the agitated application of the paint and in the contrasting and threatening blue sky of the background, heralding a storm.

In these self-portraits, we can see both Kokoschka's great stylistic

debt to Van Gogh and his differences from him. Van Gogh's vehement brushstrokes and his use of arbitrary, audacious colors were adopted and modified by Kokoschka.[23] However, when Van Gogh was experiencing emotional turmoil, he was much more subtle and subdued in his attempts to convey that turmoil to the beholder. The most revealing example of this difference is Van Gogh's extraordinary self-portrait of 1889 (Fig. 9-19).

Just before Christmas 1888, after a serious quarrel with his friend Gauguin, Van Gogh, who suffered from manic-depressive illness, sliced off part of his left ear with a razor. He then painted a portrait of himself with a bandage over his left ear. This self-portrait is considered to present the artist at the lowest point in his life, yet Van Gogh looks out at the beholder calmly.

Figure 9-16. Oskar Kokoschka, *Self-Portrait with Lover (Alma Mahler)* (1913). Coal and black chalk on paper.

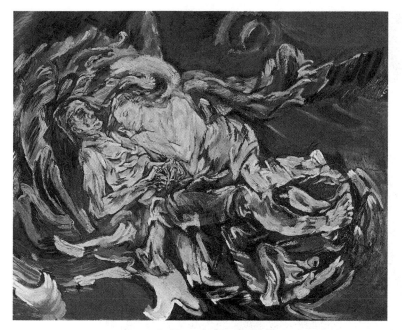

Figure 9-17. Oskar Kokoschka,
*The Wind's Fiancée* (1914). Oil on canvas.

THE IDEA THAT HANDS and gestures reveal personality emerges even more powerfully in Kokoschka's group portraits. In these, the artist manages to turn not only the sitter's face but also his or her body, and particularly the "talking hands," into vehicles of expression. The hands express emotion through eye-catching gestures, and bodily tension reveals unconscious impulses—psychic tension made visible. In his use of gestures, Kokoschka was influenced in part by the statues and drawings of Rodin.

Emphasizing the hands as well as the face is traditional in portrait painting, but Kokoschka did for hands what Klimt did for female sexuality—he gave them a modern interpretation. Thus, whereas praying or blessing hands in the Christian art of Byzantium convey spirituality, Kokoschka's hands express the psychological state of the sitter, his or her unconscious erotic and aggressive impulses. Kokoschka also uses hands to characterize social communication and interactions.

The Kokoschka scholar Patrick Werkner has argued that the artist was also inspired by the gestures of modern dance, which emerged in Vienna 1900 in newly liberated and expressive form. He may also have

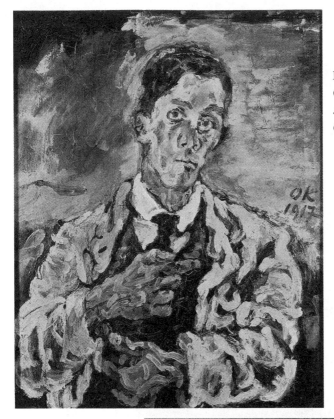

Figure 9-18.
Oskar Kokoschka,
*Self-Portrait* (1917).
Oil on canvas.

Figure 9-19.
Vincent van Gogh,
*Self-Portrait with
Bandaged Ear and Pipe*
(1889). Oil on canvas.

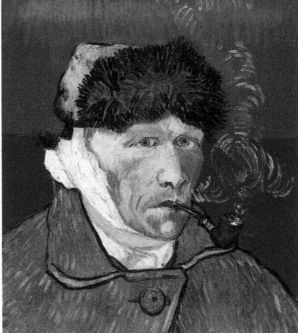

been influenced by Jean-Martin Charcot's images of his hysterical patients, whose arms and hands assumed all sorts of distorted positions. Charcot's work had led Josef Breuer, Freud, and other physicians to become fascinated by the posturing of some of their own hysterical patients. In the process of describing those postures in their publications, they created an aesthetic typology of body images associated with hysteria—a new iconography—that may well have influenced both Kokoschka and Schiele.

Three remarkable and distinctly different examples show how Kokoschka used hands to communicate an emotional state between two people. The first is the 1909 portrait of the baby Fred Goldman, entitled *Child in the Hands of Its Parents*. The mother's right hand and the father's left hand seem to protect and shelter their child. The hands stand in for the parents, and they are engaged in a dialogue of shared affection. There is both an interesting contrast and a sense of dynamic collaboration between the two hands. The father's is outstretched, both protective and restrictive, with vigorous red hues. The mother's is pale, much softer, more relaxed and gentle. This use of hands turns a portrait of a child into a family portrait (Fig. 9-20).

Even in this wonderful and loving painting, Kokoschka reveals his uncanny ability to discover vulnerabilities not always obvious to others. He paints a broken finger on the father's hand, an early childhood injury that the sitter himself had forgotten.

A very different, perhaps even more powerful dialogue of hands is played out in the double portrait of Hans Tietze and Erica Tietze-Conrat (Fig. 9-21). Both art historians, they often published together and sat at the same desk every day for years. At the time the double portrait was painted, in 1909, Hans was twenty-nine and Erica was twenty-six, and they had been married for four years. The double portrait was, according to Kokoschka, meant to symbolize their married life. Hans, a student of Riegl and a member of the Vienna School of Art History, later taught Gombrich and championed contemporary art. Erica, a specialist in Baroque art, posed separately for the painting.

Although they are husband and wife, Kokoschka paints them as if they were unrelated. He uses the occasion to focus on the contrast between the sexes and illustrated that contrast with distinctive sexualized gestures and bodily positions. Their hands, which in Hans's case are disproportionally large, create a bridge between them, but the two peo-

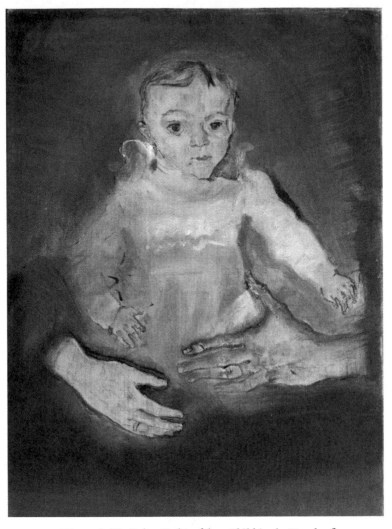

Figure 9-20. Oskar Kokoschka, *Child in the Hands of
Its Parents* (1909). Oil on canvas.

ple do not face each other. With their eyes looking in different direc-
tions, they seem to be caught in a revealing, sexually charged
conversation with their hands, a conversation that also involves the
viewer. They emerge as two independent people, each with an inner
direction and sexual needs. Carl Schorske comments on the light be-
hind Hans conveying a sense of male sexual energy. Recapitulating the
role of Alma Mahler in *The Wind's Fiancée*, Erica seems to withdraw
from her husband, who leans slightly forward as if to approach her.

Kokoschka's painting technique in this portrait is as remarkable as

Figure 9-21. Oskar Kokoschka, *Hans Tietze and
Erica Tietze-Conrat* (1909). Oil on canvas.

his use of hands. His vigorous workmanship is evident in his rapid
paint application, nervous scratching, and uneven drawing methods,
all of which are executed on a surprising fluctuating surface that oscil-
lates between dramatic golds, greens, and browns. Again, the woman's
hands are pale, the man's red.

Finally, Kokoschka uses hands to reflect the instinctual strivings of
children. His interest in the inner life of young children first appeared
in the remarkable portrait *Children Playing*, painted in 1909. This por-
trait depicts five-year-old Lotte and eight-year-old Walter, the children
of bookstore owner Richard Stein. Kokoschka does not depict the two
children in idealized poses that suggest childhood innocence, as earlier
artists would have done. Instead, he suggests through their body lan-
guage, irregular coloring, and the vaguely defined background on
which they are lying that the relationship is neither neutral nor inno-
cent (Fig. 9-22).

The children are portrayed as struggling with their attraction to
each other and with the conflict that this attraction sets up within each
of them and between the two of them. The boy appears in profile, look-
ing intently at the girl, while she is lying on her stomach, raising herself
on her elbows and facing the viewer. As in the painting of the Tietzes,
Kokoschka uses the children's arms to communicate a link between the
two of them. The brother's left hand is reaching for his sister's right
hand, which is clenched in a fist.

The public was shocked by this early painting. Its implication that

Figure 9-22. Oskar Kokoschka, *Children Playing* (1909). Oil on canvas.

children, even siblings, might entertain romantic and perhaps even erotic ideas about each other was heretical. In fact, the Nazis used *Children Playing* as a prime example of degenerate art and in 1937 removed it from the State Gallery in Dresden. Gombrich describes the painting in the following terms:

> In the past, a child in a painting had to look pretty and contented. Grown-ups did not want to know about the sorrows and agonies of childhood, and they resented it if this subject was brought home to them. But Kokoschka would not fall in with these demands of convention. We feel that he has looked at these children with a deep sympathy and compassion. He has caught their wistfulness and dreaminess, the awkwardness of their movements and the disharmonies of their growing bodies. . . . His work is all the more true to life for what it lacks in conventional accuracy.[24]

KOKOSCHKA BURST UPON the Viennese art scene like a werewolf in the garden. He captured on the surface of a canvas the unconscious instincts lying deep within the human psyche—his own as well as his sitters'. Like Freud, he grasped the importance of Eros in children and adolescents, as well as in adults. Like Klimt and Schnitzler, he em-

braced early on the intimate interplay between erotic and aggressive instincts that characterizes the Viennese modernist painters.

After staying in Berlin and Dresden, Kokoschka moved to Prague in 1934, to London in 1938, to Polperro in Cornwall, England, in 1939, and to Switzerland in 1953, where he died in 1980. Gombrich, who knew Kokoschka in Vienna and met him again in England, judged him to be the greatest portrait artist of the twentieth century.

Since Kokoschka's work was exhibited prominently in Britain, it seems likely that he and, as we shall see, Schiele influenced the British expressionists and, indirectly, Freud's grandson Lucian. I cannot help thinking that there is poetic justice in the great career of Lucian Freud, who continued in the tradition of Rokitansky, his grandfather, and Kokoschka, going deep below the surface to suggest the psychological realities that lie below. In fact, Lucian Freud writes about his work at the beginning of the twenty-first century much as Kokoschka had one hundred years earlier:

> My idea of travel is downward travel really . . . getting to know where you are better and exploring feelings that you know more deeply. I always think that "knowing something by heart" gives you a depth of possibilities which is more powerful than seeing new sights however exciting they are.[25]

# THE FUSION OF EROTICISM, AGGRESSION, AND ANXIETY IN ART

⌒⌣⌒

IN HIS PALPABLE EXISTENTIAL ANXIETY, EGON SCHIELE (FIG. 10-1) is the Franz Kafka of modern painting. While Gustav Klimt and Oskar Kokoschka, spurred by their intellectual contemporaries, took an interest in the inner lives of their subjects, Schiele more than any other artist of his time took an interest in his own anxiety. He expresses this deep anxiety—as if his private world were coming apart—in numerous self-portraits, and he superimposes a corresponding anxiety on everyone he painted, including the people in the dual portraits of his sexual experiences. There is, in those portraits, a frightening aloneness, even in union.

Although he only lived to the age of twenty-eight, Schiele completed three hundred paintings and several thousand drawings and watercolors. Like Klimt and Kokoschka, he was preoccupied with aggression and death, but his work, unlike Klimt's drawings of women enjoying their sexuality, conveys a wider range of female emotion in response to sex—torment, guilt, anxiety, sadness, rejection, curiosity, and even surprise. Especially in his early work, Schiele's women appear to suffer their sensuality rather than enjoy it.

In this sense, Schiele followed Kokoschka's lead in attempting to probe deeply his own life and the lives of those he painted. But he differed from Kokoschka in several important regards. Rather than focusing exclusively on facial expressions and hand gestures to explore beneath the surface of his subjects and obtain insights into their character and conflicts, Schiele used the whole body. Also unlike Kokoschka, who most frequently painted other people, Schiele often painted him-

Figure 10-1.
Egon Schiele
(1890–1918).
This photograph
was taken around
1914, just before
the end of his
relationship with
Wally and his
marriage to
Edith Harms.

self. He depicted himself as sad, anxious, deeply frightened, and sexually engaged with himself or with others.

Schiele's anxiety is evident not only substantively, in the narrative themes he selects to draw and paint, but also stylistically. In contrast to the ornamentation and graceful lines that characterize Klimt's art and Kokoschka's early work, Schiele's mature work is somber and often lacking in vivid color. The bodies of the people he paints are disjointed, their arms and legs contorted and twisted painfully, as if they were Jean-Martin Charcot's hysterical patients. But whereas Charcot's patients assumed their postures unconsciously, Schiele's posturing was a conscious and practiced attempt to use the position of hands, arms, and body to convey inner emotion. He often rehearsed and analyzed various postures in front of a mirror. He expressed his character and conflicts through histrionic, almost hysterical—but in reality well-planned—whole-body posturing.

Thus, Schiele's art is not simply mannerist, it is mannered. Freud and his followers used the term "acting out" to refer to the expression of forbidden impulses in action. Schiele was the first artist to use acting out to convey his inner turmoil, anxiety, and sexual desperation. Much as Max Dvořák championed the art of Kokoschka, so Otto Benesch, Dvořák's contemporary at the Vienna School of Art History and the director of the Albertina Museum in Vienna, the world's most important collection of drawings and prints, championed Schiele throughout his career. In addition, the Benesch family supported Schiele as patrons. Otto Benesch's father, Heinrich, was a patron of Schiele's, and in 1913 the artist painted a double portrait of the two: *Double Portrait of Otto and Heinrich Benesch* (Fig 10-2).

SCHIELE WAS BORN in 1890 in Tulln, a small Austrian town on the Danube River near Vienna. His father, who was of German descent,

Figure 10-2. Egon Schiele, *Double Portrait of Otto and Heinrich Benesch* (1913). Oil on canvas.

worked as an officer of the railroad and served as the stationmaster at Tulln. The family lived on the second floor of the railroad station. The Schieles had seven children, three of whom were stillborn. Of the four who survived, there were, in addition to Egon, three girls: Elvira, Melanie, and Gertrude, or Gerti. Gerti was the youngest and Schiele's favorite. The brother and sister had a very special relationship, which included her being his preferred model in his early depictions of adolescent sexuality.

On New Year's Eve 1904, when Schiele was only fourteen years old, his father died of late-stage syphilis. Witnessing his father's severe dementia and early death from a sexually transmitted disease just at the time of his own budding sexuality may well have sparked some of the anxiety and insecurity that dominated Schiele's life and work. Moreover, it probably led to his continual association of sex with death and with guilt, and to the attitudes he portrayed in his models and himself, as if both were always on the verge of a nervous collapse.

A poor student in school, Schiele possessed an exceptional ability to draw. Based on that talent, he was admitted to the Vienna Academy of Fine Arts at age sixteen, where he was the youngest student in his class. He began to perfect his already formidable drawing skills by first simulating and then elaborating upon the technique of blind contour drawing that had been developed recently by the sculptor Auguste Rodin[1] and adopted by Klimt. Schiele would observe his models and, without taking his eyes off them or lifting his pencil off the paper, would draw their figures with extraordinary speed in one continuous line, which he never modified or erased.

The result was a highly distinctive line that was at once nervous and precise—and very different from Klimt's sensuous, Art Nouveau line or the meticulous and calculated rendering of the Viennese academic tradition. Using this new line, Schiele was able to capture the gestures and movements of his models and himself and to express them by means of contours rather than light and shadow. Schiele would continue to employ this drawing technique throughout his career, communicating evocative body language through the power of outline and silhouette.

In 1908 Schiele attended the exhibition at the Kunstschau Wien organized by Klimt. There he saw for the first time Klimt's paintings and Kokoschka's early lithographs, *The Dreaming Youths*. Schiele was struck by Klimt's paintings, and he subsequently visited the artist's ate-

lier. Klimt, in turn, was impressed by Schiele's talent, and the older artist's support strengthened Schiele's confidence in his art. Much as Klimt had influenced the early Kokoschka, he now influenced Schiele.

In addition to imitating Klimt's style of painting, Schiele actually modeled himself on the older artist, wearing a long, monklike caftan when he painted. For a while he called himself the "Silver Klimt," not only because he used metallic silver in his paint, but also because he saw himself as a modern, younger version of the master.[2] Under Klimt's influence, Schiele created several paintings over the next year that featured two-dimensional figures on a flat background (Figs. 10-3, 10-4). As in Klimt's paintings, the flatness draws the viewer's attention to the inner world of the sitter.

Schiele exhibited his new works at the Kunstschau exhibition of 1909, including portraits of his sister Gerti (Fig. 10-3), of Anton Peschka (Fig. 10-4), the man who would later marry Gerti, and of Hans Massmann, a classmate at the Vienna Academy of Fine Arts. The painting of

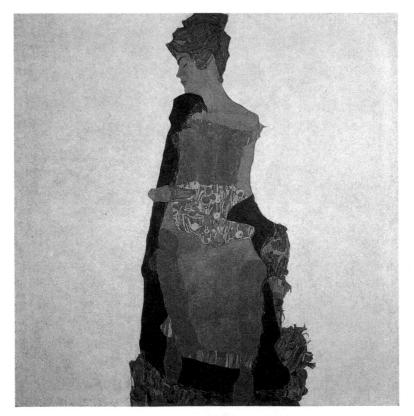

Figure 10-3. Egon Schiele, *Gerti Schiele* (1909). Oil on canvas.

Gerti is particularly elegant. She is seated with her head turned away from the viewer, her shawl and a blanket covering the chair, all with characteristic Klimtian ornamentation. The outlines of Peschka's body, like Gerti's, merge imperceptibly into the armchair in which he is sitting, very much as Adele Bloch-Bauer's outlines do in Klimt's first painting of her. These paintings of Schiele's still contain decorative detail, albeit modest, as in the extensive patterning of some parts of Gerti's dress, or in the fanciful silver brushwork comprising the background behind Anton Peschka. Kokoschka had already eliminated the ornamental background popularized by Klimt and replaced it with a simpler one, and after 1909 Schiele began to simplify his backgrounds also, ultimately eradicating them completely. As a result, the figures in Schiele's paintings pop out of the canvas, giving them a sense of isolation.

IN 1910 SCHIELE entered a new phase, moving radically away from Klimt and establishing an expressionist style, one that was initially in-

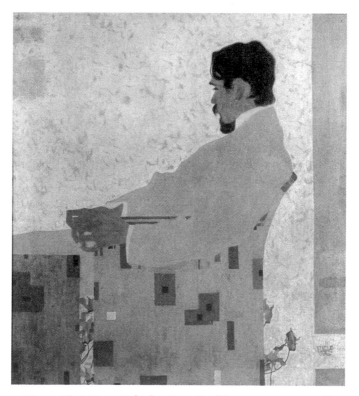

Figure 10-4. Egon Schiele, *Portrait of the Artist Anton Peschka* (1909). Oil, silver, and gold bronze paint on canvas.

fluenced by Kokoschka but that quickly became distinctly his own. In addition to eliminating ornamentation, Schiele distanced himself from Klimt by using himself as the prime subject of his psychic explorations. Thus, whereas Klimt never did a self-portrait, Schiele did a very long series of them—nearly one hundred—in 1910 and 1911. In that respect, he exceeded even Rembrandt and Max Beckmann, both of whom specialized in studying human nature over the life cycle by studying themselves throughout their lives.

In his search for what lies below the surface of everyday life, Schiele, like Kokoschka, was a true contemporary of Freud and Schnitzler: he studied the psyche and believed implicitly that to understand another person's unconscious processes, he had first to understand his own. Schiele exhibited himself compulsively in his drawings and paintings— again and again, alone or in combination with a partner—sometimes with truncated limbs, sometimes with missing genitalia, with contorted muscles, bones racked, flesh mortified with leprosy. He reveals his whole body, often naked and usually looking starved, awkward, distorted, and troubled. He uses his poses, postures, and tremendous bodily distortions to convey the full range of human emotion—anxiety, apprehension, guilt, curiosity, and surprise, combined with passion, ecstasy, and tragedy.

All of Schiele's self-portraits depict him in front of a mirror, sometimes in the act of masturbating (Figs. 10-5, 10-6, and 10-7). The paintings of himself masturbating are bold on several levels, not the least of which is that many people in Vienna at that time thought that masturbation by men led to insanity.

But the self-portraits are not simply an exhibition of nudity; they are an attempt at full disclosure of the self, a self-analysis, a pictorial version of Freud's *The Interpretation of Dreams*. In an essay entitled "Live Flesh," the philosopher and art critic Arthur Danto has written:

> Eroticism and pictorial representation have co-existed since the beginning of art. . . . But Schiele was unique in making eroticism the defining motif of his impressive . . . oeuvre. [Schiele's paintings] are like illustrations of a thesis of Sigmund Freud . . . that human reality is essentially sexual. What I mean is there is no art-historical explanation of Schiele's vision.[3]

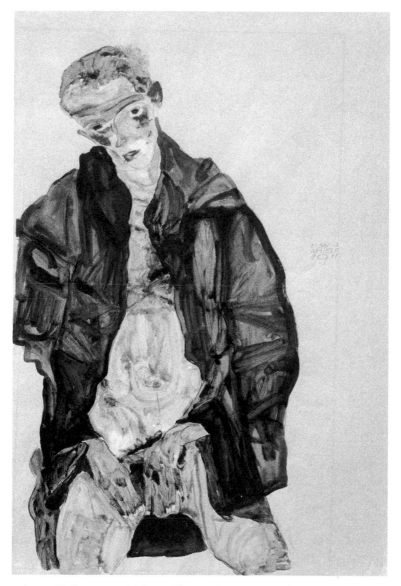

Figure 10-5. Egon Schiele, *Self-Portrait as Semi-Nude with Black Jacket* (1911). Gouache, watercolors, and pencil on paper.

Schiele's naked full-body portraits are largely without precedent in Western art. Schiele carried the nude to another level: he created a new, autoerotic art to reveal his unconscious sexual striving. His images force the viewer to be aware of the powerful erotic and aggressive tendencies within the artist. Only decades later, in the work of the British

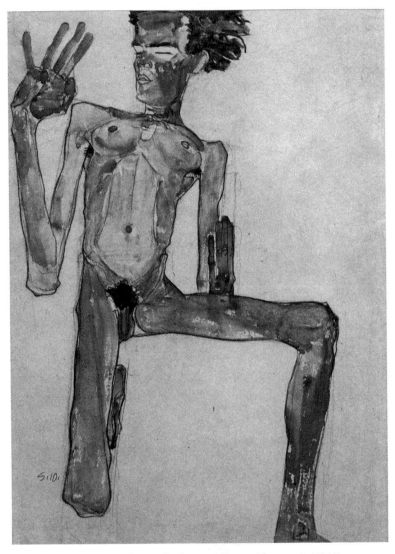

Figure 10-6. Egon Schiele, *Kneeling Self-Portrait* (1910).
Black chalk and gouache on paper.

artists Francis Bacon, Lucian Freud, and Jenny Saville, and the American artist Alice Neel, did a painter attempt to use his or her own naked body to convey a historic and artistic message in the way that Schiele did.

In these works Schiele also introduces a new kind of figurative iconography, extending Kokoschka's emphasis on hands and arms to the whole body. In the very large naked self-portraits, such as *Kneeling Self-Portrait* (Fig. 10-6) and *Sitting Self-Portrait* (Fig. 10-7), any re-

maining traces of Klimt's elegant influence have vanished. Perhaps influenced by Van Gogh or by Kokoschka's oil paintings, Schiele often used short, confident strokes in the portraits of 1910, visualizing aggression and transforming the dream state of Art Nouveau into an oppressive, tortured reality—the terror of everyday life. The viewer is unable to escape the sense of a foreboding physical presence.

Schiele also uses dramatic anatomical distortions, such as scarred and distressed skin and pale, often ghastly hues, to convey extreme despair, perverse sexuality, or decay from within. This view of human nature aligns him with Freud's reimagining of human beings as a composite of inner compulsions and hidden histories. In more general terms, Schiele was perhaps the first modern artist to capture in his body the anxiety that haunts contemporary humankind—the fear of being overwhelmed psychologically by an influx of external and internal sensory stimuli.

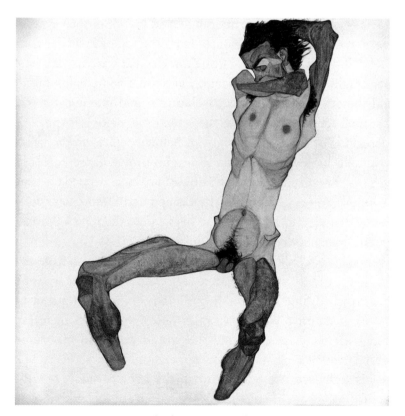

Figure 10-7. Egon Schiele, *Sitting Self-Portrait, Nude* (1910).
Oil and opaque colors on canvas.

—

IN ESTABLISHING HIS own expressionist style, Schiele introduced into his work what the art historian Alessandra Comini refers to as his artistic formula: isolation of the figure (or figures); frontal presentation and alignment of the axis of the figure with the central axis of the canvas; and an emphasis on oversized and gnarled eyes and hands, and on the whole body. The overall effect of these exaggerated features is, again, a disquieting sense of anxiety. In addition, as the art historian Jane Kallir writes, "Both in Schiele's drawing and his paintings, line was the unifying force. . . . A metamorphosis was thus completed: by substituting emotional effect for decorative effect . . . Schiele unmasked the sensual, sinister world. . . ."[4]

In his 1915 *Self-Portrait with Striped Armlets,* Schiele presents himself as a social misfit, a clown or fool (Fig. 10-8). The armlets, with their vertical stripes, recall the typical costume of a court jester. The artist has colored his hair bright orange, and his wide-open eyes hint at madness. His head tilts precariously from the top of a slender neck. In another self-portrait (Fig. 10-9), the force of his anxious expression is further heightened by the application of a thick white halo of gouache around the outlines of his head, isolating it and making it stand out against the background while at the same time making it appear large and deserving of emphasis. Moreover, Schiele depicts an immense territory above his eyes—a gigantic forehead and a deeply furrowed brow. This portrait suggests that Schiele may have wanted to recapitulate Klimt's earlier depiction of the decapitated Holofernes, but with himself as the victim: he has placed his head at the top of the sheet of paper, emphasizing that his body is missing.

Even Schiele's "talking hands" are very different from Kokoschka's (Figs. 10-6, 10-7, 10-8). They are exaggerated, theatrical, spasmodic, the outstretched fingers resembling the cut branches of a tree or the hands of a hysterical patient. Comini describes how Schiele experimented with secret gestures that he would repeat in his paintings. These included placing an extremely elongated finger of his right hand under his right eye and pulling down the lower eyelid to reveal the white of the eyeball. He also depicted his head in a variety of ways. Comini asks of these self-portraits, "Why did Schiele's work assume such imperious intensity at this time and how did he fashion a new ar-

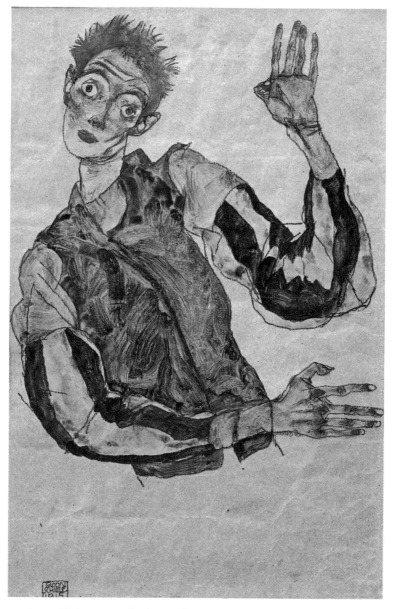

Figure 10-8. Egon Schiele, *Self-Portrait with Striped Armlets* (1915).
Pencil with covering color on paper.

tistic vocabulary that called for this concentrated vision of himself?"
She answers:

There are several external and internal explanations. One is the
concern with self that prevailed in turn-of-the-century Vi-

enna. . . . Living in the same city, moving in the same environment, and receptive to the same stimuli as . . . Sigmund Freud, Schiele partook in that general phenomenon of preoccupation with the psyche. Schiele's self-portraits, and those of . . . Kokoschka as well, deal intuitively with those aspects of sex and personality given scientific identification and analysis by Freud.[5]

Stylistically, the self-portraits seem to have had several influences, all based in biology. The first influence was the pictures of Charcot's hysterical patients, with their hands and arms assuming a variety of abnormal, contorted positions. The pictures of these patients were so popular that the Salpêtrière Hospital published a bimonthly journal from 1888 to 1918 that focused less on hysteria and more on neurological diseases such as macrodactyly—the enlargement of a single finger—infantile gigantism, and various myopathies that cause distor-

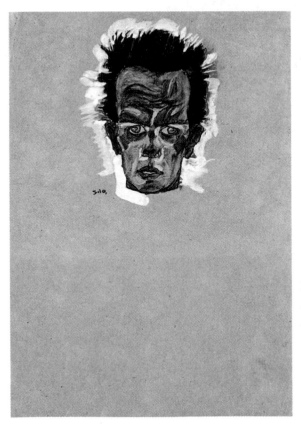

Figure 10-9. Egon Schiele, *Self-Portrait, Head* (1910). Water, gouache, charcoal, and pencil on paper.

tions of bodily forms. In addition, Schiele must have seen, and perhaps been influenced by, the famous series of character heads in Vienna's Lower Belvedere Museum sculpted by Franz Xaver Messerschmidt in the 1780s and depicting highly dramatic mental states (see Chapter 11) (Fig. 10-11). Schiele is also thought to have been influenced by his friend Erwin Osen, who studied the expressions of the disturbed patients in Steinhof, a psychiatric hospital on the outskirts of Vienna, and then used them in his painting. Erwin von Graff, a physician who had been trained in pathological anatomy in the tradition of Rokitansky and who conveyed his perspective to Schiele, gave the artist permission to draw the patients in his clinic. These patients may have imprinted on Schiele's mind the image of the diseased and distorted human body that appears repeatedly in his paintings.

But perhaps the most important influence on Schiele was his own precarious psychological state. Watching his father become increasingly psychotic may very well have terrified him and raised in his mind the specter that he, too, might someday go mad.

IN 1911 SCHIELE, then twenty-one, met Valerie Neuzil, a seventeen-year-old redhead who called herself Wally. A former model and perhaps mistress of Klimt, she became Schiele's model and his lover. Under Wally's influence, Schiele developed a much better sense of the range of female eroticism, and this led him to focus on pubescent sexuality. Schiele was fascinated by adolescent sexuality, and he posed the pubescent girls who modeled for him in sexually explicit positions. In this respect, too, Schiele's Expressionism was new. Although the depiction of adolescent female sexuality introduced into Western art by Gauguin, Munch, and Kokoschka was to become common among the German expressionists, neither they nor Kokoschka ever depicted the overt, disturbing explorations of pubescent sexuality that Schiele did.

Some of Schiele's images, unlike those of the earlier artists, focus explicitly on genitalia and sexual acts. In *Crouching Female Nude with Bent Head* of 1918 (Fig. 10-12), for example, Schiele conveys a girl's feelings by depicting her with her head deeply bowed and an expression of wistful melancholy on her face. Long, loose strands of hair frame her face, as if she were searching for protection and security. In paintings such as *Love Making* of 1915 (Fig. 10-13), sexuality, eroticism, world-weariness, exhaustion, and fear fuse to express the insepa-

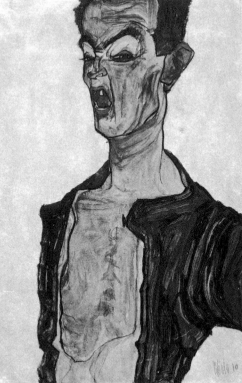

Figure 10-10.
Egon Schiele,
*Self-Portrait Screaming*
(unknown).

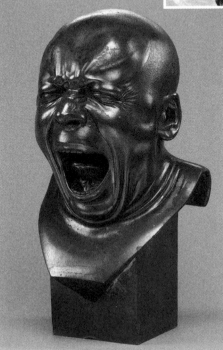

Figure 10-11. Franz
Xaver Messerschmidt,
*The Yawner*
(after 1770). Lead.

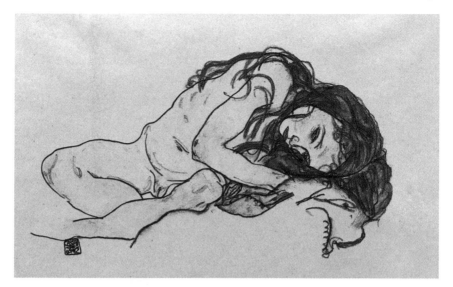

Figure 10-12. Egon Schiele, *Crouching Female Nude with Bent Head* (1918). Black chalk, watercolor, and coating paint on paper.

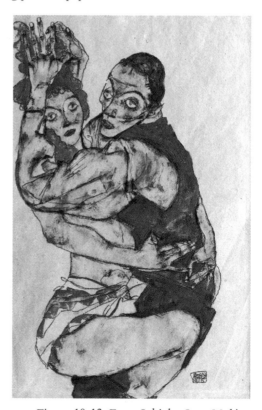

rability of Eros and anxiety. The nudes in Schiele's paintings, perhaps projecting the artist's own feelings, are often so austere, unsmiling, and frightened that they appear almost like expressionistic caricatures of the elegant, relaxed, self-indulgent ladies whom Klimt painted.

Schiele's first model was his sister Gerti, who was initially uncomfortable posing in the nude. He used child or teenage models in part because he did not have the money to pay for adult models and in part

Figure 10-13. Egon Schiele, *Love Making* (1915). Pencil and gouache on paper.

because, being young himself, he may have been more comfortable working with young models. Indeed, some of the models in Schiele's early works were just a few years younger than he. Their latent sexuality presumably corresponded to his own awakening feelings and represented his attempts to answer adolescents' perennial questions about sexuality.

In 1912, acting on suspicions that Schiele was kidnapping and taking sexual advantage of a minor, the police raided his studio in Neulengbach, a small town about twenty miles outside Vienna. It is generally thought unlikely that Schiele had sex with any of these young girls, because Wally was with him at his studio when the girls posed. Yet there is no question that Schiele asked the children, who came from conventional, middle-class homes, to pose for him nude and that he did so repeatedly, without obtaining their parents' consent. One of the girls apparently fell in love with him and came to his studio one night, refusing to leave. Wally helped get the girl back to her father, who responded by bringing charges of kidnapping and rape against Schiele. Schiele was arrested, convicted of immorality on the basis of suspicions, and imprisoned for twenty-four days on one count of having made drawings that the judge deemed pornographic. The judge proceeded to fine him and to burn in the courtroom a drawing that had been confiscated from Schiele's studio.

Back in Vienna, two years after meeting Wally, Schiele met Adele and Edith Harms, two well-educated sisters about his own age and of his own social class who moved into a building across the street from where he lived. Schiele asked Wally to intercede with them on his behalf so he could meet them. For a while he was interested in both sisters, but by 1915 he had fallen in love with Edith, the younger sister, and they planned to marry.

In response to Edith's ultimatum that marriage to her meant breaking up with Wally, Schiele painted the haunting double portrait *Death and the Maiden* (Fig. 10-14) as a farewell to Wally. In the painting—a view from above—Wally and Schiele are lying on a mattress covered with white sheets. Schiele is easily recognizable, wearing a monkish gown and comforting Wally, who embraces him, her face resting on his chest. She wears a lace undergarment in which Schiele has previously painted her. The fact that the white sheet is rumpled and lying on the ground suggests that they have just engaged in sex. Although the two

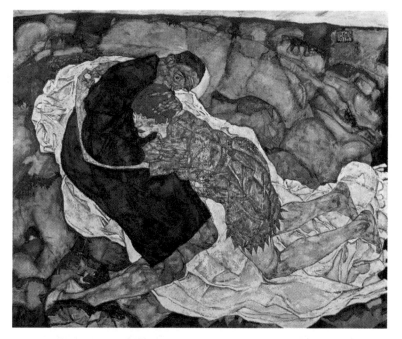

Figure 10-14. Egon Schiele, *Death and the Maiden* (1915). Oil on canvas.

are lying in a postcoital embrace, they actually stare past each other into space, as if Schiele's mind were already elsewhere. Schiele, depicted here as the messenger of death, looks devastated at the impending loss of the woman who helped him through a difficult period in his life and with whom he has had a close, meaningful relationship. He has terminated it, presumably, not just because of Edith's ultimatum, but also because he chose to: Wally was of a lower social class, and quite promiscuous—characteristics that Schiele, now aspiring to more conventional values, hoped to leave behind him in marrying Edith.

*Death and the Maiden* is often compared to Kokoschka's *The Wind's Fiancée*, depicting his tumultuous relationship with Alma Mahler, but the two paintings are actually quite different. In both works, the men are anxious, but in *The Wind's Fiancée* Alma Mahler is sleeping calmly, whereas in *Death and the Maiden* Wally is experiencing a sense of isolation and desperation comparable to Schiele's own. She senses abandonment, he a lack of fulfillment. In Schiele's world no one is ever safe.

SCHIELE STRUGGLED EARLY in his life with the image of himself as a man, a conflict he reveals in several double self-portraits of himself as

a doppelgänger, or double walker. The doppelgänger, a popular theme of German Romantic literature, is the ghostly counterpart of a person who acts just as the person does. Although the doppelgänger can take the form of a protector or imaginary companion, it is often a harbinger of death. In folklore, the doppelgänger is a phantom of the self: it casts no shadow and has no reflection in a mirror. Schiele uses the doppelgänger in both senses in his double self-portraits. In *Death and Man (Self-Seers II)* of 1911 (Fig. 10-15), Schiele fuses what appears to be either his own face or his father's face with the skeleton-like figure of death standing behind him. As with many of Schiele's works, the image is both frightening and intriguing.

The artist returns to his concern with the father a year later in another double portrait, *Hermits* (Fig. 10-16). This portrait shows him and Klimt and is perhaps influenced by the image of Kokoschka and Klimt in *The Dreaming Youths,* a copy of which Schiele owned. In Kokoschka's color lithograph, the younger artist is leaning on Klimt, his

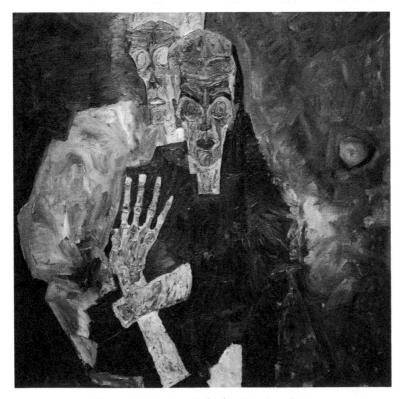

Figure 10-15. Egon Schiele, *Death and Man (Self-Seers II)* (1911). Oil on canvas.

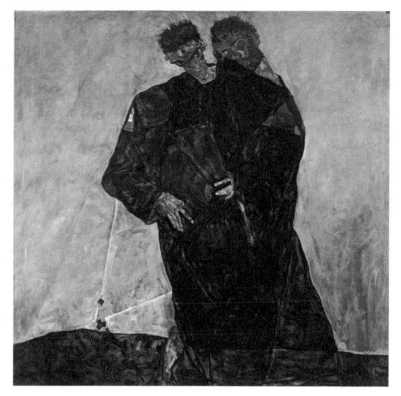

Figure 10-16. Egon Schiele, *Hermits*
*(Egon Schiele and Gustav Klimt)* (1912). Oil on canvas.

mentor and guide, for support. But in Schiele's portrait, Klimt—Schiele's artistic father—is leaning on him for support. In 1912 Klimt was still at the peak of his career, the dominant force in the artistic world of Vienna, yet in the painting he seems barely to hang on, not only to Schiele but to life itself. In fact, his wide, blank eyes suggest that he is blind. Schiele's double portrait may well reflect the artist's unconscious, Oedipal desire to eliminate his imagined rival, Klimt, and succeed him as Vienna's top artist.

Schiele was not without humor, however. Perhaps the most well-known example of his satirical humor is the painting *Cardinal and Nun (The Caress)* (Fig. 10-17), a parody of Klimt's famous painting *The Kiss* (Fig. 10-18). Schiele's painting of a taboo, forbidden kiss of a nun by a priest is made all the more ironic because Wally posed as the nun. But Schiele greatly admired Klimt, and as Kallir has argued, was the artist who was most influenced stylistically by him. This is evident not only in Schiele's early paintings (Figs. 10-3 and 10-4), but in his late draw-

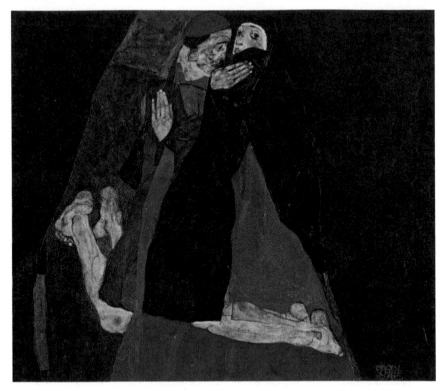

Figure 10-17. Egon Schiele, *Cardinal and Nun* (1912). Oil on canvas.

ings (Fig. 8-3), in which he sketched women enjoying their sexuality in a Klimtian manner.

Klimt died on February 6, 1918. When Schiele heard of his death, he went to the morgue, where he drew Klimt's face as a last tribute. During the next nine months, Schiele worked for the first time completely out of Klimt's shadow. With Klimt dead and Kokoschka living in Berlin, Schiele became Vienna's most important painter. His work was eagerly sought out, and his earnings increased dramatically.

Schiele died suddenly, of pneumonia, on October 31, 1918, just three days after his wife had succumbed to the same disease. Both had developed pneumonia as a complication of the Spanish influenza pandemic that was sweeping Europe.

SCHIELE'S DEATH MARKED the end of the expressionist era in Vienna, an era that saw the first step toward a potential dialogue between science and art. The five giants who emerged from Vienna 1900 could trace their immense accomplishments in psychoanalysis, literature, and

art—directly or indirectly—to the scientific influence of Rokitansky's view that surface appearances are deceptive and that to obtain the truth, we need to go deep below the surface. However, none of these five had taken the next step. While Freud was deeply influenced by art and believed that it tapped into the unconscious mind of the viewer, he could not see this connection in the very art being made in front of him. Thus Vienna 1900 had not linked biological science or Freud's dynamic psychology to art in a meaningful way. Moreover, Vienna 1900 had not produced either a cognitive psychology of how the viewer responds to art or a biological understanding of unconscious emotion and the viewer's response to emotion in art. But such psychological and biological insights were to emerge soon, beginning in Vienna in 1930 and continuing to this day.

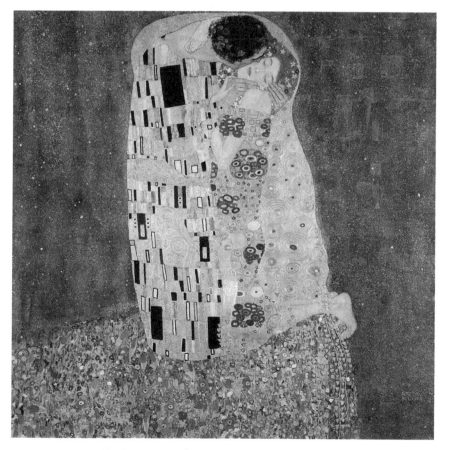

Figure 10-18. Gustav Klimt, *The Kiss* (1907–8). Oil on canvas.

PART TWO

...

A COGNITIVE
PSYCHOLOGY OF
VISUAL PERCEPTION
AND EMOTIONAL
RESPONSE TO ART

*Chapter 11*

# DISCOVERING THE
# BEHOLDER'S SHARE

᧤⌣᧥

THE PSYCHOLOGICAL AND ARTISTIC CONVERGENCE OF SIGMUND
Freud, Arthur Schnitzler, Gustav Klimt, Oskar Kokoschka, and Egon
Schiele on different aspects of unconscious instincts raises several ques-
tions: Did these pioneers realize they were moving along parallel lines?
If so, did Schnitzler and Freud make any attempt to initiate a dialogue
between themselves? Did Klimt, Kokoschka, and Schiele? Was there
any attempt to link the psychological and the artistic approaches to un-
derstanding unconscious drives?

In fact, the painters did interact with one another, as did Freud and
Schnitzler. Klimt, the father of Austrian Modernism, strongly sup-
ported and influenced Kokoschka and Schiele. The two younger artists
admired Klimt, although both later broke away from his influence and
developed their own distinctive expressionist style. Schiele recognized
Klimt as the founder of the modernist school that had molded him, and
even though he did not acknowledge it, Schiele was also influenced by
the early Kokoschka, the first true Viennese expressionist.

Freud and Schnitzler—both physicians and scientists who matured
in the Rokitanskian atmosphere of the Vienna School of Medicine—saw
each other as doppelgängers, or intellectual look-alikes. Each dealt in a
different way with the same intellectual themes, Freud as a psycholo-
gist and Schnitzler as a writer, and each read and appreciated the other's
work.

The relationship of Freud and Schnitzler to the artists, and the art-
ists to them, was at best unidirectional. Neither Freud nor Schnitzler
valued the work of the artists, and neither recognized that the artists

were also concerned with exploring the unconscious. On the other hand, it is inconceivable that the artists were not aware of, and influenced by, Freud's and Schnitzler's work. Schnitzler was, with Hugo von Hofmannsthal, the most important Austrian writer of the time, and with the publication of *The Interpretation of Dreams*, Freud became a celebrity, a major cultural force in Vienna. Kokoschka's ideas were clearly similar to Freud's, although he insisted that he had developed them independently. Kokoschka was widely read and very knowledgeable; moreover, his early supporters, Karl Kraus and Adolf Loos, were intellectuals who knew Schnitzler's and Freud's work well. Klimt had, in addition, a deep interest in biology and medicine.

OF THE FIVE, only Freud attempted to link art and science. He wrote major papers about the creative process of two Renaissance artists he admired, Leonardo da Vinci and Michelangelo, but in neither case did he address the psychology of perception, what the viewer brings to a work of art. Rather, he focused on the psychology of the artist.

In the more famous of these essays, "Leonardo da Vinci and a Memory of His Childhood," written in 1910, Freud analyzed Leonardo's life and the evolution of his work, based in good part on the artist's notebooks and particularly on a childhood recollection. Leonardo was born out of wedlock, and he spent his early childhood years with his unmarried mother. Freud argues that Leonardo's mother was typical of unsatisfied mothers living without a husband: she kissed her son passionately, doted on him, and sought from him an unusually intimate love. This behavior led to Leonardo's persistent attachment to his mother and to the premature maturation of the boy's eroticism, a developmental pathway that, Freud argues, led to Leonardo's tendencies toward homosexuality. Freud identified those tendencies both in Leonardo's childhood recollections, in which the artist experienced sensations centering on his mouth, and in his later deep emotional involvement with male students.

In analyzing the development of Leonardo's work, Freud focused on the artist's shift from an early interest in painting to a later interest in science. Freud interpreted the shift as representing a flight from the engagement with human emotions that characterizes the artist to the impersonality that characterizes the scientist. He attributed this pro-

gression to Leonardo's unconscious psychological conflict: that is, to his repudiation of his homoerotic nature.

Freud treats Leonardo's early work in art and his later work in science as if they were clinical symptoms. He analyzes the scant biographical details available about Leonardo as if they could provide insight into the artist's psyche. But without Leonardo's own elaborations through the give-and-take of free association in a psychoanalytic session, Freud had no way of testing or evaluating his interpretation of a dream—or any of his other conclusions, for that matter. Nor, as the art historian Meyer Schapiro has pointed out, did Freud know enough about the history of art and the scholarship on Leonardo to avoid misinterpretations that would allow him to write a meaningful art historical essay on the artist. Finally, Freud did not address what emerged as the critical theme in the dialogue between science and art: What is the nature of the viewer's response to art?

As a result, Freud's writing on art is interesting and informative, but it does not represent his best thinking. Despite their weakness, the essays nonetheless proved important historically because they were the first attempt to initiate a dialogue between psychoanalytic psychology and art.

Influenced in part by Freud's work, three members of the Vienna School of Art History brought about the needed conceptual advance in the dialogue between psychology and art history: Alois Riegl, whom we first encountered in Chapter 8, and Ernst Kris and Ernst Gombrich, two younger disciples. Working together and independently, these three focused on the beholder's response to a work of art and thereby laid a foundation for the emergence of a holistic, cognitive psychology of art that was substantially deeper and more rigorous than the dialogue Freud had attempted and that later served as the foundation for the emergence of a biology of aesthetics.

RIEGL WAS THE FIRST art historian who systematically applied scientific thinking to art criticism (Fig. 11-1). He and his colleagues at the Vienna School of Art History, in particular Franz Wickhoff, attained international renown at the end of the nineteenth century for their efforts to establish art history as a scientific discipline by grounding it in psychology and sociology.

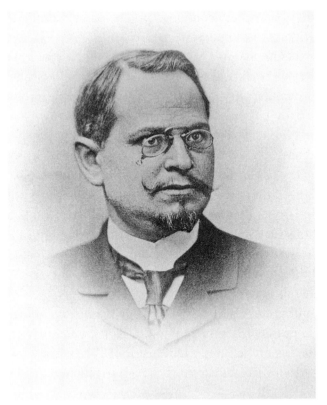

Figure 11-1. Alois Riegl (1858–1905). Riegl was an art historian and member of the Vienna School of Art History. By incorporating elements of psychology and sociology into art history, he helped establish it as a self-sufficient academic discipline. Riegl believed that artistic styles and aesthetic judgments are historically contingent on, and generated by, changes in cultural values and norms. This concept opened the door to a new understanding of art as an active and engaged cultural commentary, a theme picked up by Ernst Kris, Ernst Gombrich, and other members of the Vienna School of Art History.

In addition, Riegl's rigorous analytical approach made it possible to compare works of art from different historical periods and thus to formulate common principles. In the process, he and Wickhoff resurrected transitional periods in art history that had previously been ignored and documented their importance. For example, earlier art historians had dismissed late Roman and early Christian art as decadent in comparison to Greek art. Wickhoff, in contrast, regarded the art of these periods as highly original. While acknowledging the debt of Roman art to Greek art, he pointed out that in response to new cultural

values, Roman artists developed an illusionist style in the second and third centuries that was not to appear again before the seventeenth century. Wickhoff also created a new appreciation for early Christian art by outlining its unique narrative principles.

Riegl, Wickhoff, and the Vienna School argued that in art history, as in political history, what counts is, as Carl Schorske paraphrases it, "the equality of all eras in the eyes of God."[1] To appreciate what is unique to each cultural period, Riegl argued, we need to understand each period's intention and purpose in art. This allows us to see not simply progress or regression, but an endless series of transformations not limited by a simple, a priori aesthetic standard. In this way, Wickhoff, Riegl, and their colleagues gradually succeeded in shifting the focus of thinking in art history from the content and meaning of specific paintings to a broader concern with the structure of works and the historical and aesthetic principles underlying the development of style in art.

In 1936 Meyer Schapiro, an American art historian, called attention to these efforts of the Vienna School by recognizing "their constant search for new formal aspects of art and their readiness to absorb [into art history] the findings of contemporary scientific philosophy and psychology. It is notorious how little American writing in art history has been touched by the progressive work of our psychologists, philosophers, and ethnologists."[2] Seen in this perspective, we can appreciate why Riegl and his associates at the Vienna School, including his younger associates Max Dvořák and Otto Benesch, championed the new art that emerged in Vienna 1900.

In studying the group paintings of seventeenth-century Holland, such as Frans Hals's *A Banquet of the Officers of the St. George Militia Company* and Dirck Jacobsz's *Civic Guards* (Figs. 8-14 and 11-2), Riegl discovered a new psychological aspect of art: namely, that *art is incomplete without the perceptual and emotional involvement of the viewer.* Not only does the viewer collaborate with the artist in transforming a two-dimensional likeness on a canvas into a three-dimensional depiction of the visual world, the viewer interprets what he or she sees on the canvas in personal terms, thereby adding meaning to the picture. Riegl called this phenomenon the "beholder's involvement" (Gombrich later elaborated on it and referred to it as "the beholder's share").

This conception—that art is not art without the direct involvement of the viewer—was elaborated upon by the next generation of Vien-

Figure 11-2. Dirck Jacobsz, *Civic Guards* (1529). Oil on panel.

nese art historians: Ernst Kris and Ernst Gombrich. Based on ideas derived from Riegl and from contemporaneous schools of psychology, they devised a new approach to the mysteries of visual perception and emotional response incorporated that approach into art criticism. This radical change was described many years later by the Gestalt psychologist Rudolf Arnheim, who wrote:

> With the turn towards psychology, the theory of art began to take cognizance of the difference between the physical world and its appearance, and, subsequently, of the further difference between what is seen in nature and what is recorded in an artistic medium. . . . What is seen depends on who is looking and who taught him to look.[3]

KRIS BROUGHT A UNIQUE perspective to art criticism. In 1922 he received a doctorate in art history from the University of Vienna, where he worked with Dvořák and Julius Schlosser, both students of Wickhoff. Influenced by his future wife, Marianne Rie, the daughter of Freud's friend Oskar Rie, Kris became interested in psychoanalysis. He underwent psychoanalytic training in 1925 and three years later became a practicing psychoanalyst. Kris met Freud in 1924, and Freud asked him, in his capacity as an art historian, to review parts of the collection of antiquities he had begun to assemble in 1896. As they began to interact, Freud realized that Kris was in a key position to contribute to both art history and psychoanalysis. He urged Kris to continue both as a curator and as a psychoanalyst, which Kris did until he was forced to flee Vienna in September 1938 (Fig. 11-3).

In 1932 Freud invited Kris to work with him on *Imago,* the journal

he had founded to bridge cultural divides, such as that between art and psychology, with insights derived from psychoanalysis. Kris shifted the emphasis of psychoanalytic art criticism from Freud's psychobiography of artists to an empirical investigation of the perceptual processes of the artist and the beholder. Kris's study of ambiguity in visual perception led him to elaborate on Riegl's insight that the viewer completes a work of art.

Kris argued that when an artist produces a powerful image out of

Figure 11-3. Ernst Kris (1900–1957). This photograph was taken in the mid-1930s, while Kris was conducting his study on exaggeration and the perception of expressed emotion in Messerschmidt's bronze character heads and on Expressionism in general. Kris was appointed curator of sculpture and applied arts at the Vienna Museum of the History of Art in 1927, and in 1928 became a member of the Vienna Psychoanalytic Society. He made use of his combined perspectives on art history and psychoanalysis to initiate a new approach to art.

his or her life experiences and conflicts, that image is inherently ambiguous. The ambiguity in the image elicits both a conscious and an unconscious process of recognition in the viewer, who responds emotionally and empathically to the image in terms of his or her own life experiences and struggles. Thus, just as the artist creates a work of art, so the viewer re-creates it by responding to its inherent ambiguity. The extent of the beholder's contribution depends on the degree of ambiguity in the work of art.

In speaking of ambiguity, Kris was referring to an idea that the literary critic William Empson introduced in 1930, namely, that ambiguity exists when "alternative views [of a work of art] might be taken without sheer misreading."[4] Empson implies that ambiguity allows the viewer to read the aesthetic choice, or conflict, that exists within the artist's mind. Kris, on the other hand, argues that ambiguity enables the artist to transmit his own sense of conflict and complexity to the viewer's brain.

Kris was also familiar with the Swiss-German art historian Wilhelm Worringer's 1908 essay "Abstraction and Empathy: A Contribution to the Psychology of Style." Strongly influenced by Riegl, Worringer argues that two sensitivities are required of the viewer: *empathy,* which allows the viewer to lose himself or herself in a painting and be at one with the subject, and *abstraction,* which allows the viewer to retreat from the complexities of the everyday world and follow the symbolic language of the forms and colors in a painting.

WHILE STUDYING WITH DVORÁK, who regarded the elongated features and distorted perspective of the mannerist painters as precursors of Austrian Expressionism, Kris began to focus on how artists use distortion to convey their insights into a subject's psyche and how viewers respond to that distortion. Through Karl Bühler, a Gestalt psychologist who chaired the Department of Psychology at the University of Vienna, Kris became interested in the scientific analysis of facial expressions. These interests formed the basis of his first attempt to combine his training in art history with his psychoanalytic insights. In two studies, published in 1932 and 1933, Kris focused on the exaggerated facial expressions of the remarkable series of heads sculpted in the 1780s by Franz Xaver Messerschmidt, the extraordinarily gifted por-

trait sculptor whose work was exhibited in the Lower Belvedere Museum in Vienna 1900 and who very likely influenced Kokoschka and Schiele in their breakthrough to Expressionism.

In 1760, at the age of only twenty-four, Messerschmidt already enjoyed considerable success as an artist working in the court of Vienna. He was invited to sculpt a bronze bust of the Empress Maria Theresa and other important personages. In these early portraits, Messerschmidt emphasized, in characteristic Baroque style, the aristocratic origins and grand appearance of his sitters. In 1765 he traveled to Rome, where his style began to evolve along more classical lines. When he returned to Vienna, he adopted a less ornate style, dispensing with drapery, presenting heads more simply and straightforwardly, and no longer idealizing faces. He lived for a while in the house of Franz Anton Mesmer, who developed hypnosis as a treatment for psychological disorders and inspired Messerschmidt's later interest in the psyche.

As a highly regarded and accomplished assistant professor of sculpture at the Imperial Academy of Vienna, Messerschmidt shared the general expectation that he would be promoted to the chair of sculpture when the current chairperson died. When the time came, however, Messerschmidt was passed over; in fact, he lost his teaching position, perhaps because those making the decision were concerned that he had not yet recovered from a mental illness, later thought to be a paranoid form of schizophrenia, that had struck him three years earlier. Deeply offended by this rejection, Messerschmidt left Vienna in 1775 and ultimately settled in Pressburg (now Bratislava) in 1777. There, he devoted himself to sculpting over sixty bronze character heads depicting his—and perhaps other people's—mental states, made while observing his facial expressions in a mirror. These extraordinary heads feature dramatic, distorted, and at times exalted expressions conveying wildly different emotions (Figs. 11-4, 11-5).

The heads fascinated Kris. They showed him that someone who appeared to suffer from the symptoms of paranoia could nevertheless produce a marvelous body of art. Clearly, Messerschmidt's internal conflicts did not hinder his imagination—in fact, the character heads, done while he was ill, are even more original than the excellent work he had done earlier. Moreover, the heads are beautifully sculpted, indicating that Messerschmidt's great technique was not impaired by his illness.

Figure 11-4.
Franz Xaver Messerschmidt,
*The Yawner* (after 1770).
Lead.

Figure 11-5.
Franz Xaver
Messerschmidt,
*Arch-Villain*
(after 1770).
Tin-lead alloy.

Kris saw the emotion expressed in the heads as at once establishing contact with the viewer and conveying conscious and unconscious messages about the artist's psychotic condition—his compulsive experiencing of paranoid delusions and hallucinations. It struck Kris that the most fantastic, exaggerated heads were also the most advanced stylistically, whereas the less exaggerated heads were the most conventional. This observation reinforced his conviction of the power of caricature to convey emotion and to influence the brain's perceptual and empathic processes.

In 2010, eighty years after Kris's study of Messerschmidt, Donald Kuspit, a professor of art history and philosophy at SUNY Stony Brook, reviewed a Messerschmidt retrospective for *Artnet* magazine and entitled it "A Little Madness Goes a Long Creative Way." Citing Kris's seminal ideas and putting Messerschmidt's work in a twenty-first-century context, Kuspit writes:

His [Messerschmidt's] madness proved to be strangely liberating. Leaving cosmopolitan Vienna for his provincial hometown he began to make art that was true to himself—art that was as mad as he was. . . . Sculpting his mad face . . . he became a True Self. His demons were now his muses, and he made the creative best of them by portraying them. He had to, because they never disappeared from his mirror. . . . Messerschmidt took pleasure from his madness, the pleasure that he denied himself during his painful ascent to the social heights of art.[5]

IN EMPHASIZING THE CREATIVE aspect of the beholder's share, Kris not only acknowledged common aspects of creativity between artists and viewers, but also implicitly recognized common aspects of creativity between artists and scientists. Like Kokoschka, Kris realized that figurative painting presents a model of reality (or in the case of a portrait, a model of a person) that relies on a process of investigation and discovery in much the same way that science does, whether the science is cognitive psychology or biology. Gombrich later referred to this process of investigation as "visual discovery through art."[6]

In 1931, as he was beginning his first study of Messerschmidt, Kris met Gombrich (Fig. 11-6), who had just obtained his doctorate in art history and who would later emerge as one of the most influential art

historians of the twentieth century. As they began to interact, Kris shared his underlying concern, derived from Riegl, that art historians knew too little about the deeper structure of art to reach any valid conclusions; he strongly encouraged Gombrich to incorporate psychological thinking into his work. Gombrich became deeply interested in Kris's approach and in later years repeatedly emphasized that Kris, more than anyone else, had pointed him in the direction of the psychology of perception, the field to which Gombrich devoted the rest of his very productive career.

Kris asked Gombrich to join him in writing a book on psychology and the history of caricature, which he saw as "a series of experiments on the reading of facial expressions."[7] He also asked Gombrich to assist in mounting a major exhibition in 1936 centered on the caricatures of Honoré Daumier, the nineteenth-century printmaker, painter, and sculptor.

In the course of their work together, Kris and Gombrich began to see expressionist painting as a reaction against conventional means of depicting faces and bodies. The new style derived from a fusion of two

Figure 11-6. Ernst Gombrich (1909–2001). Once a student of Ernst Kris, Gombrich became a professor of art history at the University of London and author of the groundbreaking books *The Story of Art* (1950) and *Art and Illusion* (1960). In the latter he explores the psychology of perception and its influence on the interpretation of art. Gombrich was one of the first art historians to apply Gestalt psychology and the cognitive psychology of perception to the understanding of art.

traditions: high art, derived from the mannerists, and caricature, introduced at the end of the sixteenth century by Agostino Carracci. Carracci, a mannerist artist, used distortion and exaggeration to emphasize individual identifying features (Fig. 11-7). Later, Gian Lorenzo Bernini, a Roman architect and sculptor, took caricature to a new level. As Gombrich and Kris describe it in an unpublished manuscript that they later elaborated upon in their book *Caricature:*

> Bernini's drawings focused not on variations in bodily features but on the face alone and on the unity of facial expression. . . . Rather than single out and exaggerate distinctive physical traits . . . Bernini starts out with the whole, not with the parts; he conveys the image which we fix in our mind when we try to recall someone in memory, that is with the unified *expression* of the face—and it is this expression which he distorts and heightens.[8]

This holistic view, as we shall see, is a Gestalt principle that Bernini had grasped intuitively.

In thinking about caricature, Gombrich and Kris were struck with how late it arose in the history of art. They concluded that the appearance of caricature coincided with a dramatic change in the role of the artist and his position in society. By the end of the sixteenth century, the artist was no longer concerned with the mastery of the techniques required to represent reality. He was no longer a manual worker: he had become a creator. He now assumed a position in society that was comparable to that of a poet, who could form a reality of his own. We see this change first in Michelangelo's unfinished marble blocks of 1500, where the sculpture is emerging from the rock. We encounter it more extensively in Leonardo's and Titian's explorations of the power of oil paint on canvas. Finally, we see the central role of the artist unambiguously announced in 1656 in Velázquez's *Las Meninas.* This change in the artist's role culminates, as Gombrich writes, in the attempt of expressionists to make art a mirror of the artist's conscious or unconscious mind.

With Kris's encouragement, Gombrich began to develop a multipronged approach to art, combining insights from psychoanalysis, Gestalt psychology, and scientific hypothesis testing. Gombrich's insights

Figure 11-7. Agostino Carracci, *Caricature of Rabbatin de Griffi and His Wife Spilla Pomina*. Pen and ink on paper.

into psychoanalysis came from Kris. The Gestaltist influence came initially from Bühler. The idea of perception as hypothesis testing came, as we shall see, from Hermann von Helmholtz and Karl Popper.

GESTALT PSYCHOLOGISTS BROUGHT two radically new concepts to bear on visual perception. They insisted that the whole is more than the sum of its parts and that our ability to grasp those relationships—to evaluate sensory information holistically and assign it meaning—is largely inborn.

The German word *Gestalt* means configuration, or form. Gestalt psychologists use it to refer to the fact that in perceiving an object, a scene, a person, or a face, we respond to the whole rather than to the individual parts. We do this because the parts affect one another in such a way that the whole ends up being much more meaningful than the sum of its parts. For example, at the beginning of the twentieth century, Max Wertheimer was struck by the fact that when we look at a flock of geese migrating across the sky, we see the flock as a single entity and not as individual birds. This led him to write what would become a position statement for the Gestaltists:

> There are entities where the behavior of the whole cannot be derived from its individual elements nor from the way these elements fit together; rather the opposite is true: the properties of any of the parts are determined by the intrinsic structural laws of the whole.[9]

The Gestalt movement started in Berlin in about 1910 and was led by three psychologists: Wertheimer, Wolfgang Köhler, and Kurt Koffka. All three were students of the philosopher, physiologist, and mathematician Carl Stumpf, who in turn was a student of Franz Brentano at the University of Vienna. Brentano's ideas about perception, and those of his student Christian von Ehrenfels, were influenced by Ernst Mach's important contributions to the Analysis of Sensations, which laid out the vision of Gestalt psychology. In what is generally considered to be the founding paper of Gestalt psychology, "Gestaltqualitäten" ("On the Qualities of Form"), published in 1890, Ehrenfels provides a perfect example from everyday life: music. He points out that a melody consists of individual elements—individual notes—but is much more than the sum of these sounds. The same notes can be combined to yield a completely different melody. We perceive the melody as a whole and not as the sum of its parts because we have a built-in ability for doing so. Indeed, if a note were omitted, we would still recognize the melody.

These ideas set the stage for Gestalt psychology, and Gestalt psychology, in turn, had a far-ranging impact on research in perception. In fact, Arnheim, who was a student of Wertheimer and Köhler, devel-

oped a coherent psychology of art based on Gestalt psychology. He argued that just as perception is ordered and structured, so are works of art.

Before the Gestaltists emerged on the scene, psychologists had assumed that the sensory data that make up our perception of an image are the sum of sensory elements derived from the environment. The central idea of Gestalt psychology, however, is that what we see—our interpretation of any element in an image—depends not just on the properties of that element, but also on its interaction with other elements in the image and with our past experiences with similar images. Thus, because any image that is projected onto the retina of the eye has many possible interpretations, we must construct each image we see. In this sense, every image is subjective. Yet despite countless possibilities, children two to three years old come up with much the same interpretations of images in the world around them as older children do. Moreover, young children do this without being taught anything about vision by their parents (who may themselves be unaware of how creative their vision is).

Young children can interpret images because they are born with a brain whose visual system has a set of innate, universal cognitive rules for extracting sensory information from the physical world, similar to the rules that allow children to acquire grammar. The student of perception Donald Hoffman writes: "Without innate rules of universal vision, the child could not reinvent vision and the adult could not see. With innate rules of universal vision, we can construct visual worlds of great subtlety, beauty, and practical value."[10]

The insights of Gestalt psychology were revolutionary. Until the beginning of the nineteenth century, the chief method for understanding mind was introspection, and the academic study of normal mental activity was a subfield of philosophy. Introspection gave way later in the century to experimentation and eventually yielded to the independent discipline of experimental psychology. In its early years, experimental psychology was concerned primarily with the relation between a sensory stimulus and the subjective perception it elicits. By the turn of the twentieth century, experimental psychologists had narrowed their focus to observing behavioral responses to stimuli, and especially to understanding how those observable behavioral responses are modified by learning.

The discovery of simple experimental means of studying learning and memory, by Hermann Ebbinghaus in humans and later by Ivan Pavlov and Edward Thorndike in laboratory animals, led to a rigorous empirical school of psychology called behaviorism. Later behaviorists, notably J. B. Watson and B. F. Skinner in the United States, argued that behavior could be studied with the same precision achieved in the physical sciences, but only by abandoning speculation about what goes on in the brain and focusing exclusively on observable behavior. For behaviorists, unobservable mental processes, especially anything as abstract as perception, emotion, or conscious awareness, were simply inaccessible to scientific study. Instead, they concentrated on evaluating, objectively and precisely, the relationship between specific physical stimuli and observable responses in intact animals.

Their early successes in rigorously studying simple forms of behavior and learning encouraged the behaviorists to treat all processes that intervene between a stimulus (sensory input) and the resulting behavior (motor output) as irrelevant to a scientific study of behavior. During behaviorism's most influential period, the 1930s, many psychologists accepted the most radical behaviorist position: namely, that observable behavior is all there is to mental life. This emphasis reduced the domain of experimental psychology to a restricted set of problems, and it closed the door to studies of some of the most fascinating features of mental life. Psychoanalysis, on the one hand, and Gestalt psychology, on the other, opened that door and began to study the unconscious processes by which the brain creates its models of reality. Unlike psychoanalysis, Gestalt psychology was an empirical science whose hypotheses could be tested experimentally.

The ideas of Gestalt psychology, remarkable in their own right, were even more remarkable in the context of their time. Gestalt psychology emerged as psychologists in Germany and the United States were beginning to realize that the iron fist of behaviorism had created a "Crisis of Science."[11] Psychologists were seriously concerned with the inability of science to answer fundamental questions about how the human mind works: that is, how the brain mediates the various mental processes (perceiving, acting, thinking) that are commonly referred to as mind. The Gestalt psychologists insisted on the revolutionary idea that science was not the limiting factor, but rather how psychologists thought about science; the Gestaltists then formulated their powerful

ideas to reconnect the various fields of psychology with the natural sciences.

GOMBRICH REALIZED THAT the powerful, largely innate principles of Gestalt psychology apply primarily to the lower levels of visual perception, or "bottom-up" visual processing. Higher-order, or "top-down," perception also incorporates knowledge based on learning, hypothesis testing, and goals, which are not necessarily built into the developmental program of the brain. Because much of the sensory information that we receive through our eyes can be interpreted in a variety of ways, we must use inference to resolve this ambiguity. Based on experience, we must guess, given the current situation, what is the most likely image in front of us. The importance of top-down processing in visual perception had already been established by Sigmund Freud, who described *agnosias*—deficiencies in object recognition—in people who could accurately detect features such as edges and shapes, but could not put them together to recognize an object.

Gombrich brought his ideas on psychology and art together in his extraordinary book *Art and Illusion: A Study in the Psychology of Pictorial Representation*. In it he describes the brain's perceptual restructuring of an image as having two parts: *projection*, which reflects the unconscious, automatic rules that are built into the brain and guide our vision, and *inference*, or *knowledge*, which is based in part on inference and may be both conscious and unconscious. Like Kris, Gombrich was impressed by the parallels between the creative process of scientists and the inferential, creative model building undertaken by the artist and the beholder of art. In developing his ideas, Gombrich was influenced by Hermann von Helmholtz and the Viennese philosopher of science Karl Popper.

Helmholtz, one of the most important physicists of the nineteenth century, also made major contributions to many areas of sensory physiology and was the first modern, empirical scientist to study visual perception. In his earlier studies of tactile perception, he succeeded in measuring the speed with which electrical signals move along the axon of a nerve cell and found that it is surprisingly slow (about ninety feet per second) and that our reaction time is slower still. This discovery caused him to propose that much of the brain's processing of sensory information is carried out unconsciously. Furthermore, he argued that

information is routed to and processed at different sites in the brain during perception and during voluntary movement.

When Helmholtz turned his attention to the study of vision, he realized that any static, two-dimensional image contains poor-quality, incomplete information. To reconstruct the dynamic, three-dimensional world from which the image was formed, the brain needs additional information. In fact, if the brain relied solely on the information it receives from the eyes, vision would be impossible. He therefore concluded that perception must also be based on a process of guessing and hypothesis testing in the brain, based on past experiences. Such educated guessing allows us to infer on the basis of past experience what an image represents. Since we are not normally aware of constructing visual hypotheses and drawing conclusions from them, Helmholtz called this top-down process of hypothesis testing *unconscious inference*. Thus, before we perceive an object, our brain has to infer what that object might be, based on information from the senses.

Helmholtz's remarkable insight is not restricted to perception: it provides a general principle that, as we shall see, applies to emotion and empathy as well. The noted cognitive psychologist Chris Frith of the Wellcome Trust Centre for Neuroimaging at University College London has summarized Helmholtz's insight in the following terms: "We do not have direct access to the physical world. It may feel as if we have direct access, but this is an illusion created by our brain."[12]

The importance of scientific thinking for perception was reinforced by Popper, who was also a student of Bühler and whom Gombrich met in 1935. Popper had published a highly influential book, *The Logic of Scientific Discovery*, in which he argued that science progresses not by accumulating data but by testing hypotheses, by solving problems. He emphasized that simply recording empirical data cannot account for the complex and often ambiguous phenomena scientists observe in nature and in the laboratory. To make sense of their observations, scientists need to work by trial and error; they need to create a hypothetical model of a phenomenon by means of conscious inference, then search for new observations that will refute the model.

Gombrich saw a similarity between the ideas of unconscious and conscious inference—how the brain creates a hypothesis from visual information and how scientists create a hypothesis from empirical data. He realized that the beholder makes images and matches them to previ-

ous experiences, much as the scientist uses trial and error to create hypotheses about the natural world. In the case of visual perception, that hypothesis is based on built-in knowledge—knowledge that we inherited through natural selection and that is stored in the wiring of the brain's visual system. This is the bottom-up information processing that the Gestalt psychologists delineated. The brain then tests the hypothesis by comparing it with previously experienced and remembered images. This is the top-down information processing that Helmholtz emphasized in his writings on perception and that Popper described as the scientific method. By combining them, Gombrich provided valuable insights into the creative workings of the beholder's brain and how it structures the beholder's share.

The insight that the beholder's perception involves a top-down influence convinced Gombrich that there is no "innocent eye": that is, all visual perception is based on classifying concepts and interpreting visual information. One cannot perceive that which one cannot classify, Gombrich argued. As we shall see later, Gombrich's psychological insights into perception were to serve as a solid footing for a bridge between the visual perception of art and biology.

# OBSERVATION IS ALSO INVENTION: THE BRAIN AS A CREATIVITY MACHINE

⌒⌣⌐

THE VIEW OF THE BRAIN AS A CREATIVITY MACHINE THAT CONSTANTLY uses inferences and guesses to reconstruct the external world—the view advocated by Ernst Kris and Ernst Gombrich—was a dramatic shift from the naïve philosophical realism of the seventeenth-century British philosopher John Locke that dominated thinking about mind at that time. Locke conceived of mind as receiving all the information capable of being gathered by the senses, a view in which mind simply mirrors the reality of the external world. Kris and Gombrich's view of the brain was a modern version of Kant's theory that sensory information allows reality to be invented by mind.

The images in art, like all images, represent not so much reality as the viewer's perceptions, imagination, expectations, and knowledge of other images—images recalled from memory. As Gombrich pointed out, to see what is actually painted on a canvas, the viewer has to know beforehand what he or she might see in a painting. In this way the creative process engaged in by the artist's brain—the modeling of physical and psychic reality—parallels the intrinsically creative operations of every human brain in everyday life.

By combining art history with the intuitive ideas derived from psychoanalysis, the more rigorous thinking of Gestalt psychology, and the hypothesis testing of unconscious and conscious inference, Kris and Gombrich laid the foundation for a cognitive psychology of art. Moreover, they understood that since art is in part a creation of mind, and

mind is a series of functions carried out by the brain, the scientific study of art must include neuroscience as well as cognitive psychology.

Gombrich, Kris, and Riegl took key steps in delineating that principle. Riegl took the first step by bringing psychological science to bear on the study of art and thus recognizing the beholder's share. Kris moved forward in one direction by realizing that art is a form of unconscious communication between the artist and the beholder and that the beholder responds to the ambiguity inherent in a work of art by unconsciously re-creating the image in his or her brain. Gombrich moved further forward by focusing on the creativity inherent in visual perception and analyzing how the beholder uses a combination of Gestalt principles and hypothesis testing in viewing a work of art. Together, Kris and Gombrich used their insights to show us that art sets out, self-consciously, to encourage both perceptual and emotional processes of re-creation in the viewer's brain. In a sense, Kris and Gombrich were following Freud's attempt to establish a cognitive psychology that could link the psychology of mental processes to the biology of mind.

Kris and Gombrich now realized that their *cognitive psychology also occupies an essential explanatory position between the behavior of*

**The Three-Step Analysis of Perception, Emotion, and Empathy in Art**

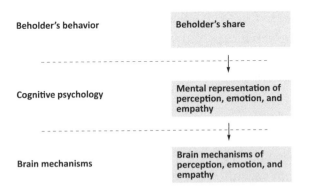

Figure 12-1. This Kris-Gombrich-Searle analysis of the behavior of the beholder shows that biological analysis of the brain mechanisms involved in perception and emotion requires, as a critical intermediate step, an analysis of how perception and emotion are represented in cognitive psychological terms.

*individuals*—the beholder's share—*and the biological processes in the brain that mediate that behavior.* They anticipated that this psychology, with its empirical footings, might eventually serve as the basis of a dialogue between art and the biology of perception, emotion, and empathy.

The philosopher of mind John Searle has similarly pointed out that to develop a biological understanding of the perceptual and emotional experiences that underlie the beholder's share, we must follow a three-step process (Fig. 12-1). First, we need a behavioral analysis of the beholder's overt response to a work of art. Second, we need a psychological analysis of the beholder's perceptual, emotional, and empathic response to the work. Third, we need an analysis of the brain mechanisms underlying these components of the beholder's response. Indeed, the new science of mind that emerged during the last decade of the twentieth century represents the successful, large-scale convergence of cognitive psychology (the science of mind) and neuroscience (the science of the brain).

As Gombrich's fascination with visual perception deepened, he became intrigued by Ernst Kris's ideas about ambiguity in art and began to study the ambiguous figures and illusions made famous by Gestalt psychologists. In the simplest cases, illusions allow for two distinctly different readings of an image. Such illusions are the simplest example of the nature of ambiguity, which Kris held was the key to all great works of art and to the beholder's response to great art. Other illusions contain ambiguous images that can lure the brain into making perceptual errors. Gestalt psychologists used these errors to explore the cognitive aspects of visual perception. In the process, they deduced several principles of the brain's perceptual organization before neuroscientists discovered them.

Such ambiguous figures and illusions intrigued Gombrich because in viewing a portrait or a scene, multiple choices are possible to the viewer. Often, several ambiguities are embedded in a great work of art, and each of them may present the beholder with a number of different decisions.

Gombrich was particularly interested in ambiguous figures and illusions that cause perception to flip between two rival interpretations. One such figure is the drawing of a duck-rabbit (Fig. 12-2) created in 1892 by the American psychologist Joseph Jastrow and illustrated by

Gombrich near the opening of *Art and Illusion*. Because the amount of information that can be processed consciously is highly limited, the viewer cannot see both animals at the same time. If we focus on the two horizontal bands at the left that look like long ears, we see the image of the rabbit; if we focus on the right, we see the duck, and the two bands at the left become a beak. We can initiate the switch between rabbit and duck with a movement of our eyes, but that eye movement is not essential for the switch.

What impressed Gombrich so greatly about this drawing was that the visual data on the page do not change. What changes is our interpretation of the data. "We can see the picture as either a rabbit or a duck," he wrote. "It is easy to discover both readings. It is less easy to describe what happens when we switch from one interpretation to the other."[1] What happens is that we see the ambiguous image and then, based on our expectations and past experiences, unconsciously infer that the image is a rabbit or a duck. This is the top-down process of hypothesis testing that Helmholtz described. Once we have formulated a successful hypothesis about the image, it not only explains the visual data but also excludes alternatives. Thus, once we have assigned the image to the duck, we have committed to the hypothesis of duck, and the hypothesis of rabbit is, so to speak, off the table. The reason these percepts are mutually exclusive is that *when each image is dominant, it leaves nothing to be explained, no ambiguity.* The image is either a duck or a rabbit, but never both.

This principle, Gombrich realized, underlies all of our perceptions of the world. The act of seeing, he argued, is fundamentally interpretative. Rather than seeing the image and then consciously interpreting it as a duck or a rabbit, we unconsciously interpret the image as we view it; thus, interpretation is inherent in visual perception itself.

The Rubin vase (Fig. 12-3), devised by the Danish psychologist Edgar Rubin in 1920, is also an example of perception flipping between two rival interpretations and also relies on unconscious inferences made by the brain. But unlike the rabbit-duck illusion, the Rubin vase requires the brain to construct an image by differentiating an object (figure) from its background (ground). The Rubin vase also requires that the brain assign "ownership" of the outline, or contour, that separates the figure from the ground. Thus, when the brain assigns ownership of the contour to the vase, we see the vase, and when

Figure 12-2. Duck-rabbit

Figure 12-3. The Rubin Vase

it assigns ownership to the faces, we see the faces. The reason the illusion works, according to Rubin, is that the contours of the vase match the contours of the faces, thus forcing the beholder to select one image or the other.

A more complex choice between competing interpretations involves the Necker cube (Fig. 12-4), discovered in 1832 by the Swiss crystallographer Louis Albert Necker. The Necker cube is a two-dimensional line drawing in oblique perspective with no depth cues, yet it appears to be three-dimensional. Curiously, either face of the cube can be seen as the front. As the viewer focuses on the drawing, the perspective seems to shift spontaneously between the two choices. The Necker cube provides a nice example of the creative power of the visual system. Although we alternate between seeing two cubes, there is actually no cube at all. There is only a single, two-dimensional drawing on the paper. We see something that is not there. Gombrich's study of illusions led him to write that "there is no rigid distinction, therefore, between perception and illusion."[2] The two orientations we alternate between, however, are not the only options; indeed, there are innumerable irregular polygonal shapes compatible with the image. Try as we might, however, we cannot perceive these even if we want to. This

Figure 12-4

demonstrates that though top-down inference allows us to select between distinct options, unconscious selection restricts our choices to the most plausible interpretations.

Of these three ambiguous figures and perceptual illusions, the Necker cube best illustrates the brain's ability to derive a three-dimensional image from a two-dimensional object. This remarkable capability, which artists have learned to explore brilliantly, derives from the fact that the brain matches components of the two-dimensional drawing on paper to previously stored knowledge in the brain and our expectations of a three-dimensional world.

The Kanizsa triangle (Fig. 12-5) is still another example of the visual system constructing a reality that is not there. In this illusion, created in 1950 by the Italian artist and psychologist Gaetano Kanizsa, our minds construct an image of two overlapping triangles. The contours that seem to define these triangles, however, are entirely illusory. There are no triangles in this image, just three open angles and three semicircles. As the brain processes this sensory information into a perception, the presence of a solid black triangle obscuring the white outline of another triangle beneath it emerges. The brain creates this image using Helmholtz's unconscious inferences. The brain is hardwired to interpret patterns like these as indicative of triangles, and thus con-

Figure 12-5.
The Kanizsa Triangle

structs a triangular perception so strong that it seems darker than the page on which it appears, even when we know this to be false.

IN EXPANDING ON THE ideas of the Gestaltists, Gombrich realized that the brain, when responding to a work of art, uses not only bottom-up, or visual contextual clues, but also top-down emotional and cognitive cues and memory. Moreover, it is this use of cognitive cues and memory that defines the unique share of each beholder. Gombrich understood that the experiments of artists over the centuries constitute a treasure trove of clues to the inner workings of the human mind. He appreciated the role of *cognitive schemata,* or internal representations of the visual world in the brain, arguing that every painting owes more to other paintings the viewer has seen than it does to the world actually being portrayed.

This perspective on art, with its emphasis on hypothesis testing and memory—that is, on the viewer's and the artist's previous exposure to works of art—easily incorporated the theory of aesthetic response put forth by the German-born art historian Erwin Panofsky, who in 1934 immigrated to the United States. A contemporary of Kris and Gombrich, Panofsky emphasized the importance of memory in aesthetic response. Art can be read and interpreted iconographically on three levels, he argued, all of which rely on the viewer's memory.

The first level is the *pre-iconographical interpretation,* which is concerned with intrinsic elements of the painting: line, color, pure form, subject matter, and emotion. On this level, the viewer's interpretation is based on practical, intuitive experience of the elements, without recourse to any factual or cultural knowledge. The second level is the *iconographical interpretation,* which is concerned with the meaning of forms and their expression in *universal* frames of reference. The third level is the *iconological interpretation,* which deals with the viewer's response to art in the more restricted cultural contexts of country, culture, class, religion, and period in history. Most Western viewers, for example, will recognize a group of twelve people arranged around a central figure at a long dinner table as a representation of the Last Supper. For them, the image of twelve people eating dinner is iconological (set in a *particular* cultural context), whereas for a non-Western viewer the image of twelve people eating dinner is iconographical (set in a *universal* cultural context).

Panofsky's ideas, with their emphasis on symbols, cultural context, and the personal memory of the beholder, gave the study of art greater salience than Gestalt psychology alone could have done. Iconographical interpretation revealed that art has historically communicated universal ideas through symbols and myth, thus adding another dimension to the creative partnership between artist and viewer.

Modern cognitive psychology, which came into full bloom in the decades following the Kris-Gombrich collaboration, continues to be concerned with analyzing the process by which sensory information is transformed by the beholder into perception, emotion, empathy, and action—that is, with evaluating how a stimulus leads to a particular perceptual, emotional, and behavioral response in a particular historical context. Only by uncovering how this transformation occurs can we hope to understand the relationship between a person's actions and what that person sees, remembers, or believes.

*Chapter 13*

# THE EMERGENCE OF
# TWENTIETH-CENTURY PAINTING

❧

THE AUSTRIAN EXPRESSIONISTS ANALYZED PRIMAL SEXUAL URGES, as well as deep fears and aggressive urges, and tried to convey them in simple pictorial language. In doing so, these artists were attempting to depict *emotional primitives,* the elements that elicit our feelings in response to art—and by extension our perception of emotion in other people, our feelings of empathy for them, and our ability to read their conscious and unconscious mental states.

Depicting emotion has been a primary goal of artists throughout history. Leonardo, Rembrandt, El Greco, Caravaggio, and later Messerschmidt all exert a timeless, universal appeal because they express universal emotions through realistic depictions of specific individuals. Many twentieth-century artists, in contrast, approached the depiction of emotion differently.

First Vincent van Gogh and Edvard Munch, then Henri Matisse, the French Fauve artists, and the contemporaneous Austrian and German expressionists began to explore explicitly, and in greater depth, the role of color and form in evoking unconscious emotion and conscious feelings. Just as the Impressionists and Post-Impressionists, such as Georges Seurat and Van Gogh, used insights derived from the science of color mixing to capture the sense of natural light, so the expressionists used insights derived from the medical and psychological science around them to gain a better appreciation of the unconscious mind.

IN HIS EXTRAORDINARY introduction to art history, *The Story of Art,* Ernst Gombrich traces the evolution of Western art through three

stages. In the first stage, artists did not have command of the rules of perspective or of color mixing; they therefore painted *what they knew.* In the second stage, artists had mastered the principles of perspective and color; they now could paint *what they actually saw.* During those two stages, which span a period of thirty thousand years, from the paintings in the caves of Chauvet to the naturalistic landscapes of the British artists of the nineteenth century, the main direction of art—despite detours, side developments, and retracings—was to depict the outside world in progressively more realistic, three-dimensional terms. But the advent of photography in the mid-nineteenth century, with its extraordinary ability to capture reality, halted this progression. Painting lost what Gombrich called its unique ecological niche in the world of depiction, and "the search for alternative niches began."[1]

Impressionism led the way with its focus on capturing the fleeting, atmospheric sensation of natural light in the outdoors, which photography had more difficulty achieving. Impressionism explicitly forced the viewer's perceptual experience away from reality and toward the imaginary. Later artists were dissatisfied with Impressionism's excessive attention to transience and to the surface appearance of objects. Realizing that photographs could capture reality in ways that they could not, these Post-Impressionist artists searched for something beyond naturalistic depiction.

Their quest led to two broad, sometimes overlapping types of experiments, both designed to enlarge the viewer's experience in ways that photography could not. One experiment, evident in the paintings of Paul Cézanne, the Post-Impressionist Nabis group of painters (Maurice Denis, Édouard Vuillard, Pierre Bonnard), and others, attempted to deconstruct and explore new dimensions of visual perception. The other experiment, evident in the work of Van Gogh and Munch, attempted to deconstruct and explore emotional experience (Fig. 13-1). At the same time that these artists were deconstructing form and emotion, a transformation was taking place in the iconography, or use of symbols, in art.

Cézanne stopped trying to portray perspective realistically. Instead, he experimented with reducing the spatial depth in his paintings, as in the mountain landscapes of Montagne Sainte-Victoire, near his house in Provence (Fig. 13-2). As the art historian Fritz Novotny has put it: "Within Cézanne's paintings . . . the life of perspective has faded away.

Figure 13-1. Highly simplified illustration of the two types of
experiments that have charcterized art since impressivism.

Perspective in the old sense is dead."[2] Moreover, Cézanne believed that
all natural forms could be reduced to three *figural primitives*—the cube,
the cone, and the sphere. He argued that figural primitives are the basic
elements, the building blocks, of our perception of complex forms,
ranging from rocks and trees to human faces. They are the key to how
we see what we see in nature.

Cézanne's experiments with perspective and his idea that what we
see in nature can be reduced to three solid forms led to the development
of Cubism by Pablo Picasso and Georges Braque (Fig. 13-3). Between
1905 and 1910, these two artists simplified perspective and the forms of
nature, deconstructing objects so as to portray their essence rather than
their appearance. Abstracting the essence of what is in nature and por-
traying it without embellishment allowed them to demonstrate that, on
canvas, art can exist independently of both nature and time. There

soon followed even more radical abstractionism, as evident in the works of Wassily Kandinsky, Kazimir Malevich, and Piet Mondrian. Abstraction of three-dimensional perspective emerged later in the works of the Swiss sculptor Alberto Giacometti, who made linear images of people as thin as a knife blade.

Working at the beginning of the twentieth century, Kandinsky started out as a figurative painter but quickly began to use colors boldly and expressively to convey not simply mood, as Van Gogh, Munch, and Oskar Kokoschka had done, but also subject matter and ideas. By 1910 his paintings had become more geometric and abstract; ultimately, his work had few discernible traces of figuration.

Mondrian also began as a figurative painter, but he soon started to deconstruct his images in a search for universal aspects of form (*Study of Trees I*, 1912, and *Pier and Ocean 5* [*Sea and Starry Sky*], 1915) (Figs. 13-4, 13-5). Inspired by Cézanne's ideas, Mondrian reduced the cube, cone, and sphere even further, building his pictures from straight lines and color. In this way, Mondrian contributed to the development of a new language of art based on *nonfigural primitives*—geometric forms and colors that have a meaning of their own, that were created with-

Figure 13-2. Paul Cézanne, *Montagne Sainte-Victoire* (1904–6). Oil on canvas.

Figure 13-3.
Georges
Braque,
*Le Sacré-Coeur
vu de l'Atelier de
l'Artiste* (1910).
Oil on canvas.

out any reference to forms in nature. Malevich and the constructivist painters also created purely abstract, nonfigurative art. These artists believed that painting, like music, could be pure expression. At its best, abstract art created an ambiguity that seemed to depend, perhaps even more than ambiguity in figurative art, on the creative processes of the brain.

Meanwhile, a transformation was taking place in the use of symbols in art. A new iconography emerged in figurative art, one based not on a deconstruction of existing icons but on a new, modernist language. This transformation is clearly evident in Vienna 1900. As we have seen, Gustav Klimt uses icons based on his knowledge of biology, and Kokoschka and Egon Schiele use the hands and other parts of the body as icons. Some of these icons, such as the hands that derived from Jean-Martin Charcot's depiction of psychiatric patients, are a means of depicting inner turmoil or insanity (Fig. 13-6).

Figure 13-4. Piet Mondrian, *Study of Trees 1: Study for Tableau No. 2/ Composition No. VII* (1912). Charcoal on paper. © 2012 Mondrian/Holtzman Trust c/o HCR International Washington D.C.

STIMULATED IN PART by these artistic experiments, brain scientists began to address key questions raised by the existence of figural, non-figural, and emotional primitives. They asked, What is the biology of the beholder's share? They first wanted to know how does the brain, the creativity machine par excellence, perceive art, and how does it se-lect and represent figural and nonfigural primitives, the basic building blocks of visual perception? They then asked, how does the brain of the beholder respond emotionally to art, and how does it select and represent emotional primitives?

The next five chapters consider what we have learned about visual perception from brain science. Visual perception begins in the retina as an information-processing system that deconstructs the form of objects and faces and then turns the critical components of those images into a neural code; this code is reflected in a pattern of action potentials in the brain. Neural codes are then elaborated in progressively higher regions of the brain concerned with vision. Analysis of these regions reveals the principles underlying our perception of faces, hands, and bodies.

Figure 13-5. Piet Mondrian, *Pier and Ocean 5 (Sea and Starry Sky)* (1915). Charcoal, ink, and gouache on paper. © 2012 Mondrian/Holtzman Trust c/o HCR International Washington D.C.

Figure 13-6. André Brouillet, *A Lesson on Hysteria by Jean-Martin Charcot* (1887). Oil on canvas.

The lower levels of information processing follow Gestalt principles. Higher-order regions also recruit top-down processing, unconscious inferences (based on hypothesis testing) and memory to integrate and give meaning to visual percepts. Following those five chapters, we begin the search for emotional primitives and the biological mechanisms of empathy and creativity involved in the beholder's share.

PART THREE

...

BIOLOGY OF THE
BEHOLDER'S VISUAL
RESPONSE TO ART

# THE BRAIN'S PROCESSING OF VISUAL IMAGES

∽

Ernst Kris's and Ernst Gombrich's studies of ambiguity and of the beholder's share led them to conclude that the brain is creative—it generates internal representations of what we see in the world around us, whether as an artist or a beholder. Moreover, they held that we are all wired to be "psychologists," because our brain also generates internal representations of other people's minds—their perceptions, motives, drives, and emotions. These ideas contributed greatly to the emergence of a modern cognitive psychology of art.

But Kris and Gombrich also realized that their ideas were the result of sophisticated insights and inferences that could not be examined directly and were therefore not amenable to objective analysis. To examine the internal representations directly, to peer into the black box of the brain and see how the deconstruction of form gives rise to figural primitives—the building blocks of perception—cognitive psychology had to join forces with brain biology.

In this and the next two chapters, we examine how brain biologists began to study visual perception. As we shall see, both the beholder's perception of art and his or her emotional response to art depend entirely on the activity of nerve cells in specific regions of the brain. But before we begin to examine the neural mechanisms underlying our visual and emotional processes, we need a basic understanding of the overall organization of the central nervous system.

THE CENTRAL NERVOUS SYSTEM consists of the brain and spinal cord; like the body as a whole, the brain and spinal cord have a left side

and a right side that are essentially symmetrical (Fig. 14-1). The spinal cord contains the machinery required for simple reflex behavior. The action of this relatively simple machinery illustrates one of the key functions of the central nervous system: receiving sensory information from the surface of the body and translating it into action. In the case of reflex behavior, sensory information from receptors in the skin is sent via long nerve fibers—sensory axons—to the spinal cord, where

Figure 14-1. The central nervous system, which consists of the brain and the spinal cord, is bilaterally symmetrical. The spinal cord receives sensory information from the skin through bundles of long axons, called peripheral nerves, and sends motor commands to muscles through the axons of the motor neurons. These sensory receptors and motor axons are part of the peripheral nervous system.

Figure 14-2.
The spinal cord extends upward to become the hindbrain, and above
the hindbrain lie the midbrain and the forebrain.

it is transformed into coordinated commands for action; the commands
are then conveyed to the muscles through another long bundle of nerve
fibers—motor axons.

The spinal cord extends upward to become the *hindbrain*. Above the
hindbrain lie the *midbrain* and the *forebrain* (Fig. 14-2). Of these re-
gions, the forebrain has particularly important responsibilities for vi-
sion, emotion, and the beholder's response to art.

If we switch our perspective and look at the central nervous system
from the top down, we first encounter the forebrain, or highest level of
the brain. The forebrain is divided into two parts: the left and right *cere-
bral hemispheres*. The cerebral hemispheres are covered by the *cerebral
cortex*. Instantly recognizable by its deep wrinkles, the human cerebral
cortex is a blanket of cells one-tenth of an inch thick, containing ten bil-
lion nerve cells, or neurons. The convolutions, or folds, of the cerebral
cortex consist of ridgelike crests known as *gyri*, separated by small
grooves, or infoldings, called *sulci*. The infoldings evolved as a space-

**RIGHT HEMISPHERE**

Central sulcus

Precentral gyrus
(motor control)

Postcentral gyrus
(touch/pressure)

Expression
of intonation

Comprehension
of intonation

Parietal lobe

Frontal lobe

Occipital
Lobe

Temporal lobe

Vision

Brain stem

Cerebellum

Figure 14-3

saving device to fit the large expanse of the cerebral cortex—which if "unfolded" would be equivalent in size to a dinner napkin one and a half feet square—into the small confines of the skull. The folds also bring into close proximity parts of the brain that need to communicate with each other, thereby making connections easier (Figs. 14-3 and 14-4). The structures of the two hemispheres are largely identical. While everyone's brain is slightly different, the more prominent gyri and the sulci are similar from one person to the next.

Each side of the cerebral cortex is divided into four distinct lobes, which are named for the bones of the skull that lie over them: frontal,

**LEFT HEMISPHERE**

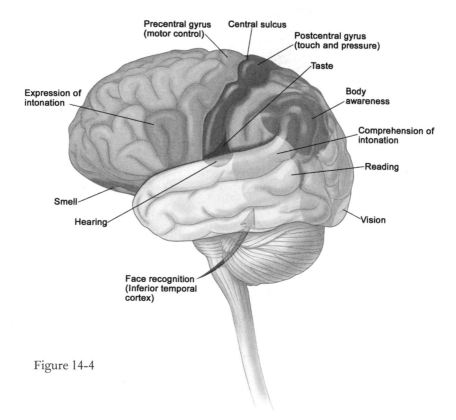

Figure 14-4

parietal, temporal, and occipital. The *frontal lobes* on each side of the cortex are largely concerned with executive functions, moral reasoning, regulation of emotion, planning future actions, and control of movement. The *parietal lobes* are concerned with touch sensation, forming a perceptual image of our own body, relating that body image to the space around us, and attention. The *occipital lobes* are concerned with processing visual information. The *temporal lobes* are important for interpreting visual information including face recognition and information related to hearing and language.

The temporal lobes are also involved with conscious recall of memory and with experiencing memory and emotion. These functions result from the temporal lobes' connections with five structures that lie deep in the forebrain below the cerebral cortex: the hippocampus, the amygdala, the striatum, the thalamus, and the hypothalamus (Fig. 14-5).

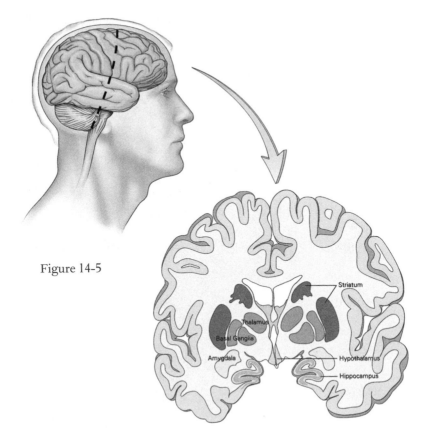

Figure 14-5

The *hippocampus* is involved in the encoding and retrieval of re-
cently formed memories. The *amygdala* is the orchestrator of our emo-
tional life: it coordinates emotional states with autonomic and hormonal
responses. In collaboration with other structures, such as the prefrontal
cortex, the amygdala also mediates the influence of emotion on cogni-
tive processes, including the generation of conscious feelings. The hip-
pocampus and the amygdala are present in both the left and right
hemispheres of the brain.

At the center of each of the hemispheres of the cerebral cortex lies
the *thalamus*—the great portal for all sensory information (except
smell) entering the cortex. Within the thalamus is the *lateral geniculate
nucleus,* which is specialized for vision and analyzes information from
the retina of the eye before relaying it to the cerebral cortex. Adjacent
to the thalamus lie the *basal ganglia,* which play a role in regulating
learned movement and aspects of cognition. The outermost region of
the basal ganglia, the *striatum,* is involved with reward and expecta-

tion. Below the thalamus sits the *hypothalamus*, a small but highly influential region that controls many of our vital bodily functions, such as heart rate and blood pressure, through its regulation of the autonomic nervous system. Typically, our emotional response to situations in life involves changes in heart rate and other bodily functions. The hypothalamus also regulates the release of hormones from the pituitary gland.

The midbrain, the smallest region of the brain, contains the machinery for eye movements, which are critical for selecting objects of interest in the world around us, including those in a painting we view. The ventral tegmental area of the midbrain also contains neurons that release dopamine, a chemical that serves to command attention and anticipate reward.

Although the two hemispheres of the brain appear identical and work together in generating perception, comprehension, and movement, they contribute to these functions in different ways: for example, the reception, understanding, and expression of language and grammar—both spoken and sign language—are located primarily in the left hemisphere (Fig. 14-4), while the musical intonation of language is primarily mediated by the right hemisphere (Fig. 14-3). Besides its role in language, the left hemisphere specializes in reading and arithmetic and in logical, analytical, and computational approaches to knowledge. The right hemisphere, in contrast, processes information in a more global, holistic, and perhaps creative manner.

HOW DOES THE BRAIN, and in particular the visual system, process information? The brain first processes the information it receives from the sensory organs: information about vision from the eyes, sound from the ears, smells from the nose, taste from the tongue, and touch, pressure, and temperature from the skin. It then analyzes this incoming sensory information in light of past experience and generates an internal representation, a perception of the outside world. When appropriate, it initiates purposeful action in response to the information it has received. In this way the brain integrates all aspects of our mental life—perception of sensory information, thought, feeling, memory, and action. As an example, suppose I spot two familiar faces across the street. I unconsciously compare the images of those faces to images I have stored in memory. I now recognize them as my friends Richard

and Tom, and I cross the street to greet them. This computational analysis, the recourse to memory, and the generation of action call upon the signaling capability of a vast number of neurons.

Neurons are elementary electrical signaling units that serve as the building blocks of the brain and spinal cord. They signal by generating *action potentials*—very brief, all-or-none electrical signals that vary only slightly in amplitude. What does vary—and thus accounts for the neurons' ability to transmit information—is the frequency and pattern of firing of action potentials.

All the sensory information that comes into the brain—vision, hearing, touch—is converted into *neural codes:* that is, patterns of action potentials generated by nerve cells. Seeing a baby's face, watching it smile, looking at a great painting or out into the sunset, experiencing the beauty and calm of a quiet holiday evening with one's family—all of these are the result of different firing patterns of neurons in different combinations of *neural circuits* in our brain.

To begin to appreciate what is required to accomplish the marvel of visual perception, it is useful to compare the brain's information-processing capabilities to those of artificial computational devices. By the 1940s, emerging knowledge about the biology of the brain and about information processing gave rise to the first computers, the first "electronic brains." By 1997, computers had become so powerful that Deep Blue, a chess supercomputer built by IBM, defeated Garry Kasparov, thought to be the world's best chess player. But to the surprise of computer scientists, Deep Blue, which was so skilled at learning the rules, logic, and calculation of chess, had great difficulty learning the rules of face perception and did not come close to distinguishing between faces. This is still true of the most powerful computers today. Computers are better than the human brain at processing and manipulating large amounts of data, but they lack the hypothesis-testing, creative, and inferential capabilities of our visual system.

HOW ARE THE ANALYTICAL triumphs of visual perception achieved? Richard Gregory raised the question: "Is the visual brain a picture book? When we see a tree is there a tree-like picture in the brain?"[1] He replies that the answer is clear: no! Rather than having a picture, the brain has a hypothesis about a tree and other objects in the outside world that it reflects as the conscious experience of seeing.

Francis Crick, co-discoverer of the structure of DNA and perhaps the most creative biologist in the second half of the twentieth century, spent the last several decades of his career studying the marvels of conscious visual perception. In explaining how we should think about vision, Crick argued, much like Gregory, that while we seem to have a picture of the visual world in our brain, we actually have a symbolic representation—a hypothesis—of that world. This should not be surprising. Machines such as computers and television sets readily present us with pictures, yet if we opened up a computer or a TV set, we would not find electronic elements or computer chips arranged into an orderly image of, say, a tree emitting lights of various colors. Instead, we would find an arrangement of parts and circuits that process encoded data. Crick concludes:

> Here we have an example of a *symbol*. The information in the computer's memory is not the picture; it symbolizes the picture. A symbol is something that stands for something else, just as a word does. The word *dog* stands for a particular sort of animal. Nobody would mistake the word itself for the actual animal. A symbol need not be a word. A red traffic light symbolizes "stop." Clearly, what we expect to find in the brain is a representation of the visual scene in some symbolic form.[2]

As Crick's comments imply, we do not yet understand the detailed neural mechanisms of this symbolic representation.

We do know that all of our perceptions of the outside world—sights, sounds, smells, tastes, and touch—begin in our sense organs. Vision thus begins in the eye, which detects information about the outside world in terms of light. The lens of the eye focuses and projects a tiny, two-dimensional image of the outside world onto the retina, a sheet of nerve cells covering the back of the eye. The data emerging from specialized cells in the retina resemble the visual world in the same way that the pixels in the image on your laptop computer resemble the actual image that you see on the screen. Both the biological and the electronic system process information. The visual system, however, creates representations in the brain (in the form of neural codes) that require far, far more information than the modest amount the brain receives from the eyes. That additional information is created within the brain.

Thus, what we see in "the mind's eye" goes dramatically beyond what is present in the image cast on the retina of our real eye. The image on the retina is first deconstructed into electrical signals that describe lines and contours and thus create a boundary around a face or an object. As these signals move through the brain, they are recoded and, based on Gestalt rules and prior experience, reconstructed and elaborated into the image we perceive. Luckily for us, although the raw data taken in by the eyes are not sufficient to form the content-rich hypothesis called vision, the brain generates a hypothesis that is remarkably accurate. Each of us is able to create a rich, meaningful image of the external world that is remarkably similar to the image seen by others.

It is in the construction of these internal representations of the visual world that we see the brain's creative processes at work. The eye does not work like a camera. A digital camera will capture an image, be it a landscape or a face, pixel by pixel, as it appears before us. The eye cannot do that. Rather, as the cognitive psychologist Chris Frith writes: "What I perceive are not the crude and ambiguous cues that impinge from the outside world onto my eyes and my ears and my fingers. I perceive something much richer—a picture that combines all these crude signals with a wealth of past experience. . . . Our perception of the world is a fantasy that coincides with reality."[3]

HOW DOES THE VISUAL system create this world, this "fantasy that coincides with reality"? A guiding principle in the organization of the brain is that each mental process—perceptual, emotional, or motor—relies on distinct groups of specialized neural circuits located in an orderly, hierarchical arrangement in specific regions of the brain. This is also true of the visual system.

The nerve cells that process visual information are grouped into hierarchical relays that send information along one of two parallel pathways in the visual system. These relays begin in the retina of the eye, go on to the lateral geniculate nucleus of the thalamus, continue to the primary visual cortex in the occipital lobe, and then to some thirty additional areas in the occipital, temporal, and frontal lobes of the cerebral cortex. Each relay performs a particular transformation process on the incoming information. The relays that make up the visual system are distinct from those that process information about touch, hearing,

taste, and smell, and they occupy their own distinctive real estate in the brain. Only at the very highest level of the brain does information from the several sensory systems come together.

Each of the two parallel pathways in the visual system analyzes different aspects of the visual world. The *what pathway* is concerned with color and with what is to be seen in the world; relays in this pathway send information to areas in the temporal lobe concerned with color, object, body, and face recognition. The *where pathway* is concerned with where those objects are to be found; its relays send information to the parietal lobe. Thus, each pathway consists of a series of hierarchically organized relays that receive, process, and convey visual information on to the next relay. The cells in each relay connect to cells in the next relay, and so on, giving rise to the visual system.

Once information reaches the higher regions of the what pathways, it is reappraised. This top-down reappraisal operates on four principles:

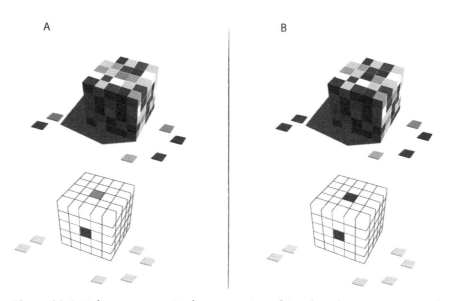

A                                                    B

Figure 14-6. Color constancy. In the top portion of Panel A, the center square of both the front and the top of the cube appear to be the same shade of orange. When these two squares are seen in isolation from lighting cues, in the bottom portion of the panel, it is apparent they are in fact different colors. The reason they appear the same is the brain understands that the cube's front is shadowed and so it adjusts color perception accordingly to compensate for a darker set of hues. In Panel B, the two squares are the same color. Yet the brain compensates for the shadow again so the squares appear to be different colors.

disregarding details that are not behaviorally relevant in a given context; searching for constancy; attempting to abstract the essential, constant features of objects, people, and landscapes; and, particularly important, comparing the present image to images encountered in the past. These biological findings confirm Kris and Gombrich's inference that vision is not simply a window onto the world, but truly a creation of the brain.

THE BRAIN'S CREATIVITY is evident in the visual system's ability to reveal the same picture under strikingly different conditions of light and distance. As we move from a brightly lit garden into a dimly lit room, for instance, the intensity of the light reaching the retina may decrease a thousandfold. Yet in the dim light of the room, as in the bright light of the sun, we see a white shirt as white and a red bow tie as red. We see the bow tie as red because the brain is interested in acquiring information about the constant characteristics of an object, in this case its *reflectance*. How is this accomplished? The brain adjusts for the changes in light; it recomputes the color of the tie and of the shirt to ensure that those critical identifying features are maintained under a wide variety of circumstances.

Edwin Land, the inventor of the Polaroid camera, proposed what is now generally considered the key to our perception of color. The brain perceives color by sampling the wavelengths of light that come from a white shirt and those that come from a red tie and then maintaining the ratio of those wavelengths under widely varying conditions. The brain ignores all the variations in wavelength of the light reflected from the surface and calls the red tie "red" under any circumstance of light or time of day. This process is known as *color constancy* (Fig. 14-6). However, the same red bow tie, under the same changing light conditions, would look quite different if it were worn with a blue shirt because the ratio of wavelengths would be different.

Thus, even though the wavelength of the red tie can be measured objectively as a physical property emanating from light shining on the retina, the color red that we see is a creation of the brain under a specific set of circumstances, that is, in a particular context. This phenomenon is known as *color contrast*. Context is influenced to a large degree by higher regions of the brain. Thus, much like our perception of form, our perception of color is constructed by the brain.

Similarly, the size, shape, and brightness of an image projected onto the retina change as we move about, yet under most conditions we do not perceive those changes. Gombrich gives an example of this in *The Image and the Eye:* as a person walks toward us from across the street, the image on our retina can double in size, yet we perceive that person as getting closer rather than as growing larger. As we shall see in Chapter 16, our brain is able to keep the person's size constant because the visual system is sensitive to sensory cues about distance—such as relative size, familiar size, linear perspective, and occlusion—that derive from the transformation of three-dimensional images into two dimensions on the retina. The brain also relies on our past experience of objects changing size on the retina but not actually growing or shrinking.

Our ability to perceive an object as constant despite changes in size, shape, brightness, and distance illustrates the brain's remarkable ability to transform transient, two-dimensional light patterns on the retina into a coherent and stable interpretation of the three-dimensional world. The next two chapters explore what brain scientists have learned about how the brain deconstructs and then reconstructs a visual image that we see in our mind's eye.

# DECONSTRUCTION OF THE VISUAL IMAGE: THE BUILDING BLOCKS OF FORM PERCEPTION

Wᴇ ᴀʀᴇ ɪɴᴛᴇɴsᴇʟʏ ᴠɪsᴜᴀʟ ᴄʀᴇᴀᴛᴜʀᴇs, ᴀɴᴅ ᴡᴇ ʟɪᴠᴇ ɪɴ ᴀ ᴡᴏʀʟᴅ that is largely oriented to sight. We search for a mate, food, drink, and companionship using information provided by the retina. In fact, fully half of the sensory information going to the brain is visual. Without vision we would have no art and probably a more restricted consciousness, so it is not surprising that biologists, like artists, art historians, psychologists, philosophers, and other scientists before them, have long been interested in exploring vision.

The biological study of visual perception was launched by another towering figure with roots in Vienna—Stephen Kuffler, a contemporary of Ernst Kris and Ernst Gombrich. In the 1950s, first Kuffler and then his younger colleagues David Hubel and Torsten Wiesel began to examine the question that fascinated Kris and Gombrich: how the brain deconstructs images as it processes visual events. They examined the response of neurons in the visual system to specific stimuli and made possible the advance from a cognitive psychology of perception to a biological analysis of perception.

Their work began to provide answers to several fundamental questions: Do certain cells in the brain encode figural primitives, the building blocks of forms? Do the combined activity of these cells coalesce into representations of complete forms? The image on the retina is deconstructed, but where in the brain is it reconstructed?

The processing of visual information begins, as we have seen, in the retina, proceeds through the lateral geniculate nucleus of the thalamus,

and continues through thirty-some visual areas of the cerebral cortex (Fig. 15-1).

In a series of seminal studies, Kuffler, Hubel, and Wiesel discovered that the signals sent by neurons in the brain ultimately produce what becomes our conscious awareness of distinct aspects of a visual image. They found that neurons in the early stages of the visual system (the retina and the lateral geniculate nucleus) respond most effectively to small spots of light. Neurons in the next relay, the primary visual cortex (V1, the first relay in the brain), organize visual information into lines, edges, and corners; these elements are combined to yield contours and figural primitives. Subsequent relays in the visual cortex, which receive information from the primary visual cortex, also carry out specialized functions: V2 and V3 respond to virtual lines and to borders, V4 responds to color, and V5 responds to motion. Finally, work by other neuroscientists showed that in the inferior temporal cortex, the highest regions of the visual brain, neurons respond to complex forms, to visual scenes, to specific places, to hands, to bodies, and particularly to faces, as well as to color, location in space, and movement of these forms.

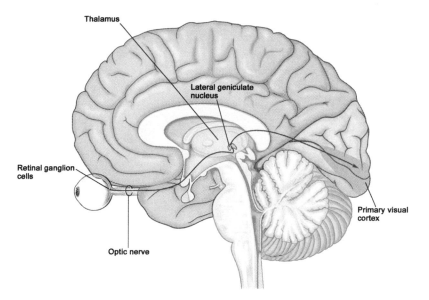

Figure 15-1. A simplified diagram of the projections of visual information from the retina to the visual areas of the thalamus (lateral geniculate nucleus), and from there to the cortex.

ELECTROMAGNETIC SPECTRUM

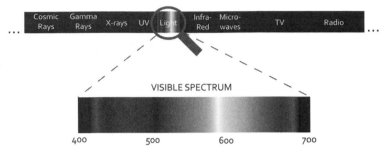

Wavelength (nm)

Figure 15-2. Humans have evolved to perceive the visible spectrum
which is a small portion of the entire electromagnetic spectrum.

VISION REQUIRES LIGHT. The light that our eyes capture is a form of
electromagnetic radiation. This radiation is characterized by waves of
varying lengths produced by particles called *photons,* which are re-
flected off the objects we see. Human vision captures a narrow band of
these wavelengths, extending from 380 nanometers, which we perceive
as deep violet, to 780 nanometers, which we perceive as dark red. This
range, the visible light spectrum, represents only a tiny portion of the
full electromagnetic wave spectrum (Figs. 15-2, 15-3).

When photons of light emitted by an image reach the lens of the
eye, the lens focuses them onto the retina, where they are captured by
photoreceptors. Photoreceptors are an orderly array of light-sensitive

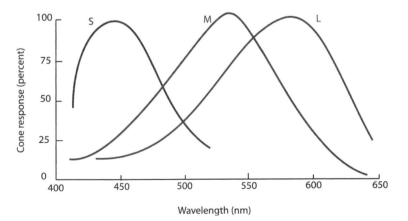

Figure 15-3. Sensitivity of three cone types.

nerve cells that respond to both the position of the light source and the intensity and colors of the light it emits. The photoreceptors respond to the photons of light, converting them into a pattern of electrical signals—a neural code—that is relayed to the retinal ganglion cells, the output neurons of the retina. The axons of the retinal ganglion cells form the optic nerve, which carries the information to the primary visual cortex (Fig. 15-4). In this way the retina captures and processes all the effects of the external visual world and conveys them to the visual system in the brain.

The retina contains four classes of photoreceptors: three classes of cones and one class of rods. *Cones* allow us to see details and thereby make possible our perception of art. They work in daylight and in well-lit rooms, and they are responsible for sensitivity to contrast, color, and fine detail (Fig. 15-5). Cones are present everywhere in the retina, but they are the only photoreceptors located in the center, or *fovea,* the most sensitive region for vision. The fovea is also the region where cones are most densely packed: as a result, our sharpest visual discrim-

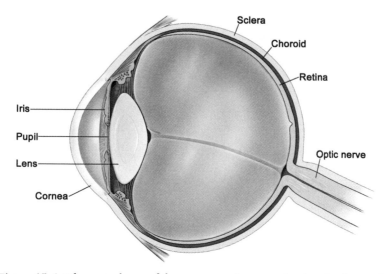

Figure 15-4. The outer layer of the eye—or *sclera*—maintains the shape of the eye. The transparent front portion of the sclera is called the cornea. Light enters the eye through the cornea and is focused by the lens. The iris is the colored part of the eye. It contains the pupil, a circular opening that increases or decreases in size depending on the brightness of the surrounding light. The light that enters the pupil falls onto the lens, where it is altered by refraction before striking the retina at the back of the eye.

Central
retina

Peripheral
retina

Cones

Rods

Figure 15-5. The center of the retina contains small densely packed cones. These get larger and interspersed with increasingly large rods toward the periphery of the retina.

ination of faces, hands, objects, scenes, and color depends on foveal cones. As one moves from the fovea out toward the periphery of the retina, cones become progressively more spread out. As a result, resolution is lower in the periphery and visual information transmitted from this region of the retina is blurred.

Each of the three classes of cones contains a different pigment, and each class is most sensitive to one particular component of the color spectrum: deep violet, green, or dark red. Thus, a green car, for example, absorbs all the frequencies of visible light shining on it *except* for the frequencies that constitute green. These frequencies are reflected by the car. The cones sensitive to green respond to them, and the brain perceives the car as green.

Color vision is essential to basic visual discrimination. It enables us to detect patterns that would otherwise go unnoticed and, together with variations in brightness, greatly sharpens the contrast between the components of an image. But color alone, without any variation in brightness, is a surprisingly poor detector of spatial details (Fig. 15-6).

Color also enriches our emotional life. We perceive colors as possessing distinct emotional characteristics, and our reaction to these characteristics varies with our mood. Thus, color can mean different things to different people. Artists, specifically modernist painters, have used exaggerated color as a way to generate emotional effects, but the

intensity or even the type of emotion depends on the viewer and the context. This ambiguity with respect to color may be another reason why a single painting can elicit such different responses from different viewers or even from the same viewer at different times.

*Rods* vastly outnumber cones, by about 100 million to 7 million, and are ineffective in daylight or normal levels of indoor light because they become saturated at those intensities. Rods also do not carry information about color and therefore do not contribute to our perception of art under normal conditions. However, rods are more sensitive

A. Full color image

Figure 15-6A. A normal full-color image of flowers contains information about variations in brightness and color.

B. Black and white only

B. A black-and-white image shows brightness variations. Spatial detail is easily discerned in this kind of image.

C. Color only

C. A purely chromatic image contains no information about variations in brightness, only information about hue and saturation. Spatial detail is hard to discern.

to light than cones are, and they amplify light signals much more than cones do.

Rods are entirely responsible for night vision. You can tell this on a clear night by looking at a star, particularly one that is not very bright. You may have difficulty seeing the star if you look at it straight on, because the cones in your fovea do not respond to low levels of light. But if you turn your head slightly and look at the star out of the corner of your eye, you will recruit the rods in the periphery of the retina, which will enable you to see the star clearly.

THE DENSELY PACKED cones in the fovea pick up the fine details of an image but do not perceive well the coarser, large-scale components of an image, whereas the more widely spaced cones in the periphery of the retina do. Thus, the brain processes visual information in two ways: on a fine scale, for a parts-based analysis, and on a coarse scale, for a holistic analysis. The parts of a visual image that we use to identify a particular face—the size and shape of the nose, for example—are processed by the foveal cones, which are sensitive to fine scale and high resolution, and the parts of the image that we use to identify the emotional state of the face are processed by peripheral cones, which are sensitive to coarser, more holistic (Gestalt) elements.

Margaret Livingstone uses this perceptual distinction in an interesting analysis of Leonardo da Vinci's enigmatic *Mona Lisa* (Fig. 15-7). As reflected in the attention it has received from both art historians and psychoanalysts, this painting is generally considered one of the great masterpieces of Western art and one of the best examples of ambiguity in painting. It symbolized the Renaissance ideal of the feminine mystique, an embodiment of what the great German poet Goethe called "the eternal feminine." One of the eternal charms, as well as one of the eternal mysteries, of this extraordinary portrait is her expression. What emotion is she exhibiting? She seems to be smiling and radiant at one moment, yet wistful or even sad at another. How is this shift in emotional expression achieved?

Ernst Kris argued that we see her expression differently at different moments because the ambiguity inherent in her facial expression allows us to interpret her expression in terms of our own mood. A traditional explanation of this ambiguity is that Leonardo used a special artistic technique developed during the early Renaissance called *sfu-*

*mato,* or shading, to create the subtle shadows around the mouth that characterize the painting. The technique involves first laying down a translucent dark paint and then painting back into it with a small amount of an opaque white, blurring or softening the pointed outlines

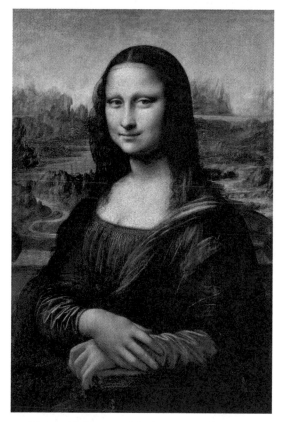

Figure 15-7. Leonardo da Vinci, *Mona Lisa*
(c. 1503–6). Oil on panel.

(in this case the corners of the mouth) with the fingertips rather than a brush.

Livingstone proposes an alternative explanation for the portrait's shifting expression, which she argues results from Leonardo's conveying two conflicting types of information. When we look at the mouth of the *Mona Lisa,* we do not immediately detect her famously enigmatic smile: our foveal vision focuses on detail, and the smile does not emerge from that detail, although the corners of her mouth are enigmatic. But like the distant star, if we look at the side of her face or at her

eyes, the smile emerges quite clearly. This happens because our peripheral cone vision, which cannot perceive details well, employs a holistic analysis that enables us to see the softening effects of the sfumato technique on her lips and the corners of her mouth (Fig. 15-8).

Livingstone uses this finding to illustrate that we can perceive things in peripheral vision—like Mona Lisa's smile—that we miss in central vision. Since facial expressions depend on deep facial muscles, and changes in deep muscle activity can be blurred by subcutaneous fat, peripheral vision may often be better than foveal vision for interpreting emotion in a face. That said, we can easily recognize a face as a face from just the edges encoded by foveal vision.

THE SCIENTIFIC STUDY of visual perception in the mammalian eye began with Stephen Kuffler. Kuffler (Fig. 15-9) was born in 1913 in Hungary, which was at that time still part of the Austro-Hungarian Empire. In 1923 he went to Vienna to attend a Jesuit boarding school, and in 1932 he entered the University of Vienna School of Medicine, where he specialized in pathology and received his medical degree in 1937. When Hitler entered Vienna in 1938, Kuffler, who was involved with an anti-Nazi student political group and whose paternal grandmother was Jewish, realized that his life was in danger. He fled first to Hungary, then to England, and then to Australia. He moved to the United States in 1945 and settled at the Wilmer Eye Institute of Johns

coarse components          medium components          fine details
(peripheral vision)        (near peripheral vision)   (central vision)

Figure 15-8. Blurring effects of peripheral vision. Note that the edge of Mona Lisa's mouth seems much less turned upward when examined with central rather than with peripheral vision.

Hopkins University. In 1959 he moved to Harvard Medical School, where in 1967 he established the first Department of Neurobiology in the country; that department combined physiology, biochemistry, and anatomy to study the brain.

Upon his arrival at Johns Hopkins, Kuffler studied how nerve cells in the brains of simple invertebrate animals such as crayfish communicate with each other. Scientists already knew from Sigmund Freud's work on invertebrates in 1884 that neurons are very similar in all brains, vertebrate as well as invertebrate.

Neurons typically have three regions: a single cell body, a single axon, and numerous dendrites (Fig. 15-10). The long, slender axon extends from one end of the cell body and carries information, often over a considerable distance, to a point of contact with the dendrites of a target, or receiving, cell. The densely branched dendrites, which generally emerge from the other end of the cell body (the end opposite the axon), receive information sent from other nerve cells. Kuffler studied the process of *synaptic communication,* the transfer of information from

Figure 15-9. Stephen Kuffler (1913–80). Kuffler, who studied at the Vienna School of Medicine, was one of the first scientists to examine how visual stimuli are processed in the mammalian retina. Here he is pictured while on a beach vacation in Punta Banda, Baja, Mexico.

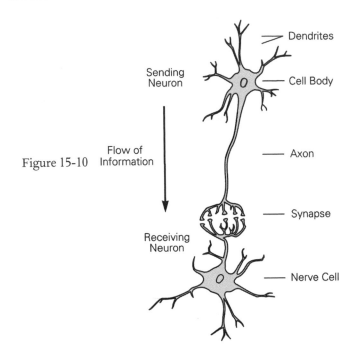

Figure 15-10

one neuron to another that takes place at the *synapse,* the point of contact between the sending cell's axon and the target cell's dendrites.

As we have seen, neurons generate rapid, all-or-none signals called action potentials. Once initiated, the electrical signal of an action potential is carried faithfully along the full length of the axon to its terminal. It is at its terminal that an axon forms one or more synapses with its target cell. The strength of the signal does not change, because the action potential is continually regenerated along the axon. The target neuron also receives signals from other nerve cells. Those cells may be excitatory neurons that increase the number of action potentials the target cell fires, or they may be inhibitory neurons that decrease the firing. The longer the excitatory neurons are active, the longer the target neuron will be active.

Kuffler realized that the way in which excitatory and inhibitory neurons interact to control the firing patterns of a single target neuron represents in microcosm the brain's organizational logic: how nerve cells in the brain add up the total excitatory and inhibitory information they receive from various sources and, based on that computation, decide whether or not to relay the information to cells in higher regions of the brain. The British physiologist Charles Sherrington, who was

awarded the Nobel Prize in Physiology or Medicine in 1932 for his pioneering work on how the nerve cells in the spinal cord communicate with one another, referred to this task as the *integrative action of the nervous system*. He argued that evaluating the relative value of the incoming information and using that evaluation to make decisions for action is the key task of the nervous system.

The findings from Kuffler's experiments with synaptic excitation and inhibition in simple crayfish encouraged him to study the more complex integration exhibited by nerve cells in the retina of mammals in response to light. At this point, he was exploring integration not simply as a question of mechanisms, but also as a question of how a sensory system of the brain processes information. Or as he put it later in life, he wanted to understand how the brain works.

IN THE BEST Rokitanskian tradition, Kuffler, and subsequently Hubel and Wiesel (Fig. 15-11) went deep into the brain of experimental animals to explore visual perception. They realized from the outset that different neurons probably have different purposes, ways of operating, and properties; therefore, to study the brain effectively, they would

Figure 15-11. David Hubel (b. 1926) and Torsten Wiesel (b. 1924). Wiesel (*right*) and Hubel expanded upon Kuffler's investigation of vision by turning from the retina to the cerebral cortex. They shared the Nobel Prize in Physiology or Medicine in 1981 for their work on information processing in the visual system.

need to examine it one cell at a time. First Kuffler, and then Hubel and Wiesel, inserted tiny recording electrodes into the retina of the eye and later into the brain and recorded electrical impulses in the nerve cells there. They connected their recording electrodes to an oscilloscope and to an audio amplifier and a loudspeaker so that they could see single cells firing action potentials on the oscilloscope and, at the same time, hear them going off like tiny firecrackers over the loudspeaker. Using these single-cell methods, Kuffler, Hubel, and Wiesel proceeded to study how cells in different regions of the visual system respond to elementary stimuli and how information is transformed by the various relays that extend from the retina to higher-order visual areas of the brain.

Kuffler began by recording the action potentials generated by individual retinal ganglion cells, both those in the center of the retina and those in the periphery. He found that these specialized neurons receive information about a visual image from both cones and rods, that they encode that information into a pattern of action potentials, and that retinal ganglion cells then transmit the information to the brain. In the process of obtaining these recordings, he made his first surprising discovery: retinal ganglion cells never sleep. They fire action potentials spontaneously, even in the absence of light or any other stimulation (Fig. 15-12). Like a self-starting device, this slow, spontaneous firing searches the environment for signals and provides an ongoing pattern of activity on which subsequent visual stimuli can act. Excitatory stimuli increase this firing and inhibitory stimuli decrease it.

Kuffler then made a second discovery. He found that the most effective way to change the spontaneous firing pattern of retinal ganglion cells is not by shining a powerful, diffuse light over the whole retina, but by shining a tiny spot of light on only a portion of it. In this way, he found that each of these retinal neurons has its own territory for receiving incoming information, its own *receptive field* that corresponds on the retina to a particular piece of the outside world. Each neuron reads and responds only to stimulation within its own receptive field, and each conveys information to the brain only from its own receptive field. Kuffler next found that the frequency of a neuron's firing is a function of the intensity of the tiny light spot striking its receptive field, and the duration of its firing depends on the duration of the light stimulus. Since the entire retina is blanketed with the receptive fields of different

## Receptive field organization of an On-center cell

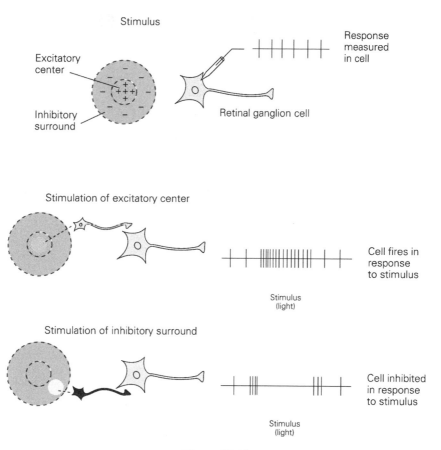

Figure 15-12

retinal nerve cells, no matter where on the retina a light is shone, some neurons will respond. This finding was one of the earliest indications of how meticulously specialized the visual system is for picking out tiny details in the environment.

The retinal ganglion cells with the smallest receptive fields are in the center of the retina. They receive information from the most densely packed cones, those concerned with the sharpest visual discrimination— looking at the details of a painting, for example—and that read the smallest pieces of the outside world. Some ganglion cells a little bit off the center of the retina have somewhat larger receptive fields that com-

bine information from many cones. These cells begin the process of analyzing the coarse-scale, holistic components of images. Kuffler found that the receptive fields of retinal ganglion cells are progressively larger the farther the cells are from the center of the retina; this accounts for the peripheral cells' inability to process fine detail and results in the blurry images discussed earlier.

As Kuffler systematically explored the retina by shining a tiny light on the receptive field of various retinal ganglion cells, he made a third discovery. He found that there are actually two types of retinal ganglion cells, that they are distributed equally throughout the retina, and that they differ in the nature of their central and surrounding regions. *On-center neurons* are excited when a small spot of light strikes the very center of their receptive field and are inhibited when light strikes the surrounding area. *Off-center neurons* have the opposite response: they are inhibited when a small spot of light strikes the center of their receptive field and excited when light strikes the surrounding area (Fig. 15-13).

The discovery of this *center-surround organization* of retinal ganglion cells revealed that the visual system responds only to those parts of an image where the intensity of light changes. In fact, Kuffler's work showed that the appearance of an object depends principally on the *contrast* between that object and its background, not on the intensity of the light source.

This led Kuffler to another insight about vision: retinal ganglion cells do not respond to absolute levels of light; rather, they respond to the contrast between light and dark. The reason a large spot of light or diffuse light is not effective at stimulating retinal ganglion cells is because diffuse light covers both the excitatory and the inhibitory regions of each neuron's receptive field. His finding also provided a biological basis for the related principle that the brain is designed to ignore unchanging patterns and to respond selectively and dramatically to contrasts. We can see this illustrated in Figure 15-14. The two gray rings are identical in hue, but the one on the left appears brighter than the other because the different backgrounds produce different contrasts. Finally, the center-surround organization of retinal ganglion cells explains why the visual system is so sensitive to discontinuities in the light falling on the retina and why neurons respond more strongly to sharp changes than to gradual changes in the luminance, or brightness,

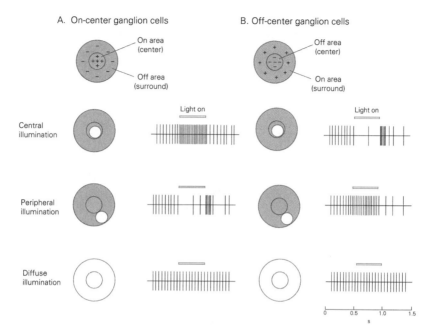

Figure 15-13. Retinal ganglion cells respond optimally to contrast in their receptive fields. Ganglion cells have circular receptive fields, with specialized center and surround regions. On-center cells are excited when stimulated by light in their center and inhibited when light strikes their surround; off-center cells have the opposite responses. The figure shows the responses of both types of cells to three different light stimuli (the stimulated portion of the receptive field is shown in yellow). The pattern of action potentials fired by the cell in response to each stimulus is shown in extracellular recordings. The duration of illumination is indicated by a bar above each record. (Adapted from Kuffler, 1953.)

A. On-center cells respond best when the entire central part of the receptive field is stimulated by a spot of light. These cells also respond well, but less vigorously, when only a portion of the central field is stimulated by a spot of light. Illumination of the surround by a spot of light reduces or suppresses the cell's firing, which resumes more vigorously for a short period after the light is turned off. Diffuse illumination of the entire receptive field elicits a relatively weak response because the center and surround oppose each other's effects.

B. The spontaneous firing of off-center cells is suppressed when the central area of the receptive field is illuminated, but it accelerates for a short period after the stimulus is turned off. Light shone onto the surround of the receptive field excites the cell.

Figure 15-14. The appearance of an object depends principally on the contrast between the object and its background. The two gray rings above are identical in brightness, but they appear to be different—the left ring appears brighter—because their backgrounds produce different contrasts.

of an image. In this way Kuffler found, much as Gombrich had predicted, that only very specific visual stimuli will "pick the locks" on the neural gateways to vision.

OUR VISUAL SYSTEM evolves in accord with the demands of the natural world. Indeed, the early stages of the visual system that Kuffler studied show Darwinian evolution in action: that is, the structure of the human eye has evolved to optimize the processing of information coming to us from our surroundings. Moreover, the limit of our visual acuity, the finest resolution, is jointly determined by the resolving power of the eye and the spacing of the cones in the fovea. These cones send information to retinal ganglion cells whose receptive fields are shaped to extract the most critical information about an image and to minimize redundancy, ensuring that no part of the signaling power of the retina is wasted. The size of the center of retinal ganglion cells relative to the surround of their receptive fields is also perfectly suited to identify the informative elements of an image and ignore redundant ones.

Kuffler's work further illustrated that the retina does not transmit images passively. It actively transforms and encodes an image from the visual world into a pattern of action potentials, using a vast number of photoreceptor neurons and other nerve cells, all working in parallel—an arrangement of parallel processing that provides great computational power. This pattern of activity is then conveyed to the lateral geniculate nucleus of the thalamus and from there to the cerebral cor-

tex, where it is further deconstructed and then reconstructed into an internal representation of an image. Thus, Kuffler's findings about the extraordinary importance of contrast for signaling in the retina prepared the way for the even more surprising insights about vision that were to emerge from studies of the visual cortex, to which we turn next.

# RECONSTRUCTION OF THE WORLD WE SEE: VISION IS INFORMATION PROCESSING

ᏧᏍᎧ

ALTHOUGH THE RETINA IS EXTREMELY SOPHISTICATED, IT CANNOT separate unnecessary details from the constant, essential features of objects, scenes, and faces. The work of sorting out visual information—keeping the core features required for recognition and discarding nonessential details—is accomplished largely in the regions of the cerebral cortex that are committed to vision. In the course of a collaboration that lasted more than twenty years, David Hubel and Torsten Wiesel carried Stephen Kuffler's analysis of the early stages of vision into those regions of the brain and dramatically enhanced our understanding of how the various relays there process visual information. Their work and that of Semir Zeki of University College London provided our initial understanding of how the brain constructs the lines and contours necessary for object recognition.

Zeki appreciated that the line assumed a dominant role for the pioneers of abstract art, such as Paul Cézanne, Kazimir Malevich, and the cubists. The artists grasped intuitively that in the viewer's brain, lines are elaborated upon in dramatic ways to give the impression of an edge. The different roles of line and contour in depicting outlines and edges in art can be seen by comparing two paintings by Gustav Klimt and Oskar Kokoschka with two drawings by Klimt and Egon Schiele.

In paintings, we easily distinguish an object or an image from its edges. Those edges, however, are not always explicitly painted; they are often created by a shared border. Compare Klimt's later portrait of Adele Bloch-Bauer with Kokoschka's portrait of Auguste Forel

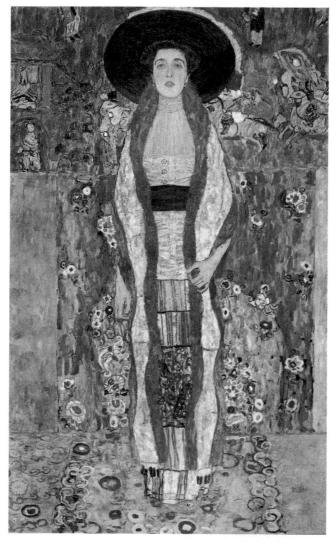

Figure 16-1. Gustav Klimt, *Adele Bloch-Bauer II* (1912). Oil on canvas.

(Figs. 16-1, 16-2). Klimt delineates Adele's face and hands from their background with dramatic differences in color and value and a relatively clean outline. We understand where her head ends and her hat begins because of the chromatic shift between a light area and a darker one. The simple contour line combines with the contrast in value to emphasize the flatness of the image and to highlight the static, immortal qualities of the sitter. Kokoschka does the inverse in his painting of Forel. He uses only slight differences in value within the face but strong contour lines to shape, even sculpt, the edges of

Forel's head, bringing it forward from the background in an attempt to capture the sitter's unconscious reverie. These outlines are even more dramatic in the depiction of Forel's hands, which are circumscribed by a thick black line.

In line drawings, our visual system can create different mental representations from subtly different treatments of lines and contours. In Figure 16-3, Klimt outlines a figure lightly and embeds it in ornamentation. In Figure 16-4, Schiele depicts his figure more simply and with greater emphasis on contours, using Auguste Rodin's technique of drawing without taking his eyes off his model. Schiele's bolder contour lines enhance the three-dimensionality of his image, emphasizing its volume. Moreover, they create an elegant and economical physical boundary between figure and ground. As a result, even though a similar representation—a nude woman—is conveyed to our visual system by both artists, we see them very differently.

While contours such as Schiele's communicate three-dimensional forms with great acuity, they do not resemble forms in nature. Objects in the world, like the figures in Klimt's paintings, are not separated from their backgrounds by a visible outline. The fact that images made

Figure 16-2. Oskar Kokoschka, *Portrait of Auguste Henri Forel* (1910). Oil on canvas.

Figure 16-3. Gustav Klimt, *Reclining Nude Female* (1912–13).
Blue pencil on paper.

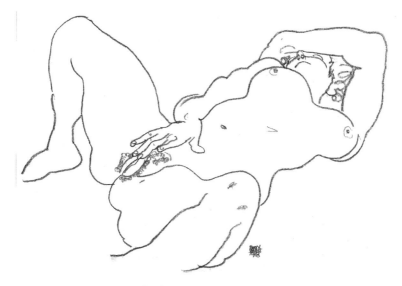

Figure 16-4. Egon Schiele, *Reclining Nude* (1918). Crayon on paper.

of artificial outlines are so convincing gives us a fascinating insight into the tools our brain uses to distinguish visual objects.

THE OPTIC NERVE, a biological cable composed of more than a million axons, carries the action potentials fired by retinal ganglion cells to the lateral geniculate nucleus. This structure is part of the thalamus, the gateway and distribution point for sensory information going to the cerebral cortex. Hubel and Wiesel began their work in the thalamus of laboratory animals, where they found that neurons in the lateral geniculate nucleus have properties very similar to those of the retinal ganglion cells. The neurons in the lateral geniculate nucleus also have circular receptive fields that are of two types, on-center and off-center.

They then examined neurons in the primary visual cortex. These neurons receive information about an image from the lateral geniculate nucleus and relay it forward to other areas of the cerebral cortex. Like neurons in the retina and the lateral geniculate nucleus, each neuron in the primary visual cortex is highly specialized and responds only to stimulation of a particular part of the retina—its own receptive field. But here Hubel and Wiesel made a remarkable discovery: neurons in the primary visual cortex do not simply and faithfully reproduce the input from the lateral geniculate nucleus; instead, they abstract the linear aspects of a stimulus. Because they have bar-shaped rather than circular receptive fields, these cortical neurons respond best to contours—to a line, a square, or a rectangle. They respond to lines that define the edges of an image or that mark the boundary between light and dark areas.

Most amazing, Hubel and Wiesel found that neurons in the primary visual cortex respond not simply to lines, but to lines with a specific orientation—vertical, horizontal, or oblique. Thus, if a black line or edge is rotated on an axis before our eyes, slowly changing the angle of each edge, different neurons will fire in response to the different angles. Some neurons will respond when the edge is vertical, others when the edge is horizontal, and still others when it is at an oblique angle. Moreover, like neurons in the retina (and the lateral geniculate nucleus), nerve cells in the primary visual cortex respond best to discontinuities of dark and light (Figs. 16-5, 16-6).

These results show dramatically that the mammalian eye is not a

camera; it does not record the image of a scene or a person pixel by pixel, nor does it capture accurately the colors of the image. Moreover, the visual system can pick and choose and discard information, which neither a camera nor a computer can.

Zeki writes of Hubel and Wiesel's discovery:

The discovery that . . . cells respond selectively to lines of specific orientation was a milestone in the study of the visual brain. Physiologists consider that orientation selective cells are the physiological building blocks for the neural elaboration of forms, though none of us knows how complex forms are neurologically constructed from cells that respond to what we regard to be the components of all forms. In a sense, our quest and our conclusion is not unlike those of Mondrian, Malevich and others. Mondrian thought that the universal form, the constituent of all other more complex forms, is the straight line; physiologists think that cells that respond specifically to what some artists at least consider to be the universal form are the very ones that constitute the building blocks which allow the nervous system to represent more complex forms. I find it difficult to believe

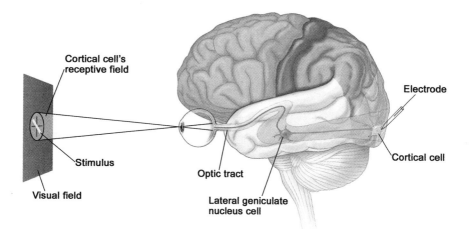

Figure 16-5

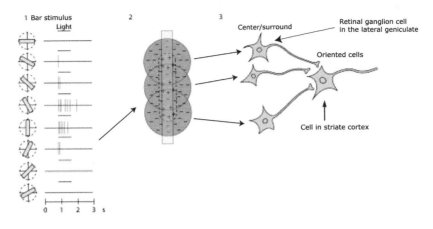

Figure 16-6. 1. The receptive field of a cell in the primary visual cortex is determined by recording its activity while bars of light are projected onto the receptive field on the retina. The duration of illumination is indicated by a horizontal line above each record of action potentials. The cell's response to a bar of light is strongest if the bar is vertically oriented in the center of its receptive field.

2. The receptive fields of simple cells in the primary visual cortex have narrow, elongated zones with either excitatory (+) or inhibitory (-) areas. Though the types of stimuli they respond to vary, the receptive fields of these cortical cells share three features: 1) a specific position on the retina, 2) discrete excitatory and inhibitory zones, and 3) a specific axis of orientation.

3. A model of the organization of inputs in the receptive field of simple cortical cells first proposed by Hubel and Wiesel. According to this model a neuron in the primary visual cortex receives excitatory connections from three or more on-center cells that together represent light falling along a straight line in the retina. As a result, the receptive field of the cortical cell has an elongated excitatory region, indicated by the colored outline in the diagram. The inhibitory surround is probably provided by off-center cells whose receptive fields (not shown) are adjacent to those of the on-center cells. (Adapted from Hubel and Wiesel, 1962.)

that the relationship between the physiology of the visual cortex and the creations of artists is entirely fortuitous.[1]

The importance of line and the power of implied line were in fact understood by artists long before these relatively recent discoveries were made in brain science. Among his many other skills, Klimt was a

master of the principles of subjective contours, whereby the viewer completes the contour of an image. This is especially clear in his Golden Phase, where he routinely occluded the body's contours with expanses of gilded ornamentation, leaving the construction of those contours to the viewer's imagination. At times, he even played off the dual meaning of occlusion. In *Judith* (Fig. 8-27), we saw that the gold choker she wears separates her head from her body. We naturally envision an outline of her neck, even though there is none in the image, because our brain uses the Gestalt principle of closure, seen in the Kanizsa triangle, to create the missing outline.

HUBEL AND WIESEL also demonstrated in their animal studies that the computations of the visual system are hierarchical: an image enters the eye in an unprocessed form and is elaborated in the higher regions of the visual system into the processed image that we consciously perceive. Moreover, they and Zeki discovered that neurons in the primary visual cortex, but especially those in the next two regions of the visual cortex, V2 and V3, respond to a *virtual* line as effectively as to a real line. As a result, these neurons are capable of completing contours, an ability that accounts for the phenomenon Gestaltists call *closure*.

Zeki argues that the Kanizsa triangle described in Chapter 12 (Fig. 12-5) is an example of *closure*—of the brain trying to complete and thereby make sense of an incomplete or ambiguous image. His later imaging experiments indicated that when a person looks at implied lines, neurons in the primary visual cortex and in the V2 and V3 regions become active, as do neurons in an area of the cortex that is critical for object recognition.

Presumably, the brain completes lines because nature often presents occluded contours that must be completed in order to perceive an image correctly, as might happen when a person sees someone coming around a corner or a lion stepping out from behind a bush. As Richard Gregory reminds us, "Our brains create much of what we see by adding what 'ought' to be there. We only realize that the brain is guessing when it guesses wrongly, to create a clear fiction."[2]

An essential feature of object recognition, as we have seen, is the separation of a figure from its background. Figure-ground separation is continuous and dynamic because the same elements that serve as part of the figure in one context can serve as part of the background in an-

other. Some cells in the V2 region of the visual cortex that respond to virtual lines, like those in the Rubin vase, also respond to the sides of figures—their borders. But simply locating borders is not enough to distinguish a figure from its background. It is also necessary to infer from the context of the image which of the two regions abutting a border owns it. The question of border ownership is particularly salient in figure-ground switching, such as that in the Rubin vase and the rabbit-duck figure.

Zeki and his colleagues have imaged the brains of people during such figure-ground switching. Their experiments reveal that while looking at the Rubin vase, activity in the brain shifts from the face recognition areas of the inferior temporal cortex to the area involved in object recognition in the parietal cortex. Moreover, each reversal is accompanied by a transient lull in the activity of the primary visual cortex. The activity of the primary visual cortex is essential for the perception of an image, be it a vase or two faces, but that activity must be stopped in order for a shift to occur. Finally, when the percept changes from one image to the other, the information is broadcast more widely so that the fronto-parietal cortex also becomes active. Zeki and his colleagues suggest that this activity represents top-down processing and that it determines which percept is consciously attended to. Thus, the recruitment of the fronto-parietal cortex is required to make the beholder consciously aware that an image has just switched, a point we shall return to in Chapter 29 on considering the switch from unconscious to conscious processing.

THE IMAGE ON the retina of each eye is two-dimensional, like a painting or a film, yet we see a three-dimensional world. How do we achieve this perception of depth? The brain uses two major types of cues: monocular cues and binocular disparity cues.

Much of depth perception, including perspective, can be obtained from *monocular cues*. In fact, at a distance of more than twenty feet, the images seen by the retina of each eye, though separated a small distance by the nose, are essentially the same. As a result, viewing an object at such a distance is equivalent to viewing it with one eye. Nevertheless, we rarely have trouble evaluating the relative location of a distant object. We can see depth with one eye because the brain relies on a number of tricks, called *monocular depth cues* (Fig. 16-7). These cues have

been known to artists for centuries and were codified by Leonardo da Vinci in the first part of the sixteenth century.

Five key monocular cues apply to our viewing of static images such as works of art. These cues are especially important to painters because

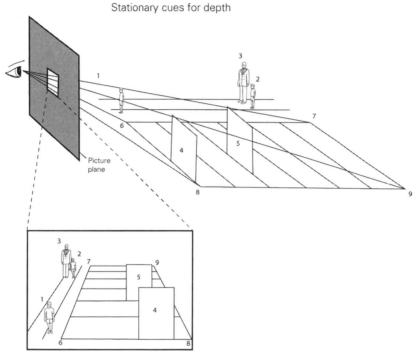

Figure 16-7. *Occlusion:* The fact that rectangle 4 interrupts the outline of rectangle 5 indicates that rectangle 4 is in front, but not how much distance there is between them.

*Linear perspective:* Although lines 6-7 and 8-9 are parallel, they begin to converge in the picture plane.

*Relative size:* Because we assume the two boys are the same size, the smaller boy (2) is assumed to be more distant than the larger boy (1) in the picture plane. This is also how we know how much closer rectangle 4 is than 5.

*Familiar size:* The man (3) and the nearest boy are drawn to nearly the same size in the picture. If we know that the man is taller than the boy, we deduce on the basis of their sizes in the picture that the man is more distant than the boy. This type of cue is weaker than the others. (Adapted from Hochberg 1968 as cited in Kandel et al., "Principles of Neural Science IV," p. 559.)

their task usually involves depicting a three-dimensional scene on a two-dimensional surface. The first cue is *familiar size:* knowledge about a person's size from previous encounters helps us judge that person's distance from us (Fig. 16-7). If the person appears smaller than the last time we saw him or her, the person is in all likelihood farther away. The second cue is *relative size:* if two people or two similar objects appear different in size, we assume that the smaller one is farther away. In addition, we judge the size of an object by comparing it to its immediate surroundings (Fig. 16-8). When we see two people at different distances, we do not judge the size of each person by comparing them to each other but by comparing them to the objects immediately surrounding them. In this comparison, we also rely on our familiarity with other objects in the image.

The third monocular cue is *occlusion:* if a person or object is partially hidden by another person or object, the viewer assumes that the person or object in front is closer than the one being hidden. In Figure 16-9, for example, we see three geometric forms on a flat surface: a circle, a rectangle, and a circle. The circle seems closest to us and the rectangle farthest away because the triangle partly occludes the rect-

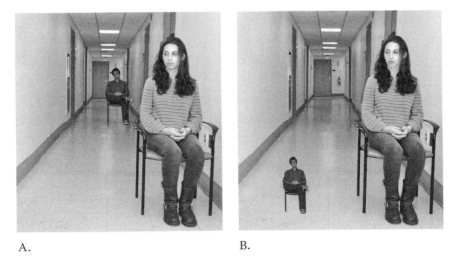

A.

B.

Figure 16-8. A.: The person in the foreground is closer to the camera while the person in the background is farther away.

B.: The farther person has been superimposed next to the closer one, making both figures appear to be close to the camera. In this case, the figure on the left seems drastically smaller, even though he is the same size as in A.

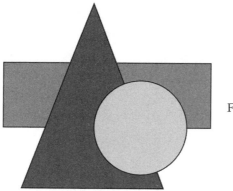

Figure 16-9

angle and the circle partly occludes the triangle. Unlike other monocular depth cues, which can indicate an absolute position in space, occlusion allows us to determine only relative nearness.

The fourth cue is *linear perspective*: parallel lines, such as those of a railway track, appear to converge at a single point on the horizon. The greater the length of the lines until they converge, the greater the beholder's sense of distance (Fig. 16-7). The visual system intuitively interprets convergence as depth because it assumes that parallel lines always remain parallel. The fifth monocular cue is *aerial perspective*. Warmer colors seem closer to the viewer than cooler colors, and objects of darker value seem closer than lighter ones.

The American astronomer David Rittenhouse, who built the first telescope in the United States and was celebrated for his mapping and surveying abilities, pointed out in 1786 that shading produces a compelling perception of three-dimensional shapes based on two inferences that we now know are built into the wiring of our brain. One inference is that there is only a single source of light that illuminates the entire image; the second is that this light source comes from overhead (Fig. 16-10). Our visual system makes these inferences because our brain has evolved in a solar system that has only one source of light, the sun, which shines from above. Based on these inferences, a round shape lit from above appears convex, while the same round shape lit from below appears concave.

These inferences are also evident when we look at the "muffin pan" of Figure 16-11. We see three rows of convex bumps, or muffins, that jump out at us from the page; these are light on top and dark at the bottom (Fig. 16-11A), an arrangement consistent with the perception of

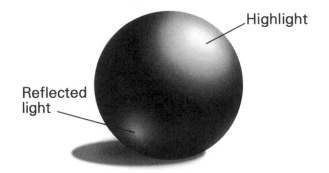

Figure 16-10. Light and shadow are reliable indicators of an object's three-dimensionality. In the absence of other depth cues, we can still tell this ball is a three-dimensional sphere.

the shadow from the ball (Fig. 16-11.A). All of the objects appear to be lit by a single, overhead source. If we turn the figure upside down, however, the images reverse. We now see five concave indentations. This reversal occurs because our brain continues to assume that the source of light is from above. We can also invert the spatial orientation of the circles without rotating the page by imagining the light source coming from below, though this is more difficult. This difficulty of inverting the image's orientation demonstrates that we are hardwired to assume an overhead light source. Another automatic inference is shown

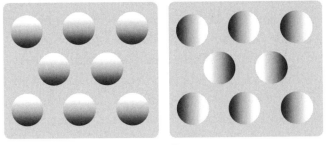

A.                                    B.

Figure 16-11. A. These convex objects appear to be lit from above. Their depth can be reversed by imagining a shift in the light source from the top of the figure to the bottom.

B. The center row appears to have the opposite orientation of the outside rows. Though these can be flipped, it is impossible to see all three rows as simultaneously convex or concave.

in the example (Fig. 16-11.B) which, as in the previous figure, shows three rows of bumps. Here, however, they are lit from the side, and the two circles in the center row have the opposite orientation to those in the adjacent rows. At first, these may appear concave, but they can easily be flipped. Notice that when you intentionally flip them, the orientation of the adjacent rows flips as well. This demonstrates again that the brain invariably assumes a single light source.

Figure 16-11.A illustrates the assumption that is hardwired into the brain we make about the light source being overhead. Intriguingly, this assumption is made not in relation to the horizon or the environment, but to our own head. We seem to assume the sun is stuck to our head: if you tilt your head toward your right shoulder, the center row of Figure 16-11.B invariably appears concave, and causing it to flip becomes much more difficult. Tilting your head toward the left shoulder will yield the opposite effect.

To achieve depth when viewing objects that are closer than one hundred feet, we use *binocular disparity cues* in addition to monocular cues. Binocular disparity arises when we view an object with both eyes, each of which sees the object from a slightly different perspective. An object viewed from a slightly different perspective by each eye produces a slightly different image on each retina. You can test this by looking at a distant object and closing first one eye, then the other.

Hubel and Wiesel found that the signals from the retina of each eye converge on common target cells in the primary visual cortex. This convergence is necessary, but not sufficient, for stereopsis—the sense of depth achieved through binocular vision. Stereopsis further requires that the target cells in the primary visual cortex *compare* the slight differences in the signals from the two retinal images and present us with a single, three-dimensional image. Binocular vision is needed primarily for work done at close range. As we have seen, for vision beyond twenty feet, one eye is perfectly adequate. In fact Jordan Underwood, a baseball player who lost an eye when a line drive hit him in the face, nevertheless developed into a top-flight pitcher.

INSPIRED BY KUFFLER, Hubel, and Wiesel's findings on how the brain deconstructs form, the British theoretical brain scientist David Marr developed a bold new approach to vision. As described in his classic book *Vision,* published in 1982, Marr combined the cognitive

psychology of visual perception pioneered by Ernst Kris and Ernst Gombrich with Kuffler's and Hubel and Wiesel's physiological insights into the visual system and with principles of information processing. In this way, Marr attempted to explain how the physiology of vision, the processing of visual information, and the cognitive psychology of visual perception are related.

Marr's basic idea was that visual perception proceeds through a series of information-processing steps, or representations, each of which transforms and enriches the previous one. Influenced by Marr, modern neuroscientists have developed a three-stage information-processing scheme. The first stage, which begins in the retina, is the *low-level visual processing* studied by Kuffler. This stage establishes the characteristics of a particular visual scene by locating the position of an object in space, and identifying its color.

The second stage, which begins in the primary visual cortex, is the *intermediate-level visual processing* described by Hubel and Wiesel and by Zeki. It assembles simple line segments, each with a specific axis of orientation, into the contours that define the boundaries of an image, thereby constructing a unified perception of an object's shape. This process is called *contour integration*. At the same time, intermediate-level vision separates the object from its background in a process called *surface segmentation*. Together, low-level and intermediate-level visual processing identify as *figures* the areas of the image that are related to an object and as *background* the areas that are not (Fig. 16-12).

These low- and intermediate-level visual processes are carried out together, mostly by means of bottom-up processing. Some of the principles underlying bottom-up processing were studied by the Gestaltists, who developed rules for determining which groupings are most likely to form recognizable patterns. One rule for grouping is the *proximity* of the line segments forming the contours of an object. Another is similarity in color, size, and orientation. Particularly important for contours is the principle of *good continuation*, which holds that the line segments in a figure will generally be oriented and grouped in such a way that the contours continue smoothly (Fig. 16-13).

Of the two stages, intermediate-level visual processing is thought to be particularly difficult because it challenges the primary visual cortex to determine—in a complex visual scene made up of hundreds or even thousands of line segments—which segments belong together in

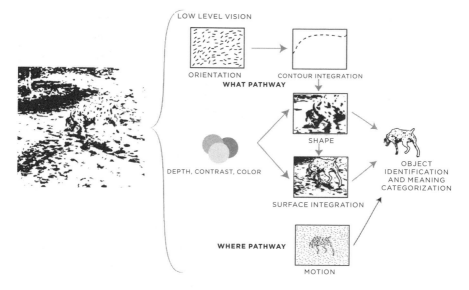

Figure 16-12. The image of the dog at the left is deconstructed and processed at three different levels of vision and along two pathways. *Low-level vision* identifies the location of the dog in space and its color. *Intermediate-level vision* assembles the shape of the dog and defines it as separate from its background. *High-level vision* enables the recognition of a specific object, the dog, and its setting.

The *what pathway* is concerned with the shape and color of the dog's image, and the *where pathway* is concerned with the movements of the dog. The what pathway deconstructs and reconstructs the image in three processing stages.

Figure 16-13. The Gestalt Principle of Good Continuation. The line segments will be grouped so that the contours will continue smoothly. Segment A-O will be grouped with O-D and C-O with O-B.

one object and which are components of other objects. Low- and intermediate-level visual processing must also take into account memories of previous perceptual experiences, which are stored in higher regions of the visual system.

The third stage, *high-level visual processing*, which is carried out along the pathway from the primary visual cortex to the inferior temporal cortex, establishes categories and meaning. Here, the brain integrates visual information with relevant information from a variety of other sources, enabling us to recognize specific objects, faces, and scenes. This top-down processing produces inferences and tests hypotheses against previous visual experience, leading to conscious visual perception and the interpretation of meaning (see Chapter 18). Interpretation of meaning is not perfect, however, and can lead to errors.

THESE NEUROBIOLOGICAL STUDIES of visual processing begin to explain why an artist's strategies for evoking three-dimensional objects and human figures on a two-dimensional surface are so successful. In the natural world, edges that separate one surface from another or from the background are everywhere. Artists have always realized that objects are defined by their shapes, which in turn derive from their edges. In painting, the artist can depict an edge by using a change in color or brightness from one region to the next or with an implied line. The edges of an object separate one surface of generally uniform color, lightness, or texture from another. Contours are important in painting only to give a sharper definition to form.

Line drawing, in contrast, is based entirely on the use of lines, whether *simple lines*—narrow markings of uniform color that are substantially longer than they are wide—or *contour lines*—lines that create a boundary around an object and thereby define its edges. In line drawings, the artist cannot depict changes in brightness, so he or she must use contour lines to create the effect of a two-dimensional edge. By adding light and dark shading to contour lines, the artist can create *complex contours* that produce the effect of a third dimension. Finally, the artist can use *expressive contours*—lines that are typically uneven, thick or thin, curved or jagged—to enhance the suggestion of an emotion.

Line drawings are ubiquitous in all types of art from all cultures.

One of the reasons we see line drawings everywhere, from newspaper comics to cave paintings, is they appear to make intuitive sense. An outline of a smiling face automatically registers as a smiling face. But how? In the actual world, there is no such thing as an outline: objects end and backgrounds begin without any clear line distinguishing the boundaries. Yet the viewer has no difficulty in perceiving a line drawing as representing a hand, a person, or a house. The fact that this sort of shorthand works so effortlessly tells us a lot about how our visual processing system works.

The reason line drawings succeed so brilliantly is that our brain cells are excellent, as Hubel and Wiesel found, at reading lines and contours as edges. The brain integrates simple lines to form the edges that differentiate a figure from its background. Each moment that our eyes are open, orientation cells in the primary visual cortex are constructing the elements of line drawings of the scene before us. Moreover, the primary visual cortex uses the inhibitory regions of those neurons' receptive fields to sharpen the contour lines of an image.

This phenomenon was inferred by the Austrian physicist-philosopher Ernst Mach even before Hubel and Wiesel explored it at the cellular level. Mach discovered a perceptual illusion now called Mach bands. When an area that appears brighter is placed next to an area that appears darker, we perceive lines of enhanced contrast at the boundaries between those areas (Figs. 16-14, 16-15, 16-16). Thus, the lighter area appears much lighter near its border, and the darker area appears much darker near its border. No such lines actually exist. We now understand those lines to be a consequence of the way receptive fields are organized: the central excitatory region of a receptive field, be it a small circular shape (as in the retina and thalamus) or a bar (as in the cortex), is surrounded by inhibitory regions that accentuate contrasts and enhance both dark and light surfaces at the margin, thereby causing the brain to perceive the enhanced boundaries of the Mach bands.

Our ability to perceive contours as edges in a drawing is only one example of the many important differences between perception of images and perception of the real world. The contour lines of drawings often do not contain the richness or even the type of information that edges provide in the real world, but as we see in Figure 16-17, they do not need to. In a drawing, contour lines suffice to allow our brain to infer and represent edges and borders of all kinds. Because contour

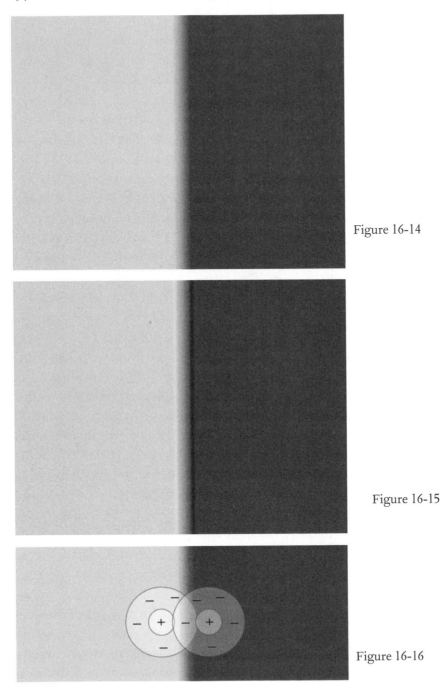

Figure 16-14

Figure 16-15

Figure 16-16

Mach bands. Notice the dark band that appears immediately to the right of the middle strip and the light band that appears immediately to the left. The effect has been artificially enhanced in Figure 16-15.

Figure 16-17. Object recognition. An outline drawing has clearly
recognizable objects because edges are powerful cues in the
perceptual organization of the visual field.

lines are cues to the edges of objects, we can recognize distinct objects
and perceive particular meanings and moods in even the simplest line
drawings, without shading or color (Fig. 16-17).

The neuroscientist Charles Stevens illustrates this point even more
dramatically, using as an example a self-portrait of Rembrandt painted
in 1699 (Fig. 16-18). Stevens compares a line drawing of the artist
(Fig. 16-19) with the painting and shows that even though the line
drawing does not bear a literal resemblance to the painting, the viewer
can easily recognize a similar, three-dimensional image of Rembrandt
in the drawing. Stevens argues that our ability to recognize a line draw-
ing of Rembrandt instantly and effortlessly reveals a fundamental as-
pect of the way images are represented in the brain. For us to recognize
a face, it is enough that the face be abstracted to just a few special con-
tour lines, those defining the eyes, the mouth, and the nose. This al-
lows artists room to make extreme distortions to a face without affecting
our ability to recognize it. As Kris and Gombrich emphasized, this is
why caricaturists and expressionists are capable of moving us so pow-
erfully.

Artists' great success in using contours to represent edges in draw-
ings raises a profound question about our perception of art: Is it learned
or is it genetic? Do we learn the convention that artists can substitute
contour lines for naturally occurring edges? Or does our visual system
have a built-in capability for perceiving an artistic depiction of a face or
a landscape as a real face or landscape?

Margaret Livingstone points out that the artist's ability to trick the
visual system in this way has been known and widely used since the

Figure 16-18.
Rembrandt
Harmenszoon
Van Rijn,
*Self-Portrait at the
Age of 63* (1669).
Oil on canvas.

Figure 16-19.
Line drawing of
Rembrandt's
self-portrait.

beginning of drawing. At the end of the Old Stone Age, some thirty thousand years ago, cave artists in southern France (e.g., Lascaux) and northern Spain (Altamira) had already intuited that the brain makes assumptions about what there is to see. To generate a three-dimensional image, these artists simply used contour lines to define boundaries and then proceeded to highlight them to create contours (Fig. 16-20). Such drawings create the illusion of three dimensions because they delineate in the viewer's brain the height, width, and form of the object or person they describe.

IN A LARGER SENSE, the ability of our visual system to interpret contours as edges in a drawing is but one example of our remarkable ability to see a three-dimensional figure on a two-dimensional background. This creative reconstruction, based on processing information from the retina, is particularly evident in art. The retina, as we have seen, extracts only limited information from the external visual world, so the brain must continuously make creative guesses and assumptions about what is out there to see. No matter how realistic a painting or drawing is, it always exists on a two-dimensional surface that must be elaborated upon.

Patrick Cavanagh, a student of perception, refers to the technical

Figure 16-20. *Bull and Horse*. Cave painting at Lascaux Caves, Périgord, Dordogne, France.

devices used by artists to create these illusions as *simplified physics*. These devices allow the brain to interpret a two-dimensional image of art as a three-dimensional image, as illustrated above in the line drawing of Rembrandt:

> These transgressions of standard physics—impossible shadows, colors, reflections or contours—often pass unnoticed by the viewer and do not interfere with the viewer's understanding of the scene. This is what makes them discoveries of neuroscience. Because we do not notice them, they reveal that our visual brain uses a simpler, reduced physics to understand the world. Artists use this alternative physics because these particular deviations from true physics do not matter to the viewer: the artist can take shortcuts, presenting cues more economically, and arrange surfaces and lights to suit the message of the piece rather than the requirements of the physical world.[3]

He argues that our brain does not apply the regular rules of physics to artistic representations. Paintings instead are allowed to breach the possibilities of reality; beholders seldom notice inconsistent or impossible colors, lighting, shadows, and reflections. These are just as unlikely as the more overt perspectival distortions seen in Cubism, or the drastic chromatic magnifications of the Fauves and Impressionists, yet all of these go undetected and do not interrupt our understanding of the image.

The brain's ability to tolerate illusions, or simplified physics, in works of art demonstrates its remarkable visual flexibility. This flexibility has allowed artists across the ages to take dramatic liberties in their presentation of a visual scene without necessarily sacrificing the believability of the image—liberties ranging from the subtle manipulations and alterations of light and shadow by artists in the Renaissance to the overt and drastic spatial and chromatic distortions of the Austrian expressionists. The types of distortions we tend to tolerate and the assumptions about physics made in these pictorial cues give us great insight into how the brain makes sense of images.

Donald Hoffman, another student of visual perception, has created an example of our ability to use simplified physics to re-create what we see in a work of art. He calls this paradigm the "ripple" (Fig. 16-21).

Figure 16-21. "Ripple."

The ripple is a drawing on a flat, two-dimensional surface, but it appears to be undulating in space like waves on a pond. As is true of other convincing three-dimensional drawings, you will not succeed in seeing the ripple as flat.

The ripple has three parts: a bump in the center, a circular wave around the bump, and another circular wave on the outside. As an aid to discussing the figure, Hoffman has drawn dashed curves along the boundaries of these parts, delineating the troughs between the waves. If you turn the figure (or your head) upside down, you will see an inverted ripple with new parts. The dashed curves now lie on the crests of the waves and not, as before, in the troughs. Turning the figure upright restores the original parts. If you turn the figure slowly, you can catch it in the act of flipping from one set of parts to the other.

The ripple is an impressive feat of your own construction. The curves you see on the page, and the ripply three-dimensional surface, are completely constructed by your brain. Hoffman writes: "You also organize the ripple into three concentric parts, which look like water waves; the dashed contours in the troughs mark roughly where one part stops and the next begins. You aren't a passive perceiver of parts, but their active creator."[4]

WE CAN NOW BEGIN to appreciate how important unconscious mental processes are to the perception of art. We are also beginning to see

the value of Gombrich's ideas about figural primitives from the historical perspective of the evolution of painting. We see that even the earliest artists we know, the cave painters of southern France and northern Spain, had already discovered what Gombrich called the master keys for opening the neural locks of our unconscious senses. The work of Kuffler, Hubel, and Wiesel on low- and intermediate-level visual processing and, as we shall see in the next two chapters, subsequent studies of high-level visual processing have given us valuable insights into how the unconscious brain creates what we consciously see.

*Chapter 17*

# HIGH-LEVEL VISION AND THE
# BRAIN'S PERCEPTION OF FACE,
# HANDS, AND BODY

ᏩᎥᎦ

WE HAVE SEEN THAT LOW- AND INTERMEDIATE-LEVEL VISUAL PRO-
cessing are responsible for assembling simple line segments into the
contours of an image, defining border ownership, and delineating a fig-
ure from its background, but how do we perceive objects? How do we
perceive faces, hands, and bodies? How is the beholder's share achieved?

The research that followed David Hubel and Torsten Wiesel's dis-
coveries traced these tasks to high-level visual processing, which is
concerned with object identification. Semir Zeki and David Van Essen
found some thirty relays beyond the primary visual cortex that con-
tinue the task of analyzing and segregating information about form,
color, motion, and depth. The information from all of these specialized
areas is segregated and conveyed separately to higher, cognitive re-
gions of the brain, including the prefrontal cortex, where they are ulti-
mately coordinated into a single, identifiable perception.

SEGREGATION OF INFORMATION begins in the primary visual cor-
tex. There, as we have seen, information is relayed along one of two
parallel pathways—the what pathway and the where pathway (Fig.
17-1). The what pathway, which receives most of its input from the
cones in the central region of the retina, carries information about our
perception and identification of people, objects, scenes, and color—
what they look like and what they are. This pathway extends from the
primary visual cortex through several additional relays before reach-
ing the inferior temporal cortex, the site of high-level visual processing

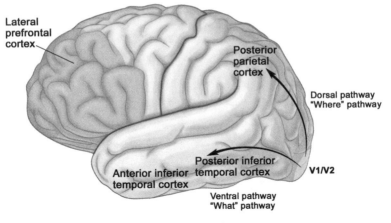

Figure 17-1

where information about the shapes and identities of objects, faces, and hands is represented (Fig. 17-2). The what pathway is further subdivided into a high-resolution *form system* that uses color and luminance to define objects and people, and a lower-resolution *color system* that defines the colors of surfaces.

The where pathway extends from the primary visual cortex to the posterior parietal cortex. This pathway receives most of its input from the rods in the peripheral regions of the retina and is specialized for detecting motion and spatial information—where an object or person is located and how it moves in three-dimensional space (Fig. 17-2). The where pathway provides the information necessary for guiding movement, including eye movements, which are essential for scanning an

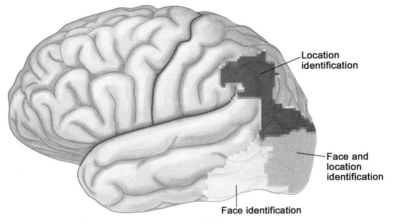

Figure 17-2

image or a scene. Unlike the what pathway, the where pathway is color-blind; however, it responds more quickly and is more sensitive to contrast (differences in brightness), making it suitable for rapid detection of moving or dim objects.

How are the activities of the two pathways coordinated? Is there a final target region where all the elements of a percept—its shape and color, its location—come together? Studies initiated by the cognitive psychologist Anne Treisman at Princeton University have found that the association of information from the what and where pathways, which she calls the *binding problem*, does not occur at any single site. Rather, it occurs when the activities of the various regions of these two pathways are coordinated—and this coordination is achieved by attention.

Indeed, Robert Wurtz and Michael Goldberg at the National Institutes of Health have discovered that attention is a powerful modulator of the response of nerve cells to a visual stimulus. When a monkey pays attention to a stimulus, the response of neurons to that stimulus is much greater than when the animal's gaze is fixed elsewhere.

How is this selective attention achieved? Clearly, to perceive and respond effectively to a face in a portrait, we must look at it and attend to it. But because we see images distinctly only in the fovea, the center of the retina, we cannot look at a whole face at once—it is too big. We can only pay attention to one thing at a time, so we scan the face rapidly, focusing first on the eyes and then on the mouth. (The eyes are important signifiers of emotion, so people who have difficulty scanning them, such as people with autism or with damage to the amygdala, also have difficulty recognizing people's emotional expressions.) The rapid scanning movements of the eyes are called *saccades,* and their purpose is twofold. They enable the fovea to explore the visual environment, and they make vision per se possible (if our eyes focus on one spot for any significant period of time, the image will start to fade).

Scanning occurs so quickly that we seem to see a whole image at once, but it is only during the *fixation period* between saccades that we consciously take in what we see. Devices that monitor eye movements show that we obtain our impressions of faces and the rest of the world around us piecemeal, fixation period by fixation period. Thus, in addition to being reflexive, as when an image appears at the periphery of our vision, saccades also seek information.

But it is the brain that determines where the eyes will move—and

the brain makes these decisions by testing hypotheses about the nature of an image. As the eyes focus on a face, they send a message back to the brain, and that message is analyzed in light of a particular hypothesis. Is this a human face or not? If human, is it a man or a woman? How old is the person? The models that our brain constructs about the world animate our visual attention on a moment-by-moment basis. Thus, we live in two worlds at once, and our ongoing visual experience is a dialogue between the two: the outside world that enters through the fovea and is elaborated in a bottom-up manner, and the internal world of the brain's perceptual, cognitive, and emotional models that influences information from the fovea in a top-down manner.

The length of time our eyes focus on any given feature of a portrait or a real face varies, depending on our visual attention. Attention is driven by a variety of cognitive factors, including intention, interest, previous knowledge recalled through memory, context, unconscious motivation, and instinctual urges. When we detect a particularly provocative or interesting feature, we may allocate our full attentional resources to it by moving our eyes or head in such a way as to focus that feature on the center of the retina. This detailed examination, again, is only possible for a very short period of time—a few hundred milliseconds—because the eye is relentless in its probing and will move on to another feature, on which it will focus for a few milliseconds before coming back to the initial feature. Even when we and the objects that interest us are not moving, the images on our retina do move, because our eyes and head are never entirely still.

OBJECTS, SCENES, AND faces are represented in the inferior temporal cortex. Sigmund Freud had already realized that higher-order visual perception was likely to be handled in the higher regions of the cerebral cortex. He proposed that the inability of certain patients to recognize specific features of the visual world resulted not from a defect in the eye, but from a defect in these higher regions that affected their ability to combine aspects of vision into a meaningful pattern. He called these defects *agnosias* (lack of knowledge).

As neurologists and neuroscientists analyzed patients with agnosias and correlated the loss of particular mental functions with defects in particular regions of the brain, they discovered that the perceptual consequences of damage to specific regions of the what and where path-

ways are amazingly specific. A person with an injury to a particular relay in the where pathway, for example, was unable to perceive depth but had otherwise intact vision. A person with a defect in a different relay in the where pathway was unable to perceive motion, even though all other perceptual abilities were normal. Damage to the color center in the what pathway, which includes the anterior region of the inferior temporal cortex, produces color blindness. Damage to a neighboring area renders a person unable to name colors, even though other aspects of color perception remain intact. Finally, damage to the inferior temporal cortex of the what pathway can produce a specific defect in face recognition known as *prosopagnosia*. To recognize a close friend or relative, people with this defect must rely on the person's voice or other distinguishing features, such as glasses.

PROSOPAGNOSIA WAS FIRST named as a syndrome in a paper published in 1947 by the German neurologist Joachim Bodamer, who named the disorder after the Greek terms for face (*prosop*) and lack of knowledge (*agnosia*). Bodamer was treating three patients who had acquired prosopagnosia through an injury to the brain. We now know that prosopagnosia exists in two forms: the acquired form and a congenital form. The congenital form, which is thought to affect about 2 percent of the population, is different from other congenital brain disorders, such as dyslexia, a difficulty in reading, because it does not improve with training; people with congenital prosopagnosia never improve their ability to recognize faces. It is different from acquired prosopagnosia, which results from damage to the face-recognition areas of the cortex, in that people with congenital prosopagnosia have surprisingly normal activity in these areas. Indeed, using special (tensor) imaging techniques, Marlene Behrmann and her colleagues have now found that in people with congenital prosopagnosia, the face-recognition areas function normally, but communication between the various areas on the right side of the cortex (the side important for face processing) is abnormal.

The inferior temporal cortex is a large area that is divided into two regions, each with its own processing function. The *posterior* inferior temporal cortex is involved in low-level visual processing of faces. Damage to this region leads to an inability to recognize a face as a face. The *anterior* inferior temporal cortex is involved in high-level visual

processing. Damage to this region results in difficulty linking perceptual representations of faces with semantic knowledge. People with this defect can recognize a face as a face, the parts of the face, and even specific emotions expressed on the face, but they are unable to identify the face as belonging to a particular person. They often cannot recognize close relatives or even their own face in the mirror: they have lost the connection between a face and an identity.

The information that these two regions of the inferior temporal cortex send to other regions of the brain is critical for visual categorization, visual memory, and emotion. Most of this information is sent in parallel to three target regions: the lateral prefrontal cortex, for categorizing and holding in short-term memory; the hippocampus, for storing in long-term memory; and the amygdala, for assigning positive and negative emotional value and for recruiting visceral responses to the perception of objects.

FACES ARE BY FAR the most important category of object recognition because they are the main way we recognize other individuals and even images of ourselves. We approach people as friends or avoid them as foes by recognizing them, and we infer their emotional state from their facial expression. As a result, realistic artists over the centuries have been judged by how well they represent the likeness of their subjects, particularly the subtleties of the face and the gestures of the body. A great artist deconstructs the complex image of the face into brushstrokes of paint in such a masterful way that the viewer can readily and pleasurably reconstruct them into a unified perception of an expressive, individual face. Gustav Klimt, and especially his protégés Oskar Kokoschka and Egon Schiele, took this perceptual challenge further, plumbing new emotional depths in their efforts to depict the inner life as well as the outward appearance of their subjects.

Artists through the ages have understood the salience of the human face. Moreover, as Ernst Kris and Ernst Gombrich appreciated, the Bolognese artists of the sixteenth century discovered that a caricature of a face—an exaggerated line drawing—is often easier to recognize than the real face, an insight that was exploited by the mannerist painters and that reappeared in expressionist art. Kokoschka and Schiele intuitively capitalized on the visual system's susceptibility to exaggerated facial features, as well as to exaggerated hand and body positions. By

distorting the physical features of their subjects, the expressionist artists tried both to express and to evoke unconscious emotions.

Considered as visual images, depictions of faces present a remarkably interesting set of problems. On the one hand, all faces are quite similar, possessing two eyes, one nose, and one mouth. We can recognize a face as a face from a minimal drawing of a circle surrounding a vertical line symbolizing a nose, two dots indicating eyes, and a horizontal line below these indicating a mouth. On the other hand, this universal configuration is susceptible to seemingly infinite variation. Each face is unique; it is as much the visual signature of an individual human being as a fingerprint is. Yet while most people are unable to recognize and remember the whorls of a magnified fingerprint, each of us without conscious effort can recognize and remember hundreds, even thousands of faces. How is this possible?

Doris Tsao and Margaret Livingstone, two neuroscientists who later developed a new approach to this question, were drawn to the study of face perception because of the challenges it poses for visual perception in general. Face perception is at the pinnacle of the what pathway. Tsao and Livingstone therefore saw face recognition as a paradigm for understanding information processing in the what pathway. Livingstone writes: "Faces are among the most informative stimuli we ever perceive: Even a split-second glimpse of a person's face tells us their identity, sex, mood, age, race, and direction of attention."[1]

Modern cognitive psychological and neurobiological studies have explained why human faces, hands, and bodies are so special—they are specific Gestalt percepts. We perceive them as a unified whole as soon as our senses detect them. Instead of trying to process a face from a pattern of lines, as it does other visual images, the brain uses a template-matching approach. It reconstructs the face from a more abstract, higher-order figural primitive: an oval containing two dots (for eyes), a vertical line between those dots (for the nose), and a horizontal line below them (for the mouth). Thus, perception of a face requires less deconstruction and reconstruction of an image than perception of other objects does.

Moreover, the brain is specialized to deal with faces. Unlike other complex forms, faces are easily recognizable *only* when they are right side up. They are difficult to recognize and to distinguish from one another when they are upside down. Giuseppe Arcimboldo, a sixteenth-

century Milanese artist who was a favorite of the Viennese, illustrates this dramatically by using fruits and vegetables to create faces in his paintings. When viewed right side up, the paintings are readily recognizable as faces, but when inverted, they are recognizable only as bowls of fruits and vegetables (Fig. 17-3). The expressions of the face are particularly sensitive to inversion, as the two depictions of the *Mona Lisa* in Figure 17-4 show. The expressions of the two faces look similar when the faces are inverted, but when the pictures are upright, large differences in the corners of the mouth and the openness of the eyes become apparent.[2] The human brain clearly gives faces a special status that depends on an upright orientation.

The brain mechanisms underlying face recognition emerge early in infancy. From birth onward, infants are much more likely to look at faces than at other objects.[3] In addition, infants have a predilection for imitating facial expressions, a finding that is consistent with the central role that face perception plays in social interaction. Three-month-old infants begin to see differences in faces and to distinguish between individual faces. At this point they are universal face recognizers: they can recognize different monkey faces as readily as different human faces.[4,5] They begin to lose their ability to distinguish between nonhuman faces at six months of age, because during this critical period in development they have been exposed primarily to different human faces and not to different animal faces. This perceptual fine-tuning of species-specific face discrimination parallels the fine-tuning of language recognition. That is, infants between four and six months of age can distinguish phonetic differences in other languages as well as their native language, but by age ten to twelve months they can differentiate phonetic variations only in their own language.

In 1872 Charles Darwin pointed out that if infants are to survive and perpetuate the human species, they need adults to respond to and care for them. Influenced by Darwin, Konrad Lorenz, a pioneering Austrian ethologist who studied animal behavior in nature, wondered what aspects of the facial structure of infants elicit intrinsic biological caring responses from parents. In 1971 he proposed that it was most likely the babies' relatively large heads, their large, low-lying eyes, and their bulging cheeks. He suggested that these features serve as an "innate releasing mechanism," signals that trigger inborn dispositions for caregiving, affection, and nurturing in parents.

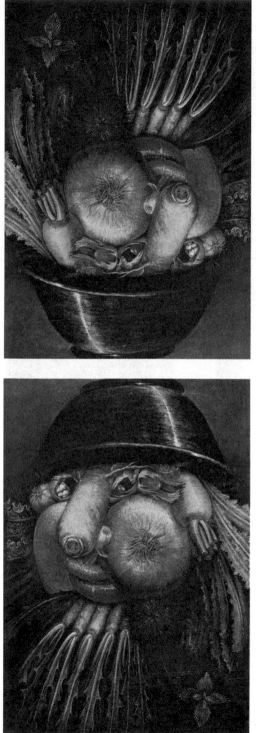

Figure 17-3.
Giuseppe Arcimboldo,
*The Vegetable Gardener*
(c. 1590). Oil on panel.
Top image flipped.

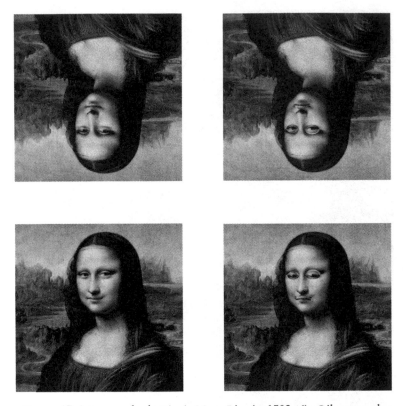

Figure 17-4. Leonardo da Vinci, *Mona Lisa* (c. 1503–6). Oil on panel.
Images have been flipped and modified.

How is facial representation reflected in cellular terms? Do some cells in the brain constitute the building blocks of a face, and do their combined activities constitute representations of a face? Or do specific cells encode the image of specific faces? Two possible answers to this question arose in the 1970s in response to the work of Hubel and Wiesel. One was the hierarchical, or *holistic* view, which held that there must be specific "pontifical" cells at the top of the hierarchy that encode images of persons—your grandmother, for example—or any other complex object, for that matter. According to this view, you might have more than one pontifical "grandmother" cell, and these cells might respond to different aspects of your grandmother, but each cell would carry a meaningful representation of her image. The alternative *parts-based*, or *distributed representation*, view was that you have no grandmother cells that encode her particular image. Instead, the

representation of your grandmother resides in coded patterns of activity in a large ensemble of neurons, a neuronal college of cardinals.

THE FIRST PERSON to attempt to distinguish between these two alternatives was Charles Gross. Picking up on the work of Hubel, Wiesel, and Bodamer, Gross began in 1969 to record from single cells in the inferior temporal cortex of monkeys, the region that, if damaged in people, can cause prosopagnosia. Gross found, amazingly, that some cells in the inferior temporal cortex responded specifically to people's hands, while other cells responded to their faces. What is more, the cells that responded to hands did so only when the individual fingers were visible: They did not respond when there was no separation between the fingers. These cells also responded regardless of the orientation of the hand—whether, for example, the thumbs and fingers pointed up or down. The cells that responded to faces were not selective for any unique face but for the general category of faces. This suggested to Gross that a particular face, a particular grandmother, is represented by a small, specialized collection of nerve cells—an ensemble of grandmother cells, or proto-grandmother cells.

The late twentieth century saw the advent of imaging methods such as positron-emission tomography (PET) and functional magnetic resonance imaging (fMRI) that revolutionized the study of the brain. They allowed scientists to measure blood flow and oxygen consumption by nerve cells, activities that are thought to correlate with nerve cell activity. These methods do not show the activity of individual cells, but rather the activity of regions of the brain containing many thousands of cells. Nevertheless, for the first time, neuroscientists had a way to correlate mental functions with various brain regions and to study those functions in the living, behaving, and perceiving human brain.

Imaging reveals which areas of the brain become active when a person engages in a particular task. It has proven particularly informative in studies of face recognition. Using PET imaging, Justine Sergent and her colleagues at the Montreal Neurological Institute found in 1992 that when normal subjects look at faces, both hemispheres of the fusiform gyrus and the anterior temporal cortex, which are part of the what pathway, are activated. Using fMRI, first Aina Puce and Gregory McCarthy at Yale University, and subsequently Nancy Kanwisher at

MIT, delineated a region in the inferior temporal lobe that is specialized for face recognition. This region—the *fusiform face area*—becomes active when an average person looks at a face. When the same person looks at a house, the region does not respond, although a different region of the brain does. The fusiform face area also becomes active when the person simply imagines a face. In fact, Kanwisher could tell whether a person was thinking about a face or a house by observing which region of the brain became active.

To explore face recognition further, Margaret Livingstone in 2006 combined the approaches of Puce and Kanwisher and those of Gross, using both fMRI and electrical recordings of individual nerve cells in the brain of monkeys. Livingstone, a student of Hubel and an intellectual grandchild of Stephen Kuffler, in turn trained and collaborated with Doris Tsao and Winrich Freiwald. Together, these three scientists expanded our understanding of face perception within and beyond the fusiform face area. They used fMRI to determine which areas of the inferior temporal lobe become active when a monkey looks at a face, and they used electrical recordings to determine how the nerve cells in those areas respond to a face.

They pinpointed six regions in the monkey's inferior temporal lobe that respond only to faces. They called these areas *face patches*. Face patches are small, about three millimeters in diameter, and they are arranged along an axis from the back of the inferior temporal lobe to the front, suggesting that they may be organized into a hierarchy. One patch is located in the back (the posterior patch), two in the middle, and three (the anterior face patches) in the front of the inferior temporal lobe. Tsao and Freiwald positioned electrodes in each of the six regions to record signals from individual nerve cells. They found that cells in the face patches are specialized for processing faces; moreover, in the two middle face patches, an amazing 97 percent of the cells respond only to faces. Their findings reinforced Kanwisher's imaging studies of the fusiform face area of the human brain and indicate that the primate brain in general uses specialized regions to process information about faces.

Tsao and Freiwald did not stop there. They next studied the connections among the six face patches by imaging all six simultaneously and electrically stimulating just one of them. They found that activating one of the middle face patches caused nerve cells within the remain-

ing five areas to become active also. This finding implies that all of the face-recognition regions in the temporal lobe of the brain are interconnected: they seem to form a unified network that processes information about different aspects of the faces they see. The entire network of face patches appears to constitute a dedicated system for processing one high-level object category: faces.

Freiwald and Tsao then asked: What types of visual information do each of these six face patches process? To answer the question, they focused on the two middle face patches and found that the neurons there detect and differentiate faces using a strategy that combines both parts-based as well as holistic, Gestalt principles. They showed monkeys drawings and pictures of faces with different shapes and orientations, and they discovered that the middle face patches are tuned to the geometry of facial features: that is, they detect the *shape* of the face. In addition, cells in these two regions respond to the *orientation* of the head and face: they are specialized for whole, upright faces.

The discovery that the middle face patches respond selectively to the orientation of the face parallels two key findings that have emerged from computer recognition of faces. Much as classical psychologists distinguished between *sensation,* the gathering of sensory information, and *perception,* the use of knowledge to interpret that sensory information, a computer vision program separates the initial *detection* of a face qua face from the later *recognition* of that face as belonging to a particular person. Thus, in the face patches, as in a computer vision program, detection serves as a filter, excluding inappropriate objects and enabling the recognition process to proceed more efficiently. Underscoring the behavioral finding that the brain can most easily recognize upright faces, scientists have found that cells in the face patches of the temporal lobe respond more weakly and less specifically when a face is presented upside down than when it is presented right side up.

Freiwald and Tsao next wanted to know how facial representation evolves across these face patches. In particular, they wanted to understand how the different patches extract information about facial identity, given that we can recognize a face not simply from a single perspective but from multiple angles: front, back, left profile, right profile, above, and below. To answer these questions, they presented monkeys with pictures of two hundred different human faces that the monkeys could compare, and they presented each of the faces from dif-

ferent angles. To study the animals' responses, they again combined fMRI with electrical recordings of activity in individual cells in the face patches.

They focused on four face patches, two middle and two anterior, and found that neurons in the middle face patches responded differently to different faces, but only when the animal was viewing the faces from a particular angle. Thus, although a neuron might respond more to Jack than to Jill when viewing their faces from the front, it might respond more to Jill than to Jack when viewing their faces in profile. Particularly fascinating, they found that cells in one of the anterior face patches were selective as to view; for example, they might respond only to profiles, whether left or right, but not to any angles in between. Freiwald and Tsao comment that finding an entire face patch with such neurons suggests that mirror symmetrical views may be important for object recognition in general. In contrast, neurons in the other anterior face patches were sensitive to the person's identity regardless of viewing angle: for example, neurons that preferred Jack to Jill when viewed from the front also preferred Jack to Jill when viewed in profile.

These findings illustrate that visual information about the viewing angle and identity of faces is processed progressively in successive face patches to generate a Gestalt percept of identity that is constant across changes in viewing angle. In the first, more posterior patch from which Freiwald and Tsao recorded, the cells are not able to link different views of an individual together, whereas the later patches respond to identity irrespective of viewing angle. Furthermore, since the monkeys were confronted with images of human faces that they had never encountered before, and the images were presented randomly, the results suggest strongly that the highly accurate recognition of an individual that occurs in the most anterior face patches, regardless of viewing angle, does not depend upon learning, although learning may well sharpen recognition further. Thus, Freiwald and Tsao concluded that the brain may contain a face-recognition system that is built to recognize a face as a face from any angle, without the need for learning.

Since people confront a large number of faces in their daily lives, it becomes interesting to ask: Do single cells in the human brain actually respond to the face of a given individual? This question was answered by scientists recording from nerve cells in the medial temporal cortex,

an area of the brain concerned with long-term memory storage. Recording from these neurons in patients being prepared for surgery, Christof Koch and his colleagues at the California Institute of Technology found a subset of neurons that do respond to images of people. Notably, a given cell might respond to a number of well-known people, such as Bill Clinton, the former president of the United States. Following up on these findings, Itzhak Fried and his colleagues at the University of California, Los Angeles, found that neurons in the medial temporal cortex are much more likely to respond to images of faces that are personally meaningful than to images of people with whom the patient has no personal contact. These findings suggested to Fried and his colleagues that more relevant and meaningful faces are encoded by a larger proportion of the neurons in the medial temporal cortex than less relevant faces.

The idea that there are special systems for face recognition, as distinct from recognition of other objects, is supported not only by the imaging studies of Puce and of Kanwisher, and by the cellular physiological studies of Livingstone, Tsao, Freiwald, Koch, and Fried, but also, as we have seen, by clinical studies of patients with damage to various regions of the what pathway. One such patient, C.K., has severely impaired object recognition but intact facial recognition. When shown Arcimboldo's images, C.K. recognizes the face but not the fruits and vegetables (Fig. 17-3). In contrast, patients with prosopagnosia, who can detect but not recognize a person's face, actually do better than normal people at seeing faces upside down, including Arcimboldo's faces.

THE GESTALTISTS HELD that we cannot process individual parts of a face without being influenced by the whole face. Freiwald, Tsao, and Livingstone found a strong biological basis for this principle. While studying the middle face patch, they showed monkeys pictures of actual monkey faces and then cartoon monkey faces made of up seven elementary parts: face outline, hair, eyes, irises, eyebrows, mouth, and nose. The cartoon faces were line drawings that lacked many of the features of real faces—pigmentation, texture, three-dimensional structure—but for these monkeys the cartoon faces were just as effective at exciting cells in the middle face patch as pictures of an actual monkey's face.

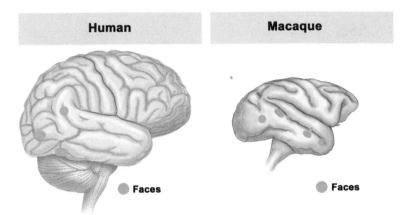

Figure 17-5. Multiple brain areas called "face patches," which recognize faces in humans and nonhuman primates.

This result inspired Freiwald and Tsao to exploit the properties of cartoon faces further. They disassembled cartoons, leaving out parts of the face, and distorted them, separating the two eyes from each other or the nose from the mouth. In analyzing responses to the cartoons, they found, consistent with the prediction of Gestalt psychology, that many cells do not respond to single features or combinations of features unless those features are contained within an oval. Cells in the monkey's face patches that respond to eyebrows or to eyes, for example, will not respond if those features are shown outside the oval image representing the face (Fig. 17-5). Similarly, these face-recognition cells will respond only to the whole face of another monkey, not to the eyes or nose alone (Fig. 17-6).

Freiwald and Tsao next examined different parameters of the face, such as the distance between the eyes, the size of the iris, and the width of the nose, and made the remarkable discovery that the cells in the two middle face patches clearly prefer caricatures. They prefer exaggerations and extremes—the largest or smallest distance between the eyes, the largest or smallest irises. This result held even when the features were exaggerated to unnatural-looking extremes. Thus, the cells respond dramatically when the eyes are made as big as saucers, or when the eyes are pushed apart to the extreme edges of the face, or when they are brought together to form a single, cyclopean eye. Finally, as expected, when the cartoon face was inverted, it proved less effective

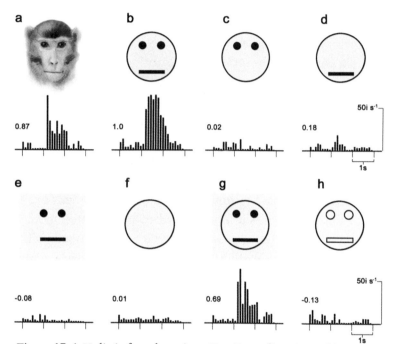

Figure 17-6. Holistic face detection. *Top:* Recording site and location of a face cell in monkey brain. *Bottom (a–h):* facial stimuli presented and responses of the face cell. The height of the bars indicates the firing rate of that cell and thus the strength of face recognition in relation to each stimulus.

than when it was right side up. The finding that cells in the middle face patches respond preferentially to extreme features of the face, especially extreme features of the eyes, may help explain why caricatures, and expressionist art, which exaggerate individual parts within a whole face, are so effective. The finding that these cells do not respond to the cartoon face when it is inverted may also explain why recognition deteriorates when a face is presented upside down.

—

BEHAVIORISTS CARRYING OUT conditioning experiments and ethologists exploring animal behavior in the natural environment had discovered earlier that extremes are particularly effective stimuli. In 1948 the British ethologist Niko Tinbergen, who like his colleague Lorenz was studying mother-offspring interactions, discovered how important exaggeration can be from a biological point of view. Tinbergen found that when a gull chick begs for food, it does so by pecking on a prominent red spot on its mother's yellow beak. The pecking of the chick stimulates the mother to regurgitate her food and feed the chick. Tinbergen calls this red spot a *sign stimulus* because it serves as a signal that triggers in the chick a full-blown, coordinated, instinctive behavior—begging for food. He proceeded to design experiments to test how the chick would respond to exaggerated sign stimuli.

As a first step, Tinbergen showed the chick just an isolated beak, unattached to a mother's body; the chick pecked at the red spot of the disembodied beak just as vigorously as it had on its mother's beak. This suggested that the chick's brain is wired to be attracted more to red spots on yellow material, rather than to the entire mother gull. Ramachandran argues that this illustrates that evolution may favor simple processes, and that recognizing a red spot on a yellow stick requires less sophisticated computing than recognizing another gull as a mother. To test this principle further, Tinbergen showed the chick a yellow stick with a red stripe on it, a simplified abstraction that does not resemble a beak, and the chick again pecked vigorously. He next asked: Would the chick's response change if this abstract beak were modified? Tinbergen now showed the chick an exaggerated beak: a yellow stick with three red stripes on it. This beak, the *exaggerated sign stimulus*, elicited even more excited pecking from the chick than the stick with a single red spot had. In fact, the chick preferred this beak to its mother's. As with caricatures, cartoons, and other exaggerations, the strongest response was elicited by a stimulus that differed substantially from the natural stimulus, a phenomenon Tinbergen called the *enhancement effect of the sign stimulus*. Because they are so exaggerated, such stimuli presumably excite the red-spot-detecting circuits in the chick's visual brain even more powerfully than the spot on its mother's beak does.

In one of his Reith lectures of 2003, Vilayanur Ramachandran dis-

cusses how exaggerations of visual primitives like these may play a role in how we think about art. He argues that it seems likely that humans, like gulls, also are predisposed to have excitatory responses to certain visual stimuli. We have, after all, evolved to react to human faces, and to detect orange and red fruits hidden in foliage. Visual primitives play an important role in art because artists know intuitively that beholders respond strongly to certain faces and color patterns. Indeed, Ramachandran argues that "if . . . seagulls had an art gallery, they would hang this long stick with the three red stripes on the wall, worship it, pay millions of dollars for it, call it a Picasso."[6]

In addition to innate stimuli like the gull beak, enhancement can also affect the response to a learned stimulus. An experimenter can teach a rat to distinguish rectangles from squares by selectively rewarding it. If a rat is presented with an image of a rectangle and presses a lever, the experimenter rewards the rat with a piece of cheese. A similar response to a square, however, has no effect. After some initial conditioning, the rats not only prefer rectangles to squares, but prefer exaggerated, long and thin rectangles to those they were originally trained with. In short, the rats learn that the more exaggerated the rectangles are, the more they are unlike squares. Rats, in all likelihood, are not by nature sensitive to different types of quadrilaterals the way gulls are to the red stripes on yellow sticks, yet rats still react strongly to exaggerations when they have been conditioned. Exaggerated responses to stimuli are therefore not only innate, they can also be learned.

PRESUMABLY, CELLS IN OUR middle face patches set off a strong emotional response to exaggerated facial features because they are connected anatomically to the amygdala, the brain structure that is critical for orchestrating emotion, mood, and social reinforcement. This connection raises the interesting possibility that the middle face patches are part of the neural foundation for Kris and Gombrich's argument that the facial exaggeration used by the mannerist painters, by cartoonists, and later by the Viennese expressionists is successful because the brain responds specifically to facial exaggeration. Moreover, the majority of cells in the middle face patches are specifically responsive to large irises, which may help explain why the eyes are important in any representation of the face. Thus, if we look again at Kokosch-

ka's double portrait of himself and Alma Mahler (see Fig. 9-16), we can begin to understand biologically why it affects us so powerfully: one of the most striking things about this painting is the large eyes, which capture almost completely both Kokoschka's and Mahler's expressions.

The enhancement effect applies to depth and color as well as form. We certainly see an exaggeration of depth in Klimt's flat paintings and amplified color in the faces Kokoschka portrayed and the body (his own) Schiele painted. Moreover, Kokoschka and Schiele reveal an intuitive grasp of the enhancement effect of sign stimuli in their emphasis on the textural attributes of faces. As we saw in Chapter 9, Kokoschka spotted what was presumably a barely perceptible drooping of the left side of Auguste Forel's face and a minor downturn in his left hand and included those details in his portrait of the man. People who saw the portrait immediately recognized them as the signs of a stroke.

Our aesthetic response to art quite likely requires more than just detection of exaggeration. Tinbergen's gull chicks and Ramachandran's rats respond powerfully to exaggeration, but we have no reason to believe that these animals have an aesthetic sense. Other processes are very likely required to elicit the emotional response in people.

The realization that face recognition depends on our seeing both the face as a whole and exaggerated features of the face has given rise to the idea that the brain responds to faces in terms of how much they deviate from the average. Gillian Rhodes and Linda Jeffery suggest the interesting idea that we distinguish a face by comparing it with a prototype of the human face and then gauging how it differs from that prototype. For example, are the eyebrows especially bushy compared with most other people's eyebrows? Is one eye smaller than the other?

Thus, much as Hubel and Wiesel found that cells in the primary visual cortex deconstruct images into line segments and contours, Freiwald and Tsao found that each of the six face patches in the temporal lobe specializes in a particular task of face recognition. Some face patches specialize in recognizing a face from a frontal view, others in profile, and others in how much each face differs from the average face, while still other face patches connect to areas of the brain that are important for orchestrating emotions. Freiwald and Tsao immediately appreciated the relevance of their remarkable findings to the Gestaltists' discovery of how we perceive complex forms.

——

IN FACE PERCEPTION, more than almost any other brain operation, we see in action the Gestalt principle that the brain is a creativity machine. It reconstructs reality according to its own biological rules, rules that are in good part inherent in the visual system. One reason for our figural and emotional response to faces in art is the important role that face perception plays in social interactions, emotion, and memory. Indeed, face perception has evolved to occupy more space in the brain than any other figural representation.

Given the importance of face recognition in social decision making, Freiwald and Tsao raised two questions: Do face patches detect information about emotion in a perceived face? If so, do they send that information on to other regions of the brain (besides the amygdala) that are concerned with decision making and emotion? With this possibility in mind, they imaged the prefrontal cortex of monkeys and found three face patches there that respond to emotional expression.

Another face patch they found is involved in working memory, a form of short-term memory that allows us to hold information, such as the image of a face, in mind for a period of seconds. Neurons in this face patch connect to the hippocampus, the area deep in the temporal lobe that is concerned with converting working memory into long-term memory. Tsao and Freiwald therefore proposed that this face patch might contribute to face-related working memory, attention to faces, face categorization, and social reasoning about the face. The face patch would be particularly important for portrait painting and for attempting to gain insight into what lies below the surface of the face, as Kokoschka tried to do.

As we might expect from these patterns of connection, functional brain-imaging studies confirm that the same face patches discovered in monkeys are also active in people. Moreover, some of them are connected to the amygdala, which, as we shall see, orchestrates both conscious and unconscious emotion. Thus, the work of Tsao and Freiwald is an important step in linking the cognitive aspects of human social interactions initiated by face perception with the unconscious and conscious processes of emotion and the feeling state initiated by face perception. Taken together, the studies of prosopagnosia (the inability to recognize a particular face) and the work of Gross, Puce, Kanwisher,

and the Livingstone school begin to explain how our visual system connects with some areas of the brain that focus attention on the face and with other areas that endow the face with emotional overtones.

THE HANDS AND BODY are represented in other regions of the brain, and they impart different information. Whereas the face is critical to the expression of emotion, the hands and body signal how a person is coping with emotion. The face conveys information even when it is not moving, whereas the body imparts information primarily through motion. Thus, as the neurologist Beatrice de Gelder has pointed out, "An angry face is more menacing when accompanied by a fist, and a fearful face more worrisome when the person is in flight."[7] Brain imaging studies by Kanwisher (2001) first revealed that neurons in the extrastriate body area, a region of the occipital lobe, respond selectively to images of the human body. Indeed, images of bodies or parts of bodies are quite powerful and capture our attention even when we are focused on another task. This might be an important factor in the historical dominance of figurative art.

While the extrastriate body area responds selectively to the presence of another person, a nearby region of the temporal lobe—the superior temporal sulcus—is critical for the analysis of *biological motion*, that is, the movements of people and animals. This region was discovered in 1998 by Puce and David Perrett, who observed that cells there respond more strongly to mouth and eye movements and to movements of the limbs than to movements that are not related to body parts. The cognitive psychologist Kevin Pelphrey at Yale University suggests that the superior temporal sulcus interprets the direction of a person's gaze by determining the person's focus of attention or the person's desire to avoid or engage in social interaction. The direction of a face's gaze and its emotional expression combine to capture the beholder's attention. Thus, portraiture draws our attention not only to the face and its expression but also to where the face is looking.

Movement is extremely informative. In the absence of other clues, the way something moves can tell us whether it is human or not and much more, including the mental life of the person moving and what that person is feeling. In 1973 Gunnar Johansson attached fourteen small lights to the major joints of one of his students and filmed her as she moved around in the dark. The film begins with only one spot of

light in motion, then shows all fourteen turned on but not moving. Looking at just one moving spot of light, we get no idea about the nature of the motion. When we see all of the spots with no movement, we gain an impression of a static object. But as soon as all of the spots start to move, a figure emerges. Moreover, we can tell whether that figure is a man or a woman and whether he or she is running, walking, or dancing. We can even tell, under many circumstances, whether the person is happy or sad. People, even infants as young as four months of age, prefer to look at moving spots of light that form a figure rather than at spots moving at random—that is, they prefer to watch biological motion rather than nonbiological motion. Our brain has evolved to use every clue available to find out what is going on in the world.

Influenced in part by Freud's intuitive insights and Kris and Gombrich's systematic attempts, neuroscientists have begun a more rigorous, cellular analysis of human sensory systems. Specifically, Richard Gregory and David Marr began to analyze human perception in terms of bottom-up Gestalt psychology and top-down hypothesis testing and information processing. By confirming on a cellular level that our sensory systems are creative—that they generate hypotheses about what faces, facial expressions, hand positions, and bodily movements are important and what distinguishes biological from nonbiological motion— these neuroscientists have taken us backstage in the private theater of the mind.

# TOP-DOWN PROCESSING OF INFORMATION: USING MEMORY TO FIND MEANING

ᴄᴠᴐ

Wᴇ HEN A GREAT ARTIST CREATES AN IMAGE OUT OF HIS OR HER LIFE experience, that image is inherently ambiguous. As a result, the meaning of the image depends upon each viewer's associations, knowledge of the world and of art, and ability to recall that knowledge and bring it to bear on the particular image. This is the basis of the beholder's share—the re-creation of a work of art by the viewer. Cultural symbols, recalled from memory, are similarly critical for the production and viewing of art. This has led Ernst Gombrich to argue that memory plays a critical role in the perception of art. In fact, as Gombrich emphasized, every painting owes more to other paintings than it does to its own internal content.

If, for example, we look at a landscape painted by Gustav Klimt, such as *A Field of Poppies* (Fig. 18-1), it is difficult to ascertain the meaning of the image from the internal content alone. What is immediately apparent is a homogenous expanse of green paint, punctuated with spots of red, blue, yellow, and white, stabilized by two small passages of white at the top edge of the canvas. Once we compare this image to what we know about painting, however, the content of the picture becomes perfectly clear. Considered in the tradition of landscape painting, specifically that of impressionist and Post-Impressionist pointillists, what emerges from the mass of green and red splotches is a beautiful pastoral scene of a poppy field covered in flowers. Even though the two trees in the foreground are difficult to distinguish from the field of flowers they are growing in, the beholder is easily able to

Figure 18-1. Gustav Klimt, *A Field of Poppies* (1907). Oil on canvas.

construct a figure-ground relationship between the two because he or she knows to look for them.

The same is true of Klimt's figurative portraits. In both *The Kiss* and *Adele Bloch-Bauer I* (Figs. 8-25 and 1-1), the bodies of the figures all but disappear into an expanse of gilded ornamentation, yet our knowledge of figurative painting and expectations of bodily contours allow us easily to distinguish figure from ground.

As we have seen, the most remarkable aspect of visual perception is that most of what we see in the faces, hands, and bodies of other people is determined by processes that operate independently of the pattern of light falling upon our retina. It depends on information processed from the bottom up—through low- and intermediate-level vision—that is then integrated with signals processed from the top down—from higher cognitive centers of the brain. It is the job of high-level visual processing to integrate the visual experiences from these two sources into a coherent whole. Top-down signals rely on memory and compare

incoming visual information with prior experiences. Our ability to find meaning in a visual experience depends entirely on these signals.

Information processed from the bottom up relies in good part upon the built-in architecture of the early stages of the visual system, which is largely the same for all viewers of a work of art. In contrast, top-down processing relies on mechanisms that assign categories and meaning and on prior knowledge, which is stored as memory in other regions of the brain. As a result, top-down processing is unique for each viewer.

ULTIMATELY, THE BRAIN processes images—faces, bodies, in fact all objects—by generalizing and categorizing them. The visual system can readily identify images of individual objects, be they apples, houses, faces, or mountains, as belonging to general categories. Faces have many shapes, as do houses, but we recognize them as faces or houses under many different conditions.

Earl Miller, who discovered that visual stimuli are categorized in the lateral prefrontal cortex, sees *categorization* as the ability to react cognitively in a similar way to stimuli that are visually distinct and to react differently to stimuli that are visually similar. We recognize that an apple and a banana are in the same category—they are each fruit—even though they have different shapes and do not resemble each other. Conversely, we consider an apple and a baseball to be fundamentally different, even though they are similar in shape. Categorization is essential: without it, raw perception would be meaningless.

We call a red sphere on our kitchen counter an apple; we may call a visually identical sphere on a playground a kickball. How and where do neurons distinguish between categories? Miller addressed this question by creating digital images in which animals from two different categories, such as a cat and a dog, are morphed from one into the other, and can thus produce an image that is 40 percent cat and 60 percent dog. He then recorded signals from neurons in the lateral prefrontal cortex of the brain of monkeys—a region that receives information from the inferior temporal cortex about objects, places, faces, bodies, and hands. Miller found that neurons in the lateral prefrontal cortex are sensitive to category-specific boundaries: they respond to images in one category but not the other, such that they will react to an image of a dog but not to a cat, or vice versa.

Miller then repeated the experiment, this time recording signals simultaneously from the lateral prefrontal cortex and the inferior temporal cortex. He found that each of these regions of the brain plays a specific role in category-based perceptions. The inferior temporal cortex analyzes the shape of an object, whereas the prefrontal cortex assigns the object to a specific category and encodes the behavioral response a person will have to it. The discovery of robust, category-specific signals in the prefrontal cortex that encode the *concept* of dog, not just the shape, is consistent with the idea that the lateral prefrontal cortex guides goal-directed behavior. Miller's findings suggest that further categorization results when neurons in the inferior temporal cortex send appropriately weighted information to neurons in the prefrontal cortex that encode behaviorally relevant information—such as the recognition of *a* house as *your* house. Thus, the inferior temporal cortex is also involved in recognizing images and assigning them to more general categories.

THE BRAIN COULD NOT establish categories—or do much else—without memory. Memory is the glue that binds our mental life together, whether in our response to art or to other events in our life. We are who we are in large part because of what we learn and what we remember. Memory is critical to the beholder's perceptual and emotional response to art: it is inherent in the top-down processing of visual perception, and, as we have seen, it is central to Panofsky's ideas about the role of iconography in the beholder's response to an image. The human memory system forms abstract internal representations that arise from previous exposure to similar images or experiences.

Modern studies of the brain and memory emerged from the coming together of the cognitive psychology of memory and the biology of memory storage. This began in 1957 with the great British-born psychologist Brenda Milner, working at the Montreal Neurological Institute. Milner described the effects on her patient H.M. of an operation that removed the medial temporal lobe on both sides of his brain in order to stop his debilitating epileptic seizures. The loss of the medial temporal lobe, and particularly the loss of the hippocampus, which lies within it, resulted in a profound loss of memory for people, places, and objects, even though H.M.'s intellectual and perceptual functions remained intact.

Milner's studies of H.M. revealed three major principles underlying

the role of the hippocampus in memory. First, since H.M.'s other intellectual faculties were intact, she was able to establish that memory is a discrete set of mental functions located in specific regions of the brain. Moreover, H.M.'s ability to remember information such as a telephone number for a short period of time, ranging from seconds to one or two minutes, indicated that the hippocampus and the medial temporal lobe are not involved in short-term memory but rather in transforming short-term memory into long-term memory. Finally, because H.M. could remember things that had occurred long before his operation, Milner inferred that very long-term memory is stored in the cerebral cortex and eventually no longer requires either the hippocampus or the medial temporal lobe.

So when we look at a new image on canvas and associate it with another image or remember it the next day, it is because our hippocampus has been at work storing that information. The reason we are able to distinguish the trees in Klimt's *A Field of Poppies* is because our hippocampus has stored information about other landscape paintings we have seen. During the next few months—a surprisingly long period—the storage of that information gradually shifts to the visual system of the cerebral cortex for permanent storage. It is thought that the same face patches that are essential for recognizing a specific face are also essential for storing the long-term memory of that face: they appear to retain indefinitely both the cognitive and the emotional information about a face that they have recognized. Indeed, recent studies indicate that any emotionally charged visual image is encoded in long-term memory and stored in the same higher-order areas of the visual system that initially processed the information about that image.

In the course of studying H.M.'s memory loss, Milner made still another remarkable discovery. She found that even though he had severe memory impairment in certain areas of knowledge, he could learn some new motor skills through repetition, without being consciously aware of the skill he was acquiring. Larry Squire at the University of California in San Diego carried these studies further and showed that memory is not a unitary faculty of mind. There are, in fact, two major forms of long-term memory storage. *Explicit memory*, the memory that H.M. had lost, is a memory of people, places, and objects. It is based on conscious recall and requires the medial temporal lobe and the hippocampus. *Implicit memory*, which H.M. retained, is the unconscious re-

call of motor skills, perceptual skills, and emotional encounters, and it requires the amygdala, the striatum, and, in the simplest cases, the reflex pathways.

Top-down processing relies on both kinds of memory. Implicit memory is critical for the beholder's unconscious recall of emotion and empathy in response to the subject of a painting. Explicit memory is critical for the viewer's conscious recall of the form and subject of the painting. Together, the two systems bring personal as well as cultural memories to bear on a work of art. The viewer's response to the artist's use of icons to convey meaning, be they Klimt's rectangular and egg-shaped symbols or the contorted arms and hands of Egon Schiele, also depends on memory. Regardless of whether an icon calls up a cultural or a personal meaning, the viewer's conscious and unconscious recognition of that icon recruits one or the other or commonly both memory system of the brain.

BEGINNING IN 1970, neuroscientists started to analyze the cellular and molecular mechanisms of memory storage. One of the most astonishing findings to emerge was that long-term memory gives rise to anatomical changes in nerve cells. Specifically, the process of learning and remembering something can significantly increase the number of synaptic contacts between the nerve cells carrying that information. Thus, Charles Gilbert of Rockefeller University has found that cells in the primary visual cortex undergo remarkable anatomical changes in the course of learning. We now know that expectations, attention, and previous images obtained through experience all influence the properties of these neurons by altering their synaptic connections.

Information stored in memory plays a critical role in resolving ambiguity—and therefore in separating a figure from its background. We have no problem in the simple figure-ground switching of faces and a vase in the Rubin vase (Fig. 12-3). But in more ambiguous images, distinguishing a figure from the background can be quite difficult, as in the image of a Dalmatian dog in Figure 18-2. At first glance, it is hard to make out the dog. But after a while, we group different fragments and contours together into a coherent form and begin to see the animal's head and its left forepaw. Once we have reconstructed and seen these parts of the dog (Fig. 18-4), it is easy to go back later and pick them out from the background by means of implicit memory of our

Figure 18-2

Figure 18-3

earlier perceptual experience (Fig. 18-2). Indeed, we quickly become so adept at spotting the Dalmatian that it becomes impossible for us *not* to see it again. Similarly, in the ambiguous image of a girl and an old woman first created by the Harvard psychologist E. G. Boring (Fig. 18-3), we can readily see the girl. But if we focus on the girl's ear, we can suddenly see it as the eye of an old woman and we can see the girl's chin as the old woman's nose (Fig. 18-5). These images suggest that having once stored a figure in memory, we can use top-down processing—with its reliance on memory—to make the switch at will.

As these images of the dog and the girl–old woman illustrate, top-down processing appears to use hypothesis testing of images in our memory to infer the category, meaning, utility, and value of a retinal image. Top-down processing starts off with a hypothesis about what is out there to see at a given moment. Usually, we are looking for and paying attention to specific things, as determined by other sensory cues and our memory of past experiences. Thus, the response of neurons in the visual pathway reflects not only the physical characteristics of an object or our memory of it, but also our cognitive state: for example, when we are paying attention, we can more readily analyze the shape and proportions of an object and relate it to objects previously encountered than when we are off daydreaming.

How do we acquire and store new visual information in memory? One common way to store implicit memory is through association, as the Russian physiologist Ivan Pavlov first demonstrated. Pavlov repeatedly presented a dog with both food, which caused the dog to salivate, and a light. He found that after a number of such pairings, the dog would begin to salivate when it saw the light, even when it was not followed by food. This principle—classical conditioning—underlies many of our cognitive and perceptual processes. Similarly, objects that we frequently see together become associated in our memory; thus, the sight of one object readily brings to mind the image of the other.

We acquire such associative memory when our brain establishes or strengthens connections between the neurons that represent the associated objects. The practical effect of this activity is that once two objects—call them A and B—have been associated and stored as implicit memory, neurons in brain cluster B will respond not only to object B but also to object A. Thomas Albright of the Salk Institute has

Figure 18-4

Figure 18-5

asked the question: Is this association limited to the hippocampus, or can these associations occur in the visual system? He discovered neurons in various higher-order regions of the visual system in monkeys that do double duty: they respond to a visual stimulus and to a stimulus elicited from memory. The finding of these memory neurons shows that higher regions of the brain can influence lower regions, and it may explain how readily something new that we have just seen in an image can remind us of something else we have seen before, how an unfamiliar painting can evoke a familiar memory.

One of the most intriguing consequences of high-level visual processing is that we experience a similar response in the brain when we encounter an object for the first time and when we recall that object from memory. The new experience is derived from the processing of visual information from the bottom up and is what we traditionally think of as seeing. The recollection, or elaboration and enrichment, of that image is a product of processing from the top down and constitutes pictorial memory and the recall of visual imagery. Thus, seeing an image and later remembering it and imagining it ultimately recruit some of the same neural circuitry.

Visual associations are intrinsic to normal perception, and bottom-up and top-down signals almost invariably collaborate to yield visual experience.

THE IMPORTANCE OF top-down processing and the effects of attention and memory on perception are immediately evident in viewing a work of art. To begin with, the attention of a person viewing a work of art differs in important ways from what the student of perception Pascal Mamassian of the University of Paris calls "everyday perception." In everyday perception the task is specified. If you are going to cross the street, you watch for a break in the traffic before starting. Your perception is therefore highly focused on the cars coming by, their speed and size, and you disregard irrelevant information such as whether a particular car is a Buick or a Mercedes-Benz, whether it is gray or blue. It is much more difficult to identify an appropriate task in the perception of visual arts. Indeed, the viewer approaches a work of art differently, and his or her response can depend on where he or she is standing. The artist, in turn, faces the challenge of not knowing where the beholder will stand—and viewing angle can greatly affect

the beholder's interpretation of a three-dimensional scene. Mamassian describes this challenge in the following terms:

> Even if the painter has mastered the laws of linear perspective . . . all viewpoints except one should theoretically lead to a geometric deformation of the scene. The only viewpoint from where the painting is a faithful rendition of the scene is the center of projection, that is the location where the painter was standing if the scene was painted on a transparent canvas. Therefore there is a fundamental ambiguity in the geometry of the depicted scene that depends upon where the observer is standing.[1]

The viewer fills in, through top-down processing, any further details needed to compensate for his or her position. As we have seen in Chapter 16, the viewer is tacitly aware that a canvas is flat, because the perspective of a painting or a drawing is never fully convincing. As a result, both the artist and the beholder implicitly use simplified physics, which allows them to interpret a two-dimensional image in art as having three dimensions.

Understanding the nature of this top-down phenomenon as it pertains to where the beholder is standing teaches us a great deal about how we perceive paintings. The best-known example is when the eyes of the subject of a portrait follow us wherever we stand. This effect, which we see in Gustav Klimt's beautiful portrait (Fig. 18-6), depends on the sitter's having been painted looking at the painter's eyes: the pupils of the sitter's eyes will then be centered on our own eyes. When we move to the side, the position of the eye becomes distorted, but our top-down perceptual system corrects for this distortion. As a result, the pupil of the sitter's eye is not altered very much, even though other distortions occur in the painting. This accounts for the illusion that the eyes of the subject follow us as we move. If the perspective in the painting were perfect, as it is in a sculpture, the portrait would look distorted from every perspective except one. Thus, if we view a bust from the side, the pupil of the eye appears asymmetrical and does not appear to be looking at us.

As Ernst Kris pointed out, to be successful in creating an important work of art, the artist must from the start produce an essentially untrue

Figure 18-6. Gustav Klimt, *Head of a Woman* (1917).
Pen, ink, and watercolor on paper.

painting. The painter must strictly limit himself to producing a work of the imagination, which will in turn serve the viewer's imagination.

Klimt exploits the limitations of perspective and the brain's top-down processing in his flat, Byzantine-like paintings. To begin with, he uses flatness to impart a sense of immediacy. His use of simple lines rather than shaded contours to delineate faces and figures thrusts those faces and figures outward, thereby astounding us with their presence. In addition, flatness demands more of the beholder: it increases our top-down responses by emphasizing the two-dimensional nature of the canvas and the more abstract features of the painting.

In a larger sense, our ability to compensate for the two-dimensional

nature of painting explains why our appreciation of art, and even our understanding of what it represents, does not depend on our assuming any specific viewing position. As Patrick Cavanagh writes:

> Flat paintings are so commonplace that we seldom ask why flat representations work so well. If we really experience the world as 3D, an image seen in a flat picture would distort jarringly when we move in front of it. But it does not do so as long as it is flat. A folded picture, in contrast, distorts as we move around it. Our ability to interpret representations that are less than 3D indicate[s] that we do not experience the visual world as truly 3D, and has allowed flat pictures (and movies) to dominate our visual environment as an economical and convenient substitute for 3D representations. This tolerance of flat representations is found in all cultures, infants, and in other species, so it cannot result from learning a convention of representation. Imagine how different our culture would be if we could not make sense of flat representations.[2]

The scientist and philosopher Michael Polanyi explains that awareness of the sort we experience when looking at a representational painting has two components: *focal awareness* of the person or scene depicted and *subsidiary awareness,* which includes surface characteristics, lines and colors, and the two-dimensional surface of the canvas, although we might be tempted to reverse these components and focus on the brushstrokes and markings in Vincent van Gogh's (Fig. 18-7) and Kokoschka's remarkable self-portraits (Fig. 9-15). These two states of awareness are critical for understanding why we see representational painting as a likeness of reality, says the perceptual psychologist Irvin Rock. Because we fully appreciate that a painting is a likeness and not a true reality, we unconsciously make both top-down (previously learned) and intuitive (unlearned) corrections in our perception of it.

As we saw in the last chapter, we continuously (and unconsciously) move our eyes when looking at art. As a result, our perception of a face in its entirety is built up by rapid, repeated scanning of various areas of interest. Although the aesthetic experience of a work of art is greater than the sum of its parts, the visual experience begins in this mosaic fashion, with a scanning of all of the parts, one feature at a time. The

importance of different types of scanning movements in picking out the essential elements in a painting is illustrated in Figures 18-8 through 18-13.

Klimt's three images of women—two of Adele Bloch-Bauer and one of Judith—differ primarily in their facial expression. In the top image, Adele is neutral, almost bored; in the second, she is modestly seductive; in the third, Judith, in the afterglow of sexual rapture, appears both victorious and ready for more encounters. But what is perhaps equally striking is how much of our visual attention, particularly for *Adele Bloch-Bauer I* and *Adele Bloch-Bauer II,* is expended on details having nothing to do with the sitter's face, such as her richly orna-

Figure 18-7. Vincent van Gogh, *Self-Portrait with Felt Hat* (1887–88). Oil on canvas.

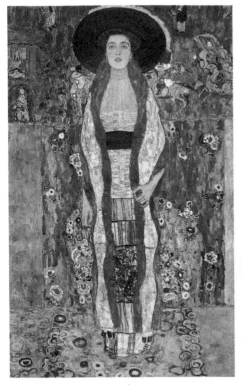

Figure 18-8. Gustav Klimt,
*Adele Bloch-Bauer II* (1912).
Oil on canvas.

Figure 18-10.
Gustav Klimt,
*Judith* (1901).
Oil on canvas.

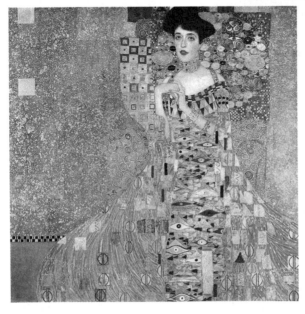

Figure 18-9.
Gustav Klimt,
*Adele Bloch-Bauer I*
(1907). Oil, silver,
gold on canvas.

Figure 18-11.
Oskar Kokoschka,
*Self-Portrait with
Hand Near Mouth
(Selbstbildnis, die Hand
ans Gesicht gelegt)*
(1918–19).
Oil on canvas.

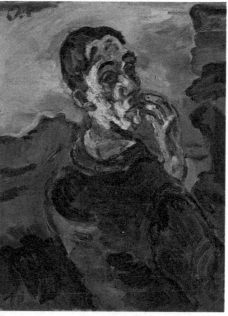

Figure 18-13.
Oskar Kokoschka,
*Ludwig Ritter
von Janikowski* (1909).
Oil on canvas.

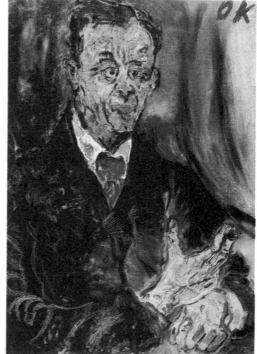

Figure 18-12.
Oskar Kokoschka,
*Rudolf Blümner* (1910).
Oil on canvas.

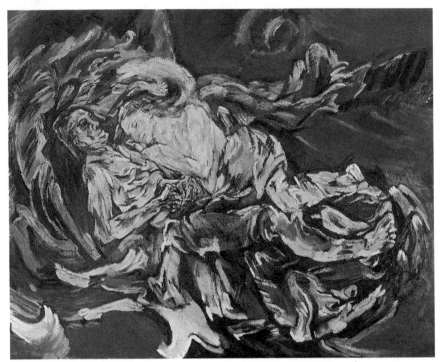

Figure 18-14. Oskar Kokoschka, *The Wind's Fiancée* (1914). Oil on canvas.

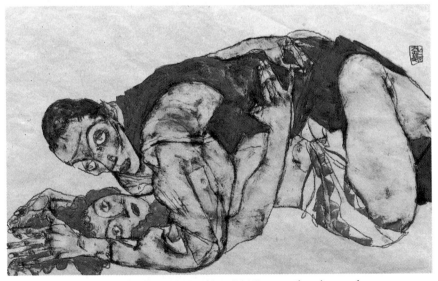

Figure 18-15. Egon Schiele, *Love Making* (1915). Pencil and gouache on paper.

mented gowns, which meld almost imperceptibly into the background. In contrast, Van Gogh and Kokoschka invite the viewer to focus primarily on facial expression. Each visage is unique and memorable. The richly textured background serves only to highlight the emotion that emerges from the facial features. Thus, in viewing Klimt's portraits, our eyes are multitasking: they scan the image as a whole to obtain a sense of the various ideas the artist is trying to convey. In Kokoschka's portraits, our attention is tightly focused on the essential facial expression of each subject and the meaning of that expression.

A very different type of contrast emerges from Kokoschka's and Schiele's depictions of themselves with a lover (Figs. 18-14, 18-15). Kokoschka painted several romantic dual portraits of himself with Alma Mahler, but none of them speaks of consummation. In all of them Kokoschka appears passive, swept along by forces beyond his control. That impression is enhanced in *The Wind's Fiancée* by the turbulent waves that surround the two lovers and that are beyond Kokoschka's ability to control. Schiele, in contrast, specializes in raw sex: no lack of consummation here. But it is a sexual union in which the bliss of romance and erotic pleasure is counterbalanced or even overridden by anxiety. The mixture of conflicting instinctual drives cancels out any pleasurable component of sex, resulting in an emptiness—the emptiness of union—which can be seen in the eyes of the subjects. In Schiele's portraits, the anxiety connected with sex is so great, and the sheer power of the emotion so strong, that he appears to need no tempest, no background effects, to dramatize it further.

The artists' stylistic differences—differences that our eyes take in all at once—convey different emotional content. It is to the biological underpinnings of the emotional content of portraits that we turn next.

*Chapter 19*

# THE DECONSTRUCTION OF EMOTION:
# THE SEARCH FOR
# EMOTIONAL PRIMITIVES

c\✓ɔ

ERNST GOMBRICH SAW THE DEVELOPMENT OF WESTERN ART AS A
movement that led, despite detours and retracings, toward an increasingly successful imitation of nature through more and more skillful illusions of reality. But this progression faltered when it encountered photography, whose mastery of the visual world coincided with the realistic depictions of nature in anatomical and botanical atlases.

As a result, modern artists began to experiment with ways of going beyond realistic depictions of the world. As we have seen in Chapter 13, Paul Cézanne, Pablo Picasso, Piet Mondrian, Kazimir Malevich, Wassily Kandinsky, and others began to explore the deconstruction of form in a search for figural primitives. They sought a new language to examine form and color, the fundamental elements of what we see in landscapes, objects, and people. During roughly the same period, Vincent van Gogh, Paul Gauguin, Edvard Munch, and, following them, the Austrian modernists Gustav Klimt, Oskar Kokoschka, and Egon Schiele and the German expressionists, began to deconstruct emotion in a search for *emotional primitives*. They sought the elements that evoke strong conscious and unconscious emotional responses to scenes and people, especially to faces, hands, and bodies.

In the search for emotional primitives, artists attempted to go below surface appearances to explore and expose aspects of the sitter's emotional life—and by extension to affect the beholder's feelings and his or her emotional response to the sitter. The idea that the beholder can re-

spond to the sitter's emotional state is based on the idea that there is a universal range of emotions that all people can experience, recall, and communicate to others. These modern artists experimented with a variety of means of conveying the emotional state of the sitter: exaggeration of form, distortion of color, and new types of iconography. Moreover, they relied on the beholder's memory of similar emotional experiences and their ability to recognize overt historical referents and to understand the meaning of symbols.

The critical importance of memory in the viewer's emotional response to art parallels its importance in the viewer's perceptual response to art. Much as the perception of a face demands that we bring our earlier experiences with the perception of faces to bear on any new face, so our response to emotion in other people is determined by our experiences with emotion in other contexts. Unlike our instinctive emotional reactions to a life-threatening signal, we reconstruct learned emotion in the brain much as we do visual perception, based in part on what our brain already knows about the emotional world and in part on what it has learned.

Gaining biological insight into emotion is a two-step process. First, we need to obtain a psychological foundation for analyzing an emotion, and then we need to study the underlying brain mechanisms of that emotion. Just as the emergence of a meaningful neuroscience of perception required a foundation in the cognitive psychology of perception, so the search for the underlying biological mechanisms of emotion and empathy requires a foundation in the cognitive and social psychology of emotion and empathy. Indeed, the biology of emotion is a relatively new domain of brain science: for a long time, emotional experiences were studied only in psychological terms.

ERNST KRIS AND GOMBRICH traced the deconstruction of emotion in expressionist art to three earlier artistic traditions. The first was caricature, which was introduced in the sixteenth century by Agostino Carracci. The basic elements of exaggeration found their way into the expressive paintings of Matthias Grünewald and Pieter Bruegel the Elder and were later elaborated on in the mannerist paintings of Titian, Tintoretto, and Veronese, in the paintings of El Greco, and finally in the works of the Post-Impressionists Van Gogh and Munch. The sec-

ond artistic tradition that gave rise to the expressionist deconstruction of emotion was Gothic and Romanesque religious sculpture, and the third was the Austrian tradition of hyperbole, which reached its apex at the end of the eighteenth century in the grimacing character heads of Franz Xaver Messerschmidt.

In 1906 the Viennese photographer Josef Wlha published forty-five pictures of the plaster casts of these heads owned by the prince of Liechtenstein. The photographs stirred the interest of the artistic community—even Pablo Picasso purchased a set of the images. In 1908, after more than a century of neglect and disdain, Messerschmidt's character heads were exhibited in the Museum of the Lower Belvedere, the same museum whose upper level (Obere Belvedere) later displayed works by Klimt, Kokoschka, and Schiele. Emil and Berta Zuckerkandl had bought two of Messerschmidt's heads in 1886, and Ludwig Wittgenstein owned one. This widespread interest caused Antonia Bostrom to write: "This reinforces the point that those concerned with the investigation of the human psyche have been continually drawn to these heads."[1]

The Austrian expressionists emphasized in modern, artistic terms four powerful emotional themes that Sigmund Freud and Arthur Schnitzler had also explored, independently, in their work: the ubiquitous presence of sexuality and its onset in early childhood; the existence in women of an independent sexual drive and erotic life that is equal to that of men; the pervasive existence of aggression; the continuous struggle between the instinctual forces of sexuality and aggression and the resulting anxiety to which this conflict gives rise.

In dealing with these four themes, expressionist artists elicited from the beholder two broad, interrelated classes of affective response: emotional and empathic. Our *emotional response* to a painting comprises both unconscious emotional reactions and conscious feelings, whether positive, negative, or indifferent. This distinction between unconscious emotion and conscious feelings parallels the distinction between unconscious detection (sensation) and conscious recognition (perception), and it derives from both Freud's and William James's appreciation that much of what we experience is unconscious. Our *empathic response* is the vicarious experiencing of the emotions of the subject of a painting—our recognition of the subject's mental state and perhaps his or her thoughts and aspirations as well.

WE OFTEN USE a person's facial expression and posture to evaluate their emotional state, and these same clues give us an understanding of the subject of a portrait. Moreover, closely observing the nuances of other people's expressions, both in person and in art, can give us an internal blueprint of our own expressions, enabling us to become more cognizant of what our face is telling others about our own feelings at any given moment.

What are emotions? Why do we need them? Emotions are instinctive biological mechanisms that color our lives and help us deal with the fundamental tasks of life: seeking pleasure and avoiding pain. Emotions are *dispositions to act* in response to someone or something important to us. It seems likely that the full, rich spectrum of human emotions evolved from the fundamental dispositions to action of simple organisms such as snails and flies. Such animals have at their disposal only two major, opposing classes of motivators: *approach* and *avoidance*. One class motivates us to approach food, sex, and other pleasurable stimuli, and the other motivates us to avoid predators or noxious stimuli. These two opposite classes of reponse have been maintained throughout evolution, and they organize and drive human behavior.

Emotions arise from the very core of our physical and mental states, and they have four independent, though related purposes. Emotions enrich our mental lives; they facilitate social communication, including the selection of a life partner; they influence our capability for rational action; and perhaps most important, emotions help us escape potential danger and approach potential sources of good or pleasure.

The idea that emotions have multiple purposes has evolved over time. Until the middle of the nineteenth century, they were thought to be private, personal experiences whose primary function was to enrich and color our mental life. In 1872 Charles Darwin departed from this monolithic way of thinking by introducing the radical idea that in addition to coloring our lives, emotions have an important evolutionary role: they facilitate social communication. In his book *The Expression of the Emotions in Man and Animals,* Darwin argued that emotions serve social and adaptive functions, including a role in mate selection—actions that could be beneficial for the survival of the species.

Freud, who studied and was greatly influenced by Darwin's writ-

ings, argued that emotions play a third role: they influence our capability for rational action. He held that emotions are central to consciousness and to conscious judgment. Indeed, Freud suggested that consciousness evolved because organisms so endowed could "feel" their emotions. He further suggested that the conscious feeling of emotion focuses our attention on the body's autonomic responses; we then use information from those unconscious responses to plan complex actions and decisions. In this way, conscious emotion extends the reach of instinctive emotional responses.

Freud's idea was a further break with the past. Philosophers had conceived of emotion as standing in opposition to reason, especially in opposition to the making of rational decisions. To make intelligent, well-thought-out decisions, philosophers have traditionally argued, we must suppress our emotions so that reason can dominate. Clinical experience convinced Freud otherwise. He found that emotions unconsciously bias many of our decisions and that emotion and reason are inseparably entwined. Today, we realize that when faced with a decision that is cognitively demanding, such as whether to learn a complex new task or whether to go to war or remain at peace, we ask ourselves not only, Can we actually succeed in accomplishing what we want to do? but also, Is the task worth the emotional effort? Will it be rewarding to do this?

BOTH FREUD AND DARWIN recognized that human behavior can give rise to a variety of emotional responses that lie between the polar extremes of approach and avoidance. Moreover, this family of emotional responses—this gradient—extending from one polar opposite to the other, is not all-or-nothing; it is modulated by another continuum that ranges from low to high intensity, or low to high levels of arousal.

According to Darwin, there are six universal components that lie along a continuum from approach to avoidance. These six include the two major emotional primitives—happiness (ranging in arousal from ecstasy to serenity) that encourages approach and the other, fear (ranging from terror to apprehension) that encourages avoidance. Between these two extremes lie four subtypes: surprise (ranging from amazement to distraction), disgust (from loathing to boredom), sadness (from grief to pensiveness), and anger (from rage to annoyance). Darwin was

careful to indicate that discrete emotions can be blended: awe, for example, is a mixture of fear and surprise; fear and trust give rise to submission; trust and joy produce love.

HOW DO PEOPLE express these six emotions, and how do they convey them to others in the course of social communication? Darwin proposed that we convey our emotions in large part through a limited number of facial expressions. He based this conclusion on his insight that people, being social animals, need to communicate their emotional state to others, and he discovered that they do this by means of facial expression. Thus, one person can attract another by smiling inquisitively or can put another off by looking stern and threatening.

Darwin proposed that facial expression is the primary social signaling system for human emotions and therefore that facial expression is central to social communication. Moreover, since all faces have the same number of features—two eyes, one nose, and one mouth—the sensory and motor aspects of emotional signaling are universal, that is, they transcend culture. Furthermore, he argued that both the ability to form facial expressions and the ability to read another person's facial expressions are innate. Thus, neither the sending of emotional and social signals nor the receiving of them requires learning.

Indeed, the cognitive development of face recognition begins in infancy. As we have seen, six-month-old infants lose the ability to discriminate between different nonhuman faces at just about the same time that they develop the ability to distinguish between different human faces. The same is true of language: Japanese infants can readily distinguish between "l" and "r" sounds soon after birth, but they lose that ability as they mature because their native language does not demand it. Thus, infants learn to make more subtle distinctions between the facial characteristics and skin color of the people they live with (the "in group") than between people from other races whom they do not encounter in infancy (the "strangers"). Darwin argued that the capacity for distinguishing the six types of facial expressions is genetically determined and evolutionarily conserved across all groups of people everywhere in the world. Even children who are deaf and blind from birth show these universal facial expressions.

Darwin's observation that faces are a primary means of conveying emotion was extended a century later by the American psychologist

Paul Ekman. In a series of detailed studies in the late 1970s, Ekman examined more than one hundred thousand human expressions in a large variety of cultures and found much the same six key facial expressions of emotion that Darwin described. There is now evidence that, in addition to these common expressions, specific cultures have added nuances that outsiders must learn to recognize in order to fully understand the emotion being expressed.

In addition to providing dynamic information, faces also provide static information. The dynamic emotion of the moment, which is mediated by rapid facial signals with eyebrows and lips, provides information about attitude, intent, and availability. The face's static signals provide different information. Skin color, for example, gives information about what group a person might belong to and even about where a person was born. Wrinkles provide information about age; the shape of the eyes, nose, and mouth give information about gender. The face thus broadcasts messages not only about emotion and mood, but also about capability, attractiveness, age, sex, race, and other matters.

The work of evolutionary biologists and psychologists in deconstructing emotion provided a basis for the early studies of neuroscientists in this area. Those neuroscientists asked, Do the six universal emotions represent elementary biological systems: the building blocks of mood? Is each discrete emotion produced by its own system in the brain? Or do all emotions have common, overlapping components that form a continuum from positive to negative? Do the six universal emotions represent points along this continuum?

Most students of emotion today think that much as the six main emotions represent points along a continuum that they are likely to have both distinctive and shared neural components. Furthermore, most scientists now believe that emotions and their facial expressions are not fully innate, but are determined in part by our previous experience with emotions and by our associating certain emotions with certain contexts.

What intrigued neuroscientists about the deconstruction of emotion was the possibility of entering the private theater of the mind and exploring, in biological terms, how emotions are generated. It also put them in a position to address the questions: Why does certain art move us emotionally in so powerful a manner? How are emotional responses to art recruited? How do the brain systems governing perception and

those governing emotion interact in response to exaggerated depictions of the face, hands, and body, like those depicted in Austrian expressionist art? How are those brain systems able, in effect, to show "how the soul of the man would express itself in his body"?[2]

We now know that emotion arises from an unconscious, subjective appraisal of ongoing situations and events. Thus, our conscious emotional response to art can be traced to the unfolding of a series of cognitive appraisal processes.

# THE ARTISTIC DEPICTION OF EMOTION THROUGH THE FACE, HANDS, BODY, AND COLOR

ᐁ

CHARLES DARWIN, PAUL EKMAN, AND LATER SCIENTISTS EM-phasized that hand movements and other gestures convey social information, just as facial expressions do. In fact, the uniform, symmetrical qualities of faces, bodies, hands, arms, and legs allow the perceptual systems in the brain to treat all bodies, as well as all faces, similarly.[1]

In exploring new ways of communicating the emotional state of their subjects Gustav Klimt, Oskar Kokoschka, and Egon Schiele therefore focused not only on the face but also on the hands and body of the sitter by exaggerating or distorting these physical features. The body allowed them to provide additional information about a person's attentional and emotional states. A simple comparison of two self-portraits, one by Oskar Kokoschka and one by Egon Schiele (Figs. 20-1 and 20-2), illustrates immediately how gestures enhance the emotion conveyed by the face. Kokoschka's insecurity during his relationship with Alma Mahler is emphasized by his bringing his hand awkwardly to his mouth. By contrast Schiele looks both proud and confident albeit highly mannered in his nude self-portrait kneeling.

In addition to using faces, hands, and bodies these artists captured the viewer's attention by laying bare their artistic techniques—using color to convey additional emotional information and symbols to jog the viewer's memory. In this way, the artists not only recruited the viewer's unconscious emotional responses to the sitter, but also made the viewer consciously aware of their own artistic methods for doing so.

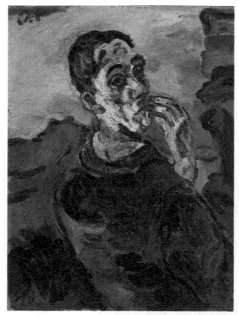

Figure 20-1. Oskar Kokoschka, *Self-Portrait with Hand Near Mouth* (*Selbstbildnis, die Hand ans Gesicht gelegt*) (1918–19). Oil on canvas.

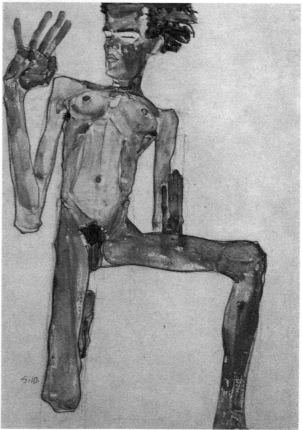

Figure 20-2. Egon Schiele, *Kneeling Self-Portrait* (1910). Black chalk and gouache on paper.

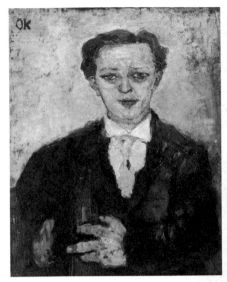

Figure 20-3.
Oskar Kokoschka,
*The Trance Player,*
*Portrait of*
*Ernst Reinhold* (1909).
Oil on canvas.

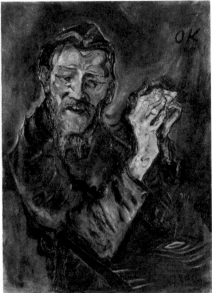

Figure 20-4.
Oskar Kokoschka,
*Portrait of Felix*
*Albrecht Harta* (1909).
Oil on canvas.

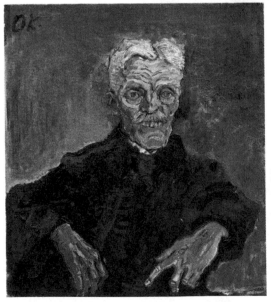

Figure 20-5.
Oskar Kokoschka,
*Father Hirsch* (1909).
Oil on canvas.

———

IN THEIR STUDIES of visual perception, neuroscientists began to uncover the biological basis for what Darwin and the artists had surmised about faces. Neuroscientists found that one reason the face is so important for perception is that the human brain devotes more area to face recognition than to the recognition of any other visual object. As we have seen, the brain has six discrete regions specialized for face recognition that connect directly to the prefrontal cortex, the area concerned with evaluation of beauty, moral judgment, and decision-making, and to the amygdala, the regions of the brain that orchestrate emotion. These findings in the biology of the brain put the work of the Austrian expressionists into a clearer perspective. For example, the extensive representation of faces in the inferior temporal cortex presumably contributes significantly to the fact that we can readily distinguish subtle differences in gaze, expression, and coloration in faces but not equally subtle changes in landscapes. The findings also strengthen the idea that when selecting images for attention, the brain gives priority to the face. It is clear that the face communicates an impressive amount of information: it identifies its owner, his or her emotional state and feelings, and under some circumstances the person's thought processes. There are also mechanisms in the brain that are particularly sensitive to the direction of a person's gaze. They process gaze readily and can trigger a rapid shift in the beholder's attention, not only to the direction of another's gaze but also to other clues about that person's psychological state, such as the orientation of the head.

For example, Uta Frith and her colleagues at University College London have found that the brain responds in dramatically different ways when we look directly into the eyes of an unfamiliar face or when we merely glance at the face. We have a stronger reaction to direct eye contact, because only direct visual contact activates effectively the dopaminergic system of the brain, which is associated with anticipation of reward and therefore with approach. These features of our perceptual and emotional brain were exploited implicitly by Kokoschka and Schiele, whose portraits focus on the face and eyes, the parts of the body that lend themselves most easily to distortion and that reveal the most information about emotion. In contrast to portrait painters in previous eras, who often painted the face from an angle, Kokoschka and

Schiele generally painted their sitters head-on, a technique that forces the viewer to look directly at the face.

This is evident in Kokoschka's three portraits of the Hirsch family—a father and two sons—all painted in 1909 (Figs. 20-3, 20-4, 20-5). Kokoschka first painted one of the sons, Ernst Reinhold (*The Trance Player*), looking directly at the viewer. The artist projects Ernst into the foreground, and into our attentional space, by using a multicolored background. Kokoschka paints Ernst's brother, Felix Albrecht (*Felix Albrecht Harta*), looking down, his goatee a mass of wild lines that makes him look much older than his twenty-five years. The young man's long fingers jut out into the picture; they are yellowish, outlined in greenish-blue, and have swollen joints that resemble rings. According to the art historian Tobias Natter, Kokoschka used this disparaging representation to distance himself artistically from Felix Albrecht, a very conventional painter who admired Kokoschka's work but was much Kokoschka's artistic inferior.

The father (*Father Hirsch*) is depicted in the least sympathetic fashion. He does not look directly at the viewer but off to the left. He exposes his teeth and gnashes them as if ready to strike. To separate the father's figure from the background, Kokoschka uses a yellow brushstroke—like a bolt of lightning—along the old man's right shoulder and upper arm, much as he did for Felix's hands. An earlier title for this painting was *A Brutal Egoist*. In his *Memoirs,* Kokoschka wrote:

> Relations between father and son [Ernst] were bad and, naturally, the portrait did nothing to improve them. I saw the father as an obstinate old man who, when roused to anger, as he very easily was, would bare his great false teeth, I liked to see him angry. Oddly enough, Father Hirsch was fond of me and proud to have his portrait painted. He hung the painting in his flat and even paid me for it.[2]

Of the three men, only Ernst appeals to us as a person. Nevertheless, they are all fascinating because of what Kokoschka reveals about the workings of their minds. In the portraits of Ernst's brother and his father, the colors are muted and the head is surrounded by a fluorescent aura. The eyes are asymmetrical, one larger than the other, and the sitter's gaze is directed away, as if he were obsessed with his inner self and

did not want to confront Kokoschka. Only Ernst looks at the viewer directly and seems interested in sharing the viewer's thoughts and emotions.

Kokoschka conveys these insights in two ways: he attempts to paint "portraits of characters, not portraits of faces."[3] Also, he further enhances the emotional impact of his portraits, as we have seen, by exposing the details of his workmanship—strong, layered brushstrokes and scratches made in the wet paint with his fingers or the handle of his brush—techniques that often enhance face recognition. In addition, the space in which Kokoschka places his subjects is vaguely defined and often a bit unstable, producing a lurching, anxious quality.

EKMAN, A STUDENT OF FACIAL EXPRESSION, points out that emotions are registered by changes in both the upper part of the face (the forehead, eyebrows, and eyelids) and the lower part of the face (the lower jaw and the lips). The upper face, Ekman argues, is particularly important in expressing fear and sadness, while the lower face, especially the mouth, is important for conveying emotions such as happiness, anger, or disgust. The eyes, however, are critical in enabling us to distinguish between a genuine smile and one that is posed. As we have seen, the fovea of our retina is so small that we can only focus on one region of the face at a time, but our brain completes the picture through the quick eye movements known as saccades. As a result, while different regions of the face signal different aspects of an emotion, the signals taken together evoke more than any part separately. This difference in signaling capability is clear in *Father Hirsch* (Fig. 20-5): the lower face conveys anger more powerfully than the upper face, which seems more estranged. Taken together, the upper and lower face convey much more information about a complex and nuanced emotion than either half alone does.

Studies by Joshua Susskind and his colleagues at the University of Toronto, and more recent studies by Tiziana Sacco and Benedetto Sacchetti in Turin, Italy, indicate that facial expressions of fear—indeed, emotionally charged images in general—arouse the beholder and thereby enhance the acquisition of sensory information. Kokoschka's and Schiele's struggles with their own anxiety facilitate their portrayal of anxiety in their sitters. These depictions of anxiety, in turn, evoke fear in the viewer. By evoking fear, the artists capture the viewer's at-

tention and may make the viewer sensitive to aspects of the portrait that he or she would otherwise have ignored.

How does a work of art capture the beholder's attention? In a beautiful set of experiments in the 1960s, the Russian psychophysicist Alfred Yarbus studied the beholder's eye movements as they examined a work of art. To do this, he developed tight-fitting contact lenses to which he attached an optical tracking device. He found that the time allocated to a feature is proportional to the information contained in it. In images of faces, a large amount of time was spent, as we might expect, on the eyes, the mouth, and the general shape of the face (Figs. 20-6, 20-7, 20-8). In one experiment, Yarbus had a viewer examine three different photographs: a girl from the Volga, the face of a young child, and the marvelous, painted limestone bust of Queen Nefertiti, one of the great works of ancient Egyptian art. In each case, the viewer's eyes lingered and centered on the eyes and mouth of the image and spent less time on other features.

In a follow-up to Yarbus's study, C. F. Nodine and Paul Locher found that there are stages in visual perception and that these stages are evident in the scanning eye movements used in examining a work of art. The first stage, *perceptual scanning,* involves a global scanning of the work. The second stage, *reflection and imagination,* involves the identification of people, places, and objects on the canvas. In this stage the beholder grasps, understands, and empathizes with the expressive nature of the work. The third stage—the *aesthetics*—reflects the beholder's feelings and the depth of his or her aesthetic response to the work.

When people look at a work of art for the first time, their eyes exhibit a wide range of fixation times—the period during which we actually apprehend what we see. Many of these fixation times are short. As the viewer becomes more familiar with the work, the number of long fixation times becomes progressively greater, implying that the viewer is shifting with time from general scanning to a more specific focus on the areas of greatest interest and finally to an aesthetic response. Interestingly, these scanning studies also reveal that viewers who are familiar with a given historical period of art move almost instantaneously from perceptual exploration to a focus on feelings and aesthetic response.

The visual psychologist François Molnar made the fascinating ob-

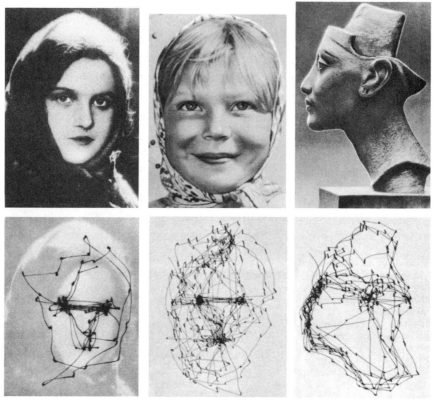

Figure 20-6            Figure 20-7            Figure 20-8

servation that different stylistic periods in art also lead to different patterns of viewing. He compared the viewing of classical art of the High Renaissance to the viewing of art from the mannerist and Baroque periods that followed it. Baroque and mannerist styles of painting are deemed by experts to be substantially more complex than classical painting because they contain much more detail than classical art. Indeed, Molnar found that classical art elicits large, slow eye movements, whereas mannerist and Baroque art elicit small, rapid eye movements that are more focused on specific areas.

These findings suggest that more complex pictures produce shorter fixation times than less complex pictures, leading the cognitive psychologist Robert Solso of the University of Nevada to observe:

It may be that . . . complex art, which is densely packed with details, demands that attention be given to a large number of vi-

sual elements. This demand can be satisfied by allocating shorter fixation times to each feature. Simple figures, such as those created by many modern abstract artists, have far fewer features vying for attention, and therefore more time is allocated to each feature. Also, one could argue that in viewing abstract paintings, the viewer is trying to find a "deeper" meaning in each of the limited number of features—and thus spends more time on each.[4]

Some aspects of Yarbus's findings are echoed in Kokoschka's lithographs (Fig. 20-9). The images look as if the artist were retracing his own eye movements as he observed the subject. Once again, Kokoschka seems to be bringing to the conscious surface of his art the unconscious processes of his mind—in this case, the mechanisms by which the eye actively explores and interprets the physical and human world, particularly the face.

JUST AS SOME regions of the brain respond selectively to faces, others respond to hands and bodies, particularly bodies in motion. Kokoschka's sitters' fingers are often clenched, unnaturally bent, or distorted—or in the case of women, long and sensitive. Sometimes the hands are outlined or stained in red, and the paint is laid down in rough layers, suggesting the texture and color of raw flesh. But Kokoschka's most interesting use of hands is as a symbolic substitute for the face and eyes in social communication. This is evident in *Hans Tietze and Erica Tietze-Conrat, Child in the Hands of Its Parents,* and *Children Playing,* all painted in 1909 (Figs. 20-10, 20-11, 20-12). In his painting of the Goldmans, Kokoschka does not even depict the parents' faces, instead conveying their love for their infant child exclusively through their hands.

Unlike Kokoschka, who relied on minor inflections of the hands and body to communicate emotion, Schiele used exaggerated distortions of his whole body in his paintings (see Chapter 10). In *Death and the Maiden,* for example, a depiction of his complex, ambivalent feelings about ending his relationship with Wally, he captures the themes of love and death (Fig. 10-14). The painting shows Wally and Schiele in the aftermath of a sexual experience, presumably their last, symbolizing the death of their love affair. Wally's arm is partially hidden by

Schiele's coat, giving the appearance of a weak embrace: she is only barely hanging on to him. This exaggerated gesture is accomplished despite the omission of Wally's arm.

Functional MRI has revealed that the brain's response to the entire body is somewhat stronger than its response to the hands. This may explain why Schiele's use of the whole body, especially the nude body, proves more powerful than Kokoschka's use of the hands (Fig. 10-6). And more than Klimt and Kokoschka, Schiele used self-portraiture as a means of exploring the tension between the instinctual drives of love and death and the sense of self. Schiele's self-portraits, often nude and in excruciatingly contorted postures, represent an attempt to re-create in an image of his body his mental state and exaggerated mood. Even more than Klimt or Kokoschka, he expresses an extraordinary exaggeration of mood through his body, especially his head, arms,

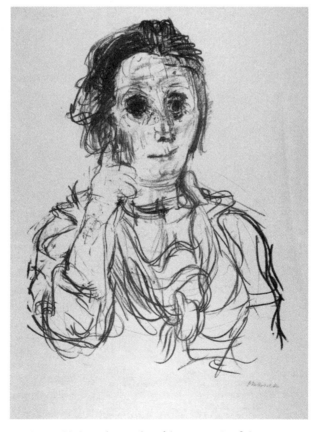

Figure 20-9. Oskar Kokoschka, *Portrait of the Actress Hermine Korner* (1920). Color lithograph.

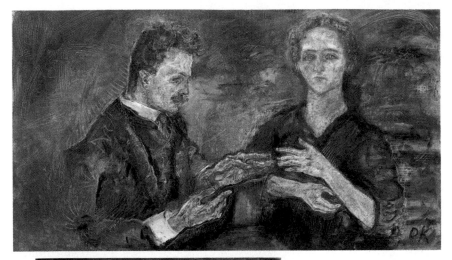

Figure 20-10.
Oskar Kokoschka,
*Hans Tietʒe and Erica
Tietʒe-Conrat* (1909).
Oil on canvas.

Figure 20-11.
Oskar Kokoschka,
*Child in the Hands
of Its Parents*
(1909).
Oil on canvas.

and hands. And more than the other two artists, Schiele used self-portraiture as a means of exploring the tension between the instinctual drives of love and death and the sense of self.

These are powerful images. Indeed the reason so many people were offended by the work of the Austrian modernists is that their art does more than passively recruit the beholder's emotions. We do not simply perceive the emotional state of another person as something separate

from our own emotional state: we enter empathically into it ourselves. When a viewer unconsciously imitates the distorted body posture in a Schiele self-portrait, he or she begins to enter the private world of Schiele's emotions, for the beholder's body is the stage on which Schiele's depiction of emotions play out. By portraying his body in distorted positions to display his emotions, Schiele also engages the viewer's empathy. For the sensitive viewer, looking at a Schiele or Kokoschka portrait is not just an act of perception, it is a powerful emotional experience as well.

We saw the conscious attempt to depict the ugliness of illness and injustice as artistically important and original in Klimt's three university murals, in Kokoschka's sculpture *Self-Portrait as Warrior,* and in the portraits in which Kokoschka introduces scratches and thumbprints into the wet paint. The interest in seeking beauty in the ugliness of life reached its height in Schiele's self-portraits. As Simpson writes: "These physical details [that they depicted] were supposed to be idealized [to] emphasize them the way Kokoschka and Schiele did was interpreted as a major visual affront."[5]

A FINAL contributor to the beholder's emotional response to art is color. Color is uniquely important in the primate brain, much as face and hand representations are, and that is why color signals are processed differently in the brain than light and forms.

We perceive colors as possessing distinct emotional characteristics, and our reaction to those characteristics varies with our mood. Thus, unlike spoken language, which often has an emotional significance regardless of context, color can mean different things to different people. In general, we prefer pure, bright colors to mixed, dull colors. Artists, specifically modernist painters, have used exaggerated color as a way to generate emotional effects, but the value of that emotion depends on the viewer and the context. This ambiguity with respect to color may be another reason why a single painting can elicit such different responses from different viewers or even from the same viewer at different times. Color also enables us to discern objects and patterns by enhancing figure-ground discrimination.

Interest in color flourished during the Renaissance. Leonardo da Vinci realized that there are at most four, and perhaps only three, primary colors—red, yellow, and blue—and that mixing them can gener-

Figure 20-12. Oskar Kokoschka, *Children Playing*
(1909). Oil on canvas.

ate the whole range of colors. Artists during this period also realized that bringing certain colors in opposition to each other gives rise to new color sensations.

In 1802 Thomas Young proposed that there are three types of color-sensitive pigments in the human retina. In 1964 William Marks, William Dobelle, and Edward MacNichol at Johns Hopkins University showed that color is mediated by three types of cones. Although the relative activity of the three types of cones explains the colors that we perceive in a well-controlled color-matching experiment in the laboratory, our perception of color in the real world is much more complex and depends, as we have seen, largely on context.

In the 1820s, the French physicist M. E. Chevreul developed "mathematical rules of colour,"[6] which gave rise to the law of *simultaneous contrast*. This law holds that dyes of a given color can appear very different, depending on neighboring hues. Eugène Delacroix made successful use of the law of simultaneous contrast in his depictions of flesh in the ceiling murals of the Palais du Luxembourg in the middle of the nineteenth century. He created artificial light by playing colors off each other and showed that the technique works even in a dark place.[7]

Other artists learned from their own experiments that using color in painting is nothing more than nuanced light and shade and that they could achieve a new level of color mixing by using small dots of different colors. This method, known as *pointillism,* was perfected and used brilliantly by Claude Monet and the Impressionists to reconstitute natural light and thus convey the atmosphere of a landscape or seascape. Pointillism is especially notable in the work of the Post-Impressionist Georges Seurat. Seurat used tiny dots of primary colors—red, blue, green—to create the impression of a wide range of secondary and tertiary colors fully suffused with light. Moreover, some of his color combinations, such as intense yellow and green, induce strong afterimages in purple and violet when the viewer stops looking at them. This caused the aesthetic impression of art to extend beyond the work itself into the beholder's realm of experience.

Following Monet's experiments with atmospheric effects and Seurat's experiments with color, Paul Signac, Henri Matisse, Paul Gauguin, and Van Gogh realized that other elements of painting besides the sitter or the landscape had the power to embody emotion and affect the emotional response of the beholder. They traveled to the south of France in search of "a greater purity of natural sensation; their aim was to discover in nature a special kind of chromatic energy, colour that spoke to the whole psyche and could be concentrated on a canvas."[8] Such a color is the intense yellow discovered by Van Gogh, writes the art critic Robert Hughes. In this vein, Van Gogh wrote to his brother in 1884:

> I am completely absorbed in the laws of colours. If only they had taught us them in our youth! . . . For that the laws of colour which Delacroix was the first to formulate and to bring to light in connection and completeness for general use, like Newton did for gravitation, and like Stephenson did for steam—that those laws of colours are a ray of light—is absolutely certain.[9]

Van Gogh's 1888 painting of a bedroom in Arles (Fig. 20-13) is the first instance in which he consciously used complementary pairs of colors to produce striking effects. "Colour," he wrote of this painting, "is to do everything . . . to be suggestive here of rest or of sleep in general."[10]

Another painting of the same year, *The Sower,* is dominated by the

intense yellow of the sun on the horizon. "A sun, a light, which for want of a better word I must call pale sulphur-yellow, pale lemon, gold. How beautiful yellow is!"[11] wrote Van Gogh. Yet, as Robert Hughes has remarked, in addition to its beauty, the yellow of this sun has a terrible force that radiates upon the solitary figure of the sower. Hughes continues:

> It is wrong to suppose that van Gogh's colour—rich and exquisitely lyrical though it is—was meant simply as expression of pleasure. . . . The freedom of modernist colour, the way emotion can be worked on by purely optical means, was one of his legacies. . . . He had opened the modernist syntax of colour wider, to admit pity and terror as well as . . . pleasure. . . . Van Gogh, in short, was the hinge on which nineteenth-century Romanticism finally swung into twentieth-century Expressionism.[12]

The development of emotive color by the Impressionists and Post-Impressionists was made possible by two technological breakthroughs in the mid-nineteenth century. One was the introduction of a series of synthetic pigments that made possible the use of a vast range of previously unavailable, vibrant colors. In addition, oil paint became available, already mixed, in tubes. Previously, artists had had to grind dry pigments by hand, then mix them carefully with a binding oil. With paints in tubes, artists could use a greater number of colors in their palettes, and since the tubes were resealable and portable, the artists could also paint outdoors. *Plein air,* or outdoor, painting allowed Impressionists like Monet to capture fleeting qualities of light, color, and atmosphere unlike any that could be painted in the studio. This opened the door to new, expressive uses of nontraditional color, as evident in Van Gogh and later in the Viennese expressionists.

Modern studies of the neural basis of color perception, such as those pioneered by Torsten Wiesel, David Hubel, and Semir Zeki, further enriched our understanding of the artistic experimentation of Van Gogh. Those studies reveal that our brain perceives forms largely through luminance (brightness) values, like those seen in black-and-white photographs. Color, therefore, can be used—and indeed was used by Van Gogh and later artists—not simply to depict the natural

surface of objects, but also to express a wide spectrum of emotion in new and more vivid ways.

Indeed, other features of vision enhance color's ability to influence our emotions. Particularly important is the fact that we perceive an object's color as much as 100 milliseconds before its form or motion. This difference in timing is analogous to the fact that we perceive the expression of a face before we perceive its identity. In both cases, our brain processes aspects of the image that relate to emotional perception more rapidly than aspects that relate to form, thus setting the emotional tone for the form—the object or the face—confronting us.

Zeki elaborates further on the significance of these differences in our perception of color and form. In saying that we perceive something, we imply that we are consciously aware of it. Yet we perceive color in area V4 of the brain, and we perceive it earlier than we perceive motion in area V5 or faces in the fusiform face patches. We therefore become conscious of color and of a face at different times and in different places in the brain. Thus, argues Zeki, there is no such thing as a unitary visual consciousness: visual consciousness is a distributed process. Zeki refers to these individual aspects of consciousness as *microconsciousness*. He writes:

Figure 20-13. Vincent van Gogh, *The Bedroom* (1888). Oil on canvas.

Since the synthetic, unified consciousness is that of myself as the source of all perception, it follows that the latter, as opposed to the . . . micro-consciousness, is only accessible through language and communication. In other words, animals are conscious, but only man is conscious of being conscious.[13]

Artists have long intuited the separation between color and form, often forsaking aspects of one to emphasize those of the other. By carefully creating soft outlines and vague contours, as well as by greatly minimizing the value range of light and dark, the Impressionists and Post-Impressionists allowed the viewer to dedicate more of the brain's limited attentional resources to the perception of pure color. Though these images lack the photographic crispness of the academic paintings that preceded them, their explosive chromatic range exerts an unprecedented emotional thrust. This prepared the psychology of fin-de-siècle beholders for the rich painting tradition of the coming generation of Viennese modernists.

*Chapter 21*

## UNCONSCIOUS EMOTIONS, CONSCIOUS FEELINGS, AND THEIR BODILY EXPRESSION

～

W E HAVE SEEN ARTISTS SUCH AS GUSTAV KLIMT, OSKAR KOKOSCHKA, and Egon Schiele communicate emotion by means of facial expression, gaze, hand and body gestures, and the use of color. Their approach poses a question for the modern neuroscience of emotion, a question that occupied Sigmund Freud as well as the Austrian expressionists: What aspects of emotion are conscious and what are unconscious? With the advent of brain imaging and other methods of directly studying the brain, we can now ask: Are conscious and unconscious emotions represented differently in the brain? Do they have different purposes and different ways of expressing themselves in the body?

Until nearly the end of the nineteenth century, the generation of an emotion was thought to consist of a particular sequence of events. First, a person recognized a frightening event—for example, the approach of a powerful-looking man with an angry expression on his face and a stick in his hand. This recognition produced in the cerebral cortex a conscious experience—fear—that induced unconscious changes in the body's autonomic nervous system, leading to increased heart rate, constricted blood vessels, increased blood pressure, and moist palms. In addition, hormones were released by the adrenal glands.

In 1884 William James dramatically reversed this assumption in an article entitled "What Is an Emotion?" James later included this discussion of emotion in his famous 1890 book *The Principles of Psychology*. Here, he summarized and discussed the most important ideas

about the brain, mind, body, and behavior that had been formulated up to that time. Among his many contributions was the profound insight that consciousness is a process, not a substance.

James's nineteenth-century psychological insights into how our body responds to an emotionally charged object or event and how our brain reads the body's response—what James referred to as how "an object-simply-apprehended [perceived]" turns into "an object-emotionally-felt"—are essential to the twenty-first century's biology of emotion.[1] According to Antonio Damasio, James's insights into the human mind were "rivaled only by Shakespeare and Freud. In *Principles*, James produced a truly startling hypothesis on the nature of emotion and feeling."[2]

James had the profound insight that not only does the brain communicate with the body, but equally important, the body communicates with the brain. He proposed that the conscious, or cognitive, experience of emotion takes place *after* the body's physiological response. Thus, when we encounter a potentially dangerous situation—a bear sitting in the middle of our path—we do not consciously evaluate the bear's ferocity and then feel afraid. Instead, we first respond instinctively and unconsciously to the sight of the bear—we run away from it—and only later experience conscious fear. In other words, we first process an emotional stimulus from the bottom up, at which point we experience increased heart rate and respiration, causing us to flee from the bear; then we process the emotional stimulus from the top down, at which point we use cognition to explain the physiological changes associated with our flight.

As James wrote:

Without the bodily states following on the perception, the latter would be purely cognitive in form, pale, colorless, destitute of emotional warmth. We might then see the bear, and judge it best to run . . . but we should not actually *feel* afraid or angry. . . . What kind of an emotion of fear would be left if the feeling neither of quickened heart-beats nor of shallow breathing, neither of trembling lips nor of weakened limbs, neither of goose-flesh nor of visceral stirrings, were present, it is quite impossible for me to think. . . . Every passion in turn tells the same story. A purely disembodied human emotion is a nonentity.[3]

In introducing his hypothesis—the emotional equivalent of Hermann von Helmholtz's top-down, unconscious inference in perception—James said, "I shall limit myself in the first instance to what may be called the *coarser* emotions, grief, fear, rage, love, in which every one recognizes a strong organic reverberation."[4] But he also wrote with characteristic insight about what he called the "subtler emotions," including those connected with the creation of and response to art. For James, the subtler emotions were connected with bodily feelings of pleasure. And like his contemporaries Klimt, Kokoschka, and Schiele, James saw the ugly and the beautiful as different sides of the coin of human life.

In 1885 the Danish psychologist Carl Lange independently proposed a similar idea: that unconscious emotion precedes conscious perception. The first stages of emotion are the bodily and behavioral responses to a strong emotional stimulus. The conscious experience of emotion (what we now call feeling) occurs only *after* the cerebral cortex has received signals about unconscious physiological changes.

ACCORDING TO WHAT soon came to be called the James-Lange theory, feeling is the direct consequence of specific information sent from the body to the cerebral cortex. In every case, the information being sent is determined by the specific pattern of physiological responses— the sweating, trembling, changes in muscle tension, and changes in heart rate and blood pressure—produced in the viscera of our body in response to the emotionally charged stimulus. Moreover, as is generally the case with unconscious perception, the unconscious perception of emotional stimuli plays an extremely important role in survival: it causes physiological changes in our body in response to changes in the environment and thus influences our behavior.

A potential weakness in the James-Lange theory was uncovered in 1927 by the Harvard physiologist Walter B. Cannon. In the course of studying how people and animals respond to emotionally charged stimuli, Cannon found that the intense emotion caused by either a perceived threat or a perceived reward triggers an undifferentiated arousal—a primitive emergency response that mobilizes the body for action. Cannon coined the expression "fight or flight" to describe this response and argued that it reflects the limited choice available to our ancestors when reacting to either a threat or a reward. (Since the re-

sponse does not differentiate between pain and pleasure, it might better be called the "approach-avoidance" response.) Because the response is not modulated, Cannon argued, it cannot account for feelings that are specific to particular stimuli. Moreover, he determined that both the fight and flight responses are mediated by the sympathetic component of the autonomic nervous system, which results in our pupils dilating, our heart rate and respiratory rate increasing, and our blood pressure rising as the blood vessels become constricted.

Cannon and his mentor Philip Bard carried out a systematic series of studies designed to find where in the brain our emotional reactions in response to painful stimuli are represented. This search led them to the hypothalamus. When Cannon and Bard disabled an animal's hypothalamus, the animal could no longer mount a fully integrated emotional reaction. In this sense, Cannon and Bard can be seen as descendants of Carl von Rokitansky and Freud. As we saw in Chapter 4, Rokitansky was the first person to relate the hypothalamus to unconscious emotion; Freud subsequently related unconscious emotion to instincts. Bard and Cannon's findings led them to propose that the hypothalamus is the key structure for mediating unconscious emotional responses and instincts. They then ascribed the conscious perception of emotion—feelings—to the cerebral cortex.

CURRENT THINKING ABOUT emotion has also been influenced by cognitive psychology and the development of more sensitive measurements of physiological changes within the body. Cognitive psychology emphasizes that the brain is a creativity machine that seeks out coherent patterns in an often confusing welter of environmental and bodily signals. Applying this understanding of the brain's creativity to Cannon's fight-or-flight response prompted the social psychologist Stanley Schachter at Columbia University to propose in 1962 that cognitive processes actively and creatively translate nonspecific autonomic signals into specific emotional signals.

Schachter suspected that different social contexts would produce different perceived emotions, even if the body's physiological reactions were the same. To examine this idea, he carried out a creative experiment. He brought young, single male volunteers into his laboratory and told some of them that an interesting woman would enter the room and told the others that a frightening animal would come into the room.

He then injected epinephrine into both groups of volunteers, knowing that this chemical would increase the activity of the sympathetic component of their autonomic nervous system and lead to an increase in heart rate and sweating palms. When Schachter interviewed the men later, he found out that this undifferentiated autonomic arousal—the fight-or-flight response—elicited feelings of approach, even love, in the men who had been told that an interesting woman would enter the room, but it elicited feelings of avoidance and fear from the men who had been told that a frightening animal would come into the room.

Schachter thus confirmed Cannon's ideas by showing that a person's conscious emotional response is determined not only by the specificity of the physiological signals themselves, but also by the *context* in which those signals occur. As with visual perception, where we have learned that the brain is not a camera but a Homeric storyteller, so with emotion: the brain actively interprets the world, using top-down inferences that depend on context. As James pointed out, feelings do not exist until the brain interprets the cause of the body's physiological signals and assembles an appropriate, creative response that is consistent with our expectations and the immediate context.

Following James's lead, Schachter proposed that the autonomic feedback a person experiences in the presence of an emotionally arousing stimulus serves as a good indicator that an emotionally significant event is occurring. However, following Cannon's lead, he argued that this bodily feedback is not always sufficiently informative to tell us what that event is. Thus, according to Schachter, the autonomic response calls our attention to the fact that something important is going on; this motivates us to examine the situation cognitively and try to infer what caused the autonomic response; in the process, we consciously label the feeling that accompanies the response.

The Schachter view of emotion was taken an important step further in 1960 by Magda Arnold, who introduced the idea of *appraisal* into the analysis of emotion. Appraisal is an early step in our response to an emotionally charged stimulus. It elicits a conscious feeling by subjectively evaluating ongoing events and situations. Appraisal results in nonspecific predispositions to approach desirable stimuli and events and to avoid undesirable ones. Although the appraisal process is unconscious, we become consciously aware of the outcome after the fact.

The psychologist Nico Frijda took Schachter's line of thought still

further in 2005 with the finding that our conscious experience of emotion—what we feel—depends on where we focus our attention at any given moment. Attention is like the conductor of a symphony orchestra who calls on different sections—strings, horns, woodwinds—to produce different musical effects, different conscious experiences at different points in time.

HOWEVER, IN ADDITION to the role played by appraisal of nonspecific arousal, there has also been a resurgence of interest in James's original idea. Hugo Critchley and his colleagues at the University of Sussex in England have found that different emotions can, in fact, trigger distinctive responses in the autonomic nervous system and that these autonomic responses produce specific physiological responses in the body. They imaged an area of the brain that coordinates conscious emotional responses and combined those images with recordings of the physiological response of the stomach and the heart to distinguish between two different forms of disgust. Although disgust is a special emotion, these experiments nevertheless support the James-Lange somatic theory of emotion. Thus, feelings seem to be triggered both by cognitive appraisal of emotionally charged stimuli and, at least under some circumstances, and by specific bodily responses to those stimuli (Fig. 21-1).

This modern view of the James-Lange theory (Fig. 21-1) has altered dramatically the way scientists view emotion. Despite the fact that emotion is mediated by neural systems that are partially independent of the perceptual, thinking, and reasoning systems of the brain, we now realize that emotion is also a form of information processing and therefore a form of cognition. As a result, we also now have a broader view of cognition, one that encompasses, as Uta and Chris Frith have insisted, all aspects of information processing by the brain—not only perceiving, thinking, and reasoning but also emotion and social cognition.

How are our emotional responses coordinated? What is the relation between our conscious feelings and the unconscious physiological changes triggered by emotionally charged stimuli?

The development of functional brain imaging techniques in the 1990s enabled scientists to explore the brain activity of alert persons doing specific tasks. The result was an amazing confirmation of James's

**James's Feedback Theory**

James's solution to the stimulus-to-feeling sequence was that feedback from bodily responses determine feelings. Since different emotions produce different responses, the feedback to the brain will be different and will, according to James, account for how we feel in such situations.

**The Schachter-Singer Cognitive Arousal Theory**

Schachter and Singer, like Cannon, accepted that while feedback is important, it alone is insufficient to specify which emotion we are experiencing. Bodily arousal motivates us to examine our circumstances: On the basis of our cognitive assessment of the situatio, we then label the arousal. This top-down processing determines the emotion we feel, thus filling the gap between the non-specificity of bodily feedback and specificity of feelings.

**Arnold's Appraisal Theory**

Arnold proposed that the brain first appraises the significance of a stimulus before producing an emotional response. Appraisals then lead to cognition and action. The felt tendency to move toward desirable objects and situtations and away from undesirable ones accounts for conscious feelings. Although the appraisal process occurs consciously and unconsciously, we have conscious access to the appraisal process after the fact.

**The Modern Synthesis**

The modern synthesis suggests that feelings are triggered both by the cognitive appraisal of a stimulus and by distinct bodily responses, as James originally proposed.

Figure 21-1

view and of subsequent elaborations by Schachter and Damasio on the distinction between unconscious emotion and conscious feeling. Using brain imaging, three independent research groups, those of Ray Dolan at University College London, of Damasio now at the University of Southern California, and of Bud Craig at Barrow Neurological Institute in Phoenix, discovered a little island of cortex located between the parietal and temporal lobes—the *anterior insular cortex,* or *insula.*

The insula (Fig. 21-2) is an area in the brain where our feelings are represented: our conscious awareness of our body's response to emotionally charged stimuli, both negative and positive, simple and complex. The insula becomes active in response to our conscious appraisal of such stimuli and thus represents our conscious awareness of a large number and variety of instinctual urges and autonomic responses, ranging from cigarette craving to thirst and hunger, from maternal love to sensual touch, romantic love, and sexual orgasm. The insula not only evaluates and integrates the emotional or motivational importance

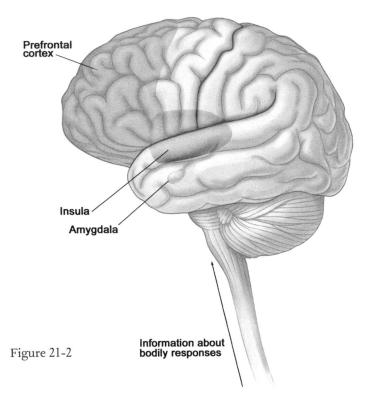

**Prefrontal cortex**

**Insula**

**Amygdala**

Figure 21-2

**Information about bodily responses**

of these stimuli, it also serves as coordinating center between external sensory information and our internal motivational states. In short, as Craig has written, this consciousness of bodily states is a measure of our emotional awareness of self—the feeling that "I am."

The discovery of the insula's role in conscious awareness was a major step forward in understanding emotion. It was on a par with an earlier, independent search for the brain structure that triggers our initial, unconscious awareness of a change in bodily state. The first clue to that structure was uncovered in 1939 by Heinrich Klüver and Paul Bucy at the University of Chicago in their studies of monkeys. After removing the temporal lobe on both sides of the brain, including two structures that lie deep within it, the amygdala and the hippocampus, they discovered a dramatic change in the animals' behavior. Monkeys that had been wild before the operation became tame after it; they also became fearless as their emotions flattened. Further research led Lawrence Weiskrantz in 1956 to focus specifically on the amygdala.

Weiskrantz found that removing the amygdala on both sides of the

brain of monkeys produced deficits in learned fear as well as in instinctive fear. Monkeys with no amygdala did not learn to avoid painful shocks; it seemed that they could not recognize either positive or negative reinforcing stimuli. Conversely, when Weiskrantz electrically stimulated the amygdala in normal monkeys, he produced fear and apprehension. His discovery provided the first inkling of the amygdala's vital, central role in emotion.

JOSEPH LEDOUX, A MODERN PIONEER in the neurobiology of emotion in experimental animals, found that the amygdala orchestrates emotions through its connections with other regions of the brain. In his studies, LeDoux used classical Pavlovian conditioning (Fig. 21-3). To produce learned fear in rats, he sounded a tone just before administering a shock to the feet of the animals, which causes them to crouch and freeze. After the tone and the shock had been paired several times, the rats learned that the tone predicts the shock and they froze as soon as they heard the sound.

LeDoux next examined the route along which the tone travels to the amygdala, the center in the brain that organizes fear. He found that auditory stimuli can take two pathways to the amygdala. One is the

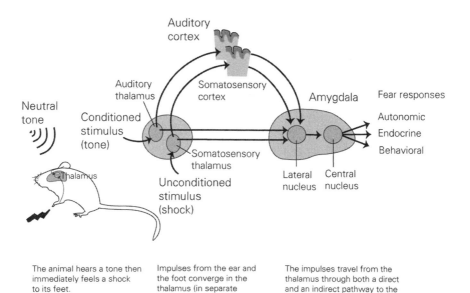

The animal hears a tone then immediately feels a shock to its feet.

Impulses from the ear and the foot converge in the thalamus (in separate auditory and somatosensory areas).

The impulses travel from the thalamus through both a direct and an indirect pathway to the amygdala, where they cause the fear responses.

Figure 21-3

direct pathway, which begins in the thalamus and goes to the amygdala. In the amygdala, auditory information is integrated with information about touch and pain, which also traveled to the amygdala via direct pathways from the thalamus. The direct pathways are used for unconscious processing of sensory data and automatically linking sensory aspects of an event together. It is rapid, crude, and rather inflexible, sending sensory information from the thalamus to the amygdala with only minimal additional processing. The amygdala then sends the information to the hypothalamus, which mediates physiological—bodily—responses to emotional stimuli and is thought to encode unconscious aspects of emotion into neural activity. The hypothalamus, in turn, conveys the physiological response to the cortex.

The second pathway to the amygdala is indirect; it parallels the direct pathway but is slower and more flexible. The indirect pathway, which is actually many pathways, sends information from the thalamus through several relays in the cerebral cortex, including those informed by the bodily responses and those that encode other aspects of the environment. Information from the indirect pathway gets to the amygdala more slowly and may reverberate for some time after the tone is turned off and the shock has ended. This pathway can, in principle, contribute to the conscious processing of information. Le Doux has argued that together, the direct and indirect pathways mediate the two components of James's object-emotionally-felt—the immediate unconscious response and the delayed conscious elaboration.

By activating the direct pathway to the amygdala and the hypothalamus, a conditioned stimulus—such as a sound with a history of predicting shock—can cause our hearts to race and palms to sweat before we realize consciously, through the indirect pathway, what we have heard. In this way, the amygdala is involved in the automatic (or instinctual) components of emotional states and perhaps in the conscious (cognitive) components as well.

The workings of the direct and indirect pathways may provide a physiological basis for the James-Lange theory that a conscious cortically mediated feeling involving the anterior cortex occurs after a bodily response, not before. The first step would be the amygdala's rapid, automatic, unconscious evaluation of the emotional value of a stimulus and its launching and orchestrating of appropriate physiological responses. The hypothalamus and autonomic nervous system then

carry out the responses by sending detailed instructions to the body. The responses occur not only within the brain, but also in the body proper: the palms of our hands sweat, our muscles tense, and our heart pounds. Although not immediately conscious of it, we may have a very painful feeling of fright.

The amygdala's connections to the visual and other sensory areas of the brain are thought to be responsible for the brain's remarkable ability to transform a biologically salient visual stimulus—a dangerous-looking animal—into a feeling, a conscious emotional response. In fact, studying the amygdala's action and its reciprocal connections to the anterior insular cortex, which connects to the medial part of the thalamus—an area concerned with emotional information such as pain and sensual touch—has at last enabled us to go beneath the surface of mental life and begin to examine how conscious and unconscious experience are related—the Holy Grail of Freud's psychoanalytic theories.

How might this work for a Kokoschka or Schiele portrait? Our initial response to the most salient features of the paintings of the Austrian modernists, like our response to a dangerous animal, is automatic. The exaggerated bodily or facial features or striking use of color or texture activate the amygdala via relatively direct pathways, not unlike the pathway taken by the shock in LeDoux's experiments. It is truly as if we have been mildly shocked. The rest of our response involves processing and integrating the remaining sensory features of the painting (and perhaps the context in which we experienced the painting) with our initial response; this is done mainly by the indirect pathways described above. Thus, a Kokoschka or Schiele portrait becomes a vivid emotional experience.

The answer to James's question of how an object simply perceived turns into an object emotionally felt, then, is that the portraits are never objects simply perceived. They are more like the dangerous animal at a distance—both perceived and felt.

THUS, THE BRAIN TRANSFORMS James's object simply perceived into an emotion consciously felt. The amygdala plays a central role in the neural system concerned with the perception and coordination of emotion. Specifically, it is vital to the nervous system in four aspects of emotion: learning the emotional significance of stimuli through experience; recognizing the significance of this experience when it reap-

pears; coordinating autonomic, endocrine, and other physiological responses appropriate to the emotional significance of the experience; and calibrating, as Freud first emphasized, the influence of emotion on other aspects of cognition, namely, perception, thought, and decision making.

In addition to its connections with all of the major sensory areas of the cortex—those involved in vision, smell, touch, pain, and hearing—the amygdala has extensive connections with the hypothalamus and the autonomic nervous system. It also connects with the anterior insular cortex, which processes conscious awareness of our bodily responses, and with cognitive structures such as the prefrontal cortex and the "what" visual pathway for perception of objects. In short, the amygdala can communicate with almost every region of the brain that is recruited for emotion. Given this extensive network of connections, Paul Whalen at the University of Wisconsin, Elizabeth Phelps at New York University, and Dolan and his colleagues have proposed that the primary work of the amygdala is to coordinate the response of these neural circuits to emotional cues, switching on the appropriate circuits for each emotion and switching off the inappropriate ones.

According to this view, the amygdala orchestrates all emotional experience, positive as well as negative. It does so by causing us to focus on emotionally important stimuli. Daniel Salzman and Stefano Fusi at Columbia University further suggest that the amygdala encodes both the valence of emotions (ranging from positive approach to negative avoidance) and the intensity of emotions (the degree of arousal). Consistent with this idea, brain-imaging experiments by Phelps indicate that the amygdala responds to a range of facial expressions. The amygdala on the left side of the brain is particularly sensitive: it responds to a fearful expression with increased activity and to a happy expression with decreased activity.

Additional information about the role of the amygdala in human emotion has come from studies of people with Urbach-Wiethe disease, a condition that results in degeneration of the amygdala. If the degeneration occurs early in life, people fail to learn the cues that would enable them to discern fear in facial expressions and to detect fine differences in other kinds of facial expression. They tend to trust others too readily, perhaps because they cannot process expressions of fear, and they have difficulty understanding the goals, aspirations, and emo-

tional states of others. Yet people with Urbach-Wiethe disease have intact visual pathways and face perception areas and therefore can respond appropriately to complex visual stimuli, including faces. Indeed, they can identify familiar people from photographs. Thus, it is not face recognition but only the processing of emotional signals from the face that is impaired.

In an effort to understand the mechanisms underlying this inability to detect others' emotions, Ralph Adolphs, Damasio, and their colleagues studied a person with Urbach-Wiethe disease. They found that the person's inability to recognize certain emotional expressions stemmed not from an inability to experience emotion, but rather from an inability to glean information from the eyes, the most revealing feature in the expression of fear. And the reason that person could not read information from the eyes was simply that people with Urbach-Wiethe disease do not focus on other people's eyes. Since the mouth is often more important than the eyes for reading emotions such as happiness, it is thought that people with Urbach-Wiethe disease are less impaired in detecting those emotions than they are in detecting fear.

Phelps and Adam Anderson have confirmed that damage to the amygdala impairs the ability to appraise facial expressions but it does not impair the ability to experience emotion. This finding led them to propose that even though the amygdala is active in the intact human brain during emotional states and is critical for the detection of emotion, the amygdala does not *produce* those states. Phelps argues that the amygdala has a largely perceptual role in emotional response: it analyzes incoming sensory information, categorizes it, and then notifies other regions of the brain as to an appropriate emotional response.

Further studies of patients with Urbach-Wiethe disease have found that the connections of the what visual pathway to the amygdala enable us to analyze cues from faces and other parts of the body that signal emotion. These cues boost the visual processing of emotionally charged stimuli, which presumably explains why the emotionally charged faces, hands, and bodies depicted by Klimt, Kokoschka, and Schiele sharpen our attention and take priority over more neutral, less emotionally charged stimuli, both in perception and in the formation of memory.

BECAUSE OF THE AMYGDALA'S interaction with the face patches of the prefrontal cortex and numerous other brain structures, its func-

tions extend beyond regulating personal emotion and feelings to orchestrating social cognition. In fact, much as Darwin proposed in *The Expression of the Emotions in Man and Animals,* there exists a close biological link between the private world of our emotions and the public world of our interactions with other people.

Our patterns of social interaction are formed in infancy, and a baby's bond with its mother remains important throughout life, influencing social behavior into adulthood. Adolphs and his colleagues have argued that the critical importance of the social environment for the survival of the individual requires that our brain be able to acclimate quickly and learn from social situations. The amygdala, as we have seen, is critical to this function because of its ability to assess emotionally charged stimuli. In nonhuman primates and in rats and mice, the primary social consequence of damage to the amygdala is an inability to detect threatening, surprising, or unexpected stimuli, ranging from dangerous snakes to dangerous people. In people, however, the major consequence of damage to the amygdala is an inappropriate response to ambiguous social cues and an inability to respond to any threat inherent in a situation. The amygdala, with its network of connections to other areas of the brain, picks up on ambiguous social cues and makes sense of them, thereby making social interaction possible.

How and where are unconscious, emotionally charged perceptions of faces processed? Are conscious and unconscious emotions represented differently in the brain? Amit Etkin of Columbia University and his colleagues addressed these questions by exploring how people respond consciously and unconsciously to pictures of people with a clearly neutral expression or an expression of fear on their faces. The pictures were provided by Paul Ekman, who, as we discussed earlier, has cataloged more than one hundred thousand human expressions and was able to show, as did Charles Darwin before him, that irrespective of sex or culture, conscious perceptions of six facial expressions— happiness, fear, disgust, anger, surprise, and sadness—have virtually the same meaning to everyone.

Etkin argued that fearful faces should elicit a similar response from all of the young student volunteers in his study, regardless of whether they perceived the stimulus consciously or unconsciously. He produced conscious perception of fear by presenting the fearful faces for a long period, so people had time to reflect on them. He produced uncon-

scious perception of fear by presenting the same faces so rapidly that the volunteers were unable to report what type of expression they had seen. Indeed, they were not even sure they had seen a face!

Not surprisingly, when he showed the volunteers pictures of faces with fearful expressions, he found prominent activity in the amygdala. What was surprising was that conscious and unconscious perception affected different regions of the amygdala; in addition, volunteers who had high scores on a test of general anxiety responded more strongly to unconsciously perceived faces than did volunteers with low general anxiety. Unconscious perception of fearful faces activated the basolateral nucleus, which receives most of the incoming sensory information and is the primary means by which the amygdala communicates with the cortex. Conscious perception of fearful faces, in contrast, activated the dorsal region of the amygdala, which contains the central nucleus. The central nucleus sends information to the parts of the autonomic nervous system that are concerned with arousal and defensive responses.

These are fascinating results. They show that in the realm of emotion, as in the realm of perception, a stimulus can be perceived both unconsciously and consciously. Moreover, the studies confirm biologically the importance of the psychoanalytic idea of unconscious emotion. They suggest, much as Freud had outlined earlier, that the effects of anxiety are exerted most dramatically in the brain when a stimulus is left to the imagination rather than when it is perceived consciously. Once the image of a frightened face is confronted consciously, even anxious people can accurately appraise whether it truly poses a threat.

PART FOUR

...

BIOLOGY OF
THE BEHOLDER'S
EMOTIONAL
RESPONSE TO ART

# TOP-DOWN CONTROL OF COGNITIVE EMOTIONAL INFORMATION

c\/⁊

E MOTIONS ARE NOT ONLY SUBJECTIVE EXPERIENCES AND A ADDED means of social communication, they also are essential elements in formulating intelligent short- and long-term plans. Indeed, the formulation of general goals requires a mix of emotional and non-emotional cognition. Even straightforward cognitive perceptual processes—recognizing a particular person or distinguishing between people—are permeated with emotion and feeling.

The philosopher of science Patricia Churchland calls this a *perceptual and cognitive-emotional consortium,* a coordinated program of cognition that involves the recruitment of both emotional and perceptual processes—a concept Freud would have endorsed. This consortium is clearly evident in the making of complex decisions—particularly social, economic, or moral decisions—in which values and options come into play. Although we understand less about how the brain processes the cognitive-emotional information necessary for moral reasoning than how it processes cognitive-perceptual information (form, color, and face recognition), there has been some progress along both lines in recent years.

AN EMOTIONAL STIMULUS can be positive and rewarding, negative and punitive, or somewhere in between. Positive emotional stimuli engender feelings of happiness and pleasure and cause us to want to approach them so as to receive more stimulation. Thus, our response to sex, to food, to the attachment of an infant, or to addictive substances such as cigarettes, alcoholic beverages, or cocaine summons the posi-

tive cognitive-emotional consortium. Negative emotional stimuli—recruited when we have an angry confrontation with a loved one or colleague or find ourselves alone on a dark street—cause us to feel loss, fear, and the possibility of potential or actual harm. We reflexively want to avoid or escape such situations. These feelings galvanize the negative cognitive-emotional consortium.

Although the amygdala has a central role in evaluating the emotional content of a stimulus, the striatum, a structure that together with the amygdala and the hippocampus lies below the cerebral cortex, is first among equals in initiating a course of action, whether approach or avoidance. The striatum does this by using information it receives from the prefrontal cortex. Thus, while the amygdala and the striatum set the level and tone of an emotion, the prefrontal cortex is the key executive in the brain, evaluating rewards and punishment and organizing the behavior elicited by emotions (Figs. 22-1, 22-2).

THE PREFRONTAL CORTEX is responsible for our ability to remember and act on our intentions, whether small or grand. Joaquín Fuster, who has studied the prefrontal cortex extensively, argues that it is at the vanguard of human evolution because it organizes our perceptions and experience and integrates emotion with behavior. Some of its roles are carried out by its control over working memory, a form of short-term memory that integrates moment-to-moment perceptions with the memory of past experiences. Working memory is essential for exercising rational judgment because it enables us to control our emotions and to anticipate, plan, and carry out complex behavior.

Fuster calls the prefrontal cortex the "supreme enabler" of the brain and argues that it is critical for creativity because it selects among options and orchestrates thoughts and actions in accordance with internal goals. As a corollary, the prefrontal cortex is also critical for planning complex behavior, making coherent decisions, and expressing appropriate social behavior.

People with damage to the prefrontal cortex function normally in most ways, but they make impulsive and irrational decisions, and have difficulty initiating goal-directed behavior. They respond normally to "startle" stimuli, such as an unexpected loud noise or a bright light, indicating that their autonomic responses are not impaired; however, the stimuli do not annoy them or make them uncomfortable, indicating

Figure 22-1

that the brain is not integrating the stimuli. As a result, these people do not feel emotion—their responses are characterized by flatness and indifference. This inability to experience emotion has profound social and behavioral consequences.

THE FIRST CLINICAL demonstration of the role of the prefrontal cortex in integrating emotion with behavior was the case of Phineas Gage. Gage was a railroad construction foreman who was blasting rock with gunpowder to clear a roadbed for a new line near Cavendish, Vermont, in 1848. While tamping down the gunpowder, he accidentally caused an explosion that drove a thirteen-pound iron rod into his skull, destroying most of his left prefrontal cortex (Fig. 22-3). John Martyn Harlow, a relatively inexperienced local physician, treated Gage at the site of the accident with great competence and thoughtfulness. As a result, Gage made a remarkable recovery from this horrible accident. He could walk, talk, and go back to work within twelve weeks of the injury.

Figure 22-2

But Gage emerged from the accident a changed man, not only in terms of his personality but also in terms of his ability to manage his social behavior. Previously, he had been a conscientious and thoughtful person; after the accident, he was totally unreliable and could no longer plan for the future or conduct himself properly. He had no regard for other people and was irresponsible on the job. Given a choice of actions, he could not decide what course would be most appropriate for him.

Harlow described him thus:

Gage came back to Cavendish in April, in fair health and strength, having his tamping iron with him, and he carried it with him until the day of his death, twelve years after. The effect of the injury appears to have been the destruction of the equilibrium between his intellectual faculties and the animal propensities. He was now capricious, fitful, irreverent, impatient of

restraint, vacillating, a youth in intellectual capacity and mani-
festations, a man in physical system and passions. His physical
recovery was complete, but those who once knew him as a
shrewd, smart, energetic, persistent businessman, recognized
the change in his mental character. The balance of his mind was
gone. He used to give his nephews and nieces wonderful ac-
counts of his hair-breadth escapes, without foundation in fact,
and conceived a great fondness for pets.[1]

Although no autopsy was performed on Gage, his skull, with the
bolt hole, was kept in a museum (Fig. 22-4). Years later, medical detec-
tive work by Hanna and Antonio Damasio suggested that the trajec-
tory of the bolt destroyed two regions of the prefrontal cortex (the
ventromedial region and part of the medial region) that are critical for
inhibiting the amygdala and for integrating emotional, cognitive, and
social information.

The Damasios based their conclusion in part on another case study,
that of E.V.R., an intelligent and skilled accountant who underwent
surgery that left him with damage to the ventral regions of his prefron-
tal cortex. Although E.V.R.'s IQ remained high normal, he was no lon-
ger the well-organized, responsible person he had once been. Instead,
he was unreliable, and his personal life was in shambles. Moreover, he
exhibited amazing abnormalities. As measured by electrodes on his
skin, E.V.R. failed to show any response to either horrific pictures or
erotic images.

The Damasios' empirical studies of E.V.R. confirmed Freud's view
that emotions are an essential component of cognition and that they are
essential for acting in accordance with reason. Whereas E.V.R. could
reason quite well, his practical decision making was seriously impaired
because there was no association in his brain between cognitive reason-
ing and emotional expression. The studies also provided independent,
empirical evidence that through its regulation of the amygdala, the pre-
frontal cortex is essential to top-down control of cognition.

The interconnection of emotion and cognition is further under-
scored by the Damasios' study of six other patients who had sustained
an injury to the ventromedial region of the prefrontal cortex in adult-
hood. These people had normal cognitive abilities but severely im-
paired social behavior. They no longer met their commitments, did not

Path of Tamping Iron

Figure 22-3

Figure 22-4.
Phineas Gage
skull and
tamping iron.

show up on time for their jobs, and did not complete assigned tasks. In addition, they could not make plans for the immediate or the distant future. They showed a surprising lack of emotion, especially social emotions such as shame and compassion.

These results led the Damasios to study thirteen people who had sustained damage to the ventromedial region early in life (between birth and age seven). They found that, as children, these people had normal intelligence but poor social interactions at school and at home. They had difficulty controlling their behavior, did not make friends, and were insensitive to punishment. In particular, these patients had lost their capacity for moral reasoning.

Thanks to these studies of the connections between the amygdala and the prefrontal cortex, the longstanding idea that thinking and emotion are in opposition to each other is no longer credible. Now we know differently. We know that emotion and cognition work together. This would have come as a surprise to rationalists, from Demokritos, an originator of Greek philosophy in 400 B.C., to the eighteenth-century German philosopher Immanuel Kant, who held the view that to make good moral judgments, we must recruit reason and exclude emotion. But it would have come as no surprise to Freud, who held that emotion is essential to moral decision making.

Joshua Greene, a modern student of moral decision making, has found that moral dilemmas vary in the extent to which they engage our emotions and that these variations in emotional engagement also influence our moral judgment. In studying this problem, he focused on an interesting puzzle known as the Trolley Problem, introduced in 1978 by Phillippa Foot and Judith Jarvis Thompson.

The Trolley Problem asks you to consider what you would do if a runaway trolley were about to run over and kill five people and you could save them by throwing a switch that would divert the trolley to a sidetrack where it would kill only one person. Most people faced with this moral dilemma would decide that saving five people is better than saving one person and would throw the switch. In an alternative version of this dilemma, a runaway trolley threatens five people, but the only way to save them is to push someone off the footbridge where you are standing into the path of the trolley, killing that person and thereby stopping the trolley. The consequence of both actions is the same, but their execution is quite different. Whereas most people find it morally

acceptable to divert the trolley in order to save five people, they find throwing a person off the bridge to save five lives unacceptable— because for most people, throwing a switch arouses less emotion than physically throwing a person.

This finding has led Greene to propose a "dual process" theory of moral decision making. *Utilitarian* moral judgments, aimed at promoting the "greater good" over individual rights, are driven by more controlled, non-emotional, cognitive processes that to a great degree recruit genuine moral reasoning. *Intuitive* moral judgments, which favor individual rights and duties (such as whether to throw someone off the footbridge), are driven by emotional responses and tend to involve self-serving moral rationalization rather than more objective moral reasoning. Each type of moral judgment recruits a different neural system.

THE PREFRONTAL CORTEX plays a key executive role in moral reasoning and makes up almost one-third of our entire cerebral cortex (Figs. 22-5 and 22-6), and as we have seen, is essential to a well-functioning mental life. In 1948 Jerzy Rose and Clinton Woolsey, working together at Johns Hopkins University, discovered that different parts of the prefrontal cortex are connected to particular groups of nerve cells in the thalamus and to all of the sensory circuits—touch, smell, taste, vision, and hearing. In their studies, they discovered the prefrontal cortex could be divided into four major parts based on their distinctive pattern of connections. There are the two ventral regions: the ventrolateral (also called orbital-frontal) region and the ventromedial region, then a dorsal lateral region, and a medial region. Each of these regions receives information from a different area of the thalamus, and each has its own connections to target regions in the brain

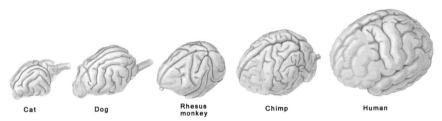

Cat          Dog          Rhesus          Chimp          Human
                          monkey

Figure 22-5

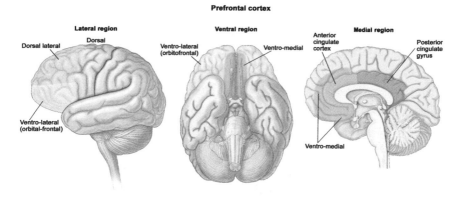
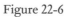

Figure 22-6

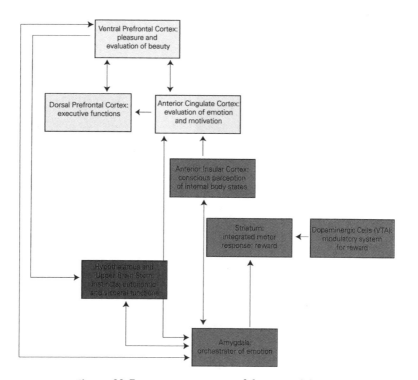

Figure 22-7. Interconnectivity of the amygdala with
other structures involved in emotion: the striatum,
cingulate cortex, and the prefrontal cortex.

(Fig. 22-7). All four regions of the prefrontal cortex connect with the amygdala.

The four regions of the prefrontal cortex have both overlapping and separate functions. The *ventrolateral* or *orbital-frontal region* has the strongest connections to the amygdala and is important for evaluating beauty, pleasure, and other positive values of a stimulus. This region is recruited both for perceiving facial expressions and for generating them, in part by processing information from the face patches in the temporal lobe. People with damage to this region of the brain can feel positive emotion, but they cannot express it in a smile.

The *ventromedial region* of the prefrontal cortex is critical for goal-directed behavior. It integrates positive emotional experiences with social behavior and moral judgment. It does this by inhibiting the amygdala, whose reaction to emotional stimuli can interfere with cognition. People with damage to the ventromedial region have normal cognition, yet they are prone to impulsive decision making. They also have impaired moral reasoning and would have little difficulty throwing a person off the footbridge.

The *dorsolateral region* mediates working memory and carries out executive and cognitive functions such as planning and organizing behavior with the goal of obtaining a desired outcome. To carry out its cognitive functions, the dorsolateral region uses information from the ventrolateral region. Acting together, the two regions ensure that behavior is directed efficiently toward satisfying our needs. The dorsolateral region is recruited in impersonal moral dilemmas, which are more heavily weighted toward the cognitive domain (throwing a switch in the Trolley Problem) than the emotional domain (throwing a person).

The fourth region of the prefrontal cortex, the *medial region,* contains the *anterior cingulate cortex* (the cingulate), which has two subregions: a ventral region that is important in evaluating emotion and motivation and in regulating blood pressure, heart rate, and other autonomic functions, and a dorsal region that plays a central role in the top-down monitoring of cognitive functioning, such as predicting rewards, making decisions, and empathy. People with damage to the anterior cingulate cortex are emotionally unstable and have difficulty resolving conflict and detecting errors in predicted rewards, resulting in inappropriate responses to changes in the environment.

Together, the ventral region of the anterior cingulate cortex and the ventrolateral and ventromedial regions of the prefrontal cortex form part of the social cognition system identified by Chris Frith. Damage to any of these regions impairs normal moral functioning, and abnormal functioning plays a critical role in disorders of social conduct.

IT IS DIFFICULT to examine current views of unconscious emotional processes and conscious feeling without being aware of Freud's influence. Freud insisted that our emotions are intimately woven into the fabric of our inner lives and that our ability to regulate them keeps us from coming unraveled. In the best of circumstances, successful regulation of stress-inducing emotions leaves us feeling slightly stressed. In the worst of circumstances, regulatory failure takes a severe toll and contributes to the genesis and symptoms of many psychiatric disorders.

How much of Freud's view of mind is relevant to the new science of mind? The neuropsychoanalyst Mark Solms has undertaken to address this question, emphasizing a theme that is one of the cornerstones of this book: namely, that modern research has consistently supported the idea of unconscious mental processes. Moreover, much as Freud argued, we have reason to believe that not all unconscious processes are the same. Some unconscious processes can readily be detected consciously by focusing attention on them (what Freud called the preconscious unconscious), while others are usually outside conscious awareness (the procedural unconscious and the dynamic—or instinctual—unconscious).

Freud held that some unconscious processes, such as the dynamic unconscious, are repressed. Solms argues that we now have evidence of certain forms of repression. For example, people with damage to the right parietal lobe will deny that their right arm is paralyzed; they will ignore the arm and may even try to throw it out of bed, claiming that it belongs to someone else. Freud pointed out that the language of the repressed unconscious mind is governed by the pleasure principle, the unconscious drive to seek pleasure and avoid pain. As we have seen, damage to the prefrontal cortex caused Phineas Gage to be guided by the pleasure principle and to disregard rules of social conduct that interfere with its expression.

Solms goes on to explore Freud's structural model of 1933—based on the ego, the id, and the superego—in terms of modern brain science

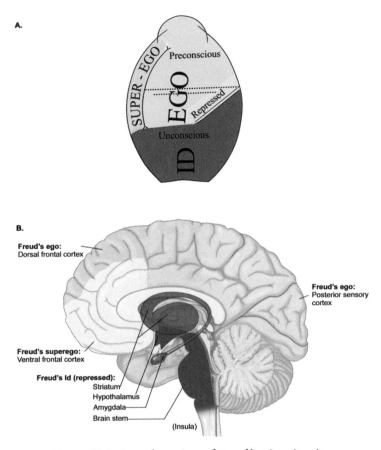

Figure 22-8. A modern view of Freud's tripartite view
of the psychological apparatuses

(Fig. 22-8). In Freud's view (Fig. 22-8A), the instinctual drives of the id are repressed by the superego, thereby preventing them from disrupting rational thought. Since most rational (ego) processes are also automatic and unconscious, only a small part of the ego (the bulb at the top of the figure) is left to manage conscious experience, which is closely tied to perception. The superego mediates the ongoing struggle for dominance between the ego and id.

Solms argues that neurological mapping studies (Fig. 22-8B) correlate with Freud's conception, though only in a very general way. The input from the ventromedial region of the prefrontal cortex that Damasio studied, which selectively inhibits the amygdala, corresponds roughly to the function of the superego. The dorsolateral region of the prefrontal cortex, which controls self-conscious thought, and the pos-

terior sensory cortex, which represents the outside world, correspond roughly to the ego. Thus, Solms finds that the crux of Freud's dynamic model seems to have held up reasonably well: the primitive, instinctual emotional systems are regulated and inhibited by higher executive systems in the prefrontal cortex.

The important point for the modern biology of mind is not whether Freud was right or wrong but that his greatest service to psychology per se was his use of careful observations to describe a set of cognitive perceptual and emotional processes that could serve as a basis for later developments in brain science. It is this aspect of Freud's work that is particularly useful in the empirical studies that are leading to a new science of mind.

# THE BIOLOGICAL RESPONSE
# TO BEAUTY AND UGLINESS IN ART

~◡~

IN ADDITION TO INSTINCTIVE SENSORY PLEASURES, WE EXPERIENCE higher-order aesthetic and social pleasures: artistic, musical, altruistic, even transcendental. These higher pleasures are in part inborn, as in our estimation of beauty or ugliness, and in part acquired, as in our response to visual art and music.

When we look at a beautiful work of art, our brain assigns different degrees of meaning to the various shapes, colors, and movements we see. This assignment of meaning, or visual aesthetics, illustrates that aesthetic pleasure is not an elementary sensation like the feeling of hot or cold, or the taste of bitter or sweet. Instead, it represents a higher-order evaluation of sensory information processed along specialized pathways in the brain that estimate the potential for reward from a stimulus in the environment—in this case, from the work of art that we view.

IN ART, AS IN LIFE, there are few more pleasurable sights than a beautiful human face (Fig. 23-1). Attractive faces activate the reward areas in the brain and inspire trust, sexual attraction, and sexual partnership. Studies of attractiveness in life and art have led to a number of surprising insights.

For a very long time, scientists believed that the standards for male and female beauty resulted from arbitrary cultural convention. Indeed, beauty has been thought to be a personal judgment—that it is in the eye (mind) of the beholder. However, several biological studies have challenged that position. The studies found that people everywhere,

Figure 23-1.
Denise Kandel.

irrespective of age, class, or race, share a common set of unconscious criteria for what is attractive. In every case, the qualities that people find attractive are indicative of fertility, health, and resistance to disease. The psychologist Judith Langlois at the University of Texas found that even completely naïve viewers—infants only three and six months old—share these values.

What makes a face attractive? One characteristic is symmetry, which is preferable to asymmetry. According to David Perrett, head of the Perception Laboratory at the University of St. Andrews in Scotland, this holds true for men's faces as well as women's. Empirical research has shown that, across cultures, women and men alike prefer symmetrical faces. Moreover, this principle underlies mate choice not only in humans and great apes but also in birds and even in insects. Why would this bilateral bias be so conserved across the animal kingdom?

Perrett suggests that good symmetry indicates good genes. During growth, challenges to health and environmental stressors can result in asymmetrical growth patterns in the face. The degree of symmetry in a person's face may therefore indicate how capable that person's genome is of resisting disease and maintaining normal development in the face of challenges. Moreover, developmental stability is largely heritable. Thus symmetry, at least in faces, is beautiful not just for strictly formal reasons but also for what it communicates about the health of a potential mate and the mate's potential offspring.

To what degree do these criteria of facial beauty apply to the portraiture of the Viennese modernists? The Art Nouveau faces in Gustav Klimt's paintings display remarkable symmetry. We can see this by digitally superimposing a mirror image of the left side of a face on top of the right side, or vice versa (Fig. 23-2). The two faces are virtually indistinguishable, and whatever differences there are can often be attributed to uneven lighting. This degree of symmetry is extraordinarily rare in nature. It represents idealized proportions that tacitly communicate signs of health and genetic quality and is surely a contributing factor to the dreamlike beauty of Klimt's faces. Clearly, the artist intuitively understood one of the most potent features of facial attraction and incorporated it elegantly into his work.

A CONCERN WITH FACIAL symmetry is also evident in the paintings of Oskar Kokoschka and Egon Schiele, but unlike Klimt these painters exaggerated faces and emotion (Fig. 23-2). In fact, that exaggeration contributed to their emergence as expressionists. While Klimt's portraits provide tacit signifiers of a person's being psychologically and developmentally at peace with his or her environment, Kokoschka's portraits show the opposite. Even his most benign and least expressionistic portraits—such as that of Ernst Reinhold (Fig. 23-2)—show asymmetries. These images are troubling because of their bilateral irregularities and because of the internal conflicts that those irregularities communicate. By tapping into these unconscious signifiers of distress, the expressionists were able to communicate narrative and emotion in a sophisticated, subtle, and decidedly modern way.

In addition to symmetry, certain other features are universally considered attractive in a female face: arched eyebrows, large eyes, small nose, full lips, narrow face, and small chin. It should come as no surprise that these facial features are ubiquitous in Klimt's oeuvre, nor that they are less common in Kokoschka's. While the women painted by Kokoschka display some of these features, such as large eyes and full lips, he tends to place them within widened, asymmetrical faces. It is perhaps this blend of attraction and repulsion that gives Kokoschka's portraits such uneasy intrigue. Teetering between beauty and anxiety, they are ineluctably interesting.

Attractive masculine features are based on different criteria. In the 1960s Gerald Guthrie and Morton Wiener found that sharply angled

**Original**          **Left Mirrored**          **Right Mirrored**

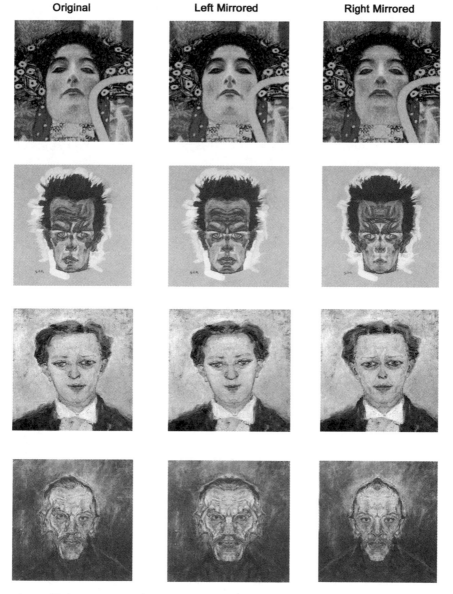

Figure 23-2. From top to bottom: Gustav Klimt, *Hygieia* (1900–7), detail from *Medicine;* oil on canvas. Egon Schiele, *Self-Portrait, Head* (1910) (detail); water, gouache, charcoal, and pencil on paper. Oskar Kokoschka, *The Trance Player, Portrait of Ernst Reinhold* (1909) (detail); oil on canvas. Oskar Kokoschka, *Ludwig Ritter von Janikowski* (1909) (detail); oil on canvas. Images have been modified.

(rather than curved) shoulders, elbows, and knees are associated with both masculinity and aggressiveness. A protruding chin, jawline, brow line, and cheeks, along with elongation of the lower face—characteristics caused by increased testosterone production during puberty—are also considered attractive in men. These facial characteristics and the implied excess of testosterone suggest not only hypersexuality but also the potential for asocial behavior, aggression, and dominance.

The preference for exaggerated features is expressed by Caucasian men and women judging images of Caucasian women as well as by Japanese men and women judging images of Japanese women. The surprising similarity of the facial characteristics judged to be attractive in both cultures indicates, as the earlier studies showed, that exaggeration of those characteristics is also likely to be universally regarded as attractive. Perrett and his colleagues suggest that the characteristics mediate biological signals of sexual maturity, fertility, and emotional expressiveness.

Evolutionary psychologists have noted that universally preferred facial features emerge in boys and girls during puberty, when the concentration of sex hormones rises. The small jaw that men favor in women results from the action of estrogens at puberty, which slows the further growth of the jaw. Similarly, as we have seen, the heavy lower face that women prefer in men results from a surge of testosterone. Following Darwin's initial suggestions, these psychologists now argue that the emergence of these traits as a result of an abundance of sex hormones would have been a good clue to primitive people—the hunter-gatherers—that a person was ready to mate.

Features that differ in men and women, such as thick brow ridges and large jaws in men and small lower face, high cheekbones, and full lips in women, also contribute to facial attractiveness. When asked to rate the personality characteristics of women with those features, men indicated that the women would be inclined to be altruistic and were preferable for dating, sexual behavior, and child-rearing capability.

What is valued as beautiful in a man relates to his ability to obtain resources for supporting his family and what is valued as beautiful in a woman's body relates specifically to her ability to bear children. On average, men, irrespective of nationality or background, ascribe beauty to women who have large breasts and hips, symbols of fertility. Needless to say, these stereotypes, although consistent across cultures, are

modified by local values and, most important, by knowledge of the individual and her social habits and values.

Schiele clearly understood the latent significance of a distortion of facial and bodily features. The portraits he painted of his own body display extreme anatomical distortions that often result in sharp cusps and angular ridges, features signifying aggression (Fig. 10-7). The faces he paints are also characterized by markers of aggression. Yet because male and female features are not necessarily mutually exclusive—because one can have, for example, a masculine jawline that meets a feminine chin—Schiele was able to emphasize feminine facial features as well. The arched eyebrows, large eyes, small nose, full lips, and narrow face of Schiele's figures communicate a sensual intimacy, while their pronounced jaw and brow speak of a fiery aggression (Fig. 10-6). By juxtaposing these two sets of features within the confines of a single face and body, Schiele subtly and effectively reveals the two Freudian instinctual drives, Eros and Thanatos, at work in the people he painted.

IN 1977 TWO developmental psychologists at MIT, Susan Carey and Rhea Diamond, introduced the Gestalt concept of *configurational information* into the study of face perception. Until then, it was thought that the brain uses only parts-based information to perceive faces—that is, information derived from the spatial elements that make a face a face: two horizontally positioned eyes separated by a central nose and above a central mouth. Configurational information is more subtle and refers to the distance between features, the position of features, and the shape of the features. Carey and Diamond suggested that while parts-based information is sufficient to allow people to distinguish faces from other objects, configurational information is needed to distinguish one face from another; it appears particularly important for evaluating the beauty of a face.

Perrett provided the first evidence of configurational information's role in gauging attractiveness by exploring the question: Does our evaluation of facial attractiveness require parts-based or configurational information? He used composite faces to determine what features in the female face study volunteers found to be attractive. Then, based on the results of those studies, he created a composite of the average attractive female face.

When Perrett exaggerated the features of the average attractive face—higher cheekbones, a thinner jaw, larger eyes, or a shorter distance between mouth and chin and between nose and mouth— volunteers judged the face to be even *more* attractive, much as predicted by the Kris-Gombrich-Ramachandran hypothesis. As we have seen, exaggeration is a device used by cartoonists and expressionist artists, who, in essence, take a characteristic feature of a person's face, subtract from it the universal feature, and then enhance the difference. Moreover, Doris Tsao and Winrich Freiwald found, as we have seen, that neurons in two of the brain areas dedicated to face recognition use a combined parts-based and holistic strategy. Showing the animals cartoon faces, Tsao and Freiwald discovered that the cells follow Gestaltian rules: they do not respond to single features or to a combination of features unless they are contained within an oval. Moreover, when the features of the face are exaggerated—as they might be in an expressionist painting—the cells' response is particularly strong.

These are not small matters. What is amazing about the biology of beauty is that the ideal of beauty has varied surprisingly little from century to century and from one culture to another. Therefore, several aspects of what we implicitly judge to be attractive are likely to have been conserved through evolution. Clearly, our biases in evaluating beauty must work, or they would not have survived more than forty thousand years of selective pressure. The existence of shared criteria for beauty that endure over time is important in understanding art. It explains why a Titian nude can move us as much as a Klimt nude does, but in a somewhat different manner.

How do facial expressions contribute to the evaluation of beauty? Our attraction to faces, and particularly to eyes, appears to be innately determined. Infants as well as adults prefer to look at eyes rather than other features of a person's face, and both infants and adults are sensitive to gaze. The direction of a person's gaze is very important in our processing of the emotions displayed by that person's face, because the brain combines information from gaze with information from facial expressions. The integration of these cues is key in eliciting the primitive emotional responses of approach and avoidance. These are the principal factors governing social interactions, and they are therefore likely to serve an important adaptive function in human evolution.

Reginald Adams from Pennsylvania State University and Robert Kleck from Dartmouth College have found that a direct gaze and an expression of happy emotion facilitate the communication and processing of joy, friendliness, and approach-oriented emotions presumably because, as Uta Frith has found, only direct gaze recruits the dopaminergic reward system. In contrast, an averted, sad, or fearful gaze communicates the avoidance-oriented emotions of fear and sadness. Although gaze and facial expression are processed together, other aspects of beauty, such as gender and age, are processed independently.

IN A BIOLOGICAL EXPERIMENT designed to examine the neural correlates of beauty—that is, the mechanisms in our brain that account for our sense of beauty—John O'Doherty and his colleagues explored the role of the smile. They found that the orbitofrontal (ventrolateral) region of the prefrontal cortex, the region that is activated by reward and thought to be the apex of the representation of pleasure in the brain, is also activated by attractive faces. Moreover, the response of this region is enhanced by the presence of a smile.

Semir Zeki of University College London found that the orbitofrontal region is also activated in response to other, subtly pleasurable images that we interpret as beautiful. Zeki conducted a study in which he first asked volunteers to examine a large number of portraits, landscapes, and still lifes. He then had the volunteers classify the art, irrespective of category, on the basis of whether they found the painting beautiful or ugly. Zeki imaged the volunteers' brains as they looked at the paintings and found that all of the portraits, landscapes, and still lifes, regardless of whether the viewer saw them as beautiful or ugly, lit up the orbitofrontal, prefrontal, and motor regions of the cortex. Interestingly, however, the pictures ranked most beautiful activated the orbitofrontal region most and the motor region least, whereas the pictures ranked ugliest activated the orbitofrontal region least and the motor region most. The activation of the motor region of the cortex suggests to Zeki that emotionally charged stimuli mobilize the motor system to be prepared to take action to get away from the stimulus in the case of ugliness or threat and toward the stimulus in the case of beauty or pleasure. Indeed, as we know, fearful faces also activate the motor region of the cortex.

The cognitive scientist Camilo Cela-Conde elaborated on Zeki's results using a different methodology: magneto-encephalography, which allows very good time resolution. His study imaged the electrical activity of participants' brains as they viewed an object that they had evaluated earlier as being beautiful. The imaging revealed changes in activity in the dorsolateral region of the prefrontal cortex, which is specialized for working memory: that is, the short-term memory necessary to plan our actions so as to obtain a desired outcome. Activity was greater in the left hemisphere, suggesting that language and aesthetic sensibilities may have evolved in parallel. Cela-Conde argues that a change in the prefrontal cortex during the course of evolution led to the ability of modern humans to create and respond to art. We shall return to this suggestion later, when we consider creativity.

The activation of the left prefrontal cortex in response to an object evaluated earlier as beautiful occurred after a relatively long period (400 to 1,000 milliseconds), unlike the usual reaction time of 130 milliseconds. Cela-Conde sees this difference as being consistent with Zeki's idea that visual processing occurs in multiple stages and that the attributes of an image are processed differently when the image is first seen than when it is viewed later.

ENJOYING BEAUTY IN a painting is one thing, but falling in love with the beauty in a portrait is another. An example of the processes in the brain that become engaged when we fall in love with a beautiful portrait may be inferred from Ronald Lauder's encounters with *Adele Bloch-Bauer I*, one of Klimt's greatest paintings, which took the artist three years to complete. When Lauder was fourteen years old, he fell in love with the image of this beautiful, enigmatic woman, her slightly opened, sensuous lips, her beautiful jeweled necklace (Fig. 1-1). The painting of Adele mesmerized him, her emotion, her sexuality, and her direct gaze.

The beauty of an image may recruit not simply a positive emotion, but something more like love, an aesthetic addiction, as appears to have been the case with Lauder and the portrait of Adele Bloch-Bauer. Lauder coveted her image. After his first visit, he returned to Vienna most summers to see Adele time and time again. He began to see her as the most important portrait of her age, the *Mona Lisa* of Vienna 1900. Ultimately, he succeeded in possessing her.

We now know that seeing a beloved image, much like seeing a be-
loved person, activates not only the orbitofrontal cortex in response to
beauty but also the dopaminergic neurons at the base of the brain in
anticipation of reward. These neurons are activated by the image of a
loved object, be it a live person or a painting, in much the same way that
they are activated in a cocaine user when he or she sees cocaine. That
being the case, the fact that Lauder was deprived of frequent, routine
access to Adele's image for forty-seven years may only have enhanced
the activity of his dopaminergic neurons and may have contributed to
his eagerness to purchase this great painting, even at a very high price,
once it became available.

The similarity between the response to a beloved image or person
and the response to an addictive drug was first demonstrated by Lucy
Brown, Helen Fisher, and their colleagues at the Albert Einstein Col-
lege of Medicine and Rutgers University. They extended Zeki's study
of the effects of looking at paintings in general to the effects of looking
at images of a lover. They studied people in an early stage of intense
romantic love and people who had been rejected by their partner in a
romantic relationship. In every case, they found that the emotional re-
sponse to images had a particular biological signature: the activation of
dopaminergic neurons as well as the neurons of the orbitofrontal cortex
(Fig. 23-3). As we shall discuss in greater detail in Chapter 26, the do-
paminergic system is the key modulatory system of the brain for re-
ward. Moreover, when a person who had been rejected but who was
still in love saw an image of the beloved, there was an even greater ac-
tivation of the dopamine reward system. Thus, love appears to be a
natural addiction, recruiting a motivational system associated with ac-
quiring reward that is more like a drive state—hunger, thirst, or drug
craving—than an emotion. It explains why feelings become even more
intense when the image of the loved one is withdrawn, as was the case
with Lauder's loss of routine access to Adele's image.

Fisher and her colleagues have also found that we have evolved sep-
arate biological systems for attraction, lust, and attachment. Attraction
is the focusing of attention on a person, or the symbolic representation
of that person, accompanied by exhilaration and by obsessional think-
ing about and craving for an emotional union with the person. Lust,
however, is the craving for sexual satisfaction. Attachment is different
still. It is the sense of close social contact and the feeling of calm, com-

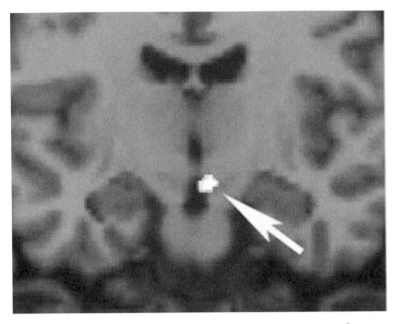

Figure 23-3. As individuals were looking at an image of
their beloved, the dopaminergic nerve cells in the right
ventral tegmental area were activated.

fort, and emotional union. Whereas attraction is a precursor to finding
a mate and lust is a precursor to mating and reproduction, attachment
is essential to parenting. Attraction recruits the dopamine system,
whereas attachment, as we shall see, recruits the systems that release
the peptide hormones oxytocin and vasopressin.

WE ARE NOT ONLY inspired and seduced by art, but also mystified,
startled, frightened, and even repulsed by it. Until 1900 beauty in art
was equated with truth. This standard derived from the high value
placed on simplicity and beauty in classical art. As we have seen, this
view was challenged in Vienna 1900 by Gustav Klimt's three murals
for the University of Vienna (Chapter 8). When the murals were re-
jected for being too radical, too pornographic, too ugly, faculty at the
Vienna School of Art History, including Alois Riegl and Franz Wick-
hoff, argued that truth is complex and often not beautiful. The illness
and death depicted in Klimt's murals for the medical faculty might not
be beautiful in the conventional sense, but the truth about diseases of
the human body is that they are often ugly and painful to comprehend.

Wickhoff argued in a lecture before the Philosophical Society of Vienna that what one historical period considers ugly, another considers beautiful. Ugliness has the ring of truth as surely as beauty does. Historically, both represent biological truths: the instinctive need to approach things that enhance one's survival and reproductive potential and to avoid things that do not. Ugliness, according to this historical view, is an issue of life and death. According to Wickhoff, this biological distinction was lost during the Renaissance, when classical artists began to produce images of beauty based on sexual preference. In the subsequent history of art, anything that deviated from this limited perspective was not considered either beautiful or truthful.

Even before Klimt painted his murals, Riegl and Wickhoff had already argued that art does not stand still. Schiele stated: "In art, immorality cannot exist. Art is always sacred, even when it takes for a subject the worst excesses of desire. Since it has in view only the sincerity of observation, it cannot debase itself."[1] As a society evolves, so does its art; therefore, the idea that contemporary art should adhere to the standards of antiquity encourages beholders to reject anything that is new or difficult as being ugly. In her excellent essay on "Ugliness and the Vienna School of Art History," Kathryn Simpson points out that three years after Wickhoff's lecture, Riegl extended this argument in a new direction. In certain contexts, he wrote, only "new" and "whole" things are considered beautiful, whereas old, fragmentary, and faded things are considered ugly.

Inspired by what they perceived to be Klimt's challenge to conventional taste, Kokoschka and Schiele developed bold, individualistic expressionist styles that depicted truth, including the ugliness of life. In the case of Schiele, this meant depicting himself as diseased, deformed, and crazed, even when engaged in sex (Figs. 10-8 and 10-3), and in the case of Kokoschka, as a frenzied warrior or a rejected, defenseless lover (Figs. 9-8 and 9-15).

This raises an obvious question. In life we gravitate in a conservative manner toward biologically specified and convergent ideals of beauty. Why is our response to art so different? Why are we genuinely fascinated by Klimt's representation of Judith as a castrating female, or Schiele's depiction of himself as an anxious, disoriented psychological wreck?

Clearly, the question speaks to the larger function of art—not sim-

ply portraiture, but all forms of art. Art enriches our lives by exposing us to ideas, feelings, and situations that we might never have experienced, or even want to experience, otherwise. Art gives us the chance to explore and try out in our imagination a variety of different experiences and emotions.

THE RELATIONSHIP BETWEEN beauty and ugliness in a face being portrayed parallels that between pleasure and pain. Beauty does not occupy a different area of the brain than ugliness. Both are part of a continuum representing the values the brain attributes to them, and both are encoded by relative changes in activity in the same areas of the brain. This is consistent with the idea that positive and negative emotions lie on a continuum and call on the same neural circuitry. Thus, the amygdala, commonly associated with fear, is also a regulator of happiness.

As might have been predicted by the founders of the Vienna School of Art History, who argued that there is no single standard for truth in art, aesthetic judgments appear to follow the same basic rules as the evaluation of emotional stimuli in general. For every evaluation of emotion, from happiness to misery, we use the same fundamental neural circuitry. In the case of art, we evaluate a portrait's potential for providing new insights into another person's psychological state. This discovery, by Ray Dolan and his colleagues at University College London, was based on a set of studies in which volunteers viewed faces whose expression of sadness, fear, disgust, or happiness was gradually changed from low to high intensity (Fig. 23-4).

Dolan and his colleagues set out to explore how the amygdala, the brain's orchestrator of emotions, responds to happy or sad faces; specifically, they studied how the amygdala responds to emotionally charged faces that are presented briefly and can therefore only be perceived unconsciously, and how it responds to such faces presented more slowly, allowing conscious perception. Dolan found that the amygdala and the fusiform face area of the temporal lobe respond to the image of a face regardless of the emotion being displayed and regardless of whether the image is perceived consciously or unconsciously. Other areas of the brain, such as the somatosensory cortex and parts of the prefrontal cortex that have strong, direct connections to the amygdala, respond only to conscious perceptions of faces, but they respond re-

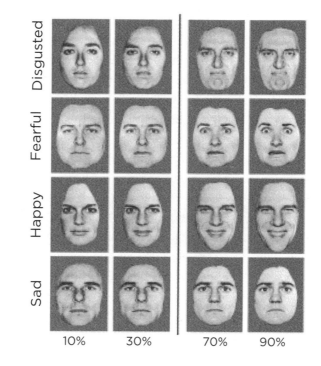

Valence

Disgusted    Fearful    Happy    Sad

10%        30%        70%        90%

## Intensity (arousal)

Figure 23-4. Ray Dolan's study of Ekman faces representing four
universal facial expressions as a function of intensity.

gardless of the emotion being displayed, suggesting that these regions
are part of the forward broadcasting of information that we shall see in
chapter 29 is necessary for the mediation of conscious feelings. The
findings also support the idea that while the amygdala is recruited for
both conscious and unconscious perception of faces and responds to
both positive and negative stimuli, only conscious perception of faces
recruits the prefrontal cortex.

In a similar vein, Dolan found, using PET imaging studies, that
when people view faces that express either fear or happiness, seeing
progressively more fearful faces increases activity in the amygdala,
whereas seeing increasingly happy faces decreases activity.

HOW CAN IT BE that the amygdala is recruited for different emotions,
including different facial expressions of emotion? Do the same cells in

the amygdala respond in opposite ways, or are different populations of nerve cells recruited for different emotions? Advances in modern biology have underscored Darwin's insight that we can learn about the foundations of human mental life by studying simpler animals. Not only are genes conserved through evolution, but bodily form, brain structures, and behavior are conserved as well. It is therefore likely that we share with other animals some of the basic neural mechanisms of fear and pleasure.

This has proven to be true. Working with monkeys, Daniel Salzman at Columbia University examined individual cells in the amygdala and found that specific groups of neurons respond more strongly when visual stimuli are paired with rewards than when they are paired with punishment. Thus, they indicate that changes in both the positive and negative value of an image affect the activity of the amygdala and that they do so by recruiting different groups of neurons.

The beholder may go beyond processing emotions and experiences in response to art and actually try to infer what someone else is thinking. This skill derives from the brain's ability to generate a *theory of mind*—that is, to form the idea that another person has his or her own ideas, intentions, plans, and aspirations that are independent of our own. Failure to read another person's intention correctly is central to fiction and was pioneered by Jane Austen, whose novels often involve misperceiving romantic intention. Arthur Schnitzler's use of the interior monologue enables his readers to inhabit two or more mental worlds at the same time.

As Ernst Kris and Ernst Gombrich have pointed out, the beholder of pictorial art may also be required to grasp what the artist is trying to convey about a subject's aspirations and goals. This exercise in reading minds, which portrait painting provides, is perhaps not only pleasurable but also useful, sharpening our ability to infer what other people are thinking and feeling.

In his book *The Art Instinct,* Dennis Dutton describes our innate response to art as a complicated ensemble of impulses elicited by the "sheer appeal of colors . . . extreme technical difficulty, erotic interests."[2] He goes on to say that we care about art because it gives us "some of the most profound, emotionally moving experiences available to human beings."[3] It also allows us to exercise our emotion, our empathy, and our theory of mind—exercises that, in principle, may benefit

our social capabilities as profoundly as physical exercise benefits our physical and cognitive capabilities.

Dutton argues further that the arts are not a by-product of evolution; rather, they are adaptations—instinctual traits—that help us survive. We evolved as natural storytellers, and the survival value of our fluent imaginative capacities is immense. Storytelling is pleasurable, he explains, because it extends our experience by giving us opportunities to think hypothetically about the world and its problems. Stories, like works of visual art, are highly organized models of reality that narrator and listener alike can repeat and turn over in their own minds, examining relations between characters acting in different social and environmental settings. Storytelling is a low-risk way of solving survival problems in the imagination. It is also a source of information. Along with the size of the human brain, language and storytelling enable us to model our world uniquely and to communicate those models to others. In the same way, Kokoschka, with his X-ray eyes, tried to infer the state of his sitter's mind and to convey that state through the person's face, hands, and body, using appropriately exaggerated features and color to heighten emotional intensity.

Our response to art stems from an irrepressible urge to re-create in our own brains the creative process—cognitive, emotional, and empathic—through which the artist produced the work. On this point Gombrich, Kris, the Gestalt psychologists, the cognitive psychologist Vilayanur Ramachandran, and the art critic Robert Hughes all agree. This creative urge of the artist and of the beholder presumably explains why essentially every group of human beings in every age and in every place throughout the world has created images, despite the fact that art is not a physical necessity for survival. Art is an inherently pleasurable and instructive attempt by the artist and the beholder to communicate and share with each other the creative process that characterizes every human brain—a process that leads to an Aha! moment, the sudden recognition that we have seen into another person's mind, and that allows us to see the truth underlying both the beauty and the ugliness depicted by the artist.

*Chapter 24*

# THE BEHOLDER'S SHARE: ENTERING THE PRIVATE THEATER OF ANOTHER'S MIND

༄

A CENTRAL IDEA IN THE BIOLOGY OF AESTHETICS IS THAT THE artist creates a virtual reality of the world in much the same way that the beholder's brain does. To do this, as Ernst Kris and Ernst Gombrich point out, the artist manipulates the brain's innate ability to make models of perceptual and emotional reality and thus to re-create the external world. To understand what cues our brains use in creating depictions of the physical and human world around us, the artist has to master intuitively the cognitive psychology of perception, color, and emotion.

It was only in the decades after the 1850s and the introduction of photography that artists began to search for new kinds of pictorial representation. As Henri Matisse described it much later, "The invention of photography released painting from any need to copy nature," allowing the artist to "present emotion as directly as possible and by the simplest means."[1] Rather than aiming to portray the outside world, the new painters strove to portray emotions, to enter the private theater of the sitter's mind.

Gustav Klimt, Oskar Kokoschka, and Egon Schiele not only entered the private theater of a sitter's mind, they also revealed a great deal about their own emotional response to the sitter and encouraged the beholder to respond emotionally as well. As part of this inward turn in perception and emotion, Kokoschka and Schiele made the viewer aware of their artistic techniques and of how they used those techniques to reveal the sitter's instinctual life. They piqued the beholder's curiosity and taught him or her the importance of the act of artistic represen-

tation itself. This is part of the reason that Austrian Modernism proved so new and exciting.

Indeed, the power of expressionist art, or any great art, stems in large part from its ability to recruit the viewer's empathy. It can do this because our perception of another person's emotion is capable of producing a comparable physical response in our own body, such as increased heartbeat and respiration rate. Because of this capacity for empathy, we can increase our sense of well-being by looking at a happy face, whereas we can increase our anxiety by looking at an anxious face. Although these individual effects are small, they can be enhanced in the context of a whole composition: the face, hands, and body, the colors of the painting, and what memories the images bring to mind. We now know from the works of the social psychologists Tanya Chartrand and John Bargh of New York University that when we imitate someone's emotional expression or actions, such as foot tapping or face rubbing, we tend to feel greater liking for, or rapport with, that person and a greater desire to interact with him or her. Similary, when we make a face expressing anger, sadnees, or some other emotion, it elicits in us a weak experience of that emotion. It is in part from such experience that empathy arises.

NEW COGNITIVE PSYCHOLOGICAL and biological studies have shown us how the Austrian modernists were able to uncover and reveal the unconscious processes through which we empathize with and model the mental states of other people. Self-portraits provide an example. Artists typically view their face in a mirror when creating a self-portrait. Messerschmidt used a mirror in sculpting his character heads, as did Kokoschka and Schiele in their self-portraits. We now know that an important component of the brain pathways recruited for self-portraiture is a special class of neurons in parts of the motor cortex called *mirror neurons*. These neurons are thought to reflect the actions and emotions of the people in front of us. Artists use them not only for self-portraiture, but also to project their own and others' actions and emotions. We will look at these fascinating neurons in the next chapter.

A few artists used mirrors in a remarkably different way—they put mirrors in the center of their paintings to engage the viewer in the private theater of both the subject's mind and the artist's. Two of the first artists to use mirrors in this way were the seventeenth-century painters Jan Vermeer and Diego Velázquez.

Figure 24-1. Jan Vermeer, *The Music Lesson*
(c. 1662–65). Oil on canvas.

In Vermeer's *The Music Lesson: A Lady at the Virginals with a Gentle-man* (Fig. 24-1), painted in 1662, the artist depicts the back of a young woman playing a virginal (a simplified harpsichord) with a young man standing attentively to her right. It appears from the angle of the woman's head that her eyes are focused on her hands as they move over the keyboard. However, Vermeer has inserted a mirror above the harpsichord that allows him to present the viewer with another, quite different reality. In the mirror, the woman's head is not bent downward, but is turned to the right so that her gaze is directed toward the man. The human brain, as we have seen, is exquisitely sensitive to the direction of a person's gaze, using people's eyes as a means of inferring their interests and emotional state. The angle of the woman's eyes in the mirror shows us that the true object of her attention, and perhaps her instinctual desires, is the man

standing and regarding her from a few feet away. Vermeer's mirror-within-the-painting emphasizes the tension between perceived reality and the true events unfolding in the woman's mind.

In addition to giving the viewer an insight into the subject's mind, painters allowed them an occasional insight into their own mind. In Velázquez's *Las Meninas* (*The Maids of Honor*) of 1656 (Fig. 24-2), the artist appears for the first time as the central figure in his own painting—not as the subject of a self-portrait but as the focus of a large group portrait that he is in the act of painting. Velázquez takes the dominant role in the picture, proclaiming that it is he who has made the picture possible. He also uses a mirror, in this case to reveal people who would not otherwise be visible to the viewer and to make the viewer conscious of the artifice involved in pictorial representation.

Figure 24-2. Diego Rodríguez de Silva y Velázquez,
*Las Meninas* (c. 1656). Oil on canvas.

*Las Meninas* depicts a room in the palace of King Philip IV of Spain, where Velázquez is painting a gigantic portrait of the royal family. Front and center in the painting is the five-year-old Princess Margarita, who will ultimately join her parents in sitting for the portrait, surrounded by her entourage—two maids of honor, a chaperone, a bodyguard, two dwarfs, and a dog. Behind her, the queen's chamberlain stands at an open doorway, turning around as if to pay homage to the king and queen before leaving the room. Standing slightly to the left, Velázquez is working on the huge canvas, proudly displaying his paintbrush and palette, the royal scepter and orb of the artist. He is looking not at the canvas but at his subjects, King Philip and Queen Mariana, whom we cannot see except as reflections in a mirror hanging behind the painter. Since we are standing where the king and queen would be standing, Velázquez is also looking directly at us. This remarkable painting is a prime example of the technique that Alois Riegl so admired in group paintings—the incorporation of the viewer into the work.

Velázquez uses the mirror to introduce ambiguity into the painting. Are we seeing a reflection of the canvas that the artist is painting? Or are we seeing a reflection of the king and queen themselves, standing outside the space of the picture? Velázquez confronts the viewer for the first time with both an artistic and a philosophical question: What is the role of the beholder? Does the beholder take on the role of the king and queen when standing before this painting? What is reality and what is illusion? Irrespective of what it actually reflects, the mirror is one step further removed from reality because it is a depiction of a reflection: it is an image of an image of an image.

We see emerging in Velázquez's painting questions that would come to dominate modern thought and that are of special importance to the Austrian expressionists and their concern with conveying physical and psychic reality. Through the ambiguity of what the mirror represents and his own dominant presence in the painting, Velázquez brings the act of representation to the forefront of the viewer's mind. He makes the viewer conscious of the process through which art conveys an illusion of reality—the illusion that the painting is the real world rather than an artistic representation of it.

By extension, Velázquez also makes us aware of the unconscious processes by which the mind represents the physical and emotional re-

alities that surround us every waking moment of our lives. This extraordinary painting, with its several levels of ambiguity and its artistically brilliant depiction, is considered one of the most important paintings in the history of Western art. It marks the beginning of self-consciousness, an emblem of modern philosophical thought and a turning point between classical and modern art.

TWO NEW APPROACHES to art that emerged from Vermeer's and Velázquez's work were taken up by Vincent van Gogh, Kokoschka, and Schiele. The first, which we see in Vermeer's work, is the painter's conscious attempt to reveal not only aspects of his subject's form, but also aspects of his subject's emotional life. The second, which appeared in Velázquez and reappears even more dramatically in Van Gogh, is the artist's revelation of the technical details of his artistry. If the artist is not merely the servant of his patron but the obvious center of his art, as Velázquez portrayed him, then the techniques that the artist uses become of central importance: they are a vehicle not only for creating an illusion of reality but also for deconstructing the means by which the artist has done so.

Beginning with the late paintings of Van Gogh—in which he used both short, obvious, expressive brushstrokes, each one laid down carefully and separately, and bright, contrasting, arbitrary colors that come together to create a face or an image—modern artists went out of their way to draw the beholder's attention to the creative process itself. In this way they emphasized that all art is illusion and that illusion is, in turn, an artistic reprocessing of reality. The nature of the penciled line, the scraping of the oil on canvas, the dramatic loss or distortion of perspective, are all attempts to convey to the viewer the ever-present contribution of the artist.

This theme recurs powerfully in the Austrian expressionists and is particularly notable in Schiele's 1910 *Nude in Front of the Mirror* (Fig. 24-3). The fully clothed Schiele depicts a nude model standing in front of him but facing away from him, looking into a mirror that is not shown in the drawing. Both Schiele and the model are reflected in the mirror, so the viewer sees the model from behind and the reflection of both figures from the front. Like Velázquez, Schiele introduces himself as the artist into the painting, but rather than depicting royalty and power, as Velázquez did, Schiele depicts eroticism and lust.

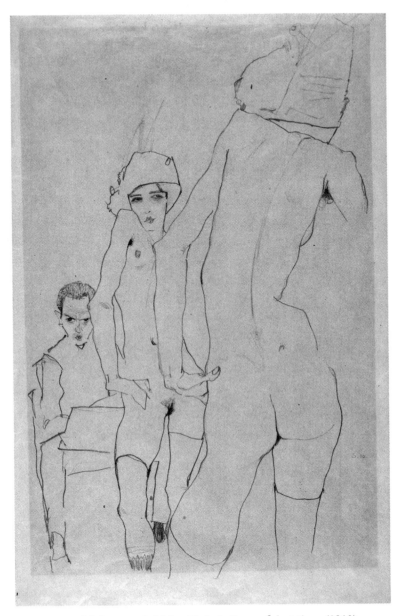

Figure 24-3. Egon Schiele, *Nude in Front of the Mirror* (1910).
Pencil on paper.

The model is nude except for her stockings, boots, hat, and makeup. These several items emphasize the clothes she is not wearing and enhance her erotic appeal. By covering parts of the body that are not usually considered necessary to cover, Schiele emphasizes those that are uncovered. Moreover, the model's posture is a perfect caricature: it

exaggerates one aspect of a woman's body that is inherently erotic, her hip. As Vilayanur Ramachandran has pointed out, erotic art enhances the features that most distinguish women from men, such as breasts and hips. The hips of Schiele's model are brilliantly drawn. They are beautifully cocked, her waist is thin, and her buttocks are generous, as are the curve and the length of her torso. Her thighs are invitingly open, and there is enough of a suggestion of her pubic hair that the viewer's eyes are irresistibly drawn to it. Schiele enhances this suggestion by putting a strong vertical line that runs from the model's face to her pubis.

Schiele appears to be drawing his model from the back, which seems innocent and not particularly seductive. But by placing her before a mirror, he is also, indirectly, drawing her nude body from the front and depicting himself sketching her. Seen in the mirror, it is unclear whether the woman is unself-consciously posing for the artist or whether she is engaging in a seduction. Her hat is stylish, and she is posing suggestively while Schiele, sitting behind her with his drawing pad, looks at her intently. Schiele's gaze is voyeuristic, but the model seems oblivious to his intensity and playfully poses while looking at herself in the mirror. Yet both artist and model look erotically charged, and the interaction between Schiele's intense gaze and the model's seductive eyes in the mirror adds to the sense that we are experiencing a lustful relationship. Moreover, the model's seductive pose and her reflection create a lustful reaction in the viewer as well as in the artist. This parallel reaction to the model creates an intimacy between Schiele and the beholder.

Like Vermeer, Schiele uses a mirror to express his interest in the direct and indirect image, the outward appearance and the private theater of the mind, the demure and the sensual. But Schiele's double depiction of the model literally uncovers her: in the mirror she is both a sexual object and a fascinating woman with a rich inner life of her own. Her attitude toward the artist is distinct from that of Arthur Schnitzler's Fräulein Else, for the nude model is as attracted to the dressed artist as he is to her. Thus, Schiele makes explicit the unconscious desire that Freud argues is present but below the surface in everyone. It is interesting that both Schiele and his model have fixed their gaze on themselves rather than on each other or on the viewer, thus indicating their inward-facing sexuality.

In *Nude in Front of the Mirror,* as in other works of Schiele and Kokoschka, one strongly senses the artist's presence, not only because he

introduces himself physically into the drawing, but also because he conveys his emotions in a direct and often quite disturbing manner. In Austrian Expressionism the physical characteristics of the artist and of the subject no longer result from the artist's attempt to create an illusion of real life. Instead, they stem from his attempt to convey his inner feelings through his psychological insights into his subject and through the artistic techniques he uses to create the image.

In an analogous but very different way from Velázquez, the Austrian expressionists Kokoschka and Schiele highlight the emotions of their subjects and bring them to the center of the painting, thereby also bringing them to the forefront of our attention. That they could accomplish this, we owe to the exquisite interaction of the brain pathways we have already seen—and to some we shall consider later that are even more finely tuned to our own emotions and those of the people around us.

# THE BIOLOGY OF THE BEHOLDER'S SHARE: MODELING OTHER PEOPLE'S MINDS

ᐒᐰᐓ

WHEN ALOIS RIEGL AND ERNST GOMBRICH FORMULATED THE IDEA of the beholder's share, they had in mind that a picture is not complete without the viewer's interaction. The beholder peruses a portrait, focuses on the face, hands, and body of the subject, responds to it emotionally, and attempts to understand what the artist is trying to convey about the subject's physical appearance and inner life. From a biological point of view, the beholder's response to a painted image of a person recruits not only the beholder's perceptual and emotional capability, but also the capability for empathy—his or her ability to read aspects of another person's mind.

The biology of the beholder's share thus ultimately derives from our social brain, which includes our perceptual, emotional, and empathic systems. We respond so readily to portraiture because we are intensely social and empathic creatures and our brain is biologically programmed to experience and express emotions. When you and I have a conversation, I have an idea of where your thinking is going, and vice versa. Similarly, when we look at a portrait, we are experiencing for a moment the sitter's emotional life, insofar as it is conveyed to us by the artist; we recognize it, and we are capable of responding to it. This social capability makes possible not only our response to works of art and our ability to communicate that response to others, but in a larger sense our ability to enter the mental state of another person.

According to the British cognitive psychologists Uta and Chris Frith of University College London, we construct mental models in

order to predict what another person is going to do and to validate our own motives for doing things. There are two likely reasons for the special features of social cognition in people, they argue. The first is that we have a built-in, unconscious drive to update the difference between our own current knowledge and that of others. This tendency drives us to share information. In fact, useful communication requires knowing what other people do not know. The second is that knowledge must be conscious in order to be shared, and most of our knowledge is represented in the brain in a specific form that can be recruited to conscious awareness. Observing the emotional state of another person, either in life or in art, automatically—unconsciously—activates in our brain a representation of that emotional state, including its unconscious bodily responses.

WHAT ARE THE BIOLOGICAL underpinnings of this ability to read and respond to other people's emotional states? There are two distinct, overlapping components: perceiving and responding to another person's emotional state, and perceiving and responding to that person's cognitive state, including his or her thoughts and desires.

To convey a sitter's emotional state to the beholder, the modernists first strove to understand that emotional state and then to understand their own emotional, empathetic, and cognitive response to it. In a discussion with Gombrich, Oskar Kokoschka described his emotional response to a person whose portrait he was painting. He spoke of the "sitter whose face he found so hard to unriddle he automatically pulled a corresponding grimace of impenetrable rigidity."[1] For Kokoschka, says Gombrich, "the understanding of another person's physiognomy took the way over his own muscular experience."[2]

Similarly, in Kokoschka's paintings of Ernst Reinhold and Rudolf Blümner, which we saw in Chapter 9, the artist distorts the surface of the face and exaggerates the details of the hands to depict the underlying mental states that he has perceived empathically. As we look at these powerful portraits, we automatically imitate subtle movements of their faces, as illustrated in experiments on "unconscious mimicry" by Ulf Dimberg, professor of psychology at Uppsala University, Sweden. Dimberg found that when a person is shown the facial expression of an emotion, even briefly, it elicits small contractions in the person's facial muscles that simulate the expression he or she has just observed. More-

over, social psychological studies have found that unconscious mim-
icry tends to evoke a sense of rapport and perhaps even friendliness
toward the person being imitated.

This aspect of mimicry may also come into play when looking at
art, and it raises the questions: How does this work? Do we interpret
the expressions of others or the expressions in portraits, and do those
expressions then drive our own facial expression? Or do we automati-
cally mimic the expressions of others as a means of comprehension?

Chris Frith gives a particularly simple example of the mimicry pro-
cess:

> There is an easy way to feel happier even if you don't see a smil-
> ing face. Hold a pencil between your teeth (withdrawing your
> lips). This forces your face into a smile and you feel happier. If
> you want to feel miserable, hold the pencil between your lips.[3]

Social psychological studies indicate that we not only identify with
and assume other people's facial expressions, we also take on their
bodily postures, gestures, and hand positions. Moreover, in a social
group, people tend not to mimic everyone equally, but to mimic the
central, most important person in the group. These unconscious pro-
cesses occur with remarkable regularity and serve to coordinate and
support social interactions. As Riegl pointed out, Dutch artists began
to use these mechanisms with great facility, bringing the viewer into
the painting.

A person's facial expressions and bodily movements do more than
reveal how he or she is coping with an emotion; they can also signal the
person's attitude toward other people. Many of our outward signs of
emotion reveal our internal emotional state in ways that are meant to be
decoded by the people with whom we are interacting. We use smiles to
signal that we share a colleague or family member's happiness upon
achieving a goal; we arch our eyebrows to signal that we share some-
one's surprise as she tells us of the disturbing behavior of a third per-
son.

Frith went on to make the remarkable discovery that the same net-
works in the brain that become active when we see an expression of
happiness or fear on someone else's face become activated when we
experience happiness or fear ourselves. These findings provide a neural

correlate—a potential mechanism in the brain—for Charles Darwin's and Paul Ekman's discoveries about our empathic response to someone else's facial expression or posture. However, our empathic response is a weaker personal, edited response; it does not completely mirror the emotion experienced by the person we are viewing. Our empathic response to pain is particularly weak.

BECAUSE WE ARE INTENSELY social creatures, we need to be able not only to read, but also to predict other people's behavior by constructing models of their minds. To create these models, we need to make use of a theory of mind—that is, an understanding of the human mind that enables us to imagine what other people are thinking and feeling and the ability to empathize with them. For this internal simulation to be complete, our brain also needs a model of itself—of its stable attributes, its personality traits, and the limits of its abilities, what it can and cannot do. It is possible that one of these two modeling capacities evolved first and set the stage for the other. Or, as often happens, the two may have evolved together and enriched each other, culminating in the reflective self-awareness that characterizes us as *Homo sapiens*.

Both the observer's brain and the artist's brain create empathic models of other people's minds. As we saw in Chapter 24, Jan Vermeer, Diego Velázquez, and Egon Schiele used mirrors in their paintings to reveal their own and their subjects' mental states. But how does the brain enable us to read another person's mind?

Just as our visual brain constructs models of reality from figural primitives, so our social brain is innately wired to function as a psychologist, forming models of other people's motivations, desires, and thoughts. The capacity to enter another person's mind requires a number of additional abilities, including imitation and empathy, and it is essential for functioning within any group, be it family, friends, school, or work.

The viewing of art is critically dependent on our ability to develop a theory of mind. Uta Frith, a pioneer in this area, illustrates the need for this ability brilliantly on the cover of her classic book *Autism* (Fig. 25-1). The cover shows *The Cheat with the Ace of Diamonds*, a painting by the seventeenth-century artist Georges de la Tour that Frith describes as follows:

Figure 25-1. Georges de la Tour, *The Cheat with the Ace of Diamonds*
(c. 1635–40). Oil on canvas.

We see four fancifully dressed people: a woman and two men
are seated at a table, engaged in card playing. Standing behind
the group is a maidservant holding a glass of wine. These bare
facts do not convey the tacit drama that is there, in front of our
eyes. However, this inner drama is not visible in the same way
that the people and their actions are visible.

We know a drama is taking place because the characters
speak eloquently with their eyes and hands. There is a curious
sideways glance by the lady in the center, and also by the ser-
vant. Both look toward the player on the left, who looks toward
us. The lady also points to him with the index finger of her right
hand. The player pointed out in this way by look and gesture
holds two aces behind his back with his left hand. In his right
hand, elbow on the table, the player holds the rest of his cards.
The other player, on the right, is looking downwards into his
cards, apparently engrossed.

Even with this added detail the description does not capture
what is going on in this scene. . . . Although we cannot see states
of mind, we can attribute them, guided by the painter's inten-
tions, with logic and precision, and not by tenuous and vague
speculation. As a result we know that the painter portrayed an

incident of cheating at cards. How do we come to know this fact with such certainty? Our understanding is based on a powerful mental tool that every normal adult possesses and uses with varying degrees of skill. This tool is a theory of mind. The theory is not the same as a scientific theory, but much more practical. It provides us with the ability to predict relationships between external states of affairs and internal states of mind. I call this ability "mentalizing."

To grasp what this strange made-up word means let us go back to the picture. One clue to the inner drama is given by the concealed aces. According to our theory of mind we automatically infer that what the others do not see, they do not know. At the same time we infer that the other players believe the aces to be in the pack, because we know that this is the rule of the game. A second clue is the staring servant girl. We infer from her standing position that she would have seen the aces held behind the player's back, and hence knows of the cheating. A third clue is the strange look of the lady in the center who points to the cheat with her finger. Therefore, the lady knows. Perhaps the cheat himself does not know that she knows. His face is averted and he looks unconcerned. A final and most important clue is that the third player does not look up from his cards at all. Therefore, the painter means us to think that he does not know what is going on. We conclude that he is the one who will be cheated, and he will lose the heap of coins that now lies in front of him.

In our understanding of the drama in the picture we indulge in a kind of unconscious mind reading. We freely assume that we can tell what the people depicted are thinking, what they know, and what they don't know. For instance, we tacitly infer that the lady *knows* what the cheat is up to. We also infer that the young man *does not know* what sinister event is unfolding. Our automatic inferences even extend to what kind of *emotional states* might arise in the characters (surprise, anger), but we are left in suspense as to what happens next. Will the lady challenge the cheat? Will she collude with him to defraud the young man? Will the young man be warned in time? The painter has led us

to make only some attributions of mental states but he leaves the outcome open.[4]

The idea of a theory of mind was introduced into modern scientific discourse by Sigmund Freud, who saw it as implicit in his concept of the psychoanalytic situation: the analyst requires empathy to understand the patient's conflicts and aspirations.

FRITH AND HER COLLEAGUES proposed that autistic children lack the ability to form a theory of mind, which is why they are unable to attribute mental states or feelings to other people and cannot predict the behavior of others. Just as prosopagnosia (the inability to recognize faces) taught us a great deal about the localization and nature of facial representation in the brain, autism has taught us a great deal about the social brain and the biology of social interactions and empathy. Many autistic children simply do not understand how to interact socially with other people because they fail to appreciate that other people have their own ideas, emotions, and points of view. They are therefore unable to empathize with other people or to predict their behavior.

Two Austrian-born pediatricians discovered autism independently—Hans Asperger, who worked at the University Clinic for Pediatrics in Vienna, and Leo Kanner, who left Europe for the United States in 1924. In 1943, while working at the Johns Hopkins School of Medicine, Kanner wrote the classic paper "Autistic Disturbances of Affective Contact," in which he described eleven children with early infantile autism. A year later, Asperger wrote the classic paper "Autistic Psychopathology of Childhood," in which he described four children with autism.

Both Kanner and Asperger thought they were studying a biological disorder that was present from birth, and both, amazingly, called the disorder autism. The term had been introduced into the clinical literature by Eugen Bleuler to characterize aspects of schizophrenia. As director of Burghöltzli, the Psychiatric Institute of Zurich, Bleuler succeeded Auguste Forel, the subject of Kokoschka's famously prescient portrait. Bleuler used the term *autistic* to refer to what we now call the negative symptoms of schizophrenia—social awkwardness

and aloofness, and the restriction of patients' social life to essentially themselves. Kanner starts his paper as follows:

> Since 1938, there have come to our attention a number of children whose condition differs so markedly and uniquely from anything reported so far, that each case merits—and, I hope, will eventually receive—a detailed consideration of its fascinating peculiarities.[5]

He then proceeds to present vivid pictures of the nine boys and two girls he considered to be suffering from this condition. Kanner's observations are incisive and serve as a reference point for the most important features of classic autism. These features—autistic aloneness, the desire for sameness, and islets of ability—are still considered to hold true in all cases, despite variations in details and despite the existence of additional problems. Regarding autistic aloneness, Kanner writes:

> The outstanding, "pathognomonic," fundamental disorder is the children's inability to relate themselves in the ordinary way to people and situations from the beginning of life. There is from the start an extreme autistic aloneness that, whenever possible, disregards, ignores, shuts out anything that comes to the child from the outside. He has a good relation to objects; he is interested in them, can play with them happily for hours. . . . The child's relation to people is altogether different. . . . Profound aloneness dominates all behavior.[6]

WHAT DO WE MEAN when we say that the theory of mind enables people to attribute mental states to another person in order to predict that person's behavior? Frith and her colleagues proposed that theory of mind is an inborn expectation about people and events that is part of normal mental life. She says, "This enterprise was built on the then [1983] radical assumption that the mind of the infant is equipped from birth with mechanisms that accumulate knowledge about important features of the world."[7]

If the healthy brain has innate mechanisms for social interaction and for theory of mind, where are they located? The idea that a network of structures in the brain is dedicated to social cognition and the theory

of mind was first developed by Leslie Brothers in 1990. As a result of progress since her important work, we now think of the social brain as a hierarchical network of about five systems that process social information and make possible a theory of mind (Fig. 25-2).

The first is the face-recognition system. A key component of this system is centered on the amygdala and analyzes facial expressions to interpret and evaluate the emotional state, especially a fearful state, of another person. The second system recognizes the physical presence of another person and that person's likely actions. The third system interprets the actions and social intentions of others through an analysis of biological motion. The fourth system imitates the actions of others by means of mirror neurons. These neurons are activated whether a person acts or observes another person acting. At the top of the network is a fifth system that is concerned specifically with the theory of mind. This system attributes mental states to other people and analyzes them.

How do we recognize faces? As we saw in Chapter 17, the inferior temporal lobe of the brain has several face-recognition regions that process information about different aspects of the faces they see (Fig. 17-5). These face patches appear to be interconnected and to constitute a dedicated system for processing one high-level object category: namely, faces.

One possible reason why people with autism have difficulty in social interactions is that they process faces in unusual ways. When looking at another person, we almost invariably look at their eyes, as Alfred

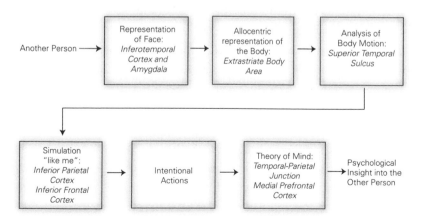

Figure 25-2. Flow diagram for neural circuits involved in the beholder's share and in the social brain.

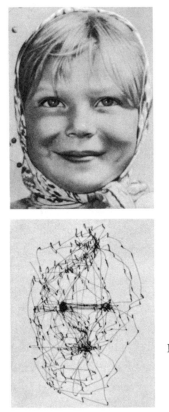

Figure 25-3

Yarbus discovered in his eye-tracking experiments (Fig. 25-3) (see also Chapter 20). Kevin Pelphrey at the Yale Child Study Center carried out a similar experiment on autistic children and found that these children focus not on the eyes but on the mouth (Fig. 25-4). What is more, they found that while all newborns fix their attention on the eyes, autistic infants switch their focus of attention to the mouth at some point between the age of six and twelve months.

Often, the initial step in inferring another person's actions, even before recognizing a face, is being aware that a person is physically present. This awareness is accomplished by the extrastriate body area of the occipital lobe. Brain-imaging studies by Nancy Kanwisher have revealed that this region of the brain responds selectively to images of the human body. These images of bodies or parts of bodies are quite powerful and capture our attention even when we are focused on another task.

The recognition of parts of the body falls into two categories: an

egocentric perspective, looking at our own hands or feet, say, and an allocentric perspective, looking at someone else's hands or feet. The extrastriate body area is more active in response to viewing another person's body, whereas some regions of the somatosensory cortex are more active when viewing our own body. Thus, the brain differentiates visual and tactile information about another person from information about ourselves. These regions of the brain, particularly the extrastriate body area concerned with information about another person, are thought to serve as a gateway for higher social cognition.

A different region of the brain is critical for the analysis of biological motion, the movement of people and animals. This region—the superior temporal sulcus—lies on the surface of the right temporal lobe, near the extrastriate body area. As social beings, we have a well-developed capability for recognizing other people's movements. Even sketchy images created by positioning lights on the major joints of a person and then filming the movements of that person in the dark are readily identified as reaching, walking, running, or dancing. Infants who are only a few days old pay attention to such moving-dot displays. Attention to biological motion is thought to be critical to a baby's initial ability to bond with its mother, to its subsequent ability to perceive emotion, and eventually to its ability to develop a theory of mind.

The superior temporal sulcus, which encodes biological motion, was discovered by Puce and her colleagues in 1998. They observed that the region responds more strongly to a person's mouth and eye movements than to any non-bodily movements. In 2002 Pelphrey demon-

AUTISM                    TYPICALLY DEVELOPING

Figure 25-4. Eye movement patterns in an autistic
versus normal individual.

strated further that this region responds strongly to eye, hand, and arm movements, to walking and dancing, but not to equally complex but nonbiological motions such as the movement of a mechanical figure.

The discovery of a region specialized for the motion of people and for parts of the human body has given rise to the idea that the role of this region in the brain's social information network is to represent perceived action. In monkeys, neurons in this region of the brain respond to socially relevant cues, including head and gaze direction. Moreover, Andrew Calder has found that there are patches in the superior temporal sulcus that respond to different components of movement, just as the face patches respond to different aspects of faces. Calder's finding gave rise to the idea that the superior temporal sulcus bases its interpretations of the actions and social intentions of others on an analysis of cues drawn from biological motion, particularly gaze. As we have seen, gaze is a powerful social cue: mutual gaze often signals an approach or threat, while an averted gaze signals submission or avoidance. Accordingly, a mutual gaze evokes greater activity in the superior temporal sulcus than an averted gaze does.

Pelphrey suggests that the superior temporal sulcus uses the direction of a person's gaze to determine the person's focus of attention or the person's desire to avoid or engage in social interaction. Indeed, as we have seen, people with autism do not look at faces in the same way that normally developed people generally do. Moreover, Pelphrey has found that in people with autism, the superior temporal sulcus is not activated effectively.

Imaging experiments reveal a region near the superior temporal sulcus that processes general motion as opposed to biological motion; this region, designated area V5 by neuroscientists, is highlighted in green in Figure 25-6. If we recorded activity in brain regions in response to two videos, one showing a ball bouncing and the other a person walking, we could see how their responses differ. Both the bouncing ball and the person walking would evoke strong activity in area V5, whereas only the video of the person walking would evoke activity in the superior temporal sulcus. Neuroscientists think that it is at this point in the visual processing system that the brain distinguishes biological motion as a special type of motion.

Body movements are less specific to particular emotions than facial expressions are; for example, no single body position always signals

fear, just as no body position always signals anger. If someone is angry, his or her body may exhibit muscular tension in the arms, legs, and posture. The person may appear ready for a physical attack, as evidenced by his or her posture, orientation, or hand movement. However, any of these movements can also occur when a person is afraid.

As first suggested by Uta Frith, the ability to distinguish between biological and nonbiological figures and action is very likely an evolutionary and developmental precursor of the theory of mind. The fact that the superior temporal sulcus, our biological motion detector, is adjacent to the region of the brain used for the theory of mind seems to imply that they may work together for some common purpose. The ability to infer goals and emotional states from a person's action has been called the *intentionality detector* and it is thought to be a component of the brain's ability to read others' mental states.

As we have seen, infants respond to biological motion within a few days of birth, a response that is believed to be critical for their attachment to their mother. Since the superior temporal sulcus develops along with the regions involved in face detection, detection of body parts, imitation, and the theory of mind, Klin and his colleagues (2009) wondered how young children with autism respond to biological motion. They found that at age two, autistic children do not respond to biological motion, although they may respond to nonbiological motion, which typical children ignore.

SOCIAL INTERACTION ALSO requires imitation, the specialty of the fourth system in the network making up the social brain. Imitation is the ability to recognize, represent in the brain, and simulate the actions of others, even when the motivation for those actions is ambiguous. Imitation can also lead to empathy and can enable us to deal with ambiguous social situations. It is therefore a key precursor of social skills and the theory of mind. Indeed, our brains possess mirror neurons that enable us to copy internally both the spontaneous and the deliberate actions of others.

This neural basis for imitation was discovered by Giacomo Rizzolatti and his colleagues at the University of Parma in 1996. In a study of monkeys, they found that neurons in two regions of the premotor cortex, the part of the brain concerned with motor control, become active selectively, depending on what kind of grasping and holding move-

ments an animal is making. Some neurons are more active when the monkey makes precise movements, using its fingers and thumb to pick up a small object such as a peanut, whereas other neurons become more active when the monkey exerts a more powerful grip, using its whole hand to pick up a glass of water. In fact, the premotor cortex contains neurons representing a whole vocabulary of grasping movements.

Surprisingly, Rizzolatti and his colleagues found that some 20 percent of the neurons that became active when the monkey picked up a peanut also responded when the monkey saw another monkey or a scientist pick up a peanut. Rizzolatti called these nerve cells *mirror neurons* (Fig. 25-5). Until the discovery of mirror neurons, most neuroscientists believed that perception and action were assigned to different brain systems.

Mirror neurons in the premotor cortex receive information from the superior temporal sulcus, the region that responds to biological motion. Some mirror neurons even become active in response to a sensory stimulus that only suggests an action, as when a scientist's hand disappears behind a barrier where the monkey knows there is food. This finding revealed that some higher-order neurons in the motor system have cognitive capabilities: they not only respond to sensory input, they understand the sensory implications of observed events. Using functional MRI, Rizzolatti, and more recently Rebecca Saxe, Nancy

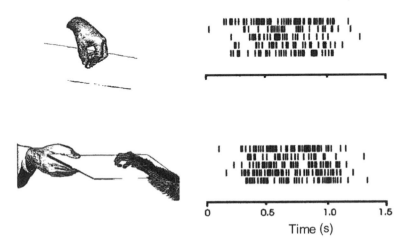

Figure 25-5. Diagram illustrating that mirror neurons fire when a monkey reaches for an object in the same way that they fire when the monkey is merely watching another reach for an object.

Kanwisher, and their colleagues at MIT, have found that some areas in our premotor cortex fire both when we move and when we simply watch someone else move. This suggests that mirror neurons exist in people as well as in monkeys.

The three regions of the brain that support our representation of other people's actions and our analysis of the intentions underlying those actions are shown in Fig. 25-6. The superior temporal sulcus (yellow) sends a visual representation of biological motion to two regions of the cerebral cortex that are thought to make up our mirror neuron system and that have a role in representing and imitating the actions of others. Those two regions are located in the parietal (lavender) and frontal (red) lobes of the cortex. They respond equally whether we move or we observe another person making that same movement, which suggests that they use some sort of simulation to represent the actions of others. Put another way, the same neurons whose firing causes our peripheral nerves and muscles to act also fire when they receive visual information concerning another person's actions.

Interestingly, the neurons in these three regions of the brain also respond to the *sound* of other people's actions. Consequently, it is becoming clear that the fundamental social functions of these regions involve at least two sensory systems, the visual and the auditory.

Although neuroscience has focused on identifying the role of each individual system in the social brain, the various subsystems should be

**There is regional localization of areas involved in social perception**

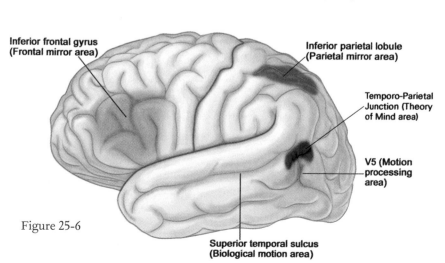

Inferior frontal gyrus
(Frontal mirror area)

Inferior parietal lobule
(Parietal mirror area)

Temporo-Parietal
Junction (Theory
of Mind area)

V5 (Motion
processing
area)

Figure 25-6

Superior temporal sulcus
(Biological motion area)

thought of as part of a network of interconnected regions that communicate back and forth to accomplish more and more sophisticated feats of social cognition. For example, the superior temporal sulcus and the mirror neurons may work together to derive more complex, higher-level meanings from biological motion, including cues such as gaze and body movements, and use that information to interpret action and make other inferences about what others are thinking.

Suppose you see a woman reaching toward a glass of water on a table. Your superior temporal sulcus allows you to represent visually both her motion and the direction of her gaze (in this case, toward the glass). This visual representation is then received by the regions containing the mirror neurons, which run a kind of simulation, allowing you to represent the action as one of reaching. This representation is then sent back to the superior temporal sulcus, where additional information regarding the context of the reach, such as her gaze being directed toward the glass and her earlier comment about being thirsty, is integrated with the results of the simulation, thereby allowing you to predict that her intention is to reach for the glass, pick it up, and drink from it, as opposed to handing it to the gentleman seated next to her. All of these processes unfold more or less unconsciously, rapidly, and automatically, thanks to efficient communication between these subsystems of the social brain.

It is unlikely that mirror neurons contribute directly to a theory of mind. Instead, they are likely to be important precursor components, like the body's unconscious emotional response to fear. To begin with, it is not known whether monkeys (the animals for which we have the strongest data on mirror neurons) even have a theory of mind. Some cognitive studies suggest that the theory of mind may be a uniquely human capability. Second, mirror neurons are not located in the regions of the brain that become active in people who are participating in experiments on the theory of mind. Finally, not all experiences that might contribute to a theory of mind can be imitated successfully.

IN 1995 CHRIS FRITH and his colleagues carried out a study of theory of mind using PET scans. They compared brain activity in two groups of volunteers—some listening to stories that required a theory of mind (putting oneself in the position of another person) and some listening to stories that did not—and found a specific pattern of activ-

ity. Stories that required a theory of mind activated three areas: an area in the medial segment of the prefrontal cortex, an area at the front of the temporal lobe, and an area of the superior temporal sulcus located at the junction of the temporal and parietal lobes. These three areas became known collectively as the theory-of-mind network. Frith and his colleagues subsequently confirmed these three regions in functional MRI studies, as did Saxe and Kanwisher.

The theory-of-mind network is used for recognizing or reasoning about other people's minds. Damage to any one of the three regions gives rise to a deficit in a person's theory of mind. Saxe and Kanwisher attempted to narrow the number of brain regions involved in the theory of mind to just one of these, the temporal-parietal junction (Fig. 25-7). Although this region comes up very strongly and consistently in theory-of-mind tests, recent studies indicate that at least one other region, the medial prefrontal cortex, is also required for a theory of mind.

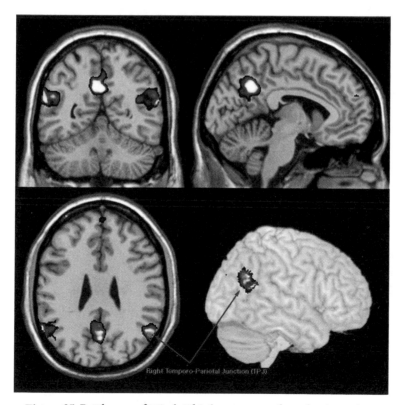

Figure 25-7. Theory of Mind. This known neural mechanism arises when thinking about someone else's thoughts, beliefs, or desires.

These findings suggest that mirror neurons facilitate learning through imitation, thereby providing a necessary step for a theory of mind. They pass that information on to the theory-of-mind region of the brain, which enables us to actually empathize with a person experiencing an emotion. The mirror neurons may thus be analogous to unconscious, bottom-up processing in visual perception and emotion, while the empathic theory of mind may be analogous to conscious, top-down processing, which is based on memories of previous empathic experiences.

In studies of empathy, the psychologist Kevin Ochsner at Columbia had volunteers watch video clips of another person and then imitate what that person was feeling. He called these conditions "active empathy" because the volunteer could both respond cognitively to another person's actions and aspirations and imitate them. He found that accurately interpreting the emotional state presented on the video clip requires activity in both the mirror neurons and the temporal-parietal junction.

Perhaps this same conjunction of the brain's biological motion, mirror neuron, and theory-of-mind regions also enables the viewer to re-enact and relive the emotions depicted by an artist (Fig. 25-6). By cunningly selecting and often exaggerating the facial and bodily cues that these brain regions use to read the emotions and minds of other people in everyday life, artists activate our innate capacity to model another person's mind.

THE HIERARCHY OF SYSTEMS in the brain that makes possible the theory of mind connects and interacts dynamically with the amygdala and parts of the prefrontal cortex. The amygdala, as we have seen, has multiple functions in emotion and orchestrates two separate emotional systems, positive and negative. The prefrontal cortex integrates the bodily reactions triggered by the amygdala and plays a large role in social cognition. Empathy, for example, is mediated by a region of the prefrontal cortex, as is triadic attention (the attention two people pay to each other and to a common task), which is required for collaborating on a shared goal. Both empathy and triadic attention are crucial components of social cognition and collaboration.

Finally, the beholder's share is modulated in a top-down manner by comparing our reaction to a particular portrait to other, similar experi-

ences. But the ability to understand another person's action—indeed, many other aspects of social behavior involved in the beholder's share—is also modulated in a bottom-up manner by two chemical transmitters in the brain concerned with bonding and other social interactions: vasopressin and oxytocin, as we shall learn in the next chapter.

On the basis of these findings, we might predict that people with autism would have difficulty developing a beholder's share because they have difficulty inferring the artist's intention about the mental state of the subject. This is exactly the point that Uta Frith made in her discussion of the social interaction arising from the card game in de la Tour's *The Cheat with the Ace of Diamonds* (Fig. 25-1). In understanding the drama of that painting, we engage in unconscious mind reading—an ability that is deficient in autistic people.

*Chapter 26*

# HOW THE BRAIN REGULATES
# EMOTION AND EMPATHY

ↄ\✓ↄ

THE BRAIN SYSTEMS RESPONSIBLE FOR DETECTING, ACTING ON, AND generating emotion and empathy were discussed in the preceding chapters. These basic neural circuits are known as mediating systems (Fig. 26-1). To function effectively as human beings, however, we must also be able to *predict* and to *regulate* the generation of emotion and empathy. This capability lies in the brain's modulating systems. Modulating systems modify the action of mediating systems: they do not turn them on or shut them off. In this way they are like the volume dial, rather than the on-off switch, of a radio.

In the modulation of emotion and empathy, as in basic perception and the experience of emotion, the brain has built-in bottom-up processes that are in large part genetically determined and top-down processes that rely on inferences and comparisons to previous experiences stored in memory. Both top-down and bottom-up processes affect how we relate to one another socially and empathically, and both are brought to bear, in the form of the beholder's share, on a work of art (Fig. 26-2). Because modulatory neurons are involved in many human diseases such as schizophrenia and depression and are the targets of many commonly used drugs, they are extremely important medically and pharmacologically.

Our understanding of top-down modulation is just beginning to emerge, but we do have a good understanding of the key bottom-up modulatory systems of the brain.

MOST OF THE SIX bottom-up modulatory systems that scientists have traced in the brain have a relatively small number of nerve cells, typi-

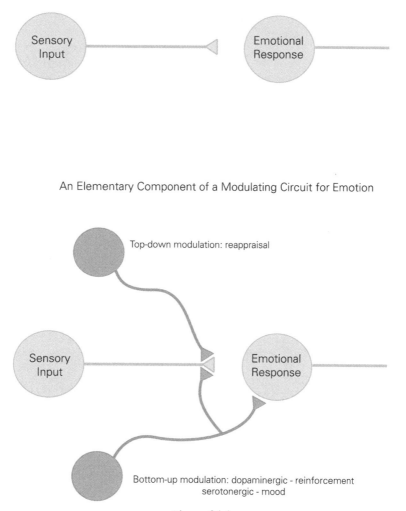

Figure 26-1

cally only a few thousand; however, they connect to many areas of the cortex, including the structures that control arousal, mood, learning, and regulation of the autonomic nervous system. Each modulatory system is responsible for a different aspect of emotional life, and each system routinely works in tandem with the others to create more complex emotional states. Moreover, the chemicals released by these neurons act not only as conventional neurotransmitters, which briefly

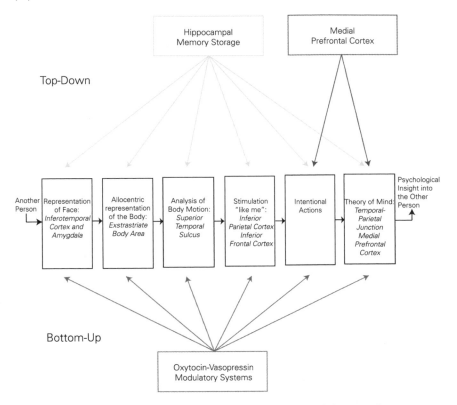

Figure 26-2. Bottom-Up and Top-Down modulation of the neural circuits involved in the beholder's share and in the social brain.

activate receptors at the synapses where they are released, but also as neurohormones, which can activate receptors in the brain located quite a distance from the site of release.

The neurons that control top-down modulation are located in the forebrain, particularly in the prefrontal cortex, while the neurons that control bottom-up modulation are typically clustered in the midbrain or the hindbrain (Fig 26-3). The bottom-up modulatory systems send their axons to cells in many different areas of the brain that are important in regulating emotion, motivation, attention, and memory, including the amygdala, the striatum, the hippocampus, and the prefrontal cortex. These structures, in turn, send information back to the bottom-up systems, thus regulating them from the top down. The various modulating systems release different neurotransmitters, each with different physiological and behavioral effects.

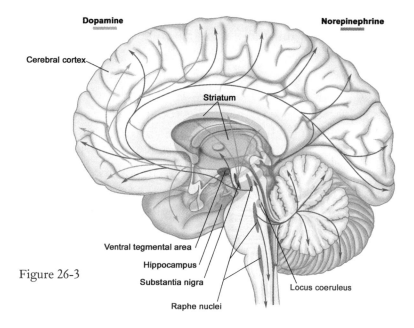

Figure 26-3

The key bottom-up modulating systems are the familiar *dopaminergic system*, which is involved in the anticipation or prediction of learning-related reward or in the registration of surprising, salient events; the *endorphin system*, which gives rise to pleasure and blocks pain; the *oxytocin-vasopressin system*, which is involved in bonding, social interaction, and trust; the *noradrenergic system*, which is recruited for attention and novelty seeking, as well as certain types of fear; the *serotonergic system*, which is involved in a variety of emotional states, including safety, happiness, and sadness; and the *cholinergic system*, which is involved in attention and memory storage.

Most behavior that we regard as important for social functioning, such as attention, memory, compassion, and emotion, depends heavily on bottom-up modulation of brain systems. Disturbance in any one of the modulatory systems can contribute to severe mental dysfunction. Thus, for example, elevated activity of the dopaminergic system is a characteristic defect in schizophrenia, reduced activity of the serotonergic and the noradrenergic systems contributes to depression, increased activity of the noradrenergic system can lead to post-traumatic stress disorder, and reduced activity of the cholinergic system is associated with cognitive dysfunction in certain forms of Alzheimer's disease.

When working properly, these modulatory systems keep our perceptions and reactions within the bounds that we think of as normal.

THE FIRST BOTTOM-UP modulating system to be studied in detail was the dopaminergic system, whose neurons release the transmitter dopamine and are involved in mediating reward. There are more dopaminergic neurons in the human brain than any other kind of modulatory neuron—about 450,000, evenly distributed in each hemisphere of the brain. The cell bodies of these neurons are located in two areas of the midbrain: the substantia nigra and the ventral tegmental area. The substantia nigra has the most dopaminergic cells; these cells extend their axons to the basal ganglia to facilitate the initiation of movement in response to stimuli from the environment. The ventral tegmental area has fewer neurons, and is involved in reward; these neurons send axons to the hippocampus, the amygdala, and the prefrontal cortex. Thus, the axons of dopaminergic neurons fan out widely and modulate several systems in the brain.

The fact that the dopaminergic system is involved in reward was discovered serendipitously in 1954 by James Olds and Peter Milner, who made the remarkable discovery that electrical stimulation of various areas deep in the brain can reinforce behavior that produces a reward. Amazingly, this deep-brain electrical stimulation is as effective as ordinary rewards in a wide range of animals, including people—but with one important difference. Whereas ordinary rewards are effective only if the animal is in a particular drive state—food, for example, will only serve as a reward when the animal is hungry—deep-brain stimulation works regardless of the animal's drive state. Rats that learn to stimulate themselves by pressing a bar will choose self-stimulation over food and sex. In his 1955 review in *Science,* Olds wrote that generally the animals die of starvation after a period of several weeks of continuous self-stimulation. This observation led him and Milner to the idea that deep-brain electrical stimulation recruits neural systems that are ordinarily activated by rewards.

What are rewards? They are objects, stimuli, activities, or internal physical states that have positive value for a person or an animal. They ensure subjective feelings of pleasure and contribute to positive emotion. They act as positive reinforcers, increasing the frequency or intensity of behavior that leads to realizing an objective.

The complex nature of the interaction between a person and the environment requires specific mechanisms that detect not only the presence of rewarding and aversive stimuli but also predict their future occurrence on the basis of past experience. We have learned a great deal about reward and the prediction of reward from the brilliant experiments in classical conditioning—learning by association—carried out by Ivan Pavlov at the beginning of the twentieth century (see Chapter 18).

The dopaminergic system has been found to respond not only to rewards but even more to stimuli that predict rewards. For many years psychologists thought that classical conditioning depended on presenting the conditioned (the neutral, sensory) stimulus and the unconditioned (reward) stimulus close together, so that the two were experienced as connected. According to this view, each time the two stimuli were paired, the neural connection between them was strengthened until eventually the bond became strong enough to change behavior. The strength of the conditioning was thought to depend solely on the number of pairings.

Then in 1969 Leon Kamin, a Canadian psychologist, made what is now generally considered to be the most significant empirical discovery in conditioning since Pavlov's initial findings. Kamin found that animals do not simply learn that the neutral stimulus precedes the reward, but rather that the neutral stimulus *predicts* the reward. Thus, associative learning does not depend on a critical number of pairings of stimuli; instead, it depends on the power of the neutral stimulus to predict a biologically significant reward.

These findings suggest why animals and people acquire classical conditioning so readily. All forms of associative learning probably evolved to enable us to distinguish events that occur together regularly from those that are only randomly associated—thereby enabling us to predict the occurrence of an outcome. For example, we may have learned to anticipate tasting a delicious red wine when we have sensed the bouquet of a good Châteauneuf-du-Pape.

Learning occurs when an actual outcome differs from the predicted outcome. Many kinds of behavior are affected by rewards and, as a result, undergo long-term changes when actual rewards are different from predicted rewards. When actual rewards are exactly as predicted, behavior remains unchanged.

Physiological studies have found that dopaminergic neurons are recruited during various types of reward-based learning: they are activated not only by predicted rewards, but also by unexpected rewards and by errors in the prediction of rewards. Errors in the prediction of rewards are indicated by fluctuations in the output of dopamine. These findings gave rise to the idea that dopamine acts as a *teaching signal*. Because of their connections to the amygdala, dopaminergic neurons probably modulate the amygdala's response to expected, positive reinforcing stimuli like those used in learning experiments.

Wolfram Schultz, now at Cambridge University in England, has shown how dopaminergic neurons act during learning. Recording from cells in the ventral tegmental area and the substantia nigra, he found that these neurons are activated by unexpected rewards, by predictions of rewards, and by errors in the prediction of rewards. In the case of errors, the cells are activated when a reward is better than anticipated and depressed when a reward is worse. The firing of these neurons is also activated when rewards occur at unexpected times and depressed when rewards do not materialize at predicted times. The cells do not respond to rewards that are exactly as predicted.

Schultz's findings are consistent with Darwin's polar view of emotional regulation—that is, approach and avoidance (fight or flight). His findings suggest that dopaminergic neurons are activated by experiencing actual rewards such as food, sex, or drugs, and that they are also activated by stimuli that predict those rewards. Thus, the flow of dopamine is set off by the simplest expectation of pleasure, even though the pleasure may not materialize.

The response of dopaminergic neurons to anticipated pleasure may be the physiological basis of the pleasure we experience when looking at art. Art may give rise to feelings of well-being because it predicts biological rewards (Fig. 26-4), even though further rewards beyond the pleasure of viewing and vicariously experiencing may never materialize.

As might be anticipated, drugs that augment or extend the natural action of dopamine produce the sensation of intense pleasure. In fact, a number of drugs of abuse, such as cocaine and amphetamine, hijack the dopaminergic system and trick the brain into thinking it is being rewarded, thus giving rise to addiction.

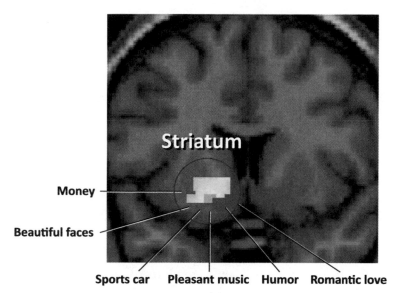

Figure 26-4. Dopaminergic neurons in the striatum respond
to all kinds of pleasure.

The brain's pleasure circuits are also activated when we enjoy a work of art, when we experience a beautiful sunset, a good meal, or a satisfying sexual experience. In each case, the experience has dimensions beyond the bottom-up release of dopamine. There are also, as we shall see, top-down influences that connect this particular experience to other experiences and other pleasures we have had. So in the emotion of pleasure, as in the perception of art and beauty, the immediate physical stimulus of the experience also triggers an unconscious inference that provides a broader context for the experience.

THE SECOND BOTTOM-UP modulatory system reduces pain and turns up the volume on pleasure, including the joy we take from art, by releasing neurotransmitters known as *endorphins*. The endorphins are peptides, complex molecules made up of chains of six or seven amino acids, and they are the body's natural painkillers. Endorphins are released by the hypothalamus and modulate the pituitary gland. They resemble morphine in their ability to block painful stimuli and create a sense of well-being. Strenuous exercise stimulates the release of endorphins, producing what athletes call an endorphin high. In fact, athletes

describe feeling lethargic and depressed when they do not exercise; this is because they are undergoing an endorphin withdrawal. Endorphins are also released by excitement, pain, spicy food, and orgasm.

The endorphins were discovered in 1975 by John Hughes and Hans Kosterlitz in Scotland. They act on opioid receptors in the brain that were discovered by Solomon Snyder at Johns Hopkins. It is thought that endorphins are released in response to the same stimuli that produce the release of dopamine and that they contribute to the feelings of pleasure that dopamine produces.

THE THIRD MODULATORY SYSTEM releases oxytocin and vasopressin, neurotransmitters that are important for mating and parental behavior and more generally for social behavior, social cognition, and our ability to read the mind and intentions of others. Both oxytocin and vasopressin are peptides and are made in the hypothalamus (as are most peptide transmitters). Both are transported to and released from the posterior lobe of the pituitary, and they activate receptors throughout the brain.

Oxytocin and vasopressin are found in a variety of animals, from worms to flies to mammals, and their genes are remarkably similar in all of them. Much of what we know about the effects of vasopressin and oxytocin derives from the pioneering experiments of Tom Insel, Larry Young, and their colleagues, who studied prairie and montane voles, two closely related species of mouselike rodents that have very different mating behaviors.

Prairie voles form monogamous pair bonds to raise their young, whereas montane voles are promiscuous and live in solitary burrows. These differences are evident in the first few days of life. Immediately after copulation, male and female prairie voles form a persistent preference for and attachment to the partner with which they mated. Male prairie voles help females raise their offspring, and they develop aggressive behavior toward other males. In contrast, male montane voles breed widely and do not engage in paternal behavior. The striking difference in the behavior of these male voles correlates with a significant difference in the amount of vasopressin released in the brain. The bond-forming prairie voles release high concentrations of vasopressin during mating, whereas the promiscuous montane voles release lower concentrations. Female prairie voles also bond with their male partners

thanks to oxytocin. Vasopressin is involved in erection and ejaculation in a variety of species, including humans, rodents, and rabbits, and it is involved in typical male social behavior, ranging from pair bonding and territoriality to aggression.

In all animals, oxytocin influences female sociosexual behavior—pair bonding, sexual intercourse, parturition, maternal attachment, and lactation. Oxytocin is released during sexual stimulation and during the birth process, where it facilitates labor, delivery, and, later, lactation, milk ejection, and nursing. In rodents, an injection of oxytocin will trigger maternal bonding to a foreign pup. Consistent with its function in pair bonding and sexual activity, oxytocin interacts with the dopaminergic reward system. In some circumstances, oxytocin is released in response to stress; in these cases, it dampens reactions to stressors. Vasopressin is released in sexual stimulation, uterine dilation, stress, and dehydration, and it plays an active role in social behavior.

Oxytocin and vasopressin are important in human social behavior and social cognition. Oxytocin enhances a person's positive social interactions by increasing relaxation, trust, empathy, and altruism. Genetic variations in the receptors for these neurohormones are thought to alter brain function and thus contribute to differences in social behavior. Sarina Rodrigues and her colleagues at the University of California Berkeley discovered that these genetic variations affect people's empathic behavior by impairing their ability to read faces and to feel distress at other people's suffering.

Indeed, Peter Kirsch and his colleagues, in the Cognitive Neuroscience Group of the University of Giessen in Germany, have found that oxytocin modulates the neural circuitry for social cognition. When given to people, oxytocin greatly reduces both the activation of the amygdala and autonomic and behavioral manifestations of fear. It also appears to enhance positive communication, at least in part by decreasing the production of cortisol, a stress hormone, and thereby inducing relaxation.

The psychologist Michael Kosfeld and his colleagues in Zurich have found that oxytocin increases trust and thus the willingness of people to bear risk. Since trust is essential for friendship, love, and the organization of families—not to mention economic exchange—this action of oxytocin may have profound consequences for human behavior. Oxy-

tocin specifically affects our willingness to accept social risks and to engage in unselfish and altruistic interactions with others.

Finally, merely viewing the faces of people with whom we have had a trusting interaction activates the hypothalamus and leads to the release of oxytocin, which in turn drives the release of endorphins, indicating that interacting with trustworthy people is rewarding and pleasurable in its own right. Oxytocin, we may presume, would enhance empathy and social bonding in response to some works of art.

THE FOURTH BOTTOM-UP modulating system releases norepinephrine, a neurotransmitter that enhances alertness; high concentrations of norepinephrine, which are produced in reaction to stress, induce fear. Some noradrenergic neurons are active during the learning of new tasks. In addition, dopaminergic and noradrenergic neurons are responsible for long-term changes in certain synapses that underlie learning.

The brain has an amazingly small number of noradrenergic neurons—only about one hundred thousand—and they are clustered together in a nucleus called the locus ceruleus, located on each side of the midbrain. Despite their small number, these neurons play an important role in modulating emotion, including our response to stress in anxiety disorders such as post-traumatic stress disorder. These neurons send their axons all over the central nervous system—to the spinal cord, the hypothalamus, the hippocampus, the amygdala, the cortex, and especially the prefrontal cortex. Norepinephrine enables us to maintain vigilance and responsiveness to unexpected environmental stimuli, especially painful ones. It causes an increase in heart rate and blood pressure and is an important part of the fight-or-flight response.

Noradrenergic neurons play an important role in attention. Blocking the transmission of norepinephrine does not interfere with an animal's memory of a particular cognitive event but does interfere with its memory of the *emotional content* of the event. Thus, in animals that have undergone classical conditioning of fear, blocking norepinephrine interferes with the animal's memory of the painful stimulus, whereas administering a drug that increases the action of norepinephrine enhances the animal's memory of the painful stimulus, thereby increasing its fear.

Similarly, volunteers given a placebo before being shown pictures accompanied by an emotional story remembered most vividly the pictures presented during the most emotional parts of the story. People given a drug that blocks the action of norepinephrine did not exhibit an enhanced memory of those pictures.

THE FIFTH BOTTOM-UP modulating system, the serotonergic system, is perhaps the most ancient. Invertebrates like flies and snails, which do not make norepinephrine, use serotonin to modulate their behavior. In people, the serotonergic neurons are clustered in nine pairs along the midline of the brain stem. They send their axons to several regions of the brain, including the amygdala, striatum, hypothalamus, and neocortex. These neurons are important in arousal, vigilance, and mood. In people, low concentrations of serotonin are associated with depression, aggression, and sexuality, and extremely low amounts correlate with suicide attempts. Indeed, the most effective pharmacological treatment for depression is based upon the ability of certain drugs to enhance the concentrations of serotonin in the brain. High concentrations of serotonin correlate with tranquillity, meditation, self-transcendence, and religious and spiritual experiences. Drugs like LSD, which regulate certain classes of serotonin receptors, lead to euphoria and hallucinations that often have spiritual components.

THE SIXTH BOTTOM-UP modulating system is the cholinergic system, which releases acetylcholine and regulates the sleep-wake cycle, as well as aspects of cognitive performance, learning, attention, and memory. Cholinergic neurons are located in several regions of the brain, and their axons extend to the hippocampus, amygdala, thalamus, prefrontal cortex, and cerebral cortex. Cholinergic neurons regulate the release of dopamine and thus can regulate reward and reward prediction error. A particularly important group of cholinergic neurons, located in the basal forebrain, contributes to memory storage, sending its axons to the amygdala, the hippocampus, and the prefrontal cortex.

THE SIX BOTTOM-UP modulating systems are a fairly ancient and evolutionarily conserved means of controlling positive and negative

emotion. They are present not only in vertebrates, but also in invertebrates, such as worms, fruit flies, and marine snails. Although they have overlapping functions, each system also has a distinctive set of actions. Together, they are essential for our well-being, the integrated functioning of the brain, and our ability to respond appropriately to and predict our environment.

WE HAVE ALSO evolved top-down modulating systems that exert cognitive control over positive and negative perceptions and emotions. These controls are represented in the higher regions of the cerebral cortex. The ability to control emotion, to evaluate it, and when necessary to reappraise it is critical to our effective functioning.

Conflicts, failures, and losses seem at times to conspire to ruin us, yet we have an extraordinary capacity to regulate the emotions occasioned by such threats. These regulatory efforts determine the impact such difficulties will have on our mental and physical well-being. Kevin Ochsner, a leading student of top-down modulatory systems, reminds us of Shakespeare's profound insight into the human mind and its capability for cognitive regulation when he has Hamlet say, "There is nothing either good or bad, but thinking makes it so."[1]

One form of top-down control of emotion that has been particularly well studied is *reappraisal,* the rethinking of feeling. The emotional impact of even a very unpleasant event or picture can be reduced and neutralized by evaluating and reappraising the experience in unemotional terms. Reappraisal is in fact the basis of cognitive behavioral therapy, which was developed by Aaron Beck, a psychoanalyst at the University of Pennsylvania. This form of therapy is designed to enable depressed people to reevaluate the cognitive processing of information in more realistic, neutral terms.

How is reappraisal achieved? Ochsner and his colleagues used functional MRI to explore the neural systems recruited when people reappraise a very negative scene in unemotional terms. The researchers found that reappraisal is associated with increased activity in the dorsolateral and ventrolateral (orbitofrontal) regions of the prefrontal cortex, both of which have direct connections to the amygdala and the hypothalamus. Moreover, the increased activity of these regions is associated with *decreased* activity in the amygdala. This finding is consistent with what we have seen earlier—namely, that higher-order regions

of the brain orchestrate and evaluate emotion not only through direct connections to the hypothalamus, but also, at least in part, through regulation of the amygdala. Moreover, they exert their top-down influence by means of the prefrontal cortex's ability to evaluate the salience of a stimulus.

The dorsolateral region of the prefrontal cortex also exerts cognitive control over working memory and response selection. Thus, reappraisal is a means of controlling emotion while engaging in tasks that require us to remain aware of what caused the emotion in the first place. The discovery of reappraisal suggests that similar cognitive control strategies are used to modulate emotion in a variety of other contexts. Ochsner concludes from these findings that higher-order regions of the prefrontal cortex may exert top-down cognitive control not only of emotion but also of thought.

STUDIES OF MODULATION and modulating systems have given us the beginning of a biological understanding of emotion and emotional neuroaesthetics—how the brain of the beholder re-creates emotional states depicted in a work of art and how emotion, imitation, and empathy are represented in the brain. The development of these insights into the biology and the cognitive psychology of perception, emotion, and empathy can help us understand why art moves us so powerfully.

Different modulatory systems, which govern different categories of emotions, can act on the same target (say, the prefrontal cortex or the amygdala) in different ways. Thus, your exact position on the emotional continuum when you look at a particular work of art is determined in part by the amygdala, the striatum, and the prefrontal cortex and in part by the various modulating systems. In fact, it is the discrete, yet overlapping functions of the modulatory systems that facilitate the ease with which you move from one emotional state to another.

Gustav Klimt's *Judith* is a good example of the complexity of emotions that we can experience in response to a painting. As we have seen, the Jews thought of Judith as a courageous, self-sacrificing heroine who saved her people from Holofernes. The depiction of Judith as a powerful, idealized young woman persisted through the Renaissance, as in Caravaggio's painting. But Klimt transformed and eroticized her. He depicts Judith as a sexually aroused femme fatale who combines her erotic urges with the sadistic satisfaction of having killed Holofernes

(Fig. 8-27). In the ultimate castration, she has beheaded him and now brings his head up to her exposed breast.

Let us speculate about the many ways in which Klimt's painting engages a hypothetical beholder's modulatory systems. At a base level, the aesthetics of the image's luminous gold surface, the soft rendering of the body, and the overall harmonious combination of colors could activate the pleasure circuits, triggering the release of dopamine. If Judith's smooth skin and exposed breast trigger the release of endorphins, oxytocin, and vasopressin, one might feel sexual excitement. The latent violence of Holofernes' decapitated head, as well as Judith's own sadistic gaze and upturned lip, could cause the release of norepinephrine, resulting in increased heart rate and blood pressure and triggering the fight-or-flight response. In contrast, the soft brushwork and repetitive, almost meditative, patterning may stimulate the release of serotonin. As the beholder takes in the image and its multifaceted emotional content, the release of acetylcholine to the hippocampus contributes to the storing of the image in the viewer's memory. What ultimately makes an image like Klimt's *Judith* so irresistible and dynamic is its complexity, the way it activates a number of distinct and often conflicting emotional signals in the brain and combines them to produce a staggeringly complex and fascinating swirl of emotions.

While the study of the biological modulators of emotion and empathy is just beginning, it promises to yield insights into why art affects us so powerfully. The art of the Viennese modernists shows that the systems recruited by face, hand, and body recognition modulate the brain regions that are concerned with emotion, imitation, empathy, and theory of mind. In this way we can perceive, identify with, and act out the feelings conveyed by an artist whose work is rich in emotional significance.

# AN EVOLVING
# DIALOGUE
# BETWEEN VISUAL
# ART AND SCIENCE

*Chapter 27*

# ARTISTIC UNIVERSALS AND
# THE AUSTRIAN EXPRESSIONISTS

⤳⟋⟍

I N 2008 THE ARCHAEOLOGIST NICHOLAS CONARD UNEARTHED IN southern Germany what may be the oldest known depiction of the human body: the *Venus of Hohle Fels*, a figurine of an idealized woman carved from mammoth ivory some thirty-five thousand years ago (Fig. 27-1). In a commentary on this remarkable find, the archaeologist Paul Mellars calls attention to the figure's "explicitly, almost aggressively, sexual nature, focused on the sexual characteristics of the female form."[1] The sculptor of this figurine minimized the body's head, arms, and legs while greatly exaggerating its "large, projecting breasts, a greatly enlarged and explicit vulva, and bloated belly and thighs."[2]

Indeed, in its exaggeration of female sexual characteristics, the newly discovered statuette resembles the so-called Venus figures carved some five to ten thousand years later in several areas of Europe. The cultural roots of the Venus figures remain obscure, although archaeologists speculate that they reflect primitive beliefs about fertility. Mellars concludes that no matter which way one views these statues "it is clear that the sexually symbolic dimension in European (and indeed worldwide) art has a long ancestry in the evolution of our species."[3] As we have seen, the Austrian expressionists essentially created a modernist version of this ivory statue thirty-five thousand years later by exaggerating the human face and body in an attempt to enhance, in new ways, the emotional, erotic, aggressive, and anxious representations of their subjects. The continuity between the oldest known depiction of the human body and the work of the Austrian expressionists poses a series of larger questions.

Figure 27-1. *The Venus of Hohle Fels.*

Does art have universal functions and features? New styles and forms of expression are created by each passing generation, driven in part by advances in science and technology and in part by the changing insights, knowledge, needs, and expectations of artists. But beyond these transformations, are certain artistic universals retained? If so, how are these universal features perceived by specialized pathways in the brain, and why are they so powerful and evocative? Can they help provide a scientific framework for understanding the artistic innovations of a particular cultural milieu, such as Vienna 1900?

ALTHOUGH WE ARE at a very early stage of providing answers to such deep questions about the nature of art and the human brain, this is a propitious time to begin grappling with them. In the last two decades of the twentieth century, a new science of mind emerged from the convergence of cognitive psychology and brain science.

The importance of the biology of mind that has emerged since then is not restricted to its contribution to scientific knowledge. Our ability to study complex mental processes such as perception, emotion, empathy, learning, and memory also promises to help bridge the gap between the sciences and art. Since the artist's creation of art and the

viewer's response to art are products of brain function, one of the most fascinating challenges for the new science of mind lies in the nature of art. It is quite likely that as we understand more about the biology of perception, emotion, empathy, and creativity, we will be in a better position to understand why artistic experience affects us and why it is part of virtually every human culture.

Semir Zeki, the pioneer of neuroaesthetics, reminds us that the main function of the brain is to acquire new knowledge of the world and that visual art is an extension of that function. Clearly, we obtain knowledge from many sources: from books, from the Internet, and from navigating through our environment. But Zeki sees the aims of art as different: art extends the functions of the brain more directly than other processes of acquiring knowledge. All of the senses serve analogous functions in acquiring knowledge of the world, but vision is by far the most efficient way to acquire new information about people, places, and objects. Moreover, there are certain types of knowledge, such as the expression of a face or the interaction of a social group, that can only be acquired through vision. Since vision is above all an active process, art also encourages an active and creative exploration of the world.

EXAMINATION OF THE Austrian expressionists has led us to ask an additional set of questions related to emotional neuroaesthetics, a field that attempts to combine the study of art with the cognitive psychology and neurobiology of perception, emotion, and empathy. Some questions in emotional neuroaesthetics can be addressed immediately: What is the biological nature of aesthetics? Do general biological principles govern our responses to works of art, or are our responses always individualistic and personal?

Dennis Dutton, a philosopher of art, identifies two views of our response to art. The first derives from the perspective that dominated much of the research in the humanities in the second half of the twentieth century—namely, that the mind is a blank slate on which are inscribed, through experience and learning, most of the characteristic human attributes, including creativity and the response to art. Dutton's second, more compelling view is that the arts are not simply a by-product of evolution, but rather an evolutionary adaption—an instinctual trait—that helps us survive because it is crucial to our well-being.

Dutton argues that we evolved as natural storytellers because of the immense survival value of our fluent imaginative capacities. Storytelling is pleasurable, he explains, because it extends our experience by giving us opportunities to think hypothetically about the world and its problems. Representational visual art is a form of storytelling that artist and beholder alike can visualize and turn over in their own minds, examining relations between characters acting in different social and environmental settings. Storytelling and representational visual art are low-risk, imaginary ways of solving problems. Language, storytelling, and certain kinds of artwork enable the artist to model our world uniquely and to communicate those models to others.

Art allows us to participate in storytelling in ways that are similar to fiction. In each case, the listener or the beholder experiences the plot unfolding from a personal, internal perspective, enabling him or her to analyze relationships and events through the mind and eyes of another person. The experience became more pronounced in the modernist work of Arthur Schnitzler, who let his readers inhabit another's mind through the interior monologues of his characters. In enjoying both fiction and art, we employ our theory of mind, which allows us to experience the world from a new perspective, where we can safely encounter and solve problems. This is evolutionarily adaptive because it allows us to rehearse and prepare for dangerous situations we may encounter later.

One of the most important breakthroughs in post-Renaissance oil painting was what Alois Riegl called "external coherence," the active involvement of the beholder in the completion of the narrative. As in fiction, the beholder of these paintings plays an active role in the narrative arc—the work is incomplete without his or her participation. A further dimension of narrative, or self-as-other imagination, in art is its ability to engage the beholder's emotional centers and modulatory systems. A painting like Klimt's *Judith,* as we have seen, manipulates and combines different emotional systems located in various regions of the brain, leading the beholder to an exceptionally nuanced, yet highly specific emotional state.

The information conveyed in a story or work of art need not be simple. It can be complex and multidimensional. Every inflection of the voice, every slight contraction of a facial muscle matters. These cues help us understand what emotions the character is experiencing and

thus to predict what he or she will do next. Survival in society is dependent on learning to read such cues, which is why we developed the neural machinery for representing them, reacting to them, and most important, *desiring* to understand them. And that is why we generate, appreciate, and desire art: art improves our understanding of social and emotional cues, which are important for survival. The capability of the human brain for language and storytelling enables us to model our world and to communicate those models to others.

Why has art survived over time? What is the basis of its universal appeal? The social psychologist Ellen Dissanayake and the art theorist Nancy Aiken, working independently, have approached these questions from the perspective of evolutionary biology. They start with the observation that art is ubiquitous: all human societies, from the Stone Age thirty-five thousand years ago to the present, have made and responded to art. Art must therefore serve some purpose that makes it critical for human existence, even though it is not, on the surface, essential for basic survival, as food and drink are. Simple forms of distinctively human attributes, such as language, symbolization, tool-making, and culture formation, can be found in other animals. But only people create art.

Interestingly, Cro-Magnon man, who was both mentally and physically similar to us, painted pictures in the Chauvet cave of southern France thirty-two thousand years ago, whereas the Neanderthal people, who lived in Europe at the same time, created no representational art, as far as we know. Aiken speculates:

> While no evidence exists to document why the Neanderthal died out or even why there is today only one species of *Homo* extant, it might be because our Cro-Magnon ancestors used art to solidify their groups into survival machines and the other species, lacking this great advantage, were unable to keep a step ahead of changing environments or were simply unable to compete with Cro-Magnon for the same resources.[4]

Dissanayake believes that art, being something that people do and feel, evolved and persisted because it was an important means of social unification in the Paleolithic period. By binding people together into communities, art enhanced the survival of individuals within the

group. One way in which art may have unified people was by making some socially important objects, activities, and events memorable and pleasurable. Since they crafted everyday objects more artistically than necessary to fulfill their purposes, Dissanayake writes (1988): "Perhaps the most outstanding feature of art in primitive societies is that it is inseparable from daily life, also appearing prominently and inevitably in ceremonial observances."[5]

Since art arouses emotion, and emotion elicits both cognitive and physiological responses in the observer, art is capable of producing a whole-body response. John Tooby and Leda Cosmides, two of the founders of evolutionary psychology, argue along the lines of Ernst Kris and Ernst Gombrich:

> We think that art is universal because each human was designed by evolution to be an artist, driving her own mental development according to evolved aesthetic principles. From infancy, self-orchestrated experiences are the original artistic medium, and the self is the original and primary audience. Although others cannot experience the great majority of our self-generated aesthetic experiences, from running and jumping to imagined scenarios, there are some avenues of expression that can be experienced by the creator and others. . . . The invention of additional recording media (paint, clay, film, etc.) has allowed a steady expansion of audience-accessible art forms over human history. We suggest, however, that the socially recognized arts are only a small part of the realm of human aesthetics, even though our ability to record performances permanently has caused the body of such audience-directed efforts to become massive, and its best exemplars [to become] overpowering.[6]

ARTISTS TAP INTO EMOTIONAL primitives to evoke a desired response from the viewer. To understand how they do this, the cognitive psychologist Vilayanur Ramachandran searched for "principles underlying all the diverse manifestations of human artistic experience"[7]— that is, laws that derive from the fundamental Gestalt principles of visual perception. Following Kris and Gombrich's argument about caricature, Ramachandran argues that many forms of art are successful because they involve deliberate overstatement, exaggeration, and

distortion designed to pique our curiosity and produce a satisfying emotional response in our brains.

In order to be effective, however, art's deviations from realistic depiction cannot be arbitrary. They must, as Aiken has argued, succeed in capturing the innate brain mechanisms for emotional release, once again reminding us of the discovery by behavioral psychologists and ethologists of the importance of exaggeration. That discovery became the basis for the exploration of a simple sign stimulus that is capable of releasing a full-blown behavior and whose exaggeration produces an even stronger behavior.

Ramachandran refers to these exaggerated sign stimuli as the *peak shift principle*.[8] According to this idea, the artist tries not only to capture the essence of a person, but also to amplify, by appropriate exaggeration, the essence of that person and thus to activate more powerfully the same neural mechanisms that would have been triggered by the person in real life. Ramachandran emphasizes that the ability of the artist to abstract the essential features of an image and to discard redundant or insignificant information is similar to what the visual system has evolved to do. Thus, the artist unconsciously provides an exaggerated sign stimulus by taking the average of all faces, subtracting this average from the face of the sitter, and then amplifying the difference.

The peak shift principle applies to depth and color as well as to form. We certainly see the exaggeration of depth in the lack of perspective in Klimt's paintings and the amplified color in the faces that Oskar Kokoschka and Egon Schiele portrayed. Moreover, following the lead of Vincent van Gogh, Kokoschka, and Schiele reveal their knowledge of the peak shift principle in their overemphasis on the textural attributes of the faces they painted. Ramachandran identifies ten additional principles of art, derived in part from Gestalt insights, that he thinks are universal: grouping, contrast, isolation, the solving of perceptual problems, symmetry, abhorrence of coincidence, repetition of rhythm, orderliness, balance, and metaphor.

The idea that there may be universal laws of aesthetics does not exclude the importance of historical and stylistic influences, local preferences, or the originality of the individual artist, issues that Riegl emphasized strongly. Indeed, as we have seen, the emergence of particular schools of art, such as modernist art in Vienna 1900, may be

deeply rooted in the intellectual and cultural events of a particular time and place. Ramachandran merely outlines some *general* rules that the artist is likely to employ, consciously or unconsciously. What *particular* rules a given artist emphasizes, and how effective that artist is, depends upon the contemporary and historical styles that influence him or her, the intellectual and artistic zeitgeist in which the artist works, and the artist's own skill, interests, and originality. One might argue, for example, that whereas the French Impressionists were masters of introducing new variations in color space by painting in natural light, the Austrian expressionists introduced shifts in emotional space by painting faces and bodies with new insights into people's emotions and instinctual lives. In each case, the artist developed new insights into the universal principles underlying the operation of the human visual and emotional systems.

Artists also have an implicit understanding of another universal biological principle: namely, that people have limited attentional resources. Only *one* stable neural representation can occupy the center stage of consciousness at any given time. Since critical information about a face or a body lies in the outline, as Ramachandran points out, everything else about it—skin tone, shape of the hair—is less relevant. In fact, such details may actually distract our attentional resources from where they are needed.

This is why Klimt's dark Art Nouveau outlines, which Kokoschka and Schiele modified into angular images, are so powerful. They delineate and call attention to the face, hands, and body, which activate the neural mechanisms of our emotional response with particular effectiveness. The artist has to introduce these peak shifts in images and throw away everything else so the viewer can allocate all available attention where the artist wants it. At times, the viewer does not even need the influence of color. Schiele used color sparingly—and sometimes not at all—in his portraits, but they are nonetheless very powerful.

THE INITIAL INSIGHTS into how perception and emotion interact in our response to art came from cognitive psychology, beginning with Riegl and continuing with Kris, Gombrich, and Ramachandran. From their work we learned that images created by the artist are re-created in our brain, which has an innate ability—first delineated by the Ge-

stalt psychologists—to make models of both perceptual and emotional reality. The central point is that in creating images of people and the environment, artists target and manipulate the same neural pathways our brains use to make these models of reality in everyday life. By extension, Kris has argued, the brain of the artist as a creative modeler of physical and psychic reality is paralleled by the brain of the viewer as a creative remodeler of the physical and psychic reality depicted by the artist.

Expressionist art succeeds by recruiting the emotional and perceptual systems of the brain in a highly coherent manner; it does this, as we have seen, by merging the emotional power of caricature with twentieth-century techniques of drawing, painting, and the use of color.

While artists have traditionally focused on the face, hands, and erotic zones because of their importance in everyday human interactions, Klimt, Kokoschka, and Schiele did more than just draw the viewer's perceptual attention to these parts of the body. By exaggerating them, and by showing the viewer how they produced those exaggerations, they invoke emotional primitives and introduce a new set of icons. In this way the Austrian expressionists uncover and bring to our conscious awareness the unconscious markers of our instinctive emotional systems.

The perception of emotion in art is in part imitative and empathic, recruiting the brain systems concerned with biological motion, the mirror neurons, and the theory of mind. We recruit those systems automatically, without having to think about them. Much as the James-Lange theory of emotion might have predicted, and as modern studies of the emotional brain have confirmed, a great work of art enables us to experience a deep pleasure that is at once unconscious yet capable of triggering conscious feelings. Thus, when we interact with the relaxed and grand people depicted in some of Klimt's art, we feel more relaxed and grand ourselves. If we instead view the anxious people in Schiele's paintings, our anxiety level rises.

As Darwin's work on facial expression indicated, there is a continuum of about six stereotypic emotions that extends from pleasure to pain. Where an emotion falls on this continuum is determined by the amygdala, the striatum, the prefrontal cortex, and the various modulatory systems of the brain. The existence of this continuum may explain how a painting can transport us through a range of emotions and why

the Austrian expressionists could so brilliantly fuse radically different emotions: the pleasure of eroticism with the terror of anxiety, the fear of death with the hope of birth.

KLIMT, KOKOSCHKA, AND SCHIELE expressed combinations of emotions as a way of conveying the unconscious drives of their subjects, while working within the parameters of universal artistic truths. They demonstrated in their own distinctive way and in their own period in history two major uses of art. First, they allowed the viewer to read emotions by emphasizing the feelings and instinctual striving that are submerged in a person's manner of presenting himself or herself. Reading those emotions and appreciating their complexity allows us to empathize with the sitter, to feel his or her emotions. Second, they focused our attention on essential emotional elements through the use of caricature. By simplifying the contours of the face, hands, and body, the Austrian expressionists could quickly communicate a likeness of their subjects and give the viewer more time to dwell on the emotion they evoked.

Ramachandran's arguments about artistic universals and peak shifts are directly related to Klimt's overstatement of the erotic and destructive power of women, to Kokoschka's exaggeration of facial emotions, and to Schiele's exaggerated, anxiety-ridden bodily postures and his depictions of the modern person struggling simultaneously with the life force and the death wish. We see evidence of universals and peak shifts carried forward to the present day in the great contemporary portraitist Lucian Freud. Freud, who painted portraits of his subjects in the nude, distorted conventional scale and perspective to express his view of reality as the exchange between our inner and outer worlds.

# THE CREATIVE BRAIN

⤳⤳

*The difference between the artist and the non-artist is not a greater capacity for feeling. The secret is that the artist can objectify, can make apparent the feelings we all have.*
—MARTHA GRAHAM[1]

*This is what the painter does, and the poet, the speculative philosopher, the natural scientist, each in his own way. Into this [simplified and lucid] image [of the world] and its formation, he places the center of gravity of his emotional life, in order to attain the peace and serenity that he cannot find within the narrow confines of swirling personal experience.*
—ALBERT EINSTEIN[2]

ARTISTS AND SCIENTISTS ALIKE ARE REDUCTIONISTS, BUT THEY have different ways of knowing and making sense of the world. Scientists make models of elementary features of the world that can be tested and reformulated. These tests rely on removing the subjective biases of the observer and relying on objective measurements or evaluations. Artists also form models of the world, but rather than being empirical approximations, artists create subjective impressions of the ambiguous reality they encounter in their everyday lives.

Making models of the world is also the core function of the perceptual, emotional, and social systems in the human brain. It is this modeling capability that makes possible both the artist's creation of a work of art and the beholder's re-creation of it. Both derive from the intrinsically creative workings of the brain. In addition, both the artist and the

viewer have Aha! moments—sudden flashes of insight—that are thought to involve similar circuits of the brain.

The role of creativity in the artist and in the beholder is now being actively explored in cognitive psychological terms by psychologists and art historians, and in an even more preliminary way in biological terms by brain scientists. For biologists, the study of creativity ranks with the study of consciousness as being on the edge of the unknown.

From the point of view of cognitive psychology, the artist depicts the world and the people in it by targeting and manipulating the brain's ability to make models of emotional and perceptual reality. To do this, the artist has to understand intuitively the brain's rules for perception, color, emotion, and empathy. In turn, the brain's capability for imitation and empathy gives both artist and beholder access to the private mental world of others.

Bernard Berenson, the American art historian, was perhaps the first person to note that the beholder has a muscular response to the subject of a painting: that is, the viewer unconsciously adjusts his or her facial expression and posture to simulate the subject of the portrait. This response, Berenson presumed, is empathic and parallels the subject's emotional state. Today, we might attribute this response of the beholder to the brain's mirror-neuron and theory-of-mind systems. Simulating the subject's expression and posture not only gives the beholder insight into the person being portrayed, it also allows the beholder to project his or her own feelings onto that person.

Ernst Gombrich argues that when the artist projects his feeling onto the person he is painting, he may make the sitter resemble himself. He uses as an extreme example Oskar Kokoschka's portrait of Tomas Masaryk, the first president of the independent Republic of Czechoslovakia, whose painted image looks very much like the artist (Fig. 28-1). Gombrich goes on to say that Kokoschka's powers of empathy and projection give the viewer special insights into the sitter, unlike the work of artists who are less involved with the psychological and emotional states of their subjects. Through his ability to experience empathy and to depict his subjects empathetically, Kokoschka allows the viewer access to both the subject's and the painter's minds.

PAINTINGS ENGAGE US, in part, by creating ambiguity. As a result, a work of art will evoke different responses from different viewers, or

Figure 28-1. Oskar Kokoschka, *Portrait of Tomas Garrigue Masaryk*
(1935–36). Oil on canvas.

even from the same viewer at different times. Indeed, the perceptual reconstruction of a work of art by two different viewers may be as distinct as the same landscape painted by two different artists.

Our relationship with a painting involves a continuous, unconscious adjustment of our feelings as our eye movements scan the work for suggestions on how to proceed and for confirmation or disconfirmation of our response.[3] The selective attention of each individual viewer is driven by a unique set of personal and historical associations. Gombrich uses as an example Leonardo's portrait of Mona Lisa, describing her as looking like a living being changing in front of our eyes. He ends up by saying: "All this sounds rather mysterious, and so it is; that is so often the effect of a great work of art."[4]

Both the artist and the viewer bring creativity to a work of art. What is common to all types of creativity, be it scientific, artistic, or merely a biological process of perception, is the emergence of something original, inventive, and imaginative. This fact raises the broader questions: What is the nature of creativity? What cognitive psychological processes contribute to it?

To begin with, we need to ask whether answers to these elusive questions are beyond our grasp. The Nobel laureate Peter Medawar

insists, I believe correctly, that the notion "that 'creativity is beyond analysis' is a romantic illusion we must now outgrow."[5] He argues further that the analysis of human creativity will require parallel studies from a variety of perspectives. Indeed, we are now beginning to see that creativity is very complex and takes a variety of different forms—and we are only beginning to understand it.

IS CREATIVITY UNIQUE to the human brain, or is it inherent in all information-processing devices that reach a certain level of complexity? Some scientists in the field of artificial intelligence claim that once computers become powerful enough, they will exhibit the same sorts of creative intelligence normally ascribed to people, giving them abilities such as face recognition and the formulation of novel ideas. This is the position advocated by the inventor and futurist Ray Kurzweil in his book *The Singularity Is Near*. Kurzweil believes that the time will come when the scientists who design the programs for these intelligent computers will create machines that are smarter than we are. Those machines, in turn, will be able to design computers that are still smarter than they are. Kurzweil believes that within decades, information-based technologies could conceivably encompass much of human knowledge. This escalation will lead to a machine-based ultra-intelligence, challenging the very nature of human intelligence.

A step forward in this ambitious project in artificial intelligence was achieved in 2011, when the room-sized IBM computer named Watson was capable of both understanding human speech and answering a broad range of questions. Watson competed in the television quiz show *Jeopardy!* which requires that contestants have not only an encyclopedic knowledge about all possible areas of human concern, but also an ability to decipher ambiguous questions and statements. Watson was able to decode the rhetorically complex phrasing of the questions and to access the relevant information required to answer them, and it did so faster than the two human champions it defeated. Watson experienced difficulty only when it came to connecting vague or ambiguously phrased questions to specific data stored in memory. The ability to handle ambiguity requires a sophisticated understanding of nuance that is still best done by the human brain.

Nevertheless, Watson and the chess-playing Deep Blue raise the fascinating question of whether complex computational systems are in-

deed "thinking" in the same psychologically robust manner as the human mind, or are merely computing data in a highly sophisticated way. Can we ascribe the word *think* to a machine, or is this merely a case of conflating a psychological subject with a computer simulation of it?

There is no clear answer to this question. John Searle, a philosopher of mind at the University of California, Berkeley, believes that a computational program, no matter how "intelligent" and sophisticated it is, cannot be equated with the human mind. He has proposed an intriguing way of demonstrating the difference between the thinking of a computational system like Deep Blue or Watson and that of a human brain.

Searle asks us to imagine a room—the Chinese room—in which someone is confined. He has with him a list of rules for systematically transforming sets of symbols in ways that will yield further sets of symbols. These sets are, in fact, Chinese expressions. Supposing, Searle argues, that the man in the room does not understand Chinese: the translation of one set of Chinese figures to another is purely *formal*, in the sense that it depends solely on the shapes of the symbols involved, not their meaning. No knowledge of Chinese is required. The man becomes very adept at manipulating Chinese expressions according to the list of instructions: whenever a string of Chinese characters is sent into the room, he promptly goes to work and soon afterward sends out an appropriate string of different Chinese characters. From the perspective of a Chinese speaker outside the room, the input strings are questions, and the output strings are answers to those questions. The input-output relationships are thus what we would expect if a genuine Chinese speaker were confined in the room. And yet the man inside the room does not understand a word of Chinese; indeed, there is no understanding of Chinese going on anywhere in that room. What is going on inside the room is the manipulation of symbols based on their shapes, or *syntax*. Real understanding requires *semantics*, or knowing what the symbols represent.

Now, if we replace the man inside the Chinese room with a computer that runs his rules as its program, Searle argues, nothing changes. Both the computer and the man are manipulating strings of symbols according to their syntax. There is no more understanding of Chinese in the computer than there is in the Chinese room. Indeed, this is ex-

actly the process we might ascribe to computer programs like Watson. Although Watson is capable of answering an exhaustive range of questions—politics and poetry, science and sports, the perfect way to prepare spaghetti carbonara—it cannot be said to understand the answers it provides any more than the man inside the room can be said to understand Chinese. While Watson exhibited the same sort of input-response behavior as his opponents on *Jeopardy!* and indeed did so with great speed and competence, his human opponents actually understood the answers they gave to the questions.

Many people working in artificial intelligence and some cognitive psychologists who espouse a computational theory of mind would suggest that we cannot make a clear distinction between thinking and merely computing data. To them, Searle's argument against the computational theory of mind is not based on evidence, but simply on the *feeling* that we are doing more than manipulating symbols when we understand a sentence. Since Searle has no hard-and-fast experimental evidence that would deny a computational theory of mind, he is arguably appealing to intuition, a process that is often faulty and could be wrong.

The weakness of intuition aside, there continue to be striking differences between the computational methods of minds and machines that might prohibit computers from achieving humanlike intelligence.

Magnus Carlsen, a Norwegian chess phenomenon who played on par with Garry Kasparov at age twenty-one, has independently reached a similar conclusion. Carlsen claims that when it comes to playing chess, computers have nothing that approaches intuition. They are extraordinarily fast and can race through their enormous stores of memory so rapidly that they do not need to be elegant or smart to beat people at chess. They can play out the next fifteen moves for every possible scenario that might arise and thus have no need for finesse. Carlsen and other highly creative chess players rely on a more intuitive judgment of where a game could go and an intuitive feel for the board. They are therefore less likely to play the way a computer does. As a result, someone like Carlsen is a difficult and unpredictable opponent for chess masters who rely on software and databases for their strategies and training.

Another example of things computers do not do well is learning the rules of face perception. As Pawan Sinha and his colleagues write:

Notwithstanding the extensive research effort that has gone into computational face recognition algorithms, we have yet to see a system that can be deployed effectively in an unconstrained setting. . . . The only system that does seem to work well in the face of these challenges is the human visual system.[6]

It is worth stating that human facial recognition does not employ a single sophisticated algorithm but a network of crude processes. This strategy is evolutionarily advantageous: it is easier to evolve multiple parallel simple processes than an exhaustive single one. By unconsciously selecting whatever process yields the best results, we are able to recognize faces in an immense variety of circumstances. Indeed, we do so more effectively than would be possible with a single sophisticated algorithm. This is a pervasive feature of visual processing, as we have seen with the numerous monocular and binocular depth cues, and it seems likely that it indeed applies to other processes as well. Vilayanur Ramachandran summarizes the approach eloquently by saying, "It is like two drunks walking toward a goal; neither can do it by himself, but by leaning on each other they can stagger towards it."[7]

The science writer and student of computer intelligence Brian Christian elaborates on further differences between human and machine intelligence: human intelligence is capable of language comprehension, grasping meaning from fragmentary information, spatial orientation, and adaptive goal setting. Most important, the human brain can recruit emotion and conscious attention as aids in decision making and predicting, whereas the computer cannot. Conscious attention, according to William James, makes us aware of brain states and thus guides us, together with emotion, to the acquisition of knowledge.

Moreover, Christian emphasizes that while computers are getting better, humans are not standing still. When Deep Blue beat Kasparov in 1997 (having lost to him previously), Kasparov proposed a rematch for 1998. IBM refused. Instead, fearing that Kasparov had figured out Deep Blue's strategy and would defeat it, the company disassembled Deep Blue, and it never again played a game of chess.

If current computers lack the emotion and rich sense of self-awareness we normally ascribe to people, or if their computational methods are irreducibly different from our own, is it still possible for

them to exhibit creativity as we normally conceive of it? Computers can be programmed to form novel ideas. They have, for example, generated novel jazz music, complete with improvised melodies based on algorithms. More broadly, they can create new ideas by randomly combining old ones and testing the results against existing models. The intuitive difficulty arising from attributing creative thought to computers turns on some of the key features of creativity in the human brain. By examining these features, we can begin to understand what exactly we mean by creativity.

ESSENTIAL PREREQUISITES for creativity are technical competence and a willingness to work hard, according to Ernst Kris and the psychiatrist Nancy Andreasen. For convenience, they divide the remaining aspects of the creative process into four parts: (1) the *types of personalities* that are likely to be particularly creative; (2) the *period of preparation and incubation,* when a person works on a problem consciously and unconsciously; (3) the initial *moments of creativity* themselves; and (4) subsequent *working through* of the creative idea.

What types of people are most likely to be creative? Historically, creative people were often viewed as touched by divine inspiration. With the advent of psychology as an academic discipline at the beginning of the twentieth century, attempts were made to measure creativity, much as intelligence quotients (IQs) were used to measure intelligence. This led to the conclusions that creativity is based on intelligence and that it is a single trait that a creative person can manifest and apply to any domain of knowledge. Thus, to be creative at one thing meant a person was creative in all things.

Only recently have most social scientists, influenced by Howard Gardner's work on multiple forms of intelligence, come to view creativity as also having multiple forms. Gardner, a cognitive psychologist at Harvard University, writes of creativity in the following way:

> We recognize a variety of relatively independent creative endeavors. A creator can solve a hitherto vexing problem (like the structure of DNA), formulate a new conundrum or theory (like string theory physics), fashion a work in a genre, [or] perform online in real or mock battle. . . . We also recognize a range of creative achievements—from the little *c* involved in a new floral

arrangement to the big *C* entailed in the theory of relativity. And most important, we do not assume that a person creative in one realm . . . could have switched places with a person creative in another realm.[8]

A similar finding has emerged from the studies of Andreasen, who also cites the systematic studies of the psychologist Lewis Terman. In a longitudinal study of 757 children who were born in California in 1910 and whose IQs ranged from 135 to 200, Terman found no relation between high IQ and creativity.

Gardner goes on to discuss the social aspect of creativity, whose importance was first recognized by the psychologist Mihaly Csikszentmihalyi. Creativity is not the solitary achievement of a lone individual or even a small group, Csikszentmihalyi held. Rather, creativity emerges from the interaction of three components: "the *individual* who has mastered some discipline or domain of practice; . . . the cultural *domain* in which an individual is working; . . . [and] the social *field*— those individuals and institutions that provide access to relevant educational experiences as well as opportunities to perform."[9] To be appreciated as creative, acts must be recognized by others; they require a social context. In a larger sense, creativity, especially in science, is often brought out by the social and intellectual environment in which the scientist works. We can clearly identify schools of scientific thought in which the work of pioneers led to important discoveries by later scientists, as in the case of Thomas Hunt Morgan, who discovered that genes were located on chromosomes, and Francis Crick and James Watson, who discovered the double helical nature of DNA.

Following the work of Gardner and Andreasen, we now realize that the types of personalities Kris was searching for—personalities that lead to a creative mind-set—are numerous and not centered entirely on the intellect: some highly creative people are slow readers or poor at arithmetic. In addition, the creative mind-set is most commonly not generalized but domain-specific. It derives from a variety of features that are extremely important, including wonderment, independence, nonconformity, flexibility, and, as we shall see, the capability for relaxation. The specificity of this mind-set is clearly evident in autistic people who have specialized talents for drawing, whom we shall consider in Chapter 31.

It is clear there are numerous ways to be creative—by writing, dancing, theorizing, or painting—but is it possible that underlying all of these is a common set of mental skills? All of the various species of creativity depend on abilities like constructing metaphor, reinterpreting data, connecting unrelated ideas, resolving contradictions, and eliminating arbitrariness. Of course, the nature of the creative project determines how these abilities are employed and defined (arbitrariness may mean something very different to a quantum physicist than to an impressionist painter) but there may well be a few very broad areas of methodological overlap. This is not to imply that Freud and Kokoschka could have swapped places—their skills and approaches were radically different—but they may have shared a similar set of overarching strategies, including a shared ability to understand aspects of the unconscious and psyche.

WHAT, THEN, IS THE PERIOD of preparation and incubation? Preparation is the period when we consciously work on a problem, and incubation is the period when we refrain from conscious thought and allow our unconscious to work. To facilitate moments of creativity, people need to relax and let their minds wander. The psychologist Jonathan Schooler at the University of California, Santa Barbara, has reviewed the history of "letting the mind wander" and concludes that big ideas, moments of creative insight, often seem to come not when people are hard at work on a problem, but when they are sidetracked: going for a walk, taking a shower, thinking about something else. All of a sudden, ideas that were previously isolated come together and people see connections that had escaped them—and others—before.

Schooler has also defined the nature of one type, or component, of creative insight—the Aha! moment—and the conditions under which it occurs. First, the Aha! moment is well within the competence of the average person; second, problems requiring creative insight are very likely to lead to an impasse—a state in which the person does not know what steps to take next; and third, such problems are quite likely to lead to a sustained effort that is rewarded with a sudden insight that breaks the impasse and clearly reveals the solution. This situation is thought to arise when the problem solver breaks free of unwarranted assumptions and forms novel, task-related connections between existing concepts or skills.

Aha! moments are a variant of the Eureka experience, named after the Greek mathematician Archimedes, who exclaimed, *"Eureka!"* (Greek for "I have found it!") when he discovered while taking a bath that he could ascertain an object's density by comparing its weight to the amount of water it displaced. (Archimedes was specifically interested in determining whether the king's crown was indeed pure gold, as it was claimed to be, or a less dense silver alloy.)

Andreasen recognizes the Aha! moment in the account of many prodigies, beginning with the musical genius Wolfgang Amadeus Mozart:

> When I am, as it were, completely in myself, entirely alone, and of good cheer—say traveling in a carriage, or walking after a good meal, or during the night when I cannot sleep; it is on such occasions that my ideas flow best and most abundantly. *Whence* and *how* they come, I know not; nor can I force them. All this fires my soul, and, provided I am not disturbed, my subject enlarges itself, becomes methodized and defined. . . . All this inventing, this producing, takes place in a pleasing lively dream.[10]

Like the artist, the beholder also experiences Aha! moments. Such moments are satisfying because, as Vilayanur Ramachandran writes, "the wiring of your visual centers to your emotional centers ensures that the very act of searching for the solution is pleasing."[11]

Relaxation is characterized by ready access to unconscious mental processes; in that sense it is somewhat analogous to dreaming. The recent discovery that, like much of our cognitive and affective life, even our decision making is partially unconscious suggests that unconscious mental processes are necessary for creative thinking as well. This connection is perhaps not surprising, given Freud's initial discovery of psychic determinism and the subsequent demonstration by Gestalt psychologists and William James of the importance of unconscious, bottom-up processing in perception and emotion.

In the next two chapters, we shall examine the preparation that precedes creative insight and the working through of the creative idea, both of which require conscious focus. Moreover, we shall see that some types of creative work and decisions are best handled unconsciously. Thanks to brain-imaging experiments, we are now beginning

to identify some of the regions in the brain that contribute to both the unconscious moments of insight and the later working through. As in all areas of mental function, we have learned a great deal from the experiments of nature—that is, from various brain disorders that are associated with enhanced skill and, in some instances, enhanced creativity.

*Chapter 29*

# THE COGNITIVE UNCONSCIOUS
# AND THE CREATIVE BRAIN

Sigmund Freud was the first person to point out that much
of our mental life is unconscious and that it is only revealed to us
through the limited vantage point of consciousness. Recent thinking
about the existence of several different types of unconscious function-
ing has gone substantially beyond Freud, but often in ways that he him-
self anticipated.

A new understanding of the role of unconscious mental process-
ing in decision making was revealed in a now classic set of experiments
first conducted in the 1970s by Benjamin Libet at the University of
California, San Francisco. The British philosopher of science Susan
Blackmore has called these experiments the most famous ever done on
consciousness. Libet used as his starting point a discovery made in
1964 by the German neuroscientist Hans Kornhuber, who asked vol-
unteers to move their right index finger. He then measured this volun-
tary movement with a sensor that calculated applied force, while at the
same time recording the electrical activity of each person's brain by
means of an electrode on the scalp. After hundreds of trials, Kornhu-
ber found that, invariably, each conscious movement was preceded by
a little blip in the electrical record from the brain, a spark of free will!
He called this potential in the brain the *readiness potential* and found
that it occurred a little less than one second *before* the voluntary move-
ment.

Libet followed up on Kornhuber's finding with an experiment in
which he asked volunteers to lift a finger whenever they felt the urge to

do so. He placed an electrode on each person's skull and confirmed that a readiness potential fired a little less than one second (1,000 milliseconds) before the person lifted his or her finger. Libet then compared the amount of time that elapsed between the person's willing the movement and the occurrence of the readiness potential. Amazingly, he found that the readiness potential appeared not after, but 300 milliseconds *before* a person felt the urge to move his or her finger! Thus, merely by observing the electrical activity of the brain, Libet could predict what a person would do before the person was actually aware of having decided to do it.

These studies were advanced in 2011 by the neurosurgeon Itzhak Fried and his colleagues at the University of California, Los Angeles, who studied the brains of patients undergoing operations for epilepsy. They found that the firing of a relatively small group of about two hundred fifty neurons in our brain predicts the will to move. This finding is consistent with the idea that our feeling of volition may in fact be simply a readout of activity in the brain areas that control voluntary action.

If an action is determined in the brain before it is consciously chosen, where is our "free" will? The latest research suggests that our sense of willing a movement is only an illusion, an ex post facto rationalization of an unconscious process, much like the relation of feeling to emotion. Can our choices be made freely, even if not consciously? Does the conscious decision have any causal relation to the act itself?

Libet proposes that the process of initiating a voluntary action occurs rapidly in an unconscious part of the brain but that just before the action is initiated, consciousness, which is recruited more slowly, exerts a top-down approval or veto of the action. Thus, in the 150 milliseconds before you lift your finger, consciousness determines whether or not you move it. Blackmore has argued, similarly, that conscious experience builds up slowly, taking hundreds of milliseconds to initiate action.

Libet's discovery of new unconscious dimensions in decision making was carried further by Daniel Wegner, a social psychologist at Harvard University. Wegner found that the feeling of conscious will helps us to appreciate and remember our authorship of the things our minds and bodies do. The conscious will is thus the compass of the mind: it is a course-sensing mechanism that examines the relationship

between thoughts and actions and responds with "I willed this" when the two correspond appropriately.

These ideas and Libet's finding have suggested to Wegner a circuit diagram in which we experience conscious will only when we perceive a sense of authorship—when we perceive our conscious thoughts as having caused a perceived action. If unconscious thoughts cause the action, or if we do not perceive the action, we do not experience the sense of will. This view of free will parallels in several ways the two-step processing scheme involved in emotion and feeling and the bottom-up and top-down processing of visual information in social interactions. Is it possible that creativity, like emotion, begins unconsciously, before we are aware of it? These recent insights into unconscious mental processes have opened up a new approach to the study of consciousness and the relative roles of conscious and unconscious processes in creativity.

But what exactly is consciousness and where in the brain is it located? The word itself is common enough, yet because it encompasses a number of different functions, an exact definition has eluded philosophers, psychologists, and neuroscientists alike until recently. At times, consciousness is used to describe an attentional awareness as in "She consciously listened." At other times consciousness describes simply the state of wakefulness, as in "He regained consciousness shortly after the surgery." Most problematic for neuroscientists is that any theory of consciousness must ultimately refer to *introspective experience,* a sense of self and of feeling, a phenomenon not readily accessible to objective scientific inquiry.

Michael Shadlen, now at Columbia University, has developed a more coherent and comprehensive characterization of consciousness. He emphasizes that its various attributes can be collapsed into two components, one that derives from an empirical, psychological-neurological perspective and one that derives from a philosophical perspective. The psychological-neurological perspective focuses on the aspects of consciousness that are linked to arousal and to the various states of wakefulness involved in interaction with the environmnet. In this context the absence of consciousness refers to conditions such as sleep, minimally conscious states, or coma, which do not allow for such interaction. In contrast, the philosophical perspective emphasizes mental processes that share subjective, personal features such as the conscious awareness

of self. These aspects of consciousness result in our capacity for introspection, our ability to report a narrative, and our sense of free will.

Antonio Damasio refers to this subjective aspect of consciousness as the "self process." In this process, he argues, we construct subjective mental images in response to bodily states, much as we experience conscious emotion in response to bodily states. The "self process" enables our conscious mind to experience our own history and that of the surrounding world. Experience requires an experiencer to provide subjectivity, Damasio argues: otherwise, our thoughts would not belong to us.

The aspects of consciousness that first derived from the philosophical, subjective perspective are still quite problematic for neuroscientists because they refer to introspective experience, a subjective personal perspective not yet readily accessible to scientific observation. However, opinion has converged to a surprising degree in recent years on a set of central concepts that are now included in most theories of the psychological-neurological perspective of consciousness.

This convergent view is based on the finding that our conscious ability to report a perceptual experience derives from synchronous activity in the cerebral cortex that emerges some time after a stimulus has been presented and is then broadcast globally to critical areas in the prefrontal and parietal cortices. It is this broadcasting that we experience as a conscious state of perception. The first such concept was introduced by William James in his textbook *The Principles of Psychology*. James described consciousness as a supervisory system, an extra organ that is designed to steer a nervous system which is too complex to steer itself. This view was later eleborated into the concept that information becomes conscious only when it is represented in this supervisory attentional system and propagated widely throughout the cerebral cortex. More recently, Francis Crick and Christof Koch have suggested that consciousness involves the formation of stable coalition of neurons throughout the brain, with the prefrontal cortex playing an essential role.

In 1988 the cognitive psychologist Bernard Baars incorporated several of these ideas into a way of thinking about consciousness that he calls the Global Workspace Theory: it has since been adopted and extended by various students of the biology of consciousness. According to this theory, consciousness corresponds to the momentary, active, subjective experience of working memory. Baars argues that

consciousness is not initiated at a single site: it can be initiated preconsciously at a number of different sites. These sites from which consciousness can be initiated form a widespread network that Baars called the *global workspace*. For the information to become available to consciousness the preconscious information from these sites needs to be broadcast to the brain as a whole. According to this view, consciousness is the widespread dissemination, or broadcasting, of preconscious information.

The Global Workspace Theory has three parts, which Baars describes metaphorically in terms of the theater: (1) a bright spotlight of attention focused on the action of the moment; (2) an unseen cast and crew who are not part of the immediate action; and (3) the audience. The metaphor represents mind—both its conscious and unconscious functions. Mind is not simply the actors, crew members, or audience, but the network of interactions among the three.

In Baars's theater, conscious access corresponds to the spotlight—*the spotlight of attention*—focused on the central players onstage. Since consciousness can only deal with a limited amount of information at a time, the spotlight illuminates only a small part of the stage and only a few members of the extensive cast and crew at any given time. The illuminated action onstage—the *conscious content*—corresponds to our working memory for a single event, a memory lasting only sixteen to thirty seconds.

The conscious content is then broadcast and distributed to other processors: both to all members of the audience and to many of the backstage cast and crew, a vast array of unconscious, autonomous, specialized brain networks that contribute to the small amount of conscious information that is the spotlight of attention.

Baars's Global Workspace Theory corresponds extremely well to what we now know about the neuronal architecture of consciousness. Stanislas Dehaene, a cognitive neuroscientist, and Jean-Pierre Changeux, a theoretical neural scientist, both at the Collège de France in Paris, have formulated a neuronal model of Baars's theory. According to their model, what we experience as conscious access is the selection, amplification, and broadcasting of a single piece of information to many different areas of the cerebral cortex. The model's neuronal network consists of certain *pyramidal neurons* in the prefrontal cortex and elsewhere in the cerebral cortex.

Dehaene has explored the nature of this broadcasting function by focusing on the transition from unconscious to conscious perception. As we have seen, an image cast on the retina must undergo critical transformations before becoming consciously perceptible. This lag in processing applies to all of the sensory information that finds its way into our consciousness and perhaps also into our memories, emotions, sensations, and volitions. Because sensory information must first undergo preliminary processing, all events that emerge in our consciousness must first have begun in our unconscious. Just as Libet found that our willing of a movement begins in the unconscious, so do all of our sensory processes, including vision. This raises an interesting question that Dehaene has tried to address: At what point in the processing of a stimulus is our consciousness ignited? At what point does information move from being unconsciously perceived to being consciously perceived?

USING FUNCTIONAL MAGNETIC IMAGING, Dehaene found that conscious awareness of an image emerges relatively late in the course of visual processing: as much as one-third to one-half of a second *after* visual processing begins. The initial, unconscious activity tends to activate only the local regions of the primary visual cortex (V1 and V2). During this first 200 milliseconds of visual processing, an observer will deny having seen a stimulus at all. But as vision crosses the threshold of consciousness, there is a burst of simultaneous broadcasting of neuronal activity to widely distributed regions of the brain (Fig. 29-1). It therefore seems likely that, much as Freud predicted, unconscious processes underlie almost every aspect of our conscious lives, including the perception, creation, and appreciation of a work of art.

To determine what happens when conscious awareness is recruited in response to a sensory stimulus, Dehaene combined brain imaging with simultaneous electrical recordings. He found that when information is broadcast widely and consciously perceived, it also synchronizes characteristic rhythms of electrical activity. These rhythms are thought to spark consciousness by activating a network of pyramidal neurons in the parietal and frontal regions of the brain that cause top-down amplification. Similar results were obtained in experiments involving the senses of sound and touch.

In Baars's theater metaphor, the spotlight of attention ignites activ-

Figure 29-1. The brain on the left depicts the widespread neuronal activity in response to a consciously perceived written word. The brain on the right depicts the localized neuronal activity in response to an unconsciously perceived written word. In this case the word is surrounded by a *masking stimulus*—a set of unrelated stimuli presented immediately before and after the word—which renders the word illegible while preserving unconscious visual detection. This activates neurons in specialized areas of the left primary visual cortex and temporal lobe. In contrast, a word that is consciously perceived activates not only areas of the cortex involved in unconscious perception but also pyramidal cells in widely distributed areas of the inferior parietal, prefrontal, and cingulate cortices.

ity in the unseen cast and crew who shape the events on stage, and in the audience. In biological terms, conscious attention is signaled when the pyramidal cells ignite activity in a vast number of regions throughout the brain, but especially in regions of the prefrontal cortex that are associated with working memory and executive decision making. Thus, pyramidal cells distribute signals about activity in the spotlight of attention to a widespread, otherwise autonomous audience.

WE DON'T KNOW exactly what roles the unconscious plays in complex cognitive operations. However, the idea that unconscious mental processes can deal with several items simultaneously in an orderly and coherent fashion while our conscious attention can only focus on a limited amount of information has led Ap Dijksterhuis, a Dutch social psychologist, to propose an interesting notion: unconscious thought and conscious thought differ in important ways in our decision making.

Dijksterhuis follows Freud in believing that conscious thought represents merely a sliver of the brain's overall processing power. More-

over, while it may be superior for simple, quantitative decisions with only a few possible options, like figuring out highway directions or solving an arithmetic problem, conscious thought becomes quickly overwhelmed in complex qualitative decisions with many possible alternative solutions, like choosing what car to purchase, changing careers, or aesthetically evaluating a painting. This is because consciousness recruits attention, which can only examine a small number of possibilities, often one at a time.

In contrast, unconscious thought comprises a vast web of autonomous, specialized networks throughout the brain that are capable of dealing with a number of processes independently. Dijksterhuis argues that because a great deal of memory is unconscious—namely, procedural memory for perceptual, motor, and even cognitive skills—unconscious thought is superior for decisions that require comparing many alternatives simultaneously.

In a typical decision-making experiment, Dijksterhuis gives study participants complex and detailed information about four different apartments. The information depicts one of the apartments in undesirable terms, two of the apartments in neutral terms, and a fourth in desirable terms. All participants receive the same information and have to select one apartment for their use. They are then divided into three groups. One group is told to make their evaluation immediately after reading the information; this group relied heavily on first impressions. A second group is told to choose after being given three minutes to think about the information; they relied on conscious deliberation. The third group is asked to choose after being distracted for three minutes with a task that prevents conscious thought, such as an anagram, thereby creating a period of unconscious thought. Curiously, this third—distracted—group was far more likely to choose the desirable apartment. The other two groups found the task of juggling so many variables too hard and chose poorly.

This result seems counterintuitive. One might assume that complex decisions involving a number of different variables would require detailed, conscious analysis. Dijksterhuis argues to the contrary, that the diffuse resources of unconscious thought processes are better suited to thinking that involves several variables. Much as we have seen in visual perception and emotion, the brain operates both from the top down and from the bottom up. Conscious thought works from the top down and

is guided by expectations and internal models; it is hierarchical. Dijk-sterhuis argues that unconscious thought works from the bottom up, or non-hierarchically, and may therefore allow more flexibility in finding new combinations and permutations of ideas. While conscious thought processes integrate information rapidly to form an occasionally conflicting summary, unconscious thought processes integrate information more slowly to form a clearer, perhaps more conflict-free feeling.

This emphasis on unconscious thought processes is not new. Arthur Schopenhauer, the great nineteenth-century German philosopher who was a major influence on Freud, wrote about the role of unconscious mental processes in creative problem solving:

> One might almost believe that half of our thinking takes place unconsciously. . . . I have familiarized myself with the factual data of a theoretical or practical problem; I do not think about it again, yet often a few days later the answer to the problem will come into my mind entirely of its own accord; the operation which has produced it, however, remains as much a mystery to me as that of an adding machine: what has occurred is, again, unconscious rumination.[1]

A number of experiments have also focused on the circumstances under which conscious decision making is superior to unconscious decision making. Many decisions involve choices that vary in probability and value. In such decisions, the best thing to do is to maximize the expected utility of a choice, which may require conscious attention. What is fascinating, however, is both that we can make any important decisions at all using unconscious mental processes and that these unconscious processes could contribute to creativity.

THE IDEA THAT unconscious mental processes can contribute to creativity was first introduced by Ernst Kris, who argued that creative people have moments in which they experience, in a controlled manner, a relatively free communication between their unconscious and conscious selves. Kris called this controlled access to unconscious thought, mediated by the brain's top-down, inferential processes, *regression in the service of the ego*. In moments of creativity, he and Ernst Gombrich argue, artists regress voluntarily in a way that benefits their

creative processes. In contrast, regressions to earlier, more primitive psychological functioning that occur in a psychotic episode are involuntary; they are not under the control of the individual and not usually to their benefit. By regressing in this controlled manner, artists are able to bring the force of unconscious drives and desires into the forefront of their images. It is perhaps because the Austrian modernists were in tune with such regressions that they were able to depict themes of sexuality and aggression so authentically and to intuit so accurately the types of exaggeration or distortion that successfully recruit the emotional underpinnings of the visual system.

Following Freud, Kris ascribes a different logic and a different language to unconscious and conscious mental processes. Unconscious mental processes are characterized by primary-process thinking. Such thinking is analogical, freely associative, characterized by concrete images (as opposed to abstract concepts), and guided by the pleasure principle. Conscious mental processes, in contrast, are governed by secondary-process thinking, which is abstract, logical, and guided by reality-oriented concerns. Because primary-process thinking is freer and hyper-associative, it is thought to facilitate the emergence of moments of creativity that promote new combinations and permutations of ideas—the equivalent of an Aha! moment—whereas the full focus of secondary-process thinking is required for the working through, the elaboration, of the creative insight.

Dijksterhuis and Teun Meurs carried out a set of studies designed to explore why unconscious thought—thought without attention—leads to creativity. In designing their experiments, they explored the common notion that the unconscious works most effectively during the period of incubation, when a person refrains from conscious thought. This idea holds that when we take the wrong approach to a problem, which happens often, we get nowhere by continuing to think about it. But if we refrain from thinking about the problem and distract ourselves, *set shifting* can take place. Set shifting is a transition from a rigid, convergent perspective to an associative, divergent perspective; the shift makes the wrong approach less accessible to our mind and sometimes leads to our forgetting it altogether.

TO TEST THE IDEA of set shifting, Dijksterhuis and Meurs compared three groups of people who were asked to generate items in response to

specific instructions, such as "a list of places starting with the letter A" or "things one can do with a brick." The groups were asked to generate a list either immediately upon request, after a few minutes of conscious deliberation, or after engaging in a distracting activity for a few minutes. Although there was no difference in the number of items each group generated, the lists produced by the unconscious thinkers were invariably more divergent, unusual, and creative. Moreover, as we saw above in the experiments involving apartments, people in the incubation group arrived at solutions that later proved more satisfactory to them than did people in the other two groups. Thus distraction, letting the mind wander, may not only encourage unconscious (bottom-up) thought, but also, as evidenced by the emergence of a new solution, recruit a new top-down process from memory storage.

AT FIRST, THE FINDINGS of Libet, Dijksterhuis, and Wegner do not seem to square with the commonsense notion that we make all important decisions about our life consciously. But as Blackmore has pointed out, once we understand that there are different types of unconscious processes, the problem disappears. Some unconscious processes are capable of coherent synthesis; others, those that Freud attributed to the id, are the repository of uncontrolled instinctual urges. As a result, we need to rethink what we mean by unconscious mental functions.

We have seen that one component of unconscious information processing involves cognition and has ready access to consciousness. This is the *cognitive unconscious*—the cognitive part of the ego. Its processes are consistent with modern psychoanalytic thinking, which holds that the ego has an autonomous sphere that is relatively free of instinctual striving and that is available for decision making. The idea of a cognitive unconscious, first introduced in 1987 by the cognitive psychologist J. F. Kihlstrom of the University of California, Berkeley, was elaborated by Seymour Epstein and, later, by a number of other cognitive psychologists.

The cognitive unconscious shares features with two unconscious components of the ego outlined by Freud: the *procedural (implicit) unconscious*, which is responsible for our unconscious memory of motor and perceptual skills, and the *preconscious unconscious*, which is concerned with organization and planning. Like Freud's two unconscious processes, the cognitive unconscious outlined by Kihlstrom is con-

stantly being updated by experience, in this case by a variety of conscious deliberations over our lifetime. Indeed, Dijksterhuis argues that without conscious, top-down processing, we would not be able to hone and update the cognitive skills required for decisions and for creative acts. Moreover, under some circumstances, the cognitive unconscious is monitored in the very act of deciding or creating by conscious, top-down cognitive processes.

There are two reasons for thinking that the cognitive unconscious may contribute to creativity. First, the cognitive unconscious can manage a greater number of operations than the conscious processes that occur at the same time. Second, as Kris argued, the cognitive unconscious may have particularly easy access to what Freud called the dynamic unconscious—our conflicts, sexual striving, and repressed thoughts and actions—and can therefore make creative use of those processes.

The studies of voluntary action, decision making, and creativity described in this chapter have led to a view of unconscious activity that is even richer and more varied than Freud could have imagined a century ago. What is more, as we understand the biology of conscious and unconscious processes better, we are likely, in the near future, to see further important advances in the dialogue between art and brain science—a dialogue that began, as we have seen, in Vienna 1900 as a dialogue between psychoanalysis and brain science.

# BRAIN CIRCUITS FOR CREATIVITY

cᴠ/ᴐ

Cᴀɴ ᴡᴇ ᴘɪɴᴘᴏɪɴᴛ ᴛʜᴇ ɴᴇᴜʀᴀʟ ᴄɪʀᴄᴜɪᴛꜱ ᴛʜᴀᴛ ᴄᴏɴᴛʀɪʙᴜᴛᴇ ᴛᴏ ᴛʜᴇ generation of creative insights, those Aha! moments?

Preliminary evidence from a number of sources suggests that, although all parts of the cerebral cortex contribute to creativity, certain aspects of creativity are more likely to take place in association areas of the cortex. There are intriguing, but by no means compelling, suggestions that creativity involves the right hemisphere of the cerebral cortex, particularly the right anterior superior temporal gyrus and the right parietal cortex. When study volunteers solve verbal problems that require creative insight, activity in this region of the right temporal lobe increases; moreover, a sudden burst of high-frequency activity occurs in the same region 0.3 seconds *before* the insight. This distinct pattern of activity in the right temporal lobe suggests that creative solutions require this area of the brain to integrate information unconsciously, thus enabling us to see a problem in a new light, in a way we would not usually think of consciously. Similarly, studies of mathematically gifted children, summarized by John Geake, have revealed that the right parietal area and the frontal lobes on both sides of the brain are recruited for creative dimensions in mathematical problem solving.

These findings are particularly interesting because for a long time it was thought that, with the exception of language, many "left brain–right brain" differences were pseudoscience. For example, in the 1980s, it was first proposed that the left hemisphere is more analytical and logical and the right hemisphere more holistic and intuitive. A number of studies failed to support that broad claim; their findings suggested, in essence, that both hemispheres are involved in cognitive activities

such as music, math, and logical reasoning. Recently, however, the results of a number of systematic studies reviewed by Robert Ornstein suggest that at least certain types of insights involve the right hemisphere preferentially.

ALTHOUGH THESE MODERN findings emerged from studies of people with intact brains, we know from the earlier work of the great nineteenth-century neurologists Paul Broca and Carl Wernicke that we can learn much about the biology of complex cognitive processes by examining the behavioral consequences of specific forms of brain damage. As a result, we have known since the middle of the nineteenth century that even though the left and right cerebral hemispheres look symmetrical and work together in perception, thought, and action, they are not functionally symmetrical. To begin with, each cerebral hemisphere is primarily concerned with the sensation and movement of the opposite side of the body. As a result, it is the left motor cortex that is responsible for most of us being right-handed. Moreover, in almost all right-handed people, the understanding and expressing of both spoken and sign language is mediated mainly by the left hemisphere. The right hemisphere is more concerned with the musicality of language, with intonation. It is also better than the left hemisphere in a range of perceptual functions that do not require language, such as visual-spatial information processing, memory for abstract design, copying, drawing, and face recognition.

Based on these observations, the founder of British neurology, John Hughlings Jackson, ascribed the differences in function to differences in cognitive specialization. Following the discoveries of Wernicke and Broca, he argued in 1871 that the left hemisphere is specialized for analytic organization and thus for the structure of language, whereas the right hemisphere is specialized for associating stimuli and responses and thus for bringing new combinations of ideas into association with each other.

Hughlings Jackson elaborated on this view in the context of his broader theory of how the brain functions. He conceived of the brain as having accrued a series of progressively more complex levels through evolution. Each higher level is governed by rules of integrative action similar to those that apply to the lower levels, and all of the levels are governed by a balance between inhibitory and excitatory action much

as Stephen Kuffler found in the retina and David Hubel and Torsten Wiesel found in the cerebral cortex. Normally, Hughlings Jackson argued, excitatory and inhibitory forces between the two hemispheres are in balance, resulting in only a certain portion of the brain's potential capabilities being expressed. Other capabilities, including the right hemisphere's capacity for creative action, are actively suppressed. But damage to one hemisphere prevents it from inhibiting the other hemisphere; as a result, previously hidden mental capabilities in the undamaged hemisphere, including creative powers, are no longer suppressed.

Hughlings Jackson formulated this idea while studying the musical capability of children who had *acquired aphasia,* a disorder of language involving the left hemisphere. He noted that damage to the left hemisphere did not diminish the children's musical ability, which is governed by the right hemisphere; instead, the damage actually heightened their musical ability. For Hughlings Jackson, this finding was an example of the release of a normally suppressed right brain function (musicality) following damage to the left side of the brain.

Although his tools for directly examining the brain were essentially indirect, and limited to a reflex hammer, a safety pin, a wad of cotton, and extraordinary clinical observational skills, Hughlings Jackson's insights into the ability of the right hemisphere to make new associations—a component of creativity—and of the left hemisphere to inhibit this creative potential turned out to be prescient, albeit probably overdrawn. To begin with, his findings showed that injuries can reveal which areas of the brain contribute to creativity, whether in a positive or a negative way. In addition, they indicated that the left side of the brain tends to use logic as its language, being oriented to detail and concerned with facts, rules, and language, whereas the right side of the brain tends to use fantasy and the imagination, being concerned with big-picture orientations, symbols, images, risk-taking, and impetuosity.

A century after Hughlings Jackson laid the foundation for modern neurology, Elkhonon Goldberg, a student of the cognitive functions of the brain, reintroduced the idea that the left hemisphere is specialized for processing routine or familiar information, while the right hemisphere is specialized for processing novel information. Goldberg's idea is supported by Alex Martin and his colleagues at the National Institutes of Health. Using PET imaging of the brain, they found that when

a stimulus such as an object or word is presented repeatedly, the left hemisphere remains consistently active. The right hemisphere, in contrast, becomes active only when a novel stimulus, or a novel task, is presented. Activation of the right hemisphere decreases as a stimulus or task becomes routine through practice, whereas the left hemisphere continues to process the stimulus.

Goldberg's earlier work had suggested that the right hemisphere of the brain plays a special role in solving problems that require insight, probably because the right hemisphere continuously processes loose or remote associations between the elements of a problem. In fact, in a study of volunteers who solved a problem using creative insight, some activity continued to occur in the right hemisphere during the resting stage.

Earl Miller at MIT and Jonathan Cohen at Princeton University have argued that the prefrontal cortex, often thought of as being involved in abstract reasoning and the top-down regulation of emotion, is also responsible for the working through of creative insights using secondary-process, logical thinking. Once a person has arrived at a creative solution, the prefrontal cortex becomes active, focusing not only on the task at hand but also on figuring out what other areas of the brain need to be engaged in order to solve the problem. Thus, the science writer Jonah Lehrer argues, if we are trying to solve a verbal puzzle, the prefrontal cortex will selectively activate—by means of top-down processing—the specific brain areas involved with verbal processing. If it decides to turn on part of the right hemisphere, we might end up with an insight. If it decides to restrict its search to the left hemisphere, we will probably arrive at a solution incrementally, if at all.

The prefrontal cortex makes all of these plans without any conscious awareness of what we are planning, which suggests that it is important for cognitive unconscious processes. This finding has led to the idea that problem solving, whether creative or methodical, does not begin from scratch, when a person starts to work on a problem. Often, the person has worked on aspects of the problem before. As a result, there is in problem solving, as in decision making, a preexisting, unconscious brain state that enables the person to choose either a creative or a methodical strategy.

WE CAN NOW ASK the question that Hughlings Jackson originally posed: What can we learn about decision making and related aspects of creativity by studying people whose talents emerge as a result of variations or deficits in "normal" brain function? Brain-imaging studies show that the prefrontal cortex is active during visual perception and imagery and that creativity tends to involve activity in both sides of the prefrontal cortex. However, as a visual artistic skill increases, connections between the right and left sides are reconfigured, with activity in the right prefrontal cortex seeming to override the inhibitory potential of the left side. Thus, interaction between the right and left prefrontal cortex may contribute to the production or inhibition of originality and creativity.

These findings may explain the sudden emergence of artistic talent in people who suffer from frontotemporal dementia. The neurologist Bruce Miller at the University of California in San Francisco studied a group of patients with this dementia whose damage was largely restricted to the *left* frontal and temporal lobes. Such damage presumably reduces the left hemisphere's ability to inhibit action in the right frontal and temporal lobes.

Because the left side of the brain is more damaged than the right side in this group of patients, their talents, like those of most autistic savants and dyslexic persons, are usually visual, not verbal. However, the release phenomenon—the outburst of creativity released by damage to the left hemisphere—seems not to be universal; rather, it may be present in people who already have the potential for creativity.

Some of the patients continued to paint and to photograph even as their disease advanced. One of these was Jancy Chang, a high school art teacher who had painted since childhood. As her frontotemporal dementia progressed, she had to retire from teaching. Miller found that as Chang lost more of her social and language abilities, indicating that her left frontal and temporal cortices had become more compromised, her art became freer and bolder. Instead of striving for realism in her work, as she had done for her entire life, she became less restrained, employing artificial colors, extreme anatomical distortions, and exaggerated facial expressions and body postures.

Unlike Chang, however, most patients with left frontotemporal dementia who show artistic talent produce paintings, photographs, and sculptures that are realistic representations lacking abstract or symbolic components. Those who paint seem to recall images from their earlier years, often their youth, and then mentally reconstruct those pictures without the mediation of language. Moreover, the artists show progressive interest in the fine details of faces, objects, and shapes. Finally, they are intensely, almost compulsively preoccupied with their art and are willing to repeat a work until it is perfect. One fifty-one-year-old housewife began to paint rivers and rural scenes that she remembered from her childhood. A fifty-three-year-old man with no prior interest in art painted churches he had seen as a child. A fifty-six-year-old businessman developed a passion for painting that led to his winning several awards. In such cases, visual elements are thought to be organized into coherent and meaningful scenes through residual neural processing in the right frontal lobe, now no longer inhibited by the left hemisphere.

Additional insights have come from studies of artists who suffered a stroke on the left side of their brain, which compromises the ability to use language and is thought to disinhibit the right hemisphere. These artists not only retained, but in some cases actually improved their technical skill following the loss of language. The cognitive psychologist Howard Gardner, who has reviewed this literature, cites a painter who became aphasic after a stroke: "There are in me two men . . . the one is grasped by reality to paint, the other one, the fool, who cannot manage words anymore."[1]

The psychologist Narinder Kapur uses the term *paradoxical functional facilitation* to describe this unexpected behavioral improvement following a brain injury. He suggests, as did Hughlings Jackson earlier and Oliver Sacks more recently, that in the healthy brain, inhibitory and excitatory mechanisms interact in complex harmony. After an injury, the removal as a result of the injury of some inhibitory actions on one side of the brain may result in the enhancement of specific functions on the other side of the brain.

Consistent with the idea that creativity involves the removal of inhibition, studies have found that the expression of artistic talent in general stems from a lessening of inhibitions on novelty seeking. Novelty seeking encompasses capacities such as the ability to think unconven-

tionally, to use divergent thinking in open-ended situations, and to be open to new experiences. The frontal lobes are part of a network that is responsible for seeking and detecting novelty, a process that is fundamental to creativity.

HOW IS CREATIVITY manifested in the brain of people without damage to the right hemisphere? As yet, no systematic brain-imaging studies have been carried out on people with demonstrable creativity, such as great artists, writers, or scientists. However, studies of one component of creativity, the Aha! moment in normal people, have been dramatically advanced by the productive collaboration between Mark Jung-Beeman at Northwestern University and John Kounios at Drexel University. Both Jung-Beeman and Kounios carried out independent cognitive psychological research on creative insight before collaborating on neuroanatomical and functional studies of *insight problem solving*—the sudden visualization of a novel solution to a problem.

THE STUDY OF GRADUAL and abrupt improvements in behavioral learning has a long history. In 1949 the great Canadian psychologist Donald O. Hebb pointed out that to produce insight, a task needs just the right degree of difficulty. It cannot be so easy that a person solves it right away, or so hard that the person fails to solve it except by rote learning in a repeated series of trials. A particularly interesting example of such a task is a 1997 study by Nava Rubin, Ken Nakayama, and Robert Shapley from Harvard University and New York University based on the Dalmatian dog illusion we considered in Chapter 18.

As we have seen, the observer of this illusion abruptly perceives the contours of the dog, an experience that resembles the Aha! phenomenon of an insight. The observer goes from a "don't know" to a "know" state without an intermediate level of learning. These experiments suggested to Rubin and her colleagues that, in addition to the specific visual features of the stimulus (that is, the dog), there must be a higher-level, general set of perceptual insights that brings about the abrupt learning of visual contours.

It is this higher-order component of Aha! perception that Kounios and Jung-Beeman addressed. Jung-Beeman first became interested in creative insight when he unintentionally followed a scientific trail similar to the one that led Hughlings Jackson to the right hemisphere of the

brain. Jung-Beeman was studying the properties of the right hemisphere in people who had suffered brain damage from stroke or surgical procedures on either hemisphere of the brain. He noticed that people who had had surgery on the right hemisphere did not lose their ability to speak and comprehend language, but they did have serious cognitive problems, particularly difficulty understanding linguistic nuance. From this he concluded that the left hemisphere excels in denotation, the primary meaning of a word, while the right hemisphere deals with connotation, the metaphorical and inferential connections of words. Continuing the line of thought that began with Hughlings Jackson and Goldberg, Jung-Beeman attributed the connotative functions to the right hemisphere's ability to process broader associations. This finding encouraged him to wonder about two ways of solving a puzzle: a moment of creative insight, and one that requires methodical testing of potential solutions.

Meanwhile Kounios also began with a cognitive psychological approach to creative insight. Insight fascinated the Gestalt psychologists. Indeed, as we have seen, it takes insight to solve some of their figure-ground problems: only after the brain has detected two images does our attention switch in an all-or-none—Aha!—way from one image to the other (Figs. 12-2 and 12-3).

Kounios started out studying insight by testing the theory that information can be processed in one of two ways: continuously or in a single moment in time. To determine whether a person's accurate and final solution to a problem occurs instantaneously or over time, Kounios and his colleague Roderick Smith measured the speed with which people assimilate information. They found that information is indeed processed in two ways: suddenly or continuously. Moreover, sudden solutions, which are characteristic of discrete processing, distinguish insight from systematic problem solving. Thus, by focusing on the suddenness with which a solution appears, Kounios and Smith developed a new experimental paradigm for studying a potential component of creativity, the Aha! phenomenon.

Their independent psychological studies led Kounios and Jung-Beeman to collaborate on a series of experiments; Jung-Beeman studied the Aha! moment using functional MRI, and Kounios explored it using electroencephalography. The two techniques for measuring brain activity complement each other perfectly: electroencephalograms

(EEGs), which are superior for pinpointing when an event occurred but poor at identifying where it occurred, have good temporal resolution but poor spatial resolution, whereas functional MRIs have the inverse strengths and weaknesses.

Jung-Beeman and Kounios gave study participants a large number of simple problems, all of which could be solved either by insight or by systematic effort. For example, they presented participants with three nouns, *crab*, *pine*, and *sauce*, and asked them to think of a single word that could be combined with each noun to form a familiar compound noun. The answer was *apple*: *crabapple*, *pineapple*, and *applesauce*. About half of the subjects came up with the answer by systematically working through various combinations, and the other half solved it in a flash of insight.

Brain imaging revealed that a region of the right temporal lobe—the anterior superior temporal gyrus—became particularly active when

Figure 30-1. Insight as detected by fMRI.
Greater activation in the right anterior superior temporal gyrus of the brain at the moment of insight than in non-insight.

the participants experienced an Aha! moment (Fig. 30-1). That same region also became active during the initial effort to solve the problem, indicating that its response is not limited to the emotional Aha! moment. Finally, the same region of the right temporal lobe was active in tasks that require integration of distantly related semantic activity, as when people have to derive the theme of an ambiguous story.

To obtain better temporal resolution and to determine what sort of brain signals are associated with these solutions, Jung-Beeman and Kounios used EEGs. They found that just before making a firm decision, a person exhibits high-frequency (gamma) activity in the same region of the right temporal lobe identified by brain imaging (Fig. 30-2).

Thus, much as Hughlings Jackson had suggested a century earlier, the right hemisphere seems capable of making connections between different types of information. Although problem solving generally relies on shared cortical networks, the sudden flash of insight that occurs when we engage distinct neuronal and cognitive processes seems to allow us to see connections that had previously been elusive.

CONTINUING THEIR WORK TOGETHER, Jung-Beeman and Kounios found that creative insight is in fact the culmination of a series of transient brain states operating at different places and over different lengths of time. This is true even though the insight occurs suddenly and seems disconnected from the thought processes that preceded it.

The first areas that are activated in study participants solving a problem with creative insight are the anterior cingulate regions of the

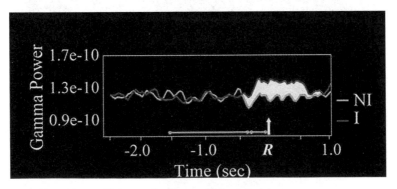

Figure 30-2. Just before making a decision, a person exhibits high-frequency (gamma) activity in the same right anterior superior temporal gyrus as in Figure 30-1.

prefrontal cortex and the temporal cortex on both sides of the brain. When solving a problem analytically, the visual cortex is activated; this suggests that participants are directing their attention to the screen on which the problem is presented. Jung-Beeman and Kounios defined this as the *preparatory phase,* the period of time just before the presentation of a problem; it is similar to the preexisting brain state identified by Goldberg. Jung-Beeman thinks that during this phase, the brain attempts to focus on the problem and block out everything else. Next, coinciding with a participant's actual derivation of the solution, the EEG registers a spike of very high frequency electrical activity. Simultaneous with this gamma burst, the functional MRI shows activity in the right temporal lobe, specifically the anterior superior temporal gyrus discussed above (Fig. 30-2 ).

Consistent with the conclusions that Nancy Andreasen drew from her study of creative writers, Jung-Beeman believes the relaxation phase is crucial for the Aha! phenomenon. He argues that creative insight is a delicate mental balancing act on which the brain lavishes a lot of attention; once focused, it needs to relax in order to seek out other potential paths to a solution, paths that are more likely to appear as a result of right-hemisphere processing. This emphasis on relaxation is perhaps why so many creative insights are thought to occur during a warm shower. Another ideal moment for creative insights is thought to be early in the morning, right after we wake up. The drowsy brain is unwound and disorganized, open to all sorts of unconventional ideas.

Jung-Beeman argues further that when a person is actively trying to solve a problem by creative insight, he or she needs to concentrate but at the same time let the mind wander—regress—at some point in the process, either when at an impasse or during incubation. This argument also applies to the appreciation of art. Looking seriously at a work of art requires that we focus on the work to the exclusion of everything else. But there are degrees of focus. If we focus on the details of a portrait rather than the overall picture, we can significantly disrupt our insight into the overall image. Therefore, it is important, as Alfred Yarbus's studies of eye movements illustrate, that we move our eyes all over the scene, taking in both the details and the big picture.

ARE CREATIVE THOUGHT and noncreative, analytical thought fundamentally different? If so, are people who think creatively, who

presumably can easily get in touch with their unconscious thoughts, fundamentally different from those who tend to think in more systematic, methodical fashion?

To explore this question further, Kounios and Jung-Beeman conducted a study in which participants were divided into two groups: those who reported solving the problem mostly by sudden insight, and those who reported solving the problem more methodically. All participants were asked to relax quietly while researchers measured their brain activity with EEGs. They were then presented with scrambled letters to rearrange as words, a task that could be solved deliberately and methodically, by trying out different combinations of letters, or with sudden insight. The two groups displayed strikingly different patterns of brain activity not only during the problem-solving period but also during the resting period at the beginning of the experiment, before they knew what the task would be. During both periods, the creative solvers exhibited great activity in several regions of the right hemisphere.

Similarly, in his book *The Emerging Mind,* Vilayanur Ramachandran identifies the right parietal lobe as part of the brain circuit concerned with a sense of artistic proportion. Lesions in this region in adults lead to a loss of artistic sense.

As a consequence, we now have some reason to entertain the idea that the brain divides work between the two hemispheres in a way that takes advantage of the relative strengths of each. Thus, although both hemispheres work on the same processes—be it in perception, thought, or action—and they do so simultaneously and cooperatively, they appear to contribute to creativity in different ways, with the right hemisphere contributing importantly to creativity. So far, however, we have only limited insight into a few components of creativity, such as the unconscious work that leads to an Aha! moment.

# TALENT, CREATIVITY, AND
# BRAIN DEVELOPMENT

ᑲᘮᕆ

CARL VON ROKITANSKY WAS INSTRUMENTAL IN ESTABLISHING
the idea that diseases are experiments of nature and that by studying them
carefully we learn a great deal about the basic biological activities they
disrupt. This principle that one can learn a great deal about normal bio-
logical functions from disease states—experiments of nature—was later
shown to apply to the brain by Paul Broca and Carl Wernicke in their
studies of patients with brain lesions who developed language impair-
ments. Since then, we have continued to learn about mental processes by
examining how they are disrupted by brain disorders. Indeed, we have
obtained some surprising insights into the nature of creativity by study-
ing people who display amazing talents despite having developmental or
acquired disorders of the brain. Those studies, which show how certain
brain disorders seem to release creative potential, complement studies of
creativity in people without any brain disorders.

People with certain developmental disorders, such as dyslexia and
autism, may exhibit artistic ability despite clear disabilities in language.
This suggests the interesting possibility that visual art and language,
though both represent methods of symbolic communication, may not
be intrinsically linked. Perhaps in human evolution the ability to ex-
press ourselves in art—in pictorial language—preceded the ability to
express ourselves in spoken language. As a corollary, perhaps the pro-
cesses in the brain that are important for art were once universal but
were replaced as the universal capability for language evolved. The
capability for art would have become restricted to a subset of creative

people, including those who do not have fully developed language skills.

Children have to learn how to distinguish "mirror" characters such as *b* and *d* or *6* and *9*, and to write *s* and not its reverse. All children initially have difficulty with these distinctions, but the difficulty is particularly pronounced in children with dyslexia. Indeed, the visual psychologists Charles Gross and Marc Bornstein have suggested that developmental dyslexia (the failure of a child of normal intelligence to read by a certain age) may reflect not simply a deficiency in the left hemisphere of the brain but also the dominance of the right, non-language hemisphere. This combination results in slower acquisition of reading, both because reading is a left-hemisphere skill and because right-hemisphere skills, such as mirror image equivalence, see a *b* and a *d* as essentially the same character. This could explain why children with dyslexia reverse individual characters.

Dyslexic people also have difficulty translating the letters on a page into the sounds those letters represent, a skill evident in reading, and translating sounds into letters, a skill evident in writing. This difficulty results in their reading slowly, which is usually the first symptom of dyslexia to be detected. Reading slowly is often taken as a reflection of limited intelligence, but this correlation does not hold for people with dyslexia, many of whom are very intelligent and inventive.

Several reports now suggest that dyslexic people have a somewhat greater tendency to be artistic and are better at drawing than the rest of the population. This tendency is evident even in early childhood, before the reading disability manifests itself. Wolff and Lundberg compared students in the art school of a highly regarded Swedish university with the rest of the student body and found a much higher incidence of dyslexia in the art school students.

THE CONNECTION OF CREATIVITY to a developmental disorder such as dyslexia is brought home by Chuck Close, one of the great painters of our time. Close is dyslexic, and like some other people with dyslexia, he is convinced that his creativity derives from his disorder. When he was young, he had enormous difficulty reading. He could not add five and five unless aided by dominoes, but from the age of four onward he loved to draw. Although his parents were of modest means,

they arranged for him to take drawing lessons. At age fourteen, he saw a Jackson Pollock exhibit that inspired him to dedicate his life to painting.

In both his art and his life, Close struggles to handle three-dimensional forms. He cannot look at a face and deal with its complexity. This is because in addition to his dyslexia, Close suffers from prosopagnosia, the inability to recognize individual faces. Eventually, he learned that he could recognize faces if in his mind's eye he flattened the three-dimensional image of a face into two dimensions. Using this ingenious method of coping with his prosopagnosia, Close has spent his entire career painting nothing but faces; indeed, his whole artistic endeavor emerged in response to his inability to see the visual world as other people see it.

Close's prosopagnosia may have enhanced his ability to paint faces. One of the greatest challenges a portrait painter faces is depicting a three-dimensional face on a two-dimensional canvas, but to Close this flattening process is no different from the one he uses every day to recognize the people in his life. For his portraits, Close first photographs his subject, and then, having a flat and enlarged surface to work with, places a tightly spaced grid of squares over the photograph. He then fills each square with a small, often decorative image and transfers them, square by square, to the canvas. Close's remarkable transformation of disorder and disability into talent is perhaps the most impressive of his many artistic accomplishments.

Knowing what we do about Close's work and developmental disorders, we might wonder, as John Hughlings Jackson would, what they can teach us about creativity. As we have seen, connections between the right and left hemispheres are thought to be reconfigured as artistic skill increases; specifically, activity in the right prefrontal cortex seems to emerge as the left side's ability to inhibit it lessens.

Sally and Bennett Shaywitz at the Yale Child Study Center have imaged the brains of dyslexic students and found that they have a defect in Wernicke's area, the area in the left hemisphere concerned with word comprehension. As these students try to develop better reading skills, an area on the right side of the brain thought to be associated with visual-spatial thinking takes over for the word-forming area on the left side. Thus, dyslexia may have interfered with Close's ability to com-

prehend written language, but it may also have enhanced the development of the regions in the right brain that are responsible for his remarkable draftsmanship and creativity.

Close is by no means unique among artists. Other dyslexic artists include the photographer Ansel Adams, the sculptor Malcolm Alexander, the painter and sculptor Robert Rauschenberg, and even Leonardo da Vinci. Other creative people with dyslexia were Henry Ford, Walt Disney, John Lennon, Winston Churchill, Nelson Rockefeller, Agatha Christie, Mark Twain, and William Butler Yeats. We perhaps should not wonder at their success, since great writing and poetry depend on the artist understanding how words affect us, not on mechanical skill.

OTHER INTERESTING AND DETAILED insights into talent associated with developmental disability have come from studies of autistic savants—people who are extremely talented in one field but generally function poorly in most others. Savants make up anywhere from 10 to 30 percent of autistic people, and they share several features. To begin with, they have an extraordinary ability to focus their attention on the task at hand. This ability derives from three common strengths of autistic savants: enhanced sensory function, a prodigious memory, and a great capacity for practice. Enhanced sensory function enables them to focus their attention on specific patterns and features in the environment, resulting in a much finer than normal discrimination of details. These three traits are also found in talented people who are not autistic, but whereas the skills of talented people may extend to many areas, the skills of savants are typically limited to four areas: music (typically performance on the piano, perfect pitch, and, rarely, composing), art (technical skill in drawing, sculpture, or painting), mathematics and calculating (including calculations at lightning speed and the ability to compute prime numbers), and mechanical or spatial skills.

The skills of some rare savants are so extraordinary that they would stand out in any group. The psychologist Darold Treffert suggests that these capabilities may reflect a dysfunction in the left hemisphere of the brain that, paradoxically, facilitates activity in the right hemisphere. Lorna Selfe, Uta Frith, and Oliver Sacks describe several fascinating examples of autistic people with such talent. One is Nadia, who at age five drew not the stick-figure drawings and circular faces typical of a gifted child her age, but horses—and not simply generic

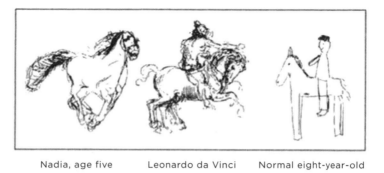

Nadia, age five        Leonardo da Vinci        Normal eight-year-old

Figure 31-1

horses, but specific, individualized horses that are admired by professionals (Fig. 31-1).

Nadia was born in Nottingham, England, in 1967. She was described in 1977 by Selfe, a psychologist, in her book *Nadia: Case of Extraordinary Drawing Ability in an Autistic Child*. At age two and a half, Nadia suddenly started to draw, first horses and then a variety of other subjects, in ways that psychologists considered simply impossible. Her drawings were qualitatively different from other children's. The earliest ones showed a mastery of space, an ability to depict appearances and shadows, and a sense of perspective that gifted children do not develop until their teens. A master of perspective, she constantly experimented with different angles and vantage points.

In her third year, Nadia began to produce line drawings of animals and people, mostly from memory, with uncanny, photographic accuracy and graphic fluency. Normal children go through a series of developmental sequences, from random scribbling to schematic and geometric figures. Nadia, still unable to speak and socially unresponsive and clumsy at age five, seemed simply to bypass those stages and move at once to highly recognizable, detailed drawings: she could draw a horse that almost leaps off the page. To illustrate Nadia's extraordinary talents, Vilayanur Ramachandran contrasted her remarkable horse with both the lifeless, two-dimensional, tadpole-like sketches drawn by most normal eight- or nine-year-olds, and a very good horse drawn by Leonardo da Vinci at the height of his career. Ramachandran argues:

In Nadia perhaps many or even most of her brain modules are
damaged because of her autism, but there is a spared island of

cortical tissue in the right parietal. So her brain spontaneously allocates all her attentional resources to the one module that's still functioning, her right parietal.[1]

PRODIGIES ARE NOT UNUSUAL in music. There are many, of whom Mozart is the best known; in fact, most great composers were prodigies and began composing at an early age. But as Picasso has pointed out, "There are no prodigies in art."[2] Picasso, himself a remarkable drafts-man by the time he was ten, could not draw a horse at age three, nor could he draw a cathedral at age seven. Both of these feats Nadia accomplished with ease at age three.

Nadia's precocity has had an interesting impact on modern thought about early humans. Her brilliantly drawn horses resemble, and have been compared to, European cave paintings of thirty thousand years ago (Figs. 31-2, 31-3). In fact, Nadia's horses and other drawings caused the psychologist Nicholas Humphrey to challenge our ideas about the nature of the human mind that painted cave art.

Ernst Gombrich and other art historians have argued that the emergence of cave art in Europe is proof that the human mind was fully formed thirty thousand years ago. Gombrich held that these early Europeans had already developed sophisticated linguistic abilities that enabled them to use symbols and to communicate. In describing his response to the then newly discovered paintings of the Cosquer and Chauvet caves in the south of France, Gombrich quotes the Latin phrase *Magnum miraculum est homo*—"Man is a great miracle."[3] He implied that in these cave paintings a new kind of mind was at work: the modern, mature, cognitively polished mind we know today.

That may not be the case, argues Humphrey. He points to the astonishing similarities between Nadia's drawings and the cave drawings. Both are characterized by a striking naturalism that is evident in their focus on individual animals. Moreover, Nadia drew more animals than people, and the Chauvet cave contains no representations of people—the first images of human figures were crudely drawn symbols in the paintings of the Lascaux cave, some thirteen thousand years later. Yet Nadia's art was the product of a three-year-old with no sophisticated capability for linguistic symbolization or communication. In fact, she communicated very poorly and had virtually no language ability. The presumed dissimilarity between Nadia's mind and the mind of the cave

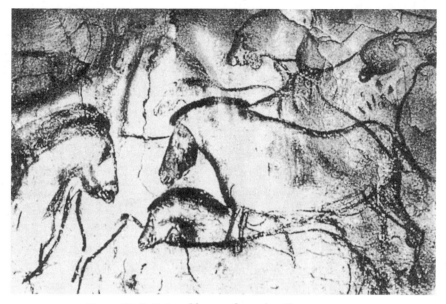

Figure 31-2. Painted horses from the Chauvet caves.

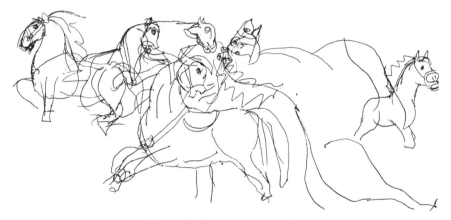

Figure 31-3. Horses by Nadia.

artists led Humphrey to question assumptions about the cave artists' linguistic ability.

Humphrey speculates that the human mind was still evolving thirty thousand years ago. Mental development at this early point may have resembled the autistic mind, with limited capability for verbal communication and empathy. Indeed, based on his studies of Nadia, Humphrey proposes that the artists of the cave paintings had distinctly

premodern minds: they were little given to symbolic thought. Cave art, far from being the sign of a new order of mentality, might just be the swan song of the old. He goes on to say that Nadia tells us something more about the nature of the human mind: a person may not need an evolutionarily modern mind to draw. Indeed, to draw that well, perhaps an artist must not have a typical modern mind at all.

By extension, Humphrey argues, language as we think of it may not have been characteristic of human beings living in Europe thirty thousand years ago. Instead, language may have evolved later and may have come at the expense of the fantastic artistic ability that Nadia and the cave artists manifested; after the advent of language, art may have developed along more conventional lines. "Maybe, in the end, the loss of naturalistic painting was the price that had to be paid for the coming of poetry. Human beings could have Chauvet or *The Epic of Gilgamesh* but they could not have both,"[4] Humphrey writes.

While these arguments elucidate a certain truth about the potential independence of art and language, they seem unlikely. Indeed, Humphrey and others speculate that the parallels between Nadia's art and cave painting could all be accidental. "Resemblances," as Humphrey himself says, "do not imply identity."[5] Instead, they tell us what we cannot assume about the mental capabilities of cave artists.

Nadia's precocious talent disappeared as quickly as it had appeared. It went away when she began making progress in other developmental areas, such as language. In other cases of autistic talent, such as the gifted young artist Claudia, studied by Uta Frith, talent was retained. Claudia continued to paint after she acquired language and is now a recognized artist; she drew Frith's portrait in fifteen minutes (Fig. 31-4).

Stephen Wiltshire, perhaps the most famous savant artist, also retained his talent after he acquired language. He drew the attention of Sir Hugh Casson, the president of the Royal Academy of Art, who called him "possibly the best child artist in Britain."[6] After looking at a building for a few minutes, Stephen could draw it quickly, confidently, and accurately. His accuracy was almost uncanny because he drew entirely from memory, without any notes, and he rarely missed or added a detail. Indeed, Stephen's perceptual abilities were so extraordinary that Casson wrote in his introduction to the book *Drawings:* "Unlike most children, who tend to draw from direct observations rather than

Figure 31-4.
Uta Frith by Claudia.

*Uta Frith
by Claudia
B. Holder*

from symbols or images seen secondhand, Stephen Wiltshire draws with amazing recollection exactly what he sees—no more, no less."[7]

Sacks was intrigued that Stephen could be so gifted artistically despite his enormous emotional and intellectual deficits. This caused Sacks to ask, "Was not art, quintessentially, an expression of personal vision, a self? Could one be an artist without having a 'self'?"[8] Sacks worked with Stephen over a period of years, and during that time it became more and more evident that Stephen had extraordinary perceptual skills yet never developed great empathy. It was as if the two components of art—the perceptual and the empathic—were separated in his brain. In support of the separation of these two characteristics, Sacks cites Monet, who wrote:

Whenever you go out to paint, try to forget what objects you have in front of you—a tree, a house, a field, or whatever. . . . Merely think, here is a little squeeze of blue, here an oblong of

pink, here a streak of yellow, and paint it just as it looks to you, the exact color and shape, until it gives your own naïve impression of the scene before you.[9]

Perhaps Stephen and other autistic artists do not have to make such deconstructions because, as Sacks points out, they never make constructions in the first place. These considerations support the view of Howard Gardner, the Harvard psychologist who argues that different kinds of intelligence can lead to artistic productivity, although not all of them lead to creativity—the ability to see something completely new in the world:

> In the case of the . . . savant . . . we behold the unique sparing of one particular human ability against a background of mediocre or highly retarded human performances in other domains. . . . the existence of these populations allows us to observe the human intelligence in relative—even splendid—isolation.[10]

Gardner postulates a multitude of intelligences—visual, musical, lexical—each of them autonomous and independent, with its own power to apprehend regularities and structures, its own rules, and its own bases in the brain.

Sacks argues more generally that savants provide strong evidence that there can be many different forms of intelligence, all potentially independent of each other. "It is not just that savant performances are off scale," he says, "but that they seem to deviate radically from normal developmental patterns."[11]

Perhaps even more interesting, savants reach the peak of their abilities almost immediately. They do not seem to develop their gifts—their talents are full-fledged from the start. Stephen's art at age seven was clearly extraordinary; at age nineteen he may have developed a bit socially and personally, but his artistic talent had not developed much further. Indeed, one might argue that savants, though immensely talented, are not creative. They do not create new art forms or generate a new worldview in their art. They manifest in full bloom Gardner's argument about multiple intelligences and multiple talents.

NO ONE HAS AN explanation for these savant skills. The Australian researcher Ted Nettelbeck suggests that they arise when the brain develops new cognitive modules in certain domains and these then create a hotline to knowledge and long-term memory, which operate independently of basic information-processing capability. Uta Frith thinks talent is released as a result of the autistic process itself. Allan Snyder, the director of the Center for Mind at the University of Sydney in Australia, champions the idea that in autism, the left hemisphere's control over the creative potential of the right hemisphere is lessened. And as we have seen, artistic accomplishment is often thought to be accompanied by decreased inhibition of the right hemisphere.

Snyder has developed an idea for explaining the extraordinary skills of autistic savants in art, music, calendar calculation, mathematics, and so on. He argues that savants have a privileged access to lower-level, less processed information that is not normally accessible to conscious awareness. This privileged access, Snyder argues, facilitates a distinct cognitive style in which the savant works from parts to the whole. These skills can sometimes be artificially induced in normal people by using certain types of experimental technology to inhibit the left anterior temporal lobe, thereby freeing up the right anterior temporal lobe.

How are we to think of this? The brain's ability to overcome certain deficits in handling the outside world, as in the case of the autistic savant and the dyslexic artist, may be the biological equivalent of social or financial hardship, which can motivate ambitious people to achieve when they might not have otherwise. But dyslexia differs from autism in that people with dyslexia do not lack empathy or a theory of mind. On the contrary, dyslexic people can feel deeply; they are not only talented but can be deeply creative and, like Chuck Close, the great painter who cannot recognize faces, can combine technical skill and emotional insight to reach the highest artistic levels.

We know that people with certain forms of sensory deprivation often display enhanced sensitivity in other areas. An example is the tactile sensitivity of blind people, whose ability to learn Braille is much greater than that of sighted people. This heightened sensitivity is not simply a result of increased motivation; it is also the result of a greater

representation of the sense of touch in the brain. The normal wiring for touch in the human brain is expanded in the brains of blind people, leading to a larger area of activity.

A FINAL EXAMPLE of creativity in people with brain disorders comes from the clinical psychologist Kay Redfield Jamison. Jamison emphasizes an interesting relationship between manic-depressive disorder and creativity, first pointed out by the German psychiatrist Emil Kraepelin in 1921. Kraepelin, the first clinical psychiatrist to distinguish manic-depressive disorder from dementia praecox (later renamed schizophrenia), thought that manic-depressive illness brings about changes in the thought processes that "set free powers which otherwise are constrained by all kinds of inhibition. Artistic activity . . . may . . . experience a certain furtherance."[12]

In her book *Touched with Fire*, Jamison documents the overlap between the artistic and the manic-depressive temperaments. She reviews research suggesting that writers and artists show a vastly higher rate of manic-depressive (bipolar) and depressive (unipolar) illness than the general population. Interestingly, two founders of Expressionism, Vincent van Gogh and Edvard Munch, both suffered from manic-depressive disorder.

Jamison also cites the work of Nancy Andreasen, who examined creativity in living writers and found that they are four times as likely to have manic-depressive disorder and three times as likely to have depression as people who are not creative. In a parallel psychiatric interview of twenty award-winning European writers, painters, and sculptors, Hagop Akiskal found that nearly two-thirds of them had manic-depressive tendencies and more than half of them had suffered a major depressive episode.

Jamison found that, much of the time, people with manic-depressive illness do not have symptoms, and as they swing from depression to mania, they experience an exhilarating feeling of energy and a capability for formulating ideas that dramatically enhance artistic creativity. Jamison argues that the interaction of tension and transition between changing mood states, as well as the sustenance and discipline that manic-depressive patients draw from periods of health, are critically important. The same tensions and transitions ultimately give creative power to the artist.

In *Exuberance: The Passion for Life,* Jamison writes:

> Creative and manic thinking are both distinguished by fluidity and by the capacity to combine ideas in ways that form new and original connections. Thinking in both tends to be divergent in nature, less goal-bound, and more likely to wander about or leap off in a variety of directions. Diffuse, diverse, and leapfrogging ideas were first noted thousands of years ago as one of the hallmarks of manic thought.[13]

She goes on to cite the Swiss psychiatrist Eugen Bleuler:

> The *thinking* of the manic is flighty. He jumps by by-paths from one subject to another. . . . With this the ideas run along very easily. . . . Because of the more rapid flow of ideas, and especially because of the falling off of inhibitions, artistic activities are facilitated even though something worthwhile is produced only in very mild cases and when the patient is otherwise talented in this direction.[14]

She notes that the expansiveness of thought so characteristic of mania can open up a wider range of cognitive options and broaden the field of observation. Mania also presumably enhances creativity by increasing the number of ideas produced, thereby increasing the likelihood that some good ideas will evolve.

Ruth Richards at Harvard University has carried this analysis further and tested the idea that a genetic vulnerability to manic-depressive illness might be accompanied by a predisposition to creativity. She examined patients' first-degree relatives who did not have manic-depressive disorder and found that the correlation indeed exists. She proposes that genes associated with a greater risk of manic-depressive disorder may also confer a greater likelihood of creativity. This is not to imply that the illness creates the predisposition to creativity, but rather that people who have this illness also have capabilities like extreme exuberance—enthusiasm and energy—that express themselves in creativity. Such a compensatory advantage, Richards speculates, would be analogous to the resistance to malaria found among unaffected carriers of the gene for sickle-cell anemia.

Jamison emphasizes, however, that like most of the general population, most writers and artists do not suffer from major mood disorders. Moreover, many people with manic-depressive illness, including artists who suffer from the disease, are usually not productive when they are very ill.

AS THESE FASCINATING studies indicate, we still are at an extremely early stage in thinking about creativity and artistic skill in neural terms, but new avenues of investigation are opening. In a sense, our understanding of the neural basis of creativity is comparable to our understanding of the neural basis of visual perception before the work of Stephen Kuffler and his colleagues in the 1950s, and our understanding of emotion in the year 2000. Yet, as a brain scientist who has seen these fields come to fruition during my working lifetime and whose own early investigations of the neuronal basis of memory were thought by some biologists to be premature and highly unlikely to succeed, I am optimistic about the new approaches to understanding creativity.

We have seen that the brain is a creativity machine. It searches for patterns amid chaos and ambiguity and it constructs models of the complex reality around us. This search for order and pattern is at the heart of the artistic and the scientific enterprise alike. The great painter Piet Mondrian expressed this idea eloquently in 1937:

> For there are "made" laws, "discovered" laws, but also laws—a truth for all time. These are more or less hidden in the reality which surrounds us and do not change. Not only science but art also, shows us that reality, at first incomprehensible, gradually reveals itself, by the mutual relations that are inherent in things.[15]

The emergence of artistic talent in people with frontal temporal dementia in the left hemisphere of the brain, the existence of autistic savants, and the creativity of artists with dyslexia give us clues to some of the brain processes that can be recruited for artistic talent and creativity. These fascinating and instructive cases most likely represent but a few of the many routes to creativity. This is the set of problems we hope that the biology of mind can tackle in an intellectually satisfying fashion over the next fifty years.

# KNOWING OURSELVES:
# THE NEW DIALOGUE BETWEEN
# ART AND SCIENCE

ᴄᐯᓅ

Engraved above the entrance to the temple of apollo at Delphi was the maxim "Know thyself." Ever since Socrates and Plato speculated on the nature of the human mind, serious thinkers have sought to understand the self and human behavior. For past generations, that quest was restricted to the intellectual and often nonempirical frameworks of philosophy and psychology. Today, however, brain scientists are attempting to translate abstract philosophical and psychological questions about mind into the empirical language of cognitive psychology and brain biology.

The guiding principle of these scientists is that mind is a set of operations carried out by the brain, an astonishingly complex computational device that constructs our perception of the external world, fixes our attention, and controls our actions. One of the aspirations of this new science is that the insights it offers will lead us to a deeper understanding of ourselves by linking the biology of mind to other areas of humanistic knowledge, including a better understanding of how we respond to and perhaps even create works of art.

Establishing a dialogue between science and art is not easy, however, and requires special circumstances. The Vienna of 1900 was successful in beginning to do so because the city was relatively small and provided a social context—the university, coffeehouses, and salons—in which scientists and artists could readily exchange ideas. Moreover, this initial dialogue was facilitated by the development of a common concern that focused on unconscious mental processes. That focus de-

rived, as we have seen, from scientific medicine, psychology and psychoanalysis, and art history. The dialogue between art and science in Vienna continued to develop in the 1930s, with the contributions of cognitive psychology and the Gestalt psychology of visual perception. This bold and successful advance of the 1930s provided the impetus at the beginning of the twenty-first century for applying to these cognitive psychological insights the lessons derived from the biological study of perception, emotion, empathy, and creativity, thus leading to the new dialogue that is now under way.

WE KNOW NOW THAT one of the reasons expressionist art appeals to us so strongly is that we have evolved a remarkably large, social brain. It contains extended representations of faces, hands, bodies, and bodily movement, and as a result we are hardwired to respond unconsciously as well as consciously to exaggerated depictions of these parts of the body and their movement. Moreover, the brain's mirror neuron system, theory-of-mind system, and biological modulators of emotion and empathy endow us with a great capacity for understanding other people's minds and emotions.

The key creative achievement of Oskar Kokoschka's and Egon Schiele's Expressionism is engaging those unconscious mental processes through their portraits. Their intuitive understanding and careful study of the ability of faces, hands, and bodies to communicate emotion and solicit empathy allowed them to convey new types of dramatic and modern psychological portraits. The Austrian modernists also possessed a distinct mastery of the perceptual principles our eyes and brain use to construct the world around us. Gustav Klimt's intuitive grasp of the power of implied line, contour, and top-down processing enabled him to create some of the most subtle and sensual works in the history of modern art. With these new insights into the unconscious empathic, emotional, and perceptual apparatuses of the brain, the Austrian modernists were indeed cognitive psychologists in their own right. In parallel with Sigmund Freud, they knew how to enter the private theater of another's mind, to understand its nature, mood, and emotion, and to convey that understanding to the viewer.

Important insights into mind have come from writers and poets as well as from philosophers, psychologists, scientists, and artists. Each kind of creative endeavor has made and continues to make specific con-

tributions to our full conception of mind, and if we disregard one in favor of another, that our conception is likely to be incomplete. After all, it took a psychologist like Freud to explain what unconscious processes *are*, but without the insights of artists like Shakespeare and Beethoven before him, and Klimt, Kokoschka, and Schiele contemporaneous with him, we would not know what some of these unconscious processes *feel like*.

Scientific analysis represents a move toward greater objectivity, toward a closer description of the actual nature of things. This is accomplished in the case of visual art by describing the observer's view of an object not in terms of the subjective impressions that object makes on the senses, but in terms of the brain's specific responses to the object. Art is best understood as a distillation of pure experience. It therefore provides an excellent and desirable complement to, and enrichment of, the science of mind. As Vienna 1900 illustrates, neither approach alone is sufficient to understand fully the dynamics of human experience. What we require is a third way, a set of explanatory bridges across the chasm between art and science.

THIS REQUIREMENT OF bridging structures raises the question: What gave rise to the chasm between art and science in the first place? The twentieth-century British intellectual historian Isaiah Berlin, who himself favored a separation between science and the humanities, traces the modern origins of the separation to Giovanni Battista Vico, an Italian historian and political philosopher who lived in Naples and worked at the beginning of the eighteenth century. Vico argued that there is little overlap between the study of the veritable truths of science and the study of human concerns. Whereas the mathematical and physical sciences involve a specific logic that is powerful for studying and analyzing "external nature," Vico believed that the study of human behavior requires a very different type of knowledge, a knowledge from the inside, which he called our internal "second nature."

Despite the successful connections established between art and science in Vienna 1900 and again in the 1930s, this separatist argument held sway in the last two decades of the twentieth century. C. P. Snow, the physicist turned novelist, brought it to the forefront in 1959 in his Rede Lecture, "The Two Cultures." Snow described the gulf of mutual incomprehension and hostility between scientists, who are con-

cerned with the nature of the universe, and humanists, who are concerned with the nature of human experience.

In the decades since Snow's lecture, the gulf separating the two cultures has begun to narrow. Several things have contributed to that narrowing. The first was Snow's coda to the second edition of his book *The Two Cultures: A Second Look*, published in 1963. In it, he discusses the extensive response to his lecture and describes the possibility of a third culture that could mediate a dialogue between scientists and humanists:

> With good fortune, however, we can educate a large proportion of our better minds so that they are not ignorant of imaginative experience, both in the arts and in science, nor ignorant either of the endowments of applied science, of the remediable suffering of most of their fellow humans, and of the responsibilities which, once they are seen, cannot be denied.[1]

Thirty years later John Brockman advanced Snow's idea in his essay "The Third Culture: Beyond the Scientific Revolution." Brockman emphasized that the most effective way of bridging the divide would be to encourage scientists to write for the general public in a language that an educated reader can readily understand. This effort is currently under way in print, on radio and television, the Internet, and in other media: good science is being successfully communicated to a general audience by the very scientists who created it.

An alternate and ambitious approach to bridging the divide is characterized by a belief in the unity of nature, called the Ionian Enchantment by the historian Gerald Holton of Harvard University. This belief was first enunciated by Thales of Miletus, who was active around 585 B.C. and is commonly regarded as the first philosopher in the Greek tradition. While contemplating the blue waters of the Ionian Sea, Thales and his followers searched for the fundamental principles of the natural world and came up with the idea that the world is made up of an infinite number of states of a single substance—water. The limitations of extending this bold line of thought to human behavior are obvious. Berlin has called Thales' unifying approach the Ionian Fallacy.[2]

How then do we extend the search for some common concepts and

meaningful dialogues of the sort engaged in in Vienna 1900 that bridges the approach of C. P. Snow and Brockman on the one hand and Holton on the other? One way is to examine earlier successful attempts to bridge disciplines and see how they were accomplished. How long did they take? How completely are they realized?

ONE MIGHT WELL ARGUE that the whole history of science is a history of attempts to unify knowledge. From these earlier examples we can learn the factors that might optimize attempts to engage in these dialogues and how likely we are to anticipate a meaningful synthesis.

Perhaps the most mature example is an attempt at the unification of the great forces of nature: physics, gravity, electricity, magnetism, and more recently, nuclear energy. This remarkable and highly successful family of attempts at unification has taken three centuries to accomplish and is still not fully complete.

The laws that govern gravity were first described in 1687 by Isaac Newton in his book *Philosophiae Naturalis Principia Mathematica*. Newton illustrated that gravity is the attractive force that accounts for the fall of an apple and keeps the moon in orbit around the earth and the earth in orbit around the sun. In 1820 the Danish physicist Hans Christian Oersted discovered that an electric current produces a magnetic field around itself. A little later in that century, the English physicist Michael Faraday and the Scottish physicist James Clerk Maxwell extended Oersted's findings conceptually with their discovery that both electricity and magnetism are a reflection of a common force, a single interaction: electromagnetism.

In 1967 Steven Weinberg, Sheldon Glashow, and Abdus Salam independently found that electromagnetism and the weak force of the atomic nucleus represent two aspects of the same *electroweak* force. In the same decade, Howard Georgi and Glashow achieved what they called Grand Unification by showing that the strong nuclear forces can be combined with the electroweak forces. Despite its grandness, however, even the unification of forces in physics is by no means complete. The unification of gravity with the other two forces is needed to begin to fulfill the dream of a final theory, as Weinberg has called this bold aspiration.

Since the beginning of the twentieth century, physicists have spo-

ken two languages that are incompatible with each other. Starting in 1905, they spoke the Einsteinian language of relativity, a language that attempts to explain the universe in terms of the very large force of stars and galaxies and the unity of space and time. At the same time, physicists spoke the language of quantum mechanics, of Niels Bohr, Werner Heisenberg, Max Planck, and Erwin Schrödinger, which attempts to explain the universe in very small terms of atomic structure and subatomic particles. How to combine the two languages continues to be the great question of physics in the twenty-first century. The physicist Brian Greene points out that "as they are currently formulated, general relativity and quantum mechanics *cannot both be right.*"[3]

Nevertheless, we know that the laws of general relativity and quantum mechanics are intrinsically connected. Events occurring on the planetary scale are necessarily determined by events on the quantum scale. The summation of all quantum effects must lead to the global effects we see. So, too, our perceptions, emotions, and thoughts are determined by the activity of our brains. In both cases we understand the necessity of an upward causal relationship, but the nature of that relationship remains unclear.

A final theory in physics, were it ever to arrive, would resolve this dilemma in a way that provides deep insight into the nature of the universe, including the details of its formation—small and large. The very possibility of a final theory raises ambitious questions for other sciences and for the bridging of the sciences and humanities: Can physics be united with chemistry? With biology? Can the new science of mind serve as a comparable focal point for a dialogue with the humanities?

An example of how the unification of one field can positively affect others is seen in the interaction between physics and chemistry, and both with biology. In the 1930s Linus Pauling began to unite physics with chemistry by using quantum mechanics to explain the structure of the chemical bond; he demonstrated that the physical principles of quantum mechanics explain how atoms behave in chemical reactions. Stimulated in part by Pauling, chemistry and biology began to converge in 1953 with the discovery of the molecular structure of DNA by James Watson and Francis Crick. Armed with this structure, molecular biology unified in a brilliant way the previously separate disciplines of biochemistry, genetics, immunology, development, cell biology,

cancer biology, and more recently molecular neurobiology. This unification set a precedent for other disciplines. It holds out the hope that in the fullness of time, the large-scale theories will include the science of mind.

AN APPROACH TO A UNITY of knowledge between biology and the humanities that is at once a broad and realistic extension of Snow and Brockman has been advocated most recently by the evolutionary biologist E. O. Wilson, who holds out the possibility of such a unity, based on consilience, a set of dialogues between disciplines.

Wilson argues that new knowledge is gained and science progresses through a process of conflict and resolution. For every parent discipline such as psychology, the study of behavior, there is a more fundamental field, an antidiscipline—in this case, brain science—that challenges the precision of the methods and claims of the parent discipline. Typically, however, the antidiscipline is too narrow to provide the more coherent framework or the richer paradigm needed to usurp the role of the parent discipline, whether it be psychology, ethics, or law. The parent discipline is larger in scope and deeper in content and therefore cannot be wholly reduced to the antidiscipline, although it ends up incorporating the antidiscipline and benefitting from it. This is what is happening in the merger of cognitive psychology, the science of mind and neural science, the science of the brain to give rise to a new science of mind.

These are evolving relationships, as can be seen with art and brain science. Art and Art History are the parent disciplines, and psychology and brain science are their antidisciplines. We have seen that our perception and enjoyment of art is wholly mediated by the activity of the brain, and we have begun to examine a number of ways in which insights from the antidiscipline of brain science enrich our discussion of art. We have also seen how much brain science can gain from trying to explain the beholder's share.

But the grand visions of Holton and Wilson must be balanced with a strong appreciation of historical reality. Rather than seeing a unified language and a useful set of concepts connecting key ideas in the humanities and the sciences as an inevitable outcome of progress, we should treat the attractive idea of consilience as an attempt to open a discussion between restricted areas of knowledge. In the case of art,

these discussions might involve a modern equivalent of Berta Zucker-kandl's salon: artists, art historians, psychologists, and brain scientists talking with one another, but now in the context of new academic inter-disciplinary centers at universities. Much as the modern science of mind emerged from discussions between cognitive psychologists and brain scientists, so now modern students of the science of mind can engage in dialogue with artists and art historians.

As the biologist Stephen Jay Gould, who has written about the gap between the sciences and the humanities, has put it:

> I want the sciences and humanities to become the greatest of pals, to recognize a deep kinship and necessary connection in pursuit of human decency and achievement, but to keep their ineluctably different aims and logics separate as they ply their joint projects and learn from each other. Let them be two musketeers—both for one and one for both—but not the graded stages of a single and grand consilient unity.[4]

As this book has tried to illustrate, it is essential to bear in mind that dialogues are most likely to be successful when fields of study are natu-rally allied, as are the biology of mind and the perception of art, and when the goals of the dialogue are limited and benefit all of the fields that contribute to it. It is very unlikely that a complete unification of the biology of mind and of aesthetics will occur in the foreseeable future, but it is quite likely that finding new interactions between aspects of art and aspects of the science of perception and emotion will continue to enlighten both fields, and that in time those interactions may well have cumulative effects.

ONE OF THE KEY characteristics of Modernism in Vienna was the conscious attempt to integrate and unify knowledge. The convergence in Vienna 1900 of medical science, psychology, and artistic explora-tions that went below the surface of the body and mind in search of hidden meaning resulted in scientific and artistic insights that altered forever the way we perceive ourselves. It uncovered our instinctual drives—our unconscious erotic and aggressive urges, our emotions—and exposed the defensive structures that hide them from view. We can see the dream of the unity of knowledge in the Vienna Circle of phi-

losophers, in the origins of psychoanalysis, and in *Imago,* the journal founded by Freud to bridge the divide between psychoanalysis and art.

More recently, we have seen the emergence of neuroaesthetics, a discipline that follows up on the work of Ernst Kris and Ernst Gombrich, who first applied modern psychological studies to art. Neuroaesthetics combines the biology of vision and psychology and applies them to the study of art. The field of emotional neuroaesthetics goes further, attempting to combine the cognitive psychology and the biology of perception, emotion, and empathy with the study of art.

The knowledge that vision is a creative process helps us understand the beholder's share and is the beginning of a productive dialogue between brain science and art. The promise of progress encourages us to stop and ask: What benefits would this dialogue confer? Who would gain from it?

The potential gain for the new science of mind is obvious. One of the ultimate goals for this new science is to understand how the brain responds to works of art, how we, the beholder, process unconscious and conscious perception, emotion, and empathy. But what is the potential usefulness of this dialogue for artists? Since the beginning of modern experimental science in the 15th and 16th centuries, artists from Filippo Brunelleschi and Masaccio to Albrecht Dürer and Pieter Bruegel to the contemporary work of Richard Serra and Damien Hirst have been interested in science. Much as Leonardo da Vinci used his newly gained knowledge of the human anatomy to depict the human form in a more compelling and accurate manner, so too, many insights into the brain processes are likely to benefit contemporary artists by revealing the critical features of emotional response.

In the future, as in the past, new insights into the biology of perception and emotional and empathic response are likely to influence artists and give rise to new forms of representation. Indeed, some artists who are intrigued by the irrational workings of the mind, such as René Magritte, have attempted this already. Magritte and other surrealists relied on introspection to infer what was happening in their own minds, but while introspection is helpful and necessary, it is often not capable of providing a detailed objective and general understanding of the brain and its workings. Traditional introspection might now be enhanced by knowing how aspects of the human mind work. Thus, insights into the neurobiology of visual perception and emotional

response are not only important goals for the biology of mind, they will also stimulate new art forms and new expressions of creativity.

REDUCTIONIST APPROACHES of the sort Gombrich advocated and that I outline in this book are central to science, yet many people are concerned that a reductionist approach to human thought will diminish our fascination with mental activity or trivialize it. Very likely the opposite is true. Knowing that the heart is a muscular pump that moves the blood around the body has not for a moment altered our admiration of its magnificent functioning. Yet in 1628, when William Harvey first described his experiments on the heart and the circulatory system, the opinion of the world was so opposed to this unromantic, reductionist view that he feared for himself and his discovery. He wrote:

> But what remains to be said upon the quantity and source of the blood which thus passes is of a character so novel and unheard-of that I not only fear injury to myself from the envy of a few, but I tremble lest I have mankind at large for my enemies, so much doth wont and custom become a second nature. Doctrine once sown strikes deep its root, and respect for antiquity influences all men. Still the die is cast, and my trust is in my love of truth and the candour of cultivated minds.[5]

Likewise, understanding the biology of the brain in no way denies the richness or complexity of thought. Rather, by focusing on one component of a mental process at a time, reduction can expand our view, allowing us to perceive previously unanticipated relationships between biological and psychological phenomena.

This type of reductionism is not limited to biologists; it is used implicitly and sometimes explicitly in humanistic endeavors, including art. Thus, abstract artists such as Wassily Kandinsky, Piet Mondrian, and Kazimir Malevich are radical reductionists, as was J.M.W. Turner in his late phase. In art, as in science, reductionism does not trivialize our perception—of color, light, and perspective—but allows us to see each of these components in a new way. Indeed, some artists, particularly modern artists, have intentionally limited the scope and vocabulary of their expression to convey, as Mark Rothko and Ad Reinhardt do, the most essential, even spiritual ideas of their art.

In the twenty-first century, we are perhaps for the first time in a position to link Klimt, Kokoschka, and Schiele to Kris and Gombrich, to address directly what neuroscientists can learn from the experiments of artists and what artists and beholders can learn from neuroscientists about artistic creativity, ambiguity, and the perceptual and emotional response of the viewer to art. In this book I have used the expressionist art of Vienna 1900 and the emerging biology of perception, emotion, empathy, aesthetics, and creativity to show how, in specific instances, art and science can enrich each other. I have illustrated the potential importance of the new biology of mind as an intellectual force, a font of new knowledge that is likely to facilitate a new dialogue between the natural sciences and the humanities and social sciences. This dialogue could help us understand better the mechanisms in the brain that make creativity possible, whether in art, the sciences, or the humanities, and open up a new dimension in intellectual history.

ACKNOWLEDGMENTS

THIS BOOK HAS A HISTORY THAT GOES BACK ALMOST TO VIENNA 1900. I was born in Vienna on November 7, 1929, eleven years after the Habsburg Empire fell apart following its defeat in World War I. Although Austria was radically reduced in size and political significance, its capital, the Vienna of my youth, was still one of the great cultural centers of the world.

My family lived in the Ninth District at Severingasse 8. Near our house were three museums that I never visited as a child, but whose subject matter later came to fascinate me and that now assumed a significant role in this book. The first and nearest to our apartment was the Vienna Medical Museum, the Josephinum, where I learned a great deal about Rokitansky. The second was Freud's apartment on the Bergasse, now the Freud Museum. A bit farther away, in the Fourth District, was the Upper Belvedere Museum, which houses the world's greatest collection of Gustav Klimt, Oskar Kokoschka, and Egon Schiele, the painters of Austrian Modernism.

In the spring of 1964, having recently returned from a year of study in Paris that included a return visit to Vienna, I went into Mirsky's Gallery on Newbury Street in Boston and I bought a 1922 Kokoschka lithograph of an adolescent girl, Trude, that had caught my imagination. I had then, as I continue to have, a particular fascination for the early portraits of Kokoschka, not only because I was haunted by his images as tangible physical reminders of the Vienna I had left, but because my impressions of Kokoschka's remarkable talents in portraiture were confirmed by the great art historian Ernst Gombrich. In a brief meeting at Harvard, where he served as a visiting professor in the summer of 1951, Gombrich told me he thought Kokoschka was the greatest portraitist of our age.

The Kokoschka portrait of Trude was the first of what would subsequently become a modest collection of works on paper by the Viennese and German expressionists that my wife, Denise, and I have put together over the years and enjoy immensely. I am reminded here of Sigmund Freud's comment in a letter to Sandor Ferenczi, his Hungarian psychoanalytic colleague, that Freud's collecting of antiquities reflected "strange and secret yearnings . . . for a life of quite *another kind:* wishes from late childhood never to be fulfilled and not adapted to reality" (cited in Gay, p. 172).

Two decades later, in June 1984, I received an honorary doctoral degree from the University of Vienna School of Medicine for my work on the molecular biology of memory. Asked by Helmut Gruber, the dean of the medical school, to respond on behalf of those of us who were being recognized that day, I decided to elaborate on my earlier interest in the Vienna School of Medicine, particularly its seminal contributions to modern and scientific psychoanalytic medicine.

In 2001, when my turn came to talk at the Practitioners Society, a small academic medical group in New York to which I belong, I spoke about my hobby, the Viennese modernists: Klimt, Kokoschka, and Schiele. In preparing my talk, I saw for the first time a connection between the Vienna School of Medicine, psychoanalysis, and the Austrian modernists. I became an even firmer believer in psychic determinism, Freud's idea that nothing in one's mental life occurs by chance. Or as I say to my friends when I urge them to follow the direction their unconscious guides them, "The unconscious never lies." *The Age of Insight* derives from that talk and represents my continued fascination with the extraordinary intellectual and artistic achievements that originated in Vienna 1900.

I AM GRATEFUL to the Klingenstein Foundation and the Sloan Foundation for grants that allowed me to undertake this book, and to my agents Katinka and John Brockman, who helped me frame the proposal for this book. I owe a further debt to my pubisher at Random House, Kate Medina, for her enthusiastic and energetic help with this book, as well as for the help of her associates Benjamin Steinberg, Anna Pitoniak, and SallyAnne McCartin. I am also grateful to Columbia University's Mind, Brain, Behavior Initiative for their support of this work as one of the first publications in the effort to establish new

forms of interdisciplinary learning. My own scientific research has been generously supported by the Howard Hughes Medical Institute.

AT MANY POINTS in this long journey, I was very fortunate to have generous and critical help from colleagues and friends more knowledgeable than I am in one or another area of scholarship. In my discussion of the Vienna School of Medicine, I benefitted greatly from the thoughtful reading and critical comments on the first five chapters of this book by three historians of Viennese medicine, beginning with Sonia Horn, the director of the Josephinum, and Deborah Coen at Barnard College of Columbia University. I am similarly indebted to Sonia's colleague Tatjana Buklijas, formerly of the Department of History and Philosophy of Science, University of Cambridge, United Kingdom, and now at the Liggins Institute, University of Auckland, New Zealand. Tatjana also made me aware that Klimt learned about biology through Berta Zuckerkandl's salon, and freely made available to me her own unpublished work on the Vienna School of Medicine.

The distinguished biologist Emile Zuckerkandl at Stanford University in the Department of Biological Sciences and grandson of Berta and Emil Zuckerkandl, kindly read and commented on the chapter relating to his grandparents and invited me to his apartment in Palo Alto, where I examined some of the mementos that remain from Berta Zuckerkandl's great salon, including the marvelous bust of Gustav Mahler by Auguste Rodin.

Mark Solms, Anna Kris Wolff, and Chris Toegel gave me the benefits of their criticisms of Chapters 4, 5, and 6, which deal with Freud and psychoanalysis. Lila Feinberg, a student of Schnitzler's writing, gave me the benefits of many thoughtful suggestions for improvement of Chapter 7.

In my discussions of the Viennese modernists in Chapters 8, 9, and 10, I was generously guided by five gifted art historians who work in this area—Emily Braun, Jane Kallir, Claude Cernuschi, Alessandra Comini, and Ann Temkin—each kindly gave me their critical insights. In addition, in her book on Berta Zuckerkandl's salon (*Ornament and Evolution: Gustav Klimt and Berta Zuckerkandl,* 2007), Emily Braun also documented for me in great detail some of the issues first raised by Buklijas about Klimt's interest in biology. I owe to Jane Kallir (*Egon Schiele: The Complete Works,* 1998) the insight that Klimt's view of sex-

uality, albeit liberating according to Vienna 1900 standards, could be seen as representing a distinctive male perspective of women's erotic lives. Claude Cernuschi (*Re/Casting Kokoschka: Ethics and Aesthetics, Epistemology and Politics in Fin-de-Siècle Vienna*) gave me the benefit of his deep insights into Kokoschka, and he and Alessandra Comini pointed out to me that Dürer had already done a pen and brush *nude* self-portrait at the beginning of the sixteenth century. Alessandra (*Egon Schiele's Portraits*, 1974; *Gustav Klimt*, 1975) also gave me new insights into Schiele's early years. Ann Temkin helped me see these three artists in the context of twentieth-century European art.

My understanding of the collaboration between Ernst Kris and Ernst Gombrich was greatly enriched by discussions with Lou Rose and by his excellent and richly detailed book (Rose 2011), which he generously made available to me before publication. I am particularly indebted to Tony Movshon's several thoughtful readings of the chapters on visual perception and for his suggestions for improvements for these chapters. I had the additional benefits of comments on the chapters on visual perception from Thomas Albright, Mitchell Asch, Charles Gilbert, Margaret Livingstone, Daniel Salzman, and Doris Tsao.

Daniel Salzman, Kevin Ochsner, Elizabeth Phelps, and Joseph LeDoux read and helped me with earlier versions of the chapters on emotion. Uta and Chris Frith and Ray Dolan read the chapters on empathy, and Oliver Sacks, John Kounios, Mark Jung-Beeman, and Nancy Andreasen read the chapters on creativity. I am much indebted to Kathryn Simpson for helping me with my discussion of ugliness in art.

Many other people have helped me with other portions of the book. I am grateful to Claude Ghez, David Anderson, Joel Braslow, Jonathan Cohen, Aniruddha Das, Joaquin Fuster, Howard Gardner, Michael Goldberg, Jacqueline Gottlieb, Nina and Gerry Holton, Mark Jung-Beeman, Lora Kahn, John Krakauer, John Kounios, Peter Lang, Sylvia Liske, George Makari, Pascal Mamassian, Roberto Miciotto, Walter Mischel, Betsy Murray, David Olds, Kevin Pelphrey, Stephen Rayport, Rebecca Saxe, Wolfram Schultz, Larry Swanson, and Jonathan Wallis.

Three of the pioneers of the study of creativity and art, Antonio Damasio, Semir Zeki, and Vilayanur Ramachandran, read the final

version of the manuscript and made numerous suggestions that improved the final manuscript. Attempts to bridge the divide between biology and art, which we encountered in the work of Stephen Kuffler, David Hubel, Torsten Wiesel, Semir Zeki, and Margaret Livingstone and her students, have laid the basis for the new field of neuroaesthetics, a field pioneered by J. P. Changeux, Zeki, Ramachandran, and more recently Livingstone. These scientists have used their extensive knowledge of visual neural science to explore how the human brain represents different kinds of art visually. Livingstone has focused in particular on how painters manipulate the brain's distinct perceptual pathways for form and color.

Finally, my colleague and friend Tom Jessell read both early and final drafts of the manuscript and contributed importantly to the changes that I was able to make in between them.

I am once again especially indebted to Blair Burns Potter, my editor and friend, for her creative and thoughtful editing of several versions of this book. I benefitted so much from Blair's work on my last book, *In Search of Memory,* that I thought it impossible to improve on her nuanced editing of that book. But the current book is broader in scope and range, which allowed Blair to introduce a new dimension in our collaboration.

I am also grateful to my colleague Jane Nevins, editor in chief of the DANA Foundation, for her help in making the text and especially the science more accessible to a general audience, to Geoffrey Montgomery for his helpful reading of an earlier draft, and to Maria Palileo for her thoughtful organization of the many drafts that went into the final text. I was privileged to have Sonia Epstein as a gifted research assistant help throughout the various stages of the book; Sonia took on the overall responsibility for the visuals in this book, checked the accuracy of quotations and references, obtained permissions for the art and quotations, and contributed to the editing of the text. In the later chapters of this work, we were joined by Chris Willcox, a gifted young artist who helped design the jacket cover image and assisted further with the art program, with editing, with illustrating, and with obtaining permissions for the art and the quotations.

*Preface*

1. Bertha Zuckerkandl, *My Life and History*, trans. John Summerfield (New York: Alfred A. Knopf, 1939), 180–81.

*Chapter 1.* AN INWARD TURN: VIENNA 1900

Ronald Lauder recalled his first encounter with Adele Bloch-Bauer in the following terms:

> When I walked into the room where the *Adele Bloch-Bauer I* was hanging, I was stopped in my tracks. She seemed to epitomize turn-of-the-century Vienna: its richness, its sensuality, and its capacity for innovation. I felt an intense personal connection to this woman, and with the man who had captured her so beautifully on canvas (Lillie and Gaugusch, p. 13).

WHEN IN 1556 CHARLES V abdicated his leadership of the Habsburg dynasty, he assigned his Spanish Empire to his son Philip II and asked his brother Ferdinand of Habsburg to succeed him as head of the German Habsburg land.

PARADOXICALLY, THE EMERGENCE of Modernism was also facilitated by the Viennese stock market crash of 1873. Between March 8 and 9, 230 bankruptcies were reported. The "great crash" quickly spread throughout Europe and a long depression ensued, undercutting both the free-market economy and the new bloom of liberalism. The depression and consequent loss of jobs energized the lower classes in Vienna, who turned their anger against the middle class, which was disproportionately Jewish. The Roman Catholic Church in Austria, which held the family and paternal authority sacred, also viewed the liberal legislation of 1868 and its advocacy of free-market individualism as potentially destructive of family values.

As a result, the liberal outlook lost some of its momentum. By 1890, public outbursts of anti-Semitism had become part of the antagonistic reaction of working-class people to the free market, which was thought to be responsible for the collapse of the market and the loss of jobs. Since many advocates of a free market were Jews, their financial success as a group as well as their advancement in the professions of medicine and law sparked resentment. In 1897, these trends culminated in the election of Karl Lueger, an unabashed, rabble-rousing anti-Semite, as mayor of Vienna. Lueger made

anti-Semitism socially acceptable, a political strategy that Hermann Broch character-
ized, appropriately, as "a demagogic employment of pre-Hitlerian methods . . . under a
Catholic banner" (Cernuschi, p. 15).

1. Sophie Lillie and Georg Gaugusch, *Portrait of Adele Bloch-Bauer* (New York:
   Neue Galerie, 1984), 13.
2. Peter Gay, *The Freud Reader* (New York: W. W. Norton, 1989), 76.
3. Ernst H. Gombrich, *Reflections on the History of Art*, ed. Robert Woodfield
   (Berkeley: University of California Press, 1987), 211.
4. Paul Robinson, *Freud and His Critics* (Berkeley: University of California Press,
   1993), 271.

*Chapter 2.* EXPLORING THE TRUTHS HIDDEN BENEATH THE SURFACE:
ORIGINS OF A SCIENTIFIC MEDICINE

My reference in this and a later chapter to Rokitansky's influence should not be taken as
the personal influence of one man, but as a systematic view of a zeitgeist for which Rok-
itansky was the most visible spokesman and which continued to exert its influence on
Viennese medical and cultural circles for decades after his death in 1878. As Erna Lesky
writes: "Rokitansky set out to arouse German medicine from its natural-philosophical
dream and to base it on solid, unchangeable, material facts" (p. 107).

In her excellent discussion of Rokitansky, Lesky points out, as have other scholars,
that despite his remarkable prescience and his insistence on evidence-based medicine,
he occasionally made serious errors. One in particular can be traced to the fact that
Rokitansky occasionally found no gross pathological changes at autopsy that he con-
sidered sufficiently important to account for a patient's death. He therefore argued that
besides the diseases he had successfully localized to particular organs, there must exist
a series of "dynamic diseases" that could not be localized to a specific organ. Since
Rokitansky believed strongly that no disease process could act without changing ma-
terial substance, he could think of only one material substance—the blood—that
was present everywhere in the body and that might be the cause of these diseases. He
therefore argued that dynamic diseases were located in the blood and that they were
caused by an imbalance in the blood mixture—the plasma and the proteins contained
within it—which he called the blood "crasis." Always drawn to chemistry, Rokitansky
thought the time had now come to apply chemical analysis to this type of disorder. This
new blood-based pathology caught on in Vienna and was promulgated by Rokitansky's
group. Rokitansky announced the theory in his *Handbook of Pathologic Anatomy*.

Rudolf Virchow (1821–1902), who wrote a very favorable review of the *Handbook*,
challenged Rokitansky and ridiculed this theory of dynamic diseases, calling it a mon-
strous anachronism that attempted to explain anatomy by means of chemistry. Rokitan-
sky realized that this criticism was just, and to his credit withdrew the theory in the next
edition of the *Handbook*.

1. Sherwin B. Nuland, *The Doctors' Plague: Germs, Childbed Fever, and the Strange
   Story of Ignac Semmelweis* (New York: W. W. Norton, 2003), 64–65.
2. Erwin H. Ackerknecht, *Medicine at the Paris Hospital 1794–1848* (Baltimore:
   Johns Hopkins University Press, 1963), 123.
3. O. Rokitansky, "Carl Freiherr von Rokitansky zum 200 Geburtstag: Eine Jubi-
   läumgedenkschrift," *Wiener Klinische Wochenschrift* 116, no. 23 (2004): 772–78.

4.  Nuland, *The Doctors' Plague*, 64.
5.  Erna Lesky, *The Vienna Medical School of the 19th Century* (Baltimore: Johns Hopkins University Press, 1976), 120.
6.  Ibid., 360.

*Chapter 3.* VIENNESE ARTISTS, WRITERS, AND SCIENTISTS MEET IN THE ZUCKERKANDL SALON

1.  Käthe Springer, "Philosophy and Science," in *Vienna 1900: Art, Life and Culture*, ed. Christian Brandstätter (New York: Vendome Press, 2005), 364.
2.  Berta Zuckerkandl, quoted in Emily D. Bilski and Emily Braun, *Jewish Women and Their Salons: The Power of Conversation* (New Haven: The Jewish Museum and Yale University Press, 2005), 96.
3.  Johann Strauss the Younger, quoted in ibid., 87.
4.  Jane Kallir, *Who Paid the Piper: The Art of Patronage in Fin-de-Siècle Vienna* (New York: Galerie St. Etienne, 2007).
5.  Berta Zuckerkandl, quoted in Emily Braun, *Gustav Klimt: The Ronald S. Lauder and Serge Sabarsky Collections*, ed. Renée Price (New York: Prestel Publishing, 2007), 162.
6.  Berta Zuckerkandl, quoted in ibid., 155.
7.  Emily Braun, *Gustav Klimt: The Ronald S. Lauder and Serge Sabarsky Collections*, 153.
8.  Ibid., 163.
9.  Tatjana Buklijas, "The Politics of Fin-de-Siècle Anatomy," in *The Nationalization of Scientific Knowledge in Nineteenth-Century Central Europe*, ed. M. G. Ash and J. Surman (Basingstoke, U.K.: Palgrave MacMillan, in preparation), 23.

*Chapter 4.* EXPLORING THE BRAIN BENEATH THE SKULL: ORIGINS OF A SCIENTIFIC PSYCHIATRY

1.  Lesky, *The Vienna Medical School*, 5.
2.  Ibid., 335.
3.  Peter Gay, *Schnitzler's Century: The Making of Middle-Class Culture 1815–1914* (New York: W. W. Norton, 2002), 67.
4.  A. Wettley and W. Leibbrand, *Von der Psychopathia Sexualis zur Sexualwissenschaft* (Stuttgart: Ferdinand Enke Verlag, 1959).
5.  Sigmund Freud (1924), *An Autobiographical Study*, The Standard Edition, trans. James Strachey (New York: W. W. Norton, 1952), 14–15.
6.  Fritz Wittels, "Freud's Scientific Cradle," *American Journal of Psychiatry* 100 (1944): 521–22.
7.  Emil du Bois Reymond, quoted in Frank J. Sulloway, *Freud, Biologist of the Mind: Beyond the Psychoanalytic Legend* (New York: Basic Books, 1979), 14.
8.  Sigmund Freud, *The Question of Lay Analysis: Conversations with an Impartial Person*, The Standard Edition, trans. James Strachey (New York: W. W. Norton, 1950), 90.
9.  Freud, *An Autobiographical Study*, 18.
10. Ernest Jones, *The Life and Work of Sigmund Freud 1919–1939: The Last Phase* (New York: Basic Books, 1981), 223.

*Chapter 5.* EXPLORING MIND TOGETHER WITH THE BRAIN:
THE DEVELOPMENT OF A BRAIN-BASED PSYCHOLOGY

Despite Freud's partial abandonment of localization and of the causal connections between brain and behavior, his reductionist concept of mind did have three remarkably prescient features. First, it emphasized, as did his earlier anatomical studies on the lamprey and the crayfish, that the nerve cell—the neuron—is the basic unit of information processing in each of the three brain systems: perception, memory, and consciousness.

Second, it accounted for memory storage. Freud proposed that the points of communication between nerve cells—the synapses, which he called the *contact barriers*—were not fixed but could be modified by learning (a feature we now call *synaptic plasticity*) and that memory storage involves the increasing permeability of the contact barriers between the neurons of the memory system. This modern idea in the neurobiology of memory is, in essence, what Ramón y Cajal postulated, also in 1894.

Third, and even more original, Freud divided the brain circuits involved in the generation of behavior into two general categories: mediating circuits and modulating circuits. Freud argued that mediating circuits make up the brain machinery that controls behavior; they analyze a stimulus, decide whether to produce a behavior, and generate a pattern of activity. But the strength of that activity can be regulated—enhanced or depressed—by modulatory circuits. We now know that neurons in modulatory circuits—the dopaminergic, serotonergic, and cholinergic systems—carry out this regulatory function by acting to strengthen or weaken the connections between neurons in the mediating circuits.

1. Sigmund Freud, *The Origins of Psycho-Analysis: Letters to Wilhelm Fliess*, ed. Marie Bonaparte, Anna Freud, and Ernst Kris, intro. Ernst Kris (New York: Basic Books), 137.
2. Freud, *An Autobiographical Study*, 19.
3. Sigmund Freud, quoted in Gay, *The Freud Reader*, 11–12.
4. Sigmund Freud (1893), *The Standard Edition of the Complete Psychological Works of Sigmund Freud 1893–99*, Vol. 3 (Early Psycho-analytic Publications), 18–19.
5. Freud, *An Autobiographical Study*, 30.
6. Ibid., 14.
7. Ibid., 41.
8. Sigmund Freud, "Heredity and the Aetiology of the Neuroses," *Revue Neurologique* 4 (1896): 148.
9. Sigmund Freud and Joseph Breuer, "Studies on Hysteria," *The Standard Edition of the Complete Psychological Works of Sigmund Freud*, Vol. 2 (1893–95), trans. James Strachey (London: Hogarth Press, 1955), 54.
10. Sigmund Freud (1891), *On Aphasia: A Critical Study*, trans. E. Stengel (London: Imago, 1953), 55.
11. Sigmund Freud, quoted in Gay, *The Freud Reader*, 21.
12. Charles Brenner, *An Elementary Textbook of Psychoanalysis* (New York: International Universities Press, 1973), 11.
13. Sigmund Freud, *The Origins of Psychoanalysis: Letters to Wilhelm Fliess*, ed. Mari Bonaparte, Anna Freud, and Ernst Kris, intro. Ernst Kris (New York: Basic Books, 1954), 134.
14. Sigmund Freud (1914), *On Narcissism*, in *The Standard Edition of the Complete Psychological Works of Sigmund Freud*, Vol. 14 (1914–16), trans. James Strachey (London: Hogarth Press, 1957), 78.

15. Sigmund Freud (1920), *Beyond the Pleasure Principle*, quoted in Eric Kandel, *Psychiatry, Psychoanalysis, and the New Biology of Mind* (Arlington, VA: American Psychiatric Publishing, 2005), 63.

16. Ulric Neisser, *Cognitive Psychology* (New York: Appleton-Century-Crofts, 1967), 4.

17. Ernst H. Gombrich and Didier Eribon, *Looking for Answers: Conversations on Art and Science* (New York: Harry N. Abrams, 1993), 133.

*Chapter 6.* EXPLORING MIND APART FROM THE BRAIN:
                ORIGINS OF A DYNAMIC PSYCHOLOGY

1. Sigmund Freud (1900), *The Interpretation of Dreams*, in *The Standard Edition of the Complete Psychological Works of Sigmund Freud*, Vols. 4 and 5 (London: Hogarth Press, 1953), xxvi.

2. Freud, *The Origins of Psychoanalysis*, 351.

3. Ibid., 213.

4. Freud, *The Interpretation of Dreams*, 6.

5. Ibid.

6. Emma Eckstein, quoted in Gay, *The Freud Reader*, 131.

7. Sigmund Freud, quoted in ibid., 139.

8. Brenner, *Elementary Textbook of Psychoanalysis*, 163.

9. Freud, *The Complete Psychological Works of Sigmund Freud*, Vol. 4, 121.

10. Freud, *The Origins of Psychoanalysis*, 323.

11. Freud, *The Interpretation of Dreams*, 2.

12. Brenner, *Elementary Textbook of Psychoanalysis*, 2.

13. Anton O. Kris, *Free Association: Method and Process* (New Haven: Yale University Press, 1982).

14. Freud and Breuer, "Studies on Hysteria," 160–61.

15. Sigmund Freud, quoted in Gay, *The Freud Reader*, 287.

16. Sigmund Freud, *An Outline of Psycho-Analysis* (New York: W. W. Norton, 1949), 70.

17. Roy Schafer, "Problems in Freud's Psychology of Women," *Journal of the American Psychoanalytic Association* 22 (1974): 483–84.

*Chapter 7.* SEARCHING FOR INNER MEANING IN LITERATURE

1. Arthur Schnitzler, *Lieutenant Gustl*, in *Bachelors: Novellas and Stories*, trans. Margret Schaefer (Chicago: Ivan Dee, 2006), 134.

2. Sigmund Freud, "Civilized Sexual Morality and Modern Nervous Illness," 1908, *Papers in the Sigmund Freud Collection*, Library of Congress Manuscript Division.

3. Sigmund Freud, quoted in Carl E. Schorske, *Fin-de-Siècle Vienna: Politics and Culture* (New York: Alfred A. Knopf, 1980), 11.

4. Sigmund Freud, quoted in Ernest Jones, *The Life and Work of Sigmund Freud, Volume 3: The Last Phase 1919–1939* (New York: Basic Books, 1957), Appendix A, 443–44.

5. Emily Barney, *Egon Schiele's Adolescent Nudes within the Context of Fin-de-Siècle Vienna* (2008), 8, http://www.emilybarney.com/essays.html (accessed September 19, 2011).

6. Sigmund Freud, *Fragment of an Analysis of a Case of Hysteria*, in *Collected Papers*, Vol. 3, ed. Ernest Jones (London: Hogarth Press, 1905).

7. Arthur Schnitzler, *Desire and Delusion: Three Novellas*, trans., ed., intro. Margret Schaefer (Chicago: Ivan Dee, 2004), 224.

8. Ibid., 225.

9. Klara Blum, quoted in W. E. Yates, *Schnitzler, Hofmannsthal, and the Austrian Theater* (New Haven: Yale University Press, 1992), 125–26.

10. Peter Gay, *Freud: A Life for Our Time* (New York: W. W. Norton, 1998), 249.

11. Ibid., 250.

*Chapter 8.* THE DEPICTION OF MODERN WOMEN'S SEXUALITY IN ART

1. Oskar Kokoschka, *My Life*, trans. David Britt (New York: Macmillan, 1971), 66.

2. Albert Elsen, "Drawing and a New Sexual Intimacy: Rodin and Schiele," in *Egon Schiele: Art, Sexuality, and Viennese Modernism*, ed. Patrick Werkner (Palo Alto, CA: The Society for the Promotion of Science and Scholarship, 1994), 14.

3. Ruth Westheimer, *The Art of Arousal* (New York: Artabras, 1993), 147.

4. Tobias G. Natter, "Gustav Klimt and the Dialogues of the Hetaerae: Erotic Boundaries in Vienna around 1900," in *Gustav Klimt: The Ronald S. Lauder and Serge Sabarsky Collection*, ed. Renée Price (New York: Neue Galerie, Prestel Publishing, 2007), 135.

5. Emily Braun, "Carnal Knowledge," in *Modigliani and His Models* (London: Royal Academy of Arts, 2006), 45.

6. Franz Wickhoff (1900), "On Ugliness," quoted in Schorske, *Fin-de-Siècle Vienna*, 236.

7. Kathryn Simpson, "Viennese Art, Ugliness, and the Vienna School of Art History: The Vicissitudes of Theory and Practice," *Journal of Art Historiography* 3 (2010): 1.

8. Auguste Rodin, *Art*, trans. P. Gsell and R. Fedden (Boston: Small, Maynard, 1912), 46.

9. Otto Wagner, quoted in Schorske, *Fin-de-Siècle Vienna*, 215.

10. Ludwig Hevesi, quoted in ibid., 84.

11. Ernst H. Gombrich, *Kokoschka in His Time* (London: Tate Gallery Press, 1986), 14.

12. Clement Greenberg, *Modernist Painting* (Washington, D.C.: Forum Lectures, 1960), 1–2.

13. Alessandra Comini, *Gustav Klimt* (New York: George Braziller, 1975), 25.

14. Lillie and Gaugusch, *Portrait of Adele Bloch-Bauer*, 59.

15. Gustav Klimt, quoted in Frank Whitford, *Gustav Klimt (World of Art)* (London: Thames and Hudson, 1990), 18.

*Chapter 9.* THE DEPICTION OF THE PSYCHE IN ART

1. Claude Cernuschi, *Re/Casting Kokoschka: Ethics and Aesthetics, Epistemology and Politics in Fin-de-Siècle Vienna* (Plainsboro, NJ: Associated University Press, 2002), 101.

2. Kokoschka, *My Life*, 33.

3. Ibid., 66.

4. Oskar Kokoschka, quoted in Donald D. Hoffman, *Visual Intelligence: How We Create What We See* (New York: W. W. Norton, 1998), 25.

5. Oskar Kokoschka, quoted in Cernuschi, *Re/Casting Kokoschka*, 37–38.

6. Karin Michaelis, quoted in ibid., 102.

7. Cernuschi, *Re/Casting Kokoschka*, 38.

8. Oskar Kokoschka (1908), "The Dreaming Youths," trans. Schorske, *Fin-de-Siècle Vienna*, 332–33.

9. Gustav Klimt, quoted by Berta Zuckerkandl, *Neues Wiener Journal*, April 10, 1927.

10. John Shearman, *Mannerism (Style and Civilization)* (New York: Penguin Books, 1991), 81.

11. Kokoschka, *My Life*, 75–76.

12. Ibid., 76.

13. Vincent van Gogh, *The Letters of Vincent van Gogh*, ed. Mark Roskill (London: Atheneum, 1963), 277–78.

14. Ernst H. Gombrich, *The Story of Art* (London: Phaidon Press, 1995), 429–30.

15. Hilton Kramer, "Viennese Kokoschka: Painter of the Soul, One-Man Movement," *The New York Observer*, April 7, 2002.

16. Ibid.

17. Kokoschka, quoted in *Re/Casting Kokoschka*, 34.

18. Kokoschka, *My Life*, 33–34.

19. Ibid., 31.

20. Ibid., 60.

21. Ibid., 37.

22. Kramer, "Viennese Kokoschka: Painter of the Soul."

23. Rosa Berland, "The Early Portraits of Oskar Kokoschka: A Narrative of Inner Life," *Image [&] Narrative* (e-journal) 18: (2007), http://www.imageandnarrative.be/inarchive/thinking_pictures/berland.htm (accessed September 19, 2011).

24. Gombrich, *The Story of Art*, 431.

25. *Lucian Freud: L'Atelier* (Paris: Éditions Centre Pompidou, 2010).

*Chapter 10.* THE FUSION OF EROTICISM, AGGRESSION, AND ANXIETY IN ART

1. Jane Kallir, *Egon Schiele: The Complete Works* (New York: Harry N. Abrams, 1998), 44.

2. Alessandra Comini, *Egon Schiele's Portraits* (Berkeley: University of California Press, 1974), 32.

3. Arthur C. Danto, "Live Flesh," *The Nation*, January 23, 2006.

4. Kallir, *Egon Schiele*, 65–68.

5. Comini, *Egon Schiele's Portraits*, 50–51.

*Chapter 11.* DISCOVERING THE BEHOLDER'S SHARE

For my discussion of Gestalt psychology, I have relied on Ash (1995), Rock (1984), and Kandel, Schwartz, and Jessell (2000). For my discussion of Popper, Helmholtz, and inductive inference, Thomas Albright also pointed out that Leonardo da Vinci was already aware of the role of the beholder. In his book *A Treatise on Painting*, Leonardo wrote: "A painter should delight in introducing great variety into his compositions, avoiding repetition, that by this fertility of invention he may attract and charm the eye of the beholder." Riegl took this idea forward in a much more detailed and programmatic way and thought of the beholder as completing the picture, thereby giving the "beholder's share" a new meaning.

1. Schorske, *Fin-de-Siècle Vienna*, 234–35.

2. Meyer Schapiro, quoted in Cindy Persinger, "Reconsidering Meyer Schapiro in the New Vienna School," *The Journal of Art Historiography* 3 (2010): 1.

3. Rudolf Arnheim, "Art History and the Partial God," *Art Bulletin* 44 (1962): 75.

4. William Empson, *Seven Types of Ambiguity* (New York: Harcourt, Brace, 1930), x.

5. Donald Kuspit, "A Little Madness Goes a Long Creative Way," *Artnet*, October 7, 2010, http://www.artnet.com/magazineus/features/kuspit/franz-xaver -messerschmidt10-7-10.asp (accessed September 16, 2011).

6. Ernst H. Gombrich, *The Image and the Eye: Further Studies in the Psychology of Pictorial Representation* (London: Phaidon Press, 1982), 11.

7. Ernst H. Gombrich, *Art and Illusion: A Study in the Psychology of Pictorial Representation* (London: Phaidon Press, 1982). ix.

8. Ernst Kris and Ernst Gombrich, "Caricature" (unpublished manuscript), property of the Archive of E. H. Gombrich Estate at the Warburg Institute, London. ©Literary Estate of E. H. Gombrich. Quoted in Louis Rose, "Psychology, Art, and Antifascism: Ernst Kris, E. H. Gombrich, and the Politics of Caricature" (unpublished manuscript), 2011.

9. Max Wertheimer, quoted in D. Brett King and Michael Wertheimer, *Max Wertheimer and Gestalt Theory* (New Brunswick and London: Transaction Publishers, 2004), 378.

10. Hoffman, *Visual Intelligence*, 15.

11. Mary Henle, *1879 and All That: Essays in the Theory and History of Psychology* (New York: Columbia University Press, 1986), 24.

12. Chris Frith, *Making Up the Mind: How the Brain Creates Our Mental World* (Oxford: Blackwell, 2007), 40.

*Chapter 12.* OBSERVATION IS ALSO INVENTION:
THE BRAIN AS A CREATIVITY MACHINE

1. Gombrich, *Art and Illusion*, 5.

2. Ibid., 24.

*Chapter 13.* THE EMERGENCE OF TWENTIETH-CENTURY PAINTING

1. Gombrich, *Kokoschka in His Time*.

2. Fritz Novotny (1938), "Cézanne and the End of Scientific Perspective," in *The Vienna School Reader: Politics and Art Historical Method in the 1930s*, ed. Christopher S. Wood (New York: Zone Books, 2000), 424.

*Chapter 14.* THE BRAIN'S PROCESSING OF VISUAL IMAGES

1. Richard Gregory, *Seeing Through Illusions* (New York: Oxford University Press, 2009), 6.

2. Francis Crick, *The Astonishing Hypothesis: The Scientific Search for the Soul* (New York: Charles Scribner's Sons, 1994), 32.

3. Frith, *Making Up the Mind*, 132 and 111.

*Chapter 15.* DECONSTRUCTION OF THE VISUAL IMAGE:
THE BUILDING BLOCKS OF FORM PERCEPTION

The Kuffler School and the work of Hubel and Wiesel are well described in D. H. Hubel and T. N. Wiesel (2005). Kuffler's life is described in Katz's scholarly *Biographical Memoirs* (1982) for the British Royal Society and is recalled by his many friends and students in McMahan's (1990) collection of brief essays. My discussion of line drawings and the relationship of Kuffler's and Hubel and Wiesel's work to figural primitives was importantly influenced by Changeux (1994), Livingstone (2002), Stevens (2001), and Zeki (1999).

*Chapter 16.* RECONSTRUCTION OF THE WORLD WE SEE:
VISION IS INFORMATION PROCESSING

1. Semir Zeki, *Inner Vision: An Exploration of Art and the Brain* (Oxford: Oxford University Press, 2001), 113.
2. Gregory, *Seeing Through Illusions*, 212.
3. Patrick Cavanagh, "The Artist as Neuroscientist," *Nature* 434 (2005): 301.
4. Hoffman, *Visual Intelligence*, 2–3.

*Chapter 17.* HIGH-LEVEL VISION AND THE BRAIN'S PERCEPTION OF
FACE, HANDS, AND BODY

1. Doris Tsao and Margaret Livingstone, "Mechanisms of Face Perception," *Annual Review of Neuroscience* 31 (2008): 411.
2. Exploratorium, "Mona: Exploratorium Exhibit," http://www.exploratorium.edu/exhibits/mona/mona.html (accessed September 14, 2011).
3. Mark H. Morton and John Johnson, *Biology and Cognitive Development: The Case of Face Recognition* (Oxford: Blackwell, 1991).
4. Andrew N. Meltzoff and M. Keith Moore, "Imitation of Facial and Manual Gestures by Human Neonates," *Science* 198, no. 4312 (October 7, 1977): 75–78.
5. Olivier Pascalis, Michelle de Haan, and Charles A. Nelson, "Is Face Processing Species-Specific During the First Year of Life?" *Science* 296, no. 5571 (2002): 1321–23.
6. Vilayanur Ramachandran, The Reith Lectures, Lecture 3: "The Artful Brain," in *The Emerging Mind* (London: BBC in association with Profile Books, 2003).
7. Beatrice de Gelder, "Towards the Neurobiology of Emotional Body Language," *Nature Reviews Neuroscience* 7, no. 3 (2006): 242.

*Chapter 18.* TOP-DOWN PROCESSING OF INFORMATION:
USING MEMORY TO FIND MEANING

1. Pascal Mamassian, "Ambiguities and Conventions in the Perception of Visual Art," *Vision Research* 48 (2008): 2149.
2. Cavanagh, "The Artist as Neuroscientist," 304.

*Chapter 19.* THE DECONSTRUCTION OF EMOTION:
THE SEARCH FOR EMOTIONAL PRIMITIVES

Sigmund Freud limited the term "emotion" to the conscious emotion and used the term "instinctual striving" for the unconscious component. Freud's position on emotions and their centrality to consciousness is discussed by Antonio Damasio in *The Feeling of What Happens* and in Solms and Nercessian's *Freud's Theory of Affect*.

1. Antonia Bostrom, Guilhem Scherf, Marie-Claude Lambotte, and Marie Potzl-Malikova, *Franz Xaver Messerschmidt 1736–1783: From Neoclassicism to Expressionism* (Italy: Officina Libraria, 2010), 521.
2. Ernst Kris, *Psychoanalytic Explorations in Art* (New York: International Universities Press, 1995), 190.

*Chapter 20.* THE ARTISTIC DEPICTION OF EMOTION THROUGH THE
FACE, HANDS, BODY, AND COLOR

1. Virginia Slaughter and Michelle Heron, "Origins and Early Development of Human Body Knowledge," *Monographs of the Society for Research in Child Development* 69, no. 2 (2004): 103–13.
2. Oskar Kokoschka, quoted in Natter, *Gustav Klimt*, 100.
3. Ibid., 95.
4. Robert L. Solso, *Cognition and the Visual Arts* (Cambridge, MA: MIT Press, 1994), 155.
5. Simpson, *Journal of Art Historiography*, 7.
6. M. E. Chevreul, quoted in John Gage, *Color in Art* (London: Thames and Hudson, 2006), 50.
7. John Gage, ibid., 53.
8. Robert Hughes, *The Shock of the New: Art and the Century of Change*, 2nd ed. (London: Thames and Hudson, 1991), 127.
9. Vincent van Gogh, quoted in Gage, *Color in Art*, 50.
10. Ibid., 51.
11. Vincent van Gogh, quoted in Hughes, *The Shock of the New*, 273.
12. Hughes, ibid., 276.
13. Semir Zeki, *Splendors and Miseries of the Brain* (Oxford: Wiley-Blackwell, 2009), 39.

*Chapter 21.* UNCONSCIOUS EMOTIONS, CONSCIOUS FEELINGS, AND
THEIR BODILY EXPRESSION

Ivan Pavlov, a contemporary of Freud, was a Russian physiologist who was awarded the Nobel Prize in Physiology or Medicine in 1904 for his study of digestion in dogs. In the course of this work, Pavlov noticed that dogs tend to salivate even before food is actually given to them, and he set out to study the phenomenon psychologically. Pavlov found that if he rang a bell every time he presented a dog with food, the dog would eventually associate the sound of the bell with food and would salivate whenever it heard the bell, even if food was not available. This type of learning requires that a neutral (conditioned) stimulus, in this case the bell, be paired repeatedly with an innately effective (unconditioned) stimulus, in this case food. In discovering the key

principles underlying conditioned responses (whether to appetitive or painful stimuli), Pavlov found a key cognitive, yet unconscious, link in the chain connecting James's object-simply-perceived to an object-emotionally-felt.

1. William James (1890), *Principles of Psychology*, Vol. 2 (Mineola, NY: Dover Publications, 1950), 474.
2. Antonio Damasio, *Descartes' Error: Emotion, Reason and the Human Brain* (New York: G. P. Putnam Sons, 1994), 129.
3. James, *Principles of Psychology*, Vol. 2, 1066–67.
4. Ibid., 449.

### Chapter 22. TOP-DOWN CONTROL OF COGNITIVE EMOTIONAL INFORMATION

1. John Martyn Harlow, quoted in Malcolm MacMillan, *An Odd Kind of Fame: Stories of Phineas Gage* (Cambridge, MA: MIT Press, 2000), 114.

### Chapter 23. THE BIOLOGICAL RESPONSE TO BEAUTY AND UGLINESS IN ART

1. Egon Schiele, quoted in Elsen, *Egon Schiele*, 27.
2. Dennis D. Dutton, *The Art Instinct: Beauty, Pleasure, and Human Evolution* (New York: Bloomsbury Press, 2009), 6.
3. Ibid.

### Chapter 24. THE BEHOLDER'S SHARE: ENTERING THE PRIVATE THEATER OF ANOTHER'S MIND

1. Henri Matisse, quoted in Hilary Spurling, *Matisse the Master: A Life of Henri Matisse: The Conquest of Colour 1909–1954* (New York: Alfred A. Knopf, 2007), 26.

### Chapter 25. THE BIOLOGY OF THE BEHOLDER'S SHARE: MODELING OTHER PEOPLE'S MINDS

1. Oskar Kokoschka, quoted in Ernst H. Gombrich, Julian Hochberg, and Max Black, *Art, Perception, and Reality* (Baltimore: Johns Hopkins University Press, 1972), 41.
2. Gombrich, ibid.
3. Frith, *Making Up the Mind*, 149.
4. Uta Frith, *Autism: Explaining the Enigma* (Oxford: Blackwell, 1989), 77–78.
5. Leo Kanner, "Autistic Disturbances of Affective Contact," *Nervous Child* 2 (1943): 217.
6. Ibid., 242.
7. Frith, *Autism: Explaining the Enigma*, 80.

### Chapter 26. HOW THE BRAIN REGULATES EMOTION AND EMPATHY

1. William Shakespeare (1599–1601?), *Hamlet*, 2.2.251, quoted in Kevin N. Ochsner, Silvia A. Bunge, James J. Gross, and John D. E. Gabrieli, "Rethinking

Feelings: An fMRI Study of the Cognitive Regulation of Emotion," *Journal of Cognitive Neuroscience* 14, no. 8 (2002): 1215.

*Chapter 27.* ARTISTIC UNIVERSALS AND THE
          AUSTRIAN EXPRESSIONISTS

Attempts to bridge the divide between biology and art can be traced as far back as 1870, when the psychophysicist Gustav Theodore Fechner developed an empirical approach to sensation by asking: What is the sequence of physiological events whereby a stimulus leads to a subjective sensation? Fechner found that even though the senses—sight, hearing, smell, taste, touch—differ in their modes of reception, they share three steps in common: a physical stimulus, a set of events that transforms the stimulus into the language of the brain nerve impulses—action potentials—and a response to those nerve impulses in the form of a perception or a conscious experience of sensation. In 1876 Fechner wrote *Introduction to Aesthetics,* in which he used his psychometric methods to measure behavioral responses to the perception of works of art.

In subsequent years, Fechner's psychophysical approaches, followed by Helmholtz's idea of unconscious inferences, were merged with recordings of single cells in the brain of monkeys and with brain imaging in monkeys and people.

1. Paul Mellars, "Archaeology: Origins of the Female Image," *Nature* 459 (2009): 176.
2. Ibid.
3. Ibid., 177.
4. Nancy E. Aiken, *The Biological Origins of Art* (Westport, CT: Praeger, 1998), 169.
5. Ellen Dissanayake, *What Is Art For?* (Seattle: University of Washington Press, 1988), 44.
6. John Tooby and Leda Cosmides, "Does Beauty Build Adapted Minds? Toward an Evolutionary Theory of Aesthetics, Fiction, and the Arts," *SubStance* 94/95, no. 30 (2001): 25.
7. Vilayanur Ramachandran, "The Science of Art: A Neurological Theory of Aesthetic Experience," *Journal of Consciousness Study* 6 (1999): 49.
8. Ibid., 15.

*Chapter 28.* THE CREATIVE BRAIN

1. Martha Graham, quoted in Howard Gardner, *Creating Minds: An Anatomy of Creativity as Seen Through the Lives of Freud, Einstein, Picasso, Stravinsky, Eliot, Graham, and Gandhi* (New York: Basic Books, 1993), 298.
2. Albert Einstein, quoted in Gerald Holton, *The Scientific Imagination: Case Studies* (London: Cambridge University Press), 231–32.
3. Michael Podro, *Depiction* (New Haven: Yale University Press, 1998), vi.
4. Gombrich, *The Story of Art,* 300.
5. Peter Medawar, quoted in Howard Gardner, *Creating Minds: An Anatomy of Creativity as Seen Through the Lives of Freud, Einstein, Picasso, Stravinsky, Eliot, Graham, and Gandhi* (New York: Basic Books, 1993), 36.
6. Pawan Sinha, B. Balas, Y. Ostrovsky, and R. Russell, "Face Recognition by

Humans: Nineteen Results All Computer Vision Researchers Should Know About," *Proceedings of the IEEE* 94, no. 11 (2006): 1948.

7. Vilayanur Ramachandran and colleague, undated correspondence.
8. Howard Gardner, *Five Minds for the Future* (Boston: Harvard Business School Press, 2006), 80.
9. Ibid., 80–81.
10. Nancy C. Andreasen, *The Creating Brain: The Neuroscience of Genius* (New York: Dana Press, 2005), 40.
11. Vilayanur Ramachandran, *A Brief Tour of Human Consciousness: From Impostor Poodles to Purple Numbers* (New York: Pearson Education, 2004), 51.

*Chapter 29.* THE COGNITIVE UNCONSCIOUS AND
THE CREATIVE BRAIN

1. Arthur Schopenhauer (1851), *Essays and Aphorisms*, trans. R. J. Hollingdale (London: Penguin Books, 1970), 123–24.

*Chapter 30.* BRAIN CIRCUITS FOR CREATIVITY

1. Howard Gardner, *Art, Mind, and Brain: A Cognitive Approach to Creativity* (New York: Basic Books, 1982), 321.

*Chapter 31.* TALENT, CREATIVITY, AND BRAIN DEVELOPMENT

1. Ramachandran, *The Emerging Mind*.
2. Pablo Picasso, quoted in Oliver Sacks, *An Anthropologist on Mars: Seven Paradoxical Tales* (New York: Alfred A. Knopf, 1995), 195.
3. Ernst H. Gombrich, "The Miracle at Chauvet," *The New York Review of Books* 43, no. 18, November 14, 1996, http://www.nybooks.com/articles/archives/1996/nov/14/the-miracle-at-chauvet/ (accessed September 16, 2011).
4. Nicholas Humphrey, "Cave Art, Autism and the Evolution of the Human Mind," *Cambridge Archeological Journal* 8 (1998): 176.
5. Ibid., 171.
6. Sir Hugh Casson, quoted in Sacks, *An Anthropologist on Mars*, 203.
7. Ibid., 206.
8. Oliver Sacks, ibid., 203.
9. Claude Monet, quoted in ibid., 206.
10. Howard Gardner, *Frames of Mind: The Theory of Multiple Intelligences* (New York: Basic Books, 1993), 63.
11. Sacks, *An Anthropologist on Mars*, 229.
12. Emil Kraepelin, quoted in Kay Redfield Jamison, *Touched with Fire: Manic-Depressive Illness and the Artistic Temperament* (New York: Free Press, 1993), 55.
13. Kay Redfield Jamison, *Exuberance: The Passion for Life* (New York: Alfred A. Knopf, 2004), 126.
14. Eugen Bleuler, quoted in ibid., 127.
15. Piet Mondrian, quoted in Arthur I. Miller, *Insights of Genius: Imagery and Creativity in Science and Art* (New York: Copernicus, 1996), 379.

*Chapter 32.* KNOWING OURSELVES: THE NEW DIALOGUE
BETWEEN ART AND SCIENCE

1.  C. P. Snow, *The Two Cultures: A Second Look* (New York: Cambridge University Press, 1963), 100.
2.  Sir Isaiah Berlin, *Concepts and Categories: Philosophical Essays* (London: Hogarth Press, 1978), 159.
3.  Brian Greene, *The Elegant Universe: Superstrings, Hidden Dimensions, and the Quest for the Ultimate Theory* (New York: Vintage Books, 1999), 3.
4.  Stephen J. Gould, *The Hedgehog, the Fox, and the Magister's Pox* (New York: Harmony Books, 2003), 195.
5.  William Harvey, quoted in George Johnson, *The Ten Most Beautiful Experiments* (New York: Vintage Books, 2009), 17.

# BIBLIOGRAPHY

*Preface*

Gombrich E, Eribon D. 1993. *Looking for Answers: Conversations on Art and Science.* Harry N. Abrams. New York.

Kandel ER. 2006. *In Search of Memory: The Emergence of a New Science of Mind.* W. W. Norton. New York.

Schorske CE. 1961. *Fin-de-Siècle Vienna: Politics and Culture.* Reprint 1981. Vintage Books. New York.

Zuckerkandl B. 1939. *My Life and History.* J Summerfield, translator. Alfred A. Knopf. New York.

*Chapter 1:* AN INWARD TURN: VIENNA 1900

All modern discussions of the intellectual flowering of Vienna 1900 are deeply indebted to the three magisterial and distinctively different scholarly works on this period: Johnston (1972); Janik and Toulman (1973); and Schorske (1981).

Other information in this chapter was drawn from the following sources:

Alexander F. 1940. Sigmund Freud: 1856–1939. Psychosomatic Medicine 2(1):68–73.

Ash M. 2010. The Emergence of a Modern Scientific Infrastructure in the Late Habsburg Era. Unpublished lecture. Center for Austrian Studies. University of Minnesota.

Belter S, editor. 2001. *Rethinking Vienna 1900.* Berghan Books. New York.

Bilski EP, Braun E. 2007. Ornament and Evolution: Gustav Klimt and Zuckerkandl. In: *Gustav Klimt.* Neue Galerie. New York.

Braun E. 2005. The Salons of Modernism. In: *Jewish Women and Their Salons: The Power of Conversation.* EP Bilski, E Braun, editors. The Jewish Museum. Yale University Press. New Haven.

Broch H. 1984. *Hugo von Hofmannsthal and His Time: The European Imagination 1860–1920,* p. 71. MP Steinberg, editor and translator. University of Chicago Press.

Cernuschi C. 2002. *Re/Casting Kokoschka: Ethics and Aesthetics, Epistemology and Politics in Fin-de-Siècle Vienna.* Associated University Press. Plainsboro, NJ.

Coen DR. 2007. *Vienna in the Age of Uncertainty: Science, Liberalism, and Private Life.* University of Chicago Press.

Comini A. 1975. *Gustav Klimt.* George Braziller. New York.

Darwin C. 1859. *On the Origin of Species by Means of Natural Selection.* Appleton-Century-Crofts. New York.

Dolnick E. 2011. *The Clockwork Universe: Isaac Newton, the Royal Society, and the Birth of the Modern World.* HarperCollins. New York.

Freud S. 1905. *Jokes and Their Relation to the Unconscious:* The Standard Edition. Introduction by Peter Gay. W. W. Norton. New York.

Gay P. 1989. *The Freud Reader.* W. W. Norton. New York.

Gay P. 2002. *Schnitzler's Century: The Making of Middle-Class Culture 1815–1914.* W. W. Norton. New York.

Gombrich E. 1987. *Reflections on the History of Art.* R Woodfield, editor. University of California Press. Berkeley.

Helmholtz H von. 1910. *Treatise on Physiological Optics.* JPC Southall, editor and translator. 1925. Dover. New York.

Janik A, Toulmin S. 1973. *Wittgenstein's Vienna.* Simon and Schuster. New York.

Johnston WA. 1972. *The Austrian Mind: An Intellectual and Social History 1848–1938.* University of California Press. Berkeley.

Kallir J. 2007. *Who Paid the Piper: The Art of Patronage in Fin-de-Siècle Vienna.* Galerie St. Etienne. New York.

Lauder R. 2007. Discovering Klimt. In: *Gustav Klimt.* Neue Galerie. New York, p. 13.

Leiter B. 2011. Just cause: Was Friedrich Nietzsche "the First Psychologist"? Times Literary Supplement. March 4, 2011, pp. 14–15.

Lillie S, Gaugusch G. 1984. *Portrait of Adele Bloch-Bauer.* Neue Galerie. New York.

Mach E. 1896. *Populär-wissenschaftliche Vorlesungen.* Johann Ambrosius Barth. Leipzig.

Main VR. 2008. The naked truth. The Guardian. October 3, 2008.

McCagg WO. Jr. 1992. *A History of Habsburg Jews 1670–1918.* Indiana University Press. Bloomington, IN.

Musil R. 1951. *The Man Without Qualities. Vol. I: A Sort of Introduction and Pseudoreality Prevails.* Sophie Wilkins, translator. Alfred A. Knopf. 1995. New York.

Nietzsche F. 1886. *Beyond Good and Evil.* H Zimmern, translator. 1989. Prometheus Books. New York.

Rentetzi M. 2004. The city as a context for scientific activity: Creating the Mediziner Viertel in fin-de-siècle Vienna. Endeavor 28:39–44.

Robinson P. 1993. *Freud and His Critics.* University of California Press. Berkeley.

Schopenhauer A. 1891. *Studies in Pessimism: A Series of Essays.* TB Saunders, translator. Swan Sonnenschein. London.

Schorske CE. 1981. *Fin de Siècle Vienna: Politics and Culture.* Vintage Books. New York.

Springer K. 2005. Philosophy and Science. In: *Vienna 1900: Art, Life and Culture.* Christian Brandstätter, editor. Vendome Press. New York.

Taylor AJP. 1948. *The Habsburg Monarchy 1809–1918: A History of the Austrian Empire and Austria-Hungary.* Hamish Hamilton. London.

Toegel C. 1994. *Und Gedenke die Wissenschafft—auszubeulen—Sigmund Freud's Weg zur Psychoanalyse (Tübingen),* pp. 102–103, for discussion of Rokitansky's presence on the occasion of Freud's presenting to the Austrian Academy of Science.

Witcombe C. 1997. The Roots of Modernism. What Is Art? What Is an Artist? http://www.arthistory.sbc.edu/artartists/artartists.html (accessed September 23, 2011).

Wittels F. 1944. Freud's scientific cradle. American Journal of Psychiatry 100:521–528.

Zuckerkandl B. 1939. *Ich erlebte 50 Jahre Weltgeschichte.* Bermann-Fischer Verlag. Stockholm. Translated as Szeps B. 1939. *My Life and History.* J Sommerfield, translator. Alfred A. Knopf. New York.

Zweig S. 1943. *The World of Yesterday: An Autobiography.* University of Nebraska Press. Lincoln, NE.

*Chapter 2:* EXPLORING THE TRUTHS HIDDEN BENEATH THE SURFACE:
ORIGINS OF A SCIENTIFIC MEDICINE

My discussion of the state of European medicine in the eighteenth century derives importantly from Nuland (2003) and Arika (2007). Erna Lesky's book still stands as the definitive work on the Vienna School of Medicine at that time.

Other information in this chapter was drawn from the following sources:

Ackerknecht EH. 1963. *Medicine at the Paris Hospital 1794–1848.* Johns Hopkins University Press. Baltimore.

Arika N. 2007. *Passions and Tempers: A History of the Humours.* Ecco/HarperCollins. New York.

Bonner TN. 1963. *American Doctors and German Universities. A Chapter in International Intellectual Relations 1870–1914.* University of Nebraska Press. Lincoln, NE.

Bonner TN. 1995. *Becoming a Physician: Medical Education in Britain, France, Germany, and the United States, 1750–1945.* Oxford University Press. New York.

Brandstätter C., editor. 2006. *Vienna 1900: Art, Life and Culture.* Vendome Press. New York.

Buklijas T. 2008. Dissection, Discipline and the Urban Transformation: Anatomy at the University of Vienna, 1845–1914. Ph.D. dissertation. University of Cambridge.

Hollingsworth JR, Müller KM, Hollingsworth EJ. 2008. China: The end of the science superpowers. Nature 454:412–413.

Janik A, Toulmin S. 1973. *Wittgenstein's Vienna.* Simon and Schuster. New York.

Kandel ER. 1984. The Contribution of the Vienna School of Medicine to the Emergence of Modern Academic Medicine. Unpublished lecture.

Kink R. 1966. Geschichte der Universität zu Wien. In: Puschmann T. *History of Medical Education.* EH Hare, translator. H. K. Lewis. London.

Lachmund J. 1999. Making sense of sound: Auscultation and lung sound codification in nineteenth-century French and German medicine. Science, Technology, and Human Values 24(4):419–450.

Lesky E. 1976. *The Vienna Medical School of the 19th Century.* Johns Hopkins University Press. Baltimore.

Miciotto RJ. 1979. Carl Rokitansky. Nineteenth-Century Pathology and Leader of the New Vienna School. Johns Hopkins University. Ph.D. dissertation. University of Michigan microfilm.

Morse JT. 1896. *Life and Letters of Oliver Wendell Holmes.* Two volumes. Riverside Press. London.

Nuland SB. 2003. *The Doctors' Plague: Germs, Childbed Fever, and the Strange Story of Ignac Semmelweis.* W. W. Norton. New York.

Nuland SB. 2007. Bad medicine. New York Times Book Review. July 8, 2007, p 12.

Rokitansky CV. 1846. *Handbuch der pathologischen Anatomie.* Braumüller & Seidel. Germany.

Rokitansky AM. 2004. Ein Leben an der Schwelle. Lecture presented at the University of Vienna.

Rokitansky O. 2004. Carl Freiherr von Rokitansky zum 200 Geburtstag: Eine Jubiläumgedenkschrift. Wiener Klinische Wochenschrift 116(23):772–778.

Seebacher F. 2000. *Primum humanitas, alterum scientia:* Die Wiener Medizinische Schule im Spannungsfeld von Wissenschaft und Politik. Dissertation, Universität Klagenfurt.

Vogl A. 1967. Six Hundred Years of Medicine in Vienna. A History of the Vienna School of Medicine. Bulletin of the New York Academy of Medicine 43(4):282–299.

Wagner-Jauregg J. 1950. *Lebens errinnerungen Wien*. Springer-Verlag.

Warner JH. 1998. *Against the Spirit of System: The French Impulse in Nineteenth-Century American Medicine*. Princeton University Press. Princeton.

Weiner DB, Sauter MJ. 2003. The City of Paris and the rise of clinical medicine. Osiris 2nd Series 18:23–42.

Wunderlich CA. 1841. *Wien und Paris: Ein Beitrag ʒur Geschichte und Beurtheilung der gegenwärtigen Heilkunde*. Verlag von Ebner & Seubert. Stuttgart.

*Chapter 3:* VIENNESE ARTISTS, WRITERS, AND SCIENTISTS MEET IN THE ZUCKERKANDL SALON

Braun E. 2005. The Salons of Modernism. In: *Jewish Women and Their Salons: The Power of Conversation*. ED Bilski, E Braun, editors. The Jewish Museum. Yale University Press. New Haven.

Braun E. 2007. Ornament and Evolution: Gustav Klimt and Berta Zuckerkandl. In: *Gustav Klimt: The Ronald S. Lauder and Serge Sabarsky Collections*. R Price, editor. Prestel Publishing. New York.

Buklijas T. 2011. The Politics of Fin-de-Siècle Anatomy. In: *The Nationaliʒation of Scientific Knowledge in Nineteenth-Century Central Europe*. MG Ash, J Surman, editors. Palgrave Macmillan. Basingstoke, UK. In preparation.

Janik A, Toulmin S. 1973. *Wittgenstein's Vienna*. Simon and Schuster. New York.

Kallir J. 2007. *Who Paid the Piper: The Art of Patronage in Fin-de-Siècle Vienna*. Galerie St. Etienne. New York.

Meysels LO. 1985. *In meinem Salon ist Österreich: Berta Zuckerkandl und ihre Zeit*. A. Herold. Vienna.

Schorske CE. 1981. *Fin de Siècle Vienna: Politics and Culture*. Vintage Books. New York.

Seebacher F. 2006. *Freiheit der Naturforschung! Carl Freiherr von Rokitansky und die Wiener mediʒinische Schule: Wissenschaft und Politik im Konflikt*. Verlag der OAW. Vienna.

Springer K. 2005. Philosophy and Science. In: *Vienna 1900: Art, Life and Culture*. Christian Brandstätter, editor. Vendome Press. New York.

Zuckerkandl B. 1939. *Ich erlebte 50 Jahre Weltgeschichte*. Bermann-Fischer Verlag. Stockholm. Translated as *My Life and History*. J Sommerfield, translator. Alfred A. Knopf. New York.

Zweig S. 1943. *The World of Yesterday*. University of Nebraska Press. Lincoln, NE.

*Chapter 4:* EXPLORING THE BRAIN BENEATH THE SKULL:
ORIGINS OF A SCIENTIFIC PSYCHIATRY

Ernest Jones's scholarly three-volume work is a definitive biography of Freud and also describes Breuer, Krafft-Ebing, Meynert, and Brücke.

Gay's biographical volume on Freud (1988) is another superb guide to Freud's life and work, and his *Freud Reader* (1989) is an excellent introduction to Freud's writing.

Other information from this chapter is drawn from the following sources:

Auden WH. 1940. In Memory of Sigmund Freud. In: *Another Time*. Random House. New York.

Breuer J. 1868. *Die Selbststeuerung der Athmung durch den Nervus vagus. Sitzungsberichte der kaiserlichen Akademie der Wissenschaften. Mathematisch–naturwissenschaftliche Classe.* Vol. II, pp. 909–937. Abtheilung. Vienna.

Freud S. 1878. Letter from Sigmund Freud to Eduard Silberstein, August 14, 1878. *The Letters of Sigmund Freud to Eduard Silberstein, 1871–1881,* pp. 168–170. W Boehlich, editor, AJ Pomerans, translator. Belknap Press. Cambridge, MA.

Freud S. 1884. The Structure of the Elements of the Nervous System (lecture). Annals of Psychiatry 5(3):221.

Freud S. 1891. *On Aphasia: A Critical Study.* E Stengel, translator. 1953. Imago Publishing. Great Britain.

Freud S. 1895. *Studies on Hysteria.* J Strachey, translator. 1957. Basic Books. New York.

Freud S. 1905. *Jokes and Their Relation to the Unconscious.* The Standard Edition. Introduction by Peter Gay. W. W. Norton. New York.

Freud S. 1909. *Five Lectures on Psycho-Analysis.* The Standard Edition. J Strachey, translator. W. W. Norton. New York.

Freud S. 1924. *An Autobiographical Study.* The Standard Edition. J Strachey, translator. 1952. W. W. Norton. New York.

Freud S. 1950. *The Question of Lay Analysis: Conversations with an Impartial Person.* The Standard Edition. J Strachey, translator. W. W. Norton. New York.

Gay P. 1988. *Freud: A Life for Our Time.* W. W. Norton. New York.

Gay P. 1989. *The Freud Reader.* W. W. Norton. New York.

Gay P. 2002. *Schnitzler's Century: The Making of Middle-Class Culture 1815–1914.* W. W. Norton. New York.

Geschwind N. 1974. *Selected Papers on Language and the Brain.* D. Reidel Publishing. Holland.

Jones E. 1981. *The Life and Work of Sigmund Freud. Vol. III, The Last Phase: 1919– 1939.* Basic Books. New York.

Kandel ER. 1961. The Current Status of Meynert's Amentia. Unpublished paper delivered to the Residents Reading Circle of the Massachusetts Mental Health Center.

Krafft-Ebing R. 1886. *Psychopathia Sexualis, with Special Reference to Contrary Sexual Feelings.* Ferdinand Enke Verlag. Stuttgart.

Lesky E. 1976. *The Vienna Medical School of the 19th Century.* Johns Hopkins University Press. Baltimore.

Makari G. 2007. *Revolution in Mind: The Creation of Psychoanalysis.* HarperCollins. New York.

Meynert T. 1877. *Psychiatry: A Clinical Treatise in Diseases of the Forebrain Based upon a Study of Its Structure and Function.* Hafner Publishing. 1968. New York.

Meynert T. 1889. *Lectures on Clinical Psychiatry (Klinische Vorlesungen über Psychiatrie).* Wilhelm Braumueller. Vienna.

Rokitansky C. 1846. *Handbuch der pathologischen Anatomie.* Braumüller & Seidel. Germany.

Sacks O. 1998. The Other Road: Freud as Neurologist. In: *Freud: Conflict and Culture,* pp. 221–234. MS Roth, editor. Alfred A. Knopf. New York.

Sulloway FJ. 1979. *Freud, Biologist of the Mind: Beyond the Psychoanalytic Legend.* Basic Books. New York.

Wettley A, Leibbrand W. 1959. *Von der Psychopathia Sexualis zur Sexualwissenschaft.* Ferdinand Enke Verlag. Stuttgart.

Wittels F. 1944. Freud's Scientific Cradle. American Journal of Psychiatry 100:521–528.

*Chapter 5:* EXPLORING MIND TOGETHER WITH THE BRAIN:
THE DEVELOPMENT OF A BRAIN-BASED PSYCHOLOGY

Ellenberger (1970) provides a scholarly introduction to the history of the discovery of the unconscious and documents the importance of Schopenhauer and Nietzsche as key predecessors of Freud's work.

Other information in this chapter was drawn from the following sources:

Alexander F. 1940. Sigmund Freud 1856 to 1939. Psychosomatic Medicine II:68–73.

Ansermet F, Magistretti P. 2007. *Biology of Freedom: Neural Plasticity, Experience and the Unconscious.* Karnac Books. London.

Brenner C. 1973. *An Elementary Textbook of Psychoanalysis.* International Universities Press. New York.

Burke J. 2006. *The Sphinx on the Table: Sigmund Freud's Art Collection and the Development of Psychoanalysis.* Walker and Co. New York.

Darwin C. 1872. *The Expression of the Emotions in Man and Animals.* Appleton-Century-Crofts. New York.

Ellenberger HE. 1970. *The Discovery of the Unconscious: The History and Evolution of Dynamic Psychiatry.* Basic Books. New York.

Exner S. 1884. *Untersuchungen über die Localisation der Functionen in der Grosshirnrinde des Menschen.* W. Braumüller. Vienna.

Exner S. 1894. *Entwurf zu einer physiologischen Erklärung der psychischen Erscheinung.* Leipzig und Wien. Vienna.

Finger S. 1994. *Origins of Neuroscience.* Oxford University Press. New York.

Freud S. 1891. *On Aphasia: A Critical Study.* E. Stengel, translator. 1953. Imago Publishing. Great Britain.

Freud S. 1893. Charcot. In: *The Standard Edition of the Complete Psychological Works of Sigmund Freud. 1893–99.* Vol. III, pp. 7–23. Early Psycho-Analytic Publications.

Freud S. 1896. Heredity and the aetiology of the neuroses. Revue Neurologique 4:161–169.

Freud S. 1900. The Interpretation of Dreams. In: *The Standard Edition of the Complete Psychological Works of Sigmund Freud.* 1953. Vols. IV and V. Hogarth Press. London.

Freud S. 1905. Three Essays on the Theory of Sexuality. In: *The Standard Edition of the Complete Psychological Works of Sigmund Freud.* 1953. Vol. VII, pp. 125–243. Hogarth Press. London.

Freud S. 1914. On Narcissism. In: *The Standard Edition of the Complete Psychological Works of Sigmund Freud.* 1957. Vol. XIV (1914–16), pp. 67–102. J Strachey, translator. Hogarth Press. London.

Freud S. 1915. *The Unconscious.* Penguin Books. London.

Freud S. 1920. Beyond the Pleasure Principle. In: Gay, *The Freud Reader.* W. W. Norton. New York.

Freud S. 1924. *An Autobiographical Study.* J Strachey, translator. 1952. W. W. Norton. New York.

Freud S. 1933. New Introductory Lectures in Psycho-analysis. In: *The Standard Edition of the Complete Psychological Works of Sigmund Freud.* Vol. XXII, pp. 3–182. W. W. Norton. New York.

Freud S. 1938. Some Elementary Lessons in Psychoanalysis. In: *The Standard Edition*

*of the Complete Psychological Works of Sigmund Freud.* Vol. XXIII, pp. 279–286. Hogarth Press. London.

Freud S. 1954. *The Origins of Psychoanalysis: Letters to Wilhelm Fliess.* M Bonaparte, A Freud, E Kris, editors. Introduction by E Kris. Basic Books. New York.

Freud S, Breuer J. 1955. Studies on Hysteria. In: *The Standard Edition of the Complete Psychological Works of Sigmund Freud.* Vol. II (1893–95). J Strachey, translator. Hogarth Press. London.

Gay P. 1988. *Freud: A Life for Our Time.* W. W. Norton. New York.

Gay P. 1989. *The Freud Reader.* W. W. Norton. New York.

Gombrich E, Eribon D. 1993. *Looking for Answers: Conversations on Art and Science.* Harry N. Abrams. New York.

James W. 1890. *The Principles of Psychology.* Harvard University Press. Cambridge, MA, and London.

Jones E. 1955. *Sigmund Freud Life and Work, Volume II: Years of Maturity 1901–1919.* Hogarth Press. London.

Kandel E. 2005. *Psychiatry, Psychoanalysis, and the New Biology of Mind.* American Psychiatric Publishing. Virginia.

Masson JM, editor. 1985. *Complete Letters of Freud to Fliess (1887–1904).* Harvard University Press. Cambridge, MA.

Meulders M. 2010. *Helmholtz: From Enlightenment to Neuroscience.* L Garey, translator and editor. MIT Press. Cambridge, MA.

Neisser U. 1967. *Cognitive Psychology.* Appleton-Century-Crofts. New York.

O'Donoghue D. 2004. Negotiations of surface: Archaeology within the early strata of psychoanalysis. Journal of the American Psychoanalytic Association 52:653–671.

O'Donoghue D. 2007. Mapping the unconscious: Freud's topographic constructions. *Visual Resources* 33:105–117.

Pribram KH, Gill MM. 1976. *Freud's "Project" Re-Assessed.* Basic Books. New York.

Ramón y Cajal S. 1894. La fine structure des centres nerveux. Proceedings of the Royal Society of London 55:444–468.

Rokitansky C. 1846. *Handbuch der pathologischen Anatomie.* Braumüller & Seidel. Germany.

Schliemann H. 1880. *Ilios: The City and Country of the Trojans.* Murray. London.

Skinner BF. 1938. *The Behavior of Organisms: An Experimental Analysis.* D. Appleton-Century. New York.

Solms M. 2007. Freud Returns. In: *Best of the Brain from* Scientific American. FE Bloom, editor. Dana Press. New York/Washington, DC.

Toegl C. Über den psychischen Mechanismus hysterischer Phanomene. Vorläufige Mitteilung. *Neurol Zbl.* Bd. 12 (1893), S. 4–10, 43–47.

Toegl C. *Aus den Anfängen der Psychoanalyse, Briefe an Wilhelm Fließ, Abhandlungen und Notizen aus den Jahren 1887–1902,* hsrg. von Marie Bonaparte, Anna Freud und Ernst Kris, London 1950; mit einer Einleitung von Ernst Kris.

Zaretsky E. 2004. *Secrets of the Soul: A Social and Cultural History of Psychoanalysis.* Alfred A. Knopf. New York.

*Chapter 6:* EXPLORING MIND APART FROM THE BRAIN:
ORIGINS OF A DYNAMIC PSYCHOLOGY

Brenner C. 1973. *An Elementary Textbook of Psychoanalysis.* International Universities Press. New York.

Darwin C. 1859. *On the Origin of Species by Means of Natural Selection.* Appleton-Century-Crofts. New York.

Darwin C. 1871. *The Descent of Man and Selection in Relation to Sex.* Appleton-Century-Crofts. New York.

Darwin C. 1872. *The Expression of the Emotions in Man and Animals.* Appleton-Century-Crofts. New York.

Finger S. 1994. *Origins of Neuroscience.* Oxford University Press. New York.

Freud S. 1893. Charcot. In: *The Standard Edition of the Complete Psychological Works of Sigmund Freud.* 1893–99. Vol. III, pp. 7–23. Early Psycho-Analytic Publications.

Freud S. 1895. *Studies on Hysteria.* J Strachey, translator. 1957. Basic Books. New York.

Freud S. 1900. The Interpretation of Dreams. In: *The Standard Edition of the Complete Psychological Works of Sigmund Freud.* 1953. Vols. IV and V. Hogarth Press. London.

Freud S. 1924. *An Autobiographical Study.* W. W. Norton. New York.

Freud S. 1938. Some Elementary Lessons in Psycho-analysis. In: *The Standard Edition of the Complete Psychological Works of Sigmund Freud.* Vol. XXIII, pp. 279–286. W. W. Norton. New York.

Freud S. 1949. *An Outline of Psycho-Analysis.* W. W. Norton. New York.

Freud S. 1954. *The Origins of Psychoanalysis: Letters to Wilhelm Fliess.* M Bonaparte, A Freud, E Kris, editors. Introduction by E Kris. Basic Books. New York.

Freud S. 1962. *Three Essays on the Theory of Sexuality.* J Strachey, translator. Basic Books. New York.

Gay P. 1989. *The Freud Reader.* W. W. Norton. New York.

Kris AO. 1982. *Free Association: Method and Process.* Yale University Press. New Haven.

Pankejeff S. 1972. My Recollections of Sigmund Freud. In: *The Wolf Man and Sigmund Freud.* Muriel Gardiner, editor. Hogarth Press and the Institute of Psychoanalysis. London.

Schafer R. 1974. Problems in Freud's psychology of women. Journal of the American Psychoanalytic Association 22:459–485.

Schliemann H. 1880. *Ilios: The City and Country of the Trojans.* Murray. London.

Wolf Man T. 1958. How I came into analysis with Freud. Journal of the American Psychoanalytic Association 6:348–352.

*Chapter 7:* SEARCHING FOR INNER MEANING IN LITERATURE

Barney E. 2008. *Egon Schiele's Adolescent Nudes within the Context of Fin-de-Siècle Vienna.* http://www.emilybarney.com/essays.html (accessed September 19, 2011).

Bettauer H. 1922. *The City without Jews: A Novel about the Day after Tomorrow.* S Brainin, translator. 1926. Bloch Publishing. New York.

Dukes A. 1917. Introduction. In: *Anatol, Living Hours and The Green Cockatoo.* Modern Library. New York.

Freud S. 1856–1939. *Papers in the Sigmund Freud Collection.* Library of Congress Manuscript Division. Washington, DC.

Freud S. 1905. Fragment of an Analysis of a Case of Hysteria. In: *Collected Papers,* Vol. III. E Jones, editor. Hogarth Press. London.

Gay P. 1989. *The Freud Reader.* W. W. Norton. New York.

Gay P. 1998. *Freud: A Life for Our Time.* W. W. Norton. New York.

Gay P. 2002. *Schnitzler's Century: The Making of Middle-Class Culture 1815–1914.* W. W. Norton. New York.

Gay P. 2008. *Modernism: The Lure of Heresy*, pp. 192–193. W. W. Norton. New York.

Jones E. 1957. *The Life and Work of Sigmund Freud. Vol. III, The Last Phase: 1919–1939.* Basic Books. New York.

Luprecht M. 1991. What People Call Pessimism. In: *Sigmund Freud, Arthur Schnitzler, and Nineteenth-Century Controversy at the University of Vienna Medical School.* Ariadne Press. Riverside, CA.

Schafer R. 1974. Problems in Freud's psychology of women. Journal of American Psychoanalytic Association 22:459–485.

Schnitzler A. 1896. *Anatol. A Sequence of Dialogues.* Paraphrased for the English stage by Granville Barker. 1921. Little, Brown. Boston.

Schnitzler A. 1900. *Lieutenant Gustl.* In: *Bachelors: Novellas and Stories.* M Schaefer, translator and editor. 2006. Ivan Dee. Chicago.

Schnitzler A. 1925. *Traumnouvelle (Dreamstory).* OP Schinnerer, translator. 2003. Green Integer.

Schnitzler A. 1925. *Fraulein Else.* In: *Desire and Delusion: Three Novellas.* M Schaefer, translator and editor. 2003. Ivan Dee. Chicago.

Schnitzler A. 2003. *Desire and Delusion: Three Novellas.* M Schaefer, translator and editor. 2003. Ivan Dee. Chicago.

Schorske CE. 1980. *Fin-de-siècle Vienna: Politics and Culture.* Alfred A. Knopf. New York.

Yates WE. 1992. *Schnitzler, Hofmannsthal, and the Austrian Theater.* Yale University Press. New Haven.

*Chapter 8:* THE DEPICTION OF MODERN WOMEN'S SEXUALITY IN ART

Bayer A, editor. 2009. *Art and Love in Renaissance Italy.* Metropolitan Museum of Art. Yale University Press. New Haven.

Bisanz-Prakken M. 2007. Gustav Klimt: The Late Work. New Light on the Virgin and the Bride in Gustav Klimt. In: *Gustav Klimt: The Ronald S. Lauder and Serge Sabarsky Collection.* R Price, editor. Neue Galerie. Prestel Publishing. New York.

Bogner P. 2005. *Gustav Klimt's Geometric Compositions in Vienna 1900.* Édition de la Réunion des Musées Nationaux. Paris.

Brandstätter C, editor. 2006. *Vienna 1900: Art, Life and Culture.* Vendome Press. New York.

Braun E. 2006. Carnal Knowledge. In: *Modigliani and His Models*, pp. 45–63. Royal Academy of Arts. London.

Braun E. 2007. Ornament and Evolution: Gustav Klimt and Berta Zuckerkandl. In: *Gustav Klimt: The Ronald S. Lauder and Serge Sabarsky Collection.* R Price, editor. Neue Galerie. Prestel Publishing. New York. In her chapter, Braun refers to Christian Nebehey, Gustav Klimt Dokumentation, Vienna. Galerie Christian M. Nebehey 1969, p. 53, under Klimt's Bibliothek, *Illustrierte Naturgeschichte der Thiere.* 4 vols. Philip Leopold Martin, general editor. Leipzig Brockhaus 1882–84.

Cavanagh P. 2005. The Artist as Neuroscientist. Nature 434:301–307.

Clark DL. 2005. The masturbating Venuses of Raphael, Giorgione, Titian, Ovid, Martial, and Poliziano. Aurora: Journal of the History of Art 6:1–14.

Clark K. 1992. *What Is a Masterpiece?* Thames and Hudson. New York.

Comini A. 1975. *Gustav Klimt.* George Braziller. New York.

Cormack R, Vassilaki M, editors. 2008. *Byzantium.* Royal Academy of Arts. London.

Dijkstra B. 1986. *Idols of Perversity: Fantasies of Feminine Evil in Fin-de-Siècle Culture.* Oxford University Press. New York.

Elsen A. 1994. Drawing and a New Sexual Intimacy: Rodin and Schiele. In: *Egon Schiele: Art, Sexuality, and Viennese Modernism*. P Werkner, editor. Society for the Promotion of Science and Scholarship. Palo Alto, CA.

Feyerabend P. 1984. Science as art: A discussion of Riegl's theory of art and an attempt to apply it to the sciences. Art &Text 12/13. Summer 1983–Autumn 1984:16–46.

Freedberg D. 1989. *The Power of Images. Studies in the History and Theory of Response*. University of Chicago Press. Chicago.

Freud S. 1900. The Interpretation of Dreams. In: *The Standard Edition of the Complete Psychological Works of Sigmund Freud*. 1953. Vols. IV and V. Hogarth Press. London.

Freud S. 1923. The Infantile Genital Organization (An Interpolation into the Theory of Sexuality). In: *The Standard Edition of the Complete Psychological Works of Sigmund Freud*. Vol. XIX (1923–25), *The Ego and the Id and Other Works*, pp. 139–146. Hogarth Press. London.

Freud S. 1924. The Dissolution of the Oedipus Complex. In: *The Standard Edition of the Complete Psychological Works of Sigmund Freud*. Vol. XIX (1923–25), *The Ego and the Id and Other Works*, pp. 171–180. Hogarth Press. London.

Goffen R. 1997. *Titian's Women*. Yale University Press. New Haven and London.

Gombrich EH. 1986. Kokoschka in His Time. Lecture given at the Tate Gallery on July 2, 1986. Tate Gallery Press. London.

Greenberg C. 1960. Modernist Painting. Forum Lectures. Washington, DC.

Gubser M. 2005. Time and history in Alois Riegl's Theory of Perception. Journal of the History of Ideas 66: 451–474.

Kemp W. 1999. Introduction to Alois Riegl's *The Group Portraiture of Holland*. Getty Publications. New York.

Kokoschka O. 1971. *My Life*. D Britt, translator. Macmillan. New York.

Lillie S, Gaugusch G. 1984. *Portrait of Adele Bloch-Bauer*. Neue Galerie. New York.

Natter TG. 2007. Gustav Klimt and the Dialogues of the Hetaerae: Erotic Boundaries in Vienna around 1900. In: *Gustav Klimt: The Ronald S. Lauder and Serge Sabarsky Collection*, pp. 130–143. R Price, editor. Neue Galerie. Prestel Publishing. New York.

Natter TG, Hollein M. 2005. *The Naked Truth: Klimt, Schiele, Kokoschka and Other Scandals*. Prestel Publishing. New York.

Price R, editor. 2007. *Gustav Klimt: The Ronald S. Lauder and Serge Sabarsky Collections*. Neue Galerie. Prestel Publishing. New York.

Ratliff F. 1985. The influence of contour on contrast: From cave painting to Cambridge psychology. Transactions of the American Philosophical Society 75(6):1–19.

Rice TD. 1985. *Art of the Byzantine Era*. Thames and Hudson. London.

Riegl A. 1902. *The Group Portraiture of Holland*. E. Kain, D. Britt, translators. 1999. Introduction by W Kemp. Getty Research Institute for the History of Art and the Humanities. Los Angeles.

Rodin A. 1912. *Art*. P Gsell, R Fedden, translators. Small, Maynard. Boston.

Schorske CE. 1981. *Fin-de-Siecle Vienna: Politics and Culture*. Vintage Books. New York.

Simpson K. 2010. Viennese art, ugliness, and the Vienna School of Art History: the vicissitudes of theory and practice. Journal of Art Historiography 3:1–14.

Utamaru K. 1803. *Picture Book: The Laughing Drinker*. Two volumes. 1972. Published for the Trustees of the British Museum by British Museum Publications.

Waissenberger R, editor. 1984. *Vienna 1890–1920*. Tabard Press. New York.

Westheimer R. 1993. *The Art of Arousal*. Artabras. New York.

Whalen RB. 2007. *Sacred Spring: God and the Birth of Modernism in Fin de Siècle Vienna.* Wm B. Eerdmans. Cambridge.

Whitford F. 1990. *Gustav Klimt (World of Art).* Thames and Hudson. London.

*Chapter 9:* THE DEPICTION OF THE PSYCHE IN ART

Berland R. 2007. The early portraits of Oskar Kokoschka: A narrative of inner life. Image [&] Narrative [e-journal], September 18, 2007. http://www.imageand narrative.be/inarchive/thinking_pictures/berlandhtm (accessed September 19, 2011).

Calvocoressi R, Calvocoressi KS. 1986. *Oskar Kokoschka, 1886–1980.* Solomon R. Guggenheim Foundation. New York.

Cernuschi C. 2002. Anatomical Dissection and Religious Identification: A Wittgensteinian Response to Kokoschka's Alternative Paradigms for Truth in His Self-Portraits Prior to World War I. In: *Oskar Kokoschka: Early Portraits from Vienna and Berlin, 1909–1914.* TG Natter, editor. Hamburg Kunstalle.

Cernuschi C. 2002. *Re/Casting Kokoschka: Ethics and Aesthetics, Epistemology and Politics in Fin-de-Siècle Vienna.* Associated University Press. Plainsboro, NJ.

Comenius JA. 1658. *Orbis Sensualium Pictus.* C Hoole, translator. 1777. Printed for S. Leacroft at the Globe. Charing-Cross, London.

Comini A. 2002. Toys in Freud's Attic: Torment and Taboo in the Child and Adolescent. Themes of Vienna's Image Makers in Picturing Children. In: *Construction of Childhood between Rousseau and Freud.* MR Brown, editor. Ashgate Publishing. Aldershot, UK.

Cotter H. 2009. Passion of the moment: A triptych of masters. New York Times Art Review. March 12, 2009.

Dvorak M. Oskar Kokoschka: Das Konzert. Variationen über ein Thema. Reinhold Graf Bethusy Saltzburg, Wien, Galerie Weltz 1988–2.

Freud L. April 2010. Exhibition, L'Atelier, Centre Pompidou, Paris.

Freud S. 1905. Three Essays on the Theory of Sexuality. In: *The Standard Edition of the Complete Psychological Works of Sigmund Freud.* Vol. VII, pp. 125–243. 1953. Hogarth Press. London.

Gay P. 1998. *Freud: A Life for Our Time.* W. W. Norton. New York.

Gombrich EH. 1980. Gedenkworte für Oskar Kokoschka. Orden pour le mérite für Wissenschaften und Künste, Reden und Gedenkworte 16:59–63.

Gombrich EH. 1986. *Kokoschka in His Time.* Tate Gallery. London.

Gombrich EH. 1995. *The Story of Art.* Phaidon Press. London.

Hoffman DD. 1998. *Visual Intelligence: How We Create What We See.* W. W. Norton. New York.

Kallir J. 2007. *Who Paid the Piper: The Art of Patronage in Fin-de-Siècle Vienna.* Galerie St. Etienne. New York.

Kokoschka O. 1971. *My Life.* David Britt, translator. Macmillan. New York.

Kramer H. 2002. Viennese Kokoschka: Painter of the soul, one-man movement. *New York Observer.* April 7, 2002.

Levine MA, Marrs RE, Henderson JR, Knapp DA, Schneider MB. 1988. The electron beam ion trap: A new instrument for atomic physics measurements. Physica Scripta T22:157–163.

Natter TG, editor. 2002. *Oskar Kokoschka: Early Portraits from Vienna and Berlin, 1909–1914.* Dumont Buchverlag. Koln, Germany.

Natter TG, Hollein M. 2005. *The Naked Truth: Klimt, Schiele, Kokoschka and Other Scandals.* Prestel Publishing. New York.

Röntgen WC. 1895. Ueber eine neue Art von Strahlen (Vorläufige Mitteilung). Sber. Physik.-med. Ges. Würzburg 9:132–141.

Schorske CE. 1980. *Fin-de-Siècle Vienna: Politics and Culture.* Alfred A. Knopf. New York.

Shearman J. 1991. *Mannerism (Style and Civilization).* Penguin Books. New York.

Simpson K. 2010. Viennese art, ugliness, and the Vienna School of Art History: The vicissitudes of theory and practice. Journal of Art Historiography 3:1–17.

Strobl A, Weidinger A. 1995. *Oskar Kokoschka, Works on Paper: The Early Years, 1897–1917.* Harry N. Abrams. New York.

Trummer T. 2002. A Sea Ringed About with Vision: On Cryptocothology and Philosophy of Life in Kokoschka's Early Portraits. In: *Oskar Kokoschka: Early Portraits from Vienna and Berlin, 1909–1914.* TG Natter, editor. Dumont Buchverlag. Köln, Germany.

Van Gogh V. 1963. *The Letters of Vincent van Gogh.* M Roskill, editor. Atheneum, London.

Werner P. 2002. Gestures in Kokoschka's Early Portraits. In: *Oskar Kokoschka: Early Portraits from Vienna and Berlin, 1909–1914.* TG Natter, editor. Dumont Buchverlag. Koln, Germany.

Zuckerkandl B. 1927. Neues Wiener Journal. April 10.

*Chapter 10:* THE FUSION OF EROTICISM, AGGRESSION, AND ANXIETY IN ART

Barney E. 2008. *Egon Schiele's Adolescent Nudes within the Context of Fin-de-Siècle Vienna.* www.emilybarney.com.

Blackshaw G. 2007. The pathological body: Modernist strategising in Egon Schiele's self-portraiture. Oxford Art Journal 30(3):377–401.

Brandow-Faller M. 2008. Man, woman, artist? Rethinking the Muse in Vienna 1900. Austrian History Yearbook 39:92–120.

Cernuschi C. 2002. *Re/Casting Kokoschka: Ethics and Aesthetics, Epistemology and Politics in Fin-de-Siècle Vienna.* Associated University Press. Plainsboro, NJ.

Comini A. 1974. *Egon Schiele's Portraits.* University of California Press. Berkeley.

Cumming L. 2009. *A Face to the World: On Self-Portraits.* Harper Press. London.

Danto A. 2006. Live flesh. *The Nation.* January 23, 2006.

Davis M. 2004. *The Language of Sex: Egon Schiele's Painterly Dialogue.* http://www.michellemckdavis.com/.

Elsen A. 1994. Drawing and a New Sexual Intimacy: Rodin and Schiele. In: *Egon Schiele: Art, Sexuality, and Viennese Modernism.* P Werner, editor. Society for the Promotion of Science and Scholarship. Palo Alto, CA.

Kallir J. 1990, 1998. *Egon Schiele: The Complete Works.* Harry N. Abrams. New York.

Knafo D. 1993. *Egon Schiele: A Self in Creation.* Associated University Press. Plainsboro, NJ.

Simpson K. 2010. Viennese art, ugliness, and the Vienna School of Art History: The vicissitudes of theory and practice. Journal of Art Historiography 3:1–14.

Westheimer R. 1993. *The Art of Arousal.* Artabras. New York.

Whitford F. 1981. *Egon Schiele.* Thames and Hudson. London.

*Chapter 11:* DISCOVERING THE BEHOLDER'S SHARE

In my discussion of Freud's writing on art, the quote from his letter to Hermann Struck was written in November of 1914. It was originally published in Anna Freud's *Gesammelte Werke* and is cited in *The Essential Gombrich.*

Edwin Boring's *A History of Experimental Psychology* has an excellent discussion of Hermann Helmholtz on unconscious inference.

Other information in this chapter was drawn from the following sources:

Arnheim R. 1962. Art history and the partial god. Art Bulletin 44:75–79.

Arnheim R. 1974. *Art and Visual Perception: A Psychology of the Creative Eye.* The New Version. University of California Press. Berkeley and Los Angeles.

Ash MG. 1998. *Gestalt Psychology in German Culture 1890–1967: Holism and the Quest for Objectivity.* Cambridge University Press. New York.

Boring EG. 1950. *A History of Experimental Psychology.* Appleton-Century-Crofts. New York.

Bostrom A, Scherf G, Lambotte MC, Potzl-Malikova M. 2010. *Franz Xavier Messerschmidt, 1736–1783: From Neoclassicism to Expressionism.* Neue Galerie catalog accompanying exhibition of work by Messerschmidt, September 2010 to January 2011. Officina Libraria. Italy.

Burke J. 2006. *The Sphinx on the Table: Sigmund Freud's Art Collection and the Development of Psychoanalysis.* Walker and Co. New York.

Da Vinci L. 1897. *A Treatise on Painting.* JF Rigaud, translator. George Bell & Sons. London.

Empson W. 1930. *Seven Types of Ambiguity.* Harcourt, Brace. New York.

Freud S. 1910. Leonardo da Vinci and a Memory of His Childhood. In: *The Standard Edition of the Complete Psychological Works of Sigmund Freud.* Vol. XII:57–138.

Freud S. 1914. The Moses of Michelangelo. Originally published anonymously in *Imago* 3:15–36. Republished with acknowledged authorship in 1924. In: *The Standard Edition of the Complete Psychological Works of Sigmund Freud.* Vol. XII:209–238.

Frith C. 2007. *Making Up the Mind: How the Brain Creates Our Mental World.* Blackwell Publishing. Oxford.

Gombrich EH. 1960. *Art and Illusion. A Study in the Psychology of Pictorial Representation.* Princeton University Press. Princeton and Oxford.

Gombrich EH. 1982. *The Image and the Eye: Further Studies in the Psychology of Pictorial Representation.* Phaidon Press. London.

Gombrich EH. 1984. Reminiscences of Collaboration with Ernst Kris (1900–1957). In: *Tributes: Interpreters of Our Cultural Tradition.* Cornell University Press. Ithaca, NY.

Gombrich EH. 1996. *The Essential Gombrich: Selected Writings on Art and Culture.* R Woodfield, editor. Phaidon Press. London.

Gombrich EH, Kris E. 1938. The principles of caricature. British Journal of Medical Psychology 17:319–342. In: *Psychoanalytic Explorations in Art.*

Gombrich EH, Kris E. 1940. *Caricature.* King Penguin Books. London.

Gregory RL, Gombrich EH, editors. 1980. *Illusion in Nature and Art.* Scribner. New York.

Helmholtz von H. 1910. *Treatise on Physiological Optics.* JPC Southall, editor and translator. 1925. Dover. New York.

Henle M. 1986. *1879 and All That: Essays in the Theory and History of Psychology.* Columbia University Press. New York.

Hoffman DD. 1998. *Visual Intelligence: How We Create What We See.* W. W. Norton. New York.

Kemp W. 1999. Introduction. In Riegl: *The Group Portraiture of Holland*, p. 1. Getty Research Institute Publications and Exhibition Program. Los Angeles.

King DB, Wertheimer M. 2004. *Max Wertheimer and Gestalt Theory.* Transaction Publishers. New Brunswick, NJ, and London.

Kopecky V. 2010. Letters to and from Ernst Gombrich regarding *Art and Illusion*, including some comments on his notion of "schema and correction." Journal of Art Historiography 3.

Kris E. 1932. Die Charakterköpfe des Franz Xaver Messerschmidt: Versuch einer historischen und psychologischen Deutung. Jahrbuch der Kunst-historischen Sammlungen. Wien 4:169–228.

Kris E. 1933. Ein geisteskranker Bildhauer (Die Charakterköpfe des Franz Xaver Messerschmidt). *Imago* 19:381–411.

Kris E. 1936. The psychology of caricature. International Journal of Psycho-Analysis 17:285–303.

Kris E. 1952. Aesthetic Ambiguity. In: *Psychoanalytic Explorations in Art.* International Universities Press. New York.

Kris E. 1952. A Psychotic Sculptor of the Eighteenth Century. In: *Psychoanalytic Explorations in Art.* International Universities Press. New York.

Kris E. 1952. *Psychoanalytic Explorations in Art.* International Universities Press. New York.

Kuspit D. 2010. A little madness goes a long creative way. Artnet Magazine Online. October 7, 2010. http://www.artnet.com/magazineus/features/kuspit/franz-xaver-messerschmidt10-7-10.asp (accessed September 16, 2011).

Mamassian P. 2008. Ambiguities and conventions in the perception of visual art. Vision Research 48:2143–2153.

Meulders M. 2010. *Helmholtz: From Enlightenment to Neuroscience.* L Garey, translator. MIT Press. Cambridge, MA.

Mitrović B. 2010. A defense of light: Ernst Gombrich, the Innocent Eye and seeing in perspective. Journal of Art Historiography 3:1–30.

Neisser U. 1967. *Cognitive Psychology.* Appleton-Century-Crofts. New York.

Persinger C. 2010. Reconsidering Meyer Schapiro in the New Vienna School. Journal of Art Historiography 3:1–17.

Popper K. 1992. *The Logic of Scientific Discovery.* Routledge. London and New York.

Riegl A. 1902. *The Group Portraiture of Holland.* EM Kain, D Britt, translators. 2000. Getty Research Institute. Los Angeles.

Rock I. 1984. *Perception.* Scientific American Library. W. H. Freeman. San Francisco.

Roeske T. 2001. Traces of psychology: The art historical writings of Ernst Kris. American Imago 58:463–474.

Rose L. 2007. Daumier in Vienna: Ernst Kris, E. H. Gombrich, and the politics of caricature. Visual Resources 23(1–2):39–64.

Rose L. 2011. *Psychology, Art, and Antifascism: Ernst Kris, E. H. Gombrich, and the Caricature Project.* Fordham University Press. In press.

Sauerländer W. 2010. It's all in the head: Franz Xaver Messerschmidt, 1736–1783: From Neoclassicism to Expressionism. D Dollenmayer, translator. New York Review of Books 57(16).

Schapiro M. 1936. The New Viennese School. In: *The Vienna School Reader.* 2000. C Wood, editor. Zone Books. New York.

Schapiro M. 1998. *Theory and Philosophy of Art: Style, Artist, and Society*. George Braziller. New York.

Schorske CE. 1961. *Fin-de-Siècle Vienna: Politics and Culture*. Reprint 1981. Vintage Books. New York.

Simpson K. 2010. Viennese art, ugliness, and the Vienna School of Art History: The vicissitudes of theory and practice. Journal of Art Historiography 3:1–14.

Wickhoff F. 1900. *Roman Art: Some of Its Principles and Their Application to Early Christian Painting*. A Strong, translator and editor. Macmillan. New York.

Worringer W. 1908. *Abstraction and Empathy: A Contribution to the Psychology of Style*. M Bullock, translator. International University Press. New York.

Wurtz RH, Kandel ER. 2000. Construction of the Visual Image. In: *Principles of Neural Science*, Chap. 25, pp. 492–506. 4th ed. Kandel ER, Schwartz JH, Jessell T, editors. McGraw-Hill. New York.

Chapter 12: OBSERVATION IS ALSO INVENTION:
THE BRAIN AS A CREATIVITY MACHINE

Ferretti S. 1989. *Cassirer, Panofsky, and Warburg: Symbols, Art, and History*. R Pierce, translator. Yale University Press. New Haven.

Friedlander MJ. 1942. *On Art and Connoisseurship (Von Kunst und Kennerschaft)*. T Borenius, translator. Bruno Cassirer Ltd. Berlin.

Gombrich EH. 1960. *Art and Illusion. A Study in the Psychology of Pictorial Representation*. Princeton University Press. Princeton and Oxford.

Handler-Spitz E. 1985. Psychoanalysis and the aesthetic experience. In: *Art and the Psyche*. Yale University Press. New Haven. For a discussion of Freud's essay on Leonardo, see pp. 55–65.

Holly MA. 1984. *Panofsky and the Foundations of Art History*. Cornell University Press. Ithaca, NY.

Necker LA. 1832. Observations on some remarkable optical phenomena seen in Switzerland, and on an optical phenomenon which occurs on viewing a figure of a crystal or geometrical solid. London and Edinburgh Philosophical Magazine and Journal of Science 1(5):329–337.

Panofsky E. 1939. *Studies in Iconology: Humanistic Themes in the Art of the Renaissance*. Westview Press. Boulder, CO.

Rock I. 1984. *Perception*. Scientific American Books. New York.

Rose L. 2010. Psychology, Art and Antifascism: Ernst Kris, E. H. Gombrich, and the Caricature Project. Manuscript.

Searle J. 1986. *Minds, Brains, and Science (1984 Reith Lectures)*. Harvard University Press. Cambridge, MA.

Wittgenstein W. 1967. *Philosophical Investigations*. GEM Anscombe, translator. Macmillan. New York.

Chapter 13: THE EMERGENCE OF TWENTIETH-CENTURY PAINTING

Gauss CE. 1949. *The Aesthetic Theories of French Artists: 1855 to the Present*. Johns Hopkins University Press. Baltimore.

Gombrich EH. 1950. *The Story of Art*. Phaidon Press. London.

Gombrich EH. 1986. *Kokoschka in His Time*. Lecture given at the Tate Gallery on July 2, 1986. Tate Gallery Press. London.

Hughes R. 1991. *The Shock of the New: The Hundred-Year History of Modern Art—Its Rise, Its Dazzling Achievement, Its Fall.* 2nd ed. Thames and Hudson. London.

Novotny F. 1938. Cézanne and the End of Scientific Perspective. Excerpts in: *The Vienna School Reader: Politics and Art Historical Method in the 1930s,* pp. 379–438. CS Wood, editor. 2000. Zone Books. New York.

*Chapter 14:* THE BRAIN'S PROCESSING OF VISUAL IMAGES

Crick F. 1994. *The Astonishing Hypothesis: The Scientific Search for the Soul.* Charles Scribner's Sons. New York.

Daw N. 2012. *How Vision Works.* Oxford University Press. New York.

Frith C. 2007. *Making Up the Mind. How the Brain Creates Our Mental World.* Blackwell Publishing. Malden, MA.

Gombrich EH. 1982. *The Image and the Eye: Further Studies in the Psychology of Pictorial Representation.* Phaidon Press. London.

Gregory RL. 2009. *Seeing Through Illusions,* p. 6. Oxford University Press. New York.

Hoffman DD. 1998. *Visual Intelligence: How We Create What We See.* W. W. Norton. New York.

Kemp M. 1992. *The Science of Art: Optical Themes in Western Art from Brunelleschi to Seurat.* Yale University Press. New Haven and London.

Miller E, Cohen JP. 2001. An integrative theory of prefrontal cortex function. Annual Review of Neuroscience 24:167–202.

Movshon A, Wandell B. 2004. Introduction to Sensory Systems. In: *The Cognitive Neurosciences* III, pp. 185–187. MS Gazzaniga, editor. Bradford Books. MIT Press. Boston.

Olson CR, Colby CL. 2012. The Organization of Cognition. In: *Principles of Neural Science.* 5th ed. Kandel ER, Jessell TM, Schwartz JH, editors. McGraw-Hill. New York.

Wurtz RH, Kandel ER. 2000. Constructing the Visual Image. In: *Principles of Neural Science* (Chap. 25). 4th ed. Kandel ER, Schwartz J, Jessell T, editors. McGraw-Hill. New York.

*Chapter 15:* DECONSTRUCTION OF THE VISUAL IMAGE:
THE BUILDING BLOCKS OF FORM PERCEPTION

Ball P. 2010. Behind the Mona Lisa's smile: X-ray scans reveal Leonardo's remarkable control of glaze thickness. Nature 466:694.

Changeux JP. 1994. Art and neuroscience. Leonardo 27(3):189–201.

Gilbert C. 2012. The Constructive Nature of Visual Processing. In: *Principles of Neural Science* (Chap. 25). 5th ed. Kandel ER, Schwartz JH, Jessell T, Siegelbaum S, Hudspeth JH, editors. McGraw-Hill. New York.

Hubel DH. 1995. *Eye, Brain, and Vision.* Scientific American Library. W. H. Freeman. New York.

Hubel DH, Wiesel TN. 2005. *Brain and Visual Perception: The Story of a 25-Year Collaboration.* Oxford University Press. New York.

Katz, B. 1982. Stephen William Kuffler. Biographical Memoirs of Fellows of the Royal Society 28:225–259. Published by the Royal Society. London.

Lennie P. 2000. Color Vision. In: *Principles of Neural Science* (Chap. 27), pp. 523–547. 4th ed. Kandel ER, Schwartz JH, Jessell T, editors. McGraw-Hill. New York.

Livingstone M. 2002. *Vision and Art: The Biology of Seeing.* Abrams. New York.

Mamassian P. 2008. Ambiguities and conventions in the perception of visual art. Vision Research 48:2143–2153.

McMahan UJ, editor. 1990. *Steve: Remembrances of Stephen W. Kuffler.* Sinauer Associates. Sunderland, MA.

Meister M, Tessier-Lavigne M. 2012. The Retina and Low Level Vision. In: *Principles of Neural Science* (Chap. 26). 5th ed. Kandel ER, Schwartz JH, Jessell T, Siegelbaum S, Hudspeth JH, editors. McGraw-Hill. New York.

Purves D, Lotto RB. 2003. *Why We See What We Do: An Empirical Theory of Vision.* Sinauer Associates. Sunderland, MA.

Sherrington CS. 1906. *The Integrative Action of the Nervous System.* University Press. Cambridge, MA.

Stevens CF. 2001. Line versus Color: The Brain and the Language of Visual Arts. In: *The Origins of Creativity*, pp. 177–189. KH Pfenninger, VR Shubick, editors. Oxford University Press. Oxford and New York.

Tessier-Lavigne M, Gouras P. 1995. Color. In: *Essentials of Neural Science and Behavior*, pp. 453–468. Kandel ER, Schwartz JH, Jessell TM, editors. Appleton and Lange. Stamford, CT.

Trevor-Roper P. 1998. *The World through Blunted Sight.* Updated edition. Souvenir Press. Boutler and Tanner. Frome, UK.

Whitfield TWA, Wiltshire TJ. 1990. Colour psychology: A critical review. Genetic, Social and General Psychology Monographs 116:387–413.

Wurtz RH, Kandel ER. 2000. Construction of the Visual Image. In: *Principles of Neural Science* (Chap. 25), pp. 492–506. 4th ed. Kandel ER, Schwartz JH, Jessell T, editors. McGraw-Hill. New York.

Zeki S. 1999. *Inner Vision: An Exploration of Art and the Brain.* Oxford University Press. New York.

*Chapter 16:* RECONSTRUCTION OF THE WORLD WE SEE:
VISION IS INFORMATION PROCESSING

Albright T. 2012. High-Level Vision and Cognitive Influences. In: *Principles of Neural Science* (Chap. 28). 5th ed. Kandel ER, Schwartz JH, Jessell T, Siegelbaum S, Hudspeth JH, editors. McGraw-Hill. New York.

Cavanagh P. 2005. The artist as neuroscientist. Nature 434:301–307.

Daw N. 2012. *How Vision Works.* Oxford University Press. New York.

Elsen A. 1994. Drawing and a New Sexual Intimacy: Rodin and Schiele. In: *Egon Schiele: Art, Sexuality, and Viennese Modernism.* P Werkner, editor. Society for the Promotion of Science and Scholarship. Palo Alto, CA.

Frith C. 2007. *Making Up the Mind. How the Brain Creates Our Mental World.* Blackwell Publishing. Malden, MA.

Gombrich EH. 1982. *The Image and the Eye: Further Studies in the Psychology of Pictorial Representation.* Phaidon Press. London.

Gregory RL. 2009. *Seeing Through Illusions.* Oxford University Press. New York.

Hoffman DD. 1998. *Visual Intelligence: How We Create What We See.* W. W. Norton. New York.

Hubel DH, Wiesel TN. 1979. Brain Mechanisms of Vision. In: *The Mind's Eye: Readings from* Scientific American. 1986. Introduced by JM Wolfe. W. H. Freeman. New York.

Hubel DH, Wiesel TN. 2005. *Brain and Visual Perception: The Story of a 25-Year Collaboration.* Oxford University Press. New York.

Kemp M. 1992. *The Science of Art: Optical Themes in Western Art from Brunelleschi to Seurat.* Yale University Press. New Haven and London.

Kleinschmidt A, Büchel C, Zeki S, Frackowiak RSJ. 1998. Human brain activity during spontaneously reversing perception of ambiguous figures. Proceedings of the Royal Society 265:2427–2433. London.

Livingstone M. 2002. *Vision and Art: The Biology of Seeing.* Abrams. New York.

Marr D. 1982. *Vision: A Computational Investigation into the Human Representation and Processing of Visual Information.* W. H. Freeman. New York.

Movshon A, Wandell B. 2004. Introduction to Sensory Systems. In: *The Cognitive Neurosciences* III, pp. 185–187. MS Gazzaniga, editor. Bradford Books. MIT Press. Cambridge, MA.

Ramachandran VS. 1988. Perceiving shape from shading. Scientific American 259:76–83.

Ratliff F. 1985. The influence of contour on contrast: From cave painting to Cambridge psychology. Transactions of the American Philosophical Society 75(6):1–19.

Rittenhouse D. 1786. Explanation of an optical deception. Transactions of the American Philosophical Society 2:37–42.

Schwartz A. 2011. Learning to see the strike zone with one eye. http://www.nytimes.com/2011/03/20/sports/baseball/20pitcher.html (accessed September 21, 2011).

Solso RL. 1994. *Cognition and the Visual Arts.* Bradford Books. MIT Press. Cambridge, MA.

Stevens CF. 2001. Line versus Color: The Brain and the Language of Visual Arts. In: *The Origins of Creativity,* pp. 177–189. KH Pfenninger, VR Shubick, editors. Oxford University Press. Oxford and New York.

Von der Heydt R, Qiu FT, He JZ. 2003. Neural mechanisms in border ownership assignment: Motion parallax and Gestalt cues. (Abstract). Journal of Vision 3:666a.

Wurtz RH, Kandel ER. 2000. Perception of Motion, Depth, and Form. In: *Principles of Neural Science* (Chap. 28), pp. 492–506. 4th ed. Kandel ER, Schwartz JH, Jessell T, editors. McGraw-Hill. New York.

Zeki S. 1999. *Inner Vision: An Exploration of Art and the Brain.* Oxford University Press. New York.

Zeki S. 2001. Artistic creativity and the brain. Science 293(5527):51–52.

Zeki S. 2008. *Splendors and Miseries of the Brain: Love, Creativity, and the Quest for Human Happiness.* John Wiley and Sons. Oxford.

*Chapter 17:* HIGH-LEVEL VISION AND THE BRAIN'S PERCEPTION
OF FACE, HANDS, AND BODY

Baker C. 2008. Face to face with cortex. Nature Neuroscience (11):862–864.

Bodamer J. 1947. Die Prosop-Agnosie. Archiv für Psychiatrie und Nervenkrankheiten 179:6–53.

Code C, Wallesch CW, Joanette Y, Lecours AR, editors. 1996. *Classic Cases in Neuropsychology.* Pyschology Press. Erlbaum (UK). Taylor & Francis Ltd. UK.

Connor CE. 2010. A new viewpoint on faces. Science 330:764–765.

Craft E, Schütze H, Niebur E, von der Heydt R. 2007. A neuronal model of figure-ground organization. Journal of Neurophysiology 97:4310–4326.

Darwin C. 1872. *The Expression of the Emotions in Man and Animals.* Appleton-Century-Crofts. New York.

Daw N. 2012. *How Vision Works.* Oxford University Press. New York.

de Gelder B. 2006. Towards the neurobiology of emotional body language. Nature Reviews Neuroscience 7(3):242–249.

Exploratorium: Mona: Exploratorium Exhibit. [Internet]. 2010. San Francisco: Exploratorium [last updated October 12, 2010; cited 2011 January 10, 2011]. Available from: http://www.exploratorium.edu/exhibits/mona/mona.html (accessed September 14, 2011).

Felleman DJ, Van Essen DC. 1991. Distributed hierarchical processing in primate cerebral cortex. Cerebral Cortex 1:1–47.

Freiwald WA, Tsao DY, Livingstone MS. 2009. A face feature space in the macaque temporal lobe. Nature Neuroscience 12(9):1187–1196.

Freiwald WA, Tsao DY. 2010. Functional compartmentalization and viewpoint generalization within the macaque face processing system. Science 330:845–851.

Gombrich EH. 1960. *Art and Illusion. A Study in the Psychology of Pictorial Representation*. Princeton University Press. Princeton and Oxford.

Gross C. 2009. *A Hole in the Head: More Tales in the History of Neuroscience*. Chap. 3, pp. 179–182. MIT Press. Cambridge, MA.

Haxby J, Hoffman E, Gobbini M. 2002. Human neural systems for face recognition and social communication. Biological Psychiatry 51:59–67.

Hubel DH, Wiesel TN. 1979. Brain Mechanisms of Vision. In: *The Mind's Eye. Readings from* Scientific American, p. 40. 1986. Introduced by JM Wolfe. W. H. Freeman. New York.

Hubel DH, Wiesel TN. 2004. *Brain and Visual Perception: The Story of a 25-Year Collaboration*. Oxford University Press. New York.

James W. 1890. *The Principles of Psychology*. Vols. 1 and 2. Henry Holt. New York.

Johansson G. 1973. Visual perception of biological motion and a model for its analysis. Perception and Psychophysics 14:201–211.

Kanwisher N, McDermott J, Chun MM. 1997. The fusiform face area: A module in human extrastriate cortex specialized for face perception. *Journal of Neuroscience* 17:4302–4311.

Lorenz K. 1971. *Studies in Animal and Human Behavior*. Harvard University Press. Cambridge, MA.

Marr D. 1982. *Vision: A Computational Investigation into the Human Representation and Processing of Visual Information*. W. H. Freeman. New York.

Meltzoff AN, Moore MK. Imitation of facial and manual gestures by human neonates. Science 198(4312):75–78.

Miller E, Cohen JP. 2001. An integrative theory of prefrontal cortex function. Annual Review of Neuroscience 24:167–202.

Moeller S, Freiwald WA, Tsao DY. 2008. Patches with links: A unified system for processing faces in the macaque temporal lobe. Science 320(5881):1355–1359.

Morton J, Johnson MH. 1991. *Biology and Cognitive Development: The Case of Face Recognition*. Blackwell Publishing. Oxford.

Pascalis O, de Haan M, Nelson CA. 2002. Is face processing species-specific during the first year of life? Science 296(5571):1321–1323.

Puce A, Allison T, Asgari M, Gore JC, McCarthy G. 1996. Differential sensitivity of human visual cortex to faces, letter strings, and textures: A functional magnetic resonance imaging study. Journal of Neuroscience 16(16):5205–5215.

Puce A, Allison T, Bentin S, Gore JC, McCarthy G. 1998. Temporal cortex activation in humans viewing eye and mouth movements. Journal of Neuroscience 18:2188–2199.

Quian Quiroga R, Reddy L, Kreiman G, Koch C, Fried I. 2005. Invariant visual representation by single neurons in the human brain. Nature 435:1102–1107.

Ramachandran VS. 2003. *The Emerging Mind*. The Reith Lectures. BBC in association with Profile Books. London.

Ramachandran VS. 2004. *A Brief Tour of Human Consciousness: From Imposter Poodles to Purple Numbers*. Pi Press. New York.

Sargent J, Ohta S, MacDonald B. 1992. Functional neuroanatomy of face and object processing. *Brain* 115:15–36.

Soussloff CM. 2006. *The Subject in Art: Portraiture and the Birth of the Modern*. Duke University Press. Durham, NC.

Thompson P. 1980. Margaret Thatcher: A new illusion. Perception 9:483–484.

Tinbergen N, Perdeck AC. 1950. On the stimulus situation releasing the begging response in the newly hatched herring gull chick. Behaviour 3(1):1–39.

Treisman A. 1986. Features and objects in visual processing. Scientific American 255(5):114–125.

Tsao DY. 2006. A dedicated system for processing faces. Science 314:72–73.

Tsao DY, Freiwald WA. 2006. What's so special about the average face? Trends in Cognitive Sciences 10(9):391–393.

Tsao DY, Livingstone MS. 2008. Mechanisms of face perception. Annual Review of Neuroscience 31:411–437.

Tsao DY, Schweers N, Moeller S, Freiwald WA. 2008. Patches of face-selective cortex in the macaque frontal lobe. Nature Neuroscience 11:877–879.

Viskontas IV, Quiroga RQ, Fried I. 2009. Human medial temporal lobe neurons respond preferentially to personally relevant images. Proceedings of the National Academy of Sciences 106(50):21329–21334.

Wurtz RH, Goldberg ME, Robinson DL. 1982. Brain mechanisms of visual attention. Scientific American 246(6):124–135.

Zeki S, Shipp S. 2006. Modular connections between areas V2 and V4 of macaque monkey visual cortex. European Journal of Neuroscience 1(5):494–506.

Zeki S. 2009. *Splendors and Miseries of the Brain: Love, Creativity, and the Quest for Human Happiness*. John Wiley & Sons. Oxford.

*Chapter 18:* TOP-DOWN PROCESSING OF INFORMATION: USING
MEMORY TO FIND MEANING

Albright T. 2011. High-Level Vision and Cognitive Influences. In: *Principles of Neural Science* (Chap. 28). 5th ed. Kandel ER, Schwartz JH, Jessell T, Siegelbaum S, Hudspeth JH, editors. McGraw-Hill. New York.

Arnheim R. 1954. *Art and Visual Perception: A Psychology of the Creative Eye*. The New Version. 1974. University of California Press. Berkeley and Los Angeles.

Cavanagh P. 2005. The Artist as Neuroscientist. Nature 434:301–307.

Ferretti S. 1989. *Cassirer, Panofsky, and Warburg: Symbols, Art, and History*. R Pierce, translator. Yale University Press. New Haven.

Gilbert C. 2011. The Constructive Nature of Visual Processing. In: *Principles of Neural Science* (Chap. 25). 5th ed. Kandel ER, Schwartz JH, Jessell T, Siegelbaum S, Hudspeth JH, editors. McGraw-Hill. New York.

Gilbert C. 2011. Visual Primitives and Intermediate Level Vision. In: *Principles of Neural Science* (Chap. 27). 5th ed. Kandel ER, Schwartz JH, Jessell T, Siegelbaum S, Hudspeth JH, editors. McGraw-Hill. New York.

Gombrich EH. 1987. In: *Reflections on the History of Art*, R Woodfield, editor, p. 211.

Originally published as a review of Morse Peckham, *Man's Rage for Chaos: Biology, Behavior, and the Arts.* New York Review of Books. June 23, 1966.

Kris E. 1952. *Psychoanalytic Explorations in Art.* International Universities Press. New York.

Mamassian P. 2008. Ambiguities and conventions in the perception of visual art. Vision Research 48:2143–2153.

Miller E, Cohen JP. 2001. An integrative theory of prefrontal cortex function. Annual Review of Neuroscience 24:67–202.

Milner B. 2005. The medial temporal lobe amnesiac syndrome. Psychiatric Clinics of North America 28(3):599–611.

Pavlov IP. 1927. *Conditioned Reflexes: An Investigation of the Physiological Activity of the Cerebral Cortex.* GV Anrep, translator. Oxford University Press. London.

Polanyi M, Prosch H. 1975. *Meaning.* University of Chicago Press. Chicago.

Riegl A. 1902. *The Group Portraiture of Holland.* EM Kain, D Britt, translators. 1999. Getty Research Institute. Los Angeles.

Rock I. 1984. *Perception.* Scientific American Library. W. H. Freeman. San Francisco.

Tomita H, Ohbayashi M, Nakahara K, Hasegawa I, Miyashita Y. 1999. Top-down signal from prefrontal cortex in executive control of memory retrieval. Nature 401:699–703.

Chapter 19: THE DECONSTRUCTION OF EMOTION: THE SEARCH FOR EMOTIONAL PRIMITIVES

Bostrom A, Scherf G, Lambotte MC, Potzl-Malikova M. 2010. *Franz Xaver Messerschmidt, 1736–1783: From Neoclassicism to Expressionism.* Neue Galerie catalog accompanying exhibition of work by Messerschmidt, September 2010 to January 2011. Officina Libraria. Italy.

Bradley MM, Sabatinelli D. 2003. Startle reflex modulation: Perception, attention, and emotion. In: *Experimental Methods in Neuropsychology,* p. 78. K Hugdahl, editor. Kluwer Academic Publishers. Norwell, MA.

Changeux JP. 1994. Art and neuroscience. Leonardo 27(3):189–201.

Chartrand TL, Bargh JA. 1999. The chameleon effect: The perception-behavior link and social interaction. Journal of Personality and Social Psychology 76(6):893–910.

Damasio AR. 1999. *The Feeling of What Happens: Body and Emotion In the Making of Consciousness.* Mariner Books. Boston.

Darwin C. 1859. *On the Origin of Species by Means of Natural Selection.* Appleton-Century-Crofts. New York.

Darwin C. 1871. *The Descent of Man and Selection in Relation to Sex.* Appleton-Century-Crofts. New York.

Darwin C. 1872. *The Expression of the Emotions in Man and Animals.* Appleton-Century-Crofts. New York.

Descartes R. 1694. *Treatise on the Passions of the Soul.* In: *The Philosophical Works of Descartes.* ES Halman, GRT Ross, translators. 1967. Cambridge University Press.

de Sousa R. 2010. Emotion. In: *The Stanford Encyclopedia of Philosophy.* Fall 2010 ed. EN Zalta, editor. Metaphysics Research Lab. Stanford, CA.

Dijkstra B. 1986. *Idols of Perversity: Fantasies of Feminine Evil in Fin-de-Siècle Culture.* Oxford University Press. New York and Oxford.

Ekman P. 1989. The argument and evidence about universals in facial expressions of emotion. In *Handbook of Psychophysiology: Emotion and Social Behavior,* pp. 143–164. H Wagner, A Manstead, editors. John Wiley & Sons. London.

Freud S. 1938. An Outline of Psycho-Analysis. In: *The Standard Edition of the Complete Psychological Works of Sigmund Freud (1937–1939)*. Vol. XXIII, pp. 139–208. Hogarth Press 1964. London.

Freud S. 1950. *Collected Papers*. Vol 4. J Riviere, translator. Hogarth Press and Institute of Psychoanalysis. London.

Gay P. 1989. *The Freud Reader*. W. W. Norton. New York.

Gombrich EH. 1955. *The Story of Art*. Phaidon Press. London.

Helmholtz H von. 1910. *Treatise on Physiological Optics*. JPC Southall, editor and translator. 1925. Dover. New York.

Iverson S, Kupfermann I, Kandel ER. 2000. Emotional States and Feelings. In: *Principles of Neural Science* (Chap. 50), pp. 982–997. 4th ed. Kandel ER, Schwartz JH, Jessell T, editors. McGraw-Hill. New York.

James W. 1890. *The Principles of Psychology*. Harvard University Press. Cambridge, MA, and London.

Kant I. 1785. *Groundwork for the Metaphysics of Morals*. 1998. Cambridge University Press. New York.

Kemball R. 2009. Art in Darwin's terms. Times Literary Supplement. March 20, 2009.

Kris E. 1952. *Psychoanalytic Explorations in Art*. International Universities Press. New York.

Lang PJ. 1995. The emotion probe: Studies of motivation and attention. American Psychologist 50(5):272–285.

Panofsky E. 1939. *Studies in Iconology: Humanistic Themes in the Art of the Renaissance*. Westview Press. Boulder, CO.

Pascalis O, de Haan M, Nelson CA. 2002. Is face processing species-specific during the first year of life? Science Magazine 296(5571):1321–1323.

Rolls ET. 2005. *Emotion Explained*. Oxford University Press. New York.

Silva PJ. 2005. Emotional response to art: From collation and arousal to cognition and emotion. Review of General Psychology 90:342–357.

Slaughter V, Heron M. 2004. Origins and early development of human body knowledge. Monographs of the Society for Research in Child Development 69(2):103–113.

Solms M, Nersessian E. 1999. Freud's theory of affect: Questions for neuroscience. Neuropsychoanalysis 1:5–14.

Strack F, Martin LL, Stepper S. 1988. Inhibiting and facilitating conditions of the human smile: A nonobtrusive test of the facial feedback hypothesis. *Journal of Personality and Social Psychology* 54(5):768–777.

*Chapter 20:* THE ARTISTIC DEPICTION OF EMOTION THROUGH THE FACE, HANDS, BODY, AND COLOR

Aiken NE. 1984. Physiognomy and art: Approaches from above, below, and sideways. Visual Art Research 10:52–65.

Barnett JR, Miller S, Pearce E. 2006. Colour and art: A brief history of pigments. Optics and Laser Technology 38:445–453.

Chartrand TL, Bargh JA. 1999. The chameleon effect: The perception-behavior link and social interaction. Journal of Personality and Social Psychology 76(6):893–910.

Damasio A. 1994. *Descartes' Error: Emotion, Reason, and the Human Brain*. G. P. Putnam's Sons. New York.

Darwin C. 1872. *The Expression of the Emotions in Man and Animals*. Appleton-Century-Crofts. New York.

Downing PE, Jiang Y, Shuman M, Kanwisher N. 2001. A cortical area selective for visual processing of the human body. Science 293(5539):2470–2473.

Ekman P. 2003. *Emotions Revealed: Recognizing Faces and Feelings to Improve Communication and Emotional Life*. Owl Books. New York.

Frith U. 1989. *Autism: Explaining the Enigma*. Blackwell Publishing. Oxford.

Gage J. 2006. *Color in Art*. Thames and Hudson. London.

Hughes R. 1991. *The Shock of the New: Art and the Century of Change*. 2nd ed. Thames and Hudson. London.

Javal E. 1906. *Physiologie de la Lecture et de l'Écriture (Physiology of Reading and Writing)*. Felix Alcan. Paris.

Langton SRH, Watt RJ, Bruce V. 2000. Do the eyes have it? Cues to the direction of social attention. Trends in Cognitive Science 4:50–59.

Livingstone M. 2002. *Vision and Art: The Biology of Seeing*. Harry N. Abrams. New York.

Livingstone M, Hubel D. 1988. Segregation of form, color, movement, and depth: Anatomy, physiology, and perception. Science 240:740–749.

Lotto RB, Purves D. 2004. Perceiving color. Review of Progress in Coloration 34:12–25.

Marks WB, Dobelle WH, MacNichol EF. 1964. Visual pigments of single primate cones. *Science* 13:1181–1182.

Molnar F. 1981. About the role of visual exploration in aesthetics. In: *Advances In Intrinsic Motivation and Aesthetics*. H Day, editor. Plenum. New York.

Natter T. 2002. *Oskar Kokoschka: Early Portraits from Vienna and Berlin, 1909–1914*. Dumont Buchverlag. Koln, Germany.

Nodine CF, Locher PJ, Krupinski EA. 1993. The role of formal art training on perception and aesthetic judgment of art compositions. Leonardo 26(3):219–227.

Pelphrey KA, Morris JP, McCarthy G. 2004. Grasping the intentions of others: The perceived intentionality of an action influences activity in the superior temporal sulcus during social perception. Journal of Cognitive Neuroscience 16(10):1706–1716.

Pirenne MH. 1944. Rods and cones and Thomas Young's theory of color vision. Nature 154:741–742.

Puce A, Allison T, Bentin S, Gore JC, McCarthy G. 1998. Temporal cortex activation in humans viewing eye and mouth movements. Journal of Neuroscience 18:2188–2199.

Sacco T, Sacchetti B. 2010. Role of secondary sensory cortices in emotional memory storage and retrieval in rats. Science 329:649–656.

Simpson K. 2010. Viennese art, ugliness, and the Vienna School of Art History: The vicissitudes of theory and practice. Journal of Art Historiography 3:1–14.

Slaughter V, Heron M. 2004. Origins and early development of human body knowledge. Monographs of the Society for Research in Child Development 69(2):103–113.

Solso RL. 1994. *Cognition and the Visual Arts*. Bradford Books. MIT Press. Cambridge, MA.

Zeki S. 2008. *Splendors and Miseries of the Brain*. Wiley-Blackwell. Oxford.

*Chapter 21:* UNCONSCIOUS EMOTIONS, CONSCIOUS FEELINGS, AND THEIR BODILY EXPRESSION

Adolphs R, Tranel D, Damasio AR. 1994. Impaired recognition of emotion in facial expression following bilateral damage to the human amygdala. Nature 372:669–672.

Adolphs R, Gosselin F, Buchanan TW, Tranel D, Schyns P, Damasio A. 2005. A mechanism for impaired fear recognition after amygdala damage. Nature 433:68–72.

Anderson AK, Phelps EA. 2000. Expression without recognition: Contributions of the human amygdala to emotional communication. Psychological Science 11(2):106–111.

Arnold MB. 1960. *Emotion and Personality.* Columbia University Press. New York.

Barzun J. 2002. *A Stroll with James.* University of Chicago Press. Chicago.

Boring EG. 1950. *A History of Experimental Psychology.* Appleton-Century-Crofts. New York.

Bradley MM, Greenwald MK, Petry MC, Lang PJ. 1992. Remembering pictures: Pleasure and arousal in memory. Journal of Experimental Psychology: Learning, Memory, and Cognition 18:379–390.

Cannon WB. 1915. *Bodily Changes in Pain, Hunger, Fear, and Rage: An Account of Recent Researches into the Function of Emotional Excitement.* D. Appleton & Co. New York.

Cardinal RN, Parkinson JA, Hall J, Everitt BJ. 2002. Emotion and motivation: The role of the amygdala, ventral striatum, and prefrontal cortex. Neuroscience and Biobehavioral Reviews 26:321–352.

Craig AD. 2009. How do you feel—now? The anterior insula and human awareness. National Review of Neuroscience 10(1):59–70.

Critchley HD, Wiens S, Rotshtein P, Öhman A, Dolan RJ. 2004. Neural systems supporting interoceptive awareness. Nature Neuroscience 7:189–195.

Damasio A. 1994. *Descartes' Error: Emotion, Reason, and the Human Brain.* G. P. Putnam's Sons. New York.

Damasio A. 1996. The somatic marker hypothesis and the possible functions of the prefrontal cortex. Proceedings of the Royal Society of London B 351:1413–1420.

Damasio A. 1999. *The Feeling of What Happens: Body and Emotion in the Making of Consciousness.* Harcourt Brace. New York.

Darwin C. 1872. *The Expression of the Emotions in Man and Animals.* John Murray. London.

Etkin A, Klemenhagen KC, Dudman JT, Rogan MT, Hen R, Kandel E, Hirsch J. 2004. Individual differences in trait anxiety predict the response of the basolateral amygdala to unconsciously processed fearful faces. Neuron 44:1043–1055.

Freud S. 1915. *The Unconscious.* Penguin Books. London.

Frijda NH. 2005. Emotion experience. Cognition and Attention 19:473–498.

Frith C. 2007. *Making Up the Mind: How the Brain Creates Our Mental World.* Blackwell Publishing. Malden, MA.

Harrison NA, Gray MA, Gienoros PS, Critchley HD. 2010. The embodiment of emotional feeling in the brain. Journal of Neuroscience 30(38):12878–12884.

Iverson S, Kupfermann I, Kandel ER. 2000. Emotional States and Feelings. In: *Principles of Neural Science* (Chap. 50), pp. 982–997. 4th ed. Kandel ER, Schwartz JH, Jessell T, editors. McGraw-Hill. New York.

James W. 1884. What is an emotion? Mind 9:188–205.

James W. 1890. *Principles of Psychology.* Vols. 1 and 2. Dover Publications. Mineola, NY.

Kandel E. 2006. *In Search of Memory. The Emergence of a New Science of Mind.* W. W. Norton. New York.

Klüver H, Bucy PC. 1939. Preliminary analysis of functions of the temporal lobes in monkeys. Archives of Neurology and Psychiatry 42(6):979–1000.

Knutson B, Delgado M, Phillips P. 2008. Representation of Subjective Value in the

Striatum. In: *Neuroeconomics: Decision Making and the Brain* (Chap. 25). P Glimcher, C Camerer, E Fehr, R Poldrack, editors. Academic Press. London.

Lang PJ. 1994. The varieties of emotional experience: A meditation on James-Lange theory. Psychological Review 101:211–221.

LeDoux J. 1996. *The Emotional Brain: The Mysterious Underpinning of Emotional Life.* Simon and Schuster. New York.

Miller EK, Cohen JD. 2001. An integrative theory of prefrontal cortex function. Annual Review of Neuroscience 24:167–202.

Oatley K. 2004. *Emotions: A Brief History.* Blackwell Publishing. Oxford.

Phelps EA. 2006. Emotion and cognition: Insights from studies of the human amygdala. Annual Review of Psychology 57:27–53.

Rokitansky C. 1846. *Handbuch der pathologischen Anatomie.* Braumüller & Scidel. Germany.

Rolls ET. 2005. *Emotion Explained.* Oxford University Press. New York.

Salzman CD, Fusi S. 2010. Emotion, cognition, and mental state representation in amygdala and prefrontal cortex. Annual Review of Neuroscience 33. June 16, 2010 (ePub ahead of print).

Schachter S, Singer JE. 1962. Cognitive, social, and physiological determinants of emotional states. Psychological Review 69:379–399.

Vuilleumier P, Richardson MP, Armory JL, Driver J, Dolan RJ. 2004. Distant influences of amygdala lesion on visual cortical activation during emotional face processing. Nature Neuroscience 7:1271–1278.

Weiskrantz L. 1956. Behavioral changes associated with ablation of the amygdaloid complex in monkeys. Journal of Comparative Physiological Psychology 49:381–391.

Whalen PJ, Kagan J, Cook RG, Davis C, Kim H, Polis S, McLaren DG, Somerville LH, McLean AA, Maxwell JS, Johnston T. 2004. Human amygdala responsivity to masked fearful eye whites. Science 306:2061.

Whitehead AN. 1925. *Science and the Modern World.* Macmillan. New York.

Wurtz RH, Kandel ER. 2000. Construction of the Visual Image. In: *Principles of Neural Science* (Chap. 25), pp. 492–506. 4th ed. Kandel ER, Schwartz JH, Jessell T, editors. McGraw-Hill. New York.

*Chapter 22:* TOP-DOWN CONTROL OF COGNITIVE
EMOTIONAL INFORMATION

Amodio DM, Frith CD. 2006. Meeting of minds: The medial frontal cortex and social cognition. National Review of Neuroscience 7(4):268–277.

Anderson AK, Phelps EA. 2002. Is the human amygdala critical for the subjective experience of emotion? Evidence of dispositional affect in patients with amygdala lesions. Journal of Cognitive Neuroscience 14:709–720.

Anderson SW, Bechara A, Damascott TD, Damasio AR. 1999. Impairment of social and moral behavior related to early damage in the human prefrontal cortex. Nature Neuroscience 2:1032–1037.

Berridge KC, Kringelbach ML. 2008. Effective neuroscience of pleasure: Rewards in humans and animals. Psychopharmacology 199:457–480.

Breiter HC, Aharon I, Kahneman D. 2001. Functional imaging of neural responses to expectancy and experience of monetary gains and losses. Neuron 30:619–639.

Breiter HC, Gollub RL, Weisskoff RM. 1997. Acute effects of cocaine on human brain activity and emotion. Neuron 19:591–611.

Cardinal R, Parkinson J, Hall J, Everitt B. 2002. Emotion and motivation: The role of

the amygdala, ventral striatum, and prefrontal cortex. Neuroscience and Biobehavioral Reviews 26:321–352.

Churchland PS. 2002. *Brain-Wise: Studies in Neurophysiology.* MIT Press. Cambridge, MA.

Colby C, Olson C. 2012. The Organization of Cognition. In: *Principles of Neural Science* (Chap. 18). 5th ed. Kandel ER, Schwartz JH, Jessell TM, Hudspeth AJ, Siegelbaum S, editors. McGraw-Hill. New York.

Damasio A. 1996. The somatic marker hypothesis and the possible functions of the prefrontal cortex. Proceedings of the Royal Society of London B 351:1413–1420.

Damasio H, Grabowski T, Frank R, Galaburda AM, Damasio AR. 1994. The return of Phineas Gage: Clues about the brain from the skull of a famous patient. Science 254(5162):1102–1105.

Darwin C. 1872. *The Expression of the Emotions in Man and Animals.* Appleton-Century-Crofts. New York.

Delgado M. 2007. Reward-related responses in the human striatum. Annals of New York Academy of Science 1104:70–88.

Foot P. 1967. The problem of abortion and the doctrine of double effect. Oxford Review 5:5–15.

Freud S. 1915. *The Unconscious.* Penguin Books. London.

Frijda NH. 2005. Emotion experience. Cognition and Attention 19:473–498.

Fuster JM. 2008. *The Prefrontal Cortex.* 4th ed. Academic Press. London.

Greene JD. 2007. Why are VMPFC patients more utilitarian? A dual-process theory of moral judgment explains. Trends in Cognitive Sciences 11(8):322–323.

Greene JD. 2009. Dual-process morality and the personal/impersonal distinction: A reply to McGuire, Langdon, Coltheart, and Mackenzie. Journal of Experimental Social Psychology 45(3):581–584.

Greene JD, Nystrom LE, Engell AD, Darley JM, Cohen JD. 2004. The neural bases of cognitive conflict and control in moral judgment. Neuron 44:389–400.

Greene JD, Paxton JM. 2009. Patterns of neural activity associated with honest and dishonest moral decisions. Proceedings of the National Academy of Sciences USA 106(30):12506–12511.

James W. 1890. *The Principles of Psychology.* Vols. 1 and 2. Harvard University Press. Cambridge, MA, and London.

Knutson B, Delgado M, Phillips P. 2008. Representation of Subjective Value in the Striatum. In: *Neuroeconomics: Decision Making and the Brain* (Chap. 25). P Glimcher, C Camerer, E Fehr, R Poldrack, editors. Academic Press. London.

Lang PJ. 1994. The varieties of emotional experience: A meditation on James-Lange theory. Psychological Review 101:211–221.

LeDoux J. 1996. *The Emotional Brain: The Mysterious Underpinnings of Emotional Life.* Simon and Schuster. New York.

MacMillan M. 2000. *An Odd Kind of Fame. Stories of Phineas Gage.* Bradford Books. MIT Press. Cambridge, MA.

Mayberg HS, Brannan SK, Mahurin R, Jerabek P, Brickman J, Tekell JL, Silva JA, McGinnis S. 1997. Cingulate function in depression: A potential predictor of treatment response. NeuroReport 8:1057–1061.

Miller EK, Cohen JD. 2001. An integrative theory of prefrontal cortex function. Annual Review of Neuroscience 24:167–202.

Oatley K. 2004. *Emotions: A Brief History.* Blackwell Publishing. Malden, MA.

Olsson A, Ochsner KN. 2008. The role of social cognition in emotion. Trends in Cognitive Sciences 12(2):65–71.

Phelps EA. 2006. Emotion and cognition: Insights from studies of the human amygdala. Annual Review of Psychology 57:27–53.

Rolls ET. 2005. *Emotion Explained*. Oxford University Press. New York.

Rose JE, Woolsey CN. 1948. The orbitofrontal cortex and its connections with the mediodorsal nucleus in rabbit, sheep and cat. *Research Publications of the Association for Research in Nervous and Mental Diseases* 27:210–232.

Salzman CD, Fusi S. 2010. Emotion, cognition, and mental state representation in amygdala and prefrontal cortex. *Annual Review of Neuroscience* 33. June 16, 2010 (ePub ahead of print).

Solms M. 2006. Freud Returns. In: *Best of the Brain from* Scientific American. F Bloom, editor. Dana Press. New York and Washington, DC.

Solms M, Nersessian E. 1999. Freud's theory of affect: Questions for neuroscience. Neuro-psychoanalysis 1(1):5–12.

Thompson JJ. 1976. Killing, letting die, and the trolley problem. Monist 59:204–217.

Thompson JJ. 1985. The trolley problem. Yale Law Journal 94:1395–1415.

*Chapter 23:* THE BIOLOGICAL RESPONSE TO BEAUTY AND
                UGLINESS IN ART

Adams RB, Kleck RE. 2003. Perceived gaze direction and the processing of facial displays of emotion. Psychiatric Science 14:644–647.

Aron A, Fisher H, Mashek DJ, Strong G, Li H, Brown LL. 2005. Reward, motivation, and emotion systems associated with early stage intense romantic love. Journal of Neurophysiology 94:327–337.

Bar M, Neta M. 2006. Humans prefer curved visual objects. Psychological Science 17:645–648.

Barrett LF, Wagner TD. 2006. The structure of emotion: Evidence from neuroimaging studies. Current Directions in Psychological Science 15(2):79–85.

Bartels A, Zeki S. 2004. The neural correlates of maternal and romantic love. NeuroImage 21:1155–1166.

Berridge KC, Kringelbach ML. 2008. Affective neuroscience of pleasure: Reward in humans and animals. Psychopharmacology 199:457–480.

Brunetti M, Babiloni C, Ferretti A, del Gratta C, Merla A, Belardinelli MO, Romani GL. 2008. Hypothalamus, sexual arousal and psychosexual identity in human males: A functional magnetic resonance imaging study. European Journal of Neuroscience 27(11):2922–2927.

Calder AJ, Burton AM, Miller P, Young AW, Akamatsu S. 2001. A principal component analysis of facial expressions. Vision Research 41:1179–1208.

Carey S, Diamond R. 1977. From piecemeal to configurational representation of faces. Science 195:312–314.

Cela-Conde CJ, Marty G, Maestu F, Ortiz T, Munar E, Fernandez A, Roca M, Rossello J, Quesney F. 2004. Activation of the prefrontal cortex in the human visual aesthetic perception. Proceedings of the National Academy of Sciences 101:6321–6325.

Cowley G. 1996. The biology of beauty. Newsweek. June 3, 1996, pp. 60–67.

Cunningham MR. 1986. Measuring the physical in physical attractiveness: Quasi-experiments on the sociobiology of female facial beauty. Journal of Personality and Social Psychology 50:925–935.

Damasio A. 1999. *The Feeling of What Happens: Body and Emotion in the Making of Consciousness*. Harcourt Brace. New York.

Darwin C. 1871. *The Descent of Man and Selection in Relation to Sex.* Appleton-Century-Crofts. New York.

Downing PE, Bray D, Rogers J, Childs C. 2004. Bodies capture attention when nothing is expected. *Cognition* B28–B38.

Dutton DD. 2009. *The Art Instinct: Beauty, Pleasure, and Human Evolution.* Bloomsbury Press. New York.

Elsen A. 1994. Drawing and a New Sexual Intimacy: Rodin and Schiele. In: *Egon Schiele: Art, Sexuality, and Viennese Modernism.* P Werner, editor. Society for the Promotion of Science and Scholarship. Palo Alto, CA.

Fink B, Penton-Voak IP. 2002. Evolutionary psychology of facial attractiveness. Current Directions in Psychological Science 11:154–158.

Fisher H. 2000. Lust, attraction, attachment: Biology and evolution of the three primary emotion systems for mating, reproduction, and parenting. Journal of Sex Education and Therapy 25(1):96–104.

Fisher H, Aron A, Brown LL. 2005. Romantic love: An fMRI study of a neural mechanism for mate choice. Journal of Comparative Neurology 493: 58–62.

Fisher HE, Brown LL, Aron A, Strong G, Mashek D. 2010. Reward, addiction, and emotion regulation systems associated with rejection in love. Journal of Neurophysiology 104: 51–60.

Gilbert D. 2006. *Stumbling on Happiness.* Alfred A. Knopf. New York.

Gombrich EH. 1987. In: *Reflections on the History of Art,* p. 211. R Woodfield, editor. Originally published as a review of Morse Peckham, *Man's Rage for Chaos: Biology, Behavior, and the Arts.* New York Review of Books. June 23, 1966.

Guthrie G, Wiener M. 1966. Subliminal perception or perception of partial cues with pictorial stimuli. Journal of Personality and Social Psychology 3:619–628.

Grammer K, Fink B, Møller AP, Thornhill R. 2003. Darwinian aesthetics: Sexual selection and the biology of beauty. Biological Reviews 78(3):385–407.

Hughes R. 1991. *The Shock of the New: Art and the Century of Change.* 2nd ed. Thames and Hudson. London.

Kawabata H, Zeki S. 2004. Neural correlates of beauty. Journal of Neurophysiology 91:1699–1705.

Kirsch P, Esslinger C, Chen Q, Mier D, Lis S, Siddhanti S, Gruppe H, Mattay VS, Gallhofer B, Meyer-Lindenberg A. 2005. Oxytocin modulates neural circuitry for social cognition and fear in humans. Journal of Neuroscience 25(49):11489–11493.

Lang P. 1979. A bio-informational theory of emotional imagery. Psychophysiology 1:495–512.

O'Doherty J, Winston J, Critchley H, Perrett D, Burt DM, Dolan RJ. 2003. Beauty in a smile: The role of medial orbitofrontal cortex in facial attractiveness. Neuropsychology 41:147–155.

Marino MJ, Wittmann M, Bradley SR, Hubert GW, Smith Y, Conn PJ. 2001. Activation of Group 1 metabotropic glutamate receptors produces a direct excitation and disinhibition of GABAergic projection neurons in the substantia nigra pars reticulata. Journal of Neuroscience 21(18):7001–7012.

Paton JJ, Belova MA, Morrison SE, Salzman CD. 2006. The primate amygdala represents the positive and negative value of visual stimuli during learning. Nature 439:865–870.

Perrett DI, Burt DM, Penton-Voak IS, Lee KJ, Rowland DA, Edwards R. 1999. Symmetry and human facial attractiveness. Evolution and Human Behavior 20:295–307.

Perrett DI, May KA, Yoshikawa S. 1994. Facial shape and judgments of female attractiveness. Nature 368:239–242.

Ramachandran VS, Hirstein W. 1999. The science of art: A neurological theory of aesthetic experience. Journal of Consciousness Studies 6(6–7):15–51.

Ramachandran VS. 2003. *The Emerging Mind*. The Reith Lectures. BBC in association with Profile Books. London.

Ramsey JL, Langlois JH, Hoss RA, Rubenstein AJ, Griffin A. 2004. Origins of a stereotype: Categorization of facial attractiveness by 6-month-old infants. Developmental Science 7:201–211.

Riegl A. 1902. *The Group Portraiture of Holland*. E Kain, D Britt, translators. 1999. Introduction by W Kemp. Getty Research Institute for the History of Art and the Humanities. Los Angeles.

Rose C. 2006. An hour with Ronald Lauder at the Neue Galerie. September 4, 2006.

Salzman CD, Paton JJ, Belova MA, Morrison SE. 2007. Flexible neural representations of value in the primate brain. Annals of the New York Academy of Science 1121:336–354.

Saxton TK, Debruine LM, Jones BC, Little AC, Roberts SC. 2009. Face and voice attractiveness judgments change during adolescence. Evolution and Human Behavior 30:398–408.

Schorske CE. *Fin-de-siècle Vienna: Politics and Culture*. 1981. Random House. New York.

Simpson K. 2010. Viennese art, ugliness, and the Vienna School of Art History: The vicissitudes of theory and practice. Journal of Art Historiography 3:1–14.

Singer T, Seymour B, O'Doherty J, Kaube H, Dolan RJ, Frith C. 2004. Empathy for pain involves the affective but not sensory components of pain. Science 303:1157–1162.

Tamietto M, Geminiani G, Genero R, de Gelder B. 2007. Seeing fearful body language overcomes attentional deficits in patients with neglect. Journal of Cognitive Neuroscience 19:445–454.

Tooby J, Cosmides L. 2001. Does beauty build adapted minds? Toward an evolutionary theory of aesthetics, fiction and the arts. Substance 30(1):6–27.

Tsao DY, Freiwald WA. 2006. What's so special about the average face? Trends in Cognitive Sciences 10(9):391–393.

Winston JS, O'Doherty J, Dolan RJ. 2003. Common and distinct neural responses during direct and incidental processing of multiple facial emotions. Neurological Image 30:84–97.

Zeki S. 1999. *Inner Vision: An Exploration of Art and the Brain*. Oxford University Press. New York.

Zeki S. 2001. Artistic creativity and the brain. Science 293(5527):51–52.

*Chapter 24:* THE BEHOLDER'S SHARE: ENTERING THE
PRIVATE THEATER OF ANOTHER'S MIND

Allison T, Puce A, McCarthy G. 2000. Social perception from visual cues: Role of the STS region. Trends in Cognitive Sciences 4:267–278.

Clark K. 1962. *Looking at Pictures*. Readers Union. UK.

Dijksterhuis A. 2004. Think different: The merits of unconscious thought in preference development and decision making. Journal of Personality and Social Psychology 87(5):494.

Dimberg U, Thunberg M, Elmehed K. 2000. Unconscious facial reactions to emotional facial expressions. Psychological Science 11(1):86–89.

Fechner GT. 1876. *Vorschule der Aesthetik (Experimental Aesthetics)*. Breitkopf and Hartel. Leipzig.

Gombrich EH. 1960. *Art and Illusion: A Study in the Psychology of Pictorial Representation*. Princeton University Press. Princeton and Oxford.

Gombrich EH. 1982. *The Image and the Eye*. Phaidon Press. New York.

Harrison C, Wood P. 2003. *Art in Theory, 1900–2000: An Anthology of Changing Ideas*. Blackwell Publishing. Malden, MA.

Ochsner KN, Beer JS, Robertson ER, Cooper JC, Kihlstrom JF, D'Esposito M, Gabrieli JED. 2005. The neural correlates of direct and reflected self-knowledge. NeuroImage 28:797–814.

Onians J. 2007. *Neuroarthistory*. Yale University Press. New Haven.

Perner J. 1991. *Understanding the Representational Mind*. Bradford Books. MIT Press. Cambridge, MA.

Ramachandran VS. 1999. The science of art: A neurological theory of aesthetic experience. Journal of Consciousness Study 6:15–51.

Riegl A. 1902. *The Group Portraiture of Holland*. E Kain, D Britt, translators. 1999. Introduction by W Kemp. Getty Research Institute for the History of Art and the Humanities. Los Angeles.

Saxe R, Jamal N, Powell L. 2005. My body or yours? The effect of visual perspective on cortical body representations. Cerebral Cortex 16(2):178–182.

Spurling H. 2007. *Matisse the Master: A Life of Henri Matisse: The Conquest of Colour, 1909–1954*. Alfred A. Knopf. New York.

*Chapter 25:* THE BIOLOGY OF THE BEHOLDER'S SHARE:
MODELING OTHER PEOPLE'S MINDS

The Gombrich quotes early in this chapter are taken from an essay entitled "The Mask and the Face" which appeared in Gombrich, Hochberg, and Black (1972).

Asperger H. 1944. Die "Autistichen Psychopathen" in Kendesalter.

Blakemore SJ, Decety J. 2001. From the perception of action to the understanding of intention. Nature Reviews Neuroscience 2(8):561–567.

Bleuler EP. 1911. *Dementia Praecox or The Group of Schizophrenias*. J Zinkin, translator. 1950. International University Press. New York.

Bleuler EP. 1930. The physiogenic and psychogenic in schizophrenia. American Journal of Psychiatry 10:204–211.

Bodamer J. 1947. Die Prosop-Agnosie. Archiv für Psychiatrie und Nervenkrankheiten 179:6–53.

Brothers L. 2002. The Social Brain: A Project for Integrating Primate Behavior and Neurophysiology in a New Domain. In: *Foundations in Social Neuroscience*. 2002. JT Cacioppo et al., editors. MIT Press. Cambridge, MA.

Brown E, Scholz J, Triantafyllou C, Whitfield-Gabrieli S, Saxe R. 2009. Distinct regions of right temporo-parietal junction are selective for theory of mind and exogenous attention. PLoS Biology 4(3):1–7.

Calder AJ, Burton AM, Miller P, Young AW, Akamatsu S. 2001. A principle component analysis of facial expressions. Vision Research 41:1179, 1208.

Carr L, Iacoboni M, Dubeau MC, Mazziotta JC, Lenzi GL. 2003. Neural mechanisms of empathy in humans: A relay from neural systems for imitation to limbic areas. Proceedings of the National Academy of Sciences 100(9):5497–5502.

Castelli F, Frith C, Happe F, Frith U. 2002. Autism, Asperger syndrome and brain mechanisms for the attribution of mental states to animated shapes. Brain 125:1839–1849.

Chartrand TL, Bargh JA. 1999. The chameleon effect: The perception-behavior link and social interaction. Journal of Personality and Social Psychology 76(6):893–910.

Chong T, Cunnington R, Williams MA, Kanwisher N, Mattingley JB. 2008. fMRI adaptation reveals mirror neurons in human inferior parietal cortex. Current Biology 18(20):1576–1580.

Cutting JE, Kozlowski LT. 1977. Recognizing friends by their walk: Gait perception without familiarity cues. Bulletin of the Psychonomic Society 9:353–356.

Dapretto M, Davies MS, Pfeifer JH, Scott AA, Stigman M, Bookheimer SY. 2006. Understanding emotions in others: Mirror neuron dysfunction in children with autism spectrum disorders. Nature Neuroscience 9(1):28–30.

Decety J, Chaminade T. 2003. When the self represents the other: A new cognitive neuroscience view on psychological identification. Conscious Cognition 12:577–596.

De Gelder B. 2006. Towards the neurobiology of emotional body language. Nature 7:242–249.

Dimberg U, Thunberg M, Elmehed K. 2000. Unconscious facial reactions to emotional facial expressions. Psychological Science 11(1):86–89.

Flavell JH. 1999. Cognitive development: Children's knowledge about the mind. Annual Review of Psychology 50:21–45.

Fletcher PC, Happe F, Frith U, Baker SC, Dolan RJ, Frackowiak RSJ, Frith CD. 1995. Other minds in the brain: A functional imaging study of "theory of mind" in story comprehension. Cognition 57:109–128.

Freiwald WA, Tsao DY, Livingstone MS. 2009. A face feature space in the macaque temporal lobe. Nature Neuroscience 12(9):1187–1196.

Frith C. 2007. *Making Up the Mind. How the Brain Creates Our Mental World*. Blackwell Publishing. Oxford.

Frith U. 1989. *Autism: Explaining the Enigma*. Blackwell Publishing. Oxford.

Frith U, Frith C. 2003. Development and neurophysiology of mentalizing. Philosophical Transactions of the Royal Society of London, Series B. Biological Science 358:439–447.

Gallagher HL, Frith CD. 2003. Functional imaging of "theory of mind." Trends in Cognitive Science 7:77–83.

Gombrich EH. 1987. In: *Reflections on the History of Art*, p. 211. R Woodfield, editor. Originally published as a review of Morse Peckham, *Man's Rage for Chaos: Biology, Behavior, and the Arts*. New York Review of Books. June 23, 1966.

Gombrich EH. 2004. *Art and Illusion: A Study in the Psychology of Pictoral Representation*. Phaidon Press. New York.

Gombrich EH, Hochberg J, Black M. 1972. *Art, Perception, and Reality*. Johns Hopkins University Press. Baltimore.

Gross C. 2009. *A Hole in the Head: More Tales in the History of Neuroscience*, Chap. 3, pp. 179–182. MIT Press. Cambridge, MA.

Gross C, Desimone R. 1981. Properties of inferior temporal neurons in the macaque. Advances in Physiological Sciences 17:287–289.

Iacoboni M. 2005. Neural mechanisms of imitation. Current Opinion in Neurobiology 15(6):632–637.

Iacoboni M, Molnar-Szakacs I, Gallese V, Buccino G, Mazziotta JC, Rizzolatti G. 2005. Grasping the intentions of others with one's own mirror neuron system. PloS Biology 3(3):1–7.

Kanner L. 1943. Autistic disturbances of affective contact. Nervous Child 2:217–250.

Kanwisher N, McDermott J, Chun MM. 1997. The fusiform face area: A module in

human extrastriate cortex specialized for face perception. Journal of Neuroscience 17(11):4302–4311.

Klin A, Lim DS, Garrido P, Ramsay T, Jones W. 2009. Two-year-olds with autism orient to non-social contingencies rather than biological motion. Nature 459:257–261.

Langer SK. 1979. *Philosophy in a New Key: A Study in the Symbolism of Reason, Rite, and Art.* 3rd ed. Harvard University Press. Cambridge, MA.

Mitchell JP, Banaji MR, MacRae CN. 2005. The link between social cognition and self-referential thought in the medial prefrontal cortex. Journal of Cognitive Neuroscience 17(8):1306–1315.

Ochsner KN, Knierim K, Ludlow D, Hanelin J, Ramachandran T, Mackey S. 2004. Reflecting upon feelings: An fMRI study of neural systems supporting the attribution of emotion to self and other. Journal of Cognitive Neuroscience 16(10):1748–1772.

Ohnishi T, Moriguchi Y, Matsuda H, Mori T, Hirakata M, Imabayashi E. 2004. The neural network for the mirror system and mentalizing in normally developed children: An fMRI study. Neuroreport 15(9):1483–1487.

Pelphrey KA, Morris JP, McCarthy G. 2004. Grasping the intentions of others: The perceived intentionality of an action influences activity in the superior temporal sulcus during social perception. Journal of Cognitive Neuroscience 16(10):1706–1716.

Pelphrey KA, Sasson NJ, Reznick JS, Paul G, Goldman BD, Piven J. 2002. Visual scanning of faces in autism. Journal of Autism and Developmental Disorders 32:249–261.

Perner J, Aichhorn M, Kronbichler M, Staffen W, Ladurner G. 2006. Thinking of mental and other representations. The roles of left and right temporoparietal junction. Social Neuroscience 1:245–258.

Perrett DI, Smith PA, Potter DD, Mistlin AJ, Head AS, Milner AD, Jeeves MA. 1985. Visual cells in the temporal cortex sensitive to face view and gaze direction. Proceedings of the Royal Society of London, Series B: Biological Science 223:293–317.

Piaget J. 1929. *Child's Conception of the World.* Routledge & Kegan Paul. London.

Puce A, Allison T, Asgari M, Gore JC, McCarthy G. 1996. Differential sensitivity of human visual cortex to faces, letter strings, and textures: A functional magnetic resonance imaging study. Journal of Neuroscience 16(16):5205–5215.

Puce A, Allison T, Bentin S, Gore JC, McCarthy G. 1998. Temporal cortex activation in humans viewing eye and mouth movements. Journal of Neuroscience 18:2188–2199.

Ramachandran VS. 2004. Beauty or brains. Science 305:779–780.

Riegl A. 1902. *The Group Portraiture of Holland.* EM Kain, D Britt, translators. 1999. Getty Research Institute. Los Angeles.

Rizzolatti G, Fadiga L, Gallese V, Fogassi L. 1996. Premotor cortex and the recognition of motor actions. Cognitive Brain Research 3(2):131–141.

Saxe R. 2006. Uniquely human social cognition. Current Opinion in Neurobiology 16:235–239.

Saxe R, Carey S, Kanwisher N. 2004. Understanding other minds: Linking developmental psychology and functional neuroimaging. Annual Review of Psychology 55:87–124.

Saxe R, Kanwisher N. 2003. People thinking about thinking people. The role of the temporo-parietal junction in "theory of mind." NeuroImage 19(4):1835–1842.

Saxe R, Xiao DK, Kovacs G, Perrett DI, Kanwisher N. 2004. A region of right posterior temporal sulcus responds to observed intentional actions. Neuropsychologia 42(11):1435–1446.

Singer T, Seymour B, O'Doherty J, Kaube H, Dolan RJ, Frith C. 2004. Empathy

for pain involves the affective but not sensory components of pain. Science 303:1157–1162.

Strack F, Martin LL, Stepper S. 1988. Inhibiting and facilitating conditions of the human smile: A nonobtrusive test of the facial feedback hypothesis. Journal of Personality and Social Psychology 54(5):766–777.

Yarbus AL. 1967. *Eye Movements and Vision*. Plenum Press. New York.

Zaki J, Weber J, Bolger N, Ochsner K. 2009. The neural bases of empathic accuracy. Proceedings of the National Academy of Sciences USA 106(27):11382–11387.

*Chapter 26:* HOW THE BRAIN REGULATES EMOTION AND EMPATHY

Berridge KC, Kringelbach ML. 2008. Effective neuroscience of pleasure: Rewards in humans and animals. Psychopharmacology 199:457–480.

Blakeslee S, Blakeslee M. 2007. *The Body Has a Mind of Its Own. How Body Maps in Your Brain Help You Do (Almost) Everything Better*. Random House. New York.

Cohen P. 2010. Next big thing in English: Knowing that they know that you know. New York Times. April 1, C1.

Damasio A. 1996. The somatic marker hypothesis and the possible functions of the prefrontal cortex. Proceedings of the Royal Society of London B 351:1413–1420.

Damasio A. 1999. *The Feeling of What Happens: Body and Emotion in the Making of Consciousness*. Harcourt Brace. New York.

Darwin C. 1872. *The Expression of the Emotions in Man and Animals*. Appleton-Century-Crofts. New York.

Ditzen B, Schaer M, Gabriel B, Bodenmann G, Ehlert U, Heinrichs M. 2009. Intranasal oxytocin increases positive communication and reduces cortisol levels during couple conflict. Biological Psychiatry 65(9):728–731.

Donaldson ZR, Young LJ. 2008. Oxytocin, vasopressin, and the neurogenetics of sociality. Science 322:900–904.

Gray JA, McNaughton N. 2000. *The Neuropsychology of Anxiety: An Enquiry into the Functions of the Septo-Hippocampal System*. 2nd ed. Oxford Psychology Series No. 33. Oxford University Press. Oxford.

Insel TR. 2010. The challenge of translation in social neuroscience: A review of oxytocin, vasopressin, and affiliative behavior. Neuron 65:768–779.

Jhou TC, Fields HL, Baxter MG, Saper CB, Holland PC. 2009. The rostromedial tegmental nucleus (RMTg), a GABAergic afferent to midbrain dopamine neurons, encodes aversive stimuli and inhibits motor responses. Neuron 61(5):786–800.

Kamin LJ. 1969. Predictability, Surprise, Attention, and Conditioning. In: *Punishment and Aversive Behavior*, pp. 279–296. BA Campbell, RM Church, editors. Appleton-Century-Crofts. New York.

Kampe KK, Frith CD, Dolan RJ, Frith U. 2001. Reward value of attractiveness and gaze. Nature 413:589.

Kandel ER. 2005. Biology and the Future of Psychoanalysis. In: *Psychiatry, Psychoanalysis, and the New Biology of Mind* (Chap. 3). American Psychiatric Publishing. Washington, DC.

Kirsch P, Esslinger C, Chen Q, Mier D, Lis S, Siddhanti S, Gruppe H, Mattay VS, Gallhofer B, Meyer-Lindenberg A. 2005. Oxytocin modulates neural circuitry for social cognition and fear in humans. Journal of Neuroscience 25:11489–11493.

Kosfeld M, Heinrichs M, Zak PJ, Fischbacher U, Fehr E. 2005. Oxytocin increases trust in humans. *Nature* 435:673–676.

Kosterlitz HW, Hughes J. 1975. Some thoughts on the significance of enkephalin, the endogenous ligand. Life Sciences 17(1):91–96.

Kris E. 1952. *Psychoanalytic Explorations in Art*. International Universities Press. New York.

Linden DJ. 2011. *The Compass of Pleasure: How Our Brains Make Fatty Foods, Orgasm, Exercise, Marijuana, Generosity, Vodka, Learning and Gambling Feel So Good*. Viking Press. New York.

Natter T. 2002. Portraits of Characters, Not Portraits of Faces: An Introduction to Kokoschka's Early Portraits. In: *Oskar Kokoschka: Early Portraits of Vienna and Berlin, 1909–1914*. Neue Galerie. New York.

Ochsner KN, Bunge SA, Gross JJ, Gabrieli JDE. 2002. Rethinking feelings: An fMRI study of the cognitive regulation of emotion. Journal of Cognitive Neuroscience 14(8):1215–1229.

Ochsner KN, Knierim K, Ludlow DH, Hanelin J, Ramachandran T, Glover G, Mackey SC. 2004. Reflecting upon feelings: An fMRI study of neural systems supporting the attribution of emotion to self and other. Journal of Cognitive Neuroscience 16(10):1746–1772.

Olds J. 1955. "Reward" from brain stimulation in the rat. Science 122:878.

Olds J, Milner P. 1954. Positive reinforcement produced by electrical stimulation of the septal area and other regions of the rat brain. Journal of Comparative and Physiological Psychology 47:419–427.

Olsson A, Phelps EA. 2007. Social learning of fear. Nature Neuroscience 10:1095–1102.

Pavlov IP. 1927. Conditioned Reflexes: An Investigation of the Physiological Activity of the Cerebral Cortex. GV Anrep, translator. Oxford University Press. London.

Pert CB, Snyder SH. 1973. Opiate receptor: Demonstration in nervous tissue. Science 179(77):1011–1014.

Ramachandran VS. 1999. The science of art: A neurological theory of aesthetic experience. Journal of Consciousness Study 6:15–51.

Rodrigues SM, Saslow LR, Garcia N, John OP, Keltner D. 2009. Oxytocin receptor genetic variation relates to empathy and stress reactivity in humans. Proceedings of the National Academy of Sciences 106(50):21437–21441.

Rolls ET. 2005. *Emotion Explained*. Oxford University Press. Oxford.

Schachter S, Singer JE. 1962. Cognitive, social, and physiological determinants of emotional states. Psychological Review 69:379–399.

Schultz W. 1998. Predictive reward signal of dopaminergic neurons. Journal of Neurophysiology 80:1–27.

Schultz W. 2000. Multiple reward signals in the brain. Nature Reviews Neuroscience 1:199–207.

Singer T, Seymour B, O'Doherty J, Kaube H, Dolan RJ, Frith C. 2004. Empathy for pain involves the affective but not sensory components of pain. Science 303:1157–1162.

Whalen PJ, Kagan J, Cook RG, Davis C, Kim H, Polis S, McLaren DG, Somerville LH, McLean AA, Maxwell JC, Johnston T. 2004. Human amygdala responsivity to masked fearful eye whites. Science 306:2061.

Young LJ, Young M, Hammock EA. 2005. Anatomy and neurochemistry of the pair bond. Journal of Comparative Neurology 493:51–57.

*Chapter 27:* ARTISTIC UNIVERSALS AND THE
       AUSTRIAN EXPRESSIONISTS

Aiken NE. 1998. *The Biological Origins of Art.* Praeger. Westport, CT.

Cohen P. 2010. Next big thing in English: Knowing they know that you know. New York Times. April 1, C1.

Darwin C. 1859. *On the Origin of Species by Means of Natural Selection.* Appleton-Century-Crofts. New York.

Darwin C. 1871. *The Descent of Man and Selection in Relation to Sex.* Appleton-Century-Crofts. New York.

Darwin C. 1872. *The Expression of the Emotions in Man and Animals.* Appleton-Century-Crofts. New York.

Dijkstra B. 1986. *Idols of Perversity: Fantasies of Feminine Evil in Fin-de-Siècle Culture.* Oxford University Press. New York.

Dissanayake E. 1988. *What Is Art For?* University of Washington Press. Seattle.

Dissanayake E. 1995. *Homo Aestheticus: Where Art Came from and Why.* University of Washington Press. Seattle.

Dutton D. 2009. *The Art Instinct: Beauty, Pleasure, and Human Evolution.* Bloomsbury Press. New York.

Fechner GT. 1876. *Introduction to Aesthetics.* Breitkoff & Hartel. Leipzig.

Hughes R. 1987. *Lucian Freud: Paintings.* Thames and Hudson. New York.

Iverson S, Kupfermann I, Kandel ER. 2000. Emotional States and Feelings. In: *Principles of Neural Science* (Chap. 50), pp. 982–997. 4th ed. Kandel ER, Schwartz JH, Jessell T, editors. McGraw-Hill. New York.

Kimball R. 2009. Nice things. Times Literary Supplement. March 20, pp. 10–11.

Kris E. 1952. *Psychoanalytic Explorations in Art.* International Universities Press. New York.

Kris E, Gombrich EH. 1938. The Principles of Caricature. British Journal of Medical Psychology 17:319–342. In: *Psychoanalytic Explorations in Art.*

Lang PJ. 1994. The varieties of emotional experience: A meditation on James-Lange theory. Psychological Review 101:211–221.

Lindauer MS. 1984. Physiognomy and art: Approaches from above, below, and sideways. Visual Art Research 10:52–65.

Mellars P. 2009. Archaeology: Origins of the female image. Nature 459:176–177.

Natter T. 2002. Portraits of Characters, Not Portraits of Faces: An Introduction to Kokoschka's Early Portraits. In: *Oskar Kokoschka: Early Portraits of Vienna and Berlin, 1909–1914.* Neue Galerie. New York.

Pinker S. 1999. *How the Mind Works.* W. W. Norton. New York.

Pinker S. 2002. *The Blank Slate.* Viking Penguin. New York.

Ramachandran VS. 1999. The science of art: A neurological theory of aesthetic experience. Journal of Consciousness Study 6:15–51.

Ryan TA, Schwartz CB. 1956. Speed of perception as a function of mode of representation. American Journal of Psychology 69(1):60–69.

Riegl A. 1902. *The Group Portraiture of Holland.* E Kain, D Britt, translators. 1999. Introduction by W Kemp. Getty Research Institute for the History of Art and the Humanities. Los Angeles.

Singer T, Seymour B, O'Doherty J, Kaube H, Dolan RJ, Frith CD. 2004. Empathy for pain involves the affective but not sensory components of pain. Science 303:1157–1162.

Stocker M. 1998. *Judith: Sexual Warriors: Women and Power in Western Culture*. Yale University Press. New Haven.

Tooby J, Cosmides L. 2001. Does beauty build adapted minds? Toward an evolutionary theory of aesthetics, fiction and the arts. SubStance 94/95(30):6–27.

Zeki S. 1999. *Inner Vision: An Exploration of Art and the Brain*. Oxford University Press. New York.

*Chapter 28:* THE CREATIVE BRAIN

Andreasen NC. 2005. *The Creating Brain: The Neuroscience of Genius*. Dana Press. New York.

Andreasen NC. 2011. *A Journey into Chaos: Creativity and the Unconscious*. In preparation.

Berenson B. 1930. *The Italian Painters of the Renaissance*. Oxford University Press. Oxford.

Bever TG, Chiarello RJ. 1974. Cerebral dominance in musicians and nonmusicians. Science 185(4150):537–539.

Bowden EM, Beeman MJ. 1998. Getting the right idea: Semantic activation in the right hemisphere may help solve insight problems. Psychological Science 9(6):435–440.

Bowden EM, Jung-Beeman M. 2003. Aha! Insight experience correlates with solution activation in the right hemisphere. Psychonomic Bulletin and Review 10(3):730–737.

Bowden EM, Jung-Beeman M, Fleck J, Kounios J. 2005. New approaches to demystifying insight. Trends in Cognitive Sciences 9(7):322–328.

Bower B. 1987. Mood swings and creativity: New clues. Science News. October 24, 1987.

Changeux JP. 1994. Art and neuroscience. Leonardo 27(3):189–201.

Christian B. 2011. Mind vs. machine: Why machines will never beat the human mind. Atlantic Magazine. March 2011.

Damasio A. 1996. The somatic marker hypothesis and the possible functions of the prefrontal cortex. Proceedings of the Royal Society of London B 351:1413–1420.

Damasio A. 2010. *Self Comes to Mind: Constructing the Conscious Brain*. Pantheon Books. New York.

De Bono E. 1973. *Lateral Thinking: Creativity Step by Step*. Harper Colophon. New York.

Edelman G. 1987. *Neural Darwinism: The Theory of Neuronal Group Selection*. Basic Books. New York.

Fleck JI, Green DL, Stevenson JL, Payne L, Bowden EM, Jung-Beeman M, Kounios J. 2008. The transliminal brain at rest: Baseline EEG, unusual experiences, and access to unconscious mental activity. Cortex 44(10):1353–1363.

Freedman DJ, Riesenhuber M, Poggio T, Miller EK. 2001. Categorical representation of visual stimuli in the primate prefrontal cortex. Science 291:312–316.

Gardner H. 1982. *Art, Mind, and Brain: A Cognitive Approach to Creativity*. Basic Books. New York.

Gardner H. 1983. *Frames of Mind: The Theory of Multiple Intelligences*. Basic Books. New York.

Gardner H. 1993. *Creating Minds: An Anatomy of Creativity as Seen Through the Lives of Freud, Einstein, Picasso, Stravinsky, Eliot, Graham, and Gandhi*. Basic Books. New York.

Gardner H. 2006. *Five Minds for the Future*. Harvard Business School Press. Boston.

Geake JG. 2005. The neurological basis of intelligence: Implications for education: An abstract. Gifted and Talented (9)1:8.

Geake JG. 2006. Mathematical brains. Gifted and Talented (10)1:2–7.

Goldberg E, Costa LD. 1981. Hemisphere differences in the acquisition and use of descriptive systems. Brain Language 14:144–173.

Gombrich EH. 1950. *The Story of Art*. Phaidon Press. London.

Gombrich EH. 1960. *Art and Illusion: A Study in the Psychology of Pictorial Representation*. Princeton University Press. Princeton and Oxford.

Gombrich EH. 1996. *The Essential Gombrich: Selected Writings on Art and Culture*. R Woodfield, editor. Phaidon Press. London.

Gross C. 2009. Left and Right in Science and Art. In: *A Hole in the Head*, Chap. 6 (with M Bornstein), pp. 131–160. MIT Press. Cambridge, MA.

Hawkins J, Blakeslee S. 2004. *On Intelligence*. Henry Holt. New York.

Holton G. 1978. *The Scientific Imagination: Case Studies*. Cambridge University Press. Cambridge.

Jackson JH. 1864. Loss of speech: Its association with valvular disease of the heart, and with hemiplegia on the right side. Defects of smell. Defects of speech in chorea. Arterial regions in epilepsy. London Hospital Reports Vol. 1(1864):388–471.

James W. 1884. What is an emotion? Mind 9:188–205.

Jamison KR. 2004. *Exuberance: The Passion for Life*. Vintage Books. Random House. New York.

Jung-Beeman M, Bowden EM, Haberman J, Frymiare JL, Arambel-Liu S, Greenblatt R, Reber PJ, Kounios J. 2004. Neural activity observed in people solving verbal problems with insight. PloS Biology 2(4):0500–0510.

Jung-Beeman M. 2005. Bilateral brain processes for comprehending natural language. Trends in Cognitive Sciences 9(11):512–518.

Kounios J, Fleck JI, Green DL, Payne L, Stevenson JL, Bowden EM, Jung-Beeman M. 2007. The origins of insight in resting-state brain activity. Neuropsychologia 46:281–291.

Kounios J, Frymiare JL, Bowden EM, Fleck JI, Subramaniam K, Parrish TB, Jung-Beeman M. 2006. The prepared mind: Neural activity prior to problem presentation predicts subsequent solution by sudden insight. Psychological Science 17:882–890.

Kris E. 1952. *Psychoanalytic Explorations in Art*, p. 190. International Universities Press. New York.

Kurzweil R. 2005. *The Singularity Is Near: When Humans Transcend Biology*. Viking. New York.

Lehrer J. 2008. The Eureka hunt: Why do good ideas come to us when they do? New Yorker. July 28, pp. 40–45.

Markoff J. 2011. Computer wins on 'Jeopardy!' Trivial, it's not. New York Times. February 17, A1.

Martin A, Wiggs CL, Weisberg J. 1997. Modulation of human medial temporal lobe activity by form, meaning, or experience. Hippocampus 7:587–593.

Martinsdale C. 1999. The Biological Basis of Creativity. In: *Handbook of Creativity*. RJ Steinberg, editor. Cambridge University Press. New York.

Max DT. 2011. A chess star that emerges from the post-computer age. New Yorker. May 21, pp. 40–49.

McGilchrist I. 2009. *The Master and His Emissary: The Divided Brain and the Making of the Western World*. Yale University Press. New Haven and London.

Miller AI. 1996. *Insights of Genius: Imagery and Creativity in Science and Art*. Copernicus. New York.

Miller EK, Cohen JD. 2001. An integrative theory of prefrontal cortex function. Annual Review of Neuroscience 24:167–202.

Podro M. 1998. *Depiction*. Yale University Press. New Haven.

Rabinovici GD, Miller BL. 2010. Frontotemporal lobar degeneration: Epidemiology, pathophysiology, diagnosis, and management. CNS Drugs 24(5):375–398.

Ramachandran VS. 2003. *The Emerging Mind*. The Reith Lectures. BBC in association with Profile Books. London.

Ramachandran VS. 2004. *A Brief Tour of Human Consciousness: From Impostor Poodles to Purple Numbers*. Pearson Education. New York.

Ramachandran VS, Hirstein W. 1999. The science of art: A neurological theory of aesthetic experience. Journal of Consciousness Studies 6(6–7):15–51.

Ramachandran V and colleague. Undated Correspondence.

Riegl A. 1902. *The Group Portraiture of Holland*. E Kain, D Britt, translators. 1999. Introduction by W Kemp. Getty Research Institute for the History of Art and the Humanities. Los Angeles.

Sacks O. 1995. *An Anthropologist on Mars: Seven Paradoxical Tales*. Alfred A. Knopf. New York.

Schooler JW, Ohlsson S, Brooks K. 1993. Thoughts beyond words: When language overshadows insight. Journal of Experimental Psychology 122:166–183.

Searle JR. 1980. Minds, brains, and programs. Behavioral and Brain Sciences 3:417–424.

Sinha P, Balas B, Ostrovsky Y, Russell R. 2006. Face recognition by humans: Nineteen results all computer vision researchers should know about. Proceedings of the IEEE 94(11):1948–1962.

Smith RW, Kounios J. 1996. Sudden insight: All-or-none processing revealed by speed-accuracy decomposition. Journal of Experimental Psychology 22:1443–1462.

Snyder A. 2009. Explaining and inducing savant skills: Privileged access to lower level, less processed information. Philosophical Transactions of the Royal Society B 364:1399–1405.

Subramaniam K, Kounios J, Parrish TB, Jung-Beeman M. 2008. A brain mechanism for facilitation of insight by positive affect. Journal of Cognitive Neuroscience 21(3):415–432.

Treffert DA. 2009. The savant syndrome: an extraordinary condition. A synopsis: past, present, future. Philosophical Transactions of the Royal Society 364:1351–1357.

Warrington E, Taylor EM. 1978. Two categorical stages of object recognition. Perception 7:695–705.

*Chapter 29:* THE COGNITIVE UNCONSCIOUS AND
        THE CREATIVE BRAIN

Baars BJ. 1997. In the theater of consciousness: Global workspace theory, a rigorous scientific theory of consciousness. Journal of Consciousness Studies 4(4):292–309.

Blackmore S. 2004. *Consciousness: An Introduction*. Oxford University Press. New York.

Blackmore S. 2007. Mind over Matter? Many philosophers and scientists have argued that free will is an illusion. Unlike all of them, Benjamin Libet has found a way to test it. Commentary. Guardian Unlimited. August 28, 2007.

Boly M, Balteau E, Schnakers C, Degueldre C, Moonen G, Luxen A, Phillips C, Peigneux P, Maquet P, Laureys S. 2007. Baseline brain activity fluctuations predict somatosensory perception in humans. Proceedings of the National Academy of Sciences USA 104:12187–12192.

Crick F, Koch C. 2003. A framework for consciousness. National Neuroscience 6:119–126.

Crick F, Koch C. 2005. What is the function of the claustrum? Philosophical Transactions of the Royal Society of London, Biological Sciences 360:1271–1279.

Damasio A. 2010. *Self Comes to Mind: Constructing the Conscious Brain*. Pantheon Books. New York.

Dehaene S, Changeux JP. 2011. Experimental and theoretical approaches to conscious processing. Neuron 70(2):200–227.

Dennett DC. 1991. *Consciousness Explained*. Back Bay Books. Little Brown. Boston and London.

Dijksterhuis A. 2004. Think different: The merits of unconscious thought in preference development and decision making. Journal of Personality and Social Psychology 87(5):586–598.

Dijksterhuis A, Bos MW, Nordgren LF, van Baaren RB. 2006. On making the right choice: The deliberation-without-attention effect. Science 311(5763):1005–1007.

Dijksterhuis A, Meurs T. 2006. Where creativity resides: The generative power of unconscious thought. Consciousness and Cognition 15:135–146.

Dijksterhuis A, Nordgren LF. 2006. A theory of unconscious thought. Association for Psychological Science 1(2):95–109.

Dijksterhuis A, van Olden Z. 2006. On the benefits of thinking unconsciously: Unconscious thought can increase post-choice satisfaction. Journal of Experimental Social Psychology 42:627–631.

Edelman G. 2006. *Second Nature: Brain Science and Human Knowledge*. Yale University Press. New Haven.

Epstein S. 1994. Integration of the cognitive and the psychodynamic unconscious. American Psychologist 49:709–724.

Fried I, Mukamel R, Kreiman G. 2011. Internally generated preactivation of single neurons in human medial prefrontal cortex predicts volition. Neuron 69:548–562.

Gombrich EH. 1960. *Art and Illusion: A Study in the Psychology of Pictorial Representation*. Princeton University Press. Princeton and Oxford.

Haggard P. 2011. Decision time for free will. Neuron 69:404–406.

Kornhuber HH, Deecke L. 1965. Hirnpotentialandeerungen bei Wilkurbewegungen und passiv Bewegungen des Menschen: Bereitschaftspotential und reafferente Potentiale. Pflugers Archiv fur Gesamte Psychologie 284:1–17.

Libet B. 1981. The experimental evidence for subjective referral of a sensory experience backward in time: Reply to PS Churchland. Philosophy of Science 48:182–197.

Libet B. 1985. Unconscious cerebral initiative and the role of conscious will in voluntary action. Behavioral and Brain Sciences 8:529–566.

Moruzzi G, Magain HW. 1949. Brain stem reticular formation and activation of the EEG. Electroencephalography and Clinical Neurophysiology 1:455–473.

Piaget J. 1973. The affective unconscious and the cognitive unconscious. Journal of the American Psychoanalytic Association 21:249–261.

Sadaghiani S, Hesselmann G, Kleinschmidt A. 2009. Distributed and antagonistic contributions of ongoing activity fluctuations to auditory stimulus detection. Journal of Neuroscience 29:13410–13417.

Sadaghiani S, Scheeringa R, Lehongre K, Morillon B, Giraud AL, Kleinschmidt A. 2010. Intrinsic connectivity networks, alpha oscillations, and tonic alertness: A simultaneous electroencephalography/functional magnetic resonance imaging study. Journal of Neuroscience 30:10243–10250.

Schopenhauer A. 1970. *Essays and Aphorisms*. RJ Hollingdale, translator. Penguin Books. London. (Original work published 1851.)

Shadlen MN, Kiani R. 2011. Consciousness as a decision to engage. In: *Characterizing Consciousness: from Cognition to the Clinic? Research Perspectives in Neurosciences*. S Dehaene and Y Christen (eds.) Springer-Verlag. Berlin Heidelberg.

Wegner DM. 2002. *The Illusion of Conscious Will*. Bradford Books. MIT Press. Cambridge, MA.

*Chapter 30:* BRAIN CIRCUITS FOR CREATIVITY

Andreasen NC. 2005. *The Creating Brain: The Neuroscience of Genius*. Dana Press. New York.

Bever TG, Chiarello RJ. 1974. Cerebral dominance in musicians and nonmusicians. Science 185(4150):537–539.

Bowden EM, Beeman MJ. 1998. Getting the right idea: Semantic activation in the right hemisphere may help solve insight problems. Psychological Science 9(6):435–440.

Bowden EM, Jung-Beeman M. 2003. Aha! Insight experience correlates with solution activation in the right hemisphere. Psychonomic Bulletin and Review 10(3):730–737.

Bowden EM, Jung-Beeman M, Fleck J, Kounios J. 2005. New approaches to demystifying insight. Trends in Cognitive Sciences 9(7):322–328.

Bower B. 1987. Mood swings and creativity: New clues. Science News. October 24, 1987.

Damasio A. 1996. The somatic marker hypothesis and the possible functions of the prefrontal cortex. Proceedings of the Royal Society of London B 351:1413–1420.

Damasio A. 2010. *Self Comes to Mind: Constructing the Conscious Brain*. Pantheon Books. New York.

Fleck JI, Green DL, Stevenson JL, Payne L, Bowden EM, Jung-Beeman M, Kounios J. 2008. The transliminal brain at rest: Baseline EEG, unusual experiences, and access to unconscious mental activity. Cortex 44(10):1353–1363.

Freedman DJ, Riesenhuber M, Poggio T, Miller EK. 2001. Categorical representation of visual stimuli in the primate prefrontal cortex. Science 291:312–316.

Gardner H. 1982. *Art, Mind, and Brain: A Cognitive Approach to Creativity*. Basic Books. New York.

Gardner H. 1983. *Frames of Mind: The Theory of Multiple Intelligences*. Basic Books. New York.

Gardner H. 1993. *Creating Minds: An Anatomy of Creativity Seen Through the Lives of Freud, Einstein, Picasso, Stravinsky, Eliot, Graham, and Gandhi*. Basic Books. New York.

Gardner H. 2006. *Five Minds for the Future*. Harvard Business School Press. Boston.

Geake JG. 2005. The neurological basis of intelligence: Implications for education: An abstract. Gifted and Talented (9)1:8.

Geake JG. 2006. Mathematical brains. Gifted and Talented (10)1:2–7.

Goldberg E, Costa LD. 1981. Hemisphere differences in the acquisition and use of descriptive systems. Brain Language 14:144–173.

Hawkins J, Blakeslee S. 2004. *On Intelligence*. Henry Holt. New York.

Hebb DO. 1949. *Organization of Behavior*. New York: John Wiley and Sons.

Jackson JH. 1864. Loss of speech: Its association with valvular disease of the heart, and with hemiplegia on the right side. Defects of smell. Defects of speech in chorea. Arterial regions in epilepsy. London Hospital Reports Vol. 1 (1864):388–471.

Jamison KR. 2004. *Exuberance: The Passion for Life*. Vintage Books. Random House. New York.

Jung-Beeman M. 2005. Bilateral brain processes for comprehending natural language. *Trends in Cognitive Sciences* 9(11):512–518.

Jung-Beeman M, Bowden EM, Haberman J, Frymiare JL, Arambel-Liu S, Greenblatt R, Reber PJ, Kounios J. 2004. Neural activity observed in people solving verbal problems with insight. PloS Biology 2(4):0500–0510.

Kapur N. 1996. Paradoxical functional facilitation in brain-behavior research. Brain 119: 1775–1790.

Katz B. 1982. Stephen William Kuffler: Biographical Memoirs of Fellows of the Royal Society 28:225–259.

Kounios J, Fleck JI, Green DL, Payne L, Stevenson JL, Bowden EM, Jung-Beeman M. 2007. The origins of insight in resting-state brain activity. Neuropsychologia 46:281–291.

Kounios J, Frymiare JL, Bowden EM, Fleck JI, Subramaniam K, Parrish TB, Jung-Beeman M. 2006. The prepared mind: Neural activity prior to problem presentation predicts solution by sudden insight. Psychological Science 17:882–890.

Lehrer J. 2008. The Eureka hunt: Why do good ideas come to us when they do? New Yorker. July 28, pp. 40–45.

Martin A, Wiggs CL, Weisberg J. 1997. Modulation of human medial temporal lobe activity by form, meaning, or experience. Hippocampus 7:587–593.

Martinsdale C. 1999. The Biological Basis of Creativity. In: *Handbook of Creativity*. RJ Steinberg, editor. Cambridge University Press.

McMahan UJ, editor. 1990. *Steve: Remembrances of Stephen W. Kuffler*. Sinauer Associates. Sunderland, MA.

Miller AI. 1996. *Insights of Genius: Imagery and Creativity in Science and Art*. Copernicus. New York.

Miller EK, Cohen JD. 2001. An integrative theory of prefrontal cortex function. Annual Review of Neuroscience 24:167–202.

Orenstein R. 1997. *The Right Mind: Making Sense of the Hemispheres*. Harcourt Brace. New York.

Rabinovici GD, Miller BL. 2010. Frontotemporal lobar degeneration: Epidemiology, pathophysiology, diagnosis and management. CNS Drugs 24(5):375–398.

Ramachandran VS, Hirstein W. 1999. The science of art: A neurological theory of aesthetic experience. Journal of Consciousness Studies 6(6–7):15–51.

Ramachandran VS. 2003. *The Emerging Mind*. The Reith Lectures. BBC in association with Profile Books. London.

Ramachandran VS. 2004. *A Brief Tour of Human Consciousness: From Impostor Poodles to Purple Numbers*. Pearson Education. New York.

Rubin N, Nakayama K, Shapley R. 1997. Abrupt learning and retinal size specificity in illusory-contour perception. Current Biology 7:461–467.

Sacks O. 1995. *An Anthropologist on Mars: Seven Paradoxical Tales*. Alfred A. Knopf. New York.

Schooler JW, Ohlsson S, Brooks K. 1993. Thoughts beyond words: When language overshadows insight. Journal of Experimental Psychology 122:166–183.

Schopenhauer A. 1970. *Essays and Aphorisms*. RJ Hollingdale, translator. Penguin Books. London. (Original work published 1851.)

Sherrington CS. 1906. *The Integrative Action of the Nervous System*. Yale University Press. New Haven.

Sinha P, Balas B, Ostrovsky Y, Russell R. 2006. Face recognition by humans: Nineteen

results all computer vision researchers should know about. Proceedings of the IEEE 94(11):1948–1962.

Smith RW, Kounios J. 1996. Sudden insight: All-or-none processing revealed by speed-accuracy decomposition. Journal of Experimental Psychology 22:1443–1462.

Snyder A. 2009. Explaining and inducing savant skills: Privileged access to lower level, less processed information. Philosophical Transactions of the Royal Society B 364:1399–1405.

Subramaniam K, Kounios J, Parrish TB, Jung-Beeman M. 2008. A brain mechanism for facilitation of insight by positive affect. Journal of Cognitive Neuroscience 21(3):415–432.

Treffert DA. 2009. The savant syndrome: An extraordinary condition. A synopsis: Past, present, and future. Philosophical Transactions of the Royal Society 364:1351–1357.

Warrington E, Taylor EM. 1978. Two categorical stages of object recognition. Perception 7:695–705.

Yarbus AL. 1967. *Eye Movements and Vision*. Plenum Press. New York.

*Chapter 31:* TALENT, CREATIVITY, AND BRAIN DEVELOPMENT

Akiskal HS, Cassano GB, editors. 1997. *Dysthymia and the Spectrum of Chronic Depressions*. Guilford Press. New York.

Andreasen NC. 2005. *The Creating Brain: The Neuroscience of Genius*. Dana Press. New York.

Baron-Cohen S, Ashwin E, Ashwin C, Tavassoli T, Chakrabarti B. 2009. Talent in autism: Hyper-systemizing, hyper-attention to detail and sensory hypersensitivity. Philosophical Transactions of the Royal Society 364:1377–1383.

Bleuler E. 1924. *Textbook of Psychiatry*, p. 466. AA Brill, translator. Macmillan. New York.

Close C. 2010. Personal communication.

Enard W, Przeworski M, Fisher SE, Lai CS, Wiebe V, Kitano T, Monaco AP, Svante P. 2002. Molecular evolution of FOXP2, a gene involved in speech and language. Nature 418:869–872.

Frith U, Happe F. 2009. The beautiful otherness of the autistic mind. Philosophical Transactions of the Royal Society 364:1345–1350.

Gardner H. 1983. *Frames of Mind: The Theory of Multiple Intelligences*. Basic Books. New York.

Gardner H. 1984. *Art, Mind, and Brain: A Cognitive Approach to Creativity*. Basic Books. New York.

Gardner H. 1993. *Creating Minds: An Anatomy of Creativity Seen Through the Lives of Freud, Einstein, Picasso, Stravinsky, Eliot, Graham, and Gandhi*. Basic Books. New York.

Gombrich E. 1996. The miracle at Chauvet. New York Review of Books 43(18), November 14, 1996, http://www.nybooks.com/articles/archives/1996/nov/14/the-miracle-at-chauvet/ (accessed September 16, 2011).

Gross CG. 2009. Left and Right in Science and Art. In: *A Hole in the Head: More Tales in the History of Neuroscience*. In: Chap. 6, pp. 131–160. With MH Bornstein. MIT Press. Cambridge, MA.

Happe F, Vital P. 2009. What aspects of autism predispose to talent? Philosophical Transactions of the Royal Society 364:1369–1375.

Heaton P, Pring L, Hermelin B. 1998. Autism and pitch processing: a precursor for savant musical ability. Music Perception 15:291–305.

Hermelin B. 2001. *Bright Splinters of the Mind. A Personal Story of Research with Autistic Savants.* Jessica Kingsley. London.

Holton G. 1978. *The Scientific Imagination: Case Studies.* Cambridge University Press. London.

Howlin P, Goode S, Hutton J, Rutter M. 2009. Savant skills in autism: Psychometric approaches and parental reports. Philosophical Transactions of the Royal Society 364:1359–1367.

Humphrey N. 1998. Cave art, autism and the evolution of the human mind. Cambridge Archeological Journal 8:165–191.

Jamison KR. 1993. *Touched with Fire: Manic-Depressive Illness and the Artistic Temperament.* Free Press. New York.

Jamison KR. 2004. *Exuberance: The Passion for Life.* Alfred A. Knopf. New York.

Miller AI. 1996. *Insights of Genius: Imagery and Creativity in Science and Art.* Copernicus. New York.

Mottron L, Belleville S. 1993. A study of perceptual analysis in a high-level autistic subject with exceptional graphic abilities. Brain and Cognition 23:279–309.

Nettelbeck T. 1999. Savant Syndrome—Rhyme Without Reason. In: *The Development of Intelligence,* pp. 247–273. M Anderson, editor. Psychological Press. Hove, UK.

Pugh KR, Mencl WE, Jenner AR, Katz L, Frost SJ, Lee JR, Shaywitz SE, Shaywistz BA. 2001. Neurobiological studies of reading and reading disability. Journal of Communication Disorders 34(6):479–492.

Ramachandran VS. 2003. *The Emerging Mind.* The Reith Lectures. BBC in association with Profile Books. London.

Ramachandran VS. 2004. *A Brief Tour of Human Consciousness: From Impostor Poodles to Purple Numbers.* Pearson Education. New York.

Ramachandran VS, Hirstein W. 1999. The science of art: A neurological theory of aesthetic experience. Journal of Consciousness Studies 6(6–7):15–51.

Richards R. 1999. Affective Disorders. In: *Encyclopedia of Creativity,* pp. 31–43. MA Runco, SR Pritzker, editors. Academic Press. San Diego.

Richards R (ed.) 2007. *Everyday Creativity and New Views of Human Nature: Psychological, Social, and Spiritual Perspectives.* American Psychological Association. Washington, DC.

Sacks O. 1995. *An Anthropologist on Mars: Seven Paradoxical Tales.* Alfred A. Knopf. New York.

Selfe L. 1977. *Nadia: Case of Extraordinary Drawing Ability in an Autistic Child.* Academic Press. London.

Smith N, Tsimpli IM. 1995. *The Mind of a Savant: Language Learning and Modularity.* Blackwell. Oxford.

Snyder A. 2009. Explaining and inducing savant skills: Privileged access to lower level, less processed information. Philosophical Transactions of the Royal Society B 364: 1399–1405.

Treffert DA. 2009. The savant syndrome: An extraordinary condition. A synopsis: Past, present, future. Philosophical Transactions of the Royal Society 364:1351–1357.

Wiltshire S. 1987. *Drawings.* Introduction by H Casson. JM Dent & Sons. London.

Wolff U, Lundberg I. 2002. The prevalence of dyslexia among art students. Dyslexia 8:34–42.

Zaidel DW. 2005. *Neuropsychology of Art: Neurological, Cognitive and Evolutionary Perspectives*. Psychology Press. Hove, UK.

Chapter 32: KNOWING OURSELVES: THE NEW DIALOGUE
              BETWEEN ART AND SCIENCE

Berlin I. 1978. *Concepts and Categories: Philosophical Essays*. Hogarth Press. London.

Berlin I. 1997. The Divorce Between Science and the Humanities. In: Berlin I. *The Proper Study of Mankind: An Anthology of Essays*, pp. 326–358. Farrar, Straus and Giroux. New York.

Brockman J. 1995. *The Third Culture: Beyond the Scientific Revolution*. Simon and Schuster. New York.

Cohen IB. 1985. *Revolution in Science*. Belknap Press of Harvard University. Cambridge, MA, and London.

Edelman GM. 2006. *Second Nature, Brain Science and Human Knowledge*. Yale University Press. New Haven.

Gleick J. 2003. *Isaac Newton*. Vintage Books. Random House. New York.

Gould SJ. 2003. *The Hedgehog, the Fox, and the Magister's Pox*. Harmony Books. New York.

Greene B. 1999. *The Elegant Universe: Superstrings, Hidden Dimensions, and the Quest for the Ultimate Theory*. Vintage Books. Random House. New York.

Holton G. 1992. Ernst Mach and the Fortunes of Positivism in America. Isis 83(1):27–60.

Holton G. 1995. On the Vienna Circle in Exile. In: *The Foundational Debate*, pp. 269–292. W. Depauli-Schimanovich et al., editors. Kluwer Academic Publishers. Netherlands.

Holton G. 1996. Einstein and the Goal in Science. In: *Einstein, History, and Other Passions: The Rebellion Against Science at the End of the Twentieth Century*, pp. 146–169. Harvard University Press. Cambridge, MA.

Holton G. 1998. *The Advancement of Science and Its Burdens*. Harvard University Press. Cambridge, MA.

Johnson G. 2009. *The Ten Most Beautiful Experiments*. Vintage Books. New York.

Newton I. 1687. *Philosophiae Naturalis, Principia Mathematica*. A Motte, translator. 2007. Kessinger Publishing. Whitefish, MT.

Pauling L. 1947. *General Chemistry*. Dover Publications. New York.

Prodo I. 2006. *Ionian Enchantment: A Brief History of Scientific Naturalism*. Tufts University Press. Medford, MA.

Singer T, Seymour B, O'Doherty J, Kaube H, Dolan RJ, Frith C. 2004. Empathy for pain involves the affective but not sensory components of pain. Science 303:1157–1162.

Snow CP. 1959. *The Two Cultures and the Scientific Revolution* 1998. Cambridge University Press. Cambridge.

Snow CP. 1963. *The Two Cultures: A Second Look*. Cambridge University Press. Cambridge.

Vico GB. 1744. *The New Science of Giambattista Vico*. TG Bergin, MH Fisch, translators. 1948. Cornell University Press. Ithaca, NY.

Weinberg S. 1992. *Dreams of a Final Theory: The Scientist's Search for the Ultimate Laws of Nature*. Vintage Books. Random House. New York.

Wilson EO. 1978. *On Human Nature*. Harvard University Press. Cambridge, MA.

Wilson EO. 1998. *Consilience: The Unity of Knowledge*. Alfred A. Knopf. New York.

## Chapter 1

1-1. Klimt, Gustav (1862–1918), *Adele Bloch-Bauer I*. 1907. Oil, silver, and gold on canvas. This acquisition made available in part through the generosity of the heirs of the Estates of Ferdinand and Adele Bloch-Bauer. Photo: John Gilliland. Location: Neue Galerie New York, N.Y., U.S.A. Photo credit: Neue Galerie New York/Art Resource, N.Y.

1-2. *Crown Princess Stephanie of Belgium, Consort to Crown Prince Rudolf of Austria* (1858–89), by Hans Makart (1840–84), Kunsthistorisches Museum, Vienna, Austria/The Bridgeman Art Library.

1-3. *Fable*, 1883, by Gustav Klimt (1862–1918), Wien Museum Karlsplatz, Vienna, Austria/The Bridgeman Art Library.

1-4. *The Auditorium of the Old Castle Theatre*, 1888 (oil on canvas) by Gustav Klimt (1862–1918), Wien Museum Karlsplatz, Vienna, Austria/The Bridgeman Art Library.

1-5. *The Auditorium of the Old Castle Theatre*, 1888 (oil on canvas) by Gustav Klimt (1862–1918), Wien Museum Karlsplatz, Vienna, Austria/The Bridgeman Art Library.

1-6. *Déjeuner sur l'Herbe*, 1863 (oil on canvas) by Édouard Manet (1832–83), Musée d'Orsay, Paris, France/Giraudon/The Bridgeman Art Library.

## Chapter 2

2-1. Permission granted under Creative Commons license; PD-US.

## Chapter 3

3-1. Zuckerkandl Szeps, courtesy Österreichische Nationalbibliothek.

3-2. Zuckerkandl, Emil; Austrian anatomist and pathologist, 1849–1910. Portrait. Photograph, 1909. Photo: akg-images/Imagno.

3-3. Klimt, Gustav (1862–1918), *Hope I*, 1903. Photo: Austrian Archive. Inv. No. D129. Photo credit: Scala/Art Resource, N.Y.

3-4. *Danaë*, 1907–8 (oil on canvas) by Gustav Klimt (1862–1918). Galerie Wurthle, Vienna, Austria/The Bridgeman Art Library.

## Chapter 4

4-1.  Sonia Epstein
4-2.  Terese Winslow
4-3.  Mary Evans Picture Library

## Chapter 5

5-1.  Sarah Mack and Mariah Widman
5-2.  Terese Winslow
5-3.  Terese Winslow
5-4.  Sonia Epstein

## Chapter 6

6-1.  Sonia Epstein

## Chapter 7

7-1.  Mary Evans Picture Library

## Chapter 8

8-1.  Gustav Klimt (1862–1918), *Seated Woman in Armchair,* ca. 1913, pencil and white chalk. Private collection, courtesy of Neue Galerie New York.

8-2.  Gustav Klimt (1862–1918), *Reclining Nude Facing Right,* 1912–13, pencil and red and blue pencil. Private collection, courtesy of Neue Galerie New York.

8-3.  Schiele, Egon (1890–1918), *Reclining Nude,* 1918. Crayon on paper, H. 11-3/4, W. 18-1/4 inches (29.8 x 46.4 cm.). Bequest of Scofield Thayer, 1982 (1984.433.310). Location: The Metropolitan Museum of Art, New York, N.Y., U.S.A. Photo credit: Image copyright © The Metropolitan Museum of Art/Art Resource, N.Y.

8-4.  *The Sleeping Venus,* 1508–10 (oil on canvas) by Giorgione (Giorgio da Castelfranco) (1476/8–1510), Gemaeldegalerie Alte Meister, Dresden, Germany, © Staatliche Kunstsammlungen Dresden/The Bridgeman Art Library.

8-5.  *Venus of Urbino,* before 1538 (oil on canvas) by Titian (Tiziano Vecellio) (c. 1488–1576), Galleria degli Uffizi, Florence, Italy/The Bridgeman Art Library.

8-6.  *The Naked Maja,* c. 1800 (oil on canvas) by Francisco José de Goya y Lucientes (1746–1828) Prado, Madrid, Spain/The Bridgeman Art Library.

8-7.  *Olympia,* 1863 (oil on canvas) by Édouard Manet (1832–83), Musée d'Orsay, Paris, France/Giraudon/The Bridgeman Art Library.

8-8.  Gustav Klimt (1862–1918), *Reclining Nude Facing Right,* 1912–13, pencil and red and blue pencil. Private collection, courtesy of Neue Galerie New York.

8-9.  Modigliani, Amedeo (1884–1920). 9/12/2011 *Female Nude on a White Cushion,* 1917/18. Oil on canvas, 60 x 92 cm. Stuttgart, Staatsgalerie. Photo: akg-images.

8-10. Gustav Klimt, Austrian painter, 1862–1918. Portrait. Photograph by Moritz Nähr, ca. 1908, signed by Klimt. Photo: akg-images.

8-11. *Hygieia,* 1900–07 (detail from *Medicine*) by Gustav Klimt (1862–1918), Schloss Immendorf, Austria/The Bridgeman Art Library.

8-12.   Klimt, Gustav (1862–1918) *Medicine*. Destroyed by fire in 1945. Location: Schloss Immendorf, Austria. Photo credit: Foto Marburg/Art Resource, N.Y.

8-13.   *The Trinity*, 1427–28 (fresco) (post restoration) by Tommaso Masaccio (1401–28), Santa Maria Novella, Florence, Italy/The Bridgeman Art Library.

8-14.   *A Banquet of the Officers of the St. George Militia Company*, 1616 (oil on canvas) by Frans Hals (1582/3–1666), Frans Hals Museum, Haarlem, The Netherlands/Peter Willi/The Bridgeman Art Library.

8-15.   *Schubert at the Piano*. Painting, 1899, by Gustav Klimt (1862–1918). (Destroyed in World War II.) Photo: akg-images.

8-16.   Albertina, Vienna. Inv. Foto2007/9/2 detail.

8-17.   Graphische Sammlung der ETH Zurich. Inv. 1959/49.

8-18.   Albertina, Vienna. Inv. Foto2007/13/131.

8-19.   Albertina, Vienna. Inv. 23538.

8-20.   Albertina, Vienna. Inv. Foto2007/13/234a.

8-21.   Private collection

8-22.   Albertina, Vienna. Inv. Foto2007/13/257.

8-23.   Gustav Klimt, *Reclining Half-Nude*, 1914, pencil on paper. Wien Museum, Vienna, inv. 101059.

8-24.   Ravenna (Italy), S. Vitale. *The Empress Theodora with Her Entourage*. Apse mosaic, c. 547. Photo: akg-images.

8-25.   *The Kiss*, 1907–8 (oil on canvas) by Gustav Klimt (1862–1918), Österreichische Galerie Belvedere, Vienna, Austria/The Bridgeman Art Library.

8-26.   *Adele Bloch-Bauer II*, 1912 (oil on canvas) by Gustav Klimt (1862–1918). Private collection/Index/The Bridgeman Art Library Nationality/copyright status: Austrian/out of copyright.

8-27.   *Judith*, 1901 (oil on canvas) by Gustav Klimt (1862–1918), Österreichische Galerie Belvedere, Vienna, Austria/The Bridgeman Art Library Nationality/copyright status: Austrian/out of copyright.

8-28.   *Judith and Holofernes*, 1599 (oil on canvas) by Michelangelo Merisi da Caravaggio (1571–1610), Palazzo Barberini, Rome, Italy/The Bridgeman Art Library Nationality/copyright status: Italian/out of copyright.

8-29.   *Death and Life*, c. 1911 (oil on canvas) by Gustav Klimt (1862–1918). Private collection/The Bridgeman Art Library Nationality/copyright status: Austrian/out of copyright.

*Chapter 9*

9-1.    Permission granted under Creative Commons license; PD-US.

9-2.    Deutsche Bank Collection. © 2012 Foundation Oskar Kokoschka/Artists Rights Society (ARS), New York-Prolitteris, Zürich.

9-3.    NORDICO Stadtmuseum Linz, photo Thomas Hackl.

9-4.    Kokoschka, Oskar (1886–1980), © 2012 Foundation Oskar Kokoschka/Artists Rights Society (ARS), New York-Prolitteris, Zürich. *Reclining Female Nude*. Watercolor, gouache, and pencil on heavy tan wove paper. 19087. 31.4 x 45.1 cm. Private collection.

9-5.    Illustration for *Die Träumenden Knaben*, 1908 (color litho) by Kokoschka, Oskar (1886–1980). © 2012 Foundation Oskar Kokoschka/Artists Rights Society (ARS), New York-Prolitteris, Zürich. Private collection/The Stapleton Collection/The Bridgeman Art Library.

9-6.    *The Dreaming Boys*, 1908, pub. 1917 (color litho) by Oskar Kokoschka

(1886–1980). © 2012 Foundation Oskar Kokoschka/Artists Rights Society (ARS), New York-Prolitteris, Zürich. Scottish National Gallery of Modern Art, Edinburgh, UK/The Bridgeman Art Library.

9-7.  Oskar Kokoschka (sepia photo) by Hugo Erfurth (1874–1948). © 2012 Artists Rights Society (ARS), New York/V-G Bild-Kunst, Bonn. Private collection/ The Stapleton Collection/The Bridgeman Art Library.

9-8.  Kokoschka, Oskar (1886–1980), *Self-Portrait as Warrior.* © 2012 Foundation Oskar Kokoschka/Artists Rights Society (ARS), New York-Prolitteris, Zürich. Photograph by Sharon Mollerus, permission granted under Creative Commons license.

9-9.  Franz Xaver Messerschmidt (1736–1783), *The Incapable Bassoonist,* 1771–77? Tin cast. Private collection, courtesy of Neue Galerie New York.

9-10. Kokoschka, Oskar (1896–1980), *The Trance Player, Portrait of Ernst Reinhold.* 1909. Royal Museums of Fine Arts of Belgium, Brussels. © 2012 Foundation Oskar Kokoschka/Artists Rights Society (ARS), New York-Prolitteris, Zürich. Inv. no. 6152. Dig. photo: J. Geleyns.

9-11. Kokoschka, Oskar (1886–1980), © 2012 Foundation Oskar Kokoschka/Artists Rights Society (ARS), New York-Prolitteris, Zürich. *Rudolf Blümner* (WV 51), 1910. Oil on canvas. 80 x 57.5 cm. Private collection, courtesy Neue Galerie New York. Location: private collection. Photo credit: Neue Galerie New York/ Art Resource, N.Y.

9-12. *Portrait of Auguste Henri Forel* (oil on canvas) by Oskar Kokoschka (1886–1980), Stadtische Kunsthalle, Mannheim, Germany/The Bridgeman Art Library.

9-13. Oskar Kokoschka (1886–1980), *Ludwig Ritter von Janikowski,* 1909, oil on canvas. Private collection, courtesy of Neue Galerie New York. © 2012 Foundation Oskar Kokoschka/Artists Rights Society (ARS), New York-Prolitteris, Zürich.

9-14. Poster design for the cover of *Der Sturm* magazine, 1911, by Oskar Kokoschka (1886–1980), Museum of Fine Arts, Budapest, Hungary/The Bridgeman Art Library.

9-15. Kokoschka, Oskar (1886–1980), © 2012 Foundation Oskar Kokoschka/Artists Rights Society (ARS), New York-Prolitteris, Zürich. *Selbstbildnis, die Hand ans Gesicht gelegt.* Oil on canvas (1918–1919), 83.6 x 62.8 cm. W. 125. Location: Museum Leopold, Vienna, Austria. Photo credit: Erich Lessing/Art Resource, N.Y.

9-16. Kokoschka, Oskar (1886–1980), © 2012 Foundation Oskar Kokoschka/Artists Rights Society (ARS), New York-Prolitteris, Zürich. *Self-Portrait with Lover (Alma Mahler).* Coal and black chalk on paper, 1913. Location: Museum Leopold, Vienna, Austria. Photo credit: Erich Lessing/Art Resource, N.Y.

9-17. *The Wind's Fiancée,* 1914 (oil on canvas) by Kokoschka, Oskar (1886–1980), Kunstmuseum, Basel, Switzerland/Giraudon/The Bridgeman Art Library. © 2012 Foundation Oskar Kokoschka/Artists Rights Society (ARS), New York-Prolitteris, Zürich.

9-18. *Self Portrait,* 1917 (oil on canvas) by Oskar Kokoschka (1886–1980), Van der Heydt Museum, Wuppertal, Germany/Giraudon/The Bridgeman Art Library. © 2012 Foundation Oskar Kokoschka/Artists Rights Society (ARS), New York-Prolitteris, Zürich.

9-19. *Self Portrait with Bandaged Ear and Pipe,* 1889 (oil on canvas) by Vincent van Gogh (1853–90). Private collection/The Bridgeman Art Library Nationality/ copyright status: Dutch/out of copyright.

9-20.  O. Kokoschka, *Child in the Hands of Its Parents* (*Kind mit den Händen der Eltern*), Inv. 5548 Belvedere, Vienna. © 2012 Foundation Oskar Kokoschka/Artists Rights Society (ARS), New York-Prolitteris, Zürich.

9-21.  Kokoschka, Oskar (1886–1980), © 2012 Foundation Oskar Kokoschka/Artists Rights Society (ARS), New York-Prolitteris, Zürich. *Hans Tietze and Erica Tietze-Conrat*. 1909. Oil on canvas, 30-1/8 x 53-5/8" (76.5 x 136.2 cm). Abby Aldrich Rockefeller Fund. Location: The Museum of Modern Art, New York, N.Y., U.S.A. Photo credit: digital image © The Museum of Modern Art/Licensed by SCALA/Art Resource, N.Y.

9-22.  *Children Playing*, 1909 (oil on canvas), Kokoschka, Oskar (1886–1980)/Wilhelm Lehmbruck Museum, Duisburg, Germany/© 2012 Foundation Oskar Kokoschka/Artists Rights Society (ARS), New York-Prolitteris, Zürich./The Bridgeman Art Library International.

*Chapter 10*

10-1.  Schiele, Egon; Austrian painter, 1890–1918. Portrait. Photograph, ca.1914. Josef Anton Trcka. Photo: akg-images.

10-2.  *Double Portrait of Otto and Heinrich Benesch*, by Egon Schiele (1890–1918). Oil on canvas. Neue Galerie, Linz, Austria/The Bridgeman Art Library.

10-3.  *Gerti Schiele*, 1909 by Egon Schiele (1890–1918). Oil on canvas. Private collection/The Bridgeman Art Library Nationality/copyright status: Austrian/out of copyright.

10-4.  Schiele, Egon, 1890–1918. *Portrait of the Artist Anton Peschka*, 1909. Oil, silver and gold bronze paint on canvas, 110 x 100 cm. London, Sotheby's. Lot 25, 31/3/87. © Sotheby's/akg-images.

10-5.  Schiele, Egon; Austrian painter; Tulln/Danube 12.6.1890. Hietzing near Vienna 31.10.1918. *Self-Portrait as Semi-Nude with Black Jacket*, 1911. Gouache, watercolors, and pencil on paper, 48 x 32.1 cm. Inv. 31.159 Vienna, Graphische Sammlung Albertina. Photo: akg-images.

10-6.  Schiele, Egon, Austrian painter and illustrator, Tulln a.d.Donau 12.6.1890–Hietzing near Vienna 31.10.1918. *Kneeling Self-Portrait*, 1910. Black chalk and gouache on paper, 62.7 x 44.5 cm. Vienna, Leopold Museum—Privatstiftung. Photo: akg-images.

10-7.  Schiele, Egon, 1890–1918. *Sitting Self-Portrait, Nude*, 1910. Oil and opaque colors on canvas, 152.5 x 150 cm. Inv. no. 465 Vienna, Leopold Museum—Privatstiftung. Photo: akg-images.

10-8.  Schiele, Egon; Austrian painter, drawer; Tulln an der Donau 12.6.1890–Hietzing near Wien 31.10.1918. *Self-Portrait with Striped Protective Sleeves*, 1915. Pencil with covering color on paper 49 x 31.5 cm. Vienna, Sammlung Leopold. Photo: akg-images.

10-9.  Egon Schiele (1890–1918), *Self-Portrait, Head*, 1910. Watercolor, gouache, charcoal, and pencil. Private collection, courtesy of Neue Galerie New York.

10-10. *Self-Portrait Screaming* by Egon Schiele (1890–1918). Private collection/The Bridgeman Art Library.

10-11. Messerschmidt, Franz Xaver (1736–1783). *The Yawner*, after 1770. Lead, 41 cm. N. inv.: 53.655.S3. Photo: Jozsa Denes. Location: Museum of Fine Arts (Szepmuveszeti Muzeum), Budapest, Hungary. Photo credit: © The Museum of Fine Arts Budapest/Scala/Art Resource, N.Y.

10-12. Schiele, Egon; Austrian painter; 1890–1918. *Kauerndes Mädchen mit gesenktem*

*Kopf* (*Crouching Female Nude with Bent Head*), 1918. Black chalk, watercolor, and coating paint on paper, 29.7 x 46.2 cm. Vienna (Austria), Collection Leopold. Photo: akg-images.

10-13. Schiele, Egon, 1890–1918. *Liebesakt* (*Love Making*), 1915. Pencil and gouache on paper, 33.5 x 52 cm. Vienna, Leopold Collection. Photo: akg-images.

10-14. *Death and the Maiden* (*Mann und madchen*), 1915 by Egon Schiele (1890–1918). Österreichische Galerie Belvedere, Vienna, Austria/The Bridgeman Art Library.

10-15. Schiele, Egon, 1890–1918. *Death and Man* (*Self Seers II*), 1911. Oil on canvas, 80.5 x 80 cm. Inv. no. 451 Vienna, Leopold Museum—Privatstiftung. Photo: akg-images.

10-16. Schiele, Egon, *Eremiten* (*Hermits*) *Egon Schiele and Gustav Klimt.* Oil on canvas (1912), 181 x 181 cm. L. 203. Location: Museum Leopold, Vienna, Austria. Photo credit: Erich Lessing/Art Resource, N.Y.

10-17. Schiele, Egon (1890–1918), *Cardinal and Nun* (*Liebkosung*). 1912. Location: Museum Leopold, Vienna, Austria. Photo credit: Erich Lessing/Art Resource, N.Y.

10-18. *The Kiss,* 1907–8 (oil on canvas) by Gustav Klimt (1862–1918), Österreichische Galerie Belvedere, Vienna, Austria/The Bridgeman Art Library.

### Chapter 11

11-1. Permission granted under Creative Commons license; PD-US.

11-2. Dirck Jacobsz, *Een groep schutters,* 1529. Rijksmuseum, The Netherlands.

11-3. Courtesy Anna Kris Wolff.

11-4. Messerschmidt, Franz Xaver (1736–1783). *The Yawner,* after 1770. Lead, 41 cm. N. inv.: 53.655.S3. Photo: Jozsa Denes. Location: Museum of Fine Arts (Szepmuveszeti Muzeum), Budapest, Hungary. Photo credit: © The Museum of Fine Arts Budapest/Scala/Art Resource, N.Y.

11-5. Messerschmidt, Franz Xaver, 1736–1785. *Ein Erzbösewicht* (*Arch-Villain*), after 1770. No. 33 of the series of "Charakterköpfe" (character heads). Tin-lead alloy. Height 38.5 cm. Inv. no. 2442 Vienna, Österr. Galerie im Belvedere. Photo: akg-images.

11-6. Courtesy Leonie Gombrich

11-7. *Caricature of Rabbatin de Griffi and His Wife Spilla Pomina* (pen and ink on paper) (photo) by Agostino Carracci (1557–1602). © Nationalmuseum, Stockholm, Sweden/The Bridgeman Art Library.

### Chapter 12

12-1. Sonia Epstein
12-2. Chris Willcox
12-3. Chris Willcox
12-4. Sonia Epstein
12-5. Sonia Epstein

### Chapter 13

13-1. Sonia Epstein

13-2. *Montagne Sainte-Victoire,* 1904–6 (oil on canvas) by Paul Cézanne (1839–1906), Kunsthaus, Zurich, Switzerland/The Bridgeman Art Library.

13-3. Braque, Georges, 1882–1963. *Le Sacré-Coeur vu de l'atelier de l'artiste* (*Sacré-Coeur as Seen from the Artist's Studio*), 1910. Oil on canvas, 55.5 x 40.7 cm. ©

2012 Artists Rights Society (ARS), New York/ADAGP, Paris. Roubaix, private collection. Photo: akg-images/André Held.

13-4.   Mondrian, Piet (1872–1944), *Study of Trees 1: Study for Tableau No. 2/Composition No. VII*, 1912. Location: Haags Gemeentemuseum, The Hague, Netherlands © Mondrian/Holtzman trust c/o International Washington D.C. Photo: © DeA Picture Library/Art Resource, N.Y.

13-5.   Mondrian, Piet (1872–1944), *Pier and Ocean 5 (Sea and Starry Sky)* (1915) (inscribed 1914). Charcoal and watercolor on paper, 34-5/8 x 44 (87.9 x 111.7 cm). © Mondrian/Holtzman Trust c/o HCR International Washington, D.C., Mrs. Simon Guggenheim Fund. Location: The Museum of Modern Art, New York, N.Y., U.S.A. Photo: Digital Image © The Museum of Modern Art/Licensed by Scala/Art Resource, N.Y.

13-6.   Brouillet, André (1857–1914), *A Lesson on Hysteria* by Jean-Martin Charcot (1825–93), pioneer of neurology, at the hospital "la Salpêtrièr." The patient is Blanche Wittmann, held by Babinski, who hypnotized the patients. Sigmund Freud took lessons with Charcot in 1885–86. Location: Hôpital Neurologique, Lyon, France Photo: Erich Lessing/Art Resource, N.Y.

*Chapter 14*

14-1.   Sonia Epstein
14-2.   Terese Winslow, Chris Willcox
14-3.   Terese Winslow
14-4.   Terese Winslow
14-5.   Terese Winslow, Chris Willcox
14-6.   Sonia Epstein

*Chapter 15*

15-1.   Terese Winslow
15-2.   Sonia Epstein
15-3.   Sonia Epstein
15-4.   Terese Winslow
15-5.   Chris Willcox
15-6.   Sonia Epstein
15-7.   *Mona Lisa*, c. 1503–6 (oil on panel), Vinci, Leonardo da (1452–1519), Louvre, Paris, France/Giraudon/The Bridgeman Art Library International.
15-8.   Courtesy Margaret Livingstone
15-9.   Courtesy Damien Kuffler
15-10.  Chris Willcox
15-11.  Courtesy Torsten Wiesel
15-12.  Columbia Art Department
15-13.  Sonia Epstein
15-14.  Sonia Epstein

*Chapter 16*

16-1.   *Adele Bloch-Bauer II*, 1912 (oil on canvas) by Gustav Klimt (1862–1918). Private collection/Index/The Bridgeman Art Library Nationality/copyright status: Austrian/out of copyright.

16-2.  *Portrait of Auguste Henri Forel* (oil on canvas) by Oskar Kokoschka (1886–1980) Stadtische Kunsthalle, Mannheim, Germany/The Bridgeman Art Library.

16-3.  Private collection

16-4.  Schiele, Egon (1890–1918), *Reclining Nude*, 1918. Crayon on paper, H. 11-3/4, W. 18-1/4 inches (29.8 x 46.4 cm.). Bequest of Scofield Thayer, 1982 (1984.433.310). Location: The Metropolitan Museum of Art, New York, N.Y., U.S.A. Photo: Image copyright © The Metropolitan Museum of Art/Art Resource, N.Y.

16-5.  Terese Winslow

16-6.  Columbia Art Department

16-7.  Sonia Epstein

16-8.  Photo credit: Eve Vagg. Chris Willcox, Sonia Epstein.

16-9.  Chris Willcox

16-10. Chris Willcox

16-11. Chris Willcox

16-12. Sonia Epstein

16-13. Chris Willcox

16-14. Chris Willcox

16-15. Chris Willcox

16-16. Sonia Epstein

16-17. Sonia Epstein

16-18. *Self-Portrait at the Age of 63*, 1669 (oil on canvas) by Rembrandt Harmensz. van Rijn (1606–69), National Gallery, London, U.K./The Bridgeman Art Library.

16-19. Courtesy Charles Stevens

16-20. *Bull and Horse*, cave painting. Location: Lascaux Caves, Périgord, Dordogne, France. Photo: Art Resource, N.Y.

16-21. From *Visual Intelligence: How We Create What We See* by Donald D. Hoffman. Copyright © 1998 by Donald D. Hoffman. Used by permission of W. W. Norton & Company, Inc.

*Chapter 17*

17-1.  Terese Winslow

17-2.  Terese Winslow

17-3.  *The Vegetable Gardener,* c. 1590 (oil on panel) by Giuseppe Arcimboldo (1527–93), Museo Civico Ala Ponzone, Cremona, Italy/The Bridgeman Art Library.

17-4.  *Mona Lisa,* c. 1503–6 (oil on panel) by Leonardo da Vinci (1452–1519). Image modified by Chris Willcox.

17-5.  Terese Winslow

17-6.  Terese Winslow

*Chapter 18*

18-1.  Klimt, Gustav (1862–1918), *A Field of Poppies*, 1907. Oil on canvas, 110 x 110 cm. Location: Oesterreichische Galerie im Belvedere, Vienna, Austria. Photo: Erich Lessing/Art Resource, N.Y.

18-2.  Courtesy Richard Gregory Estate

18-3.  Chris Willcox

18-4.  Courtesy Richard Gregory Estate, modified by Sonia Epstein

18-5.   Chris Willcox

18-6.   *Head of a Woman* (pen and ink and watercolor on paper) by Gustav Klimt (1862–1918), Neue Galerie, Linz, Austria/The Bridgeman Art Library.

18-7.   *Self-Portrait with Felt Hat*, 1887–88 (oil on canvas) by Vincent van Gogh (1853–90) Van Gogh Museum, Amsterdam, the Netherlands/The Bridgeman Art Library.

18-8.   *Adele Bloch-Bauer II*, 1912 (oil on canvas) by Gustav Klimt (1862–1918). Private collection/Index/The Bridgeman Art Library Nationality/copyright status: Austrian/out of copyright.

18-9.   Klimt, Gustav (1862–1918), *Adele Bloch-Bauer I*. 1907. Oil, silver, and gold on canvas. This acquisition made available in part through the generosity of the heirs of the Estates of Ferdinand and Adele Bloch-Bauer. Photo: John Gilliland. Location: Neue Galerie New York, N.Y., U.S.A. Photo: Neue Galerie New York/Art Resource, N.Y.

18-10. *Judith*, 1901 (oil on canvas) by Gustav Klimt (1862–1918), Österreichische Galerie Belvedere, Vienna, Austria/The Bridgeman Art Library Nationality/Copyright status: Austrian/out of copyright.

18-11. Kokoschka, Oskar (1886–1980), © 2012 Foundation Oskar Kokoschka/Artists Rights Society (ARS), New York-Prolitteris, Zürich. *Selbstbildnis, die Hand ans Gesicht gelegt*. Oil on canvas (1918–19), 83.6 x 62.8 cm. W. 125. Location: Museum Leopold, Vienna, Austria. Photo: Erich Lessing/Art Resource, N.Y.

18-12. Kokoschka, Oskar (1886–1980), © 2012 Foundation Oskar Kokoschka/Artists Rights Society (ARS), New York-Prolitteris, Zürich. *Rudolf Blümner* (WV 51), 1910. Oil on canvas. 80 x 57.5 cm. Private collection, courtesy Neue Galerie New York Location: private collection. Photo: Neue Galerie New York/Art Resource, N.Y. © 2012 Foundation Oskar Kokoschka/Artists Rights Society (ARS), New York-Prolitteris, Zürich.

18-13. Oskar Kokoschka (1886–1980), *Ludwig Ritter von Janikowski*, 1909. Oil on canvas. 60.2 x 55.2 cm. Private collection, courtesy of Neue Galerie New York. © 2012 Foundation Oskar Kokoschka/Artists Rights Society (ARS), New York-Prolitteris, Zürich.

18-14. *The Wind's Fiancée*, 1914 (oil on canvas) by Kokoschka, Oskar (1886–1980). Kunstmuseum, Basel, Switzerland/Giraudon/The Bridgeman Art Library.

18-15. Schiele, Egon, 1890–1918. *Liebesakt* (*Love Making*), 1915. Pencil and gouache on paper, 33.5 x 52 cm. Vienna, Leopold Collection. Photo: akg-images.

*Chapter 20*

20-1.   Kokoschka, Oskar (1886–1980), © 2012 Foundation Oskar Kokoschka/Artists Rights Society (ARS), New York-Prolitteris, Zürich. *Selbstbildnis, die Hand ans Gesicht gelegt*. Oil on canvas (1918–19), 83.6 x 62.8 cm. W. 125. Location: Museum Leopold, Vienna, Austria. Photo: Erich Lessing/Art Resource, N.Y.

20-2.   Schiele, Egon, Austrian painter and illustrator, Tulln a.d.Donau 12.6.1890–Hietzing near Vienna 31.10.1918. *Kneeling Self-Portrait*, 1910. Black chalk and gouache on paper, 62.7 x 44.5 cm. Vienna, Leopold Museum—Privatstiftung. Photo: akg-images.

20-3.   Kokoschka, Oskar (1896–1980), *The Trance Player, Portrait of Ernst Reinhold*. 1909. Royal Museums of Fine Arts of Belgium, Brussels. © 2012 Foundation Oskar Kokoschka/Artists Rights Society (ARS), New York-Prolitteris, Zürich. Inv. no. 6152. Dig. photo: J. Geleyns.

20-4. Hirshhorn Museum and Sculpture Garden, Smithsonian Institution, Gift of the Joseph H. Hirshhorn Foundation, 1966. Photo by Lee Stalsworth.

20-5. Lentos Kunstmuseum Linz, photo: Reinhard Haider.

20-6 through 20-8. Springer and Plenum, 1967, pp. 179–181, *Eye Movements and Vision*, A. L. Yarbus, figures 114–17, © 1967 Plenum Press, with kind permission from Springer Science+Business Media B.V.

20-9. Kokoschka, Oskar (1886–1980), © 2012 Foundation Oskar Kokoschka/Artists Rights Society (ARS), New York-Prolitteris, Zürich. *Portrait of the Actress Hermine Korner*, 1920. Color lithograph. 26 x 18-1/4 in. Minneapolis Institute of Arts, Gift of Bruce B. Dayton, 1955.

20-10. Kokoschka, Oskar (1886–1980), © 2012 Foundation Oskar Kokoschka/Artists Rights Society (ARS), New York-Prolitteris, Zürich. *Hans Tietze and Erica Tietze-Conrat*, 1909. Oil on canvas, 30-1/8 x 53-5/8" (76.5 x 136.2 cm). Abby Aldrich Rockefeller Fund. Location: The Museum of Modern Art, New York, N.Y., U.S.A. Photo: digital image © The Museum of Modern Art/Licensed by SCALA/Art Resource, N.Y.

20-11. O. Kokoschka, *Child in the Hands of Its Parents (Kind mit den Händen der Eltern)*, Inv. 5548 Belvedere, Vienna. © 2012 Foundation Oskar Kokoschka/Artists Rights Society (ARS), New York-Prolitteris, Zürich.

20-12. *Children Playing*, 1909 (oil on canvas), Kokoschka, Oskar (1886–1980)/Wilhelm Lehmbruck Museum, Duisburg, Germany/ © 2012 Foundation Oskar Kokoschka/Artists Rights Society (ARS), New York-Prolitteris, Zürich/The Bridgeman Art Library International.

20-13. *The Bedroom*, 1888 (oil on canvas) by Vincent van Gogh (1853–90), Van Gogh Museum, Amsterdam, the Netherlands/The Bridgeman Art Library.

## Chapter 21

21-1. Joseph LeDoux, *The Emotional Brain*, p. 51, modified by Sonia Epstein

21-2. Terese Winslow, Sonia Epstein

21-3. Sonia Epstein

## Chapter 22

22-1. Terese Winslow

22-2. Terese Winslow

22-3. Chris Willcox

22-4. Phineas Gage's skull and tamping iron, photograph, courtesy Woburn Public Library, Woburn, MA.

22-5. Terese Winslow

22-6. Terese Winslow

22-7. Sonia Epstein

22-8. Terese Winslow, Sonia Epstein

## Chapter 23

23-1. Courtesy Eric Kandel

23-2. *Hygieia*, 1900–07 (detail from *Medicine*) by Gustav Klimt (1862–1918), Schloss Immendorf, Austria/The Bridgeman Art Library.

23-3. Egon Schiele (1890–1918), *Self Portrait, Head*, 1910. Watercolor, gouache,

charcoal, and pencil. Private collection, courtesy of Neue Galerie, New York, N.Y.

23-4.   Kokoschka, Oskar (1896–1980), *The Trance Player, Portrait of Ernst Reinhold.* 1909. Royal Museums of Fine Arts of Belgium, Brussels. © 2012 Foundation Oskar Kokoschka/Artists Rights Society (ARS), New York-Prolitteris, Zürich. Inv. no. 6152. Dig. photo: J. Geleyns.

23-5.   Oskar Kokoschka (1886–1980), *Ludwig Ritter von Janikowski,* 1909. Oil on canvas, 60.2 x 55.2 cm. Private collection, courtesy of Neue Galerie, New York, N.Y.

23-6.   Reprinted from *Journal of Comaparative Neurology,* vol. 493, H. Fisher, A. Arthur, L. L. Brown, "Romantic Love: An fMRI Study of a Neural Mechanism for Mate Choice," p. 59, Oct. 2005, with permission from John Wiley and Sons.

23-7.   Reprinted from *NeuroImage,* vol. 20, J. S. Winston, J. O'Doherty, R. J. Dolan, "Common and Distinct Neural Responses During Direct and Incidental Processing of Multiple Facial Emotions," p. 89, Sept. 2003, with permission from Elsevier.

## Chapter 24

24-1.   *A Lady at the Virginals with a Gentleman (The Music Lesson),* c. 1662–65 (oil on canvas) by Jan Vermeer (1632–75). The Royal Collection © 2011 Her Majesty Queen Elizabeth II/The Bridgeman Art Library.

24-2.   *Las Meninas* or *The Family of Philip IV,* c.1656 (oil on canvas) by Diego Rodríguez de Silva y Velázquez (1599–1660) Prado, Madrid, Spain/Giraudon/The Bridgeman Art Library.

24-3.   Albertina, Vienna. Inv. 26276.

## Chapter 25

25-1.   *The Cheat with the Ace of Diamonds,* c. 1635–40 (oil on canvas) by Georges de la Tour (1593–1652), Louvre, Paris, France/Giraudon/The Bridgeman Art Library.

25-2.   Sonia Epstein

25-3.   Springer and Plenum, 1967, pp. 179–181, *Eye Movements and Vision,* A. L. Yarbus, figures 114–17, © 1967 Plenum Press, with kind permission from Springer Science+Business Media B.V.

25-4.   Used with kind permission from Springer Science & Business Media: *Journal of Autism and Developmental Disorders,* "Visual Scanning of Faces in Autism," 32, 2002, p. 257, Kevin Pelphrey, Figure 3. Image courtesy Kevin Pelphrey.

25-5.   Reprinted from *Trends in Cognitive Science,* vol. 2, V. Gallese, A. Goldman, Mirror Neurons and the Simulation Theory of Mind-Reading, p. 494, 1998, with permission from Elsevier.

25-6.   Terese Winslow (assisted by Sonia Epstein)

25-7.   Reprinted from *Encycolpedia of Consciousness,* vol. 2, R. Saxe in William P. Banks, *Theory of Mind (Neural Basis),* p. 402, 2009, with permission from Elsevier.

## Chapter 26

26-1.   Sonia Epstein
26-2.   Sonia Epstein

26-3.   Terese Winslow (assisted by Sonia Epstein)
26-4.   Columbia Art Department

*Chapter 27*

27-1.   *The Venus of Hohle Fels.* Photo: H. Jensen. Copyright: Universität Tübingen.

*Chapter 28*

28-1.   Oskar Kokoschka, 1886–1980, © ARS, N.Y. *Portrait of Tomas Garrigue Masaryk,* 1935–36, oil on canvas, 38-3/8 in. x 51-1/2 in., Carnegie Museum of Art, Pittsburgh; Patrons Art Fund. © 2012 Foundation Oskar Kokoschka/Artists Rights Society (ARS), New York-Prolitteris, Zürich.

*Chapter 29*

29-1.   Reprinted from *Neuron,* 70(2), Stanislas Dehaene, Jean-Pierre Changeux, "Experimental and Theoretical Approaches to Conscious Processing," pp. 200–227, Copyright 2011, with permission from Elsevier.

*Chapter 30*

30-1.   "Neural Activity Observed in People Solving Verbal Problems with Insight," Mark Jung-Beeman, Edward M. Bowden, Jason Haberman, Jennifer L. Frymiare, Stella Arambel-Liu, Richard Greenblatt, Paul J. Reber, John Kounios, *PLoS Biology* 2(4): 0500–0510. 2004. p. 0502&0505.
30-2.   "Neural Activity Observed in People Solving Verbal Problems with Insight," Mark Jung-Beeman, Edward M. Bowden, Jason Haberman, Jennifer L. Frymiare, Stella Arambel-Liu, Richard Greenblatt, Paul J. Reber, John Kounios, *PLoS Biology* 2(4): 0500–0510. 2004. p. 0502&0505.

*Chapter 31*

31-1.   *Nadia: A Case of Extraordinary Drawing Ability in an Autistic Child,* 1977, (ISBN 9780126357509), Selfe ed, p. 20, drawing by Nadia of horse and rider, copyright Elsevier.
31-2.   Nicholas Humphrey, "Cave Art, Autism, and the Evolution of the Human Mind," *Cambridge Archaeological Journal,* 8(2), p. 166, reproduced with permission, *Cambridge Archaeological Journal.*
31-3.   Nicholas Humphrey, "Cave Art, Autism, and the Evolution of the Human Mind," *Cambridge Archaeological Journal,* 8(2), p. 166, reproduced with permission, *Cambridge Archaeological Journal.*
31-4.   Uta Frith, *Autism: Explaining the Enigma,* Wiley-Blackwell Publishing.

Note: **Bold** page numbers refer to figures.

ERIC R. KANDEL is University Professor and Kavli Professor at Columbia University and a Senior Investigator at the Howard Hughes Medical Institute. Kandel is founding director of the Center for Neurobiology and Behavior at the College of Physicians and Surgeons of Columbia University, and recipient of the 2000 Nobel Prize in Physiology or Medicine for his work on memory storage in the brain. He is the author of *In Search of Memory*, a memoir that won a *Los Angeles Times* Book Award, and co-author of *Principles of Neural Science*, the standard textbook in the field. He was born in Vienna and lives in New York with his wife, Denise.